GOLDEN

DUTCH AND FLEMISH

MASTERWORKS

FROM THE ROSE-MARIE

AND EIJK VAN OTTERLOO

COLLECTION

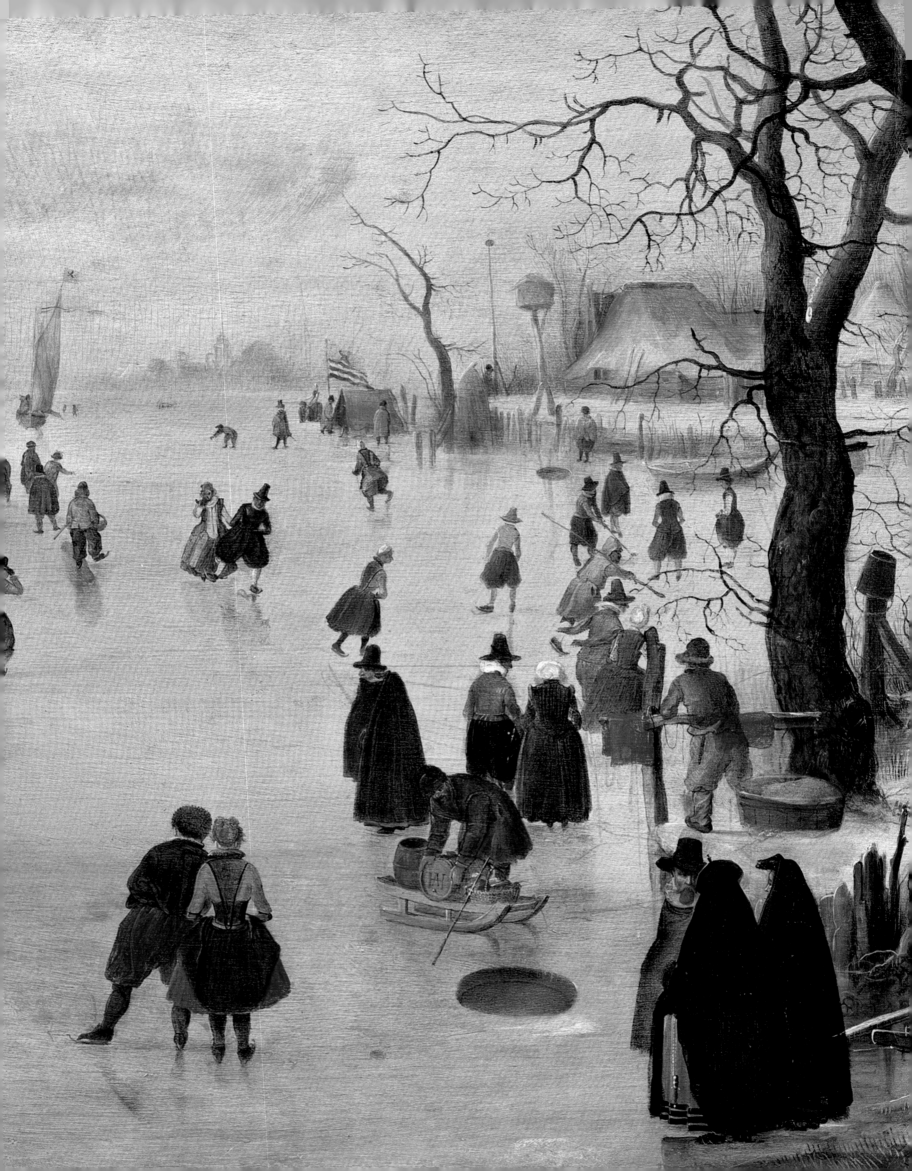

PEABODY ESSEX MUSEUM, SALEM, MASSACHUSETTS
in conjunction with the Mauritshuis, The Hague
and in association with Yale University Press, New Haven and London

GOLDEN

DUTCH AND FLEMISH MASTERWORKS FROM
THE ROSE-MARIE AND EIJK VAN OTTERLOO
COLLECTION

FREDERIK J. DUPARC

WITH FEMKE DIERCKS, REINIER BAARSEN,

AND LOEK VAN AALST

Golden: Dutch and Flemish Masterworks from the Rose-Marie and Eijk van Otterloo Collection accompanies the exhibition of the same name organized by the Peabody Essex Museum, Salem, Massachusetts, in conjunction with the Mauritshuis, The Hague. The exhibition is on view from February 26 through June 19, 2011; and travels to the Fine Arts Museums of San Francisco, July 9 through October 2, 2011, and the Museum of Fine Arts, Houston, November 13, 2011 through February 12, 2012.

Peabody Essex Museum
East India Square
Salem, Massachusetts 01970
www.pem.org

Published in association with
Yale University Press, New Haven
and London.

Yale University Press
302 Temple Street
P.O. Box 209040
New Haven, Connecticut
06520-9040
www.yalebooks.com

Library of Congress Control
Number: 2010937601
ISBN: 978-0-87577-222-6
(Peabody Essex Museum, pbk)
ISBN: 978-0-300-16973-7
(Yale University Press, cloth)

Front cover: Willem Claesz. Heda, *Still Life with Glasses and Tobacco*, 1633 (catalogue 29, detail)
Back cover: Ambrosius Bosschaert the Elder, *Still Life with Roses in a Glass Vase*, ca. 1619 (catalogue 11, detail)

Coordinated and edited by
Terry Ann R. Neff,
t. a. neff associates, inc.
Tucson, Arizona

Designed and produced by
Studio Blue, Chicago, Illinois
Typeset in DTL Haarlemmer
Printed by Graphicom, Italy
Printed on 135 gsm Gardapat Kiara
Color separations by ProGraphics,
Rockford, Illinois

TABLE OF CONTENTS

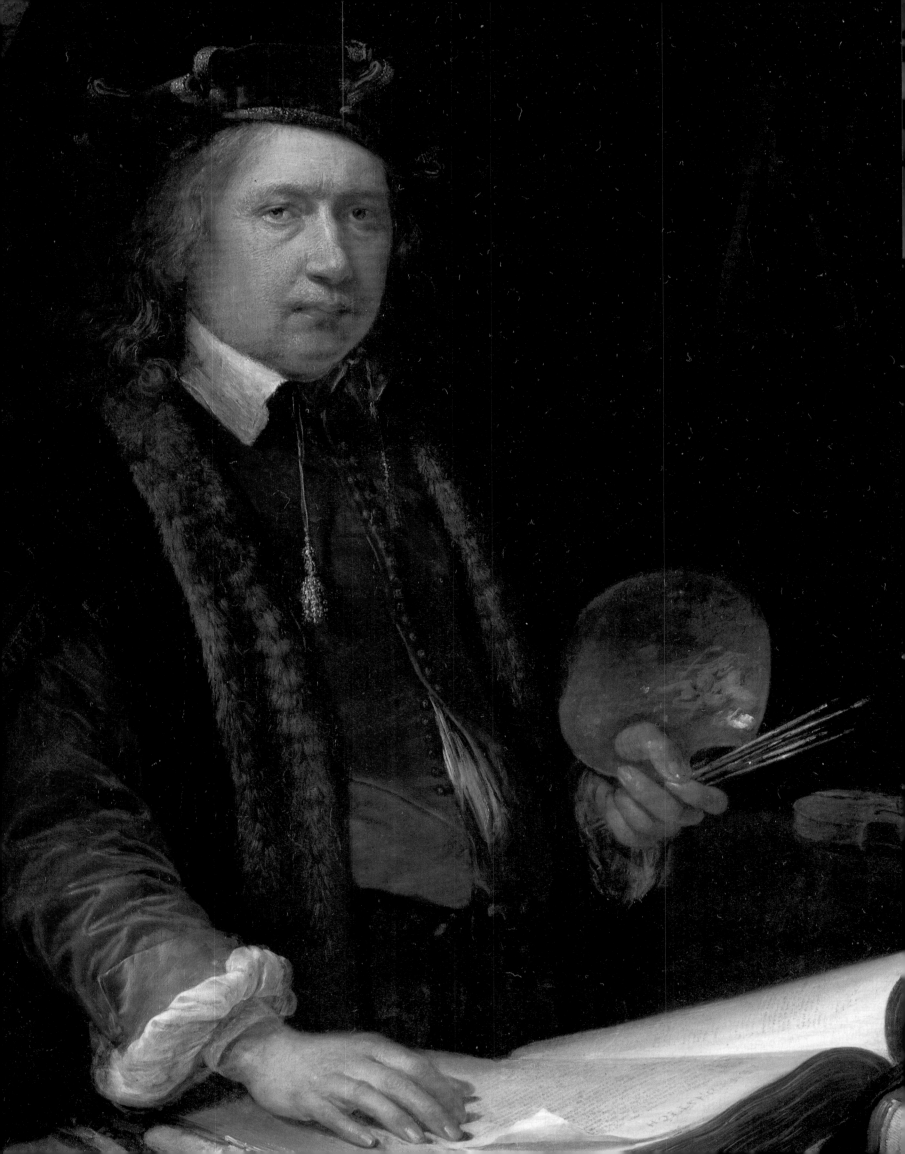

FOREWORD

The golden age is before us, not behind us.
WILLIAM SHAKESPEARE (1565–1616)

Timing and quality – these are the hallmarks of a Golden Age. The Greek and Roman poets originated the concept to describe the first and best age in the world, when mankind lived in a state of ideal prosperity and happiness. Not surprisingly, the poets chose gold, the metal long considered most important and precious, as their metaphorical measure of the superlative. Hence, we often identify as Golden Ages periods in which a nation or culture enjoys its highest state of prosperity or attains an acme of excellence in art, literature, philosophy, and science. Unprecedented activity in a circumscribed area can also acquire this prized status, as in the Golden Age of Hollywood or French couture. Whether the time frame and achievement are broad or specialized, the confluence of commerce, technology, and culture in a Golden Age is pronounced, creating a crucible for innovation and ambition. And, in that respect, as Shakespeare reminds us, a Golden Age is not just about retrospective evaluation but is a phenomenon always in the making, stimulated by exceedingly favorable times or propitious opportunity.

It is easy to assume that the Golden Age of seventeenth-century Dutch painting owes its laurels to the glowing, golden quality of light conveyed by an array of Dutch painters, especially Rembrandt. However, the achievement goes far beyond the medium of painting and encompasses rapidly changing, opportunity-rich circumstances that the Northern Netherlands experienced from approximately 1585 to 1702. This was an efflorescence fostered by the quest for independence from Spain, migration of talent from Flanders, dominance in international commerce, rise of a wealthy middle class, intensive urbanization, religious and political tolerance, and cheap energy sources. As never before, Dutch painters, as well as writers, scholars, scientists, architects, and engineers, began shaping a different way of looking at the world around them.

With wealth came a healthy art market, the demand created not by royal or religious patrons but by merchants whose homes became centers for fostering culture and the arts. In fact, in domesticating the source of patronage and the site of display, the Dutch Golden Age laid the foundation for the tradition of the private collector. This tradition has promoted the appreciation of European, but especially Dutch, Old Master paintings as a cornerstone of mankind's artistic achievements. And, with so many examples now held by museums, the opportunity to assemble great private collections of seventeenth-century Dutch paintings has become increasingly rare – an ironic outcome for the constituency that initiated the ascendancy of these works.

Yet, as ambitious and disciplined collectors know, it is possible to defy the odds. With deep admiration and pride, the Peabody Essex Museum presents, for the first time in its entirety, the seventeenth-century Dutch and Flemish masterworks that Rose-Marie and Eijk van Otterloo

have collected with such determination and connoisseurship over the past three decades. Their richly deserved renown for this achievement rests on three principles: first, an unswerving commitment to quality as expressed by the artists sought and the paintings chosen to represent the period's breadth of subjects, the artists' best works, and the works' finest possible condition; second, a passion informed by their openness to scholarly counsel and their personal legacies derived from Belgium (Rose-Marie) and the Netherlands (Eijk); and third, their belief in the responsibility to share the works through generous loans to museums. The story of seventeenth-century Dutch painting includes the artists who set the stage in what was the Southern Netherlands, and key Flemish examples in the Van Otterloo collection speak to this evolution. They have further distinguished their collection by incorporating choice seventeenth-century Dutch furniture and decorative arts, a reflection of their understanding of the integration of the visual arts during this Golden Age. To Rose-Marie and Eijk goes our profound appreciation for the privilege of organizing this nationally touring exhibition and companion publication of their exquisite collection.

A remarkable gathering of expertise has brought this ambitious undertaking to fruition. For his superb erudition and international perspective as guest curator and the book's principal author, we thank Dr. Frederik J. Duparc, former Director of the Mauritshuis, The Hague. Karina Corrigan, The H. A. Crosby Forbes Curator of Asian Export Art at the Peabody Essex Museum, has brought an abiding passion for the relationship between art and culture as well as a keen eye for nuance to her role as coordinating curator. Authors Femke Diercks, Reinier Baarsen, and Loek van Aalst have contributed fresh insights into the art of collecting, the interrelationship of the arts in the Netherlands during the 1600s, and the rise and meaning of Dutch furniture in this period. The polish and beauty of this monumental book reflect the talent of editor Terry Ann Neff and the design team at Studio Blue, Lauren Boegen, Claire Williams Martinez, and Silja Hillmann, headed by Kathy Fredrickson. Sarah Chasse, Nicole Lucey, and Mary Beth Bainbridge, the project's curatorial team, translators John Rudge and Diane Webb, and consultant David de Haan delivered heroic attention to the publication's many complexities and details. We would also like to thank our colleagues at the Museum of Fine Arts, Boston, especially Jean Woodward and Greg Heins, for their invaluable assistance and collegiality.

In keeping with the spirit of civic and private patronage associated with the Dutch Golden Age, we are most fortunate to have received generous support from those acknowledged on the book's Patrons page. The Peabody Essex Museum has organized this exhibition in conjunction with the Mauritshuis, The Hague; we extend our appreciation to Director Emilie Gordenker and Curator Quentin Buvelot. We are delighted that John Buchanan, Director, the Fine Arts Museums of San Francisco, and Peter C. Marzio, Director, the Museum of Fine Arts, Houston, have provided such prestigious venues for the show's national tour, and we similarly thank Patricia Fidler and Yale University Press for co-publishing the book.

Like the global entrepreneurs who founded this museum in 1799, the Peabody Essex Museum values the dialogue between art and culture. It is with great pleasure that we offer *Golden: Dutch and Flemish Masterworks from the Rose-Marie and Eijk van Otterloo Collection* as a stellar expression of that dialogue.

DAN L. MONROE, Executive Director and CEO
LYNDA ROSCOE HARTIGAN, The James B. and Mary Lou Hawkes Chief Curator

AUTHOR'S ACKNOWLEDGMENTS

First of all, I would like to offer my heartfelt thanks to Rose-Marie and Eijk van Otterloo for the trust they have placed in me by asking me to compile this catalogue of their paintings. In doing so, I have tried to exercise the same conscientious care they have shown in building up their magnificent collection. The excellent archive kept by Rose-Marie provided a firm basis for my work, and the generous hospitality repeatedly extended to me by the Van Otterloos gave me the peace and quiet necessary to study the paintings.

Catalogues are almost never the work of one person, and this book is certainly no exception. Many people have helped me to write it, and I am extremely grateful to them. I owe a huge debt of thanks to Baukje Coenen, who, with the patience of a saint, checked, corrected, and completed the provenance, exhibition, and literature listings for all the paintings. In this endeavor, the Netherlands Institute for Art History (RKD) was of inestimable value, as it always is with this kind of work. Quentin Buvelot advised and assisted me time after time, and was also kind enough to read the entire manuscript. With regard to the individual paintings, I called upon the expertise of many friends – art historians and art dealers alike – who never hesitated to share their knowledge and sometimes still-unpublished findings. For their invaluable help, I would like to thank Edwin Buijsen, Pippa Cooper, Rudi Ekkart, Arthur Eyffinger, Michiel Franken, Bob Haboldt, Johnny Van Haeften, Egbert Haverkamp-Begemann, Peter Hecht, Roman Herzig, Eddy de Jongh, Rob Kattenburg, Jack Kilgore, David Koetser, Danielle Lokin, Fred Meijer, Norbert Middelkoop, Otto Naumann, Eddy Schavemaker, Erik Schmitz, Anthony Speelman, Christiaan Vogelaar, Anke van Wagenberg-Ter Hoeven, and John Walsh. My conversations with Simon Levie about the collection were particularly inspiring. At the Mauritshuis, Lea van de Vinde and Geerte Broersma were always willing to look things up quickly, and for special photographic wishes, such as macro photos, I could always turn to Jean Woodward.

My gratitude extends to many others as well, since a catalogue like this is largely based on work carried out, whether recently or in the distant past, by fellow art historians. I am therefore grateful to Abraham Bredius, Cornelis Hofstede de Groot, Wilhelm Martin, Wolfgang Stechow, Horst Gerson, Seymour Slive, and those of my own generation, such as Peter Sutton, Arthur Wheelock, and Walter Liedtke, to name only a few. The translation was in the capable hands of Diane Webb and John Rudge. Finally, my deepest gratitude goes to Renée, my muse and never-failing source of help and encouragement.

FREDERIK J. DUPARC

DEDICATION

For us, this is a heady moment in our collecting days, to see an exhibition and catalogue of our seventeenth-century paintings, furniture, and objects become a reality and to share this with you. We started to focus on the seventeenth-century Dutch and Flemish Old Masters approximately twenty-five years ago. It has been a joy to build the collection from nothing to what it is today. We have sought to create a near-complete representation of the themes that occupied the artists of the time.

We received help from many individuals who have advised us, brought us ideas, and helped us to fill "gaps." Most important among these were the art dealers: Johnny Van Haeften, Otto Naumann, Jack Kilgore, Robert and William Noortman, Bob Haboldt, Salomon Lilian, Roman Herzig, Richard and Jonathan Green, Charles Roelofsz, Konrad Bernheimer, Emmanuel Moatti, and others. These people – while crucial – certainly cost us buckets!

In addition, we sought and received help from curators, Peter Sutton, Ronni Baer, Walter Liedtke, and others; also from conservation specialists, Jean Woodward, Andrew Haines, Rhona MacBeth, Martin Bijl, Nancy Krieg, Patrick Corbett, and Hans van Dam.

We are grateful to Dan Monroe and Lynda Hartigan of the Peabody Essex Museum for urging us to show the collection to a wider audience and for their efforts and resourcefulness to make this exhibition and publication a reality.

Very special thanks go to Frits Duparc, former director of the Mauritshuis in The Hague, who is one of our closest friends. He has been supportive from the beginning and has undertaken to write the greater part of this catalogue.

While it is only a start, Loek van Aalst has been instrumental in introducing us to both the beauty and importance of seventeenth-century Dutch and Flemish furniture. He has convinced us to begin to add pieces of furniture to augment and enhance the setting for the paintings.

Finally, it is with our deepest appreciation and gratitude that we dedicate this catalogue to Simon Levie, former director of the Rijksmuseum in Amsterdam and a long-time member of the Rembrandt Research Project. During the course of advising us, Simon became a best friend. He encouraged us to seek out works in a systematic way and to discipline ourselves to focus on thematic considerations. He also pushed us to deaccession from time to time in order to rebalance the collection. On occasion, we have regretted parting with beautiful works, some of which, shockingly, we now see hanging on the walls of some of our dear collecting friends. Oh, well.

Rest assured, our collecting days are not yet over.

Fondly,
ROSE-MARIE AND EIJK

PATRONS

The Peabody Essex Museum wishes to acknowledge with gratitude the following generous supporters of the exhibition and publication: the Richard C. von Hess Foundation, with special thanks to Chairman Thomas Hills Cook; J. P. Morgan; Christie's; and the Circle of Friends in honor of Rose-Marie and Eijk van Otterloo, with special thanks to Chair Linda H. Kaufman. We also thank those who joined the Circle of Friends after this publication went to press.

CIRCLE OF FRIENDS
Linda H. Kaufman, Chair
The Acorn Foundation/Barbara and Theodore Alfond
Greg and Candy Fazakerley
Martin and Kathleen Feldstein
Richard Green Gallery, London
Bob P. Haboldt, Paris and New York
Daphne Recanati Kaplan and Thomas S. Kaplan
John H. Kilgore
Carolyn and Peter S. Lynch
Gail and Ernst von Metzsch
Otto Naumann, Ltd.
Noortman Master Paintings, Amsterdam
Sotheby's
Mr. and Mrs. Henri Termeer
Sarah and Johnny Van Haeften
Matthew A. and Susan B. Weatherbie Foundation

Additional support has been provided by the Netherland-America Foundation in honor of Frederik J. Duparc; and by the East India Marine Associates (EIMA) of the Peabody Essex Museum. This exhibition is supported by an indemnity from the Federal Council on the Arts and Humanities.

NATIONAL
ENDOWMENT
FOR THE ARTS

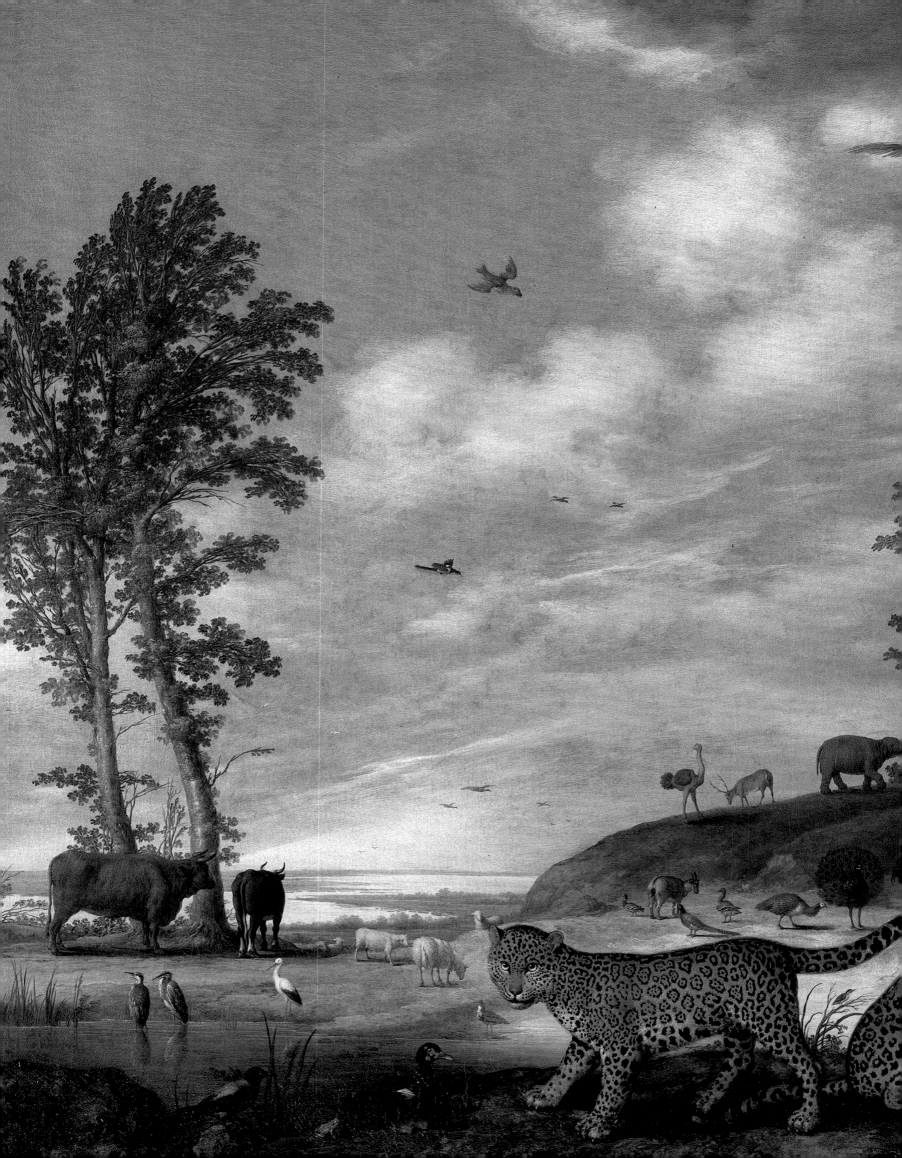

TREASURED IMAGES

THE COLLECTION OF

ROSE-MARIE AND EIJK

VAN OTTERLOO

FREDERIK J. DUPARC

Art has the privilege of remaining where much that is ephemeral is lost.
F. SCHMIDT-DEGENER, 1935[1]

The collection Rose-Marie and Eijk van Otterloo have built over the past twenty-some years offers a magnificent picture of Dutch painting from the seventeenth century, a period in which the arts flourished as never before in both the Southern and the Northern Netherlands. In the sixteenth century, culture blossomed mainly in the Southern Netherlands – with Antwerp and Brussels in the lead – but from 1585 the core of artistic activity gradually shifted to the cities in the North, most notably Amsterdam. A remarkable series of painters, sculptors, draftsmen, engravers, tapestry designers, silversmiths, and architects inundated the Netherlands with splendid works of art.

And it was not only art that rose to new heights, for in the Northern Netherlands in particular, the seventeenth century saw notable advances in many other fields as well. Numerous scientists, scholars, writers, and philosophers – not necessarily natives of the Low Countries – found in the Netherlands a climate favorable to the development of their ideas. The mathematician and engineer Simon Stevin was the first to describe decimal notation for fractions; Antoni van Leeuwenhoek designed a simple yet powerful microscope that enabled him to lay the foundation of cellular biology; the mathematician, physicist, and astronomer Christiaan Huygens invented the pendulum clock and explained the rings of Saturn; the inventor Cornelis Drebbel produced innovative microscopes and telescopes; the hydraulic engineer Jan Leeghwater was the architect of the most important land reclamations (polders) in Holland; and the explorer Abel Tasman sailed to the other side of the world. The philosopher René Descartes became famous for his supposition "I think, therefore I am," and Baruch Spinoza for his Pantheism (the belief that God and the universe are identical). The humanists Josephus Scaliger and Petrus Scriverius developed their philosophies, and the jurist Hugo Grotius laid the basis of international, martial, and maritime law. Joost van den Vondel, Pieter Cornelisz. Hooft, and Jacob Cats penned poetry and plays that are still held in high regard; the composer Jan Pietersz. Sweelinck was instrumental in the development of organ music; and last but not least, the *Homo universalis* Constantijn Huygens – statesman, poet, writer, composer, art connoisseur, and architect – was one of the most sparkling jewels in the crown of the Dutch Golden Age. Countless names could be added to this list, but it is the painters in particular who were responsible for the enduring fame of the seventeenth-century Netherlands.

To understand what brought about this explosion of art, culture, and science, it is necessary to understand something of the political situation then prevailing in northwestern Europe. What enabled a country as small as the Netherlands to develop into a powerful trading nation and hotbed of culture? This phenomenon, rare in itself, appears even more extraordinary when one considers that what we conveniently call the Northern Netherlands was then an unstable political entity, insecurely founded on a treaty signed in 1579 and fighting for its independence from powerful Spain. Although Holland's rise to power and prosperity can no doubt be accounted for, a number of questions concerning this so-called Golden Age defy explanation. An unusual set of circumstances allowed the Dutch not only to achieve their goal of freedom, but to turn the venture into an unparalleled success.

For a proper understanding of the situation, we must return to the year 1555, which saw the abdication of Charles V, Holy Roman Emperor, king of Spain, and sovereign of the Netherlands and various Italian possessions. His younger brother Ferdinand succeeded him as Holy Roman Emperor; the other territories, among them the Netherlands, were relinquished to Charles's son,

Philip II. Charles V had attempted, through various administrative measures, to further the
unification of the Dutch provinces, which were demanding regional independence. It is an irony
of fate that Charles thereby laid the foundations of unity that were to lead to the revolt against
Spanish rule and the subsequent independence of the Northern Netherlands. At first, it was not
apparent that the conflict between Philip and the Netherlands would take such a serious turn.
Objections to the king's policies of heavy taxation had been voiced by the States General (a parlia-
mentary body in which all the provinces were represented), but such protests were rather
common. Philip had even appointed members of the Dutch nobility, such as William of Orange,
to the Council of State, the Dutch political advisory body. Even so, there was rising discontent
among various groups: the upper aristocracy wanted more influence; the Calvinists, considered
heretics by the Roman Catholic authorities, demanded freedom of religion; the cities feared fur-
ther centralization of power; the people were hard hit by high food prices and unemployment.
The situation worsened considerably during the 1560s, and in 1566, when Philip appeared unwill-
ing to negotiate, the Iconoclastic Fury erupted, causing the destruction of altars and religious
images throughout the Netherlands. This proved to be a turning point. Because compromise now
seemed out of the question, Philip II sent the duke of Alva, one of his most capable commanders,
to the Netherlands to restore law and order – heavy-handedly, if necessary – and to eradicate the
Calvinist heresy. By strictly enforcing the laws against heresy and imposing heavy taxes, Alva
succeeded only in inflaming the opposition. Dissatisfied nobles rallied around William of Orange,
who had initially led the military campaign against the Spanish, but with little success. From
1572, the tide began to turn, especially in the Northern Netherlands. Several cities were conquered
by William's followers and some of the poorly paid Spanish troops began to mutiny. The insur-
gent cities proclaimed William of Orange *stadholder* (governor). In 1579, William – who had mean-
while become a Calvinist – was instrumental in bringing about the Union of Utrecht, a treaty
that united the rebellious provinces of the Northern Netherlands into a military alliance intended
to last "for all time."

Out of this shaky union grew the Dutch Republic, which was to hold its own until 1795.
The union included the provinces of Holland, Zeeland, Groningen, Utrecht, and Gelderland. The
years 1572–79 were thus auspicious for William of Orange and his followers, but in the following
years the ideal of freedom seemed more remote than ever. Several cities were lost, William was
assassinated in 1584, and the important harbor city of Antwerp fell to the Spanish in 1585,
along with the Flemish cities of Brussels, Bruges, and Ghent. It was precisely this loss of Antwerp,
however, that indirectly boosted the economy of the Northern Netherlands, especially that
of Amsterdam. Numerous merchants, artists, and artisans were drawn to Holland and Zeeland,
including Gillis van Coninxloo (1544–1606), David Vinckboons (1576–ca. 1632), Karel van
Mander (1548–1606), Roelant Savery (1576–1639), Pieter Claesz., and Hans Bol, while Ambrosius
Bosschaert, Frans Hals, and Jan Porcellis and many others came at a young age with their
parents. Trade with Antwerp was obstructed by sealing off the lower reaches of the River Scheldt.
This largely explains the rapid rise of Amsterdam as a port and center of commerce.

The period 1588–97 saw a definite reversal of fortune for the rebels. Two men were mainly
responsible for this turn of events: Prince Maurits (son of William of Orange), who emerged as
a great military strategist, and Johan van Oldenbarneveldt, a lawyer and statesman who is
considered the principal architect of Dutch independence. By the century's end, the Republic of
the United Netherlands had increased in size and taken measures to protect itself. The territory

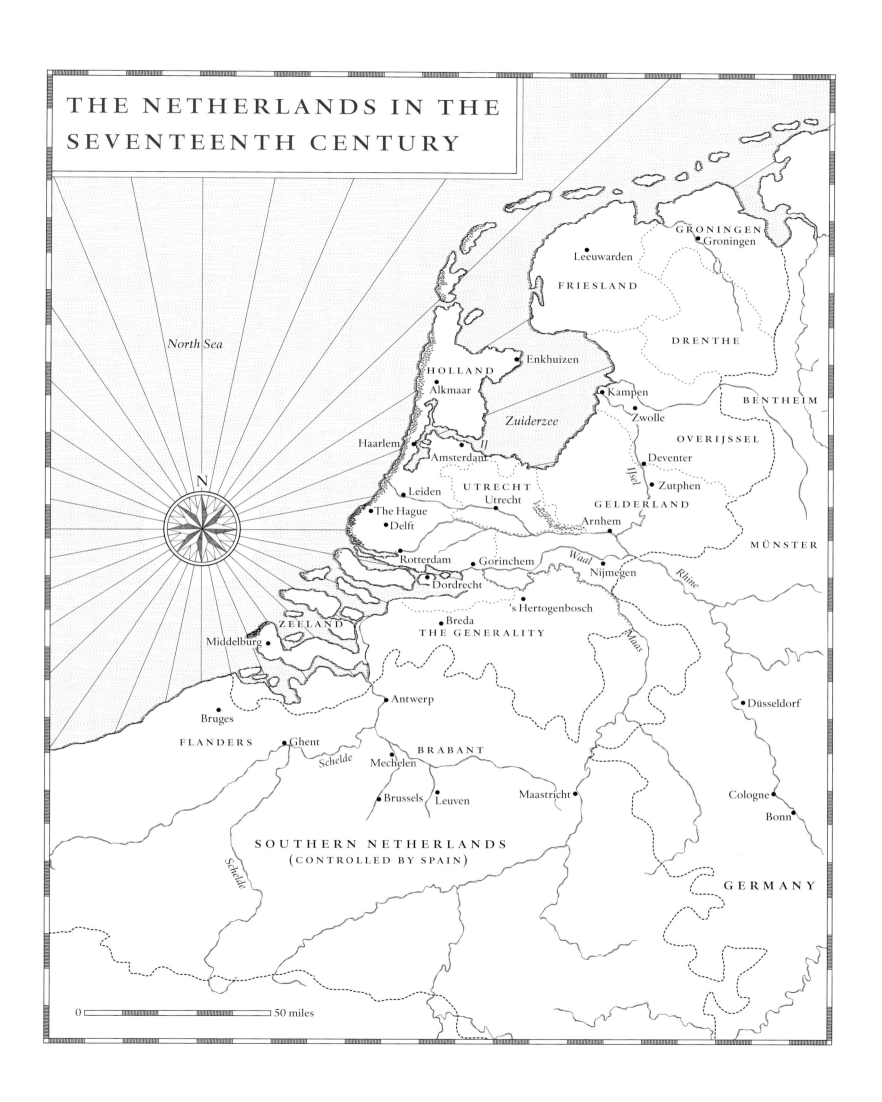

THE NETHERLANDS IN THE
SEVENTEENTH CENTURY

North Sea

N

GRONINGEN
• Groningen

Leeuwarden •

FRIESLAND

DRENTHE

BENTHEIM

• Enkhuizen

HOLLAND
• Alkmaar

Zuiderzee

• Kampen
• Zwolle

OVERIJSSEL

Haarlem •
Amsterdam • • IJ

• Deventer
• Zutphen

Leiden •

UTRECHT
Utrecht

GELDERLAND

MÜNSTER

• The Hague
• Delft

Arnhem •

Rotterdam • • Gorinchem
• Dordrecht

Waal
Nijmegen •

Rhine

• 's Hertogenbosch

Maas

ZEELAND
Middelburg •

• Breda
THE GENERALITY

• Düsseldorf

• Antwerp

Bruges •

FLANDERS • Ghent

Schelde
Mechelen •

BRABANT

Maastricht •

Cologne •

• Brussels • Leuven

Bonn •

SOUTHERN NETHERLANDS
(CONTROLLED BY SPAIN)

Schelde

GERMANY

0 |▭▭▭▭▭▭▭▭▭▭▭▭▭▭| 50 miles

now consisted of the provinces of Holland, Zeeland, Utrecht, Groningen, Friesland, Overijssel, Gelderland, and a large part of Brabant. The Northern Netherlands had become an international power, while the Southern Netherlands remained part of the Spanish empire. Holland and Zeeland – of great importance to trade since the fourteenth century, thanks to their favorable location on the North Sea between England, Germany, and France – expanded their merchant fleet into one of the largest in the world. In addition to the already well-traveled routes to the Baltic, Norway, France, and Spain, the late sixteenth century witnessed the development of trade routes to the Levant and India, and before long to Persia and the Far East.

Between 1568 and 1609 in particular, the Dutch economy, which was based on economic free-dom and decentralization without state interference, showed great improvement. This was possible in spite of the war, since fighting was intermittent and localized, and the Dutch troops consisted mainly of mercenaries. Consequently, trade and industry met with little obstruction, despite disruptions caused by Spanish and Portuguese assaults on the sea routes. This flourishing trade created the fertile conditions that gave rise to the extraordinary flowering of culture in the seventeenth-century Netherlands.

Power resided for the most part in the city governments (especially those of Holland and Zeeland) and in the hands of the resident wealthy merchants. Clergy no longer played an important role, nor, with few exceptions, did the nobility. Industry was still based on the conserva-tive but well-functioning guild system. Other factors that fueled the rising prosperity were the above-mentioned fall of Antwerp in 1585, the ample opportunities for land reclamation, and the strong westerly winds that drove Holland's countless windmills. The political situation in Western Europe in the last quarter of the sixteenth century also worked to the Netherlands' advan-tage: Germany was torn by religious strife, England had serious internal problems, and France was also in the throes of a religious war.

By 1600, the struggle against Spain had changed fundamentally. It was no longer led by badly organized rebels who were dissatisfied with taxation and religious persecution. Now, they were fighting for complete independence as an internationally recognized power, and Calvinism had replaced Roman Catholicism as the state religion. Meanwhile, Spain had begun to realize that victory over the young but ever stronger republic was less likely than ever. Both sides had tired of the struggle and the prospects for negotiations had improved. A lasting peace did not yet seem possible, but the Twelve Years' Truce (1609–21) represented Spain's de facto recognition of the Dutch Republic.

Toward the end of the truce, Prince Maurits strongly urged the resumption of hostilities against Spain. Perhaps he expected to force a quick decision by military means, hoping thereby to divert attention from domestic problems. After Maurits's death in 1625, Frederik Hendrik, his younger half-brother, succeeded him as *stadholder*. Apart from the spectacular capture of a few towns, there were no more extensive military operations on land, but at sea the admirals Piet Heyn and Maarten Harpertsz. Tromp scored decisive victories over the Spanish fleet.

The military threat had been greatly reduced, a state of balance had been achieved, and it had become clear that reunification of the Calvinist North and Catholic South was no longer possible. The Spanish, whose international power was waning, had little hope of regaining control of the Northern Netherlands. Both parties were therefore ready to settle their differences once and for all. In 1648, after long negotiations, the Treaty of Munster was concluded. For the Dutch Republic, the peace meant not only recognition by Spain and Germany, but above all, independence.

Both the Dutch Republic and the House of Orange gradually came to occupy an important
position in Europe, owing in part to the marriage in 1641 of Frederik Hendrik's son, William II, to
Mary, daughter of Charles I of England. The *stadholder*'s increasing power led, however, to internal
dissension. The urban regents feared a strong governor who would limit the power of the cities and
provinces, so even before the Treaty of Munster was signed, a power struggle had arisen between
the *stadholder* – supported by a number of nobles, the Reformed Church, and the common folk –
and the regents, especially those of Holland. William II, who had succeeded his father in 1647, died
unexpectedly in 1650. The five provinces of which William II had been *stadholder* chose not
to name a successor. This decision strengthened provincial independence, which had long been the
basis of the Dutch Republic. Holland, under the leadership of Councilor Johan de Witt, exerted
a strong influence over the other provinces.

England feared the growing economic and political power of the Netherlands. No clear-cut
victor emerged from the naval battles between the two maritime powers, but the republic was able
to maintain its leading role until 1672, when it was attacked simultaneously by France, England,
and two German states. Driven into a corner, the Dutch appealed to William II's son, William III,
and the *stadholder*-ship was restored. The House of Orange rose to unprecedented heights under
William III, who succeeded in repulsing the French invasion. Thanks to the heroism of Admiral
Michiel de Ruyter, the Dutch inflicted a series of defeats upon the English fleet, thus strengthening
William III's position both nationally and internationally. His marriage in 1677 to Mary, daughter
of James II of England, assured him a leading role in Western Europe. In 1688, when the Catholic
James II was overthrown, the Protestant William III acceded to the English throne. This event,
known as the Glorious Revolution, ushered in the reign of William and Mary, England's first con-
stitutional monarchs. The death in 1702 of the childless William III, king of England and *stadholder*
of the Netherlands, marked the end of the Dutch Republic as a world power.

As the preceding has no doubt made clear, the Dutch Republic was not a state based on a
central authority. Indeed, it was precisely the objection to centralized government that was a
motivating force in the Dutch struggle against Spain. The republic was a confederation of states,
with the member provinces retaining considerable independence. In spite of the States General,
in which the provinces were represented, and the Council of State, which acted as the day-to-day
legislative body, power resided primarily in the provinces and especially in the traditionally autono-
mous cities. Legislative, administrative, and legal matters were dealt with mostly by the provinces.
Moreover, the larger cities, such as Amsterdam, Haarlem, Leiden, Dordrecht, and Delft, could
exert extensive regional and national influence through their representatives in the provincial gov-
ernments and the States General. The unity of the republic was actually founded, therefore, on
the common interests of the urban oligarchies. Even so, the *stadholder*, who acted as captain-gener-
al of the army and also appointed most of the city magistrates, commanded considerable power.

The republic's regional and urban character impacted not only government but also trade,
manufacturing, and the arts. Although the type of court so important to the promotion of the arts
in England, France, Spain, and Sweden was lacking in the Netherlands, the court in The Hague
began to flourish under Frederik Hendrik, his wife, Amalia van Solms, and his extremely versatile
secretary, Constantijn Huygens. Under their patronage, rapid progress was made in the arts,
although the gains seemed modest when compared with artistic developments at royal courts else-
where in Europe. Nor could the Netherlands boast numerous palaces inhabited by the upper
nobility. Wealth and prosperity were found in the cities among the merchant classes, whose homes

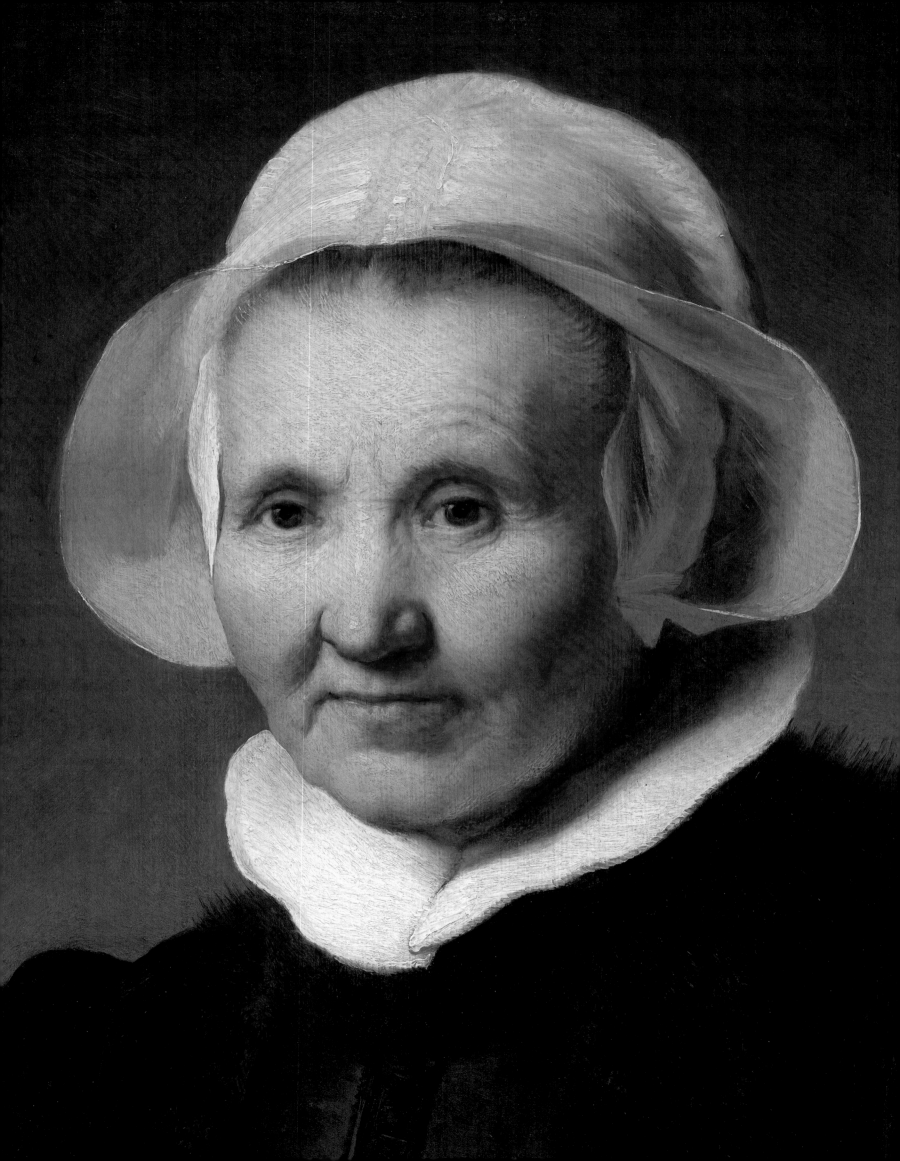

REMBRANDT VAN RIJN,
*PORTRAIT OF
AELTJE UYLENBURGH*,
1632 (CATALOGUE
48, DETAIL)

became centers for fostering culture and the arts. The remarkable pictorial legacy of the seventeenth-century Dutch painters – who portrayed not only the happy few but also people from all walks of life, their cities and villages, and the Dutch countryside in all its grandeur and intimacy – was in total harmony with the strong civic pride and well-developed artistic awareness of the new merchant class.

The paintings in the Van Otterloo collection all date within the time frame outlined above and are remarkable in both quality and diversity. Landscapes, marine paintings, townscapes, church interiors, still lifes, portraits and self-portraits, *tronies* (expressive facial studies), and genre scenes are all represented by superb examples. The collection also boasts several fine examples of history painting. Because painting in the Northern Netherlands was often indebted, particularly in the first decades of the seventeenth century, to developments in the Southern Netherlands, it is both appropriate and edifying to find in the Van Otterloo collection several Flemish paintings, mostly from around 1600.

Works of art are unique creations that are difficult to label or categorize. For the sake of convenience, however, this overview of the Van Otterloo collection assigns each painting to one of five groups: portraits, history paintings, landscapes, genre scenes, and still lifes.

PORTRAITURE

Portraiture is one of the oldest genres in painting. In the fifteenth and sixteenth centuries, portraits were often included in devotional pictures. A donor had his portrait incorporated in an altarpiece, for example, or his likeness combined with a religious representation to form a diptych. At first, only princes, nobles, and members of the higher clergy occasionally had their portraits painted in a secular context, but the rise of the middle classes at the end of the sixteenth and particularly in the seventeenth century brought with it a rapid increase in the demand for portraits. Successful merchants, powerful politicians, influential scholars, and other prominent individuals began to commission portraits of themselves, their wives, and sometimes their children. Often these were private commissions, but cities and institutions increasingly commissioned portraits, sometimes of an individual but frequently of groups, such as civic militiamen or the officers of a guild. Every important city had its own portraitists. In Haarlem, an economic and cultural center, Frans Hals was the undisputed king of portraiture. The small, late *Portrait of a Preacher* is proof of his brilliance in this area (catalogue 28). His great counterpart in Amsterdam was Rembrandt, but while Hals confined himself to painting portraits, Rembrandt ventured – in drawings, etchings, and paintings – to work in all genres. His magnificent *Portrait of Aeltje Uylenburgh* shows that even at age twenty-six he had already mastered all the tricks of the portraitist's trade (catalogue 48). Rembrandt had moved from his native Leiden to Amsterdam less than a year before but he was already considered the city's foremost portraitist. This early portrait is the unquestionable jewel of the Van Otterloo collection.

That artists who did not specialize in portraiture could also paint outstanding examples is evidenced by Jan Baptist Weenix's portrait of Christina Lepper and her children (catalogue 65). Weenix owes his fame mainly to his Italianate landscapes, but this moving group portrait proves that he made successful forays into other genres.

Portraiture harbors the important subgroup of self-portraits, which show us what countless Dutch and Flemish painters looked like. As early as the seventeenth century, self-portraits were eagerly sought by collectors, who would thereby acquire in one fell swoop both an example of

the master's work and his likeness. No Dutch artist made more self-portraits than Rembrandt, and it was probably his influence that prompted Gerrit Dou, who was not yet fifteen when he became Rembrandt's pupil in Leiden, to produce a number of his own. In his *Self-Portrait* in the Van Otterloo collection, Dou is portrayed as a successful and self-assured artist (catalogue 20). Also in the collection, although during this period painting was a profession practiced almost exclusively by men, is a rare self-portrait in her studio by Maria Schalcken, one of the few women painters in the Northern Netherlands (catalogue 57).

Although not a true portrait, a related type of picture is the *tronie*, which derives from the old French word *trogne*, meaning head. The term *tronie* is used for paintings, drawings, or prints in which the individual's likeness is less important than the mood or emotion it conveys. Sometimes these pictures are called "costume *tronies*," because the emphasis lies in the rendering of exotic attire or costly jewelry. The Van Otterloo collection contains an exceptional ensemble of three *tronies*, all representing young women, by Jacob Backer, Salomon de Bray, and Jan Lievens (catalogue 5, 13, and 35).

HISTORY PAINTINGS

History paintings include religious, mythological, allegorical, and historical representations. The small minority of such works in this collection boasts some remarkable pieces. Special mention must be made of *Orpheus Charming the Animals*, an ambitious early work by the landscape painter Aelbert Cuyp (catalogue 18). Amazingly, this large and important work by one of Holland's most prominent masters did not surface until 1994. Entirely different in character is *Esau Selling His Birthright to Jacob* by the Pre-Rembrandtist Claes Moeyaert, which is published here for the first time (catalogue 39). The exceptional versatility of Nicolaes Berchem, whose fame rests primarily on his Italianate landscapes, is apparent from his *Saint Peter*, whose style and subject matter differ dramatically from the rest of his oeuvre (catalogue 8).

LANDSCAPES

That landscapes comprise by far the largest group in the collection is hardly surprising, for as early as around 1630 Constantijn Huygens wrote: "The crop of landscape painters – for this is what I prefer to call those who specialize in painting woods, meadows, mountains, and villages – is, in our Netherlands, so immense and so famous, that anyone wishing to mention each and every one of them could fill a book with their names."[2] This genre originated in the work of such fifteenth-century Flemish masters as Joachim Patinir (1480/85–1524) and Pieter Bruegel the Elder (1525/30–1569). While Patinir invariably peopled his scenes with biblical figures, Bruegel was the first to paint true landscapes. Bruegel's ideas about landscape were widely disseminated through numerous prints made after his designs. His son Jan Brueghel the Elder, represented in the collection by an exceedingly refined village view (catalogue 14), followed in his footsteps, developing into one of the most influential and most innovative of the painters active around 1600. After the fall of Antwerp in 1585, Brueghel remained in the city, but many of his fellow artists sought refuge and a more favorable business climate in the Northern Netherlands. They, in turn, became a source of inspiration to numerous painters in the North. But while the work of Brueghel and the other Flemish landscape painters was mainly imaginary in character, seventeenth-century Northern Netherlandish landscapes were distinguished by their naturalism.

The Northern painters constructed their landscapes mostly on the basis of sketches and drawings made outdoors. One of the first artists in the Dutch Republic to devote himself fully to

landscapes – in particular winter landscapes – was Hendrick Avercamp. The example in the Van Otterloo collection is one of the most beautiful in his oeuvre (catalogue 4). In his wake, the winter landscape developed into one of the most popular genres of the seventeenth century. Jan van Goyen, Aert van der Neer, Isack van Ostade, and Jacob van Ruisdael are each represented in the collection by winter landscapes that succeed admirably in conveying the bitter cold of the winters typical of this period, known as the Little Ice Age (catalogue 24, 41, 44, and 51). For the extraordinarily productive Van Goyen, the winter scene was just one of many types of landscapes that he drew and painted. Van der Neer, by contrast, confined himself to two types: in addition to winter landscapes, he excelled at landscapes with striking illumination, provided, for example, by a rising or setting sun. His romantic *Estuary at Twilight* testifies to his superb skills in this subgenre (catalogue 40).

Most Dutch landscape painters, however, preferred to depict the flat countryside of Holland, usually criss-crossed by rivers plied by ferries or sailboats beneath impressive, cloud-filled skies. Between 1635 and 1655, Jan van Goyen and Salomon van Ruysdael were the most prominent practitioners of this genre. The large *River Landscape with a Ferry* is one of the latter's masterpieces (catalogue 53). Shortly after the middle of the century, Philips Koninck painted a small series of impressive panoramas, one of which is in the Van Otterloo collection (catalogue 34). Dutch landscape painting reached its apex in the work of the versatile Jacob van Ruisdael, so it is only appropriate that he is represented here by not only a winter landscape but two other canvases as well (catalogue 49 and 50). In contrast to the relatively uncomplicated views of earlier landscape painters, such as his uncle Salomon van Ruysdael and Jan van Goyen, Ruisdael's compositions are generally characterized by their dramatic or heroic atmosphere. The inspiration Ruisdael gained in his younger years on a journey to the Dutch-German border region is apparent because of the mountainous scenery and the type of architecture in the large *Wooded River Landscape*. His late *View of Haarlem*, showing the city beneath thick clouds, exudes monumentality despite its modest size. Such views were his answer to the panoramas of Koninck.

Other Dutch artists sought inspiration farther from home. Encouraged by art theorists such as Karel van Mander, they undertook the perilous journey to Italy to study the art of classical antiquity and the Renaissance. Many of them also fell under the spell of the Roman *campagna* and the warm Southern light, and took note of developments in the field of Italian landscape painting. Jan Asselijn, Jan Both, Karel du Jardin, and Adam Pijnacker were just a few of the important Dutch artists who subsequently devoted themselves wholly to painting and drawing Southern landscapes or Mediterranean harbors (catalogue 2, 12, 21, and 45). Instead of being filled with dark clouds, their skies are bright blue with friendly white clouds – even after the artists returned to Holland. In fact, the Southern landscapes in the Van Otterloo collection by the aforementioned Italianate painters were all produced on Dutch soil.

In a country that owed its prosperity in large part to water, it is hardly surprising that seascapes were in great demand. Like the Dutch landscapists, the marine painters hold a prominent place in the collection, with the most outstanding masters each represented by a superb work. The earliest seascape is by Jan Porcellis, whose panel in the Van Otterloo collection – a rather rare, atmospheric storm scene – is an eye-catching highlight among the monochrome landscape and marine paintings (catalogue 46). Simon de Vlieger was following in the footsteps of Porcellis when he produced his picture of ships on a stormy sea (catalogue 64). Around the mid-seventeenth century, father and son Van de Velde and Jan van de Cappelle were the leading masters in the genre. While the latter's marine paintings focus more on the placid water and hushed atmosphere and

less on the precise portrayal of the ships, both Van de Veldes applied themselves to the accurate rendering of maritime events and the precise depiction of the various types of ships: Willem van de Velde the Elder in his black-and-white "pen paintings," and Willem van de Velde the Younger in his colorful seascapes (catalogue 61–63). The versatility of the latter clearly emerges from his two canvases in this collection. Without becoming lost in detail, he succeeded in rendering with convincing accuracy not only the various ships but also the atmosphere on the water, whether stormy or calm. In 1672, as economic conditions worsened in the Netherlands, the Van de Veldes moved to England, where their marine paintings became just as popular as they were in Holland. After their departure, Ludolf Bakhuizen became the foremost seascapist in the Netherlands. His *Ships in a Gale on the IJ before the City of Amsterdam* expresses the glory of the city and the Dutch fleet (catalogue 6).

Civic pride also pervades another genre that flourished as never before during the Golden Age: townscapes and church interiors. City profiles had begun to appear in topographical publications in the mid-sixteenth century. Later on, maps as well as city profiles were regularly embellished with depictions of important buildings, such as town halls and churches. The Flemish artist Hans Bol was a pioneer in painting town views as independent works of art. His 1589 gouache of Amsterdam is one of the first of its kind (catalogue 10). In the course of the seventeenth century, various artists specialized in townscapes, while others devoted themselves to church interiors. The most prominent in the first group was Jan van der Heyden. His *View of the Westerkerk, Amsterdam* is one of the most beautiful Dutch townscapes ever made (catalogue 31). It is a splendid expression of the pride taken by the people of Amsterdam in their new, monumental church. Fascination was also felt for important monuments of older vintage – such as the St. Bavokerk in Haarlem, the Nieuwe Kerk in Delft, and the Oude Kerk in Amsterdam – as evidenced by the many "portraits" of these churches by Pieter Saenredam, Gerard Houckgeest, and Emanuel de Witte, respectively, who were among the most prominent and most inventive painters of church interiors, a typically Dutch genre. Their predecessors in Flanders and Holland had almost always painted imaginary churches and palaces. Saenredam was the first to concentrate completely on the correct portrayal of existing churches, and from 1650 onward, Houckgeest followed suit. Emanuel de Witte, too, drew inspiration from existing churches, but he frequently took artistic liberties, as seen in his *Interior of the Oude Kerk in Amsterdam*, a painting that brilliantly depicts the central role of the church in the lives of seventeenth-century Dutch burghers (catalogue 66).

GENRE SCENES

The lives of those burghers – and others from all segments of society – is the main theme in the work of countless Dutch masters, whose scenes capture everyday life in the Netherlands during the seventeenth century. While terms such as "portrait" and "landscape" were already current at that time, no generic name existed for these paintings. Depending on the kind of picture, they were called a *cortegaerde* (guardroom scene), *boerenkermis* (peasant fair), *geselschap* (company), *bordeeltje* (brothel scene), *kaartspeelders* (card players), *musiek* (music-making company), *conversatie* (conversation piece), or *bambootserytje* (a painting in the style of the Bamboccianti, the followers of Pieter van Laer, alias Bamboots [1599–ca. 1642 or after], who painted Roman street scenes and low life). Today, this group is described collectively as genre. These genre scenes originated in the moralizing allegories painted in the first quarter of the sixteenth century by Hieronymus Bosch (ca. 1450–1516), Quinten Metsys (1466–1530), and Lucas van Leyden (1494–1533). The most important forerunner in this field was the Flemish artist Pieter Bruegel the Elder, who in the third quarter of the sixteenth

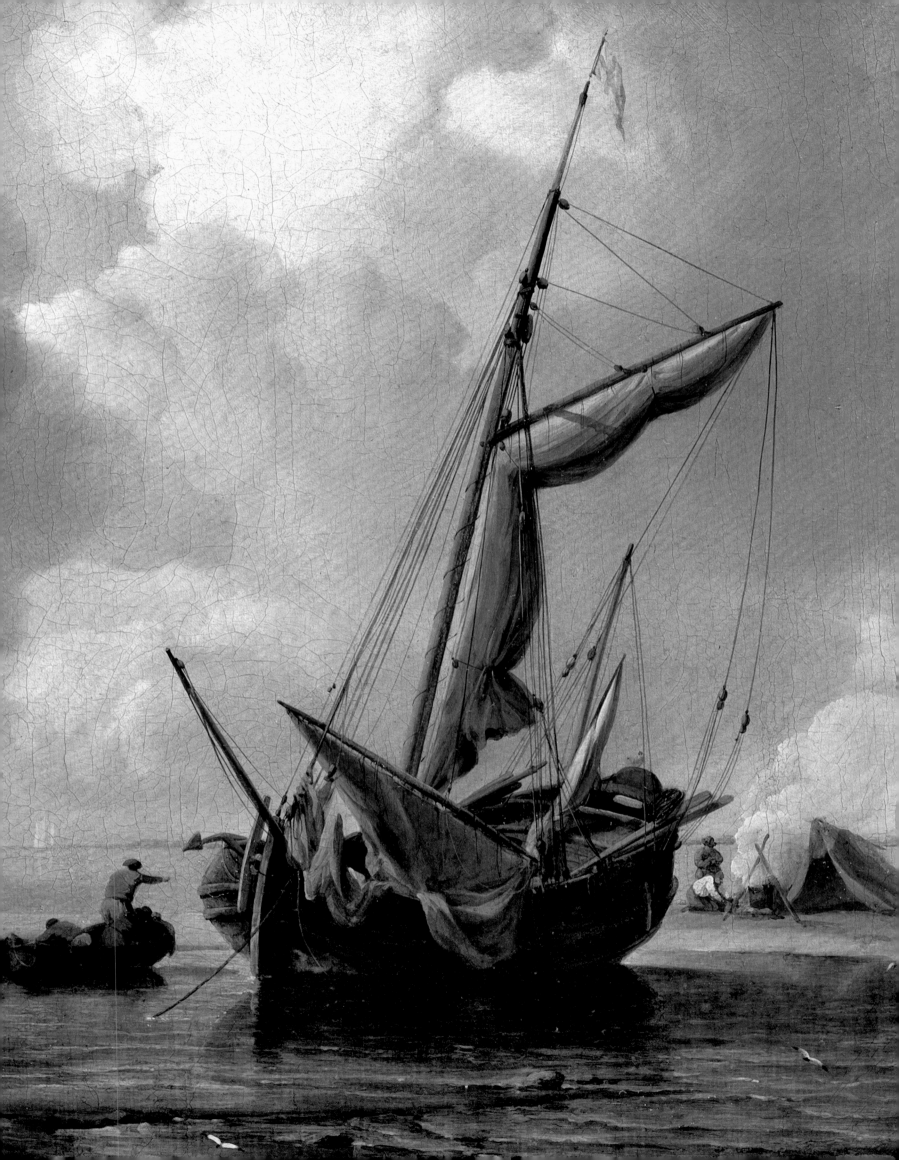

century introduced to this genre various themes, mainly from peasant life. Flemish immigrants
such as David Vinckboons and Roelant Savery were largely responsible for bringing this genre
to the Northern Netherlands. Esaias van de Velde was one of the first Dutch artists who took the lead
from Vinckboons and began to paint *buitenpartijen* (outdoor companies). *An Elegant Company
in a Garden* is not only one of the earliest but also one of the finest examples of this pictorial type
(catalogue 60). Apart from scenes of this kind, Esaias created a furor mainly with his naturalistic
landscapes, whereas Dirck Hals, the younger brother of Frans Hals, made elegant companies
his specialty. Like the painting by Esaias van de Velde, Dirck Hals's *An Elegant Party Making Music*
shows young people from the higher social circles consorting in an atmosphere of lighthearted
merriment (catalogue 27). Philips Wouwerman and Nicolaes Berchem, the former famous for his
equestrian paintings and the latter for his Italianate landscapes, link to these "merry companies"
with their landscapes with scenes of the hunt, a pastime reserved for the nobility and a small group
of privileged individuals. In addition to the luxurious lifestyle of well-to-do burghers, the simple
life of peasants and the urban lower classes also provided an inexhaustible source of subject matter.
Thus, Adriaen van Ostade created a glimpse of a simple peasant interior, while Gabriël Metsu
produced a touching picture of an old woman eating a meal in her humble dwelling (catalogue 43
and 37). Both artists painted a respectful but painfully honest picture of people who had failed
to profit from the prevailing prosperity. In one of his most handsome genre scenes, Nicolaes Maes
engaged the viewer with a woman who picks the pockets of an old gentleman who has dozed off
(catalogue 36). The masterpiece by the little-known Isaack Koedijck acquaints us with the interior
of a barber-surgeon's shop (catalogue 33) – an example of the kind of painting that proves so infor-
mative regarding the trades and the furnishings of the time. The painting profession, for example,
is documented not only in the artists' self-portraits but also in pictures of artists at work in their
studios. Jan Steen showed a master instructing a pupil, while Caspar Netscher's candlelit scene
depicts two children who, perhaps in imitation of their father, attempt to draw a statuette (catalogue
58 and 42). Frans van Mieris the Elder captured a glimpse through the window of a tavern, where
an old violinist sits, sunk in thought, staring blankly into space (catalogue 38).

STILL LIFES

Thanks to the Flemish and particularly the Dutch masters, still-life painting experienced a heyday
in the seventeenth century. The term *stilleven* (still life), incidentally, did not come into use until
after 1650. Until then, as with genre scenes, such paintings were referred to by their subject: *beesten*
(animals), *fruyten* (fruit), *keuckenen* (kitchens), *gevogelte* (poultry), *bloemen* (flowers), or *banquetjes*
(banquets, or breakfast pieces). The earliest pure still lifes produced in the Netherlands have been
found on the backs of portraits or religious representations painted in the last quarter of the fif-
teenth and first quarter of the sixteenth centuries by such artists as Hans Memling (ca. 1433–1494)
and Jan Gossaert (1478–1532). Around the mid-sixteenth century, the work of Pieter Aertsen
(1508–1575) proved especially influential. The earliest still life in the Van Otterloo collection, painted
in 1609, is by the Flemish artist Osias Beert, who convincingly depicted neat arrangements of
precious objects and exclusive fare (catalogue 7). Similar pictures, but less tidy and therefore less
stiff, became popular after 1620, particularly in Haarlem. The two undisputed masters of this type
of still life, Pieter Claesz. and Willem Claesz. Heda, are both represented in the collection by
examples from their best period, around 1630 (catalogue 16 and 29). Two small paintings by Willem
van Aelst and Gerrit Dou from the mid-seventeenth century cannot properly be called still lifes,

because they include living animals, but they are nevertheless categorized as such (catalogue 1 and 19). Van Aelst is known for his still lifes, but Dou's reputation rests firmly on his genre scenes, although his versatility is further confirmed by his self-portrait in the Van Otterloo collection. Half a century later, Adriaen Coorte produced his small still life with shells, whose simple, intimate character suggests that the paintings of this intriguing master can be linked more easily to those of his Haarlem predecessors than to those of his contemporaries (catalogue 17).

Flower paintings comprise a special group within still lifes. As with landscape painting, the foundations of this subject type were laid by artists from the Southern Netherlands, particularly Jan Brueghel the Elder, and then interest spread from Antwerp to the North. The most important practitioners of this genre in the Northern Netherlands are represented in the Van Otterloo collection with works of the highest quality. In the Dutch Republic, one pioneering and most prominent specialist in this field was Ambrosius Bosschaert the Elder, who devoted himself entirely to flower still lifes. The almost ethereal *Still Life with Roses in a Glass*, rediscovered less than twenty years ago, is among his finest works (catalogue 11). His much younger brother-in-law Balthasar van der Ast followed in his footsteps, but Van der Ast's bouquets are livelier and more transparent than those of Bosschaert, as evidenced by the panel in this collection (catalogue 3). These tendencies continued in the work of Jan Davidsz. de Heem, the most important still-life painter in the mid-seventeenth-century Netherlands (catalogue 30). The flower still life by Rachel Ruysch, one of the few professional female painters of her day, admittedly brings us into the eighteenth century, but is entirely in the tradition of her seventeenth-century predecessors (catalogue 52).

THE END OF THE GOLDEN AGE

By 1670, the glory of the Golden Age was fading, and this was becoming more apparent every year. The deaths of Frans Hals in 1666, Rembrandt in 1669, Johannes Vermeer in 1675, and Jacob van Ruisdael in 1682 left the Dutch Republic bereft of its greatest painters. The tide was turning rapidly in the political arena as well. Power had waned and the invasion in 1672 by French and English troops brought the republic to the brink of ruin. The English fleet had taken the lead at sea, resulting in the decline of the country's economic strength, which had been based primarily on the shipping trade. Under *Stadholder* Willem III – to whom an appeal to save the republic was made in 1672, the "year of disaster" – the country experienced a slight recovery, but only a faint reflection of it can be detected in the visual arts. The death of Willem III in 1702 definitively marked the end of the Golden Age. Fortunately, however, much of its legacy has survived. Apart from the scientific, technological, and medical developments, as well as some splendid music and literature, many palaces, town halls, churches, private residences, and even entire cities still recall that unique period. Nothing, however, bears greater testimony to its glory than the many thousands of magnificent paintings that were created by a wide range of outstanding artists. As F. Schmidt-Degener, a former director of the Rijksmuseum, said in 1935: "Art has the privilege of remaining." Thanks to those paintings, we too are privileged to become acquainted with – indeed, to marvel at – the Golden Age of the Dutch Republic. This exhibition of paintings from the collection of Rose-Marie and Eijk van Otterloo offers a unique opportunity to contemplate and savor all that was admirable and edifying in seventeenth-century Holland.

Notes:
1. Schmidt-Degener 1949, p. 1.
2. Huygens 1897.

"MY DEAR ROSE-MARIE, DEAR EIJK"

A SHORT HISTORY OF THE VAN OTTERLOO COLLECTION

FEMKE DIERCKS

It is said that every collector makes one big mistake when starting out. For Eijk and Rose-Marie van Otterloo, it was a "Flemish painting" that Eijk saw in 1991 at an art dealer's in Mexico City. After two years of negotiations, which were seriously hampered by the erratic Mexican postal service, they managed to acquire the work. When the painting finally arrived, it appeared to be none other than Jan Steen's Poultry Yard. *Unfortunately, however, it was a copy, and only its composition resembled the masterpiece at the Mauritshuis in The Hague. They can laugh about it now, especially because in Eijk's view this cloud had a silver lining, for it taught them that if they wanted to collect art seriously, they would have to enlist the help of experts.*

EIJK AND ROSE-MARIE VAN OTTERLOO

Eijk de Mol van Otterloo was born in Amsterdam on February 27, 1937. He moved to the United States to attend Harvard Business School, and after graduation began working at Phoenix Mutual Life Insurance. Rose-Marie Jacobs was born on December 2, 1945, in Kinrooi, Belgium. She came to the United States in 1967 as an au pair, and later worked as a secretary for Merrill Lynch, which had Phoenix Mutual as a client. The couple met in 1973 and married a year later on October 23, 1974 (figure 1). In 1976, they moved to Marblehead, Massachusetts. The following year, Eijk founded the Boston-based investment firm Grantham, Mayo, Van Otterloo & Co. (GMO) together with Jeremy Grantham and Richard Mayo.

It was Peter Sutton, then curator of European Painting at the Museum of Fine Arts in Boston, who encouraged the Van Otterloos in the early 1990s to start collecting seventeenth-century Dutch paintings instead of carriages and sporting prints – an earlier passion inspired by their New Hampshire farmhouse. He pointed them toward their first purchases, showed them the ropes at the most important auctions, introduced them to dealers in London and New York, and took them to The European Fine Art Fair (TEFAF) in Maastricht. He also introduced them to collectors' circles in the Boston area and kept them informed of opportunities in the market.[1]

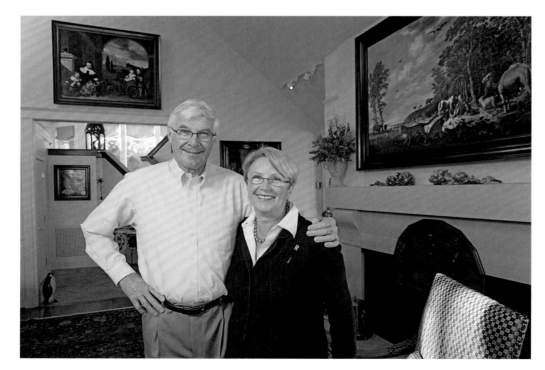

Figure 1. Eijk and Rose-Marie van Otterloo in their home in Marblehead, Massachusetts, with Aelbert Cuyp's *Orpheus Charming the Animals* (catalogue 18) at the right and Jan Baptist Weenix's *Portrait of the De Kempenaer Family* (catalogue 65) in the background.

Sutton's encouragement marked the beginning of a period in which the couple bought art
enthusiastically, albeit somewhat nervously, both at auction and through dealers. Although
they were still rather inexperienced, their eagerness and intuition drew enough attention for art
dealers to recognize them as serious collectors and begin to offer them specific works. Many
of the paintings the couple purchased in this period have since been de-accessioned, but among
those that remain are works by Jan Asselijn, Jan Bruegel the Elder, and Adriaen Coorte (catalogue
2, 14, and 17), as well as the flower still life by Ambrosius Bosschaert the Elder (catalogue 11), a
surprise from Eijk for Rose-Marie's fiftieth birthday.[2]

A HANDSHAKE DEAL

The late art dealer Robert Noortman from Maastricht put the Van Otterloos in touch with Simon
Levie, former director of the Rijksmuseum, Amsterdam (1975–89), whom they enlisted as their
advisor in October 1995 (figure 2). Peter Sutton's new position as head of the Old Masters depart-
ment at Christie's in New York prevented him from becoming their official advisor, although
he continued to keep them abreast of the best Dutch paintings sold by the firm and did what he
could to help them.[3]

Engaging Levie proved to be a decisive step: together, they soon laid the foundation that deter-
mined the course of future purchases and the building of the collection as a whole. "We particular-
ly wished to avoid making any big mistakes," Eijk commented. "At that time, so much was offered
to us that we could not see the forest for the trees. Besides, we thought every painting equally
beautiful. We didn't want to do anything stupid, and realized that we needed help." Shortly after
their first meeting, the three came to what Rose-Marie called a true "handshake deal." With
a single fax – the usual method of correspondence in those first years – the arrangement was agreed
upon.[4] Informality characterized the relations between Levie and the Van Otterloos, and they
and the Levies became good friends.

At this early stage in the Van Otterloos' collecting career, art was not in short supply. Both
Levie and the Van Otterloos pored over auction catalogues in search of suitable works of art.

Figure 2. Simon H. Levie,
artistic advisor to the Van
Otterloos from 1995 to 2009.

When the Van Otterloos showed particular interest in a work, Levie would write a report – often lyrical in tone – on the artist and the art-historical background of the painting, but he would not assess its condition until he had seen it firsthand. *Still Life of Oysters, Sweetmeats, and Dried Fruit in a Stone Niche* by Osias Beert offers a case in point (catalogue 7). Levie described the painting based on his first reaction to the sale catalogues, but mentioned that "the condition of many of Beert's panel paintings leaves a lot to be desired; many of the thinly painted brown areas have suffered substantially. His works on copper are in much better condition. If that is the case here and the composition in a niche, which I like a lot, appeals to you too, then the painting is worth giving serious consideration."[5] To evaluate its state, Levie traveled to London and examined the painting under ultraviolet light. The long fax with his findings describes some small overpaintings in the background, "but far fewer and far less drastic than I had expected."[6] Eijk replied: "I'm glad that you like this one too, and think it good enough for the collection."[7] The London art dealer Peter Mitchell was called in to bid on the piece. Levie wrote from Madrid: "Just before leaving London, I heard the price of the Osias B. and knew that everything had gone all right. Fantastic, a beautiful acquisition!"[8] He immediately proceeded to suggest a number of conservators who could put the work to rights. Following Levie's advice, the Van Otterloos chose Hans van Dam. On April 29, 1997, Levie wrote to tell them that the treatment had turned out very well and the piece was on its way to Marblehead.[9]

From the beginning, the Van Otterloos had a clear sense of what the quality of the collection should be. On October 8, 1995, Eijk sent a list with eight points he wanted Levie to consider when he recommended a painting. "1. importance of subject matter, 2. importance of artist, 3. quality rank within oeuvre of artist, 4. rarity, 5. provenance, 6. quality and condition of the work of art, 7. affordability (we have limits), 8. other."[10] And although Levie set his own priorities within these parameters, they formed a guideline for his counsel.

Levie almost always confined his advice to the artistic side of business – the condition of the work and its place within the artist's oeuvre. He also judged whether both the master and the picture were suitable additions to the collection, but he did not concern himself with financial matters: "I am not an appraiser, and besides, Eijk has enough financial savvy." In the beginning, contact from both sides was somewhat circumspect. Levie guarded against imposing his opinion on the Van Otterloos. "It must remain *their* collection," he emphasized repeatedly. An example of this can be found in a letter in which he advised against buying a painting by Jacob van Walscapelle (1644–1727): "P.S. Upon rereading the letter, it appears that I did not mince my words at the end. It was my intention to express my opinion. Not to force it on you."[11] Not every favorable report resulted in a purchase, but there was no crying over spilled milk. As Rose-Marie said: "We let Simon know whether a purchase had taken place or not, and that was that." And Levie declared: "Fortunately, I have a very bad memory when it comes to failures." Because of Levie's modest attitude, the Van Otterloos sometimes found him – in hindsight – a bit too circumspect.[12] By looking at art constantly, and listening carefully to Levie's advice, the Van Otterloos have developed a good eye themselves. Even so, they continue to seek the advice of experts. "It's easy to become over-confident," said Eijk, "to think: now I know it myself, but you never really know."

With Levie's counsel, the Van Otterloos were able to expand the collection rapidly. One of the first purchases in which he was involved was the *tronie* (facial study) of the apostle Peter by Nicolaes Berchem (catalogue 8): a powerful figure painting that stood out among the mainly landscapes and still lifes acquired up until this time. As art dealers became more aware of the rela-

tionship between Levie and the Van Otterloos, they began to send transparencies and fact sheets
to both parties. Sometimes, dealers even referred explicitly to Levie's opinion of certain pieces.[13]
Conversely, Eijk stipulated on occasion that Levie be allowed to assess a work's condition before a
deal was made final – as was the case with the so-called *Margaretha Portrait* by Jan Baptist Weenix
that was purchased from Noortman Master Paintings in 1996 (catalogue 65).[14] Levie's involvement
sometimes even exerted a restraining influence when he felt a work failed to meet the standards
the Van Otterloos had set for the collection. For example, in advising against the purchase of a late
self-portrait by Frans van Mieris, he explained that it "would represent the master nicely, but
would never become a highlight of the collection."[15] The same was true of a work by Willem Kalf
(1619–1693) from his weaker Paris period, which (the dealer admitted in a letter) Levie initially
found unsuited to the collection. However, taking into consideration how much the Van Otterloos
liked the painting and how difficult it is to acquire a work from Kalf's Amsterdam period, Levie
somewhat revised his opinion and traveled to Zurich to see the work. But his initial doubts
ultimately dissuaded them from buying the painting.[16] Eijk explained: "Frits [Duparc] and Simon
always win. It can't be otherwise, because in the end we trust their judgment one hundred
percent." This principle has been of inestimable value in maintaining the consistently high quality
of the collection.

THE SIGNIFICANCE OF CONDITION AND CONSERVATION

As a rule, the Van Otterloos purchase only works that are in reasonably good condition, but
the appearance of a piece can sometimes be improved by removing old retouches or yellowed var-
nish. Levie often supervised the conservation of new acquisitions. As with the correspondence
about new acquisitions, he faxed the Van Otterloos detailed reports on conservation treatments
conducted in Holland.

In 2005, Levie suspected that the condition of a newly purchased painting by Jan van de
Cappelle (catalogue 15) could be improved by having Dutch paintings conservator Martin Bijl
treat the work with an experimental technique to undo the flattening of the paint layers that
occurred when the canvas was relined. The method was a bit of a gamble, but the Van Otterloos
trusted Levie's advice and the work of Bijl, who had treated other paintings for them in the past.
The result was, according to Levie, stunning: "There are no words to describe the atmospheric
weather conditions as portrayed by the painter in their most subtle nuances – as though you're
experiencing them firsthand."[17]

The Van Otterloos have never hesitated to consult other experts as well. In 2002, when
they were considering a work by Nicolaes Maes that would need some conservation, Levie's
positive advice was seconded (at the dealer's request) by art historian and Maes expert William
Robinson.[18] At Levie's urging, Martin Bijl was also consulted and he subsequently treated the
piece (catalogue 36). On both sides of the pond, the couple has benefited from the expertise of
conservators and curators, most notably of the Museum of Fine Arts, Boston, and the
Mauritshuis in The Hague. The Van Otterloos are grateful for this continuing assistance from
the museum world. "We could not have done it without them," Rose-Marie remarked.

INTRODUCTION OF THE THEMES

After a little more than a year of collecting with Levie's advice, the Van Otterloos felt the need
for more structure and direction for their collection, then numbering thirty-six paintings. Together

with Levie, the Van Otterloos drew up a plan: the criteria of quality and condition remained unaltered, but they formulated an additional goal: they would strive to make the collection representative of Dutch Golden Age painting. In the autumn of 1996, Levie proposed to write an analysis intended to point out the gaps in the collection.[19] He first arranged this overview geographically, grouping the names of the most prominent seventeenth-century painters according to the most important centers of production. Soon, however, Levie found "the connection and applicability to your present . . . collection unsatisfactory. No pleasure could be derived from an alphabetical list of names; that is merely a kind of shopping list, as though the only objective were completeness, as in a stamp collection."[20] Instead, he devised a thematic division into genres and proceeded to write about each of them – portraits, landscapes, still lifes, history paintings, animal paintings, seascapes and beach scenes, church interiors and townscapes, figure paintings, and genre pieces – an art-historical overview that included a list of the most important artists in each specialization. The lists included both artists already represented in the collection and those regarded as desiderata.[21] This remarkably systematic approach would become the guideline for the continuing growth of the collection (figure 3).

Figure 3. Letters concerning the desiderata list. Simon Levie's archive.

Levie also supplied each theme with a critical analysis of the possibilities and impossibilities of developing it. For example, he wrote that it would be difficult for a private collection to represent every aspect of the genre of history painting, because many of the foremost works had been made for town halls and palaces, and were therefore too large for a private collection or simply not for sale. In his opinion: "the supply . . . will determine the possibility of having the theoretically extensive theme of the history painting represented in your collection."[22] Finally, he wrote what he called a "conversation piece" on the ultimate scope of the collection. He envisioned it growing to about sixty-five paintings, and predicted that landscapes, alongside figure paintings, would continue to occupy center stage. Totaling sixty-seven paintings in 2010, including twenty landscapes and nearly ten figure pieces, the collection today bears out both predictions.

CHARMED BY ORPHEUS

In many respects, the acquisition in September 1997 of Aelbert Cuyp's monumental *Orpheus Charming the Animals* ushered in a new phase (catalogue 18). The painting was of a size and price hitherto unmatched in the collection. Furthermore, its acquisition was made possible by the carefully considered decision to sell a number of smaller paintings. As to which were the best candidates for sale, Levie wrote in a lengthy introduction to his list: "My museum background ensures, I think, that I will not make any hasty or ill-considered recommendations as to 'what can be disposed of.'"[23] Indeed, he carefully justified his evaluation for every painting thus earmarked (figure 4).[24] For the Van Otterloos, too, acquiring the Cuyp was a decision of fundamental importance. The paintings they had obtained as novice collectors were particularly dear to them – sacred, even, according to Levie – and thus not easy to part with. Another aspect of the Cuyp purchase was expressed perfectly by Eijk when he said: "It's a strange feeling, realizing that you have a painting in your home that is worth more than the entire house." Rose-Marie, in particular, found this difficult at first, but was pleasantly surprised at how well the work harmonized with the interior of their home. Selling the less distinguished works to improve the quality of the whole had already been suggested by art dealers, but now the revenues of this directly impacted the status of the collection, through the Cuyp.[25]

INSTALLATION IN THEIR MARBLEHEAD HOME

A remarkable spin-off of Levie's advisory role were two visits he made to the Van Otterloos' home in Marblehead, Massachusetts, during which he planned and oversaw hanging the paintings. The first visit was in 1997, after the house had been renovated. During the process, the collection (then thirty-five paintings) was on loan to the Museum of Fine Arts in Boston. The nature of the collection as a constant work in progress clearly emerges from Levie's list and plans (figure 5). In deciding where each painting would hang, he took into account the placing of a number of recent purchases, noting, for instance, that a Leonaert Bramer (1596–1674) in the dining room would eventually be replaced by Osias Beert's still life, which was still being restored at the time.[26] A number of other works were crossed off the list because they had been marked for sale to support the purchase of the Cuyp. When the lights were installed and Ludolf Bakhuizen's *Ships in a Gale on the IJ before the City of Amsterdam* (catalogue 6) first appeared in full glory, one of the workers exclaimed, to the delight of Levie and Rose-Marie: "It sailed right out of the frame!" In October 2004, Levie returned for another round of installation. The Van Otterloos' generous lending policy ensures that the display of paintings throughout their house is far from static and

Figure 4. Simon Levie, fax of September 10, 1997, with his list of the paintings that might be deaccessioned to buy the Aelbert Cuyp. Simon Levie's archive.

had led to a somewhat untidy appearance. During this second round, some paintings – particularly the river scenes and seascapes – were grouped thematically. Since then, the collection has grown too large for the house – a situation that benefits exhibitions and collection installations at many museums, from the Mauritshuis in The Hague to the J. Paul Getty Museum in Los Angeles.

MATURE COLLECTORS

Moving into the new century, the collection started to take on ever more serious proportions. The Van Otterloos' interactions with art dealers, including some with whom they have very close ties, continued smoothly, with business conducted with a great deal of humor and in a very relaxed atmosphere despite the considerable money involved. Nonetheless, because they searched for specific artists or types of works still missing within the genres of the collection, fewer paintings were bought in this period.

Owing in part to the sharp rise in art prices, in the summer of 2000 the Van Otterloos asked Levie to draw up a balance sheet of the desiderata lists. Describing the state of affairs for each theme, he concluded that landscapes still occupied a very strong position in the collection, but – even for this genre – he also listed the masters still missing, such as Aert van der Neer and Jan Both. He further remarked that a number of other painters whose work was present in the collection were not represented by examples from their best period. In the following years, the collectors took both pieces of advice to heart. But Levie also cautioned against letting the list govern the collecting process too rigidly: "What should be done if, for example, a good (and affordable) Salomon van Ruysdael of around 1650 presents itself? Should you say no, and wait until you can fill a real gap? Will that waiting be rewarded? I don't think that at this point you should make a definite decision about the possibility of acquiring a second work by a master already represented. It would be more realistic to weigh the pros and cons (and perhaps consider a trade) when the occasion arises."[27] The example of the Ruysdael is striking, seeing as Levie had written very enthusiastically in his previous letter about a Ruysdael of around 1650 that had been given a low estimate.[28]

THE ENTRANCE OF THE DECORATIVE ARTS

Meanwhile, the Van Otterloos decided to incorporate decorative arts into the collection. Levie, who had occasionally pointed them toward decorative arts of various periods, introduced them to the Breda antique dealer Loek van Aalst, from whom they bought various pieces of seventeenth-century furniture. "Since these pieces of furniture have been in our home, the collection looks completely different. The minute they arrived we knew that they belonged with the paintings. It felt right," said Rose-Marie, who had long wanted to buy antique furniture. Her reaction betrays the more decorative streak that prompted these acquisitions. Levie, too, wrote in November 2001: "A beautiful piece of furniture has a great impact on the ambiance."[29] In this arena, too, the Van Otterloos sought advice, particularly from Van Aalst, before making a purchase. Both his and Levie's encouragement also prompted them to buy a number of cabinet pieces, including a mother-of-pearl plaque by Cornelis Bellekin, a medallion commemorating the siege of Amsterdam of 1650, a plaque with the conversion of Saint Paul by Adam van Vianen, and, more recently, an inlaid panel by Dirck van Rijswijck (catalogue 68, 71, 70, and 69, respectively).

REMBRANDT AND BEYOND

The name of the quintessential Dutch seventeenth-century master had not even appeared on the first list of desiderata, but in 2000, when *Portrait of a Bearded Man* was offered to the Van Otterloos (through the Dutch art scholar Egbert Haverkamp-Begemann), they seriously considered the acquisition of a painting by Rembrandt for the first time.[30] Levie, delighted that negotiations were underway, wrote: "If you can fill that gap [in portraiture] with a painting by the hand of our greatest seventeenth-century painter (not yet represented in your collection), which is, moreover, a splendid work of truly high quality . . . you will enrich your collection in an inimitable way. At least that's how I see it. Rembrandts have become scarce, extremely scarce, if you also want one in good condition."[31]

Levie's reaction was premature: the negotiations came to nothing. But, encouraged by this positive reaction from the Van Otterloos, Levie demonstrated more confidence when, less than three months later, there appeared on the art market another portrait from Rembrandt's early Amsterdam period – *Old Woman, Sixty-two Years Old* (not then identified as Aeltje Uylenburgh) (catalogue 48). He knew the work from his days as a member of the Rembrandt Research Project and described its condition and subsequent identification of the sitter in great detail. At the sale at Christie's in London on December 13, 2000, the Van Otterloos bought a half-share of the painting. Even though they hoped to one day add it to the collection, it would take another five years before they became the full owners of the piece. As other collectors showed interest in the painting,

Figure 5. Simon Levie, Plans for the installation of the paintings in the Marblehead house, 1997 and 2004. Simon Levie's archive.

their desire increased along with the urgency to make a decision. So, in 2005, they came to an agreement with the co-owner, dealer Robert Noortman. Defraying the cost involved making difficult decisions, including selling a large number of their paintings to Noortman. Although a similar situation had arisen earlier with the Cuyp, relinquishing no fewer than eighteen paintings was a difficult decision. Eijk was initially the most reluctant, but both Rose-Marie and Levie saw the Rembrandt as the crowning glory of the collection. In the spring of 2005, the Van Otterloos, Simon Levie, and Frits Duparc, then director of the Mauritshuis, who was to succeed Levie as their advisor – drew up a list of paintings to be parted with. The list scarcely differed from the works that were ultimately traded. It included the Bakhuizen ("beautiful painting and very popular subject. Included in this list only because of its less good condition") and Maria Schalcken's self-portrait ("Much-loved? Then not. Sweet and attractive as a subject, but a light-weight"), both of which ultimately remained at Marblehead (catalogue 6 and 57).[32] By contrast, a Jan Wijnants (1632–1684), a Salomon van Ruysdael, and two paintings by Philips Wouwerman – which were not on Levie's list – went to Noortman.[33]

Upon reviewing his own list, Levie admitted that it was substantial, "enough to give one a shock." Nevertheless, the Van Otterloos decided to proceed with the purchase. The decision was more difficult for Eijk than for Rose-Marie, who feels that the collection has become more harmonious since parting with the lesser masters. Moreover, it is not in her nature to dwell on a decision once taken: "water under the bridge," she calls it. Eijk, on the other hand, particularly regretted selling the two works by Philips Wouwerman and one Jan van der Heyden (figures 6 and 7). "Those were pieces of high quality," he lamented – which perhaps is why he has declared that going forward they do not wish to sell anything else. Although they have not yet lived with *Aeltje*, as the Rembrandt portrait is fondly called, they are deeply touched by how much visitors have

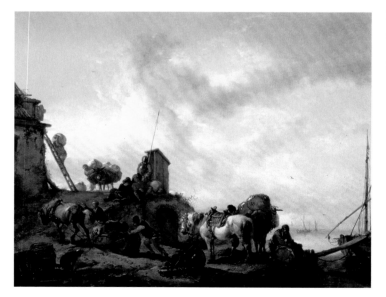

Figure 6. Philips Wouwerman, *A Customs House on the River Maas*, 1655–56. Oil on panel. 15 1/2 × 19 inches (39.5 × 48.5 cm). Private Collection, The Netherlands (formerly Van Otterloo collection).

appreciated the portrait during its loans to the Museum of Fine Arts, Boston, and the Mauritshuis, The Hague.

In addition to the acquisition of the Rembrandt, 2005 was an exceptional year for the collection. The landscape theme was enhanced with a work by Hendrick Avercamp (catalogue 4), "to [Levie's] knowledge the most important work by his hand that might still appear on the market," and a riverscape by Jan van de Cappelle (catalogue 15).[34] Furthermore, in May, Gerrit Dou's endearing painting of a little dog appeared on the market (catalogue 19). Levie's letters are filled with his enthusiasm for the painting, even though he detected a possible conflict: "Will we soon see it [in your collection]? I hope so with all my heart, provided it does not endanger the Old Lady of 1632, who, of course, takes top priority!"[35]

NOBLESSE OBLIGE

The acquisitions made since 2005 testify to the fact that *Aeltje* not only became the pinnacle of the collection but also set a new standard. The following years saw the purchases of highly important pieces, such as Salomon van Ruysdael's impressive *River Landscape with a Ferry* (catalogue 53), which was immediately loaned to the Rijksmuseum as a replacement for a comparable work that had been returned to the Goudstikker heirs.[36] Levie commented about the Van Otterloos' painting:

The water and the sailboats (with many details painted wet-in-wet) in the full light are magnificent, as is the horizon, which is legible down to the last detail, thanks to the splendid state of the large panel.
Also exceptional is the shadowy landscape passage on the right, with the lovely reflections in the water and the light-catching leafy trees above, which stand out against the masterly clouds against a blue sky.
Its subject, composition, handling of light, palette, and condition make this painting one of the master's best works, and its format puts it among his largest.[37]

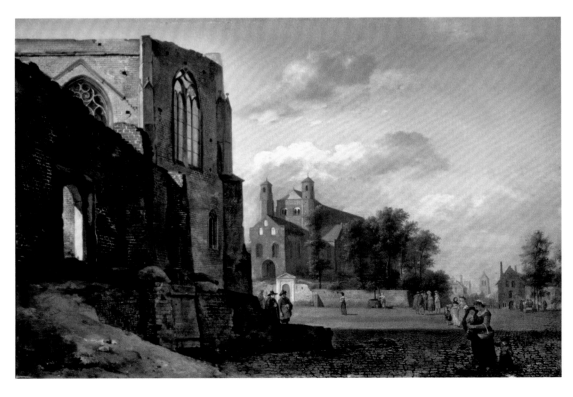

Figure 7. Jan van der Heyden, *View of a City Square with Weidenbach Cloister and St. Pantaleon, Cologne*, date unknown. Oil on panel. 15 1/2 × 23 inches (39.4 × 58.4 cm). Private Collection (formerly Van Otterloo collection).

Frans Hals's *Portrait of a Preacher* entered the collection at almost the same time (catalogue 28). It was followed in 2007 by Jan Lievens's *Young Girl in Profile* and Jan Both's monumental *Italianate Landscape with Travelers on a Path*, which was immediately lent for an indefinite period to the Getty Museum, which had lost in the bidding to the Van Otterloos (catalogue 35 and 12, respectively).

One ironic consequence of their high level of collecting is that the Van Otterloos are now bound by the very standards they have set for themselves. As early as the summer of 2004, Levie was asked to look at a small painting by the minor Leiden painter Jan Mortel (1652–1719). His response holds a small reprimand: "This is by no means art with a capital A. The painting would be suitable for a beginning collector, but not for you, with your trained eye and finely honed sense of quality."[38] Nevertheless, the window of Eijk's office next to the kitchen, to which the transparencies of possible purchases are affixed, is none the emptier. Indeed, just in time for this exhibition, they acquired a magnificent still life by Pieter Claesz. (catalogue 16).

A NEW CHAPTER

On April 30, 2009, Levie resigned from his position as advisor, writing to the couple:

This [receipt of the last payment] closes the chapter of my role as your advisor with a feeling of great thankfulness. In the years behind us, you have developed a tremendous eye for the painting of our Golden Age, and a collection has been created that, to my mind, can no longer be equaled. Working on it in such a harmonious atmosphere has been a great privilege.[39]

Levie misses his involvement but felt – at age eighty-four – that he was getting too old to carry on. His natural successor, Frederik (Frits) Duparc, like Levie, had experience both in the museum world (as director of the Mauritshuis) and in counseling private collectors, and had been involved with the Van Otterloo collection in the past. As with the Levies, the Duparcs are close friends of the Van Otterloos.

Rose-Marie explained that Duparc's working method differs from Levie's. Duparc is still very involved with the Mauritshuis, and his ties to the art trade are even closer than Levie's, which at times enables him to negotiate at an earlier stage. This more direct way of operating means that they have to do without Levie's thoughtful essays and descriptions, which over fourteen years amounted to four folders of letters, faxes, and emails. However, Duparc's research for this catalogue of the collection will bring the connoisseurship and scholarship that set the tone for the collection from the very beginning to the attention of a much wider audience than just those who can fit around the Van Otterloos' kitchen table.

ENLIGHTENED PATRONAGE

The Van Otterloos have always been generous in their lending policy. A rare refusal is usually prompted because the work has been promised to another institution or has been "on the move" too long and is thus at risk for damage. Initially, requests from unfamiliar institutions were put to Levie; at other times, institutions would approach the Van Otterloos through him. While Eijk usually negotiates new acquisitions, Rose-Marie handles all the documentation, shipping, and loan arrangements. For a collection of nearly seventy paintings, this is no small task. In a letter thanking the couple for allowing him to view their collection in 2007, Kurt Sundstrom, associate curator of the Currier Museum in Manchester, New Hampshire, wrote: "Rose-Marie, as a curator

you have done an expert job that is on par with the best professionals. And together your acquisition policy is the archetype that all museums and private collectors should strive to attain."[40] Indeed, the meticulous way in which Rose-Marie has cared for the collection demonstrates the aptness of Sundstrom's designation of her as "curator."

The more the Van Otterloos made individual works in their collection available to the public, the greater became the demand for an exhibition. In considering the idea, they realized that because pieces are frequently on loan, even they themselves had never seen their collection in its entirety. When the New York–based art dealer Otto Naumann learned in 2005 that the Van Otterloos had acquired the Rembrandt, he wrote:

> *Do you realize that you've done something here that is historical? You have managed to assemble a group of paintings that are comparable to what was done by the best collectors of the 19th century, like the Marquess of Hertford of the Wallace collection. Forget the 20th century, where Norton Simon was probably the best. . . . In short you've created a wonderful monster that deserves to become its own entity. You have to think about the broad issues of whether or not the collection should remain intact in perpetuity [or at least] commemorate the achievement with a catalogue.*[41]

Although the Van Otterloos never seriously compared themselves with these great collectors of the past century, the example of two other collections of seventeenth-century Dutch paintings has been a great influence on their collection and their thoughts about its future. At the very beginning of their collecting career in the early 1990s, they were inspired by The Edward and Hannah Carter Collection, based in Los Angeles. Eijk showed Levie a catalogue of the collection as an example of what he wished to achieve; notes from this period contain a thematic overview of the Carter collection, followed by a comparison with the Van Otterloos' then considerably more modest holdings.[42] During a much more recent visit to the Los Angeles County Museum of Art, the Carter collection's home since 2004, they were once again deeply impressed by its high quality as well as by the public recognition accorded to the Carters' achievements as collectors. Shortly before, the Van Otterloos had seen The Harold Samuel Collection of seventeenth-century Dutch paintings in London, which Lord Samuel bequeathed in 1987 to the Corporation of London, to hang permanently in Mansion House, the Lord Mayor's residence. Eijk described it as a tremendous collection, but believes that in the mayor's residence it is almost inaccessible to the public and also suffers from lack of climate control and poor lighting. "When we realized that our collection provided an overview of seventeenth-century Dutch painting in terms of genres and quality, we decided we want to follow the example of the Carter collection rather than the Samuel collection."

The shared passion for art among the many collectors of Dutch paintings and drawings in the Boston area has also inspired the Van Otterloos. Camaraderie rather than competition has guided these local collectors, with whom the couple occasionally traded works and often discussed individual pieces at brunches organized by the late Maida Abrams in the tradition of eighteenth-century collectors.[43] Indeed, what better place could the Van Otterloos choose to showcase their collection than, as Rose-Marie described, in their own "back yard?"

Rose-Marie and Eijk are indeed very curious to hear what visitors will think of the collection. This will also nurture their decision about its ultimate fate, which has not yet been decided. For now, their generous lending policy and the financial support they give to various museums in the

United States and the Netherlands are an integral part of their patronage. They see it – in a very American way – as their duty to help these institutions, "to further their existence and, if possible, to leave them better than we found them."

Notes:

Author's note. "Lieve Rose-Marie, beste Eijk:" Simon Levie began the letters, faxes, and emails that make up his fourteen years of correspondence with the Van Otterloos with the salutation in the title of this essay. I am greatly indebted to Rose-Marie and Eijk van Otterloo, Simon Levie, and Frits Duparc, for without their input this piece could never have been written. All quotations in the essay unless otherwise noted are from interviews with Levie and the Van Otterloos conducted in the autumn of 2009. My conversations with Levie and the Van Otterloos, as well as the access I was given to Rose-Marie's extensive documentation on the collection, were indispensable to my research. I am therefore especially grateful to Rose-Marie for her meticulous management of this treasure trove of information. All correspondence quoted is from those archives.

1. Peter Sutton to Eijk van Otterloo, January 20, 1993. In this letter, Sutton congratulated Van Otterloo on his purchase of a Wouwerman. The painting by Jacob Duck (1600–1667) with art dealer Johnny Van Haeften that Sutton advised him to buy in this letter was purchased by the Van Otterloos the following year. That same month, Sutton compiled an overview of the most important collectors and the art on offer: "I do this as a matter of course for several collectors that we advise. The idea is just to keep you apprised of what's passing through the open market." Sutton to Van Otterloo, January 27, 1993.

2. In this period, they also decided to have the Claes Moeyaert, an heirloom from Eijk's family, cleaned by Hans van Dam. During restoration, a previously unknown signature in initials was found, which proved the attribution to Moeyaert correct. The go-between was the art dealer Charles Roelofsz, from whom they also bought the Coorte (catalogue. 17).

3. Correspondence between Sutton and Van Otterloo, 1993–95.

4. Eijk van Otterloo to Levie, October 8, 1995.

5. Levie to Van Otterloo, December 3, 1996.

6. Levie to Van Otterloo, December 9, 1996.

7. Van Otterloo to Levie, December 9, 1996.

8. Levie to Van Otterloo, December 12, 1996.

9. Levie also mentioned that an interesting *pentimento* (trace of an earlier composition) had been found during conservation: Beert initially placed a knife on the tinderbox, but apparently had a change of heart and painted it over. Levie to Van Otterloo, April 29, 1997.

10. Van Otterloo to Levie, October 8, 1995.

11. Levie to Van Otterloo, May 15, 1998. In the end, the work was not purchased.

12. Levie to Van Otterloo, April 15, 1996. Levie was very noncommittal about the pieces that predated his relationship with the Van Otterloos and the purchases in which he was not involved. He was usually much more cautious in the descriptions he sent to Van Otterloo than in his own notes of viewing days or his short written reactions to their choices from sale catalogues (where he sometimes wrote no more than "no!," "bad condition," or "disagreeable piece").

13. With art dealers in particular, Levie's advisory role could lead to complications, for his involvement immediately signaled that the Van Otterloos had taken an interest in a work. On May 22, 1996, London art dealer Johnny Van Haeften wrote to Eijk: "Don't let Simon know yet, because then everyone will know."

14. This same period saw the purchase from Noortman of an etched copper plate by Adriaen van Ostade and a painting by Dirck Hals (not in exhibition and catalogue 27). Van Otterloo to Noortman, November 17, 1995.

15. Levie to Van Otterloo, February 15, 1996.

16. Letters dating from late April and early May 1998.

17. Levie to Van Otterloo, June 29, 2007.

18. Notes from Eijk's telephone conversation with William Robinson, December 21, 2001: "Bill Robinson says: 1978 saw it. Move heaven and earth to get it. Quality is phenomenal and is better than the Mauritshuis picture. Only two left to come to the market."

19. Levie to Van Otterloo, August 22, 1996.

20. Ibid.

21. For the sake of completeness, he noted in brackets the painters of greatest art-historical importance for each genre, whom he thought were no longer attainable for a private collection. One of the artists was Johannes Vermeer (1632–1675), but Gabriël Metsu, Rembrandt, and Frans Hals, who were also mentioned in this respect are now represented in the Van Otterloo collection.

22. Overview of history painting, September 23, 1996.

23. Levie to Van Otterloo, September 10, 1997.
24. All the paintings on his list eventually left the collection, some to facilitate the purchase of the Cuyp, some to enable the acquisition of the Rembrandt, and others because they were replaced by a better work by the same master. Ibid.
25. Naumann to Van Otterloo, October 25, 1997.
26. Installation in Marblehead, end of July 1997; the purchase of the Bramer is described in the letter: Levie to Van Otterloo, March 11, 1997.
27. Levie to Van Otterloo, July 13, 2000.
28. Levie to Van Otterloo, June 16, 2000.
29. Levie to Van Otterloo, November 1, 2001. This remark was prompted by a chest they intended to buy from Loek van Aalst.
30. They already owned some Rembrandt etchings.
31. Levie to Van Otterloo, July 13, 2000.
32. Levie to Van Otterloo, March 9, 2005.
33. Noortman to Van Otterloo, invoice of May 5, 2005.
34. Levie to Van Otterloo, January 2004.
35. Levie to Van Otterloo, April 27, 2005.
36. Some 202 paintings that had belonged to the Jewish art dealer Jacques Goudstikker (1897–1940) and had become part of the Dutch National Collection after World War II were returned to his heirs in 2007 after a legal and political struggle of nearly a decade.
37. Levie to Van Otterloo, fall 2006.
38. Levie to Van Otterloo, July 1, 2004.
39. Levie to Van Otterloo, April 30, 2009.
40. Sundstrom to Van Otterloo, August 8, 2007.
41. Naumann to Van Otterloo, June 9, 2005.
42. Van Otterloo collection documentation.
43. For example, they acquired various paintings from Charles C. Cunningham in 2003: an Aert van der Neer (catalogue 40), a Willem van de Velde the Younger (catalogue 63), and a Jacob van Ruisdael (catalogue 51). Agreement between the Van Otterloos and Cunningham, December 2003.

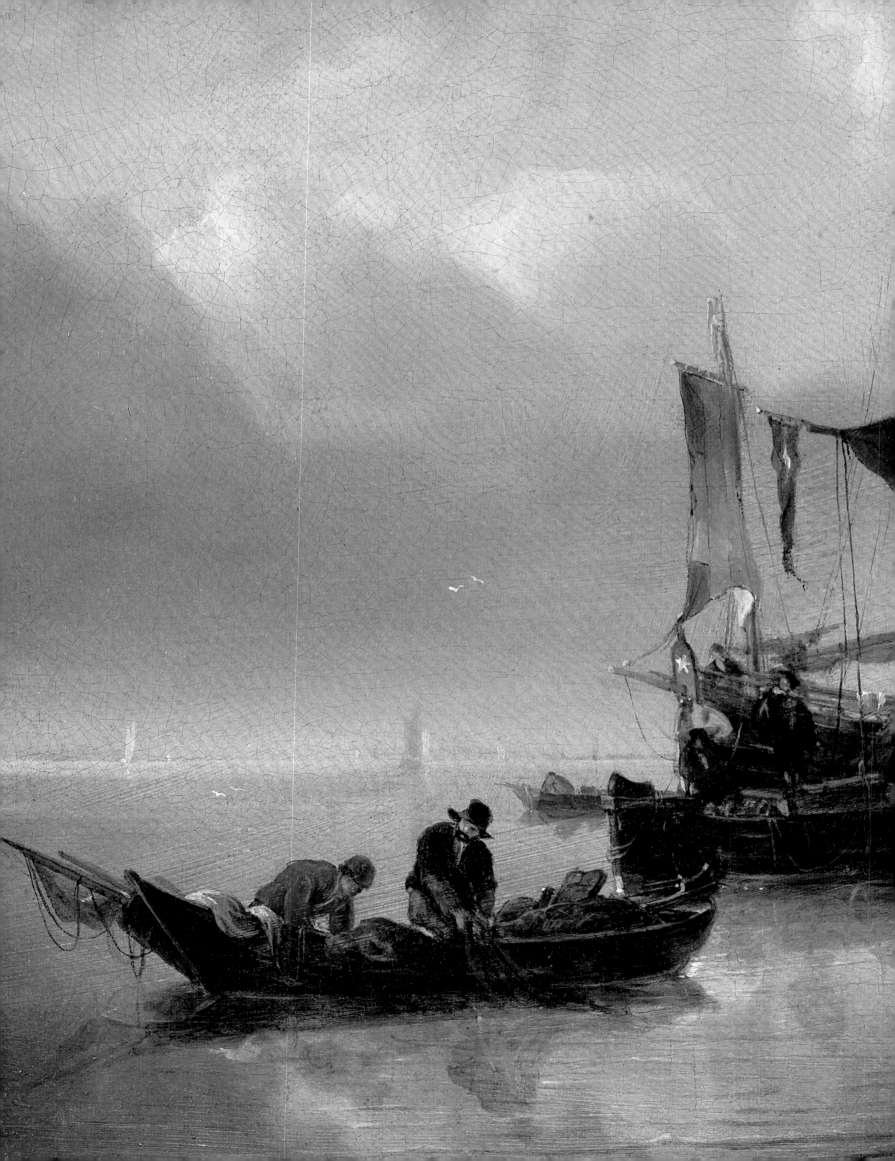

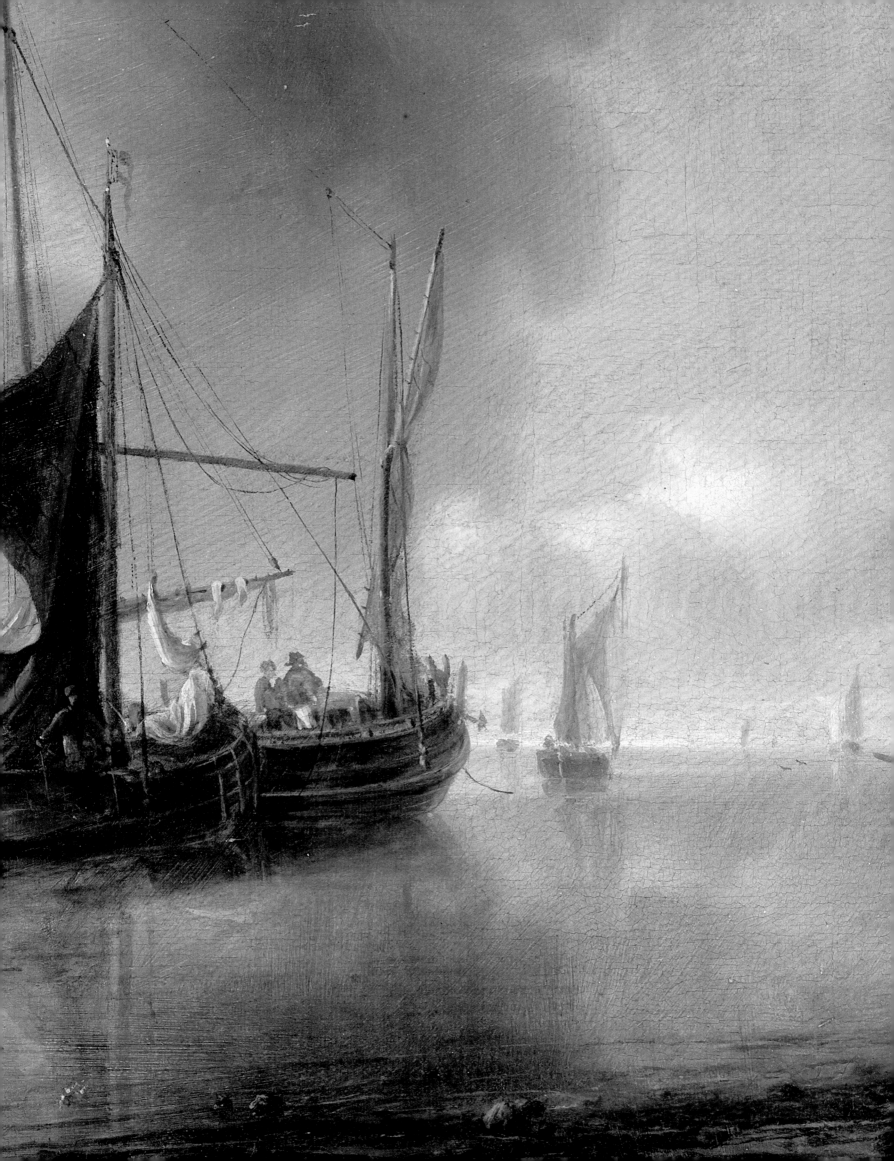

WILLEM VAN AELST

DELFT 1627–1683 OR LATER DELFT

The son of a notary, Willem van Aelst was baptized in Delft on May 16, 1627. He was apprenticed to his uncle Evert van Aelst (1602–1657), who also lived in Delft, and became a member of the local guild at an early age in November 1643. In 1645, Willem left for France, where he remained until traveling on to Italy in 1649. In Florence, he worked as an assistant to the still-life painter Otto Marseus van Schrieck (1619/20–1678) at the court of Cosimo III de' Medici, the future grand duke of Tuscany. Beginning in 1653, he was paid directly by the court and even awarded a gold medal for his services. In 1656, he returned to Holland with Van Schrieck. According to Houbraken, he settled in Delft, but there is no documentary evidence of a stay there.[1] What is certain is that he soon moved to Amsterdam. In 1672, Van Aelst and six other artists were asked to assess a collection of Italian paintings that the Amsterdam dealer Gerrit Uylenburgh had sold to the great elector of Brandenburg. Their verdict was extremely unfavorable. In January 1679, Van Aelst married his housekeeper, Helena Nieuwenhuys. At that time, he was living on Keizersgracht in Amsterdam. The date of his death is not precisely known, but his last dated painting bears the year 1683.

Van Aelst was an exceptionally successful and productive artist. His oeuvre consists almost exclusively of elegant floral still lifes, game pieces, still lifes with fruit, and tables laden with food. His compositions are outstanding in their sureness of design, but the objects sometimes take on a severe and cool quality because of the combination of bright, hard colors and a smooth application of paint. His technique is extremely refined and the rendering of the various fabrics and materials is virtually unequaled. In Italy and also afterward, he usually signed himself *Guill[er]mo van Aelst*, as a reminder of his Italian period; after 1658, he always used this signature.

CATALOGUE 1. *Still Life with a Candle, Walnuts, and a Mouse*, 1647. Oil on copper, 7 5/8 × 9 3/4 inches (19.3 × 24.7 cm). Signed and dated lower center: *W.V aelst. [16]47*

Among Van Aelst's several pupils were Maria van Oosterwijck (1630–1693) and Rachel Ruysch, the two most important women painters of floral still lifes in seventeenth-century Holland. Simon Verelst (1644–1710/17) was also greatly influenced by Van Aelst's work.

Literature: Sullivan 1984; *Still-Life Painting in the Netherlands 1550–1720* 1999–2000, pp. 242–49; Broos 2000, pp. 1–2; Van der Willigen and Meijer 2003, pp. 25–26.

CATALOGUE I

STILL LIFE WITH A CANDLE, WALNUTS, AND A MOUSE

DESPITE ITS MODEST FORMAT, unpretentious subject, and the remarkable fact that it is a relatively early work, painted in France when Willem van Aelst was about twenty, this still life is among the most attractive in his oeuvre. Because of the low point of view, only slightly higher than the table top, modest objects such as the walnuts and especially the candlestick acquire a certain monumentality. Moreover, through them the artist emphasized how small the mouse is.

Van Aelst is best known for his elegant still lifes, painted with a velvet touch, a convincing rendering of materials, and usually a bright and richly colored palette. With its predominantly gray, brown, and white tones, however, this still life is mainly monochrome in feeling, like, for example, the still lifes painted by Pieter Claesz. and Willem Claesz. Heda in the 1630s. The touch is also clearly different from Van Aelst's later, smoother manner. Many individual brushstrokes are visible and here and there he has deliberately allowed the reddish-brown ground to be seen through the paint. Moreover, instead of canvas, the support is a copper plate, which contributes to the particularly brilliant impression. Toward the end of his life, Van Aelst painted another mouse with walnuts as part of a much more elaborate still life with grapes and a peach.[2]

The various elements of the composition – walnuts, a candlestick with a candle that has just been snuffed out, and a mouse on a stone table-top – regularly occur in Dutch seventeenth-century still lifes, but rarely in this combination. It can perhaps be traced back to a 1594 drawing by the miniaturist Joris Hoefnagel (1542–1600) (figure 1), as Sam Segal has suggested.[3] Hoefnagel is known primarily for his extremely delicate images of plants and animals. The drawing in

Figure 1. Joris Hoefnagel, *Mouse with a Candle Stump and a Nut*, 1594. Watercolor, 3 1/2 × 4 7/8 inches (8.9 × 12.3 cm). Rijksmuseum, Amsterdam.

Amsterdam shows a mouse on a wooden table-top next to a cracked walnut and a half-burnt candle; a second mouse sticks its head up through a hole in the table.[4]

The combination of a recently extinguished candle, a cracked table-top, and walnuts that are open and gnawed indicate that Van Aelst's painting is not just a still life, but a *vanitas* that refers to the transitory nature of things. This symbolism is present in numerous Dutch seventeenth-century still lifes, including those by Van Aelst, but is commonly expressed by watches, flowers, and partly eaten leaves.[5]

Provenance: With Brian Koetser, London; private collection, London; Joost R. Ritman, Amsterdam, until ca. 1995; with Noortman Master Paintings, Maastricht and London; Benoit Wesley, Maastricht, from 2001; acquired from Noortman Master Paintings, Maastricht and London, 2002.

Exhibitions: The Brian Koetser Gallery, London, *Autumn Exhibition of Fine Dutch, Flemish and Italian Old Master Paintings*, 1973; The Metropolitan Museum of Art, New York, and The National Gallery, London, *Vermeer and the Delft School*, 2001.

Literature: *Autumn Exhibition of Fine Dutch, Flemish and Italian Old Master Paintings* 1973, cat. no. 6; *Vermeer and the Delft School* 2001, pp. 212–13, no. 1.

Notes:
1. Houbraken 1718–21, vol. 1, p. 228.
2. Oil on canvas, 19 1/4 × 16 1/8 inches (49 × 41 cm), signed with full name and dated 1682 (Kunsthandel Salomon Lilian, Amsterdam, 2001).
3. Sam Segal, who, according to Axel Rüger, wrote an unpublished text about the painting.
4. Kaufmann 1988, cat. no. 9.6; *Vermeer and the Delft School* 2001, pp. 212–13, n. 4.
5. *Stilleben in Europa* 1979, pp. 191–218.

JAN ASSELIJN

DIEMEN OR DIEPPE CA. 1610–1652
AMSTERDAM

Where and when Jan Asselijn was born is uncertain. In 1652, when he obtained the civil rights of a citizen of Amsterdam, he was described as coming from "Diepen." This has been interpreted variously as Diemen, a village close to Amsterdam, and as Dieppe, in France. Asselijn was probably apprenticed to Jan Martszen the Younger (1609?–after 1647), a moderately gifted painter of battle scenes. Like many of his Dutch colleagues, Asselijn traveled to Italy (ca. 1639/40), where he worked in Rome until 1643 or 1644. There, under the nickname of *Crabbetje* (Little Crab), a reference to his misshapen left hand, he joined the *Bentvueghels* (Birds of a Feather), a group formed by the Dutch and Flemish artists in Rome. According to Houbraken, during his return journey, around 1645 in Lyon, Asselijn married Antonetta Houwaart, whose elder sister was the wife of the painter Nicolaes van Helt Stockade (1614–1669).[1] The two artists worked for some time in Paris before leaving for the Netherlands in August 1646. In 1647, Asselijn was back in Amsterdam, where he lived for the rest of his short life. Around that same year, Rembrandt etched his portrait.[2] Asselijn had his will drawn up on September 28, 1652, and died a few days later. He was buried on October 3.

Together with Jan Both and Nicolaes Berchem, Asselijn was among the best and most influential painters in the second generation of Dutch Italianate landscapists. Influenced by Pieter van Laer (1599–1642 or later), he also painted scenes from Italian street life as well as several winter landscapes. His earliest work, done between 1634 and his departure for Italy, consists almost entirely of battles in the style of his teacher. In the absence of dated works from between 1635 and 1646, when

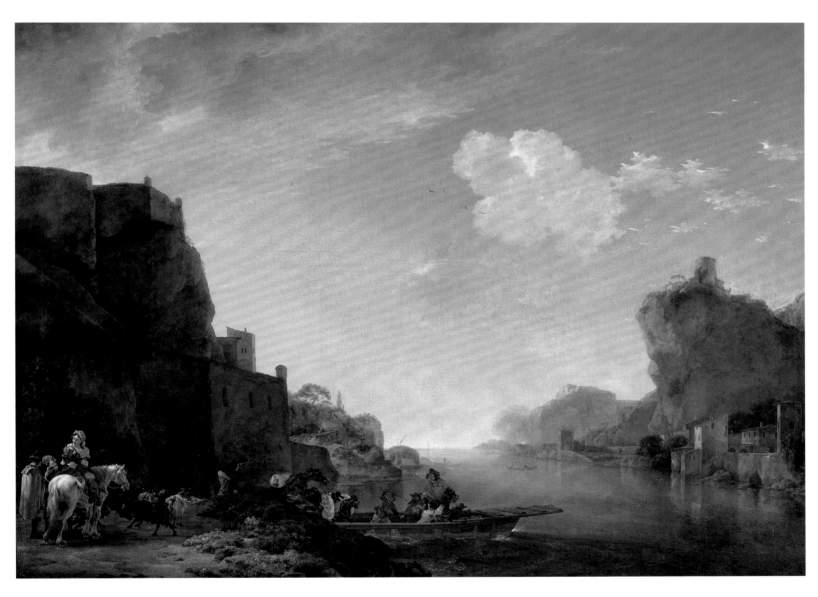

CATALOGUE 2. *River Landscape with the Fort Saint-Jean and the Château de Pierre-Scize in Lyon*, ca. 1650.
Oil on canvas, 28 3/8 × 39 1/8 inches (72 × 99.5 cm). Monogrammed lower left of center: *JA*

he was in Italy and must have evolved his Italianate style, it is difficult to trace his artistic development closely. The influence of his period in France is also unclear. In addition to paintings, he left countless drawings, and Gabriel Perelle (1603–1677) made eighteen engravings after drawings by Asselijn.

Literature: Steland-Stief 1971; *Dutch 17th Century Italianate Landscape Painters* 1978, pp. 129–44; Steland 1989; Steland 2000, pp. 2–3.

CATALOGUE 2

*RIVER LANDSCAPE
WITH THE FORT
SAINT-JEAN AND THE
CHÂTEAU DE
PIERRE-SCIZE IN LYON*

IN A SUN-BAKED, SOUTHERN RIVER LANDSCAPE, travelers and herders are boarding a ferry with their horses, mules, and goats. Two men with sticks are trying to keep the three mules under control but one mule has sprung onto the back of another. A woman seeks safety at the front of the boat. At the far left, a woman and two men wait their turn to board while a goat and a dog are quarreling. The commotion in and around the boat contrasts sharply with the tranquil atmosphere of the landscape.

This work was probably painted around 1650. In contrast to the Italianate landscapes Asselijn painted immediately after his return to the Netherlands, such as a river landscape dated 1647 (figure 1), here there is a clear division of space.[3] On the other hand, the bright palette is different from the more subdued tonality of the landscapes from the last years of his life.

Many of Asselijn's drawings depict recognizable buildings and locations in Rome and the surrounding *campagna*, but most of his Italianate paintings are imaginary. No topographical drawings exist from his time in France, but this painting indicates that he must have drawn there as well. The fort on the rock to the right is derived from the Château de Pierre-Scize on the northeast side of Lyon. Originally built in the tenth century and strategically located on a 164-foot-high rock on the Saône, it served as the residence of the archbishop of Lyon and later as a prison. It was demolished in 1793. The fort at the left in the painting, Fort Saint-Jean, still survives. It was one of the strongholds built in the sixteenth century to protect the city of Lyon. Asselijn was not alone in choosing this spot as the subject of a landscape. Johannes Lingelbach (1622–1674) painted almost the same view, but from farther away and from a higher vantage point (figure 2).[4] Houbraken

Figure 1. Jan Asselijn, *River Landscape*, 1647. Oil on canvas, 30 1/2 × 40 1/2 inches (77.5 × 103 cm). Staatliches Museum, Schwerin.

Figure 2. Johannes Lingelbach, *River Landscape with Distant View of Fort Saint-Jean*, 1647–50. Oil on canvas, 35 3/8 × 41 inches (89.9 × 104.2 cm). Private Collection.

says Lingelbach visited France in 1642 on his way to Rome, where he arrived two years later. Like Asselijn a few years earlier, he was evidently impressed by Lyon's situation with a fort on each bank.[5] The Dutch Italianate painter Jacob de Heusch (1656–1701) was also inspired by the site. A drawing from the first half of the 1670s in the Frits Lugt collection in Paris shows the Château Pierre-Scize.[6] It is hardly surprising that so many Dutch artists stopped at Lyon. The city lay on one of the best-known routes from Holland to Italy and was even called "Italy's antechamber."

In the distance, slightly to the right of center, is a lime kiln with a plume of smoke. Pieter van Laer was probably the first Dutch Italianate to include these kilns, which were common in Italy, in his paintings. Their representation may have had a symbolic significance as well: because they were used to process architectural fragments of classical buildings, they could be seen as allusions to the transitory nature of what was once the glory of ancient Rome.

The theme of an Italianate or, as in this case, southern river landscape is frequently seen in Asselijn's work, but the presence of a ferryboat makes this painting unusual for him. But, there does exist a drawing that shows a river landscape with a fully loaded ferry and rocks with buildings to the left and right.[7] As to the theme of the ferry, he was probably inspired by earlier Dutch artists. Esaias van de Velde, Jan van Goyen, and above all Salomon van Ruysdael painted numerous Dutch river landscapes with packed ferries. In turn, Asselijn's southern river landscapes inspired the slightly younger Italianate Adam Pijnacker, who made this subject one of his specialties. A somewhat similar group of travelers with a woman on a horse can be seen in a drawing by Asselijn in the De Grez collection in the Museum voor Schone Kunsten in Brussels.[8]

Provenance: Augustin Blondel de Gagny, Paris (1695–1776), trésorier général de la caisse des amortissements, Paris; sale, Paris (Rémy), December 10–24, 1776, and January 8–22, 1777, no. 186, to Le Brun for Beaujon (ffr. 2450, –); Jules Porgès, his estate sale, Paris (Galerie Georges Petit), June 17, 1924, no. 2 (to Féral); anonymous sale (W. Cornwallis and others), Brussels (Galerie Fievez), December 19, 1924, no. 5 (ffr. 1700); sale Duvinage van den Wiele, Brussels (Galerie "Le Centaure"), January 26, 1929, no. 1; private collection, 1929–92; sale London (Sotheby's), December 9, 1992, no. 70 (to Johnny Van Haeften); acquired from Johnny Van Haeften, London, 1994.

Exhibitions: Museo Thyssen-Bornemisza, Madrid, *The Golden Age of Dutch Landscape Painting*, 1994.

Literature: Steland-Stief 1971, pp. 71, 149, no.156; Steland-Stief 1980, p. 253, fig. 58; Steland 1989, pp. 90, 236, 238 under cat. no. 122, ill. p. 111, no. 96; *The Golden Age of Dutch Landscape Painting* 1994, p. 60, no. 1, ill. p. 61; Alsteens and Buijs 2008, pp. 197–98, 210 n. 35, fig. h.

Notes:
1. Houbraken 1718–21, vol. 3, p. 64.
2. Bartsch 1797, no. 277.
3. Steland-Stief 1971, cat. no. 205.
4. With Colnaghi, London, 2008; Burger-Wegener 1976, p. 274, cat. no. 98.
5. I thank S. Alsteens for this new identification. See Alsteens and Buijs 2008.
6. Alsteens and Buijs 2008 attribute this drawing to Jan Wils.
7. Steland 1989, cat. no. 122, fig. 95.
8. Ibid., cat. no. 40, fig. 68.

BALTHASAR VAN DER AST

MIDDELBURG 1593/94–1657 DELFT

Balthasar van der Ast was born in Middelburg in 1593 or 1594. In 1609, on the death of his father, a wealthy merchant in woolen clothing, fifteen-year-old Balthasar was taken into the family of his elder sister Maria and her husband, the painter Ambrosius Bosschaert the Elder, who also lived in Middelburg. In 1615, Van der Ast probably moved with them to Bergen op Zoom. The Bosschaert family settled in Utrecht the following year, but Van der Ast is mentioned there only from 1619, when he joined the local St. Luke's Guild. He lived in Drieharingsteeg, an alley between Vredenburg and Oude Gracht. In 1625, Maria, now widowed, and her children moved in with him. In 1629, Van der Ast moved to a house on Jacobijnestraat. In 1632, he settled in Delft and joined the guild there. He died in Delft in December 1657.

Van der Ast was taught to paint by Bosschaert, whose work remained a permanent influence. In turn, Ambrosius Bosschaert's three sons were probably all apprenticed to Van der Ast and possibly Jan Davidsz. de Heem as well. Van der Ast also seems to have drawn inspiration from the still lifes of Roelant Savery (1576–1639), who registered with the Utrecht guild in the same year as Van der Ast. Like Bosschaert, Van der Ast generally painted flower still lifes, often combined with exotic shells and enlivened by insects and lizards. But Van der Ast's approximately two hundred paintings demonstrate greater variety than those of his teacher. Besides floral works, he painted still lifes with shells or fruit as the main subject or a combination of both.

The development of Van der Ast's style is difficult to track because after 1628 he rarely dated his paintings. In his early work in particular, the painting manner and the almost symmetrically arranged, compact bouquets are very reminiscent of those of his teacher. The later pieces have greater dynamism and transparency.

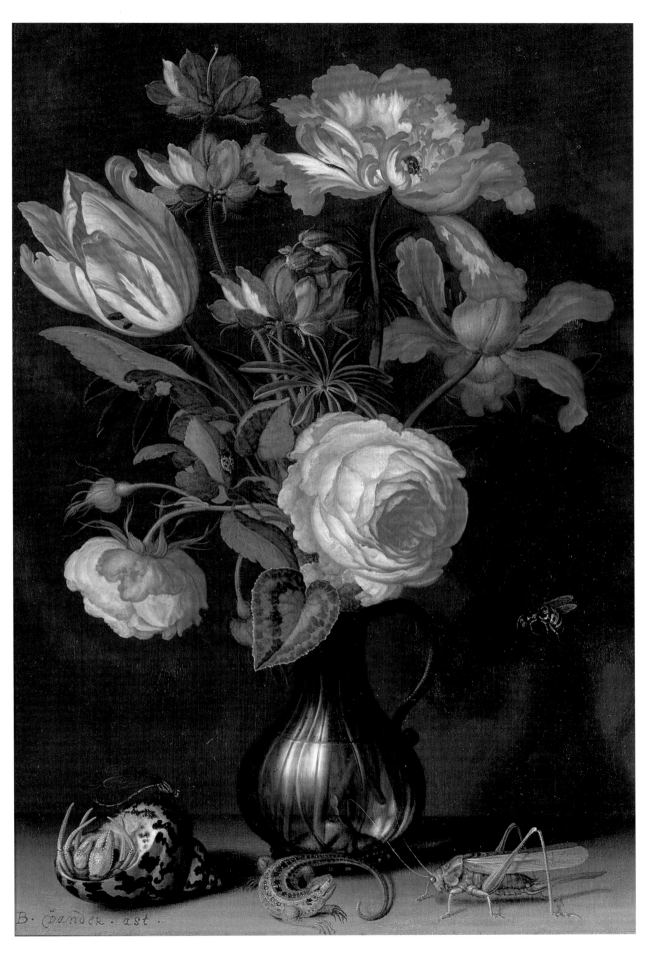

CATALOGUE 3. *Still Life with Flowers*, ca. 1630. Oil on panel, 14 5/8 × 9 5/8 inches (37.2 × 24.5 cm). Signed lower left: *.B. v̄andeR.ast.*

In the seventeenth century, Van der Ast already had a certain reputation beyond the places where he lived, as shown by a manuscript by Jan Sysmus, a city doctor in Amsterdam who compiled a register, *Huidendaegse Schilders* (Contemporary Painters), between 1669 and 1678. He added a brief description to most of the hundreds of names he included. Of Van der Ast, he wrote: "With flowers, whelk shells, and lizards, beautiful."[1]

Literature: Bol 1960; *Masters of Middelburg* 1984; Haberland 2000, pp. 3–4; Van der Willigen and Meijer 2003, p. 28.

FOR A LONG TIME, interest in the floral still lifes of Balthasar van der Ast and his teacher Ambrosius Bosschaert was limited. Over the last fifty years, however, their work has received considerable attention, which has led in part to the rediscovery of many of their paintings. This present still life was entirely unknown until it came up at auction in 1956. The fact that it was listed as a work by "Bartholomeus" instead of "Balthasar" van der Ast is a commentary on the state of knowledge at the time. It is being displayed and published here for the first time.

A simple bouquet is arranged in a ribbed glass carafe with a handle. The combination of flowers – some, such as the tulip, spring bloomers, and others, such as the rose (*Rosa gallica*), that bloom in the summer – shows that this is an imaginary composition. This was a method often used by most Dutch seventeenth-century still-life painters. We may assume that the artists painted the individual flowers from life or after drawings or studies done earlier. This is confirmed by the fact that some flowers appear in various works by one painter dating from different phases of his career. In the case of Van der Ast, the pink rose at the bottom right appears in another still life.[2] Probably a studio prop, the carafe reappears as well, for instance in an earlier floral still life in the Schönborn Collection in Pommersfelden.[3]

Bosschaert's influence never completely disappeared, but Van der Ast was increasingly successful at developing his own style. In place of the compact, almost symmetrical bouquets from his early career, which closely resemble those of his teacher, during the 1620s his bouquets become ever more transparent and the symmetry loosens to allow for more dynamic and natural compositions. Moreover, the lighting becomes less uniform and the contours softer than with Bosschaert. These characteristics are clearly evident in this still life, which was probably painted around 1630. In addition, Van der Ast used the subtle shadows cast by the bouquet and the vase to create a certain effect of space.

The foreground is enlivened by a hermit crab in a tapestry turban shell (*Turbo petholatus*), a sand lizard (*Lacerta agilis*), and a katydid (*Tettigonia viridissima*). A wasp hovers on the right; on the turban shell is a dragonfly and a kind of ladybird sits on one of the rose petals. Van der Ast no doubt borrowed the combination of bouquets of flowers and costly, exotic shells from Bosschaert, but the inspiration for the lizard and grasshopper probably lay in the work of Roelant Savery.

In the seventeenth century, many flowers were extremely expensive and often rare. They were cultivated with care by botanists and plant lovers and admired in special gardens. Few people could afford cut flowers indoors, where they soon wilted. Floral still lifes were an attractive and permanent alternative.

Provenance: Possibly sale, Amsterdam (V.d. Schley/Spaan), June 13, 1809, no. 3 ("Een Glaze Fles, staande op een Tafel, gevuld met geurige Bloemen, door B. van Ast. Paneel. 14=10 d. [Dutch *duim* (thumb or inch) [36.62 × 26.16 cm]"); possibly sale (anonymous single-owner collection), Amsterdam (V.d. Schley/Yver), June 20, 1810, no. 2 ("Een Glazen Fles, gevuld met geurige Bloemen, staande op eene Tafel. Uitvoerig op paneel, door van Ast. H. 14, br. 10 dm.") (sold for f. 1, –); Mrs. A. R. Sinclaire, sale, London (Sotheby's), April 25, 1956, no. 155 (as Bartholomeus van der Ast); sold to Speelman for £1.400, – ; with Edward Speelman, London; sale, Düsseldorf (Karbstein & Schultze), October 12, 1983, no. 46 (advertisement in *Die Weltkunst*, December 15, 1983, p. 3601, ill.) (sold for dm 270.000, – ; with Richard Green, London, 1985;) private collection; with Xavier Scheidwimmer, Munich, 1997–98; where acquired in 1998.

Literature: Daniëlle Lokin, catalogue raisonné on Van der Ast, no. Ast 0178 (forthcoming.)

Notes:
1. Bredius 1890, p. 4.
2. Private collection, London, on loan to the National Gallery, London. See *Vermeer and the Delft School* 2001, cat. no. 3, ill., previously described in *Masters of Light* 1997, cat. no. 76.
3. Bol 1960, p. 71, cat. no. 11, pl. 35.

HENDRICK AVERCAMP

AMSTERDAM 1585–1634 KAMPEN

Hendrick Avercamp was baptized on January 27, 1585, in the Oude Kerk in Amsterdam. He was
the son of Barent Avercamp, a schoolmaster and apothecary who came from Friesland. A year later,
the family moved to Kampen, a Hanseatic port on the Zuiderzee, in the east of the Netherlands,
which by that time had already lost much of its importance. But Avercamp's isolation was not only
geographical. He is believed to have been deaf, and as a consequence, mute. Shortly after 1600,
Avercamp returned to Amsterdam, where he moved in with the history and portrait painter Pieter
Isaacsz. (1569–1625). At an auction of Isaacsz.'s effects in 1607, when he returned to his native
country of Denmark, one of the buyers was "the Mute to Pieter Isacqs" – no doubt Hendrick
Avercamp, who was often referred to as "The Mute of Kampen." He is again mentioned as being in
Kampen in 1614, but he probably returned much earlier. He continued to live in Kampen until
his death. His mother's will, drawn up in December 1633, two weeks before her death, clearly reflects
her concern about "her mute and wretched son," who was still unmarried and living at home.
She asked the Kampen magistrates to grant him an annuity of one hundred guilders in addition to
his legal portion. But Hendrick died less than six months later; he was buried in the Bovenkerk
in Kampen on May 15, 1634.

Avercamp's drawn and painted oeuvre consists almost exclusively of winter landscapes enlivened with countless small figures who skate, play "kolf" (a forerunner of golf), ride sleds, and fish through holes in the ice. His work continues the Flemish tradition of Pieter Bruegel the Elder (1525/30–1569) and his followers, particularly Hans Bol and David Vinckboons (1576–ca. 1632), who painted multicolored landscapes with a high horizon and a bird's-eye view. Avercamp would have seen similar compositions by the various Flemish landscapists who fled to Amsterdam after Antwerp fell to the Spanish in 1585.

Winter landscapes were usually part of a series of the four seasons or the twelve months but Avercamp elevated the subject into a separate genre. Although many Dutch painters followed his lead, his winter landscapes are among the finest of the entire seventeenth century. His paintings strongly influenced later Dutch winter landscapists such as Esaias van de Velde, Jan van Goyen, and Aert van der Neer.

Avercamp's painted oeuvre is relatively small. Dated paintings are extremely rare: the earliest dates from 1608, the last from 1620. There are also numerous – often colored – landscape drawings and figure studies that he sometimes used for his paintings. His nephew Barent Avercamp (1612/13–1679) learned the art of painting from him and for a long time the works were confused. His contemporary Arent Arentsz., named Cabel (1586–1635), was also a follower of Hendrick Avercamp.

Literature: Welcker 1933; *Hendrick Avercamp 1585–1634* 1979; *Frozen Silence* 1982; *Hendrick Avercamp: Master of the Ice Scene* 2009–2010.

CATALOGUE 4

WINTER LANDSCAPE NEAR A VILLAGE

IN THIS PAINTING, Hendrick Avercamp has convincingly captured the atmosphere in the country on a winter day. Under a gray sky, people of all ages and every rank and class are enjoying themselves on a frozen waterway – skating and sledding with ski poles or being pushed along; others walk on the ice or stand watching the wintry spectacle. To the left is an elegantly dressed group: two men with tall hats and a woman with a high hairdo. In front of them, two men are tying on their skates; a couple strolls by at the right. The man, his face protected from the cold by his cloak, is derived from the print *Skaters outside St. George's Gate in Antwerp* by Pieter Bruegel the Elder. To the right of the couple skating away in the middle is a round hole for ice fishing. Three bare trees, the middle one pollarded, lead the viewer's eye toward the distance, while on the far right a red-brick house closes off the composition. A coat of arms above the open door and the stone jar hanging from a rope on the right under the edge of the thatched roof indicate that this is probably an inn. Magpies occupy the roof and the tree in the foreground. Next to the house, a man makes use of a boat that has been turned upright to serve as a toilet. In the right foreground is a bearded old man wearing a fur hat with a basket on his arm. The same man appears in reverse in a closely related winter landscape by Avercamp in the Toledo Museum of Art, Ohio, and in a much smaller, round winter landscape in the Museum of Fine Arts in Budapest.[1] Avercamp may have meant this figure to be the personification of winter. In various sixteenth-century prints after Maerten van Heemskerck (1498–1574), Hendrick Goltzius (1558–1618), and Hans Bol, winter is personified by a warmly dressed old man with a long beard and a cap. Beside Avercamp's figure, two boots have been upended on fence posts to dry. The composition ends on the left with a thatched farmhouse and a tree trunk. Behind them is a farmhouse with a haystack and beyond it a church spire can be

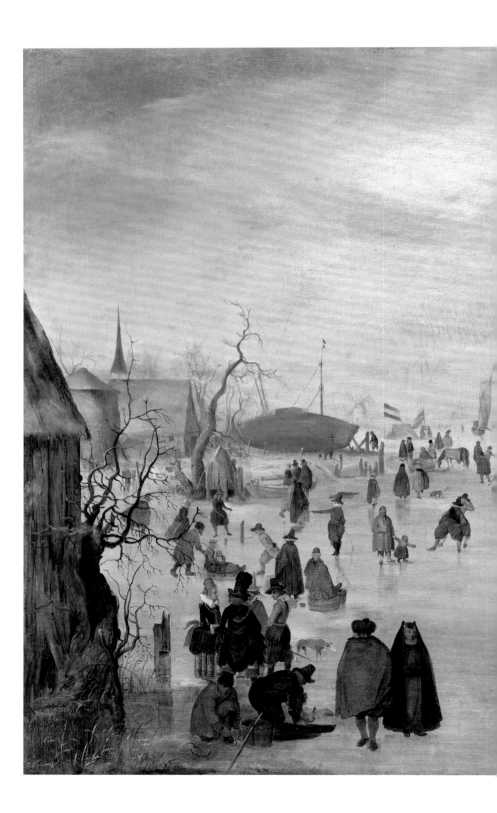

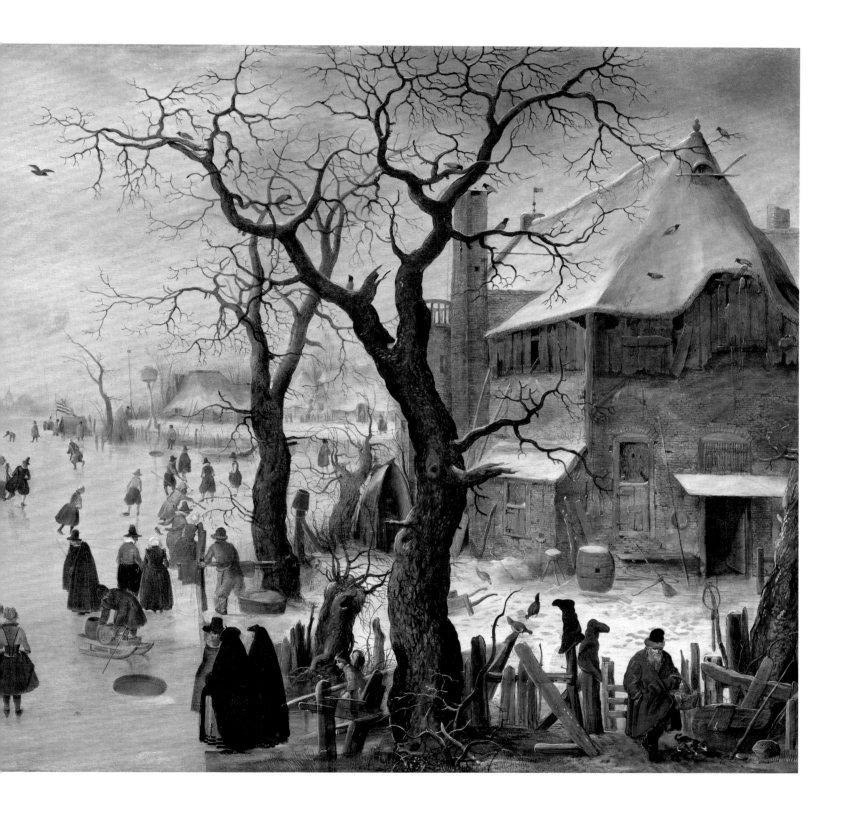

seen. Next to the tree, a second boat serves as a public convenience, and a little farther along a boat has been pulled onto the shore to prevent its being damaged by the ice. Behind the boat on the horizon is a windmill; a distant boat sails along the ice. Another village with a church tower can be vaguely discerned. On the left of the waterway stands a tent with two Holland flags and on the right, a tent with a Zeeland flag, where tired skaters can find refreshments.

Several figures, such as the couple skating in the middle of the composition and the woman with a high hairdo in the left foreground, are also found in other paintings by Avercamp. We can assume that he based them on the countless figure studies he drew. A number of these studies have survived but not the ones for these models.

The underdrawing faintly visible through the transparent paint at various points is typical of Avercamp. The traces here occur mainly in the middle ground; the cloths hanging out to dry on the central tree were originally longer and additional underdrawing is visible on the left side of the tree. To the left can be seen the outline of a boat that Avercamp first planned to show trapped in the ice. *Pentimenti* are also visible on the ground in front of the inn and in the right foreground. The old man with the fur hat was originally a little farther to the left, where the fence posts with the boots now stand; the chicken perched on the bowsprit of the frozen boat on the right was originally farther to the right.

Flemish masters of the sixteenth century were the first to choose the winter landscape as a subject for their paintings. In 1565, perhaps inspired by the first extremely cold winter in more than fifty years, Pieter Bruegel the Elder painted two winter landscapes, *Hunters in the Snow* (Kunsthistorisches Museum, Vienna) and *Winter Landscape with Bird Trap* (1565; Koninklijke Musea voor Schone Kunsten, Brussels). Other Flemish artists drew inspiration from these works but Avercamp was the first to specialize in this genre. This large panel, one of the biggest compositions in his oeuvre, is an example of his finest work. The composition is reminiscent of Bruegel's *Winter Landscape with Bird Trap*. It similarly depicts a frozen river with numerous small figures enjoying themselves on the ice; snow-covered houses and bare trees are on either bank. But there are also significant differences: Avercamp has opted for a lower point of view, and the people on the ice are much more true to life and more conspicuously present.

Avercamp must have witnessed scenes like this regularly. Beginning with the winter of 1564–65, Northern Europe experienced an extremely cold period, sometimes referred to as the Little Ice Age. Particularly in the first quarter of the seventeenth century, the relevant period in the case of Avercamp, many winters were bitterly cold, with heavy snowfalls and spells of frost lasting for five to ten weeks.

In some of Avercamp's winter landscapes, the city of Kampen can be seen, but in this painting the surroundings seem to have sprung from the artist's imagination. As in many of his other works, he has paid great attention to the depiction of the clothing. For example, in the right foreground are two ladies with wide black cloaks: the cut of one is typical of the northern-most provinces of the Netherlands and the other is a type fashionable in Holland.

Given that Avercamp rarely dated his paintings, and that there are no dated pieces between 1609 and 1620, it is impossible to say precisely when this panel was painted. His early work shows a much stronger affinity to the sixteenth-century Flemish winter landscapes, whereas he subsequently opted for a lower horizon and a lower point of view. Thus, it may be assumed that he painted this scene between 1610 and 1615, at about the same time as the closely related, undated panel in Toledo, whose overall composition is practically the present work in reverse.

Provenance: Jacobus J. Lauwers, Amsterdam (1753–1800), his estate sale, Amsterdam (Van der Schley, etc.), December 13, 1802, no. 5 (as "A. Avercamp") (bought by Gruiter); Dr. Charles Mannheim, Neuilly-sur-Seine, before 1900; by descent to his grandson, Dr. Charles Maillant (who Gallicized his surname), until 1966; J. Lenthal, Paris, by 1966; with Herbert Terry-Engell, London, 1966; Dr. and Mrs. Leonard Slotover, London, 1966–72/73; with Leonard & David Koetser, London, 1972/73; Mr. D. Crabtree, Cape Town, 1977; with Leonard & David Koetser, Geneva, 1977; Diethelm Doll, Bad Godesberg, 1977–2004; sale, New York (Sotheby's), January 22, 2004, no. 26; acquired from Richard Green, London, in 2005.

Exhibitions: H. Terry-Engell Gallery, London, *Fifteen Important Old Master Paintings*, 1966– 67; Victoria & Albert Museum, London, *The British Antique Dealers' Association Golden Jubilee Exhibition*, 1968; Waterman Gallery, Amsterdam, *Hendrick Avercamp, 1584–1634, Barent Avercamp, 1612–1679: Frozen Silence: Paintings from Museums and Private Collections*, 1982; Mauritshuis, The Hague, *Holland Frozen in Time: The Dutch Winter Landscape in the Golden Age*, 2001; Rijksmuseum, Amsterdam, *Hendrick Avercamp: Master of the Ice Scene*, 2009–2010.

Literature: *Country Life* 1966; *Weltkunst* 1966, p. 939, no. 20; *Fifteen Important Old Master Paintings* 1966–1967, no. 6, ill.; *Apollo* 1968, p. 5, no. 16, ill.; *The British Antique Dealers' Association Golden Jubilee Exhibition* 1968, no. 2, pl. VII; Welcker 1933, p. 216, no. S 156; *Hendrick Avercamp 1585–1634* 1979, pp. 212, no. S 55.1, 222, no. S 156, ill. frontispiece and jacket; *Frozen Silence* 1982, pp. 27, 30, 45, cat. no. 7, ill. p. 89; Keyes 1982, p. 45; *Holland Frozen in Time* 2001, pp. 82–85, no. 6, ill. pp. 83, 85; *Hendrick Avercamp: Master of the Ice Scene* 2009–2010, pp. 47, 48, 78, 176, ill. p. 47.

Notes:
1. *Hendrick Avercamp 1585–1634* 1979, cat. nos. S73.2, S40.

JACOB BACKER

HARLINGEN 1608/1609–1651 AMSTERDAM

Jacob Adriaensz. was born in Harlingen in Friesland between August 1608 and September 1609. His father owned a bakery, and the name "Backer" that Jacob later adopted no doubt referred to his occupation. Jacob's mother died shortly after his birth and in 1611 his father married a woman who lived in Amsterdam and he and his three sons moved in with her. In Amsterdam, Jacob was probably apprenticed to the history painter Jan Pynas (1581/82–1631). After his father's death in 1626, he moved to Leeuwarden. There, he became a pupil of a painter of biblical scenes, Lambert Jacobsz. (ca. 1592–1637), who was also teaching Govert Flinck (1615–1660). In 1632 or 1633, Backer returned to Amsterdam, where he soon built up an excellent reputation as a portraitist and later as a history painter as well, creating many biblical, mythological, and allegorical scenes in a large format. He also did various *tronies* and half-length figures in imaginary dress, and was a gifted draftsman as well.

Backer was awarded various important and prestigious commissions for group portraits of governors of Amsterdam institutions. He also received a commission from *Stadholder* Frederik Hendrik, Prince of Orange-Nassau. His fame was subsequently overshadowed in Amsterdam by that of Rembrandt, but he was renowned in his day. He died in Amsterdam on August 27, 1651.

Literature: Bauch 1926; Sumowski 1983, pp. 133–279; *Jacob Backer (1608/9–1651), Rembrandts Tegenpool* 2008–2009.

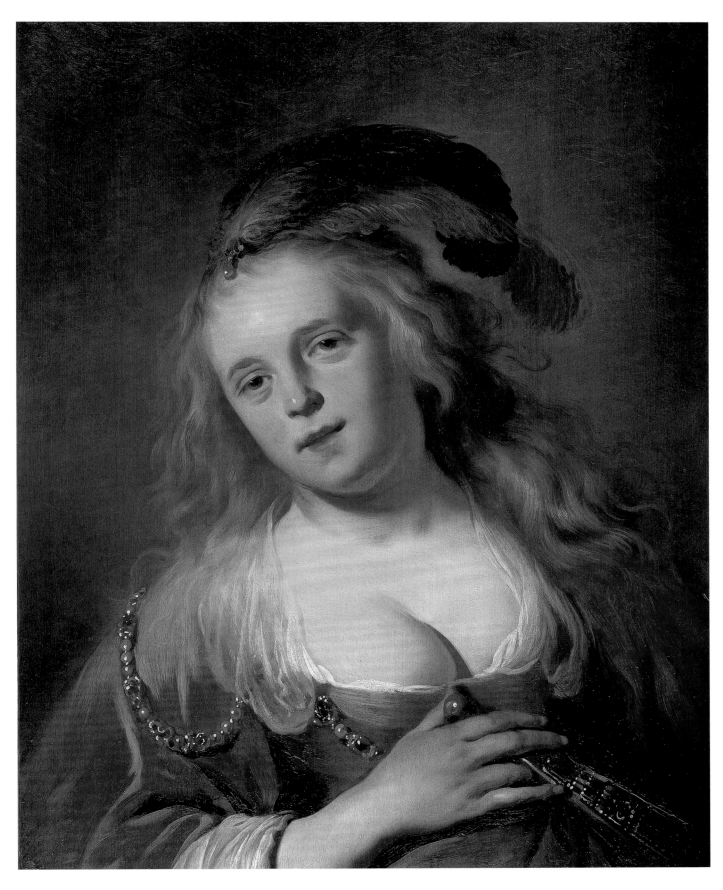

CATALOGUE 5. *Young Woman Holding a Fan*, ca. 1645. Oil on panel, 27 1/8 × 22 1/2 inches
(69 × 57 cm). Monogrammed upper right: *JAB* (in ligature)

CATALOGUE 5

YOUNG WOMAN
HOLDING A FAN

THIS "PORTRAIT" IS UNQUESTIONABLY one of the most attractive of Backer's known paintings. He has depicted the woman in fluent brushstrokes executed with conviction. The splendid lighting – with reflections in her eyes and on her nose, the necklace, the fan, and the pearl on her forehead – and the relaxed pose and cheerful glance, coupled with this free technique combine to produce an expressive, lively, and elegant image. The excellent condition of this work permits us to gain insight into Backer's manner of painting. He began with the dark passages and worked toward the lighter ones, for example, adding a lighter touch under the chin to give it depth and volume. The same technique is also evident under the feather, in the hair, and in the clothing. The veins faintly showing through the skin of the sitter's bosom are especially subtle. Other painters were also impressed by Backer's talents. In his *Inleyding tot de hooge schoole der Schilderkonst* of 1678, the artist and author Samuel van Hoogstraten (1627–1678) praised Backer's flesh tones.[1]

Although painters would have used a model for a work such as this, it is not a true portrait but a kind of genre piece. Half-length images of women in imaginary clothing with a deep décolletage, so-called courtesans, were first painted in Italy. Gerrit van Honthorst (1592–1656), Jan van Bijlert (1597/98–1671), and Hendrick ter Brugghen (1588–1629) introduced this genre in the Northern Netherlands beginning in the 1620s. These Utrecht painters had all spent time in Italy, where they were impressed above all by the work of Caravaggio (1573–1610), whose style they brought back home with them. Backer may have been influenced by their images of courtesans singing and playing music, but his inspiration may also have lain elsewhere. Images of courtesans were particularly fashionable in sixteenth-century Venice, and Italian art could be found in several Amsterdam collections. We know, for example, that Gerard Reynst had a large collection with numerous Venetian masters and two *courtisanes*, one by Paris Bordone (1500–1571) and one by Palma Vecchio (ca. 1480–1528). Backer's painting closely resembles the former painting, now lost, but known by a drawn copy. It shows a young woman with a deep décolletage and her head turned slightly to one side as she holds one hand on her stomach, just under one of her breasts. Reynst maintained contact with various Amsterdam artists, who subsequently sometimes drew inspiration from works in his collection. Thus, Willem Drost (1633–1659), while painting his *Bathsheba with King David's Letter* (1654; Musée du Louvre, Paris), and Rembrandt, while painting his *Woman at an Open Door* (ca. 1659; Gemäldegalerie, Berlin), seem to have looked at a Palma Vecchio *courtisane* in the Reynst collection. Backer probably painted this panel around the mid-1640s. Following his return to Amsterdam ten years earlier, Backer had painted *tronies* of men and women at regular intervals. This painting, like several others from this period, such as *Shepherd with Garland and Flute* (Mauritshuis, The Hague),[2] is painted with greater conviction than his first pieces in this genre; it is also one of the last of this type Backer painted.

The provenance of this panel is unfortunately very incomplete. However, it may possibly be identified with "a woman *tronie* with a plume" by Jacob Backer listed in a 1653 inventory of the estate of Dirrick Backer, Jacob's deceased brother.

Provenance: W. Leyendecker, Berlin; sale, Munich (Hugo Ruef), November 8–10, 1995, lot 1229 (to Haboldt for dm 210.000); with Haboldt & Co., Paris and New York, by 1995–96; where acquired in 1996.

Exhibitions: Museum het Rembrandthuis, Amsterdam, *Jacob Backer (1608/9–1651), Rembrandts tegenpool*, 2008–2009 (traveled to Suermondt-Ludwig-Museum, Aken, Germany).

Literature: Sumowski 1983, vol. 6, p. 3689, no. 2176, ill. p. 3759 (the given provenance and literature refer to a different painting); Hirschfelder 2008, pp. 196, 282 n. 10, 315 ns. 52, 53, and 400, cat. no. 18, ill. pl. 4; *Jacob Backer (1608/9–1651), Rembrandts tegenpool* 2008–2009, p. 240, no. A106, ill.

Notes:
1. Van Hoogstraeten 1678, pp. 227, 228.
2. *Jacob Backer (1608/9–1651), Rembrandts tegenpool* 2008–2009, cat. no. A101.

LUDOLF BAKHUIZEN

EMDEN 1630/31–1708 AMSTERDAM

Ludolf Bakhuizen was born in December 1630 or 1631 in Emden in East Friesland, Germany. His career as an artist began in an unusual way. Around 1650, he came to Amsterdam as a clerk and bookkeeper for the wealthy merchant Guglielmo II Bartolotti van den Heuvel, who also came from Emden. Bakhuizen is mentioned as a calligrapher in 1656, by which time he had also begun to make pen drawings and later pen paintings of maritime scenes in the style of Willem van de Velde the Elder. According to Houbraken, he studied with the landscapist Allart van Everdingen (1621–1675) and the marine painter Hendrick Dubbels (ca. 1620–1676), but there is no documentary evidence of this.[1] It seems more likely that he was self-taught. He did not become a member of the Amsterdam St. Luke's Guild until 1663.

Bakhuizen married four times, in 1657, 1660, 1664, and 1680. On November 12, 1680, he had his will drawn up while "lying ill in bed." He remained in Amsterdam until his death during the night of November 6–7, 1708. He was buried in the Westerkerk in Amsterdam on November 12.

Bakhuizen's large body of paintings consists mainly of stormy seascapes but he also did portraits, a few religious scenes, landscapes, genre scenes, and cityscapes. He was also an extraordinarily prolific draftsman. There are dated paintings from 1658 onward. His best work dates from early in his career; with a few exceptions, the quality declines after 1670. When Willem van de Velde and his son left for England in 1672, Bakhuizen became the leading marine painter in the Netherlands. He received numerous commissions, including some from abroad. Tsar Peter the Great is said to have had drawing lessons from him.

Literature: Hofstede de Groot 1907–28, vol. 7, pp. 211–321; De Beer 2002; *Ludolf Backhuysen, Emden 1630–Amsterdam 1708* 2008–2009.

CATALOGUE 6

SHIPS IN A GALE ON
THE IJ BEFORE THE CITY
OF AMSTERDAM

IN NOVEMBER 1665, Ludolf Bakhuizen was awarded an extremely prestigious commission by the burgomasters of Amsterdam for a large view of the city from the River IJ which was to be given to the Marquis de Lionne, the foreign minister of King Louis XIV of France. Despite the large format (50 3/8 × 87 3/8 inches), Bakhuizen managed to complete the commission fairly quickly and very successfully. As early as July 1666, he was paid the princely sum of four hundred ducats for this work (Musée du Louvre, Paris). The imposing painting was widely acclaimed from the outset. Perhaps encouraged by its success, Bakhuizen often returned to the same subject. In the very year in which he painted the large commission, he also painted this much smaller view of Amsterdam seen from the waters of the IJ. But there is no question of repetition; the two compositions diverge substantially. One of the most striking differences concerns the point of view. For the commission, Bakhuizen chose a slightly higher viewpoint, thus creating a kind of panorama. The viewpoint in the present painting, however, is very low, conveying the impression of being on the water, an effect the marine painter Jan Porcellis had achieved much earlier in his marines (catalogue 46). Moreover, the buildings on the horizon are much less prominent and a little less identifiable than in the large canvas. Comparing the two paintings, George Keyes wrote: "Although lacking the sweep of the larger panorama in Paris, this work shares a concentration and dramatic intensity rarely encountered in views of this type."[2]

It is evidently morning; the sunlight comes from the east, as does the stiff breeze. Bakhuizen's vantage point is farther to the east than in the Paris work, because the Haringpakkerstoren is now seen to the right of the Westerkerk, not to the left as in the larger work. He probably made a sketch for this painting at the level of the still existing Nieuwendam lock, on the north side of the IJ, and retained the actual low vantage point instead of artificially raising it as he did for the work in the Louvre. For the higher view, he was positioned near the Toll House, at the most southerly tip of De Volewijck, a spit of land on the north side of Amsterdam across the river IJ. For this lower view over the IJ, he turned his gaze much farther west, all the way to the extreme limit, the western bulwark known as the Blauwhoofd, which is regularly seen in drawn and painted cityscapes of Amsterdam by, among others, Rembrandt and Roelant Roghman (1627–1692).

Characteristic of the artist is the structure with dark waves in the foreground, beyond them a light strip of water with several brightly lit sails, and finally the horizon partly in shadow with first dark clouds above, then white clouds, and lastly a partly blue sky. Prominent in the foreground is a pleasure boat, a so-called *boyer*; to the left of it is a narrow ship, used for inland shipping, and to the right is a second, smaller *boyer*. The large warship on the left in the background has the Amsterdam coat of arms on the stern. A three-master of the Admiralty of Amsterdam named *Amsterdam* took part in various sea battles in 1652 during the First Anglo-Dutch War (1652–54). It seems probable that Bakhuizen has depicted that ship here, but since there were several ships with that name at the time the identification is not certain. The same ship, with another narrow ship and a smaller sailboat at the far right, can be seen in a drawing by Bakhuizen (National Maritime Museum, Greenwich).

On the far left of the cityscape, catching the light on the horizon, is the town hall (the later Palace on the Dam), with its recently completed dome, and next to it the Nieuwe Kerk, the Jan Rodenpoortstoren on the Singel, to the right of the *Amsterdam*, the Westerkerk and the Haringpakkerstoren on the IJ, and on the right side of the large *boyer* the Noorderkerk. Farther to the right, with the red roof, is the Toll House on the IJ and, on the extreme right, the Leeuwenberg bulwark, also known as 't Blauw or Blauwhoofd, with the De Bock mill.

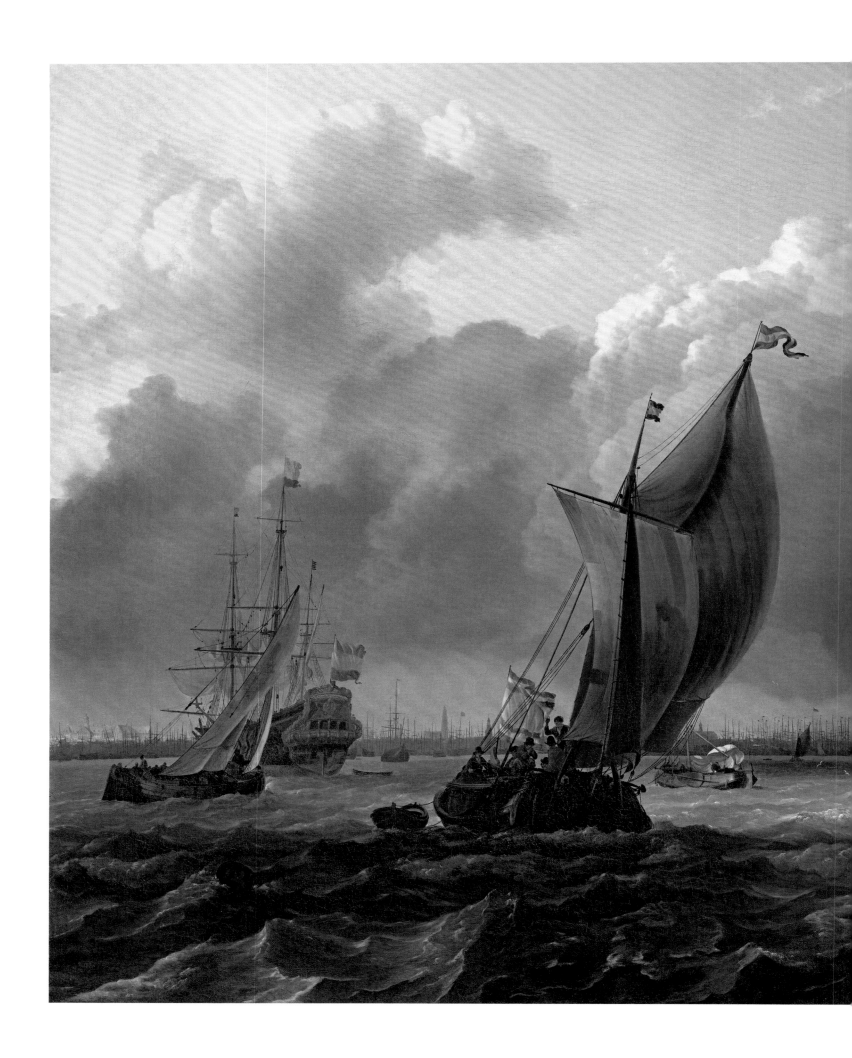

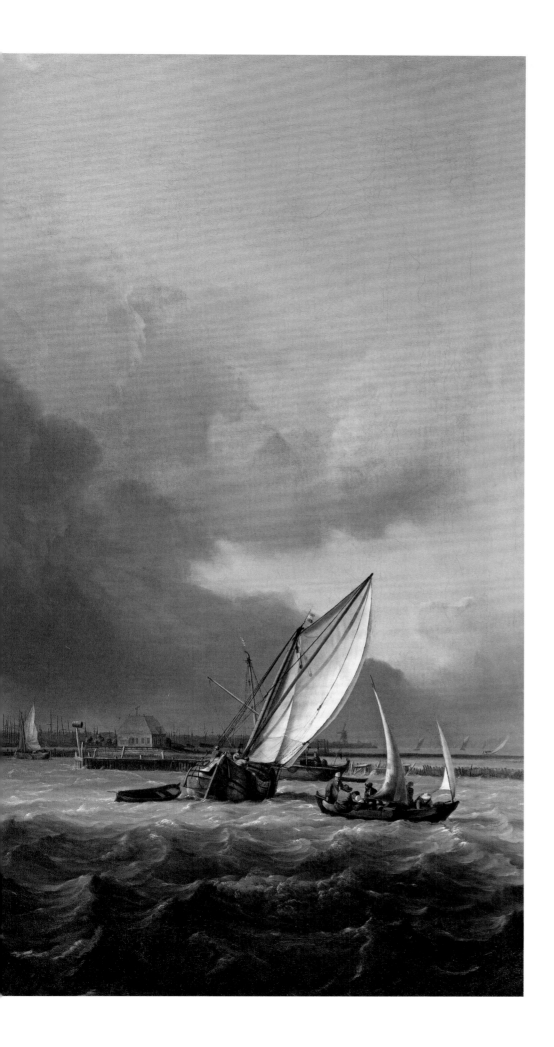

CATALOGUE 6. *Ships in a Gale on the IJ before the City of Amsterdam*, 1666. Oil on canvas, 30 1/2 × 42 1/2 inches (77.5 × 108 cm). Signed on the little boat left of center: *LBackhuysen*; dated on the fusta lower left: *1666*

Between the narrow ship and the small sailboat on the far right, the "Court" can be seen: three gallows above a pit on the other side of the IJ on De Volewijck.

Provenance: Mr. Crawford, by 1801, his sale, London (Christie's), April 26, 1806, no. 17 (gns. 60 to Ridley); Sir M. W. Ridley, Bt., London, until 1867; Viscount Ridley of Blagden, London, before 1918; with Vermeer Gallery, London, 1936; Lt. Col. T. R. Badger, D. S. O., purchased from Leggatt Brothers, March 17, 1936 (£270); Mrs. E. M. Gordon, Biddlesden Park, Brackley, Northamptonshire, her estate sale, London (Christie's), April 11, 1986, lot 44; with French & Company, New York; Shearson and Lehman Brothers, New York; with Hirschl & Adler Galleries, Inc., New York; with Jack Kilgore, New York, in 1994; where acquired in 1995.

Exhibitions: British Institution, London, *Exhibition of the Works of the Ancient Masters and Deceased British Artists*, 1867; Museum of Fine Arts, Boston, *The Poetry of Everyday Life: Dutch Painting in Boston*, 2002.

Literature: Buchanan 1824, p. 184; Smith 1829–42, vol. 6, p. 412, no. 27; *Exhibition of the Works of the Ancient Masters and Deceased British Artists* 1867, cat. no. 154; Hofstede de Groot 1907–28, vol. 7, p. 232, no. 75; *Mirror of Empire* 1990, pp. 28, 92, ill. p. 29, fig. 24; *Poetry of Everyday Life* 2002, ill. p. 100.

Notes:
1. Houbraken 1718–21, vol. 2, pp. 237, 238.
2. *Mirror of Empire* 1990–91, p. 92.

OSIAS BEERT

ANTWERP? CA. 1580–1623 ANTWERP

Osias Beert was born around 1580 in or near Antwerp. He probably spent all his life in Antwerp, where he was inscribed in the local guild in 1596 as a pupil of Andries van Baseroo (dates unknown) and was admitted as a master in 1602. He married Margareta Yckens on January 8, 1606; his son Elias (1622–ca. 1678) also became a painter. Osias Beert collaborated at least once with Rubens (1577–1640) and he had a number of pupils, which confirms his reputation as an esteemed artist. Frans Ykens (1601–1693), his wife's nephew, is the best known among his registered pupils. Nevertheless, like so many of his colleagues at the time, he had difficulties earning a living as a painter and thus also worked as a cork merchant. Beert was a member of the rhetoricians' chamber *De Olijftak* (The Olive Branch) from 1615 on. He died in Antwerp in December 1623 at only age forty-three.

Until Curt Benedict's article of 1938, Beert's important role in the early development of still life was virtually unknown. Today, Beert is regarded as one of the most important artists among the first generation of Flemish still-life painters. His oeuvre consists exclusively of three types of still lifes: "breakfast" pieces, flower still lifes, and fruit still lifes. They are characterized by a careful and detailed execution and rather cool tones; the compositions are often somewhat archaic. Paintings with his signature are extremely rare and none bears a date, making it virtually impossible to establish a reliable chronology of his works.

Literature: Benedict 1938, pp. 307–14; Hairs 1951, pp. 237–51; Hairs 1955, pp. 122–26; Greindl 1983, pp. 22–36, 181–90, 335–37.

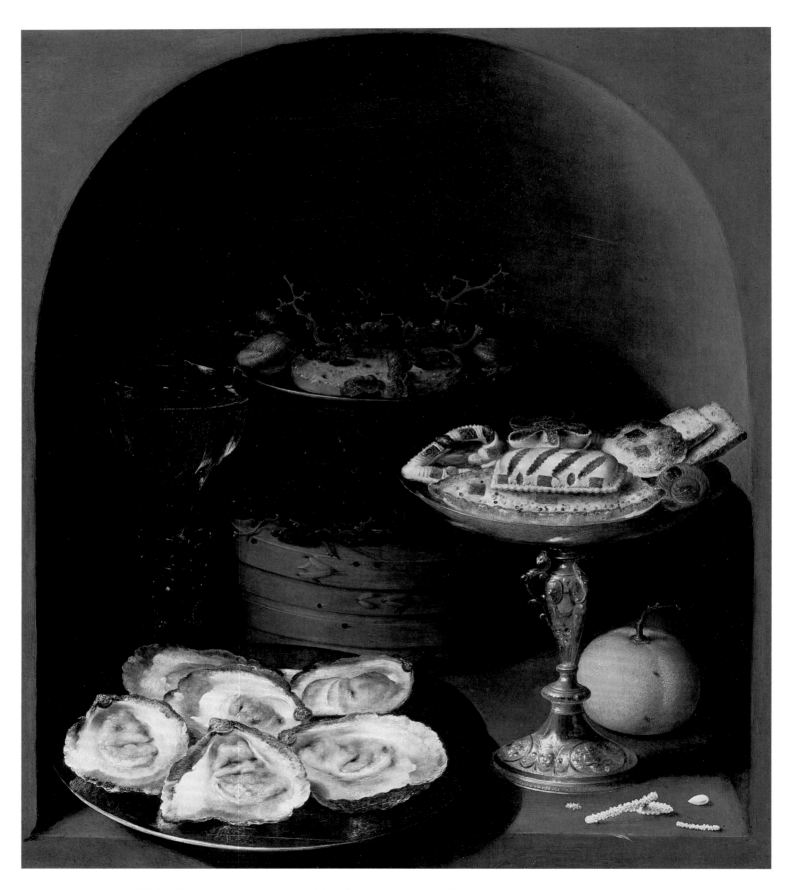

CATALOGUE 7. *Still life with Oysters, Sweetmeats, and Dried Fruit in a Stone Niche*, 1609.
Oil on copper, 20 × 17 3/4 inches (51 × 45 cm). Monogrammed lower center: *OB F*. The copper
plate is stamped on the reverse with the maker's mark of Peeter Stas and the date 1609.

CATALOGUE 7

STILL LIFE WITH
OYSTERS, SWEETMEATS,
AND DRIED FRUIT IN A
STONE NICHE

THIS STILL LIFE DISPLAYS all the characteristics of Osias Beert's work and technique. The various items are convincingly depicted: a pewter plate with juicy oysters, a handsome *Façon-de-Venise* glass with wine, two wooden boxes and on them a dish of raisins, bread rolls, and figs, a silver tazza with skillfully made cookies and candy, an orange, and at the bottom right more confectionery. The assemblage expresses wealth and abundance, for neither the objects nor the foods were within the reach of the common man in the seventeenth century. The candy was made of cane sugar, a costly and exotic product, like the orange. Oysters, raisins, and figs likewise were not everyday items. The extremely expensive tazza was a drinking vessel that was filled with wine during festive gatherings and passed from hand to hand. Such vessels were also used to present flowers, jewelry, or other luxury articles, as shown here and in similar paintings. Although Beert worked in Antwerp, this type of tazza probably came from Holland or from Zeeland, which was closer.

The objects are presented in a shallow niche, which is depicted from a slightly higher point of view. This common convention practiced by most Dutch and Flemish still-life painters from the beginning of the seventeenth century enabled the artist to create space in which to portray the objects at their best. Here, they light up splendidly against the dark background. Amidst the predominantly muted colors, the oysters and the tazza stand out. The pewter plate reflects the shells, and the light shines beautifully from the tazza's finely worked foot. Beert used a lot of white lead for both. For the cookies, he even mixed gold pigment into the paint to produce an extra glitter. Raking light reveals that Beert originally painted a knife on the bottom box.

The back of this panel bears the mark of Peeter Stas, the leading maker of copper plates for paintings in Antwerp. His stamp consists of a hand, the symbol of Antwerp, and beneath it his own mark, a circle with his monogram in a heart surrounded by his full name. In between the two stamps is the date 1609, which establishes a reliable *terminus post quem* for the painting. Since Stas made not only the best but probably the most expensive copper plates, we can assume that Beert used this plate for this still life in the same year or shortly afterward, since it represented a sizable investment.

Another monogrammed still life with flowers in a glass vase in a niche with almost the same dimensions may have been intended as a companion piece for this painting.[1] It, too, is painted on copper and bears an identical mark with the same date on the back. Various components of this still life, such as the plate of oysters, the tazza of cookies, and the *Façon-de-Venise* glass, also appear in an undated painting by Beert (Staatsgalerie, Stuttgart).

Provenance: Acquired at sale, London (Sotheby's), December 11, 1996, no. 20, through John Mitchell and Son, London.

Exhibitions: Phoenix Art Museum, Phoenix, Arizona, *Copper as Canvas: Two Centuries of Masterpiece Paintings on Copper 1575–1775,* 1998–99 (traveled to Nelson-Atkins Museum of Art, Kansas City, Missouri; and Mauritshuis, The Hague)

Literature: Greindl 1983, pp. 28, 335, no. 11, fig. 4; *A Prosperous Past* 1988–89, pp. 66, 67, ill. 4.7; *Copper as Canvas* 1998–99, no. 3, p. 106, fig. 5.17, p. 110; *Still-Life Paintings from the Netherlands 1350–1720* 1999–2000, p. 126, fig. A.

Notes:
1. Private Collection, 20 × 16 3/8 inches (50.7 × 41.5 cm). See Greindl 1983, cat. no. 12, fig. 5.

NICOLAES BERCHEM

HAARLEM 1621/22–1683 AMSTERDAM

Nicolaes Pietersz. Berchem was born in Haarlem, the son of the still-life painter Pieter Claesz.
In an archival document of 1661, he is mentioned as "oudt sijnde 39 jaeren," so he must have
been born in 1621 or 1622. According to the Haarlem Guild records, his father gave him drawing
lessons in 1634, and according to Houbraken he subsequently studied with Jan van Goyen in
Haarlem, Claes Moeyaert in Amsterdam, and Pieter de Grebber (ca. 1600–1652/53) in Haarlem.[1] In
May 1642, Berchem was registered in the Haarlem Guild. In October 1646, he married Catharina
Claes, stepdaughter of the painter and dealer Jan Wils (1603–1666), in Haarlem.

 Drawings that appear to have been done in situ suggest that the artist visited Westphalia, the
region east of the Dutch-German border, with fellow painter Jacob van Ruisdael about 1650.
A change of style has repeatedly been explained by a journey to Italy during the first half of the
1650s. However, early written sources do not mention such a journey, nor is there any archival
evidence to support this supposition. In 1661, Berchem had moved to Amsterdam, probably because
the market was stronger there than in Haarlem. However, in the spring of 1670 he returned to
his native city. In 1677, the artist presumably moved again to Amsterdam, where he died on February
18, 1683; he was buried five days later in the Westerkerk.

 Berchem is one of the most important and certainly the most versatile of the Dutch Italianate
artists. He was extremely productive: more than six hundred paintings, five hundred drawings, and
more than fifty etchings bear his name. They depict mostly Italian landscapes with shepherds
and cattle but he also painted and drew a number of mythological, allegorical, and biblical scenes. His
earliest drawings reveal the influence of Jacob van Ruisdael, and his paintings from that period

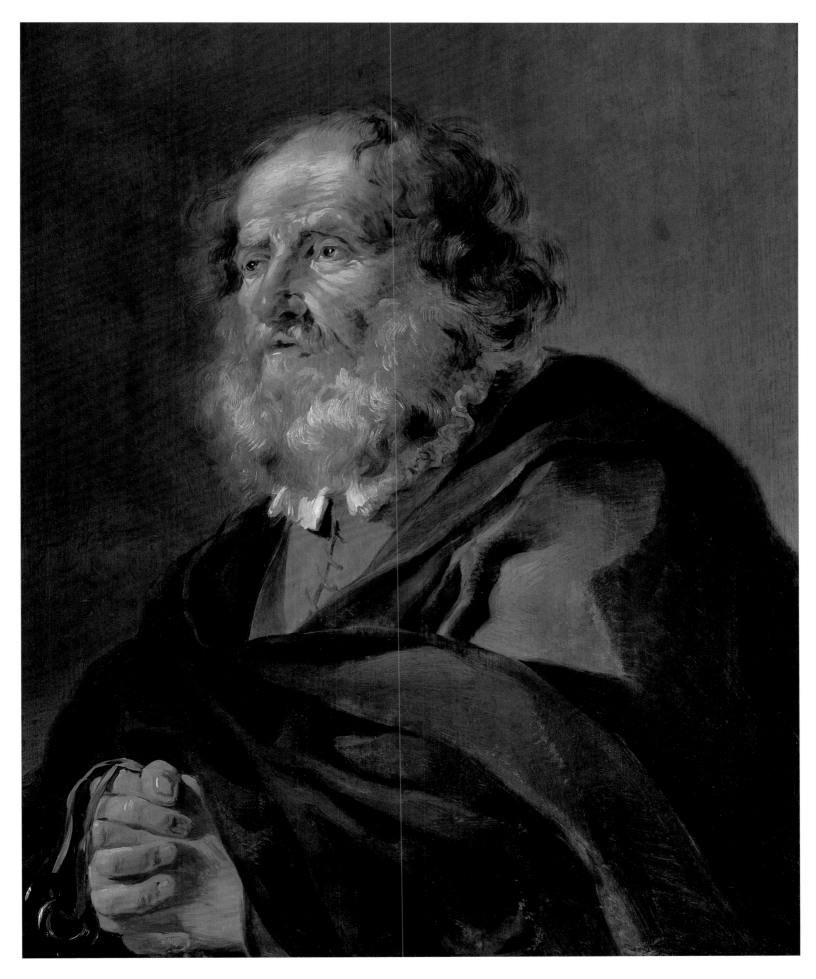

CATALOGUE 8. *Saint Peter*, 1644. Oil on panel, 24 1/4 × 19 1/4 inches (61.6 × 48.9 cm).
Signed and dated left center: *CBerghem/1644* (*CB* in ligature)

are also indebted to Pieter van Laer (1599–after 1642), Jan Both, and Jan Asselijn. It was only after 1650 that he developed a more personal and occasionally decorative style, although Asselijn's work continued to provide an important example. Berchem collaborated with Gerrit Dou, Jan Baptist Weenix, Jan Wils, and Jacob van Ruisdael. His numerous pupils included not only many Italianate painters, such as Karel du Jardin, Hendrick Mommers (ca. 1623–1693), Willem Romeyn (ca. 1624–1694), Abraham Begeyn (ca. 1630–1697), Johannes van der Bent (ca. 1650–1690), and Dirk Maas (1659–1717), but also painters of a completely different type, such as Pieter de Hooch (1629–1684) and Jacob Ochtervelt (1634–1682). During the seventeenth and eighteenth centuries, numerous engravings were made after Berchem's paintings, and his work became extremely popular, particularly in France.

Literature: Hofstede de Groot 1907–28, vol. 9, pp. 52–292; Von Sick 1929; Schaar 1958; *Dutch 17th Century Italianate Landscape Painters* 1978, pp. 147–71; *Nicolaes Pietersz. Berchem: In het licht van Italië* 2006–2007.

CATALOGUE 8

SAINT PETER

THIS IMAGE OF THE APOSTLE PETER is a major exception in Nicolaes Berchem's oeuvre, in which half-length figures placed against a neutral background are otherwise unknown. A painting of Saint Peter that was in The Art Institute of Chicago has been attributed to Berchem, but an old photograph showing a completely different style appears to make this untenable.[2] Perhaps this present *Saint Peter* differs so distinctly from his other work because it was done for a commission, but we have no evidence of this. Berchem did paint other religious scenes, mainly at the beginning of his career, such as *Landscape with Ruth and Boaz* (Rijksmuseum, Amsterdam) and *Jacob and Rachel* (Historisches Museum, Frankfurt), but these are landscapes with biblical figures as staffage. This *Saint Peter* is also relatively early. Despite some debate about the last numeral, it is absolutely certain that the date should be read as 1644.

With this painting, Berchem may have had in mind his teacher Pieter de Grebber's half-length figures against a neutral background. In contrast to De Grebber's and even his own typically smooth brushwork, Berchem used rapid, free brushstrokes, and even scratched in the wet paint with the end of his brush.

In view of Peter's strongly sideways pose, it is quite possible that the panel originally had a pendant depicting Saint Paul looking to the right, although no documentary evidence for this exists. Peter and Paul were the most important of the twelve apostles and like the others they were both portrayed countless times down the centuries, often together. Peter, "the prince of the apostles," was the first among Christ's disciples. His appearance in the various representations is fairly consistent, thus making him easily identifiable; his chief attribute, keys to "the Kingdom of Heaven," further establish his identity. As in the panel by Berchem, Peter is generally portrayed as an old but vigorous man, slightly bald but with graying, curly hair and a full gray beard. He usually wears a blue tunic and a yellow cloak, but here Berchem has switched the colors.

In sixteenth-century Germany and the Netherlands, series of the apostles were a popular theme for artists. Famous examples include the two life-size panels of 1517 by Albrecht Dürer (1471–1528) depicting John and Peter and Paul and Mark (Alte Pinakothek, Munich). In the seventeenth century, the Flemish artists Peter Paul Rubens (1577–1640) and Anthony van Dyck (1599–1641) each painted series of the twelve apostles at half length. Around 1611, Rubens painted an impressive series of the twelve apostles (Museo Nacional del Prado, Madrid). In the largely

Protestant Northern Netherlands in the seventeenth century, the apostles were a much less frequent subject. It was mainly the Utrecht *Caravaggisti* such as Hendrick ter Brugghen (1588–1629) and Gerrit van Honthorst (1592–1656) who took Peter as their subject. Remarkably, in the 1620s Frans Hals, a portraitist par excellence, who like Berchem lived in Haarlem, painted a series of four half-length figures of the evangelists. These religious pieces are as exceptional in Hals's oeuvre as the *Saint Peter* is in Berchem's. Later in the seventeenth century, Rembrandt was also to paint a series of apostles and evangelists. As with Rubens, Van Dyck, Hals, and Berchem, these are half-length figures.

Provenance: Reportedly in Scottish possession, nineteenth century; unidentified collection, Vienna, 1890s, where acquired by Stillwell; Dr. John E. Stillwell, New York (1899–1927), his estate sale, New York (Anderson Galleries), December 1–3, 1927, no. 235 (as "Nicholaus Berghem"); Henry Blank, Glen Ridge (New Jersey), his estate sale, New York (Parke-Bernet Galleries), November 16, 1949, no. 29 (sold for $600); with Lock Galleries, New York, by 1949; Baron Cassel van Doorn, Englewood, New Jersey, his sale, New York (Parke-Bernet Galleries), December 9, 1955, no. 46; Dr. Miklos Rosza, Hollywood, California, 1962; acquired at anonymous sale, New York (Sotheby's), January 11, 1996, no. 99, through Johnny Van Haeften Ltd., London.

Exhibitions: Frans Hals Museum, Haarlem, *Nicolaes Pietersz. Berchem: In het licht van Italië*, 2006–2007 (traveled to Kunsthaus Zürich; and Staatliches Museum Schwerin, Germany.)

Literature: Muller 1919, pp. 79–84, ill. p. 81, fig. 1; Hofstede de Groot 1907–28, vol. 9, no. 31; *Nicolaes Pietersz. Berchem: In het licht van Italië* 2006–2007, pp. 13, 134, cat. no. 2, ill. (reversed), pp. 12, 134; Jansen 2007, p. 355, ill. p. 356, no. 64.

CATALOGUE 9. *Landscape with an Elegant Hunting Party on a Stag Hunt*, 1665–70.
Oil on panel, 15 × 19 1/8 inches (38.1 × 48.6 cm). Signed lower left: *Berchem*

HUNTING SCENES make up only a small part of Nicolaes Berchem's work; like those of most other Dutch Italianates, his landscapes are generally populated by herders or travelers. Yet, the versatile Berchem excelled in this genre, too, as shown by this panel and several related pieces such as a panoramic landscape with a deer hunt (The Museum of Fine Arts, Houston). For works such as these, he no doubt drew inspiration from Philips Wouwerman, a fellow townsman for whom hunting scenes were a specialty. More than one hundred of Wouwerman's paintings have the theme as their subject. In particular, his landscapes with elegant hunting parties from the second half of the 1650s and the first half of the 1660s must have served as examples for Berchem. Wouwerman was not the first artist in the Netherlands to paint this subject. In 1565, Pieter Bruegel the Elder (1525/30–1569) painted his famous *Landscape with Hunters in the Snow* (Kunsthistorisches Museum, Vienna). His son Jan Brueghel the Elder painted numerous small landscapes with hunters as staffage (catalogue 14), while his contemporary Rubens produced several larger landscapes with hunters. In the first quarter of the seventeenth century, Flemish immigrants in Amsterdam such as Gillis van Coninxloo (1544–1607) and David Vinckboons (1576–before 1633) introduced the theme in the Northern Netherlands. But, in contrast to most of those earlier scenes, Wouwerman's and Berchem's hunters are no longer insignificant figures in a wooded landscape but often the main subject.

In seventeenth-century Holland, hunting was a privilege of the nobility. The hunters depicted by Berchem and Wouwerman are not the humble farmers and country folk who populate the landscapes of Pieter Bruegel the Elder and Gillis van Coninxloo. By contrast, as seen here, they are elegantly dressed, aristocratic ladies and gentlemen assisted by servants. Judging by the bright palette, the refined facture, and the clothing of the horseman and horsewoman in the right foreground, Berchem's painting must date from the second half of the 1660s.

Provenance: Johannes Lubbeling (Lublink), Amsterdam, by 1752; Jacob Simonsz. Crammer, his estate sale, Amsterdam (Van de Schley), November 25, 1778, no. 2; Pierre Fouquet Jr., his estate sale, Amsterdam (Van de Schley), April 13, 1801, no. 3; Langeac de Lespinasse, his estate sale, Paris (Paillet/Delaroche), January 16–18, 1809, no. 14 (ffr. 2,410); Casimir Pierre Périer (1777–1832), his estate sale, London (Christie and Mason), May 5, 1848, no. 1 (bought back by the family); Comtesse de Ségur-Périer, Paris, by 1919; thence by descent, until 1993; sale, Paris (Audap-Solanet, Godeau-Veillet), December 11, 1992, no. 47; acquired from Bob P. Haboldt & Co., New York and Paris, 1993.

Exhibitions: Museo Thyssen-Bornemisza, Madrid, *The Golden Age of Dutch Landscape Painting*, 1994.

Literature: Hoet 1752, vol. 2, p. 518; Smith 1829–42, vol. 5, p. 48, no. 141; Hofstede de Groot 1907–28, vol. 9, no. 145; *The Golden Age of Dutch Landscape Painting* 1994, p. 76, no. 7, ill. p. 77.

Engraved: By D. Danckerts (1634–1666), cf. Hollstein 1949–, vol. 5, p. 131, no. 27; De Winter 1767, no. 58.

Notes:
1. Houbraken 1718–21, vol. 2, p. 109.
2. Hofstede de Groot 1907–28, vol. 9, cat. no. 33.

HANS BOL

MECHELEN 1534-1593 AMSTERDAM

Hans Bol was born in Mechelen on December 16, 1534. At age fourteen, he was apprenticed
to a tapestry designer there and trained in the local tradition of painting with watercolors on canvas.
Such watercolor or tempera paintings were used as wall decorations – an alternative to expensive
tapestries. After training for two years in Heidelberg, in 1560 he joined the guild in Mechelen. In 1572,
the Spanish captured and plundered the city and Bol lost everything. He fled to Antwerp, where
he concentrated on making miniatures. In 1584, he again fled from the war and came to Bergen op
Zoom. He went on to Dordrecht and later to Delft before finally settling in Amsterdam in 1591.
He was buried there in the Oude Kerk on November 30, 1593.

 Hans Bol is primarily known for his meticulously executed colored drawings and gouaches. His
work formed an important link between Flemish art and that of the Northern Netherlands,
particularly in landscape. Partly through his prints and drawings, the Flemish landscape tradition
had followers in the North. Bol's principal pupils were Jacob Savery (1565–1603), Joris Hoefnagel
(1542–1601), and his stepson Frans Boels (date unknown–1594).

Literature: Franz 1965, pp. 19–67; Briels 1987.

THIS BEAUTIFULLY PRESERVED GOUACHE depicts one of the earliest known profiles of the city of Amsterdam. With great topographical accuracy, Bol captured the city from the south across the Amstel river. He viewed the panorama from a point higher up, probably from a tower of one of the houses along the Amsteldijk (quay), as shown not only by the perspective but also by the tip of the roof down low in the center. Various buildings on the horizon can be identified. The most prominent one with the highest tower, slightly to the right of center, is the Oude Kerk; farther to the right is the Schreierstoren (tower), while on the left the church of the Begijnhof and the tower of the old town hall can be discerned. In the right foreground, a horse-drawn barge loaded with passengers makes its way toward the city. Numerous sailboats and other vessels demonstrate the heavy traffic on the waterway and the quay is equally busy: a fully laden ox-cart, farmers with their livestock, strollers, and a few horseback riders are setting out. Farther to the left in the middle ground, meadows can be seen between the farmhouses. In the left foreground is a partly walled garden with several courting couples and parents with small children and dogs. Their clothing suggests these are all prosperous people who have probably opted to take a break from the stench and noise of the city. Three years after he painted this gouache, Bol painted a second, less detailed version from the same angle but with different staffage and boats on the river (1592; Pushkin Museum, Moscow).[1]

About eighty years after Bol made this gouache, Jacob van Ruisdael chose the same location to draw a panorama of Amsterdam (Museum der bildenden Künste, Leipzig).[2] He used this drawing for two painted views of the city (figures 1 and 2).[3] Together, the views by Bol and Van Ruisdael

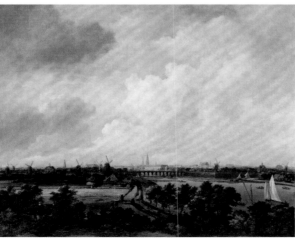

Figure 1. Jacob van Ruisdael, *View on the Amstel Looking Towards Amsterdam*, 1675–82. Oil on canvas, 20 1/2 × 26 inches (52.1 × 66.1 cm). The Fitzwilliam Museum, Cambridge.

Figure 2. Jacob van Ruisdael, *View of Amsterdam from the Amsteldijk*, 1675–82. Oil on canvas, 20 7/8 × 26 1/8 inches (53 × 66.5 cm). Amsterdams Historisch Museum, Amsterdam.

CATALOGUE 10. *View of Amsterdam from the South*, 1589. Gouache, heightened with gold, on vellum laid down on panel, 4 5/8 × 12 1/4 inches (11.7 × 31.1 cm). Signed and dated lower center: *HANS BOL | 1589*

give a sense of the developments in Amsterdam during that period. The images are exceptions in that they show the city from the south; most artists preferred to present Amsterdam from the north across the IJ.

This sort of city profile finds its origins in cartography. From the middle of the sixteenth century, topographically accurate panoramas of European cities were drawn by Anton van den Wijngaerde (1510–1572) for King Philip II of Spain and by Joris Hoefnagel. They appeared in cartographical publications. Flemish book illustrators from Mechelen, Bol's birthplace, played a prominent role in this enterprise and Bol came from this group. His miniature city profiles were already much sought after during his lifetime. They were seen as costly collectors' items and were intended for cabinets of curiosities. The painter and author Karel van Mander (1548–1606) may have had this gouache among others in mind when in 1604 he wrote in his *Schilder-Boek* that Bol "had made many beautiful and handsome miniatures, as well as Amsterdam from life . . . and from the land side, very lively."[4] Van Mander also stated that Bol made a good living from such miniatures.

Provenance: J. T. Cremer, New York, his sale, Amsterdam (Sotheby Mak van Waay), November 17, 1980, no. 32 (as *View of Middelburg*); private collection, Belgium, by 1997; acquired from Noortman Master Paintings, Maastricht, in 1997.

Exhibitions: Rijksmuseum, Amsterdam, *Dawn of the Golden Age: Northern Netherlandish Art, 1580–1620*, 1993–94; Stadsarchief, Amsterdam, *Het Aanzien van Amsterdam: Panorama's, Plattegronden en Profielen uit de Gouden Eeuw*, 2007–2008; Mauritshuis, The Hague, and National Gallery of Art, Washington, *Pride of Place: Dutch Cityscapes in the Golden Age*, 2009.

Literature: Van Mander 1604; Briels 1987, p. 176; Suchtelen 1993, pp. 220–21, ill. p. 221, fig. 2; *Dawn of the Golden Age* 1993–94, pp. 96, 260, 518–20, cat. no. 196, ill. pp. 260, 519; Miedema 1997, p. 215, fig. 153; Bakker 2004, p. 37, fig. 21; *Het Aanzien van Amsterdam* 2007–2008, no. 27a; *Pride of Place* 2009, pp. 96–99, 219–20, no. 13.

Notes:
1. Levitin 1991, no. 108.
2. Slive 2001, cat. no. D77.
3. Ibid., cat. nos. 3, 4.
4. Van Mander 1604, folio 260v.

AMBROSIUS BOSSCHAERT THE ELDER

ANTWERP 1573–1621 THE HAGUE

Ambrosius Bosschaert the Elder was born in Antwerp and baptized there on November 18, 1573. His father is also referred to as a painter but no work by him is known. In or shortly after 1587, the family – like so many others – left Antwerp for religious reasons and moved to Middelburg, the prosperous provincial capital of Zeeland. We do not know who Bosschaert's teacher was but according to his daughter he became an "excellent painter of flowers and fruit."[1] In 1593, he joined the local guild, and in subsequent years he regularly held the office of dean. In 1604, he married Maria van der Ast, the elder sister of Balthasar van der Ast, who would later become his pupil. In 1615, he is mentioned as being in Bergen op Zoom in Brabant, and in the following year he acquired civil rights in Utrecht. From 1619 until his death, he lived in Breda, although he died in The Hague, where he had gone "to deliver a flowerpot that he had made for the steward of His Highness [Prince Maurits] for which a thousand guilders had been agreed."[2] His three sons Ambrosius the Younger (1609–1645), Johannes (ca. 1610/11–1628 or later), and Abraham (1612/13–1643) followed in their father's footsteps but were clearly less talented.

With his extremely detailed, symmetrically constructed, and quite compact paintings of flowers in a vase, Bosschaert was one of the principal founders of the Dutch floral still life. He established a tradition that lasted until the middle of the seventeenth century in Middelburg. Its popularity coincided with keen local interest in botany and gardens. Bosschaert's oeuvre is relatively small: about sixty-five paintings, mostly floral still lifes but also a few with fruit. Although he was registered with the St. Luke's Guild from 1593, his only known work from before

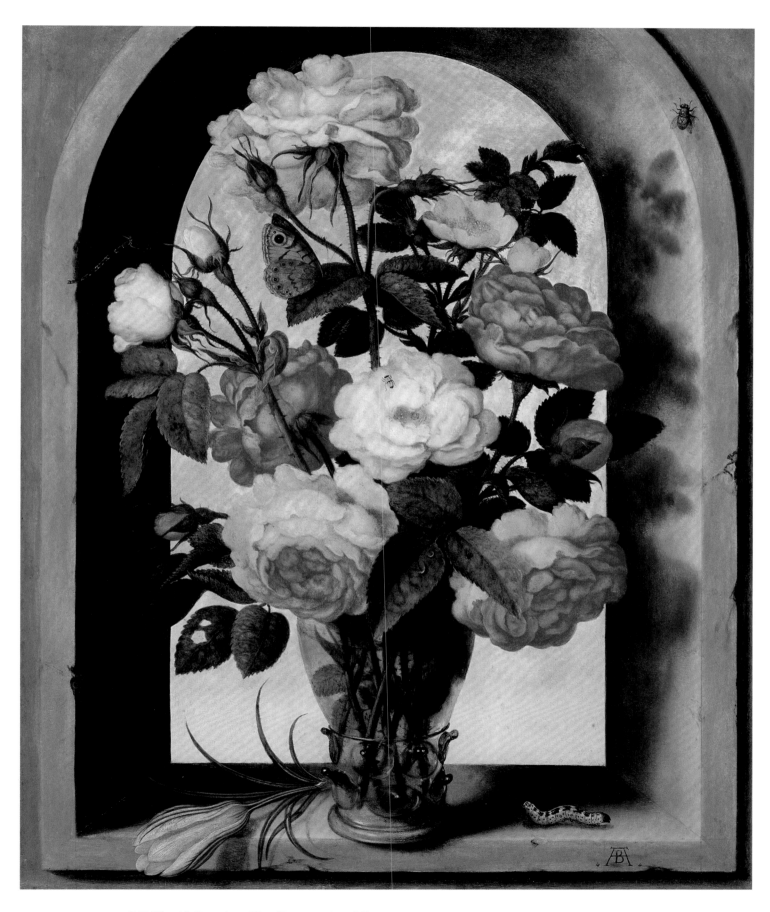

CATALOGUE II. *Still life with Roses in a Glass Vase*, ca. 1619. Oil on copper,
11 × 9 inches (28 × 23 cm). Monogrammed lower right: *AB* (in ligature)

1605 is a pen drawing from 1602 of a boy on a dromedary in an *album amicorum*; it is also the only drawing known by the master. Dated still lifes from nearly every year between 1605 and 1621 are extant.

Bosschaert was successful not only as a painter but also as a dealer. Numerous archives bear witness to all kinds of transactions involving England, Germany, Ireland, and other countries, particularly in the last ten years of his life. He sold paintings by Dutch masters but also works by foreign artists such as Georg Flegel (1566–1638) and Paolo Veronese (1528–1588). During the eighteenth, nineteenth, and much of the twentieth centuries, both Bosschaert and Van der Ast were almost completely forgotten. Since the 1960s, however, their importance has gradually been acknowledged and their work has become very popular.

Literature: Bol 1960; *Masters of Middelburg* 1984; Van der Willigen and Meijer 2003, p. 45.

CATALOGUE 11

STILL LIFE WITH ROSES IN A GLASS VASE

UNTIL 1992, this remarkably vivid floral still life was completely unknown in the art-historical literature. Its rediscovery is important in several respects. Not only is it an addition to Ambrosius Bosschaert's fairly small oeuvre, it is one of his finest still lifes. It must date from his last years, probably around 1619 when he was at the height of his ability. Moreover, it is one of only six known still lifes in which the bouquet is placed not against a fairly smooth, usually quite dark background, but in an open niche or window with a view – in this case, of the sky. The other five, which all show a landscape and sky, are in the Mauritshuis, The Hague (figure 1); the Musée du Louvre, Paris; the Carter collection, Los Angeles County Museum of Art; and two private collections.[3]

Bosschaert seems to have been the first artist to place his bouquets in this fashion against a bright, open background. This approach may well have been inspired by an intriguing panel of 1562 by Pieter Bruegel the Elder (1525/30–1569) (figure 2). This small painting depicts two chained

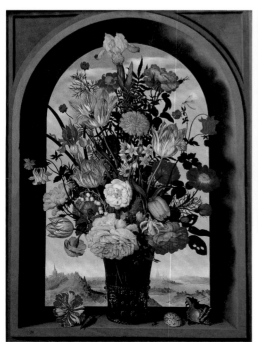

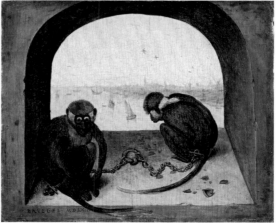

Figure 1. Ambrosius Bosschaert the Elder, *Vase with Flowers in a Window*, ca. 1618. Oil on canvas, 25 1/4 × 18 1/8 inches (64 × 46 cm). Royal Picture Gallery Mauritshuis, The Hague.

Figure 2. Pieter Bruegel the Elder, *Two Chained Monkeys*, 1562. Oil on oak panel, 7 7/8 × 9 inches (20 × 23 cm). Gemäldegalerie, Staatliche Museen, Berlin.

monkeys in a similar kind of niche with the city of Antwerp on the Scheldt river in the background. Bosschaert may have been young when he left that city but the influence of the Antwerp painters on those in the Northern Netherlands, particularly in nearby Zeeland, was considerable. Prints may have been another source of inspiration for Bosschaert. A print of 1599 by Hendrick Hondius (1573–1650) after a work by the little known Delft artist Elias Verhulst (ca. 1560? –1601) shows a large, compactly constructed bouquet of mixed flowers in a vase within an open niche with a view of a landscape with mountains and a harbor. A few years later, Claes Jansz. Visscher (ca. 1587–1657) made a print after Adriaen Collaert (ca. 1560–1618) showing a mixed bouquet also in a niche with a landscape in the background.

Bosschaert's still life demonstrates great subtlety. At first, it appears completely natural and realistic. Thanks to the shadows of the flowers on the inside of the niche and the small areas of wear and cracks in the stone, it also has a strong illusionistic effect that is accentuated by the dewdrops on the foliage and several partly eaten leaves. The setting is artificial nonetheless, for despite the bright sky in the background the still life is lit solely from the left.

The floral still lifes by Bosschaert and other specialists in this genre such as Jan Brueghel the Elder and Balthasar van der Ast mostly consist of flowers that bloom in different seasons. Thus, even though individual flowers may be correctly rendered, these bouquets are imaginary. Indeed, often their many stalks would not have fit into the small and narrow vases. In this still life, however, roses alone comprise the bouquet and their stems can be traced into the glass. Nevertheless, it was not the custom in this period to paint an existing bouquet from life. Bosschaert would have relied on studies of individual flowers for different still lifes. The yellow crocus in the foreground appears, for example, in another work by the artist, and two of the still lifes mentioned above depict almost identical bouquets. Yet, this painting is unique because it shows only sky and no landscape and the tonality is in sharp contrast.

Provenance: Private Collection, Lorraine, France, in the nineteenth century; anonymous sale, Paris (Ader Tajan), December 14, 1992, no. 24; with Johnny Van Haeften Ltd, London, by 1993–94, where acquired in 1994.

Exhibitions: Rijksmuseum, Amsterdam, *Dawn of the Golden Age, Northern Netherlandish Art 1580–1620*, 1993–94; National Gallery of Art, Washington, *From Botany to Bouquets: Flowers in Northern Art*, 1999.

Literature: *Dawn of the Golden Age* 1993–94, p. 607, cat. no. 279, ill. pp. 272, 607; *From Botany to Bouquets* 1999, pp. 39–41, 43, cat. no. 10, ill. p. 41, fig. 31; Segal 2002, vol. 1, pp. 63–66, fig.s 5, 6.

Notes:
1. Bredius 1913, p. 138.
2. Ibid., pp. 138–39.
3. Formerly Wetzlar collection, Amsterdam, and sale, London (Sotheby's), July 10, 2002, no. 15, ill.; and with dealer Scheidwimmer, Munich (1977).

JAN BOTH

UTRECHT CA. 1615–1652 UTRECHT

Jan Both was born in Utrecht probably around 1615. He studied first with his father, the glass paint-
er Dirck Boot (dates unknown), and after that, according to Joachim von Sandrart, with Abraham
Bloemaert (1564–1651).[1] It is not known when Both left for Italy but he is recorded in Rome in
the summer of 1638. He had probably gone to join his elder brother and fellow artist Andries Both
(ca. 1612–1641), who is recorded as having been in Rome since 1635. In 1641, the two brothers
left for the Netherlands but during their voyage Andries drowned in Venice and Jan returned alone
to Utrecht, where he settled permanently. In 1649, he served as an overseer of the local St. Luke's
Guild together with his Italianate confrères Cornelis van Poelenburch (1594/95–1667) and
Jan Baptist Weenix. He died young, and was buried on August 9, 1652, in the Buurkerk, Utrecht.

 Even more than the Italians themselves, foreign painters were captivated by the beauty of
the Roman *campagna*, and celebrated it as an independent theme. It is difficult to say which artists
were most responsible for this phenomenon – French painters such as Claude Lorrain (1600–1642)
or Dutch artists such as Jan Both.

 The great majority of Both's paintings are idyllic Italian landscapes, bathed in soft, glowing
sunlight, but he also produced some urban genre scenes. More than forty drawings and
seventeen etchings by the artist are known. His paintings show remarkable consistency in finish and

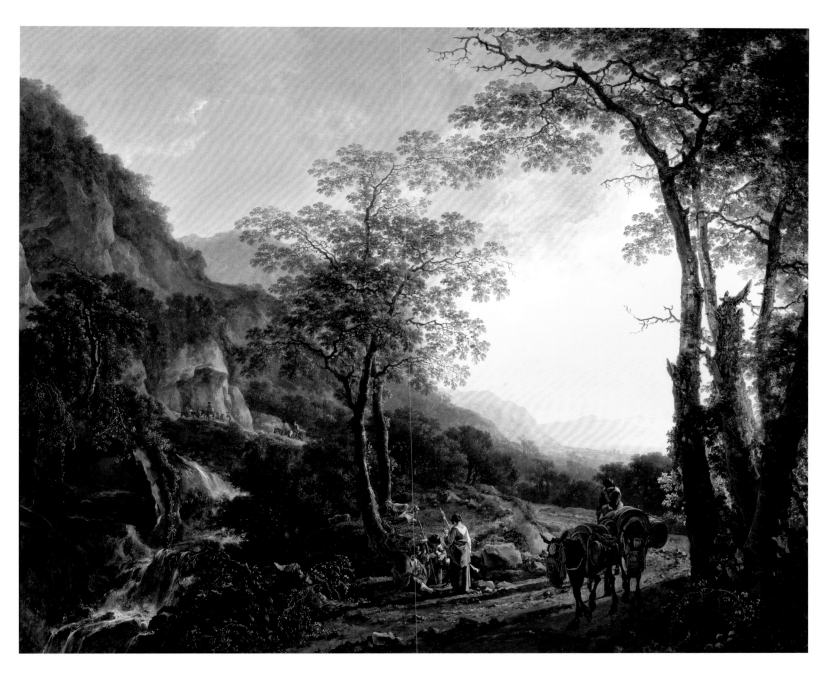

CATALOGUE 12. *Italianate Landscape with Travelers on a Path*, 1645–50. Oil on canvas, 54 3/8 × 66 inches (138.1 × 167.6 cm). Signed lower right on the donkey's pannier: *JBoth* (*JB* in ligature)

quality. Apart from four landscapes commissioned in 1639 for King Philip IV's Buen Retiro Palace in Madrid that are now in the Museo Nacional del Prado, very few works can be securely assigned to his Italian sojourn. Dated works are extremely rare. Both was clearly influenced by Claude's work, but while the Frenchman used the *campagna* as a setting for mythological or classical scenes, Both depicted shepherds, peasants, travelers, and artists. He had a considerable influence on the Dutch landscapists, especially Aelbert Cuyp, and on English landscape painters of the eighteenth and early nineteenth centuries. Hendrick Verschuuring (1627–1690) and Willem de Heusch (ca. 1625–1692) were among his pupils in Utrecht.

Literature: Hofstede de Groot 1907–28, vol. 9, pp. 418–518; Stechow 1966, pp. 147–58; Waddingham 1964, pp. 13–43; Burke 1976; Trezzani 2000, pp. 46–50.

CATALOGUE 12

ITALIANATE LANDSCAPE WITH TRAVELERS ON A PATH

ONE OF JAN BOTH'S LARGEST AND MOST AMBITIOUS PAINTINGS, this southern landscape is an impressive example of his mature style. Characteristic in subject matter and style, it demonstrates Both's ability to compose large-scale, unified landscapes, skillfully balancing foreground, middle distance, and background. On the one hand, Both paid considerable attention to the rendering of the staffage – the tree trunks and vegetation in the immediate foreground; on the other hand, he convincingly depicted a distant view, and linked the two by means of a meandering road and a waterfall on the left. The trees on the right act as a frame for the landscape, a compositional device he would often employ in his later work. The zig-zag composition in combination with the successive areas of light and dark lend the painting a great sense of depth. The golden sunlight of late afternoon bathes the landscape in a still and peaceful atmosphere. Although the scene suggests the Italian countryside, it surely depicts an imaginary landscape. It is the type of painting that brought Both great fame during the eighteenth and first half of the nineteenth centuries. It is precisely the type of landscape that must have inspired Aelbert Cuyp after the mid-1640s, when for several of his works he adopted Both's light and warm atmosphere as well as his compositions and motifs.

Given the almost complete absence of dated and datable works, it is hazardous to apply a chronology to Both's landscapes. The few that can be securely assigned to his Italian period are characterized by an almost monochromatic yellowish palette. This tonality seems to have gradually diminished after his return to the Netherlands. As far as composition, style, and execution are concerned, Both seems to have been rather consistent during the last seven or eight years of his life. Only color seems to have changed in meaningful ways, shifting from the overall yellow cast to a more colorful palette. In the present painting, which has only recently resurfaced, the southern landscape is suffused with a soft yellowish light but the color is more varied than in the Roman work. In combination with the transparent foliage as opposed to the denser masses of leaves in his earlier works and the highly refined treatment, the second half of the 1640s seems a likely date.

In the nineteenth century, the painting was part of the famous collection of Pieter van Winter and subsequently that of his daughter Anna Louisa Agatha van Winter. It was one of the most important collections of Dutch paintings ever brought together.

Provenance: Willem Jan van Vollenhoven, Amsterdam; his widow, Maria Feitama van Vollenhoven, her estate sale, Amsterdam (Posthumus/Voorhoeve), April 2, 1794, no. 10; Pieter van Winter, Amsterdam; died 1807; inventory 1815; his daughter Anna Louisa Agatha van Winter, wife of Willem van Loon, Amsterdam, 1807–77; sold en bloc after her death in 1877 to Baron Gustave de Rothschild, Paris; Baron Lionel de Rothschild; Rothschild Inventory, p. 34, no. 1; 1882 Division, p. 2; Nathaniel, First Lord Rothschild, his (anonymous) sale, London (Christie, Manson & Woods), May 7, 1898, no. 82; bought by A. Smith; Thomas Humphrey Ward, London; with Dowdeswell and Dowdeswell Ltd., London; J. Felbrach, Wezel, Germany; anonymous sale, Cologne (Lempertz), May 20, 2006, no. 1015 (with wrong Smith reference number); acquired from Johnny Van Haeften Ltd., London, in 2007.

Exhibitions: On loan to the J. Paul Getty Museum, Los Angeles, since 2007.

Literature: Smith 1829–42, pp. 195–96, no. 67; Hofstede de Groot 1907–28, vol. 9, no. 209; Priem 1997, nos. 2, 3, pp. 103–235, ill. p. 169, fig. 69.

Notes:
1. Von Sandrart 1925, pp. 184–85.

SALOMON DE BRAY

AMSTERDAM 1597–1664 HAARLEM

Salomon Simonsz. de Bray was born in Amsterdam in 1597, the son of a Catholic, Simon de Bray, from Flanders. The family was highly gifted and artistic. Salomon is first mentioned in Haarlem in 1616 as a member of the civic guard and as a *beminnaer* (lover) of the *De Wijngaardranken* (The Vine Leaves) chamber of rhetoric. Thanks to a memorandum of 1621 from the entrepreneur and author Theodoor Rodenburg to the Danish king Christian IV, in which he recommended a number of Dutch artists and craftsmen, we know that De Bray was taught by the two best known classicist painters in Haarlem: Hendrick Goltzius (1558–1617) and Cornelis van Haarlem (1562–1638).[1] However, their influence on De Bray's work was fairly limited. On May 13, 1625, in The Hague, De Bray married Anneke Westerbaen, the sister of the portraitist Jan Westerbaen (1600/1602–1686) of The Hague and of the poet and physician Jacob Westerbaen. The couple had ten children, including the sons Jan (1626/27–1697), Dirck (ca. 1635–1694), and Joseph (ca. 1628/34–1664), who all became painters. Between 1630 and 1661, De Bray is documented as a member of the St. Luke's Guild of Haarlem as a painter and architect. He regularly held administrative posts in the guild and played a prominent part in its reorganization. Among his architectural projects was the design of the façade of the Haarlem city hall. De Bray was also active as a poet; his writings indicate that he must have had a good education and was very well read.

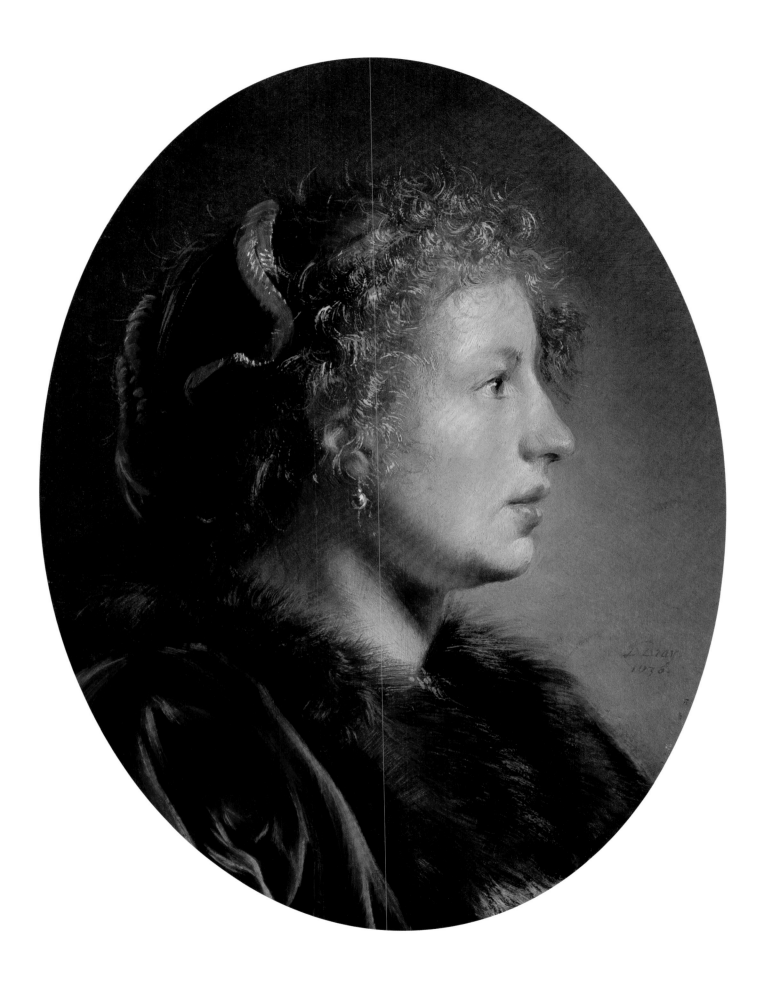

CATALOGUE 13. *Study of a Young Woman in Profile*, 1636. Oil on panel, 10 1/2 × 8 inches (26.7 × 20.5 cm). Signed and dated lower left: *SD Bray.| 1636.* (*SD* in ligature)

In 1663 and 1664, the entire De Bray family except for Jan and Dirck fell victim to the plague epidemic. De Bray's wife was buried in the Grote or St. Bavokerk in Haarlem on March 6, 1663, and the artist was laid to rest in the same grave on May 14. A posthumous double portrait (National Gallery of Art, Washington) was painted by their son Jan probably in 1664. In his 1628 description of the city of Haarlem, Samuel Ampzing praised Salomon de Bray as both a painter and an architect.[2]

Initially, De Bray painted mainly portraits. Around the middle of the seventeenth century, however, he and his son Jan became the leading history painters in Haarlem. They were among the most prominent exponents of Dutch classicism. In the late 1640s, Salomon and several other artists were given the prestigious commission for a number of large canvases to decorate the Oranjezaal in Huis ten Bosch in The Hague, the palace of Amalia van Solms, the widow of *Stadholder* Frederik Hendrik.

Literature: Von Moltke 1938–39, pp. 309–420; Lammertse 2008.

CATALOGUE 13

STUDY OF A YOUNG WOMAN IN PROFILE

THIS EXTREMELY SUBTLY PAINTED and beautifully preserved panel shows perfectly what a gifted master Salomon de Bray was. The young woman's brightly lit face draws the viewer's attention, since on the left half of the panel the back of her head and neck and her fur-trimmed jacket are largely in shadow. Using fluent and effective brushstrokes, De Bray painted the blond locks around her face over the dark ground and partly over the red hair band, making the curls seem almost tangible. The palette is limited: besides the flesh tones of the face and neck and her blond hair, the bright red of her lips is especially striking, and recurs in her hair band and on both shoulders. Reflections in her eye and on her pearl earring add a lively touch.

Portraits and studies in profile are relatively rare in Dutch seventeenth-century painting. They are found chiefly in court circles and in the work of several classicist painters, such as Salomon de Bray and his son Jan. Two of the best-known examples are the 1631 profile portrait of *Stadholder* Frederik Hendrik (Stichting Historische Verzamelingen van het Huis van Oranje-Nassau, Palace Huis ten Bosch, The Hague) by Gerrit van Honthorst (1592–1656) and that of his wife Amalia van Solms painted a year later by Rembrandt (Musée Jacquemart-André, Paris). A few years afterward, Rembrandt painted a profile portrait of his wife Saskia (Staatliche Museen, Gemäldegalerie, Kassel). In the Southern Netherlands, it was Rubens above all who around 1614/15 tried his hand at this type of painting, for example in his panel *Agrippina and Germanicus* (National Gallery of Art, Washington). The pictorial type is regularly found in fifteenth-century Italy, in most cases derived from ancient coins, medals, and cameos depicting Roman emperors and other prominent figures in profile. It was widely thought that artists were generally more successful at capturing a perfect likeness with a profile rather than a full-face or three-quarter portrait.

This painting seems to be a facial study or *tronie* rather than a formal portrait. De Bray used the same model for Judith in his *Judith Delivering the Head of Holofernes* from the same year (figure 1).[3] Moreover, a portrait study of what seems to be the same woman is attributed to De Bray's fellow townsman Pieter de Grebber (ca. 1600–1653).[4] It has been suggested that an oval panel from the same year with a study of a boy looking to the left is a pendant to the present painting.[5]

Recent examination of the panel revealed the numbers *46/1636./4/14* written on the back.[6] Similar inscriptions have been found on other panels by De Bray. All the evidence suggests that

they were applied by the artist himself, and that they indicate an opus number and a date. This painting, therefore, is number 46 in De Bray's oeuvre, and was finished on April 14, 1636. The back of *Judith Delivering the Head of Holofernes* bears the inscription 47/1636/4/25, which means that it originated immediately after the present painting and that De Bray completed it on April 25, 1636, eleven days after *Study of a Young Woman in Profile*. The proximity of these dates confirms that De Bray used the same model for both paintings.

Figure 1. Salomon de Bray, *Judith Delivering the Head of Holofernes*, 1636. Oil on panel, 35 × 28 inches (89 × 71 cm). Museo Nacional del Prado, Madrid.

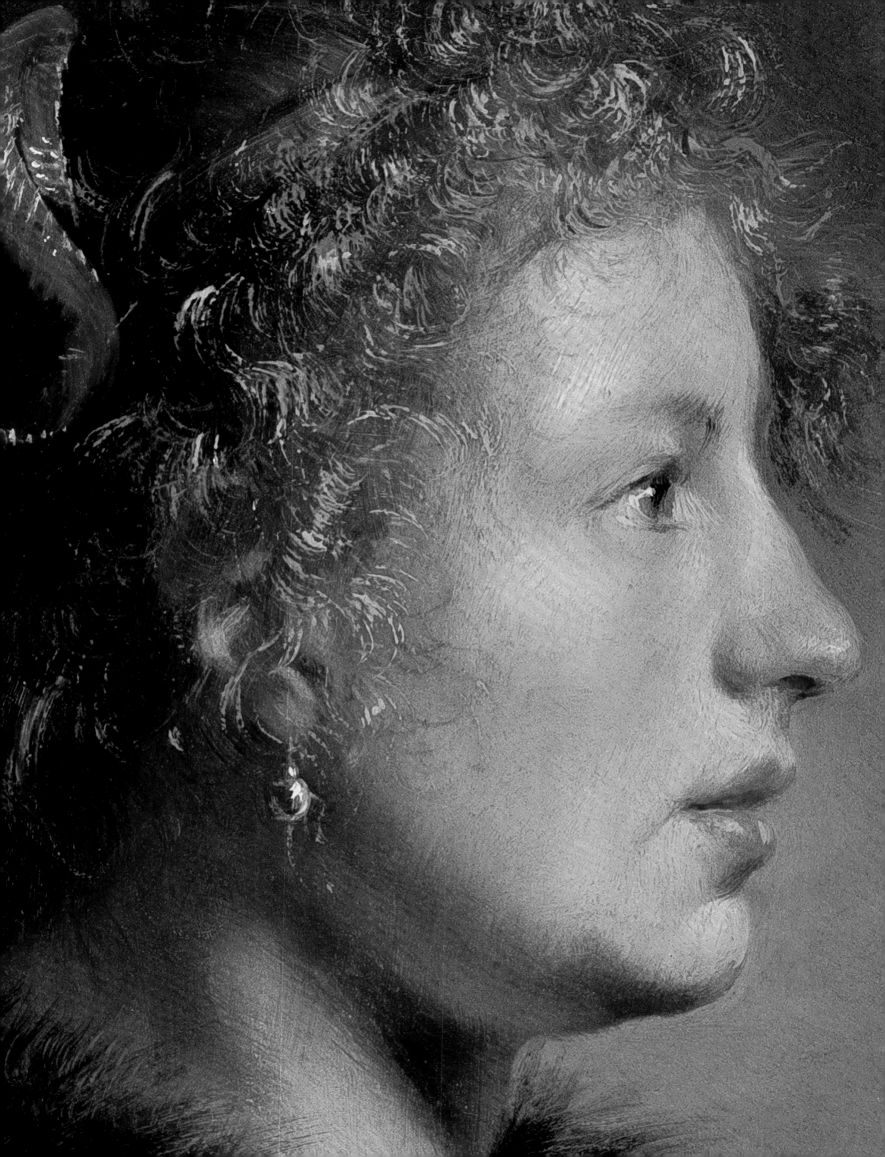

The provenance of the painting can be traced with a high degree of probability to the second half of the seventeenth century, when it most likely belonged to Robert Spencer, Second Earl of Sunderland, at Althorp. Spencer was apparently very fond of De Bray's work, since he also owned pendants by his hand: a 1635 depiction of a shepherd and shepherdess,[7] and a *Study of an Old Man*.[8] Remarkably, these two pendants and the present panel were attributed – when still hanging at Althorp – to Leonaert Bramer (1596–1674), whose work bears little, if any, resemblance to that of Salomon de Bray.

Provenance: Probably Robert Spencer, Second Earl of Sunderland (1640–1702), Althorp, Northamptonshire; The Earls of Spencer, Althorp from at least the mid-eighteenth century (perhaps no. 185 in the inventory drawn up at the death of The Hon. John Spencer in 1746: *A Girl's Head in an Oval by Bremar*); thence by descent at Althorp to Albert Edward John Spencer, Seventh Earl of Spencer (1892–1975), until the mid-1980s; with Johnny Van Haeften Ltd., London, 1987; Dr. Hinrich Bischoff, Bremen, on loan to Kassel, Staatliche Museen Kassel, Schloss Wilhelmshöhe, Gemäldegalerie Alte Meister, until 2002 (inv. no. L. 1106); sale, New York (Sotheby's), January 22, 2004, no. 62 (for $1,350,000); private collection, France; acquired at anonymous sale ("The Property of a Gentleman"), London (Sotheby's), July 8, 2009, no. 7, through Johnny Van Haeften Ltd., London.

Exhibitions: Thomas Agnew & Sons, London, *Exhibition of Pictures from the Althorp Collection . . .*, 1947.

Literature: Von Moltke 1938–39, pp. 357, 358, 386, no. 82, ill. p. 358, fig. 46; *Exhibition of Pictures from the Althorp Collection* 1947, p. 20, no. 31; Waterhouse 1947, p. 77, ill. p. 79, fig. C; Garlick 1976, p. 9, no. 62; Schnackenburg 1993, pp. 90–92, no. 34, ill. p. 91; Foucart 1996, p. 78 n. 2; Von Moltke 1996, p. 702 (as "the small, superbly painted *Portrait of a Woman in Profile . . .*"); Posada Kubissa 2009, pp. 40, 42 n. 4 (incorrectly suggesting an identification of the girl as Medusa), 299 n. 2; Buvelot and Lammertse 2010, pp. 390–92, ill. pp. 30, 31.

Notes:
1. Kernkamp 1902, pp. 216–17.
2. Ampzing 1628, p. 372.
3. *De Gouden Eeuw Begint in Haarlem* 2008, pp. 42–43, ill. The painting is not dated, but a drawn *ricordo* – of the type De Bray often made – is dated 1636.
4. Schnackenburg 1993, p. 92, ill.
5. Corstius sale, Geneva, October 27, 1934, no. 72, and which was seen with the dealer Walter Paech in Amsterdam in the same year. See Von Moltke 1938–39, p. 387, no. 90, fig. 47.
6. Buvelot and Lammertse 2010, pp. 390–92, ill. pp. 30, 31.
7. Private collection, Montreal; Von Moltke 1938–39, p. 388, cat. nos. 96, 105.
8. Von Moltke 1938–39, p. 368, ill. no. 59, p. 386, cat. no. 76.

JAN BRUEGHEL
THE ELDER

BRUSSELS 1568–1625 ANTWERP

Jan Brueghel, the son of Pieter Bruegel the Elder (1525/30–1569), was born in Brussels the year before his famous father died. He probably received his first training from his grandmother Mayken Verhulst (ca. 1518–ca. 1599), a miniaturist. According to Karel van Mander, he then studied with Pieter Goedkindt (dates unknown) in Antwerp.[1] In 1589, he traveled to Italy; in 1590 he was in Naples and in 1592–94 in Rome, where he enjoyed the patronage of Cardinal Ascanio Colonna. He must have met the Flemish landscapist Paulus Bril (1554–1626) in Rome and the two artists strongly influenced each other. In 1595, Brueghel moved to Milan, where he worked under the patronage of Cardinal Federigo Borromeo. By 1596, he had returned to Antwerp where the following year he entered the local guild. On January 23, 1599, he married Elisabeth de Jode. Their son Jan Brueghel the Younger (1601–1678) also became a painter, and their daughter Paschasia married the painter Jan van Kessel (1626–1679). In 1601, Brueghel became a citizen of Antwerp; in 1602, he served as dean of the guild. The following year, his wife Elisabeth died. In 1605, he married Catharine Marienbourg, who bore him eight children. Brueghel traveled to Prague in 1604 and to Nuremberg in 1606. Archduke Albert of Austria, governor of the Southern Netherlands, appointed him as court painter in Brussels. Emperor Rudolph II and Sigismund, king of Poland, also commissioned works from him. In 1613, Brueghel and his friend Peter Paul Rubens (1577–1640) traveled to the Northern Netherlands on an official mission. Brueghel died on January 13, 1625, in Antwerp, a victim of a cholera epidemic.

One of the most celebrated and successful Flemish artists of his time, Brueghel was very prolific; his oeuvre consists of more than four hundred paintings. Apart from flower still lifes, he

is mainly known for his miniaturelike landscapes, often with biblical scenes, and allegorical and mythological subjects. He earned the nickname "Velvet Brueghel" for his beautifully detailed and smooth way of painting. The earliest known works date from his years in Rome. Among the artists with whom he collaborated on paintings were Rubens, Joos de Momper (1564–1635), and Hendrick van Balen (1575–1632). Brueghel was also an accomplished draftsman who executed a variety of drawings. Daniël Seghers (1590–1661) was his only recorded pupil but his son Jan the Younger must also have studied with him.

Literature: Ertz 1979; Ertz and Nitze-Ertz 2008–2010.

CATALOGUE 14

*VILLAGE SCENE WITH
A CANAL*

IN THIS BEAUTIFULLY PRESERVED PAINTING ON COPPER, Jan Brueghel the Elder captured a view of a village street from a slightly higher vantage point. Numerous colorfully dressed figures of all ranks and classes stand talking in groups or pause to rest during their busy day. It has been suggested that the man in black in the left foreground is a self-portrait and the surrounding figures are members of his family. In other paintings, Brueghel used himself and his family along with other figures as staffage.[2] Horses both loose and harnessed to wagons are dispersed over the foreground and middle ground. Pigs, chickens, and geese scratch about on the right. To the left and right, farms and houses act like the wings of a stage to close off the scene. A sign with a white swan on the middle building of the three on the left indicates it is an inn. A large tree casts shade over part of the middle ground. The first building on the right houses the shop of a cartwright who is hard at work out front. A canal leads into the background; it is bordered by a sandy track lined by houses and, closer to the horizon, trees – all under a blue sky with veiled clouds. More horses and wagons stand in front of the houses on the left.

There is an earlier version of this composition from 1607 (figure 1), a possibly autograph but undated version was sold in Paris (Christie's) on June 26, 2003, lot 21, and there is a copy of the painting, probably by Jan Brueghel the Younger (Staatsgalerie, Aschaffenburg).

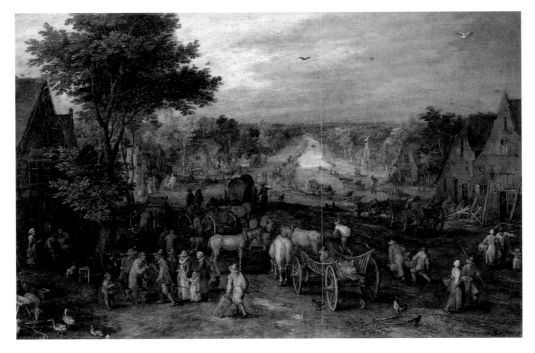

Figure 1. Jan Brueghel the Elder, *Village Scene with a Canal*, 1607. Oil on copper, 8 1/4 × 12 5/8 inches (21 × 32 cm). Pinacoteca di Brera, Milan.

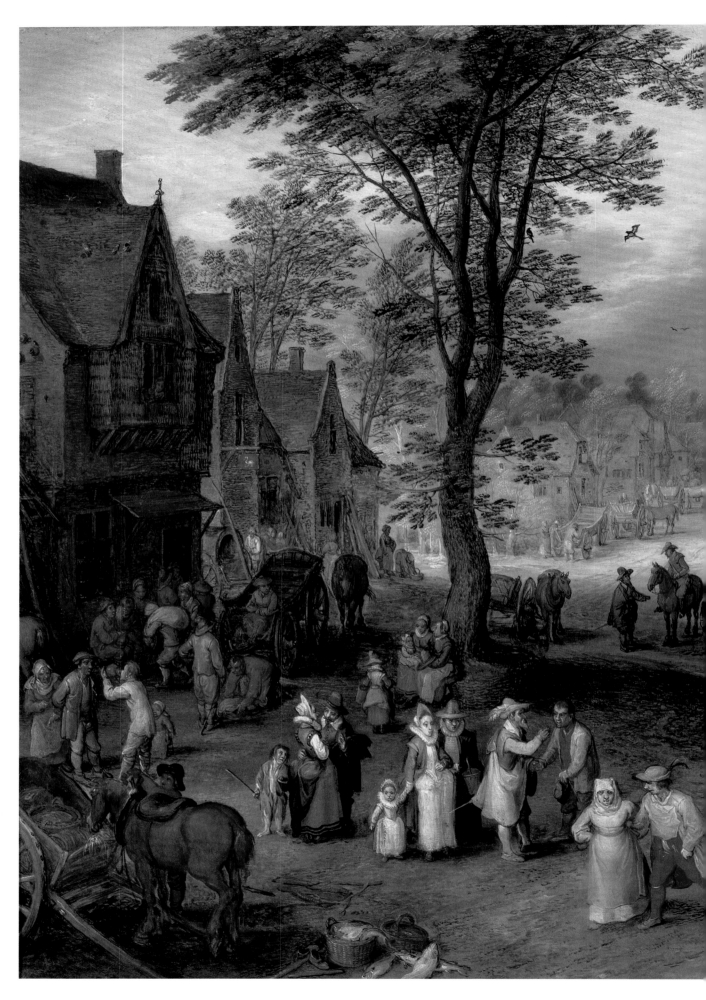

CATALOGUE 14. *Village Scene with a Canal*, 1609. Oil on copper, 8 5/8 × 13 3/8 inches
(22 × 34 cm). Signed and dated lower left: *BRVEGHEL 1609*

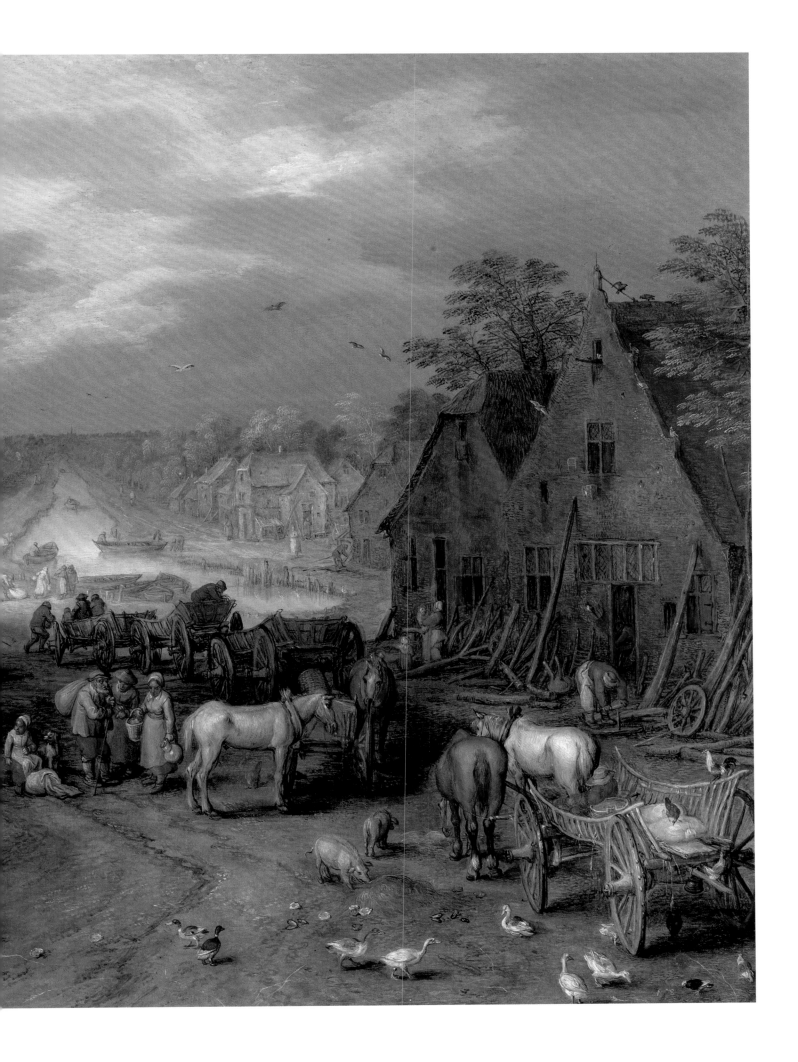

Brueghel's earliest landscapes, the so-called *weltlandschaften* (panoramic or "world" land-
scapes), from the first half of the 1590s, were still entirely reflective of sixteenth-century tradition.
During the first years of the seventeenth century, however, he developed a new type of landscape
featuring single-point perspective, as in *Entrance to a Village with a Windmill* of 1603 or 1605.[3]
Village Scene with a Canal from 1609 shows how Brueghel refined this theme, which he returned
to throughout his life, sometimes re-using elements from earlier paintings, such as the cart
and horses in the foreground on the right and the gray horse slightly to the left of it. Despite the
modest format, Brueghel managed to create a sense of spaciousness, chiefly by choosing a
slightly higher point of view. Typically, he constructed his landscape compositions on one or
more diagonals, but here he has opted for an almost centrally placed vanishing point, which
is accentuated by the vertically positioned canal and the church, which can be seen in line with it
on the horizon. Such a bold, clearly vertical axis was rare in seventeenth-century compositions.
Many years later, both Aelbert Cuyp, in *The Avenue at Middelharnis* (early 1650s; National Gallery,
London), and Meindert Hobbema (1638–1709), in *The Avenue at Meerdervoort* (1689; Wallace
Collection, London), chose this device.

Provenance: Elector-Palatine Johann Wilhelm II von der Pfalz (1690–1716), Düsseldorf; thence by descent to Karl
Theodor von Pfalz-Sulzbach (1724–1799), in the Kurfürstliche Galerie Mannheim (inv. no. 193), by 1730;
Schloss Nymphenburg, Munich, by 1799; Alte Pinakothek, Munich (inv. no. 2839), until 1933 when deaccessioned
(to Galerie Arnold); with Galerie Arnold, Dresden, by 1933; Robert J. Gellert, New York, his estate sale, New
York (Parke-Bernet), May 20, 1971, no. 26, bought by Terry Engell; with H. Terry-Engell Gallery, London; private
collection, Great Britain (sold at the Antique Dealers Fair, London, in June 1971); Sir Maxwell Joseph; with David
Koetser, Geneva, and Colnaghi, London, at the beginning of 1977; Robert Smith, Bethesda, Maryland, by 1977;
Richard Kirstein, Bethesda, Maryland; with Edward Speelman, London; acquired from Noortman Master Paintings,
London, in 1995.

Exhibitions: Brod Gallery, London, *Jan Brueghel the Elder*, 1979; Villa Hügel, Essen; Kunsthistorisches Museum,
Vienna; Koninklijk Museum voor Schone Kunsten, Antwerp, *Breughel-Brueghel, Pieter Breughel der Jüngere –
Jan Breughel der Ältere: flämische Malerei um 1600: Tradition und Fortschritt*, 1997; Villa Hügel, Essen; Kunsthistorisches
Museum, Vienna; Koninklijk Museum voor Schone Kunsten, Antwerp, *Breughel-Brueghel, Pieter Breughel de Jonge –
Jan Breughel de Oudere: een Vlaamse Schildersfamilie rond 1600*, 1998.

Literature: "Détail des Peintures du Cabinet Electoral de Düsseldorf," ca. 1719, printed manuscript, Herzog
August Bibliothek, Wolfenbüttel, no. 25; Gool 1750 ("… een nette Catalogus en uitvoerige Beschryvinge
der voortreffelyke en onschatbaere Schilderkunst, welke in de Gaenderyen en Kabinetten der Keurvorstelyke
Residentie binnen Dusseldorp gezien word …") (1719); Müller and von der Schlichten 1730; *Détail des Peintures des
deux Cabinets Electoraux à Mannheim* before 1736, no. 193; Brinckmann 1756, no. 100; *Catalogue des tableaux qui
sont dans les quatre cabinets de* S. A. S. E. *Palatine à Mannheim*, 1756, p. 16, no. 100 (second cabinet: "La vue d'un Canal
dans un Village avec beaucoup de figures, par Jean Breugel, hauteur 8 pouces. Largeur 1 pied" [8 1/2 × 12 3/4 inches
(21.7 × 32.5 cm)]; possibly *Beschreibung der Churfürstlichen Bildergalerie in Schleisheim*, Munich, 1775, p. 187, no. 747
("Eine Landschaft mit einem Kanale, vielen Wagen, Leuten und Viehe. Auf Kupfer 11 1/2 Zoll breit, 8 1/2 Zoll hoch"
[8 3/4 × 11 7/8 inches (22.3 × 30.1 cm)], or p. 194, no. 772 ("Eine Landschaft mit dem Prospekte eines Kanals bei
Boom zwischen Brüssel und Antwerpen. Zu beiden Seiten stehen Häuser, und im Vorgrunde viele Leute, Wägen
und Pferde vor einem Wirthshause. Auf Kupfer 1 Fuss 1/2 Zoll breit, 8 Zoll hoch" [8 1/4 × 12 15/16 inches (21 × 32.8 cm)];
Catalogue de la Gallerie de Mannheim actuellement au Chateau de Nymphenbourg commencé à 19 novembre 1799;
Churfürstl. Gemälde-Samlung von Mannheim, den 26. October 1802; *Verzeichniss der Gemälde der Churfl: Bilder-Gallerie
von Mannheim, verfasst den 22ten July 1802. in München; Verzeichniss derjenigen Gemälde, welche aus der Churfürstl.
Mannheimer Gemälde-Sammlung nach den Churfürstlichen Schloss Schleissheim abgeschiket worden sind*, all the four above
as no. 321 (manuscripts in the Archiv der Bayerischen Staatsgemäldesammlungen, Munich; see Baumstark 2009,
vol. 2, p. 252 under Von Mannlich 1810 (see J. G. Prinz von Hohenzollern, *Staatsgalerie Schleissheim*, Munich, 1980,
p. 11); possibly Von Dillis 1839, p. 205, no. 200 (Cabinet IX: "Paysage. Un grand chemin passé auprès d'un cabaret
de village, où des voyageurs à pied et en voitures prennent des rafraîchissemens. On remarque dans le lointain un
canal traversant en ligne droite une forêt. – Sur cuivre, haut 8"7,'" large 1'1'" "); possibly Von Dillis 1845, p. 205,
no. 200; possibly Marggraff 1866, p. 168, no. 200; possibly Marggraff 1878, p. 39, no. 797 ("Markttag bei einem Dorfe

mit Fluss") or p. 40, no. 806 ("Dorf an einem Schiffbaren Flusse") or p. 40, no. 822 ("Dorf, von Reisenden belebt");
Von Reber 1879–1911, 1885, 1886, 1891, 1893, p. 142, no. 690, 1898, 1900, 1904, p. 157, no. 690, 1908, p. 149,
no. 690, 1911, p. 21, no. 690; Von Würzbach 1906–11, vol. 1, p. 205; Bénézit 1976, vol. 2, p. 168 (both the above as
listed under the Munich provenance); *Katalog Bayerischen Staatsgemäldesammlungen* 1964, pp. 27–28, under no. 1897;
Burlington Magazine 1971, p. 31; *Weltkunst* 1977, p. 611; Van Gehren 1979, pp. 1760–61, ill. p. 1761; *Jan Brueghel the
Elder* 1979, pp. 80–81, cat. no. 21, ill.; Ertz 1979, pp. 58, 62, 79–80, 217, 445, 486, cat. no. 196, fig.s 31, 55, 56, 266, 534;
Brueghel; Een dynastie van schilders, Brussels, Paleis voor Schone Kunsten, 1980, p. 189; *Breughel-Brueghel,
Pieter Breughel der Jüngere, Jan Brueghel der Ältere* 1997, pp. 210–12, cat. no. 55, ill. p. 211; *Breughel-Brueghel: Pieter
Breughel de Jonge, Jan Brueghel de Oudere* 1998, pp. 170–73, cat. no. 52, ill. pp. 171, 173; Wegener 2006; Ertz and
Nitze-Ertz 2008–2010, vol. 1, pp. 372–74, cat. no. 181, ill.; *Kurfürst Johann Wilhelms Bilder* 2009, vol. 1, p. 238, ill. as
part of fig. 25, p. 256, ill., pp. 272–74, no. 10, ill., vol. 2, p. 184, no. 54, ill.

Notes:
1. Van Mander 1604, folio 234.
2. See, for example, *Village Landscape* (1614; Kunsthistorisches Museum, Vienna).
3. Private Collection, Zurich; Ertz 1979, no. 93.

JAN VAN DE CAPPELLE

AMSTERDAM 1626–1679 AMSTERDAM

Jan van de Cappelle was baptized in Amsterdam on January 25, 1626. He was the son of Franchoys van de Cappelle, the owner of a flourishing crimson dyeworks ("de gecroonde handt") on Raamgracht. Jan learned the trade and worked in his father's business, which he later inherited and continued, thus ensuring a large income throughout his life. On February 2, 1653, he married Anna Grotingh, who also came from a wealthy family. Van de Cappelle appears to have lived his entire life in Amsterdam, and in houses that reflect his affluence: up to 1663 on Keizersgracht, along with some of Amsterdam's richest citizens, and later in an expensive home on Koestraat. In June 1666, during an illness, he had his will drawn up. Although he survived for many years – he died on December 22, 1679 – he seems to have given up painting after 1666.

The inventory made after his death states that he had slightly over ninety thousand guilders in cash and bonds (a fortune in those days), as well as six houses, several parcels of land, the dyeworks, and a "pleasure yacht." He was also was one of the greatest collectors of his time, with nearly two hundred paintings that included works by Simon de Vlieger (9), Jan Porcellis (16), Peter Paul Rubens (1577–1640), Hercules Seghers (ca. 1580–ca. 1638), and many others. Among the approximately six thousand drawings were works by contemporaries such as Rembrandt (500), Jan van Goyen (400), Hendrick Avercamp, Jan Porcellis, and Simon de Vlieger (1,300).

Painting was very probably not Van de Cappelle's main occupation, as various documents refer to him successively as "crimson dyer," "merchant," and "skillful painter." In 1654, the Amsterdam painter Gerbrand van den Eeckhout (1621–1674) wrote of his colleague in an *album*

amicorum of the Amsterdam poet and rector of the Gymnasium, Jacob Heyblock, that he "had learned painting for his own pleasure…."[1] Van de Cappelle may have had no formal training as a painter, but he must have been very familiar with the marines and other paintings of Simon de Vlieger, who worked in Weesp and with whom he may also have worked for a while. A number of Van de Cappelle's paintings from around 1650 are inspired to a large extent by works by De Vlieger. The work of Porcellis also seems to have been an influence.

Today, of about seventy-five known marines by Van de Cappelle, half are in museums. The earlier paintings are a cool silver-gray in tone, while brown dominates the later work. In addition to his usually tranquil marines, there are beach scenes and some fifteen less ambitiously conceived serene, silver-white winter landscapes. His marine and winter landscape drawings are extremely rare, although his estate inventory refers to eight hundred drawings by him.

Van de Cappelle was probably productive for only a short time. He rarely dated his work, but the paintings he did date were all done between 1649 and 1663. He holds a unique position within marine painting at that time: his best work demonstrates the monumentality and tranquility characteristic of the so-called "classical" phase of Dutch landscape art, when Jacob van Ruisdael and Philips Koninck aspired to the same goal. In marine painting, Van de Cappelle occupies a place between Simon de Vlieger – his great example – and Willem van de Velde the Younger, the preeminent painter in this genre in the last decades of the century.

Literature: Hofstede de Groot 1907–28, vol. 7, pp. 159–209; Russell 1975.

CATALOGUE 15

A KAAG AND A SMAK IN A CALM

NO DUTCH PAINTER could depict the hazy atmosphere on the water as convincingly as Jan van de Cappelle. Here, as in many of his paintings, an almost unruffled water surface unfolds beneath an imposing, cloudy sky. In the left foreground, two fishermen in a rowboat are bringing in their nets. In the middle ground are two small sailboats; there is almost no wind, the sails hang limply. The boats can be identified as a *kaag*, a kind of barge or river vessel, and a *smak*, a sailing ship with lee boards used in fishing and sailing along the coast. The boats are reflected in the smooth, brightly lit water. The almost tangibly damp atmosphere above the water is the connecting link in the scene. Van de Cappelle used a subdued palette consisting mainly of cool, silver-gray tints for the sea and the sky and brown for the boats. By having the surface of the water catch the light toward the horizon, he subtly indicated the division between water and sky. Principally through the impressive cloudy sky against which the dark ships and their sails stand out, he created a monumental scene that seems larger than it really is.

Dated paintings by Van de Cappelle are relatively scarce. The date on this work has been read as 1651, 1653, and 1654, but recent restoration has established it as 1651. The form of the signature adds confirmation: up to 1650 the painter signed "I V Capel;" in 1650 and 1651 "I V Capelle;" and later "I V Cappelle." Only three other marines by Van de Cappelle dated 1651 are known: in the Mauritshuis, The Hague; in The Art Institute of Chicago; and one in the Kunsthaus Zürich (figures 1–3). The present painting closely resembles the paintings in Chicago and The Hague, particularly because of the presence of genre-type figures in the foreground.

The porpoises or dolphins in the left foreground persuaded Margarita Russell in her monograph on the painter to identify the location depicted as near Vlissingen in Zeeland, where these creatures are found in the shallow water.[2] It must be assumed, however, that Van de Cappelle

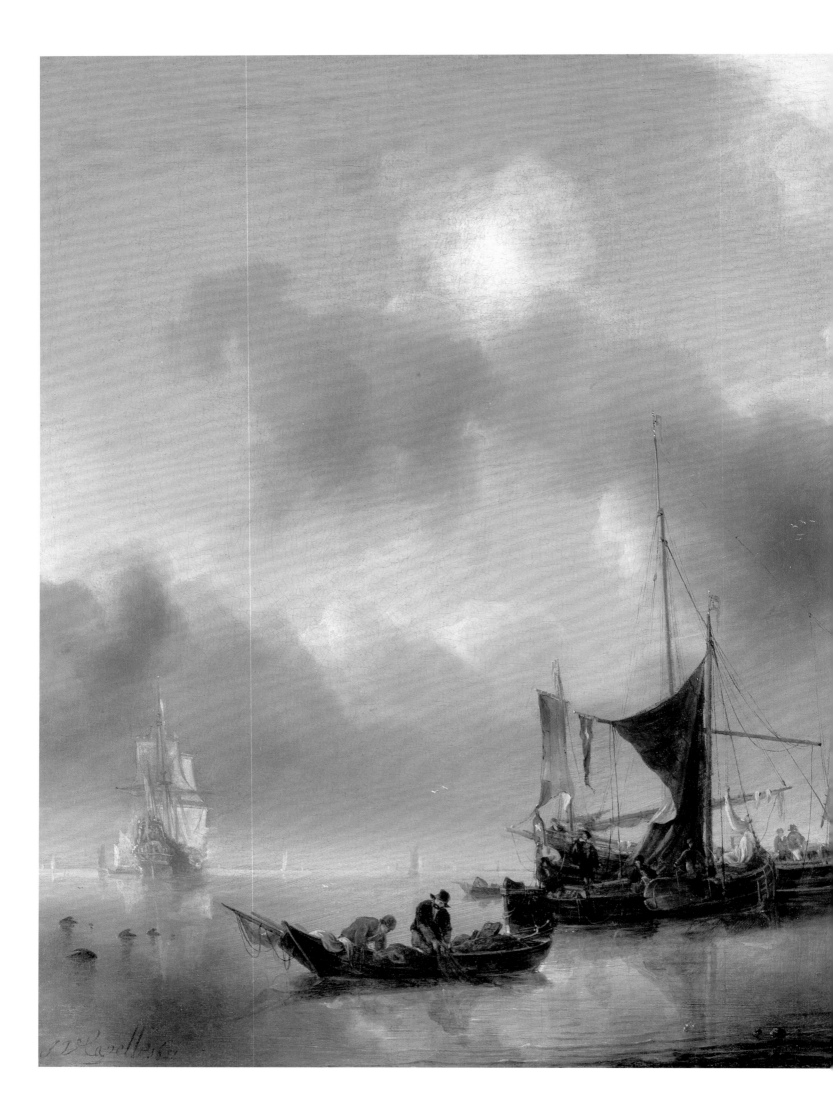

CATALOGUE 15. *A* Kaag *and a* Smak *in a Calm*, 1651. Oil on canvas, 18 3/4 × 20 7/8 inches (47.6 × 53 cm). Signed and dated lower left: *IV Capelle 1651 (VC in ligature)*

Figure 1. Jan van de Cappelle,
Ships Off the Coast, 1651. Oil on
canvas, 28 1/2 × 34 1/4 inches
(72.5 cm × 87 cm). Royal Picture
Gallery Mauritshuis, The Hague.

Figure 2. Jan van de Cappelle,
Fishing Boats in a Calm, 1651. Oil on
canvas, 22 11/16 × 28 inches
(57.6 × 71.2 cm). The Art Institute
of Chicago, Mr. and Mrs. Martin
A. Ryerson Collection, 1933.1068.

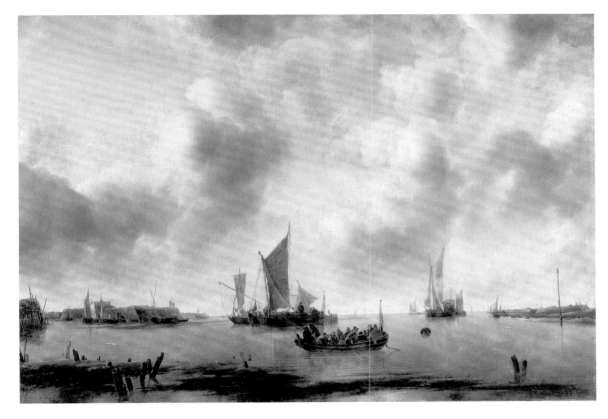

Figure 3. Jan van de Cappelle, *Boats on the Mouth of the Scheidt*, 1651. Oil on canvas, 26 × 38 1/4 inches (66 × 97 cm). Kunsthaus Zürich, Ruzicka-Foundation.

did not intend to portray an existing spot and that, as with his other marines and winter landscapes, this is an admittedly highly realistic but nonetheless imaginary scene.

Provenance: Richard Clemson Barnett, Chester Terrace, Regent's Park, London, his sale, London (Christie's), June 18, 1881, no. 125 (as "J. van de Capella – A Calm with a Man of War and fishing boats at anchor, two men in a boat drawing in a net in front," dated 1653) (530 gns. to Colnaghi); with Colnaghi's (?), London, 1881, whence acquired for 609 gns. by Lieutenant Colonel Arthur Pemberton Heywood-Lonsdale (d. 1897), Shavington, Shropshire, and thence by descent, London (Christie's), July 8, 2005, no. 33; acquired 2005.

Exhibitions: Royal Academy, London, *Exhibition of Works by the Old Masters and by Deceased Masters of the British School. Winter Exhibition*, 1885; Royal Academy, London, *Exhibition of 17th Century Art in Europe*, 1938; City of Manchester Art Galleries, Manchester, *Art Treasures Centenary Exhibition: European Old Masters*, 1957; Peabody Essex Museum, Salem, Massachusetts, *The Golden Age of Dutch Seascapes*, 2009 [Exhibition originally *Turmoil and Tranquility: The Sea Through the Eyes of Dutch and Flemish Masters, 1550–1700*. Organized by National Maritime Museum, Greenwich, England; this painting was only at the PEM venue].

Literature: *Exhibition of Works by the Old Masters and Deceased Masters of the British School* 1885, p. 26, no. 117 (as dated 1651); Graves 1921A, p. 290; Hofstede de Groot 1907–28, vol. 7, p. 175, no. 69 (as signed and dated 1654); and p. 187, no. 111 (as signed and dated 1653), pp. 21–22, 70, no. 69; *Exhibition of 17th Century Art in Europe* 1938, p. 85, no. 193, ill.; *Illustrated Souvenir of the Exhibition of 17th Century Art in Europe* 1938, ill.; *Art Treasures Centenary Exhibition: European Old Masters* 1957, p. 31, no. 112; Russell 1975, p. 70, cat. no. 69, p. 77, cat. no. 111; *Hollandse Schilderkunst; Landschappen 17de eeuw* 1980, p. 19.

Notes:
1. *Album Amicorum Jacob Heyblocq 1645–78* 1998, p. 282.
2. Russell 1975, p. 26.

PIETER CLAESZ.

BERCHEM 1596/97–1660 HAARLEM

Relatively little is known about the life of Pieter Claesz. He was probably born around 1596/97
in Berchem, Flanders, since two documents of 1640 record him as approximately forty-three years
old. In 1619/20, a painter named Pieter Clasen(s) joined the Antwerp guild, but it is not certain
that this was the same painter.[1] As can be deduced from similarities in their work, Claesz. likely saw in
Antwerp the work of the still-life painters Clara Peeters (active 1607–d. 1621 or later) and Osias Beert.
In about 1620/21, Claesz. settled in Haarlem, where he probably remained for the rest of his life.
Neither the date of his first marriage nor the name of his first wife is known. In 1622, his son,
the landscape painter Nicolaes Berchem, was born in Haarlem. On August 8, 1635, Claesz. married
his second wife, Trijntien Lourensdr., a native of Flanders. When he became a member of the
Haarlem Guild of St. Luke is not known; his name occurs in a 1634 list of members, but he must have
joined long before that, given the guild's strict regulations. When his son, Nicolaes Berchem,
joined the guild in 1642, Pieter Claesz. was referred to as a "painter of banquets." His name appears
in a list drawn up in 1647 by Constantijn Huygens, secretary to *Stadholder* Frederik Hendrik,
of painters qualified to decorate the Oranjezaal (Orange Hall) in the palace Huis ten Bosch.
Claesz. did not take part in this prestigious project, however. As early as 1628, Samuel Ampzing's
Beschrijvinge ende lof der stad Haerlem[2] had already drawn attention to the still relatively young
Claesz., but several documents indicate that his career did not flourish; for example, he could never

afford to buy a house of his own. Pieter Claesz. died at the end of December 1660 and was buried on January 1, 1661, in the Nieuwe Kerk in Haarlem.

Claesz.'s oeuvre consists entirely of still lifes, including several *vanitas* still lifes. His earliest work – representations of linen-covered tables with a profusion of objects, seen slightly from above – was entirely in the tradition of Floris van Dyck (ca. 1575–before 1651), Floris van Schooten (active 1605–d. 1656), and other early Haarlem masters of the still life. Toward the end of the 1620s, Claesz. and Willem Claesz. Heda introduced a new kind of painting, the so-called *monochrome banketje*, or monochrome banquet piece, in which the objects were drastically reduced in number and the palette limited to only a few colors. After 1640, Claesz.'s compositions regained some of their former colorfulness, but his technique became less refined.

With the exception of one early work, signed *pieter claessen*, he signed all his paintings with the monogram *PC*, to which he sometimes added *H*(arlemensis). Dated paintings exist from almost every year from 1621 to 1660, but the technical and artistic qualities of his earliest known work suggest that he began painting before the 1620s.

Literature: Vroom 1945; Vroom 1980; Brunner-Bulst 2004; *Pieter Claesz.; Meester van het stilleven in de Gouden Eeuw* 2004–2005.

CATALOGUE 16

BREAKFAST STILL LIFE WITH A HAM AND A BASKET OF CHEESE

A HAM ON A PEWTER PLATTER takes pride of place on a white linen tablecloth. Ranged around it are various foods. The composition is closed off on the left by a remarkably large rummer of white wine, which partly obscures a loaf of bread also on a pewter plate. In front of the rummer is a plate of sausages. The foreground features a knife with a beautiful inlaid handle, a pewter plate with sausages and an open oyster, a small loaf of bread with two pieces sliced off (lying on a large napkin that seems to have been nonchalantly laid aside) and, at the far right, a pewter mustard pot. The composition is framed at the upper right by a basket containing two cheeses, and a china butter plate balanced on its edge. Similar baskets of cheese occur – with or without a plate – several times in Claesz.'s work from the mid-1620s.[3]

At first glance, the objects in this painting seem to have been placed on the table in an arbitrary manner, but in fact Claesz. carefully constructed the composition along two diagonals: the first runs from the corner of the table at the lower left, past the knife and a bone on the pewter plate and along the edge of one of the cheeses to the upper right-hand corner; the other runs from the lower right-hand corner through the crumpled napkin and alongside the bread and the large ham bone to the upper edge of the rummer. Just how painstakingly Claesz. composed his still lifes is revealed by an infrared image that shows the alterations he made to the handle of the mustard pot.

A striking element in this composition is the wall in the background, vaguely rendered by means of two vertical lines. This, combined with the somewhat lighter palette on the right, makes the wall seem to protrude slightly on that side, thus heightening the spatial effect. Such a background is unusual in Claesz.'s work. Most of his still lifes are placed against rather neutral backdrops, with no clear spatial definition. The same kind of protruding wall appears, however, in his *Vanitas Still Life with Spinario* (1628; Rijksmuseum, Amsterdam). In the present still life, the three-dimensionality is enhanced by the reflections of a window on the rummer and mustard pot. Moreover, the light falling from the upper left casts a beautiful, yellow-flecked shadow on the white tablecloth.

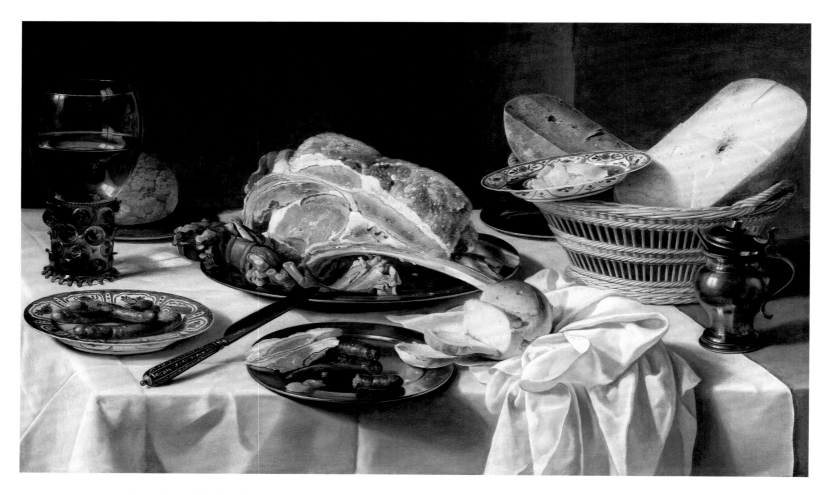

CATALOGUE 16. *Breakfast Still Life with a Ham and a Basket of Cheese*, ca. 1627. Oil on panel, 21 3/4 × 36 1/2 inches (55.2 × 92.7 cm). Monogrammed on the knife blade: *PC*

This impressive panel is one of Claesz.'s most important still lifes from the period before 1630. It is a splendid illustration of the transition from his earliest compositions, which were still clearly influenced by Floris van Dyck and other early Haarlem still-life painters, to his monochrome *banketjes*, which he began to paint toward the end of the 1620s and for which he became widely known. Various elements in this still life – such as the rummer with its reflections, the inlaid knife, the mustard pot, and the loaf of bread – thus anticipate his generally smaller and more intimate still lifes of the following years. The palette, too, is more subdued here than in work dating from the first half of the 1620s.

This panel was previously dated to about 1625, but recent dendrochronological research (using growth rings in trees) has shown that the earliest the painting might have been made is 1626, if not slightly later. Its above-mentioned resemblance to the 1628 *Vanitas Still Life with Spinario*, as well as similarities to other pieces from 1627 and 1628, make a date around 1627 more plausible. The rather elongated format of this painting is typical of Claesz.'s work from these years.

Provenance: With Arthur Tooth and Sons, London, 1931; with J. Schlichter, London, 1933; with John Mitchell, London; with Douwes Fine Art, Amsterdam, 1936; B. Brenninkmeyer, London, 1939; private collection, Hilversum, The Netherlands; acquired in 2009.

Exhibited: Arthur Tooth and Sons, London, *Still Life*, 1931; Douwes Fine Art, Amsterdam, 1938; Douwes Fine Art, Amsterdam, *Jubileum tentoonstelling Douwes 1805–1955*, 1955; Frans Hals Museum, Haarlem, *Pieter Claesz.; Meester van het stilleven in de Gouden Eeuw*, 2004–2005 (traveled to Kunsthaus Zürich as *Pieter Claesz.: der Hauptmeister des Haarlemer Stillebens*, and to the National Gallery of Art, Washington as *Pieter Claesz.: Master of the Haarlem Still-Life*).

Literature: Vroom 1945, pp. 28, 29, fig. 16, p. 98, cat. no. 26; *Jubileum tentoonstelling Douwes 1805–1955* 1955, cat. no. 12; Vroom 1980, vol. 1, p. 34, fig. 36; vol. 2, cat. no. 47; *Pieter Claesz.; Meester van het stilleven in de Gouden Eeuw* 2004–2005, p. 117, cat. no. 10; Brunner-Bulst 2004, pp. 158–60, 166, 215, ill. p. 31.

Notes:
1. Rombouts 1864–75, pp. 560–61.
2. Ampzing 1628, p. 372.
3. Brunner-Bulst 2004, cat. nos. 12–14, 22.

ADRIAEN COORTE

MIDDELBURG? ACTIVE CA. 1683–1707 MIDDELBURG?

Scarcely anything is known about Adriaen Coorte, not even where and when he was born or with whom he studied. There is good reason, however, to assume that he was mainly active in or around Middelburg, in the province of Zeeland, where in 1695 or 1696 he was fined for the illegal sale of paintings. His works are frequently mentioned in inventories and sale catalogues in Middelburg in the eighteenth and nineteenth centuries, but seldom in other cities in that period. His work is limited, both in variety and number. Only about sixty-five still lifes are known today and most of the paintings are small. They usually depict strawberries, grapes, apricots, currants, gooseberries, and asparagus, sometimes shells, invariably arranged on a shelf or bench. Coorte's still lifes are remarkable for their pure, ascetic simplicity.

As an artist, Coorte seems to have taken a rather isolated position. Only in his earliest works, which portray ducks and other birds in a landscape, does he appear to have been influenced by the Amsterdam still-life painter Melchior d'Hondecoeter (1636–1695), his supposed teacher.

After his death, Coorte's still lifes were consigned to oblivion. He was not rediscovered until after World War II. Since then, the popularity of his work has continued to grow.

Literature: Bol 1952, pp. 193–232; Bol 1977; *The Still Lifes of Adrian Coorte* 2008.

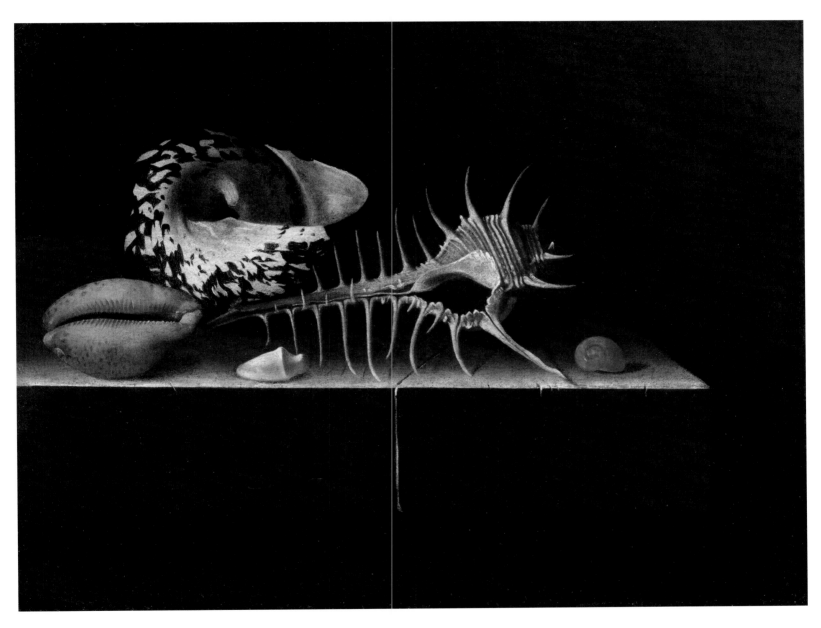

CATALOGUE 17. *Still Life with Seashells,* 1698. Oil on paper on panel, 6 3/4 × 8 3/4 inches (17.2 × 22.2 cm).
Signed and dated lower left on the stone ledge: *A. Coorte. 1698*

EXOTIC SHELLS FROM TROPICAL SEAS were eagerly collected in the sixteenth and seventeenth centuries. Depending on their rarity and the fashion of the day, they often fetched high prices. Several Dutch but also Flemish, German, and French painters of the time incorporated shells in their still lifes or even made them the main theme. In the Northern Netherlands, Balthasar van der Ast and Willem Kalf (1619–1693) were two of the leading painters who occasionally made shell still lifes. Toward the end of the seventeenth century, Adriaen Coorte also tried his hand at this subject. This is one of the finest of the five known remarkably attractive still lifes with shells by him from the years 1696 to 1698. It is worth noting that as far as can be determined, Coorte painted no shell still lifes either before or after these dates, although he chose other subjects such as strawberries and asparagus again and again. In two *vanitas* still lifes of 1686 and 1688, he did depict a single shell among the other objects. Four of the five shell still lifes mentioned stayed together until 1969. Two of them, which quite clearly appear to have been conceived as pendants, are in the Musée du Louvre in Paris.[1] As far as its subject and dimensions are concerned, the present painting could be the pendant of the fourth shell still life in this group, but in contrast to the pendants in the Louvre, both show the same corner of the stone ledge rather than left and right corners.

Here, Coorte has depicted five types of shells with great subtlety. From left to right, they can be identified as *Trona stercoraria, Cittarium pica*, and *Murex tribulus* (the skeletonlike shell also known as *Venus comb*), with *Cyphoma gibbosum* in front and on the right probably *Nerita spec.*[2] The shells catch the light beautifully against the dark background. As usual in Coorte's work, the objects are arranged on a stone ledge, with the front part in particular still catching quite a lot of light. The break in the table, which is accentuated by the fall of light, is also a characteristic element in Coorte's art. It is from small, intimate, tranquil paintings of this kind that he deservedly derives his reputation.

Provenance: Probably Gerardus Beljard, Middelburg, his sale, Middelburg, October 13–18, 1806, no. 23; Colonel T.A. Samuel, London, by whom sold, London (Sotheby's), March 26, 1969, no. 35 (sold with a pendant for £5500 to Speelman: see Buvelot 2008, p. 100, cat. no. 31, ill. p. 101); with Edward Speelman, London; with Silvano Lodi, Campione D'Italia (Switzerland), by 1974; private collection, Germany; with Charles Roelofsz., Amsterdam, by 1993, where acquired in 1995.

Exhibitions: Rijksmuseum, Amsterdam, *Het Nederlandse Stilleven 1550–1720* 1999–2000 (traveled to The Cleveland Museum of Art); Museum of Fine Arts, Boston, *Poetry of Everyday Life: Dutch Painting in Boston* 2002; National Gallery of Art, Washington, *Small Wonders. Dutch Still Lifes by Adriaen Coorte* 2003; Mauritshuis, The Hague, *The Still Lifes of Adriaen Coorte*, 2008.

Literature: Van Braam 1969, p. 110; Foucart 1970, pp. 40–41; *Burlington Magazine* 1971, p. 54; Bol 1977, pp. 11, 21 ns. 56, 57, pp. 42, 51, cat. no. 32, and p. 51, cat. no. 35 (double cataloguing); *Masters of Middelburg* 1984, p. 91; *A Prosperous Past* 1988–89, p. 233; European Fine Art Fair 1995, p. 106, ill.; European Fine Art Fair 1999, p. 121; *Het Nederlandse Stilleven 1550–1720* 1999–2000, pp. 275–76, no. 74, ill.; *The Golden Age of Dutch Painting from the Collection of the Dordrechts Museum* 2002, p. 230, ill.; Sutton 2002, p. 87; *Poetry of Everyday Life* 2002, p. 93, ill.; *Small Wonders* 2003, pp. 7, 11, cat. no. 9, ill.; *Stilleben: Meisterwerke der holländischen Malerei* 2004, pp. 72–73, 139, ill.; *The Still Lifes of Adriaen Coorte* 2008, pp. 50, 102–104, cat. no. 35, ill. p. 52, fig. 42, and p. 103; Buvelot 2008, no. 1, p. 23, fig. 13.

Notes:
1. Buvelot 2008, cat. nos. 21, 22.
2. This identification by R. G. Moolenbeek is slightly different from that in *Het Nederlandse Stilleven 1550–1720* 1999–2000, pp. 275, 276 n. 1; see Buvelot 2008, p. 104.

AELBERT CUYP

DORDRECHT 1620–1691 DORDRECHT

Aelbert Cuyp was born in October 1620. His father was the portraitist Jacob Gerritsz. Cuyp (1594–1651/52); his grandfather Gerrit Gerritsz. (ca. 1565–1644) was a glass painter; and his father's half-brother Benjamin Cuyp (1612–1650) was a genre and history painter. Little is known about Aelbert's life. He studied with his father and at the beginning of his career occasionally collaborated with him. A number of drawings attest to one or perhaps more visits to the provinces of Holland and Utrecht around 1642. During the first years of the 1650s, he traveled along the Rhine to the eastern part of the Netherlands and crossed the border into Germany. He spent his entire life in Dordrecht, which though not an important artistic center was a wealthy city along the Maas River. After his marriage on July 30, 1658, to Cornelia Boschman, the well-to-do widow of an important Dordrecht Regent, Cuyp seems to have gradually lost interest in painting. Initially, they lived in her house on Hofstraat but in 1663 the family moved to a large house on Wijnstraat. Cuyp held several public offices and also served as a deacon of the local Reformed Church. A well-respected and wealthy man, he died in Dordrecht in November 1691 and was buried on November 15 in the Augustinian church.

Cuyp's earliest work shows his father's influence and, from 1639 to around 1645, also that of Jan van Goyen. After 1645, the artist was strongly influenced by the work of Jan Both, who had returned from Italy around 1641. Although Cuyp fully mastered rendering the southern light, there is no documented evidence that he ever visited Italy. In Dordrecht, and especially after his father and uncle died, he became the leading artist, enjoying the patronage of the most prominent families, including Pompe van Meerdervoort and De Rovere.

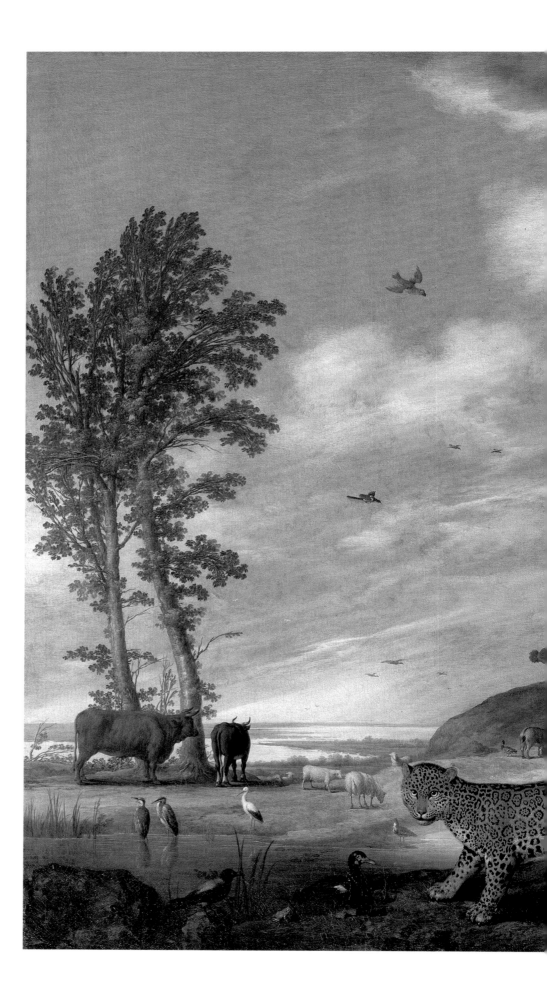

CATALOGUE 18. *Orpheus Charming the Animals*, ca. 1640. Oil on canvas, 44 1/2 × 65 3/4 inches (113 × 167 cm). Signed lower right: *A. cuyp*

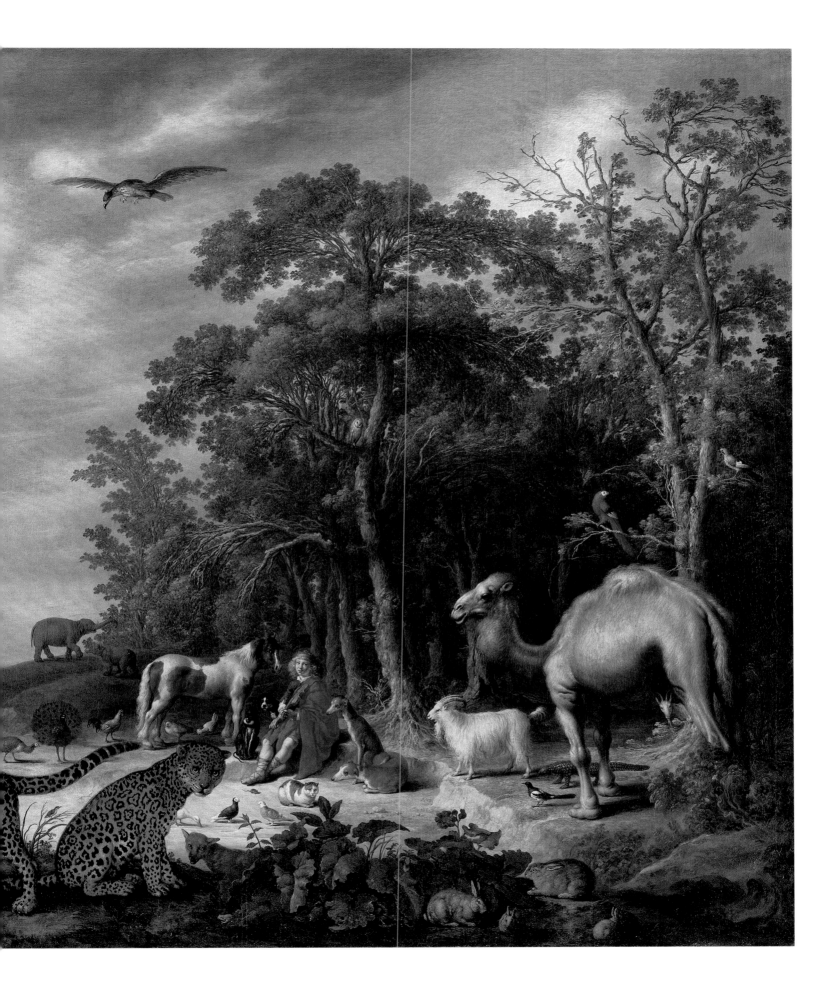

Aelbert Cuyp was one of Holland's greatest and most influential artists. Together with Jacob van Ruisdael, Philips Koninck, and Meindert Hobbema (1638–1709), he is considered the most important representative of the "classical" period of Dutch landscape painting, during the middle of the seventeenth century. He painted primarily idyllic scenes of the Dutch countryside, but also townscapes, cattle scenes, marines, and equestrian portraits. His earliest dated landscape known originated in 1639, but Cuyp rarely dated his pictures. During his lifetime, he was virtually unknown outside his native city, but in the second half of the eighteenth and in the nineteenth century his landscape paintings became immensely popular, especially in England, and he was praised as "the Dutch Claude [Lorrain]." Cuyp also left a considerable oeuvre of striking landscape drawings.

Literature: Hofstede de Groot 1907–28, vol. 2, pp. 1–248; Reiss 1975; *Aelbert Cuyp en zijn familie; schilders te Dordrecht* 1977–78; *Aelbert Cuyp* 2001–2002.

CATALOGUE 18

ORPHEUS CHARMING THE ANIMALS

THANKS CHIEFLY TO THE MANY TRANSLATIONS and illustrated editions that appeared from the middle of the sixteenth century, *Metamorphoses* by the Roman poet Ovid (Ovidius Naso, 43 BC–17 AD) became increasingly well known and popular in the Netherlands. The author and painter Karel van Mander (1548–1606) even added a translation of *Metamorphoses* and a commentary to his *Schilderboeck* of 1604. In the sixteenth and seventeenth centuries, numerous artists drew inspiration from Ovid and made his mythological stories the subject of their paintings. *Orpheus Charming the Animals*, a frequently depicted episode, tells the story of Orpheus, the son of Apollo and the muse Calliope. When he played his music, this Thracian poet and singer was able to entice not only the animals but even trees to draw near and shelter him from the sun. This tale was a favorite subject of artists who specialized in painting animals, such as Roelant Savery (1576–1639) and Paulus Potter; more than twenty paintings of this subject by Savery are known. Evidently, early in his career, Aelbert Cuyp also found the theme of Orpheus attractive. In addition to this work, which can fairly certainly be dated to 1640, at around the same time the barely twenty-year-old artist painted a second, much smaller version (Anhaltische Gemäldegalerie Schloss Georgium, Dessau). He had painted a very closely related scene in 1639: *Adam Naming the Animals* (Private Collection).[1] These paintings offered the young artist, who was to become one of the best Dutch painters of landscapes with cattle, ample opportunities to paint both the setting and the animals.

Various details of the large *Orpheus Charming the Animals*, such as the left-most leopard of the pair in the foreground, also appear in the Dessau painting and in *Adam Naming the Animals*. Cuyp probably based them on a 1639 panel of two leopards made by his father during the period when Aelbert still worked regularly in his father's workshop and assisted him with several large pieces.[2] Other animals, such as the two goats and a bull, are clearly based on drawings by Jacob Gerritsz. Cuyp for the series *Diversa Animalia*, which was published in 1641. In about the middle of the 1640s, Cuyp was to paint another *Orpheus Charming the Animals* in a format still larger than the present painting (Collection of the Marquess of Bute, Isle of Bute, United Kingdom), for which he again made use of several prints from this series.[3] In every case, Orpheus is shown playing a violin, although Ovid spoke of a lyre. Other Dutch painters, such as Savery, also chose to show Orpheus with another instrument on occasion.

Like much of Dutch seventeenth-century art, this painting probably has a deeper symbolic meaning. His combination of musical and poetic talents and his gift for taming animals made Orpheus a symbol of sensible and peace-loving government. Referring to Horace, Van Mander attributed to Orpheus the ability to encourage people to lead better lives, build houses and cities, and obey the lawful authorities.

It is remarkable that for this youthful work, Cuyp dared to choose such a large format. It is almost equally remarkable that from 1768 until 1994 – over two centuries – this large painting was missing until it was rediscovered in a private collection in Madrid, where it was attributed to Roelant Savery. Thanks to this ambitious painting, we have a much better understanding of Cuyp's early work and his father's influence on him. In several aspects, especially in the panorama on the left and the trees, this piece looks forward to Aelbert's work in the first half of the 1640s.

Provenance: Probably Johan van Nispen, a councilman in The Hague, his sale, The Hague (Rietmulder), September 12, 1768, no. 139 ("Orpheus alle de Dieren tot zig strekkende, door het geluit van zyn Lier, zeer fray in alle deelen, en zeer uitvoerig, door A. Cuyp," on canvas, measuring 43 by 64 duim [44 3/16 × 65 3/4 inches (12.2 by 167 cm)] (sold for 171 guilders); probably Hendrik Verschuuring (ca. 1695–1769), commissioner of Finances of Holland, his estate sale, The Hague (Rietmulder), September 17, 1770, no. 38 ("Een kapitaal en fray stuk, verbeeldende Orpheus, welke door zyn aangenaam speelen op deszelfs Lier, al the Gedierte tot zig verzamelt; zynde in allen deelen zeer uitvoerig en natuurlyk geschildert op D" (to Lemmens for 350 guilders); Harper family, London; private collection, Paris, ca. 1930; private collection, Madrid, until 1994, when sold, London (Sotheby's), July 6, 1994, no. 8; acquired from Johnny Van Haeften Ltd., London (together with Konrad Bernheimer, Artemis Ltd., London, and Otto Naumann, New York), in 1997.

Exhibitions: Rijksmuseum, Amsterdam, *The Glory of the Golden Age: Painting, Sculpture and Decorative Art* 2000, no. 88; National Gallery of Art, Washington, The National Gallery, London, and Rijksmuseum, Amsterdam, *Aelbert Cuyp*, 2001–2002.

Literature: Smith 1829–42, vol. 5, p. 340, no. 196; Hofstede de Groot 1907–28, vol. 2, p. 13, no. 19; Reiss 1975, p. 83, under no. 48 ("another Orpheus about half the size which passed through the van Nispen and Verschuuring sales in the mid eighteenth century"); Chong 1994, pp. 30–31, ill.; *The Glory of the Golden Age* 2000, pp. 138–39, no. 88; *Aelbert Cuyp* 2001–2002, pp. 88–91, cat. no. 1, ill.; W. Kloek 2002, pp. 56–57, fig. 61.

Notes:
1. *Aelbert Cuyp* 2001–2002, p. 90, fig. 2.
2. Private Collection; *Jacob Gerritsz. Cuyp* 2002, cat. no. 48.
3. Oil on canvas, 58 5/8 × 105 1/ 8 inches (149 × 267 cm); Hofstede de Groot 1907–28, vol. 2, no. 19.

GERRIT DOU

LEIDEN 1613–1675 LEIDEN

Gerrit Dou was born in Leiden on April 7, 1613, the son of the glass-engraver Douwe Jansz. (dates unknown). According to Leiden historian Jan Orlers, Dou trained initially with his father and subsequently with the engraver Bartholomeus Dolendo (ca. 1571–ca. 1629) and the glass-painter Pieter Couwenhorn (1599/1600–1654) before entering Rembrandt's studio in February 1628.[1] Dou probably stayed with Rembrandt until the latter moved to Amsterdam in 1631 or 1632. Already during his lifetime, Dou's works were highly admired and fetched high prices. Dou charged for his paintings at the rate of one Flemish pound per hour. According to Joachim von Sandrart, his small paintings sold for the then substantial price of 600–1,000 Dutch guilders.[2] Despite the fact that the artist acquired an international reputation and was even invited by King Charles II to come to London, he seems to have remained in Leiden all his life. Visits to Dou's studio by such foreign scholars and aristocrats as the Dane Ole Borch (1662), the Frenchman Balthasar de Monconys (1663), and Cosimo III de' Medici (1669) are further indications of his popularity. He became one of the founding members of the local Guild of St. Luke in 1648. Dou died in 1675, and was buried in the Pieterskerk in Leiden on February 9.

Gerrit Dou is considered the founder and most famous member of the group of artists referred to as the Leiden *fijnschilders* ("fine painters"). He specialized in small-format paintings in which the details and surfaces are carefully observed and meticulously rendered. He was greatly praised as a painter of artificial light by Samuel van Hoogstraeten in 1678,[3] and he was responsible for popularizing both the night scene and the niche format.

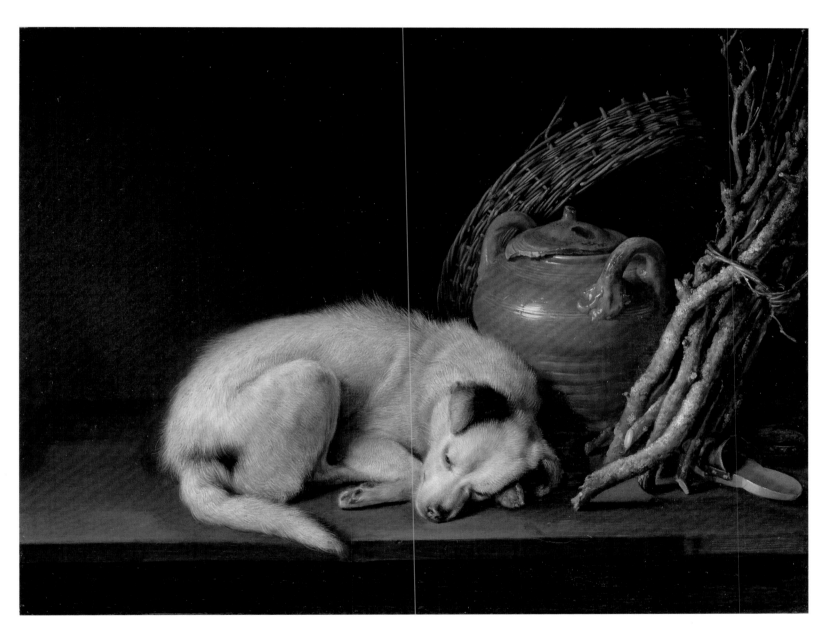

CATALOGUE 19. *Sleeping Dog*, 1650. Oil on panel, 6 1/2 × 8 1/2 inches (16.5 × 21.6 cm).
Signed and dated lower center: *GDov. 1650* (*GD* in ligature)

Dou's oeuvre consists mainly of highly finished genre scenes. In addition, he painted portraits, historical scenes, and a few still lifes in an equally meticulous technique. He was also very successful as a teacher: Frans van Mieris the Elder, Godfried Schalcken, and his nephew Domenicus van Tol (ca. 1635–1676) were among his pupils.

Literature: Hofstede de Groot 1907–28, vol. I, pp. 337–470; Martin 1913; Sumowski 1983, vol. I, pp. 498–607; Baer 1990; *Gerrit Dou 1613–1675* 2000.

CATALOGUE 19

SLEEPING DOG

GERRIT DOU OWES HIS REPUTATION mainly to his intimate genre scenes; still lifes and animal pieces make up only a small part of his oeuvre. But this appealing panel of 1650 shows that he could also excel in these fields. Here, he convincingly depicted a dog asleep beside a still life of several ordinary objects. Dou's talent for careful observation and subtle painting is seen here at its finest. He was an absolute master in rendering various materials and surfaces. The dog's hairy coat, his wet nose, the leathery pads on his paws, and the red in the corners of his eyes are all examples of virtuoso painting. The gaze of the one open eye is also beautifully observed. The glazed earthenware pot that reflects the light, the damaged lid, the bundle of firewood, and the wooden mule are almost tangible. Partly because of the small format, the painting exudes intimacy. A few years earlier, around 1645, Dou painted the same dog at rest next to an earthenware pot with a lid in a genre scene (figure 1).

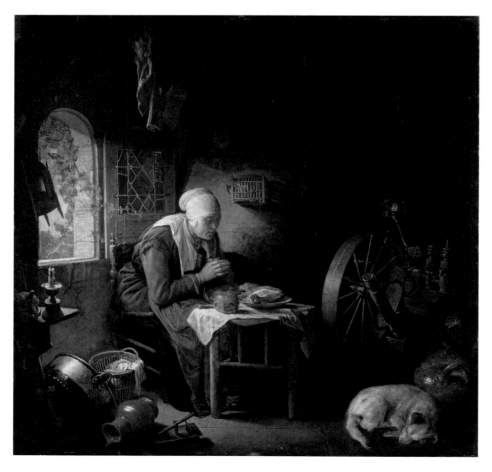

Figure 1. Gerrit Dou, *Prayer of the Spinner*, 1645. Oil on wood, 10 7/8 × 11 1/8 inches (27.7 × 28.3 cm). Alte Pinakothek, Munich.

The exceptional quality of this present panel was wonderfully expressed by the art historian and dealer John Smith in 1834 when he wrote: "It is impossible for painting to be carried to higher perfection than that displayed in this exquisite little picture."[4] Other art historians, including Hofstede de Groot, also praised it. From the time of the auction in 1865, when it was sold for the enormous sum for that time of 22,000 francs, until it resurfaced in 2005, it had not been seen in public. Not only does this perfectly preserved panel represent an important addition to the one or two still lifes by Dou that are known, but it is also one of the highlights of his oeuvre.

Dou was undoubtedly inspired by a drawing by Rembrandt, *Sleeping Guard Dog*, of around 1637–40 (Museum of Fine Arts, Boston), and even more influenced by a Rembrandt etching, *Sleeping Dog*, of around 1639–40.[5] In both the drawing and the etching, the emphasis is on the fall of light on the dog's coat. It almost seems as if Dou saw it as a challenge to match in oils the refined technique of Rembrandt's dry-point etching. In turn, around 1664, Frans van Mieris the Elder drew inspiration from his master Dou when he made a drawing of a sleeping dog.[6] Van Mieris used this drawing as the model for the dog in a painting of 1671 (Collection Dutuit, Musée du Petit Palais, Paris) and for a panel of 1680 (Rijksmuseum, Amsterdam).[7]

Provenance: Johan Pompe Van Meerdervoort, Leiden, his estate sale, Leiden (Delfos), May 19, 1780, no. 2 ("Een verwonderlijk uitvoerig en fraaij Kabinet Stukje; op het zelve vertoond zig een wit Hondje met zwarte vlekken, rustende op een tafel, waar nevens een bos Takken met Mosch begroeit; daar bij staat een stenne Doofpot, waar tegen een Fruitben rust, en ander Bijwerk; alles zoo uitmuntend geschilderd, dat het de Natuur evenaard, op Paneel, hoog 6 1/2, breed 8 1/2 duim") (800 fl. to Cremer); Thomas Theodore Cremer, Rotterdam, his estate sale, Rotterdam (Van Leen/Netscher), April 16, 1816, no. 18 (900 fl. to Josi); M. Jurriaens, Amsterdam, his (anonymous) sale, Amsterdam (Van de Schley), August 28, 1817, no. 11 (1,199 fl. to Cranenburg); William Joseph, Baron van Brienen, lord of Groote Lindt, Dortsmonde, Stad aan het Haringvliet (1760–1839), Amsterdam; his son, Arnold Willem, Baron van Brienen, lord of Groote Lindt (1793–1846); his son, Willem Diederik Arnoud Maria, Baron van Brienen, lord of Groote Lindt (1815–1873), chamberlain to the king of Holland (whose wax collector's seal is on the reverse), The Hague, his sale, Paris (Le Roy), May 8, 1865, no. 6 (22,000 ffr.); Baroness von Rothschild, Frankfurt, before 1908; with J. & S. Goldschmidt, Frankfurt, from whom purchased by Mrs. H. J. Stark on December 7, 1927; The Nelda C. and H. J. Lutcher Stark Foundation; by whom sold, New York (Christie's), May 25, 2005, no. 12, bought by Johnny Van Haeften Ltd., London, where acquired in 2005.

Exhibitions: On loan to the Mauritshuis, The Hague, 2005–2006; Bruce Museum of Arts and Science, Greenwich, Connecticut, and The Museum of Fine Arts, Houston, *Best in Show: The Dog in Art from the Renaissance to Today*, 2006.

Literature: Smith 1829–42, vol. 1, p. 20. no. 59 (as dated 1664); Smith 1842, vol. 1, p. 16, no. 47 (as signed and dated 1650; "The skill of this ingenious painter has given extraordinary interest and value to this humble subject"); Martin 1901, pp. 243–44, no. 361; Hofstede de Groot 1907–28, vol. 1, no. 382 (as signed and dated 1650; "The dog is very delicately and brilliantly painted. . . ."); Sumowski 1983, p. 538, under no. 306; *Best in Show* 2006, pp. 32–33, fig. 28.

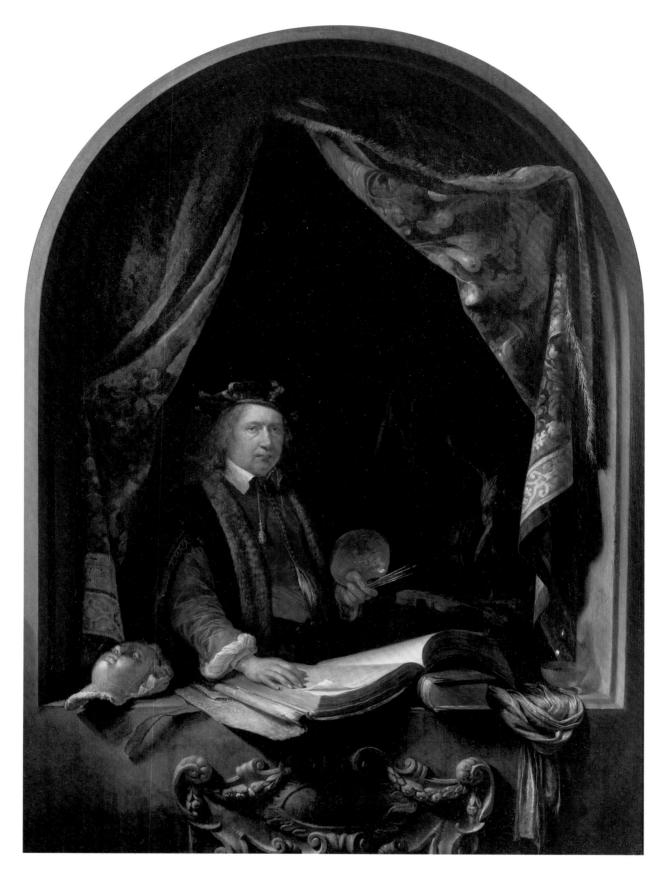

CATALOGUE 20. *Self-Portrait*, ca. 1665. Oil on panel, 22 7/8 × 17 inches (58 × 43 cm).
Signed lower center in the cartouche: *GDov. (GD* in ligature).

GERRIT DOU LEFT TEN SELF-PORTRAITS. In this respect, he trod in the footsteps of
Rembrandt, who painted, drew, and etched his own likeness throughout his life. Dou confined the
subject to paintings and the number is considerably smaller than in the case of his master, but
the series is extraordinarily informative all the same. It enables us to have an idea of the artist's
appearance over the years and of his artistic development, while also giving us insight into
his rising social status and the self-awareness that went with it. In one of his earliest self-portraits,
the panel in the Cheltenham Art Gallery & Museum, painted when he was in his early twenties,
Dou depicted himself much as in this self-portrait: with palette and brushes, wearing the
same bonnet, and with the same plaster head in the foreground; the self-aware pose is not there
yet.[8] In the present panel, which dates from around 1665, Dou depicted himself not just as an
artist but as a successful and learned person, too. The palette and the brushes he holds, the easel
in the background, the écorché (muscle study) figure on the table, and the plaster head on the
window sill all refer to the profession of painter. But, his hands show no spots or smears of paint
and he is not wearing a painter's smock. Instead, he is dressed in an expensive, fur-trimmed
gown of the kind worn by scholars. Together with the impressive books, the globe, and the violin,
they indicate the sitter's erudition. At the same time, these objects symbolize the transience
of life. As a man of the world who had passed fifty, he was no doubt aware of his mortality.

In this self-portrait, Dou presented not only himself, but also samples of his abilities as an
artist. His subtle painting technique is given full expression here and several of his trademarks are
highlighted. One of the most characteristic is the stone window sill, a motif that he introduced
in the second half of the 1640s. Along with this, he showed what he was capable of in the field of
trompe l'oeil and illusion, and how he excelled at rendering different materials, from the hard
stone, in which his name is enduringly recorded, the almost tangibly heavy tapestry, the fragile
paper, and the crumbling leather of the book bindings, to the velvet and fur of his gown.

Provenance: Baroness Wilhelm von Rothschild, Frankfurt, before 1906; with Jacques Goudstikker, Amsterdam,
by 1932; Ernest Masurel, Roubaix, by the end of 1932; private collection, France, until 1997; acquired from Johnny
Van Haeften Ltd., London, in 1997.

Exhibitions: National Gallery of Art, Washington, Dulwich Picture Gallery and Mauritshuis, The Hague,
Gerrit Dou 1613–1675: Master Painter in the Age of Rembrandt, 2000; Museum of Fine Arts, Boston, *Poetry of Everyday
Life: Dutch Painting in Boston*, 2002

Literature: Hofstede de Groot 1907–28, vol. 1, p. 368, no. 75 and p. 435, no. 271; Martin 1911, p. 171, no. 52;
Martin 1913, ill. p. 19; *Gerrit Dou 1613–1675* 2000, pp. 122–23, cat. no. 29, ill.; *Poetry of Everyday Life* 2002, p. 76;
De Jongh 2006, p. 168, ill. p. 169; Liedtke 2008, p. 144, ill. 26a.

Notes:
1. Orlers 1641, p. 377.
2. Von Sandrart 1925, p. 196.
3. Van Hoogstraeten 1678, p. 262.
4. Smith 1829–42, vol. 1, p. 20. no. 59.
5. John H. and Ernestine A. Payne Fund, pen and brown ink and brown wash; Benesch 1973, vol. 2, p. 109, fig. 541,
 cat. no. 455, 5 5/8 x 6 5/8 inches (14.3 × 16.8 cm); and Bartsch 1797, no. 158, 1 1/2 × 3 3/16 inches (3.8 x 8.1 cm),
 respectively.
6. Private collection; *Frans van Mieris 1635–1681* 2005–2006, p. 142, ill. 24a.
7. Hofstede de Groot 1907–28, vol. 10, no. 180 and Naumann 1981, cat. no. 88; and Hofstede de Groot 1907–28,
 vol. 10, no. 157 and Naumann 1981, cat. no. 118, respectively.
8. Hofstede de Groot 1907–28, vol. 1, no. 282.

KAREL DU JARDIN

AMSTERDAM 1626–1678 VENICE

Karel du Jardin was baptized in the Lutherse Kerk in Amsterdam on September 27, 1626. According to Houbraken, he was a pupil of Nicolaes Berchem, but there is no evidence for an apprenticeship with him except a similarity in the subject matter of their paintings.[1] It has been suggested that he traveled to Italy in the latter part of the 1640s, but again, there is no documentary evidence for this. In 1650, someone of his name described as a merchant (*coopman*) was preparing to travel from Amsterdam to France where, according to Houbraken, he married Susanna van Royen in Lyon.[2] In 1652, he was recorded in Amsterdam, when he made his will. In 1656, however, he had moved to The Hague where he became one of the members of the newly founded Confrérie Pictura, which had broken off from the artists' Guild of St. Luke. In 1659, he moved back to Amsterdam, where his portrait was painted by Ferdinand Bol (1616–1680) and by Bartholomeus van der Helst (1613–1670). In 1661, he was lauded extensively in Cornelis de Bie's biography of celebrated artists.[3] He sailed to Italy in 1675 in the company of Joan Reynst, whose father had assembled an important collection of Venetian paintings. On the way, they probably visited Tangiers in North Africa. In Rome, Du Jardin probably joined the *Bentvueghels* – the local fraternity of northern painters – and was given the nickname *Bokkebaard* (goat's beard). In 1678, he moved to Venice, where he died on November 20 of that year.

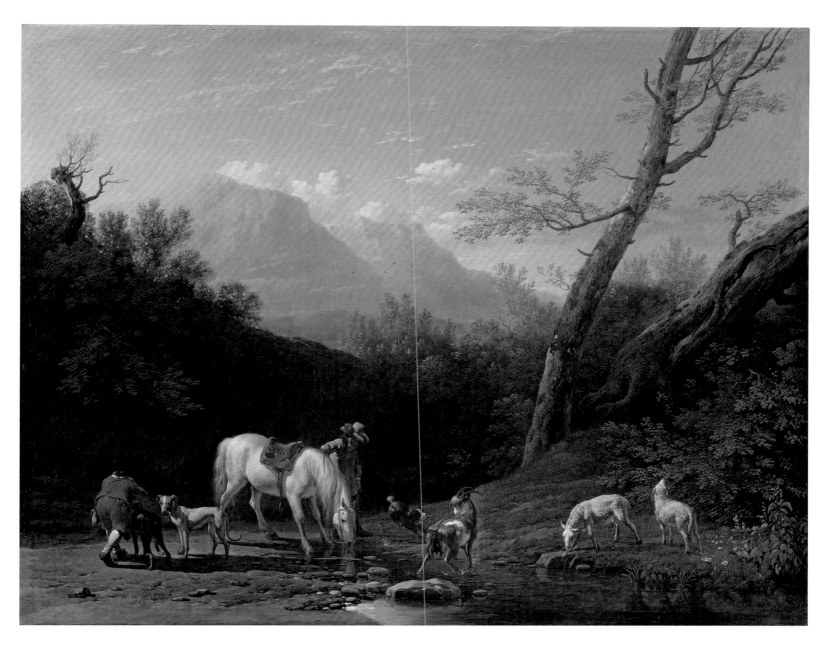

CATALOGUE 21. *Horseman and His Horse at a River*, 1660. Oil on canvas, 14 × 18 inches (35.6 × 45.7 cm). Signed and dated: *K. DV IARDIN | f. 1660*

An exceptionally versatile and gifted artist, Karel du Jardin belonged to the second generation of Dutch Italianate painters. Although primarily a painter of Italian landscapes with herders and their animals, he also produced portraits and a number of impressive classicizing history paintings, undertaking large commissions. He was influenced by the works of Nicolaes Berchem and Jan Asselijn and by Paulus Potter and Pieter van Laer (1599–after 1642) in his cattle scenes. He also painted Italianate genre scenes that are related to those of the *Bamboccianti*. Du Jardin retained a strong visual memory of the sunny southern atmosphere even years after his return from Italy. The luminosity and subtle rendering of details attest to his remarkable skill as a landscapist. He also produced a substantial body of work in etching.

Literature: Hofstede de Groot 1907–28, vol. 9, pp. 295–417; Brochhagen 1958; *Dutch 17th Century Italianate Landscape Painters* 1978, pp. 195–212; Kilian 2005.

CATALOGUE 21

HORSEMAN AND HIS HORSE AT A RIVER

HORSEMAN AND HIS HORSE AT A RIVER was painted in 1660, when Karel du Jardin was at the height of his powers as a landscapist. In a subtle way characteristic of him at this time, he depicted the peaceful atmosphere of a late afternoon in mountainous country. An elegantly dressed rider lets his white horse drink from a stream while he himself urinates into the water. A servant with a striking red jacket takes care of two dogs. A few sheep on the right and a goat, which walks through the water, appear to be slightly lost in these surroundings. A third dog barks at the goat. Two crooked trees frame the composition on the right-hand side. Hills hide the horizon from view, giving the scene a certain intimacy. Farther away, we see imposing mountains and a blue sky with fleecy clouds, which are reflected in the water in the foreground. These reflections together with the daisies on the right produce light accents in the foreground.

In the same year, Du Jardin painted several more idyllic landscapes with a similar compositional structure, such as the much larger landscape in the Musée Château d'Annecy (figure 1). Such compositions are also found in Du Jardin's graphic work. A drawing of 1658 in the Petit Palais in Paris (figure 2) and a 1660 etching based on it depict a related landscape that includes a crooked tree with damaged bark just as in this painting.[4]

Figure 1. Karel du Jardin, *Cart with a White Horse*, 1660. Oil on canvas, 35 3/4 × 47 5/8 inches (91 × 121 cm). Musée Château d'Annecy, France.

Figure 2. Karel du Jardin, *Landscape with a Walking Shepherd and Donkeys*, 1658. Pen and pencil on paper, 5 3/4 × 7 inches (14.5 × 18 cm). Petit Palais, Musée des Beaux-Arts de la Ville de Paris.

Because it has not been displayed in public for a long time, this painting is currently little known. In the past, however, it was greatly – and rightly – admired. In 1834, the influential London dealer John Smith wrote: "This admirable picture is painted in the artist's sparkling manner, with a full pencil of color, and a brilliant effect." The celebrated German connoisseur Gustav Waagen was also deeply impressed and wrote in 1854: "Represented in a most masterly way."[5] In the eighteenth century, the painting was already part of the renowned Randon de Boisset collection. De Boisset was evidently a great lover of Du Jardin's work, for he owned another four paintings by him including the famous small panel *Le Diamant* (Fitzwilliam Museum, Cambridge).[6] That landscape, which is generally considered to be among the artist's masterpieces, was painted at about the same time as the present work.

Provenance: Pierre-Louis-Paul Randon de Boisset (1708–1776), receveur général des finances, Paris; his sale, Paris (Rémy-Julliot), February 27–March 25, 1777, no. 148 (sold for ffr. 4,402 to Donjeux together with pendant, now in Brussels, Musées Royaux des Beaux-Arts; see Kilian 2005, pp. 137–38, no. 19); Dutartre, his estate sale, Paris (Paillet), March 19, 1804, no. 28 (sold for ffr. 5,001 to Lebrun together with pendant); anonymous sale, London (Christie's), February 7, 1807, no. 50 (sold to Birch); William Wells, Readleaf (London), by 1822, his estate sale, London (Christie's), May 12–13, 1848, no. 114 (sold to Nieuwenhuys); Frederick Heusch, London, by 1854; Anthony de Rothschild, London; with F. Kleinberger, New York, 1950; W. Hugelshofer, Zurich, 1950; Römer Fine Art, Zurich; acquired from Noortman Master Paintings, Maastricht, in 2006.

Exhibitions: British Institution, London, *Exhibition of Pictures of the Italian, Spanish, Flemish, and Dutch Schools*, 1822; British Institution, London, *Exhibition of Pictures by Italian, Spanish, Flemish, Dutch, and French Masters*, 1837

Literature: *Exhibition of Pictures of the Italian, Spanish, Flemish, and Dutch Schools* 1822, p. 17, no. 94; Smith 1829–42, p. 240, no. 25; *Exhibition of Pictures by Italian, Spanish, Flemish, Dutch, and French Masters* 1837, p. 7, no. 4, Waagen 1854, p. 254; Hofstede de Groot 1907–28, vol. 9, p. 356, no. 228; Brochhagen 1958, pp. 38, 140; Kilian 2005, pp. 166–67, no. 61, ill. pl. 50 (as whereabouts unknown).

Notes:
1. Houbraken 1718–21, vol. 3, p. 56.
2. Ibid., p. 60.
3. De Bie 1661, p. 377.
4. *Tekenen van warmte* 2001, p. 157, fig. F.
5. Smith 1829–42, p. 240, no. 25; Waagen 1854, p. 254.
6. Hofstede de Groot 1907–28, vol. 9, p. 329, no. 137 and p. 358, no. 235; Kilian 2005, cat. no. 68.

WILLEM DUYSTER

AMSTERDAM 1599–1635 AMSTERDAM

Willem Cornelisz. Duyster was baptized on August 30, 1599 in the Oude Kerk in Amsterdam. In 1620, he moved with his family to a house on Koningstraat named *De Duystere Werelt* (The Dark World) from which Duyster took his surname. The earliest mention of Duyster as his surname is in a document dated July 1, 1625, concerning a quarrel between Duyster and his colleague Pieter Codde (1599–1678). An inventory of October 16, 1631, taken after the death of his parents, shows that the family was reasonably well off. In September 1631, Duyster married Margrieta Kick; on the same day, his sister Styntge married Margrieta's brother, the Amsterdam genre painter Simon Kick (1603–1652). Both couples lived in *De Duystere Werelt*. Duyster died in 1635, a victim of the plague epidemic then ravaging Holland. He was buried on January 31 in the Zuiderkerk in Amsterdam.

Relatively little is known about Duyster: there are no documents stating to whom he was apprenticed. Partly because of his early death, he left only a small body of work consisting mainly of elegant companies, guardrooms with soldiers, soldiers dividing booty, and a few portraits. Dated pieces are unknown and he often neglected to sign his work. Duyster's gift for rendering various materials was recognized early on. In his *Lof der Schilderconst* of 1642, the painter and writer Philips Angel (1616–after 1683) mentioned him because he was better than anyone else at depicting both rough fabrics and smooth satin.[1]

Literature: Playter 1972.

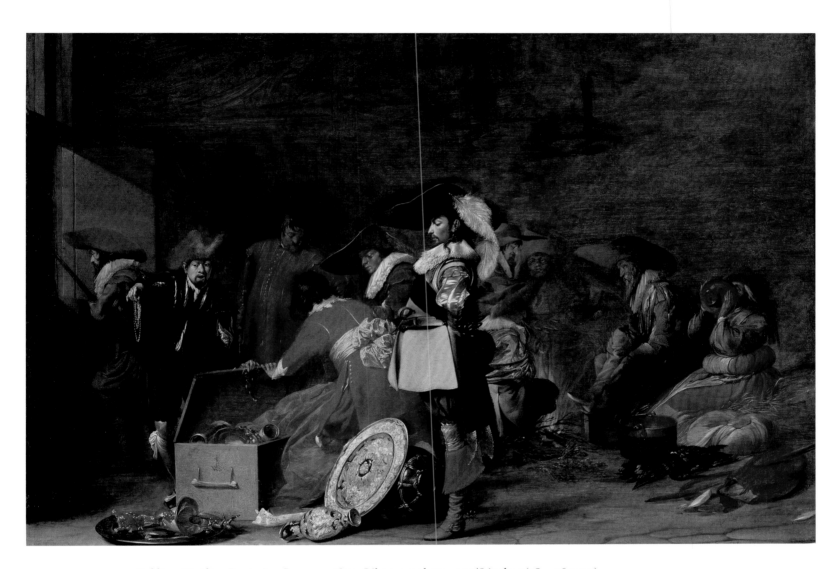

CATALOGUE 22. *Soldiers Dividing Booty in a Barn*, ca. 1630. Oil on panel, 15 × 22 1/8 inches (38 × 56.2 cm).
Signed lower left center on the wrapping paper on the ground: *WC: DUYSER* (WC in ligature)

CATALOGUE 22

SOLDIERS DIVIDING
BOOTY IN A BARN

TOGETHER WITH PIETER CODDE, Willem Duyster was largely responsible for the development and popularization of interiors with soldiers, the so-called *cortegaerdjes* (guardroom scenes). The soldiers are usually portrayed drinking, smoking, playing cards, dancing, or making music, but sometimes they are dividing booty, as in this painting. In a humble barn, the bound woman on the right watches helplessly as a group of soldiers examine and apportion their loot. On the left, a richly dressed soldier with an exotic fur hat holds up a string of pearls, while an elegantly turned-out officer in the foreground watches as two of his companions go through a chest containing all kinds of valuables. On the floor at his feet lie a costly silver ewer and basin and a nautilus cup. This officer type, shown in profile, appears repeatedly in Duyster's oeuvre.[2]

Duyster's ability to depict various fabrics and materials convincingly, which Philips Angel admired so much, is seen here at its best. As usual in his work, the characterization of the various figures, particularly those in the foreground, is excellent: the officer in the center foreground seems lost in thought, while the soldier on the left gazes open-mouthed at the pearls. The figures in the foreground are painted quite thickly and in attractive colors, whereas the other figures and the interior are almost monochrome and executed in highly transparent paint.

Duyster's life took place entirely within the Eighty Years War. Nonetheless, in Amsterdam he would not have seen much of the war, given that in the last decades of the conflict the fighting was mainly in the country, in the east and south of the Dutch Republic, where mercenaries and others regularly plundered and robbed. Duyster may well have drawn his inspiration for scenes of this kind from the stories he heard about such exploits. It is also possible that he was inspired by early seventeenth-century plays about officers and soldiers such as Theodore Rodenburgh's *Jeronimo* and Gerbraud Adriaenszoon Bredero's *Moortje*.

Provenance: Sir Harold Wernher, Luton Hoo, Bedfordshire, England, 1925, by whose estate sold, London (Christie's), July 4, 1997, no. 12; acquired from Johnny Van Haften Ltd., London, in 1997.

Exhibitions: Royal Academy of Arts, London, *Dutch Pictures 1450–1750*, 1952–53; Graves Art Gallery, Sheffield, *Dutch Masterpieces: An Exhibition of Paintings*, 1956.

Literature: *Dutch Pictures 1450–1750* 1952–53, p. 47, no. 217; *Dutch Masterpieces* 1956, p. 6, cat. no. 12; Sutton 1984, p. xxxvii; Borger 1996, p. 57, under cat. no. 4, ill. fig. 4.1; Kunzle 2002, pp. 379–80, fig. 12–20.

Notes:
1. Angel 1642, p. 55.
2. For example, *Prisoners before an Officer* (Kunsthalle, Hamburg); *The Plunderers* (Musée du Louvre, Paris); and *Study for an Officer* (Sør Rusche-sammlung), Raupp 1996, pp. 102–105, no. 23.

HENDRIK DE FROMANTIOU

MAASTRICHT 1633/34 – IN OR AFTER 1694 BERLIN

Hendrik de Fromantiou was born in Maastricht in 1633 or 1634 but probably did not live there for long. In 1658, he is mentioned as living in The Hague. In 1672, De Fromantiou was invited by Friedrich Wilhelm, elector of Brandenburg, to come to Berlin to be his court painter. Friedrich Wilhelm maintained good relations with the court in The Hague; in 1646, he married the eldest daughter of *Stadholder* Frederik Hendrik of Orange-Nassau. Other Dutch artists also worked for long or short periods at the court in Berlin. In 1672, De Fromantiou was sent to Amsterdam to act on behalf of the elector, who was involved in legal proceedings against the dealer Gerrit Uylenburgh, a great-nephew of Rembrandt's wife Saskia. During his stay in Holland, the painter married Ludovina Wouwerman, a daughter of the painter Philips Wouwerman. In 1674, De Fromantiou acquired a country house in Potsdam and went there to live, but he traveled a great deal as the elector's agent and in pursuit of his own interests. In 1687, he was appointed keeper of the elector's art collections. After the death of Friedrich Wilhelm in 1668, his successor, Friedrich III, also appointed De Fromantiou the court painter. The artist died in Berlin in 1694 or shortly thereafter.

Little is known about De Fromantiou as a painter. His oeuvre is remarkably small. Apart from a few fruit and floral still lifes, his work consists of a small number of game pieces with dead birds and attributes of the hunt.

Literature: Sullivan 1984; Duparc 1985, no. 1, pp. 4–5.

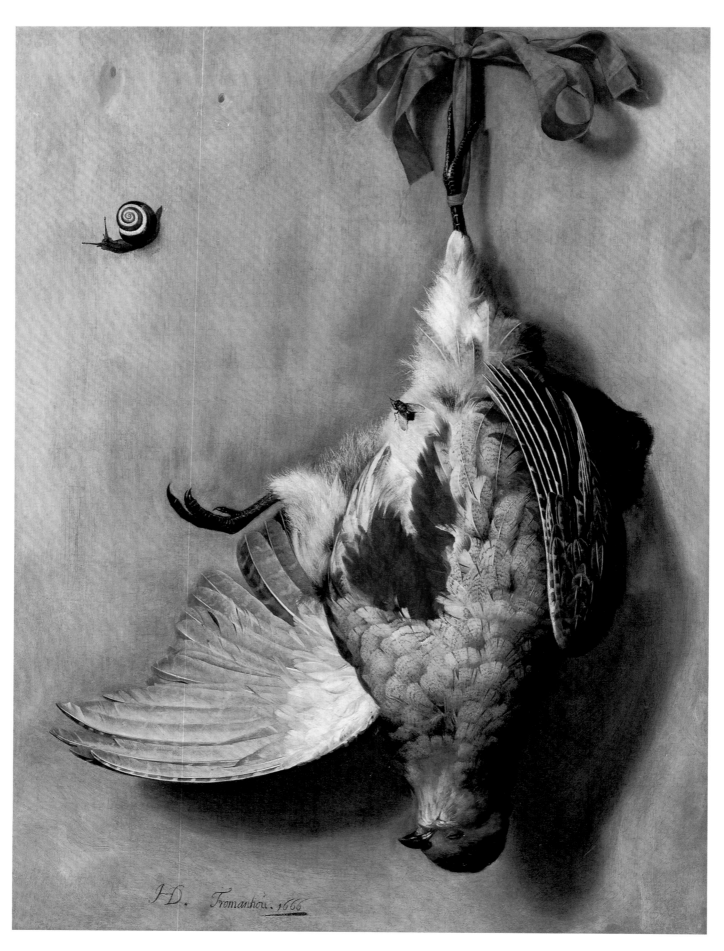

CATALOGUE 23. *Trompe l'Oeil with a Dead Partridge*, 1666. Oil on canvas, 19 1/4 × 14 3/4 inches (48.9 × 37.5 cm). Signed and dated lower left center: *HD. Fromantiou. 1666* (HD in ligature)

CATALOGUE 23

TROMPE L'OEIL WITH A DEAD PARTRIDGE

THIS IS ONE OF THE RARE TROMPE-L'OEIL STILL LIFES by Hendrik de Fromantiou. Like several related pieces by him, it was painted during his stay in The Hague. He probably borrowed the idea for this composition from the work of Jan Baptist Weenix, who is known chiefly for his Italianate landscapes but also painted a number of game pieces. *Trompe l'Oeil with a Dead Partridge* closely resembles two still lifes by Weenix from around 1650, each with a dead partridge hanging from a nail against a light, plastered wall.[1] Just as with Weenix, the rich range of gray, brown, and white hues is beautifully set off by the light background. On the other hand, the vivid red of the ribbon holding up the bird is entirely different. The trompe-l'oeil effect is heightened by the depiction of a snail at the top left and a fly on the partridge's belly. De Fromantiou appears to have been influenced not only by Weenix but also by Willem van Aelst, who made game pieces one of his specialties. Apart from the subject, it is above all the refined painting manner and the eye for detail that recall the work of Van Aelst.

In the same year, De Fromantiou painted a second, slightly larger game still life (Jagdschloss Grunewald, Berlin) that depicts a dead partridge but is otherwise very different. Instead of a light wall, the background consists of a shallow niche in which hang the partridge, another dead bird, and some hunt attributes.

Provenance: Anonymous sale, London (Sotheby's), November 19, 1958, no. 95; with Matthiesen, London, 1958; private collection, Vancouver, 1959–2006, by whom sold, New York (Christie's), April 6, 2006, no. 51; with Johnny Van Haeften Ltd., London, 2006, where acquired in 2007.

Literature: Sullivan 1984, p. 143; G. J. M. Weber 2003, p. 137 under n. 4; Van der Willigen and Meijer 2003, p. 86.

Notes:
1. *Dead Partridge Hanging from a Nail* (ca. 1650–52; Mauritshuis, The Hague) and private collection, Rotterdam (sale Noortman, Amsterdam [Sotheby's], December 17, 2007, no. 167, ill).

JAN VAN GOYEN

LEIDEN 1596–1656 THE HAGUE

The son of a cobbler, Jan Josephsz. van Goyen was born in Leiden on January 13, 1596. His father was an art lover and apprenticed him at the age of ten to various Leiden painters, among them the landscapist Coenraet van Schilperoort (ca. 1577–1635/36) and Isaack Swanenburgh (ca. 1538–1614). Around 1615/16, Jan traveled to France and in 1618 he completed his apprenticeship with the Haarlem painter Esaias van de Velde, one of the pioneers of Dutch landscape art. His influence was very strong, especially in Van Goyen's early work.

On August 5, 1618, Van Goyen married Anna Willemsdr. van Raelst in Leiden. In 1625, he bought the house *De Vergulde Troffel* (The Gilded Trowel) on Pieterskerkstraat in the center of Leiden; he resold it to the marine painter Jan Porcellis in 1629. In 1627, he bought a house on Nieuwsteeg which he sold in 1633. In 1632, Van Goyen moved from Leiden to The Hague, where he acquired civil rights on March 13, 1634. The following year, he bought a house on Veerkade in The Hague and in 1636 he moved to Dunne Bierkade. In 1638 and 1640, he held the post of dean of the local guild. In October 1649, his eldest daughter, Margriet, married the painter Jan Steen. Beween 1649 and 1652, he rented the building next to his own house on Dunne Bierkade to the animal painter Paulus Potter. Van Goyen moved one more time: he bought a house on Wagenstraat and sold his previous home. As a few sketchbooks reveal, he made various trips from The Hague that took him as far as Brussels and Cleves, just over the border with Germany. Apart from a short stay in Haarlem in 1634, he continued to live in The Hague until his death on April 27, 1656.

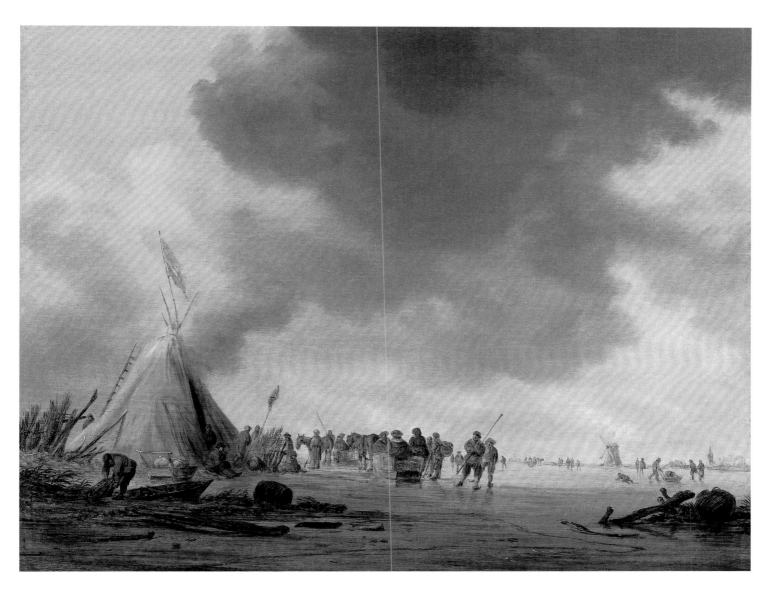

CATALOGUE 24. *Frozen River with Skaters*, 1637. Oil on panel, 12 1/4 × 16 1/4 inches (31 by 41.3 cm).
Signed and dated lower left center: *VG 1637* (*VG* in ligature)

Despite his productivity, Van Goyen had financial worries throughout his life. In addition to painting, he was also active as an art dealer, broker, and appraiser, but evidently without great success. He tried his luck in the highly speculative tulip trade, but that did not improve his financial position either. Thus, in 1647 and again in 1652, he was obliged to sell part of his art collection. After his death, it was found that his debts amounted to eighteen thousand guilders, a formidable sum for that time. His widow was accordingly forced to sell the rest of the collection and the household effects.

Jan van Goyen was one of the most influential Dutch landscapists of the seventeenth century, as well as one of the most productive. More than a thousand drawings, often rapid sketches made during his many journeys through the Netherlands, and over twelve hundred, often small, paintings are credited to him. Van Goyen often dated his paintings: dated pieces from all the years from 1621 to 1655 make it possible to follow his artistic development closely. He was one of the teachers of Nicolaes Berchem, whose work nonetheless shows little of his influence.

Literature: Hofstede de Groot 1907–28, vol. 8, pp. 1–323; Dobrzycka 1966; Beck 1972–91; *Jan van Goyen* 1996–97.

CATALOGUE 24

FROZEN RIVER WITH SKATERS

AT THE BEGINNING OF HIS CAREER, between 1621 and 1628, Jan van Goyen painted more than thirty-five winter landscapes filled with numerous small, brightly colored figures. These landscapes were strongly influenced by his teacher Esaias van de Velde and often formed pendants to summer landscapes. Under the influence of the Haarlem landscapists and the marine painter Jan Porcellis, in the subsequent years Van Goyen moved away from these colorful landscapes and concentrated on more monochrome, naturalistic scenes. He also abandoned the traditional season iconography: winter landscapes were no longer the pendants of summer landscapes. The emphasis now lay on the general atmosphere, and the horizon is much lower than it had been before. Consequently, a large part of the composition is taken up by often impressive, cloudy skies. Van Goyen thus became one of the leading representatives of this so-called "tonal phase" in Dutch landscape painting. At the same time, he developed a new, fast, and highly efficient painting technique that enabled him to be extremely productive. At first, he confined himself to simple dune and river landscapes. It was not until the late 1630s that he again took up the theme of the winter landscape with any regularity.

Frozen River with Skaters is one of the finest examples of this period. Van Goyen has presented a view of a wintry day on a large sheet of ice seen from a low angle; the sensation of cold is convincingly conveyed. This is a typically Dutch winter scene whose atmosphere and activities can still be found almost unchanged in today's rare cold winters. People are enjoying themselves on skates or in horse-drawn sleighs; in the left foreground a fisherman lifts a basket next to a small boat frozen in the ice. Smoke rises from the tent with the flag on the left; it is probably a spot where tired skaters can buy hot drinks and soup. In front of the tent sits a man smoking a pipe. The viewer's gaze is led from the somewhat shaded foreground, via the tent, two sleighs, and a host of figures, to the horizon. On the horizon, beneath the heavily clouded sky, from right to left a church tower, a windmill, and a church can be discerned. Unlike in Van Goyen's early ice scenes, the staffage is entirely in tone with the rest of the landscape. Only occasionally has a light color accent been added, such as the red hat of the skater in the center foreground. Van Goyen's fluent painting manner, frequently with transparent paints, is seen here to splendid effect.

Provenance: Possibly Jan Willem Heybroeck, Rotterdam, his estate sale, Rotterdam (Burgvliet/Bothall), June 9, 1788, no. 25 (as dated 1652; "Een Wintergezicht met een meenigte Schaetzen – ryders en Sleden op het ys; by een tent met meerder Volk, een Dorp in 't verschiet, Fiks met het penseel op panel geschilderd, hoog 10 breed 14 duim;" 21 fl. to Van der Laan; according to Hofstede de Groot); Thomas Loridon de Ghellinck, Ghent, 1790 (cat. 1790, no. 449); H. Roxard de la Salle, Nancy, his sale, Paris (Féral/Pillet), March 28, 1881, no. 14 (ffr. 4,100 to Richard; as dated 163?); Laurent Richard, Paris, his estate sale, Paris (Mannheim/Féral), May 28, 1886, no. 19 (ffr. 2,700 to M. Kann; as dated 163?); L. Salavin, Paris, by 1950; with Jacques O. Leegenhoek, Paris, 1951; Robert H. Smith, Washington, 1969; anonymous sale ("The Property of a Gentleman"), London (Christie's), November 30, 1973, no.132 (gn. 35.000 to Katz); acquired at anonymous sale ("Property from a European Collection"), London (Christie's), December 3, 1997, no. 26.

Exhibitions: Musée Carnavalet, Paris, *Chefs-d'oeuvre des Collections Parisiennes*, 1950.

Literature: De Ghellinck 1790, pp. 163–64, no. 449; Eudel 1887, pp. 435–36; Hofstede de Groot 1907–28, vol. 8, p. 298, no. 1179; Beck 1972–91, vol. 2, pp. 48–50, no. 94, ill. p. 49 (as dated 16??), and vol. 3, p. 148, no. 94 (as dated 1637); *Chefs-d'oeuvre des Collections Parisiennes* 1950, p. 19, no. 24.

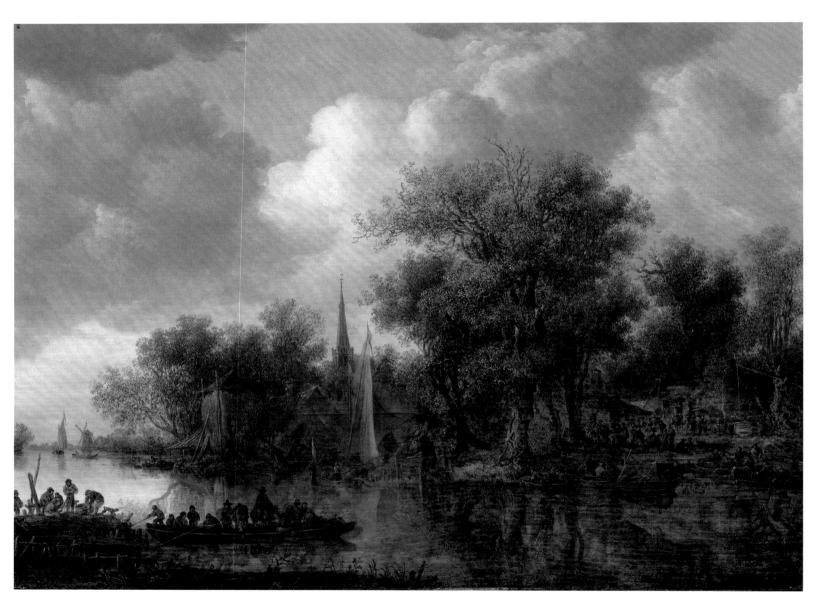

CATALOGUE 25. *River Landscape with Peasants in a Ferryboat*, 1648. Oil on panel, 21 1/4 × 29 inches (54 × 73.7 cm). Signed and dated lower left on the ferry: *VG 1648* (*VG* in ligature)

CATALOGUE 25

*RIVER LANDSCAPE
WITH PEASANTS IN A
FERRYBOAT*

THROUGHOUT ALMOST HIS ENTIRE CAREER, beginning in 1627[1] until his death, Jan van Goyen painted river landscapes with great regularity. Just as in this panel, he usually constructed his compositions along two diagonals that come together on the horizon. As in most of his river landscapes, the water extends over the whole foreground. In this painting, the stretch of water is broken by a ferryboat loaded with passengers and horses, which has just cast off from the bank on the left to cross to the other side, where several boats are moored. Behind them, numerous small figures can be made out near several farmhouses and a well in the shadow of some big trees. Farther to the left, past a second landing stage with a sailboat and a rowboat, there is another farmhouse with a haystack, and behind that the spire of a church tower can be seen between the trees. On the far left on the horizon is another sailboat and a rowboat, while to the right of them is another windmill.

Although the palette is still fairly limited, the painting is clearly less monochrome than most of Van Goyen's compositions from the 1630s and the first half of the 1640s. Besides the many shades of brown and green in the foreground and middle ground, the white and gray clouds in the partly blue sky are striking. This landscape also differs in its technique from those from the preceding decades when Van Goyen used an even more rapid manner of painting. He especially worked more on the trees and foliage than was his general practice in the years prior and the paint is less transparent.

Van Goyen evidently enjoyed success with this composition because in the following years he painted several river landscapes that greatly resemble this panel. There are closely related compositions from 1650, 1651, and probably 1652[2] in which Van Goyen merely gave some elements, such as the church tower, a slightly different location. He doubtless drew upon one or more sketches he had made over the years, although not a single drawing among the hundreds of sheets that survive seems to be the direct basis for this painting.

Provenance: William McKay, Esq., London, by 1900; with P. & D. Colnaghi and Co., London, 1900; Dr. James Simon, Berlin, by 1914; with Karl Haberstock, Berlin; Ch. A. de Burlet, Berlin; Dr. Hans Wetzlar, Amsterdam, by 1959, his sale, Amsterdam (Sotheby's), June 9, 1977, no. 64 (fl. 240,000 to Douwes); with Gebr. Douwes, Amsterdam; private collection, Great Britain; acquired at anonymous sale, New York (Christie's), January 12, 1994, no. 23.

Exhibitions: Burlington Fine Arts Club, London, *Exhibition of Pictures by Dutch Masters of the Seventeenth Century*, 1900; Akademie der Künste, Berlin, *Ausstellung von Werken Alter Kunst aus dem Privatbesitz der Mitglieder des Kaiser Friedrich-Museums-Vereins*, 1914; Singer Museum, Laren, N. H., *Kunstschatten: Twee Nederlandse Collecties Schilderijen uit de Vijftiende tot en met de Zeventiende eeuw en een Collectie oud Aardewerk*, 1959; Dordrechts Museum, Dordrecht, *Nederlandse Landschappen uit de Zeventiende Eeuw*, 1963; Waterman Gallery, Amsterdam, *Jan van Goyen 1596–1656: Conquest of Space*, 1981; Museo Thyssen-Bornemisza, Madrid, *The Golden Age of Dutch Landscape Painting*, 1994.

Literature: *Exhibition of Pictures by Dutch Masters of the Seventeenth Century* 1900, p. 31, no. 39; *Ausstellung von Werken Alter Kunst aus dem Privatbesitz der Mitglieder des Kaiser Friedrich* 1914, p. 18, no. 46; Hofstede de Groot 1907–28, vol. 8, p. 132, no. 514; Friedländer 1952, p. 13, no. 37, ill.; *Nederlandse Landschappen uit de Zeventiende Eeuw* 1963, p. 24, no. 37, ill. pl. 62; Beck 1972–91, vol. 2, pp. 278–79, no. 614, and vol. 3, p. 217, no. 614, ill.; *Jan van Goyen 1596–1656: Conquest of Space* 1981, p. 116, ill. p. 117; *The Golden Age of Dutch Landscape Painting* 1994, no. 27.

Notes:
1. City Art Gallery, York; Beck 1972–91, vol. 2, no. 425 and vol. 3, no. 425.
2. Beck 1972–91, vol. 3, cat. no. 540A, p. 205; cat. no. 551, p. 206; and vol. 2, cat. no. 559, p. 258.

JACOB GRIMMER

ANTWERP CA. 1525–1590 ANTWERP

Jacob Grimmer (also known as Grimer or Grimmaer), was probably born around 1525 in Antwerp. According to Karel van Mander (1548–1606), who was full of praise for him in his *Schilder-Boeck* of 1604, he was apprenticed successively to Matthijs Cock (ca. 1509–before 1548), Gabriel Bouwens (dates unknown), and Christian van den Queborn (ca. 1515–1578).[1] To what extent the last two artists influenced Grimmer is unclear because no work by either of them is known. Grimmer traveled to Italy and is mentioned by the historians Giorgio Vasari (1550), who acclaimed him as one of the best landscape painters of his time, and Francesco Guicciardini (1567).[2] He joined the *De Violieren* (The Stocks) chamber of rhetoric in 1546 and in the next year he became a master of the St. Luke's Guild of Antwerp. In 1548, he married Lucia van de Wouwer, with whom he had four children. Their son Abel (ca. 1570–after 1617) became a painter in the style of his father, but the quality of his work is generally inferior. In 1550, Grimmer bought a small house on Paddengracht in Antwerp, where he seems to have lived for the rest of his life.

Grimmer was highly respected in his time, and his work was still sought after in the seventeenth century. Both Rembrandt and his teacher Pieter Lastman (1583–1633) owned work by him. His oeuvre consists mainly of landscapes in the tradition of Pieter Bruegel the Elder (1525/30–1569). Sometimes he worked with other artists, such as Gillis Mostaert (ca. 1529–1598) and Maarten van Cleve (1527–1581).

Literature: De Bertier de Sauvigny 1991.

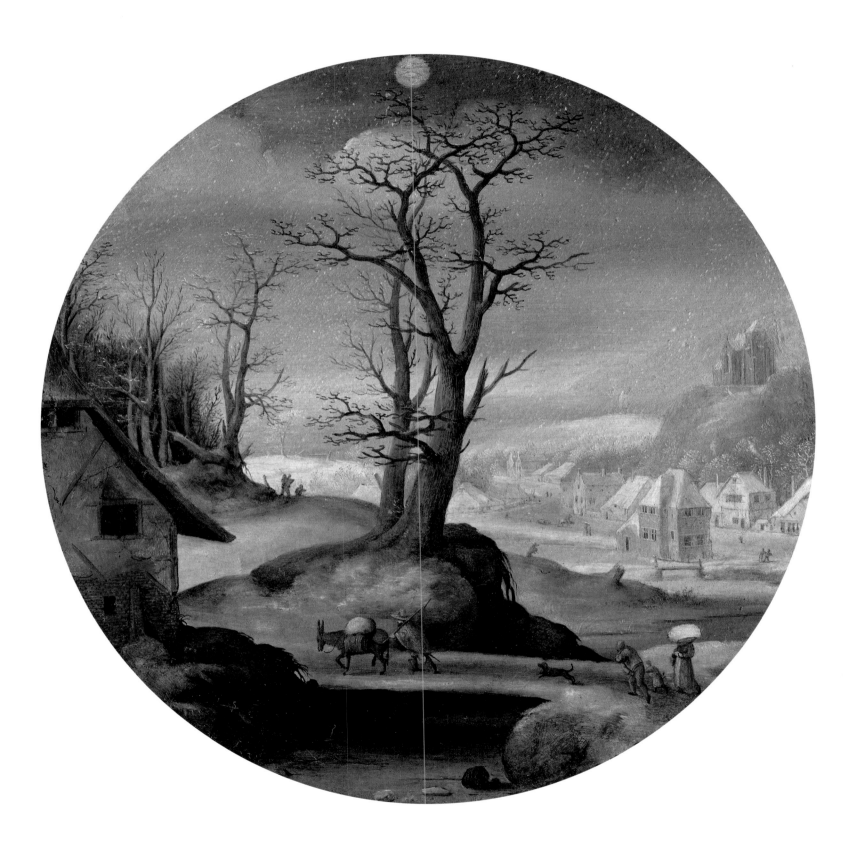

CATALOGUE 26. *February*, 1570–80. Oil on panel, diam. 7 1/8 inches (18.2 cm).
Incised twice on the reverse: Z

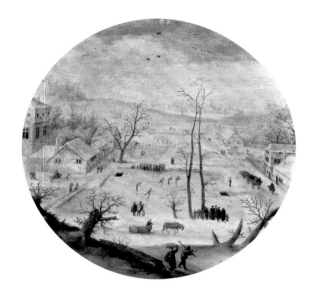

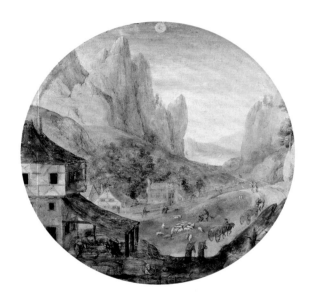

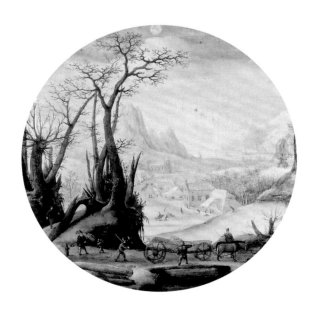

Figure 1. Jacob Grimmer, *January*, date unknown. Oil on panel, diam. 7 1/8 inches (18.1 cm). Private Collection.

Figure 2. Jacob Grimmer, *October*, date unknown. Oil on panel, diam. 7 1/8 inches (18.1 cm). Private Collection.

Figure 3. Jacob Grimmer, *December*, date unknown. Oil on panel, diam. 7 1/8 inches (18.1 cm). Private Collection.

CATALOGUE 26

FEBRUARY

IN THE TRADITION OF PIETER BRUEGEL THE ELDER, who was the first to paint autonomous winter landscapes, here Jacob Grimmer has painted a mountainous winter landscape. As is the case in Bruegel's landscapes, he has chosen a high point of view with plenty of room for depicting the country and village life. But Grimmer's charming landscapes exude a less charged atmosphere than those of Bruegel.

In the center are two trees that divide the composition in two. In front of them, a traveler with a heavily laden mule crosses a bridge. Behind him come a dog, a man, a child, and a woman with a big basket on her head. Farther behind is a village street with houses at the foot of a mountain with a church. On the left, the composition ends with a farmhouse and, higher up, the edge of a wood is marked by a snow-covered road on which two travelers can just be seen.

Grimmer's refined painting technique is well evident, especially in the depiction of the houses on the right, the small figures, and the way in which he has rendered the countless snowflakes in the gray sky. At some points, for example in the mountain on the right with the church, the sketchy underdrawing is visible through the somewhat transparent paint.

Jacob Grimmer owes his reputation chiefly to his winter landscapes. No less a person than Rembrandt owned a *wintertie*, which hung in his *agtercaemer offte sael* (hall), as shown by an inventory of his household effects made in 1656.[3] These winter landscapes were generally painted as autonomous works, but sometimes they were originally part of a series of the four seasons or the twelve months. The depiction of the activities in the different months or seasons had its origins in the calendar scenes in medieval books of hours. One of Grimmer's finest series of the four seasons is in the Szépmûvészeti Múzeum, Budapest.[4]

The present panel was once part of a series of the twelve months; it depicts February, as confirmed by the zodiac sign Pisces Grimmer painted in the sky. The panels of this series are dispersed in a number of private and public collections: *June* and *July* are in the Musée de Nancy,[5] and three other panels were auctioned in London in December 2000 at the same time as this panel (figures 1–3). The fact that they originally belonged together is evident from their identical formats and painting manner, and probably also from the identical frames, which appear to be contemporary with the paintings.

Jacob Grimmer's son Abel Grimmer, following in his father's footsteps, painted several series of the seasons and the months, such as a four-panel cycle in the Museum Smidt van Gelder, Antwerp.[6]

Provenance: De Vaulx, France, before 1963; Auguste Fourcroy, Brussegem, by 1963; private collection, Brussels (both the above as the complete set of the twelve months; see Bertier de Sauvigny 1991); anonymous sale, London (Christie's), December 13, 2000, no. 3; acquired from Johnny Van Haeften Ltd., London, in 2000.

Exhibitions: Musées Royaux des Beaux-Arts de Belgique, Brussels, *De eeuw Van Bruegel: De Schilderkunst in België in de 16e eeuw*, 1963.

Literature: *De eeuw Van Bruegel* 1963, p. 170, no. 226 (as Martin van Valckenborgh), ill. fig. 216; De Bertier de Sauvigny 1991, pp. 94, 100, no. 5, ill. p. 169, pl. 36.

Notes:
1. Van Mander 1604, folio 256b.
2. Vasari 1550, vii, p. 586; Guiccardini 1567, p. 98.
3. Gemeentearchief, Amsterdam, arch. no. 5072, inv. no. 364, fol. 29–38v, of July 25 and 26, 1656. See also *Rembrandts Schatkamer* 1999, p. 148, no. 116.
4. De Bertier de Sauvigny 1991, nos. 8–11.
5. June and July.
6. De Bertier de Sauvigny 1991, no. 2.

DIRCK HALS

HAARLEM 1591–1656 HAARLEM

Dirck Franchoisz. Hals was baptized on March 19, 1591, in Haarlem. He was the younger brother of the much better-known portraitist Frans Hals, from whom he probably learned the fundamentals of painting. Their father was a cloth worker from Mechelen who had moved to Antwerp and then fled to Holland when that city fell into Spanish hands in 1585. Although he was active as an independent master much earlier on, Dirck Hals did not join the local guild until 1627. He was also an art dealer on occasion. From 1618 on, he was a member of the Haarlem chamber of rhetoric *De Wijngaertrancken* (The Vine Branch), to which his brother also belonged. In 1621 or 1622, he married Agneta Jansdr., with whom he had seven children. Their son Anthonie Hals (1621–1691) was a portraitist and genre painter in Amsterdam. From 1641 to 1643 and possibly even up to 1648, Dirck lived in Leiden, but otherwise he appears to have resided his whole life in Haarlem. He was buried there on May 17, 1656.

Dirck Hals painted and drew genre scenes with small figures almost exclusively, above all, merry companies, either indoors or outside. He drew his inspiration chiefly from the work of the painters Willem Buytewech (1591/92–1624) and Esaias van de Velde, who had both been members of the Haarlem St. Luke's Guild since 1612. He no doubt borrowed his fluent painting technique from his brother. His best work dates from the first half of the 1620s. On occasion, he was responsible for the staffage in the works of the architecture painter Dirck van Delen (1605–1671). In his *Beschryvinge ende Lof der Stad Haerlem* of 1628, Samuel Ampzing praised his

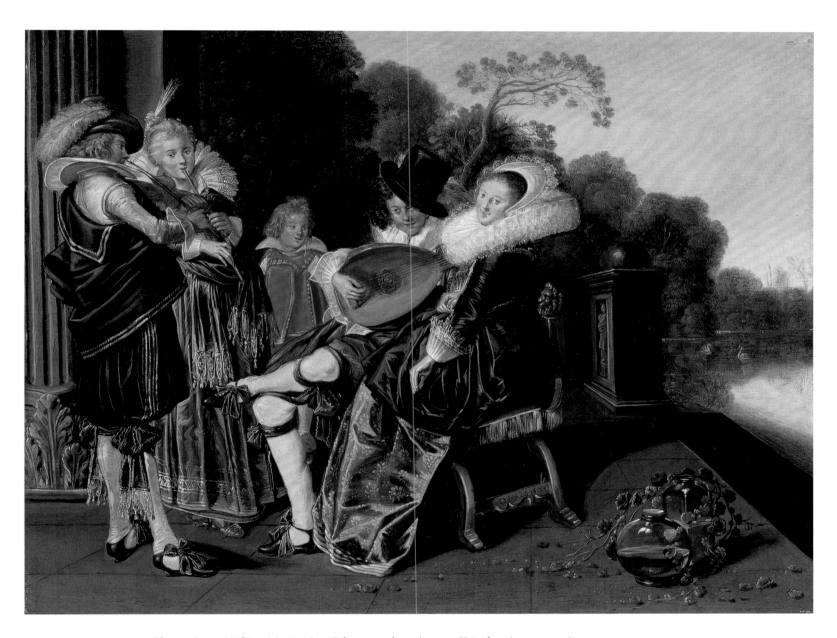

CATALOGUE 27. *An Elegant Party Making Music*, 1621. Oil on panel, 11 1/2 × 15 3/8 inches (29 × 39 cm).
Signed and dated lower center on the chair: *DHals 1621* (*DH* in ligature)

"well executed figures."[1] The eminent Haarlem jurist Theodorus Schrevelius also acclaimed Dirck Hals in his history of the city of Haarlem, *Harlemias, ofte, om beter te seggen, de eerste stichtinghe der stadt Haerlem . . .* of 1648.[2]

Literature: Nehlsen-Marten 2003.

CATALOGUE 27

AN ELEGANT PARTY MAKING MUSIC

DIRCK HALS OWES MUCH OF HIS REPUTATION to his outdoor groups and merry companies. With them, he was following in the footsteps of David Vinckboons (1576–before 1633), Esaias van de Velde (catalogue 60) and Willem Buytewech, who were the first to develop this theme in the Northern Netherlands during the first two decades of the seventeenth century. The influence of Buytewech is mainly evident in the slightly stiff and elongated figures. *An Elegant Party Making Music* of 1621 is one of the earliest paintings by Dirck Hals in this genre.[3] On an imaginary terrace by water, two elegant, fashionably dressed couples are entertaining themselves with music. The standing man on the far left plays the violin and the woman next to him plays an exceptionally long flute. The man sitting in the middle plays the lute while the woman on the right listens. She has turned her head and looks at the viewer as if to suggest that he is disturbing them. Between the two couples is a boy. On the left, the composition ends with a strangely shaped pilaster: acanthus leaves that normally decorate Corinthian capitals are on the column base. On the right, several swans swim on the almost unruffled water of a pond with a wood in the background.

 Amusing Party in the Open Air dates from the same year (figure 1). A comparison of both panels confirms that Hals must have made use of figure studies. Several such studies have been preserved,

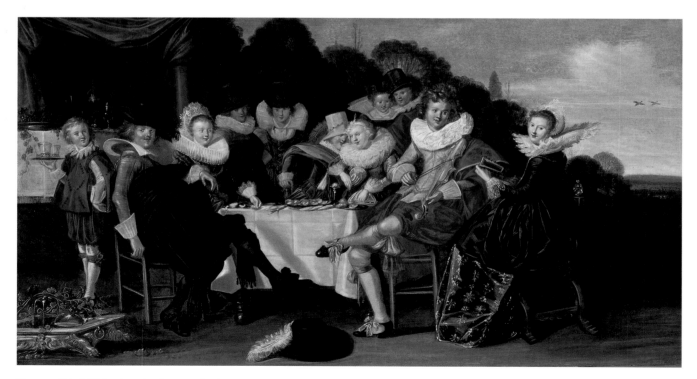

Figure 1. Dirck Hals, *Amusing Party in the Open Air*, 1621. Oil on panel, 13 3/8 × 24 1/8 inches (34 × 61.3 cm). Szépművészeti Múzeum, Budapest.

but the sheets he must have used for this composition are no longer known. The seated woman appears in almost identical form on the right in *Amusing Party in the Open Air*, and there Hals also repeated the crossed legs of the man playing the lute. Some of the figures also recur in other paintings.[4]

The carefree gaiety in this and other related paintings was often combined by Hals and his contemporaries with a more or less concealed admonition. Thus, in 1623, Cornelis van Kittensteyn (1598–1652) published a series of five engravings of the senses after Dirck Hals. Hearing is portrayed by three musicians of the same type as those in this painting. The accompanying Latin text states: "The song that is sung appeals to Hearing, and the sounds of the strings delight the ear with refreshing sweetness. Who would deny it? Yet I condemn too keen an interest in the arts, for they deprive the mind of the spirit's higher aspirations."[5] Similar warnings are regularly found in the writings of contemporaries such as Jacob Cats and even more outspokenly in Johan de Brune the Elder. But this painting by Hals seems to contain no moralizing message.

Provenance: Baron M. de Rothschild, Vienna; R. von Hirsch; Max Freiherr von Goldschmidt-Rothschild, Frankfurt, by 1925; Städtische Galerie, Frankfurt, 1928, inv. no. 825 (as dated 1620; see *Diebstahl von Gemälden*, 1946, no. 44), presumed stolen during the Second World War; returned to the family of the previous owner in 1948; with Edward Speelman, London; anonymous sale ("The Property of a Lady of Title"), London (Christie's), April 21, 1989, no. 32; with Albrecht Neuhaus, Würzburg, March 1990; with Noortman Master Paintings, London and Maastricht 1990; J. R. Ritman, Amsterdam, 1990; with Noortman Master Paintings, Maastricht, before 1994; where acquired in 1995.

Exhibitions: Städelsches Kunstinstitut, Frankfurt, *Ausstellung von Meisterwerken alter Malerei aus Privatbesitz*, 1925; Städelsches Kunstinstitut, Frankfurt, 1928; Städelsches Kunstinstitut, Frankfurt, *Diebstahl von Gemälden*, 1946.

Literature: *Ausstellung von Meisterwerken alter Malerei aus Privatbesitz* 1925, p. 33, no. 98, ill. pl. LXXIII; Frankfurt 1928, cat. no. 96, ill.; *Diebstahl von Gemälden* 1946, no. 44, ill.; *Prized Possessions* 1992, p. 166; Nehlsen-Marten 2003, pp. 112, 263, 327, cat. no. 1, ill. p. 367, fig. 101; Kolfin 2005, p. 106, fig. 84.

Notes:
1. Ampzing 1628, p. 371.
2. Ibid.; Schrevelius 1648, p. 383.
3. Kolfin 2005.
4. For example, *Elegant Company* (Musée du Louvre, Paris).
5. *Afficit Auditum carmen vocale, sonique | Chordarum mulcent aures dulcedine blanda. | Quis neget hoc? Nimium tamen artibus hisce favere | Improbo, nam mentem studiis milioribus orbant.*

FRANS HALS

ANTWERP CA. 1582/83–1666 HAARLEM

We are rather poorly informed about the life of Frans Hals. He was probably born in Antwerp
in 1582 or 1583. His father, Franchoys, was a cloth worker who had moved to Antwerp in
1562. Not long after Antwerp fell to the Spanish on August 17, 1585, the family moved to Haarlem.
There, Dirck Hals, a younger brother of Frans, was baptized on March 19, 1591. Frans Hals
lived in Haarlem for the rest of his life. Tradition has it that he received his first painting lessons
from the Mannerist artist Karel van Mander (1548–1606), but Van Mander makes no mention
of this in his *Schilder-Boeck* of 1604. It was not until the posthumous edition of 1618 that Hals is
mentioned as a pupil.[1] If this was indeed the case, that must have been before 1603, when
Van Mander left Haarlem. In 1610, when Hals was about twenty-eight, he became a member of
the Haarlem guild. It is not known if before then he had worked in another painter's studio
or even in another town. Around the same time, he married Anneke Harmensdr. In May 1615, she
died. Of the couple's three children, only Harmen (1611–1669) survived; he became a painter
like his father. In 1612, Frans Hals joined the St. George's Civic Guard. In 1616, he was commis-
sioned to paint a portrait of the officers of this guard. This was the first of a series of large
group portraits of civic guards in Haarlem. In the same year, he joined the chamber of rhetoric
De Wijngaertrancken (The Vine Branch) and spent some time in his native city of Antwerp.

 On February 12, 1617, Hals married Lysbeth Reyniersdr. in Spaarndam, a village near Haarlem.
The couple had no fewer than eleven children. Four of their seven sons – Frans the Younger,
Reynier, Claes, and Jan – also became painters. Hals and his wife moved innumerable times
within Haarlem. At first, they rented accommodations in a house on Peuzelaarsteeg, then in

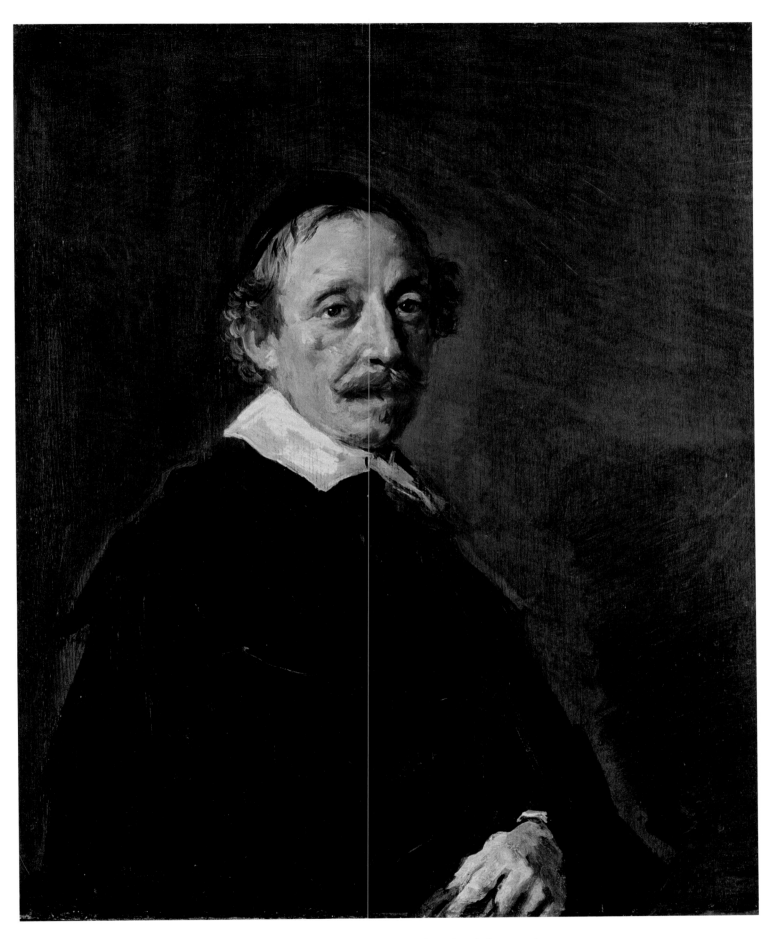

CATALOGUE 28. *Portrait of a Preacher*, ca. 1660. Oil on panel, 14 1/4 × 11 7/8 inches (36 × 30 cm).
Monogrammed lower right: *FH* (in ligature)

1636 on Groot Heiligland, from 1643 to 1650 on Oude Gracht, and after 1653 on Ridderstraat. Despite his many portrait commissions, Hals gradually got into ever greater financial difficulties.

In 1633 – as a Haarlem painter – he was given a highly prestigious commission by the city of Amsterdam for a large group portrait of one of the Amsterdam militias, the so-called Magere Compagnie (Meager Company). Hals left the painting unfinished and in the end it was completed by Pieter Codde (1599–1678). In 1644, he was elected warden (*vinder*) of the Haarlem guild. Because of his advanced age, in 1661 he was granted an exemption from paying his guild membership fees and beginning in the following year he received a modest pension from the burgomasters of Haarlem. Hals died on August 29, 1666, in Haarlem and was buried in the choir of the St. Bavokerk on September 1.

Without doubt, along with with Rembrandt, Frans Hals was the best portrait painter of the Dutch Golden Age. His forceful and virtuoso technique was unequaled. He succeeded in stripping the traditional group portrait of its schematic stiffness. His oeuvre is relatively small – fewer than two hundred paintings – but the portraits he painted throughout his life bear witness to his brilliant technique and original vision. Besides portraits, he also painted genrelike scenes. No drawings or studies by him are known.

During his lifetime, Hals received great praise for his painting. In his *Beschryvinge ende Lof der Stad Haerlem* of 1628, Samuel Ampzing applauded the true-to-life quality of his portraits: "How alertly Franz paints people from life!" The eminent jurist Theodorus Schrevelius wrote admiringly about Hals in his history of Haarlem, *Harlemias, ofte, om beter te seggen, de eerste stichtinghe der stadt Haerlem . . .* of 1648.[2] In later centuries, Hals fell from favor, but he was rediscovered in the second half of the nineteenth century and since then his reputation has only grown.

Literature: Moes 1909; Hofstede de Groot 1907–28, vol. 3, pp. 1–139; Von Bode and Binder 1914; Valentiner 1923; Valentiner 1936; Slive 1970–74; Grimm 1989; *Frans Hals* 1989–90.

CATALOGUE 28

PORTRAIT OF A PREACHER

TOWARD THE END OF HIS LIFE, in the years around 1660, Frans Hals painted several portraits in a small format. *Portrait of a Preacher* and the other panels from this series are among his most appealing, despite their seeming simplicity and modest size.[3] Hals was in his late seventies when he painted this work, but his abilities were undiminished. Using an economical painting technique, he produced a completely convincing portrait. Against an almost uniform background, he presented an elderly man with a moustache done in his characteristic fluent painting manner. Because the painting has been exceptionally well preserved, Hals's virtuoso technique can be seen here at its best. The restrained character of the portrait and the intense observation of the sitter are fully in keeping with Hals's large-format portraits of regents from his last years. The free painting manner of this portrait also resembles that of his renowned group portraits.

The expression of the subject, as he looks at the viewer, is tellingly caught. His face draws all the attention because the background is almost uniform. Hals has made ingenious use of the lighter ground that shines through the transparent grayish paint. The doublet is also very thinly painted in places. The face, on the other hand, is highly worked. The richly variegated flesh tones stand out beautifully against the dark background. Small red marks in his face make it clear that Hals has painted the sitter "honestly." The man is wearing a simple black doublet,

conservative in style, with a modest white collar. His skullcap has led to his identification
as a preacher, however, in the Dutch Republic in the seventeenth century, members of other pro-
fessions also wore these calottes. In his left hand, the sitter holds a book, probably a pocket
Bible, which in combination with his sober dress might support his identification as a preacher.
This pose, in which the other hand is hidden behind the black cloak, is characteristic of Hals's
portraits of clergymen, such as that of the leading Amsterdam preacher Herman Langelius of
around 1660 (Musée de Picardie, Amiens).[4]

At virtually the same time as this portrait, Hals painted three other small-format portraits of
soberly dressed men.[5] To date, none of these men has been convincingly identified. In 1680, Arnold
Moonen wrote a poem about Hals's portrait of the Haarlem preacher Jan Ruyll.[6] Unfortunately,
it does not go into detail about the work. Moonen emphasized that Hals could portray the sitter's
outward appearance but not the wise lessons from his "golden mouth." The poem was linked to
the present portrait by the art historian Hofstede de Groot in 1910,[7] but it remains open to question
whether the poem was related to this portrait or to another one by Hals.

Provenance: Baron Von Liphart, until 1919 in Gusthof Raddi (Rathshof), Tartu, Estland, later in Dresden;
Mr. and Mrs. Edward W. Bok, Philadelphia; Mrs. Edward W. Bok, later Mrs. Efrem Zimbalist, Philadelphia; Cary
W. Bok, Philadelphia; sale, London (Christie's), June 25, 1971, no. 18; with A. Brod Gallery, London, 1971; Robert
Potel, London, 1971–74; with A. Brod, London, 1974; Robert H. Smith, Bethesda, Maryland; with Noortman Master
Paintings, Maastricht and London; private collection, London and Brussels; acquired from Noortman Master
Paintings, Maastricht, 2006.

Exhibitions: Schaeffer Galleries, New York, *Paintings by Frans Hals*, 1937; Frans Hals Museum, Haarlem, *Frans Hals*,
1962; National Gallery of Art, Washington, *Frans Hals*, 1989–90; Mauritshuis, The Hague, *Uit de schatkamer
van de Verzamelaar*, 1995–96; National Gallery, London, and Mauritshuis, The Hague, *Dutch Portraits: The Age of
Rembrandt and Frans Hals*, 2007–2008.

Literature: Hofstede de Groot 1907–28, vol. 3, no. 273; *Paintings by Frans Hals* 1937, no. 25; *Frans Hals* 1962, no. 76;
Slive 1970–74, vol. 1, p. 198, vol. 3, p. 107, no. 209; Grimm 1989, p. 283, no. 139; *Frans Hals* 1989–90, pp. 346–47,
no. 78; *Uit de schatkamer van de Verzamelaar*, 1995–96, pp. 36–37, no. 14; Broos and Van Suchtelen 2004, p. 118 n. 25;
Dutch Portraits 2007–2008, pp. 134–35, 243–44, no. 26, ill.

Notes:
1. Anonymous biography in the second, posthumous edition of Karel van Mander's *Schilder-Boeck*, Haarlem,
 1604, n.p.
2. Ampzing 1628, p. 371; Schrevelius 1648, p. 289.
3. In the Rijksmuseum, Amsterdam; Mauritshuis, The Hague; and the Alte Pinakothek, Munich. See Slive 1970–74,
 cat. nos. 208, 210, 213.
4. Slive 1970–74, cat. no. 215; see also *Frans Hals* 1989–90, pp. 352–53, cat. no. 81.
5. Broos and Van Suchtelen 2004, cat. no. 25; Slive 1970–74, vol. 3, pp. 107–108, cat. no. 210; also cf. vol. 3,
 pp. 106–107, cat. no. 208.
6. Hofstede de Groot 1907–28, vol. 3, p. 79; see also Slive 1970–74, vol. 3, p. 107.
7. Slive 1970–74, vol. 3. pp. 107–108; Broos and Van Suchtelen 2004, p. 118 n. 25.

WILLEM CLAESZ. HEDA

HAARLEM 1594–1680 HAARLEM

Willem Claesz. Heda was born on December 14, 1594, in Haarlem; he was the son of the Haarlem city architect Claes Petersz. On June 9, 1619, Willem married Cornelia Jacobsdr., who bore him at least five daughters and two sons. The youngest son, Gerrit Heda (ca. 1624–1649), also became a painter. Gerrit, Hendrick Heerschop (1626/27–1690), and Maerten Boelema de Stomme (the Mute) (1611–1644 or later) were all apprenticed to Willem Claesz. Heda.

Before 1628, Heda inherited a house on Schagchelstraat where he lived for the rest of his life. He must have been fairly wealthy; over the years he acquired several houses and pieces of land while also speculating in tulips. He died in 1680 at the venerable age of eighty-five and was buried in the Grote Kerk in Haarlem on August 24.

Nothing is known about Heda's training. He must have been a respected figure: between 1631 and 1651 he held the post of warden of the St. Luke's Guild in Haarlem several times, and in 1644 and 1652/53 he was dean. He was also a member of the St. George's Civic Guard and served there as a corporal from 1642 to 1645.

Together with his fellow townsman Pieter Claesz., Heda became the chief exponent of the so-called "monochrome banquet." In 1628, in his description of Haarlem, Samuel Ampzing named Heda in the same breath as Pieter Claesz. as a painter of banquets. According to an inscription on a drawn copy by Cornelis van den Berg (1699–1774) after a portrait drawing of Heda by Jan de Bray (1626/27–1697), Heda began his career as a "skillful painter of Histories and life-size Figures but later he concentrated on painting all manner of still lifes. . . ."[1] We can get no more than a rough idea of his work as a history painter and draftsman from a drawing of John the Baptist signed and dated 1626 (Herzog Anton Ulrich-Museum, Braunschweig) and a painting, *Christ on the Cross* (sale, Amsterdam [Sotheby's], May 8, 2001), of the same year.

Literature: Van Gelder 1941, pp. 9–20; Bergström 1956, pp. 123–34, 139–43; Dijk-Koekoek 2000, pp. 146–47; Van der Willigen and Meijer 2003, p. 103.

THIS PANEL, WHICH IS PAINTED WITH GREAT REFINEMENT, was rediscovered in 1995 and is a classic example of the monochrome still lifes that made Willem Claesz. Heda and his contemporary and fellow townsman Pieter Claesz. all the rage. It was painted when Heda was at the height of his powers. At first sight, the various objects appear to have been placed at random, but in fact Heda arranged the "banquet" with great care. At the center of the composition stands a large rummer, probably holding white wine. The windows of the painter's studio are reflected in the glass. Two diagonals run from the top of the glass to the table-top, which is largely covered by a moss-green cloth. To the left of the rummer lies a richly ornamented, overturned tazza. Both Heda and Pieter Claesz. regularly included a dish lying on its side like this in their still lifes. It was a tried and tested method of enlivening their compositions, both through the countless reflections and through the different oval forms of the dish. In the left foreground, a half-peeled lemon and a handsome knife inlaid with whalebone and mother-of-pearl lie on a pewter plate in which the lemon is partly reflected. On the far left on the table-top and on the ruffled tablecloth are various smoking requisites: a piece of paper holding tobacco, three Gouda clay pipes (one broken), a silver tobacco box, and a rope fuse with a glowing end for lighting the pipe. Farther toward the back, the composition ends in a *Façon-de-Venise* glass, a half-full beer glass, and a pewter plate of olives that is reflected on the base of the rummer.

The subtle use of color and balanced harmony of color and tone are striking. Amidst the many shades of green, gray, and white, the yellow of the lemon provides the only bright color accent. The different fabrics and materials are all convincingly depicted: the soft cloth, the shining silver and pewter of the tazza, the plates, and the tobacco box, the cold clay of the pipes, the fragile glass, the crumpled paper with the crumbling tobacco, and the moist lemon and olives. Despite the diversity in their form and material, the objects in the still life, together with the table and background, make up a perfect entity. Partly as a result, the still life makes a monumental impression.

Several other related compositions by Heda from the same year are known.[2] Comparing them with this still life gives good insight into how Heda managed to construct a new, successful composition time after time using similar objects.

A still life of 1632 (Museo Nacional del Prado, Madrid) by Heda has the same tazza as in the present painting. Other compositions show related tazzas. Although Heda was quite well off, it seems unlikely that he would have owned these costly objects; he probably borrowed them from a local silversmith.

Provenance: Private collection, Lugano, since the nineteenth century, until 1995; acquired from Newhouse Galleries, New York, in 1996.

Exhibitions: Museum of Fine Arts, Boston, *Poetry of Everyday Life: Dutch Painting in Boston*, 2002.

Literature: *Poetry of Everyday Life* 2002, p. 69, ill.

Notes:
1. Archiefdienst voor Kennemerland, Haarlem, Atlas no. 53–1383.
2. For example, in the Frans Hals Museum, Haarlem, and with Noortman Master Paintings, Amsterdam, 2010.

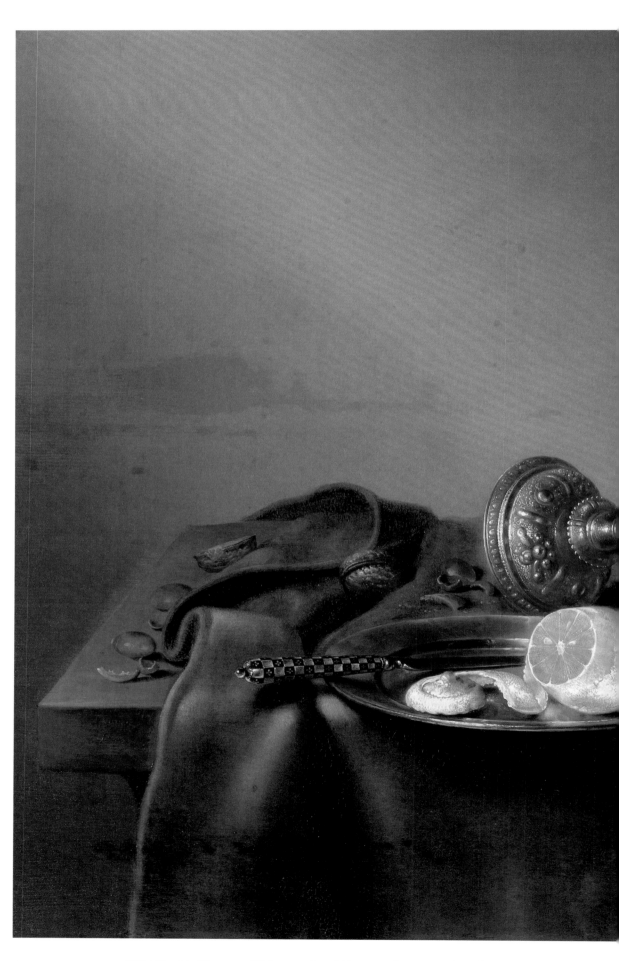

CATALOGUE 29. *Still Life with Glasses and Tobacco*, 1633. Oil on panel, 20 × 29 3/4 inches (50.8 by 75.6 cm). Signed and dated lower left: – *HEDA* | *1633* –

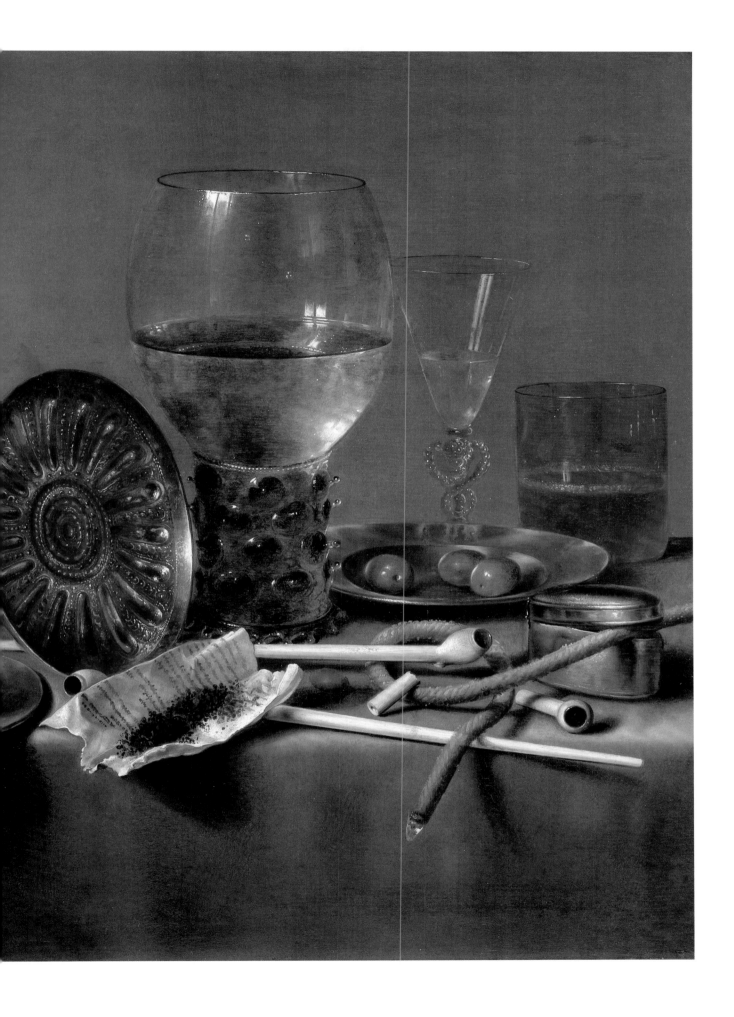

JAN DAVIDSZ. DE HEEM

UTRECHT 1606–1683/84 ANTWERP

Jan Davidsz. was born in Utrecht in April 1606 as Jan Davidsz. van Antwerp. His father was a musician from Antwerp. From 1626 without exception, Jan Davidsz. was referred to as Johannes de Heem and also signed with that name. We do not know where he derived this new name. His early work seems to have been influenced by Balthasar van der Ast, who was living in Utrecht at that time, but there is no documentary evidence that he was taught by him. On December 3, 1626, De Heem, who had meanwhile moved to Leiden, married Aeltgen Cornelisdr. van Weede. Cornelis (1631–1695), one of their three children, also became a still-life painter. Between 1631 and 1636, De Heem settled in Antwerp – one of the very few seventeenth-century artists to move from the Northern to the Southern Netherlands instead of the other way around. In the guild year 1635/36, he was registered as a master painter in the St. Luke's Guild of Antwerp and in 1637 he acquired citizenship. After the death of his wife in 1643, he married Anna Ruckers, the daughter of a well-known harpsichord-maker, on March 6, 1644. They had six children, one of whom, Jan Jansz. de Heem (1650–after 1695), also became a painter. Following another sojourn in his native city from 1665 to 1672, De Heem moved back to Antwerp after the French invasion of the Netherlands, and died there at the end of 1683 or beginning of 1684.

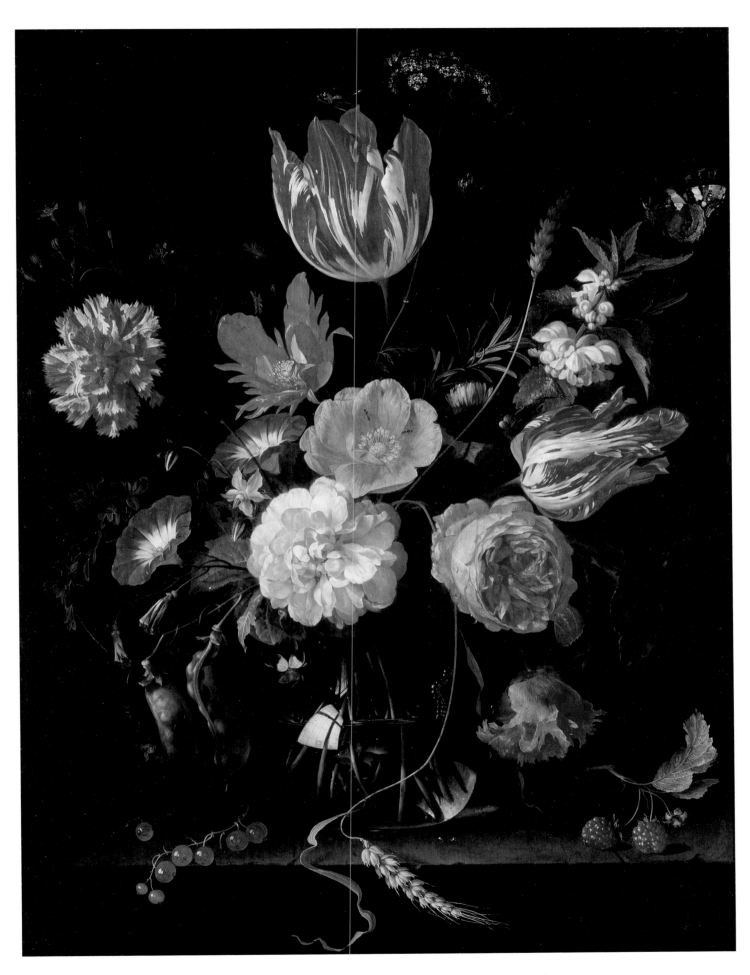

CATALOGUE 30. *Glass Vase with Flowers on a Stone Ledge*, 1655–60. Oil on panel, 18 5/8 × 14 inches (47.3 × 35.7 cm). Signed on the ledge lower left center: *J D De Heem*

In Leiden, De Heem specialized in delicate, monochrome *vanitas* still lifes. In Antwerp, he became one of the most influential and innovative painters of *pronkstillevens* (sumptuous still lifes) and floral still lifes. The refinement and elegance of these paintings are unequaled. From Antwerp, he still had a great deal of influence on still-life painting in Holland in the second half of the seventeenth century. Among his various pupils and followers were his sons Cornelis and Jan and Abraham Mignon (1640–1679).

Literature: Greindl 1983, pp. 123–28, 241–50, 359–63; Meijer 1988, pp. 29–36; Bergström 1988, pp. 37–50; Segal 1991, pp. 54–69; Van der Willigen and Meijer 2003, pp. 105–106.

CATALOGUE 30

GLASS VASE WITH FLOWERS ON A STONE LEDGE

AFTER HIS MOVE FROM UTRECHT TO ANTWERP, Jan Davidsz. de Heem initially concentrated on painting *pronkstillevens*. In this center of flower painting, however, he was impressed by the work of Daniël Seghers (1590–1661). This Jesuit brother specialized in painting colorful floral still lifes and garlands. Especially after 1650, De Heem tried his hand at floral pieces with great success and was responsible for several new developments in the genre. Fewer than twenty floral still lifes by him are known, and with one exception they were not dated by the painter, which makes their dating and chronology problematic. But this panel can be allocated with a fair degree of certainty to his earlier work in this genre; it was probably painted in the second half of the 1650s. Compared with his floral still lifes of the 1660s and the beginning of the 1670s, the composition of this panel is simpler in structure and the bouquet is less compact. It is also less exuberant and elegant than his later still lifes. Here, De Heem was clearly harking back to examples by Seghers and by Balthasar van der Ast.

In a glass vase in which the stained-glass window of the studio is beautifully reflected, various flowers have been carefully arranged so that they scarcely overlap each other: in the center a white rose, a pink Provence rose, and a yellow rose; on the left blue and white flowers of the convolvulus, a poppy, a carnation, white borage, and a violet, above a red-and-white tulip and cow parsley; and on the right a marigold, dead nettle, another flamed tulip, and a pinkish-red poppy. Dew drops further enliven the surface of several flowers and leaves. Pea pods, ears of corn, and a sprig of rosemary complete the bouquet. The vase rests on a stone ledge on which lie a sprig of blackberries and a sprig of shining red currants that also holds the reflection of the window. Dispersed over the painting are various insects, such as an Atalanta butterfly, several ants, a mosquito, and a caterpillar.

The painting clearly shows De Heem's amazing technique. The splendid colors of the bouquet are superbly displayed against the dark background. The flowers, insects, and other components of the still life are depicted with the greatest delicacy and plasticity. The texture and the luster of each element, as well as the transparency of the red currants and the glass vase, are beautifully caught. Yet, it is not possible that De Heem painted the still life entirely from nature, given that the various flowers do not bloom at the same time. In view of how true to nature the flowers are, we can assume that he painted the individual blooms from life or made use of studies after nature. However, in contrast to some other painters of flower still lifes, he never painted the same kind of flower exactly the same way twice, and so the latter possibility is less likely.

For the seventeenth-century viewer, a floral still life such as this had not only great aesthetic value but also symbolic content. The transient beauty of flowers was a standard metaphor for the

finite nature of life. At the same time, with a still life like this, the painter conveyed a message about
the importance and value of art. The flowers in this bouquet will continue to radiate long after
the flowers in nature have gone. This idea of *ars longa, vita brevis* was an essential part of seventeenth-
century still-life painting in the Netherlands.

Provenance: With Van Diemen, Amsterdam; Simon del Monte (1878–1930), Brussels, by descent to his son
F. del Monte; with Knoedler, London, before 1948; Frits del Monte, Brummen, his estate sale, Amsterdam (Christie's),
May 29, 1986, no. 172; with David M. Koetser, Zurich (together with Richard Green, London); Flick, Munich;
acquired from Galerie Sanct Lucas, Vienna, in 1997.

Exhibitions: Koninklijke Kunstzaal Kleykamp, The Hague, *Tentoonstelling van schilderijen door oud-Hollandsche en
Vlaamsche meesters*, 1932; P. de Boer, Amsterdam, *Bloemstukken van Oude Meesters*, 1935; Frans Hals Museum,
Haarlem, *In den Bloemhof der Schilderkunst – tentoonstelling van bloemstillevens uit vier eeuwen*, 1947; Château des
Rohan, Strasbourg, *La Hollande en Fleurs*, 1949–50; Teylers Museum, Haarlem, *Bloemenwereld van Oude en
Moderne Nederlandse Kunst*, 1953.

Literature: *Tentoonstelling van schilderijen door oud-Hollandsche en Vlaamsche meesters* 1932, p. 25, no. 68; *Bloemstukken
van Oude Meesters* 1935, p. 12, no. 62; *In den Bloemhof der Schilderkunst* 1947, p. 21, no. 12; *La Hollande en Fleurs*
1949–50, p. 17, no. 20; *Bloemenwereld van Oude en Moderne Nederlandse Kunst* 1953, p. 7, no. 21; Hairs 1955, pp. 220–21;
Hairs 1965, p. 385; Hairs 1985, vol. 2, p. 30; Grimm 1988, pp. 143, 225–26, ill. fig. 160 (detail of wheat); Bakker 1991,
pp. 19–21, ill. p. 20; Stuurman-Aalbers et al. 1992, p. 309, ill.

JAN VAN DER HEYDEN

GORINCHEM 1637–1712 AMSTERDAM

Jan van der Heyden was born on March 5, 1637, in Gorinchem (Gorkum), the third of nine children. His father owned an oil mill in Gorinchem, which he sold in 1646 when the family moved to Amsterdam. Goris, Jan's eldest brother, started a business there making mirrors where Jan was probably an apprentice. In 1652, Jan witnessed the old town hall of Amsterdam burning down, an event that would play an important role in his later life.

From 1656 on, Jan lived with his mother and eldest brother in a house on Dam Square. The painter and biographer Arnold Houbraken stated that Van der Heyden was trained as a glass engraver and was also active as a painter from 1660.[1] Yet, he never became a member of the St. Luke's Guild. Shortly before his marriage to Sara ter Hiel on June 26, 1661, in Amsterdam, Van der Heyden traveled along the Rhine and visited Cologne, Cleves, and Düsseldorf, among other places. Later, he also traveled to Antwerp and Brussels.

Van der Heyden was extremely versatile and talented; he was an engineer and inventor as well as an artist. In 1668, he submitted a plan to the city of Amsterdam for street lighting using 2,556 lanterns with oil lamps. His plan was implemented and in the following year he was appointed "overseer and director of the lanterns burning by night." A few years later, Groningen and Berlin introduced street lighting based on Van der Heyden's system. In 1672, Van der Heyden designed the first fire pump and fire engine – an important advance for a city such as Amsterdam, with its many wooden houses. Two years later, he and his younger brother Nicolaas were appointed "supervisors of the city fire pumps and fire equipment." In 1679, he bought a piece of land on Koestraat upon which to build a house and a fire pump factory. In 1690, Van der Heyden and his son Jan together published *Grote Brandspuitenboek* (The Big Fire Pump Book). His various civic posts and the patents on his inventions brought Van der Heyden a substantial income. On March 28, 1712,

Jan van der Heyden died in his house on Koestraat. He left a considerable estate and an important art collection, including seventy of his own paintings.

Van der Heyden's oeuvre comprises about two hundred paintings; drawings and prints also exist. At first, he painted a few still lifes and landscapes as well as townscapes. After 1666, he painted townscapes, imaginary or otherwise, almost exclusively. Toward the end of his life, he again painted some still lifes. Along with Gerrit Berckheyde (1638–1698), Van der Heyden was one of the first painters to develop the townscape as an autonomous genre. He was also the first to paint imaginary townscapes depicting existing streets and houses. His extremely refined and detailed paintings were much sought after in the eighteenth century.

Literature: Hofstede de Groot 1907–28, vol. 8, pp. 325–426; Wagner 1971; L. De Vries 1984; *Jan van der Heyden (1637–1712)* 2007.

CATALOGUE 31

VIEW OF THE WESTERKERK, AMSTERDAM

THIS MAGNIFICENTLY PRESERVED PANEL is undoubtedly one of Jan van der Heyden's finest townscapes. The main subject is the Westerkerk in Amsterdam seen from the southeast. The church was built between 1620 and 1631 on a square between Keizersgracht, visible here in the foreground, and Prinsengracht. The location at the center of the recent expansion of the city was carefully chosen. The well-known city architect of Amsterdam Hendrick de Keyser (1565–1621) designed the building, but after his death the work was largely taken over by his son and successor Pieter de Keyser (ca. 1595–1696). The original design for the wooden superstructure of the tower, which was not completed until 1639, was altered by Pieter and the architect Cornelis Danckerts (1561–1634) from partly twelve-sided and partly octagonal to square. At almost 279 feet (85 m), the tower was the highest in Amsterdam for centuries. It is literally and figuratively capped by the imperial crown granted by Emperor Maximilian for the city coat of arms in 1489. During the recent restoration of the Westerkerk, the original bright blue of the crown was restored, partly on the basis of this painting.

The monumental Westerkerk, which was intended to be the city's principal church for the Reformed congregation, was long regarded as the finest church in the world built specially for Protestant worship; until the construction of St. Paul's Cathedral in London it was also the largest. Many eminent citizens of Amsterdam were buried in the Westerkerk, such as the painters Nicolaes Berchem and Rembrandt and his son Titus.

In Van der Heyden's painting, the church is partly concealed from view by the Westerhal, which was completed in 1619 and served as the civic guard's main guard house. The first floor was used as a meat market, as indicated by the slaughtered hog being boned by a butcher, and by the two butchers with white aprons who are standing talking. In the summer of 1857, shortly before the building was pulled down (despite loud protests), the English photographer Benjamin Brecknell Turner (1815–1894) took a photograph of the Westerhal and the Westerkerk from about the same spot Van der Heyden chose.[2] In many of his Amsterdam townscapes, Van der Heyden took various liberties with reality. A comparison of the photograph with the painting makes it clear that in this instance, with the odd exception, Van der Heyden kept very close to topographical reality. The main difference is the absence of the two dormer windows high up on the Westerhal. Like the Westerhal, the brick bridge over the canal is also gone, demolished in 1793. On the far right, the two step-gables of Keizersgracht 196–198 can just be seen; it had been built in 1618 for the Flemish merchant and collector Lucas van Uffel.

CATALOGUE 31. *View of the Westerkerk, Amsterdam*, ca. 1667–70. Oil on panel, 21 × 25 1/4 inches (53.5 × 64.2 cm). Signed lower right: *VHeyd* (*VH* in ligature)

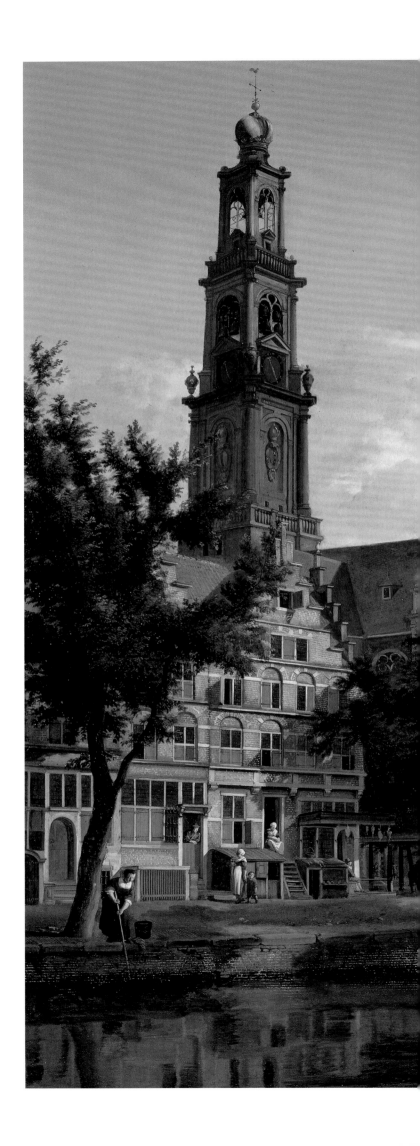

The painting probably dates from between 1667 and 1670, when Van der Heyden was at the height of his abilities and not yet so involved in his activities as an engineer and inventor. The imposing church stands out sharply against the bright blue sky. The almost improbably meticulous rendering of details such as the bricks, paving slabs, and foliage of the trees is characteristic of the painter. While discussing a related Amsterdam townscape by Van der Heyden, Jacob Campo Weyerman wrote: "the piece appears to be conjured up by magic rather than painted."[3] Peter Sutton was probably right to suggest that the painter made use of copper plates to model the bricks.[4] In contrast to earlier work, he succeeded in creating a more harmonious entity through more subtle color nuances.

The staffage, which consists of more than twenty figures, is probably by the Amsterdam painter Adriaen van de Velde (1636–1672), who often collaborated with Van der Heyden. It is noteworthy that while Van der Heyden put so much care into a representation that is true to nature, reflections of the figures, such as the woman on the left drawing water from a well, are missing from the water of the canal.

The Westerkerk features prominently in two more paintings by Van der Heyden: a large panel in the National Gallery, London, and a smaller one in the Wallace Collection, London.[5] In both, the church's eastern façade is depicted frontally and prominently, so that, much more than in the present work, they seem more like "church portraits" than a townscape.

Provenance: Colonel de Beringhen, The Hague; Prince Amédée of Savoy; Comte Cherisey, Paris; with F. Muller & Co., Amsterdam; Marcus Kappel (1839–1919), Berlin (cat. 1914, no. 10, ill.); thence by descent to Ernest T. Rathenau, Berlin, New York, and Zurich, and his sister Ellen Rathenau-Ettlinger, Oxford; with Otto Naumann Ltd., New York, 1993–2000, where acquired in 2000.

Exhibitions: Kaiser Friedrich Museum, Berlin, *Ausstellung von Werken alter Kunst aus dem Privatbesitz der Mitglieder des Kaiser Friedrich-Museum-Vereins*, 1914; The Albright Art Gallery, Buffalo, New York, *Paintings Looted from Holland. Returned through the Efforts of The United States Armed Forces*, 1946 (traveled to Ann Arbor, Michigan, and Baltimore, Maryland); on loan to The Metropolitan Museum of Art, New York, ca. 1970–93; on loan to the Frick Collection, New York, 1998–2000; Museum of Fine Arts, Boston, *Poetry of Everyday Life: Dutch Painting in Boston*, 2002; *Fire! Jan van der Heyden (1637–1712)*, Bruce Museum, Greenwich, Connecticut, and Rijksmuseum, Amsterdam, 2006–2007; Mauritshuis, The Hague, and the National Gallery of Art, Washington, *Pride of Place: Dutch Cityscapes of the Golden Age*, 2008–2009.

Literature: Hofstede de Groot 1907–28, vol. 8, no. 11; Hooft 1912; *Ausstellung von Werken alter Kunst aus dem Privatbesitz der Mitglieder des Kaiser Friedrich-Museum-Vereins* 1914, p. 64; Von Bode 1914, p. 25, ill. no. 10; Friedländer 1923, p. 309, ill.; *Paintings Looted from Holland* 1946, p. 18, no. 19, ill.; Von Bode 1958, p. 367 (as formerly in the Marcus Kappel Collection, Berlin); Wagner 1971, no. 9, ill. p. 128; Lawrence 1991, p. 52 n. 22; Nicholas 1994, p. 102; Ingamells 1992, p. 149 n. 6; *Poetry of Everyday Life* 2002, p. 125; *Fire! Jan van der Heyden 1637–1712* 2006–2007, p. 134, no. 13, ill. p. 135; *Pride of Place* 2008–2009, pp. 122–24, 226, no. 23.

Notes:
1. Houbraken 1718–21, vol. 3, pp. 80–82.
2. Albumin print from wax paper negative, 10 3/4 × 15 1/4 inches (27.3 × 38.8 cm), Stadsarchief, Amsterdam.
3. Weyerman 1729, vol. 2, pp. 391–92.
4. *Jan van der Heyden 1637–1712* 2007, p. 37.
5. Hofstede de Groot 1907–28, vol. 8, cat. no. 14; Wagner 1971, cat. no. 7.

GERARD HOUCKGEEST

THE HAGUE CA. 1600–1661
BERGEN OP ZOOM

Gerard Houckgeest's exact date of birth is not known. He came from a well-to-do family. His uncle, Joachim Houckgeest (ca. 1585–1641/44), was a reasonably successful but somewhat old-fashioned portraitist. Gerard was probably apprenticed to the architecture painter and architect Bartholomeus van Bassen (ca. 1590–1652) of The Hague. In 1625, Houckgeest joined the guild in The Hague, but in 1635 he turns out to have moved to Delft, where in the following year he married Helena van Cromstrijen. In 1639, he is listed as a member of the local St. Luke's Guild, but in the same year he rejoined the guild in The Hague. He is mentioned in 1640 as a designer of tapestries for the assembly chamber of the States-General. In December 1644, he was living in Delft again, at the *De Clauw* brewery; it is not clear whether he was also working as a brewer. Thanks mainly to several legacies from his wife's family, by this time Houckgeest was doing fairly well and owned various country estates. In 1651, he moved to the house known as *De Gulden Leeuw* (The Golden Lion) in Steenbergen in the province of North Brabant, and from 1653 until his death in August 1661 he lived in nearby Bergen op Zoom, where he also owned various houses and estates.

Houckgeest seems to have confined himself to painting architecture pieces. His oeuvre is remarkably small. Perhaps this can be partly explained by his financial independence. His earliest known dated painting is from 1635, when he was already about thirty-five. Up to 1650, he painted imaginary architecture exclusively, but in that year there was a radical change in his work and he concentrated on paintings of existing churches. In 1650, he painted his monumental *Interior of the Nieuwe Kerk in Delft with the Tomb of William of Orange* (or William the Silent, as he is also known)

(Kunsthalle, Hamburg). This may well have been commissioned by a member or supporter of the House of Orange-Nassau. In the following years he painted several more views of this church but he also painted the interior of the Oude Kerk in Delft, the St. Jacobskerk in The Hague, and the Grote or St. Geertruidskerk in Bergen op Zoom. In these pieces, of which barely a dozen are known, not only has the subject changed but also the point of view. He no longer chose a spot on the longitudinal or latitudinal axis of the church, as Pieter Saenredam tended to do. Instead, he granted us a vista from a relatively low angle diagonally into the church, thus creating all kinds of fascinating intersections. Through these works, he had a considerable influence on the Delft church painters Emanuel de Witte and Hendrick van Vliet (1611/12–1675).

Literature: L. De Vries 1975, pp. 25–566; Jantzen 1979; Liedtke 1982, p. 100; Liedtke 2000.

CATALOGUE 32

THE NIEUWE KERK IN DELFT WITH THE TOMB OF WILLIAM OF ORANGE

IN 1650, Gerard Houckgeest painted the interior of the Nieuwe Kerk in Delft with William of Orange's tomb on a remarkably large panel (Kunsthalle, Hamburg). This imposing piece was a great success and marked a change of direction in Houckgeest's work. In the period immediately following, Houckgeest chose the same theme several times. The much smaller panel here is an almost exact, autograph version of the version dated 1651 in the Mauritshuis, The Hague (figure 1) and probably dates from not much later, around 1651–52. The underdrawing is clearly visible in many places. On the basis of the costumes, it must be assumed that the figures were added later, very probably by another hand. Here, too, the underdrawing can be seen clearly and it reveals

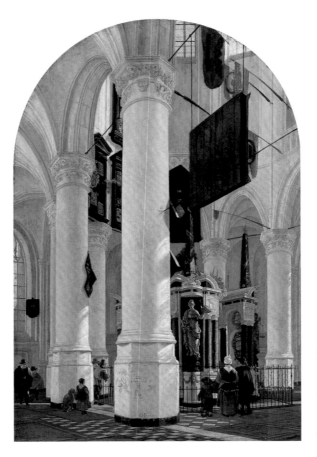

Figure 1. Gerard Houckgeest, *Tomb of William of Orange in the Nieuwe Kerk in Delft*, 1651. Oil on panel, 22 × 15 inches (56 × 38 cm). Royal Picture Gallery Mauritshuis, The Hague.

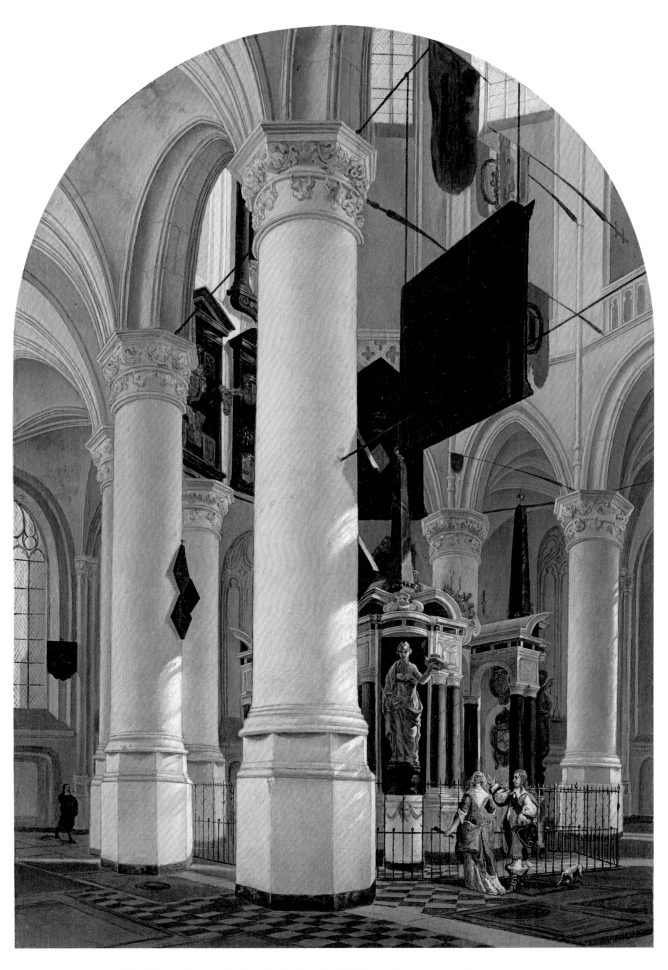

CATALOGUE 32. *The Nieuwe Kerk in Delft with the Tomb of William of Orange*, ca. 1651–52.
Oil on panel with rounded top, 23 5/8 × 16 1/8 inches (60 × 41 cm).

that the original intention was to have another child to the left of the woman. A second painting of 1651 in the Mauritshuis shows the same subject but with a different composition. In both these pieces, the monumental tomb is the central motif. William of Orange had been at the head of the revolt of the Northern provinces against Spanish rule from its beginning in 1568. In 1584, he was assassinated in his palace Prinsenhof in Delft. He was buried in the nearby Nieuwe Kerk. In 1614, when the Northern Netherlands were in a much better position in their conflict with the Spanish, the States-General commissioned the most eminent sculptor and architect of the day, Hendrick de Keyser (1565–1621), to design a tomb that would not only do justice to the hero's honor and reputation but at the same time give expression to both the glory of the young Dutch Republic and the power of the States-General. After the death of De Keyser in May 1621, the tomb was completed in the following year by his son Pieter de Keyser (ca. 1595–1676). The white-and-black marble structure is still regarded as the finest and most important tomb in the Netherlands.

The choice of Houckgeest to depict this tomb in the choir of the Nieuwe Kerk in Delft in 1650 and the years immediately thereafter would not have been accidental, as these years were critical both for the Dutch Republic and the dynasty of the Orange-Nassau family. After eighty years of war, in the Treaty of Münster of 1648, Spain recognized the Dutch Republic as an independent state. A year earlier, *Stadholder* Frederik Hendrik, the son of William of Orange, who had led the revolt from 1625, had been interred in this church. The body of his older half-brother Prince Maurits, who had succeeded his father, William of Orange, in 1584, had been interred in the crypt of the same church in 1625, as was that of William II, the son of Frederik Hendrik, in 1650. William II had died unexpectedly while he was marching on Amsterdam with an army after a serious disagreement had arisen between him and that city. His widow would give birth later that year to their son William III. Patriotic and Orangist feelings were prominent in the young Dutch Republic and in particular in Delft in the period after 1648. So, it seems likely that Houckgeest painted one or more of these pieces for a commission from a member or supporter of the Orange-Nassau family.

Together with the Oranjezaal dedicated to Frederik Hendrik at Paleis Huis Ten Bosch in The Hague, the tomb in Delft was one of the most important symbols of the Orange dynasty. The three memorial boards that hang partly concealed behind the columns of the choir underline this function. The top board is dedicated to *Stadholder* Frederik Hendrik, the board below to William of Orange, the board on the left to Prince Maurits, and the one on the right to Louise de Coligny, the fourth wife of William of Orange. A fourth board hanging between the two columns in the foreground can only be seen from behind. It adds to the sense of space and perspective in the painting.

Here and in the other related panels, Houckgeest created an overwhelming feeling of space and light. From the mostly shaded floor, one's gaze is led up the columns to where the light streams in through the windows. Subtle shadows on the floor, walls, and columns enliven the image. Other painters active in Delft in these years, such as Carel Fabritius (1622–1654), Pieter de Hooch (1629–1684), and Emanuel de Witte also took a keen interest in light, space, and perspective. There can be no doubt that these painters influenced and inspired each other.

As can still be seen today, Houckgeest created a fairly exact representation of the church seen from the north transept. There are only two points where his version deviates substantially from reality. He gave the floor a black-and-white pattern and eliminated the column that should have been on the far right. The effect of this last intervention becomes evident when the present panel is compared with the painting in Hamburg, in which this column is depicted.

One noteworthy aspect is that Houckgeest chose a point of view from which the two sculptures of William of Orange that are part of the tomb cannot be seen. At the front-most corner of the tomb, however, the gilt-bronze figure of a woman symbolizing Freedom is prominently depicted. Of the figures on the other corners, which personify Strength, Faith, and Justice, only the last is visible in profile on the right-hand side of the tomb.

Provenance: The earl of Shrewsbury, Alton Towers, his sale, London (Christie's), June 1, 1861, lot 100 (as Emanuel de Witte, "Interior of a Flemish Church, with monuments and figures; a gleam of sunshine falls on one of the columns with admirable effect") (bought by J. Mayor Threlfall); John Mayor Threlfall, Singleton House, Manchester; possibly Schwartz, Vienna, 1895 (as De Witte; see Jantzen 1979); anonymous sale ("The Property of a Lady"), London (Sotheby's), March 28, 1979, lot 75; private collection; with Noortman Master Paintings, Maastricht, 2000; where acquired in 2002.

Exhibitions: The Metropolitan Museum of Art, New York, *Vermeer and the Delft School*, 2001; Metropolitan Art Museum, Tokyo, *Vermeer and the Delft Style*, 2008.

Literature: Possibly Jantzen 1979, no. 193, p. 225 ("Delfter Kirch [oben abgerundet], ehem. Slg. Schwartz [1895 als de Witte], Wien"); Liedtke 1982, p. 100, no. 6d; Liedtke 2000, pp. 107, no. 5a and 115, ill. pl. VII; *Vermeer and the Delft School* 2001, pp. 104, 299–301, no. 38; *Vermeer and the Delft Style* 2008, pp. 96–97.

ISAACK KOEDIJCK

AMSTERDAM OR LEIDEN? 1617/18–1668 AMSTERDAM?

Little is known about Isaack Koedijck's early life. He was probably born in Amsterdam or Leiden, in 1617 or 1618 on the basis of later documents. On May 18, 1641, in Leiden, he married the well-to-do widow Sophia de Solemne, the daughter of a captain of the West India Company (WIC). They settled in Amsterdam, where Koedijck traded in jewelry. Although he is not referred to there as a painter, an inventory of 1644, which lists various primed paintings and an easel, shows that this is the same person. In subsequent years, he lived in turn in Leiden and Amsterdam. He seems to have had financial problems in both cities, which is probably why Koedijck and his wife decided to try their luck elsewhere. On August 4, 1651, they arrived in Batavia (modern Jakarta), in the Dutch East Indies. At the request of the Dutch East India Company (VOC), he was to go to Agra in northern India to be the court painter of the great Mughal emperor Shah Jahan. Toward the end of the year, he and his wife reached Surat, on the northwest coast of India, where there was an important trading post of the VOC. The plans changed, however, and Koedijck was appointed the merchant for the VOC in Ahmadabad, north of Surat, and later in Surat itself as well. After also working for some time as secretary of the government in Batavia, he was charged with leading a return fleet to Holland. He and his wife embarked on December 14, 1658, and in August 1659 he was reported as being back in the Dutch Republic. In the following years, when his financial position had clearly improved, he lived in turn in Haarlem and Amsterdam. His wife died in February 1667 in Haarlem. Koedijck made his will on April 28, 1667, and died shortly before March in 1668, probably in Amsterdam.

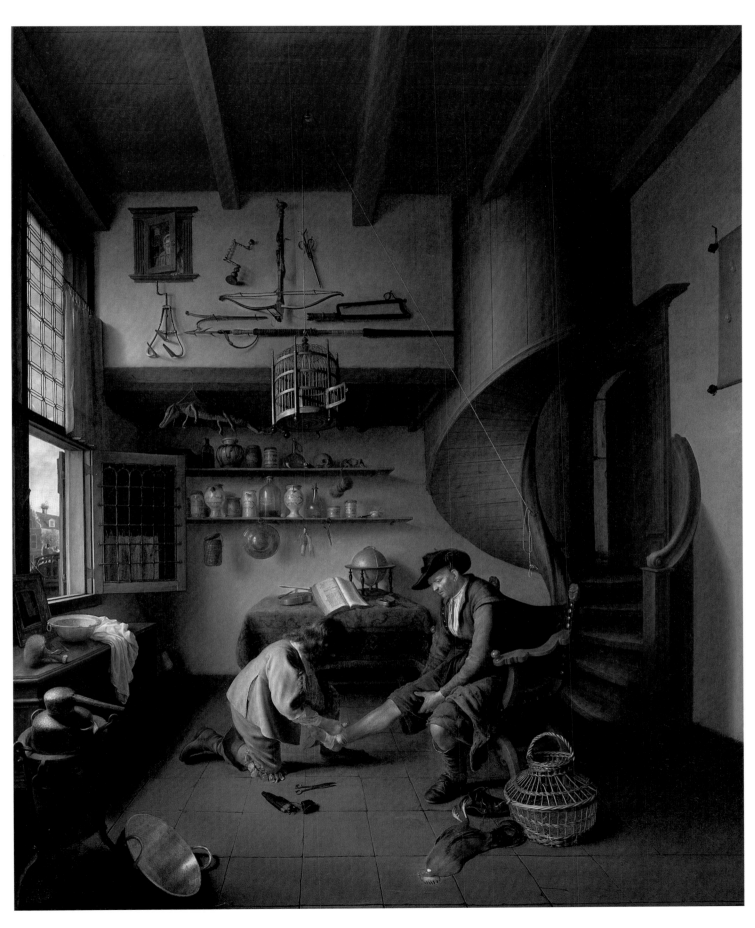

CATALOGUE 33. *Barber-Surgeon Tending a Peasant's Foot*, ca. 1649–50. Oil on panel, 35 7/8 × 28 3/8 inches (91 × 72 cm). Signed on the crosspiece of the table: *I Koedijk*

DETAIL OF
CATALOGUE 33

Given the long time he spent abroad and his activities as a jewelry dealer and a merchant, it is not surprising that Koedijck left only a small body of work, almost entirely genre pieces. Moreover, two of his most outstanding paintings, acquired by Catherine the Great from the Braamcamp collection in 1771, were lost in a shipwreck that same year. The only known piece from the period after his time outside the Netherlands is a stylistically very different, large-format *Tobias with the Fish* of 1662 (Museum Catharijneconvent, Utrecht).

Literature: Martin 1909, pp. 1–4; Bredius 1909, pp. 5–12; Hofstede de Groot 1927A, p. 112; Hofstede de Groot 1927B, pp. 181–90.

CATALOGUE 33

BARBER-SURGEON
TENDING A PEASANT'S
FOOT

BARBER-SURGEON TENDING A PEASANT'S FOOT has long been widely regarded as Isaack Koedijck's masterpiece. It shows a high-ceilinged room with a convincing depiction of space. In the center, a barber-surgeon kneels as he bandages the foot of a humbly dressed man sitting in a large armchair. On the floor lie a large pair of scissors and an open case in which the scissors and other instruments are kept. The anxious-looking patient supports his leg with both hands. Next to him are his right shoe, an empty bird basket, and a dead cockerel, which is probably the payment in kind for the treatment. The left foreground is taken up by a large, gleaming copper dish and behind that a distilling flask. A striking feature of the room is the spiral staircase in the right-hand corner with a door leading to another room. The space contains numerous objects referring to the various tasks of a seventeenth-century barber-surgeon. On the table below the window are a shaving brush or powder brush, a comb, a copper shaving bowl, a mirror, and a towel, all implements of his occupation as a barber. At the back of the room on the left in the corner there is a brush and to the right of that a cloth-covered table with a violin, a globe, an open silver tobacco box, and a large open book on which can be read "Maurits van Nassau." The book has recently been identified as *Beschrijvinghe ende af-beeldinge van alle de VICTORIEN . . .*, published in 1610.[1] This important publication extensively describes and illustrates *Stadholder* Prince Maurits's many victories over the Spanish, glorifying the prince and thus the Orange-Nassau family. Given the date of the painting, 1649 or 1650, the depiction of this particular page of the book prominently displaying the name of Prince Maurits may have had a special political significance. Maurits's half-brother Frederik Hendrik had died in 1647 and in 1650 William II, the latter's son, unexpectedly died while marching on Amsterdam in a serious dispute with the city. As a result, the survival of the Orange-Nassau dynasty was at great risk at that moment in history. It is not clear to what extent special significance should be attached to this reference to *Stadholder* Prince Maurits, who had died in 1625.

Above the table are shelves with all kinds of objects such as glasses and earthenware apothecary's pots and bottles, some of which are labeled, a human skull, the skeleton of a small animal, a wicker basket possibly used to store a urinal, a copper shaving basin, a corncob, and a pair of forceps. Above them hangs a small stuffed crocodile, a traditional furnishing in an apothecary's or barber-surgeon's workshop. Still higher hangs an odd combination of various weapons, medical instruments, and tools such as a speculum (used for difficult births),[2] a crossbow, a crow-bill, a harpoon, a trepan or skull drill, and a saw for amputations. Outside, a woman peers in through a window. On the ceiling, finally, hangs an empty birdcage, and against the right-hand wall can just be seen a cloth to which small pots probably containing medicines are attached. Traveling barber-surgeons and quacks hung up such cloths when practicing their profession at fairs.

The open leaded window on the left affords a view of a bridge over a canal and a house with a bell gable. On the bridge, a man with a black hat and a red cloak points out a nest with a stork on the roof of the house to a woman dressed in black. It is not clear whether this has a symbolic meaning.

In the seventeenth century, there were two kinds of physicians in Holland. Besides the university-trained *doctores medicinae*, there were the barber-surgeons, who had generally acquired their knowledge and skill through practical experience. The former were concerned primarily with the diagnosis and treatment of internal illnesses, while the barber-surgeons treated injuries, ulcers, and pustules, and carried out the bleeding considered necessary for many diseases at the time. In most Dutch towns, the barber-surgeons were organized in guilds, which supervised the enforcement of the guild rules. They often combined their medical work with being a barber, as can be seen in this painting. These barber-surgeons should not be confused with the many quacks operating at markets and fairs.

In the sixteenth and especially the seventeenth century, paintings of both quacks and physicians were very popular in the Northern Netherlands. In Leiden, above all, they were a recurring theme in the work of Jan Steen, Gerrit Dou, Gabriël Metsu, and Frans van Mieris. In almost all cases, these works make fun of the quack or physician, and contain allusions to the pangs of love and unwanted pregnancies. There seems to be nothing like this in the case of Koedijck. Here, the barber-surgeon appears to be taking his tasks seriously. Unlike in most other paintings in this genre, the physician is not dressed in an old-fashioned costume derived from the *commedia dell'arte*.

Only a few of Koedijck's already rare paintings are dated, which makes it difficult to date this one. It bears a close stylistic and compositional relationship, however, to *The Empty Wine Glass*, of which two versions dated 1648 are known (formerly with Otto Naumann, New York; and sale, Amsterdam [Fred. Muller], April 26, 1927). On the grounds of these correspondences, and

Figure 1. Gerrit Dou, *Interior with a Young Violinist*, 1637. Oil on panel, 12 1/4 × 9 3/8 inches (31.1 × 23.7 cm). National Gallery of Scotland, Edinburgh. Purchased with the aid of the National Heritage Memorial Fund, 1984.

the superior quality, this panel appears to have been painted shortly thereafter, and in any case prior to Koedijck's departure for the East Indies in 1651.

Cornelis Hofstede de Groot undoubtedly had this painting in mind when he wrote: "In neatness of handling Koedijck is scarcely inferior to Dou, while in delicacy of coloring he perhaps surpasses his master."[3] Although nothing is known about possible contacts between Koedijck and Gerrit Dou in Leiden, this painting shows that Koedijck must have known Dou's work well. A number of paintings by Dou from the 1630s show a single figure sitting in an armchair in a high room with a wooden floor, a window on the left, and a prominent spiral staircase on the right, as in *Interior with a Young Violinist* of 1637 (figure 1). Each of these elements is present in this panel in a related fashion. Several other works by Koedijck contain many of these components. Yet, Koedijck's work clearly differs from that of Dou. In Koedijck's paintings, the light is much less diffuse and as a result the colors are brighter. In the 1650s, Koedijck's interiors with their lucidly constructed spaces and light streaming in must have influenced painters like Nicolaes Maes and Pieter de Hooch (1629–1684).

Provenance: Jacques Ignatius de Roore (1686–1747), painter and picture dealer, The Hague; Willem Lormier (1682–1758), solicitaire militaire, collector and dealer, The Hague (Lormier's storeroom catalogue, 1752, no. 157); sold to Prince Galitzin on November 10, 1756 (dfl. 700); Prince Dmitri Alekseyevich Galitzin; with Julius Böhler, Munich, by 1906; Adolphe Schloss (d. 1910), Paris, his sale, Paris (Galerie Charpentier), December 5, 1951, no. 32 (ffr. 900.000); with Alfred Brod, London, 1952 (sold to J. Lowenstein); Julius Lowenstein, London; The Trustees of the Late Julius Lowenstein, before 1984; private collection (Mrs. E. Phillip), London, her sale, London (Christie's), December 10, 1993, no. 20; acquired from Johnny Van Haeften Ltd., London, in 1994.

Exhibitions: Stedelijk Museum De Lakenhal, Leiden, *Rembrandt – Hulde te Leiden. Tentoonstelling van Schilderijen en Teekeningen van Rembrandt en van schilderijen van andere Leidsche Meesters der Zeventiende Eeuw*, 1906; London, Royal Academy, *Dutch Pictures 1450–1750*, 1952–53; Philadelphia Museum of Art, *Masters of Seventeenth-Century Dutch Genre Painting*, 1984 (traveled to Gemäldegalerie, Berlin, and Royal Academy, London); Museum of Fine Arts, Boston, *Poetry of Everyday Life: Dutch Painting in Boston*, 2002.

Literature: Gool 1750–51, vol. 1, p. 36 (on Lormier's collection including Koedijck); *Catalogus van Schilderyen, van den heer agent Willem Lormier, in 's Gravenhage* 1752, p. 15, no. 157 ("Een Chirurgyn die een boer zyn been verbindt, met veel ander bywerk"); Thoré 1860B, vol. 2, p. 64; *Rembrandt – Hulde te Leiden* 1906, p. 11, no. 23a, ill. pl. 21; Hofstede de Groot 1907–28, vol. 1, pp. 339–40; Martin 1909, p. 2 and n.1; Hofstede de Groot 1927A, p. 112; Hofstede de Groot 1927B, p. 181; De Loos-Haaxman 1941, vol. 1, p. 63 n. 3, ill., vol. 2, p. 26, fig. 26; Bazin 1950, no. 120, ill.; *Dutch Pictures 1450–1750* 1952–53, p. 81, no. 421; *Illustrated Souvenir of Dutch Pictures 1450–1750* 1938, ill. p. 51; F. W. Robinson 1974, pp. 92, 98–99, 222, ill. fig. 226; *Masters of Seventeenth-Century Dutch Genre Painting* 1984, pp. 229–30, cat. no. 59, ill. pl. 63; Mallalieu 1994, pp. 66–67, ill. fig. 5; *Delft Masters: Vermeer's Contemporaries* 1996, p. 140, fig. 128; Marland and Pelling 1996, pp. 223, 246 n. 5, ill. p. 222, fig. 10.1; Mooij 1998, p. 7, ill.; Korthals Altes 2000, pp. 282, 309, no. 49, fig. 33; *Poetry of Everyday Life* 2002, p. 69, ill.

Notes:
1. Orlers and Van Haestens 1610, folios 14, 15.
2. With thanks to Professor O. P. Bleker.
3. Hofstede de Groot 1907–28, vol. 1, p. 340.

PHILIPS KONINCK

AMSTERDAM 1619–1688 AMSTERDAM

Philips Aertsz. Koninck was born on November 5, 1619, the sixth son of the goldsmith Aert de
Koninck. His older brother Jacob (1614/15–after 1690) and his cousin Salomon (1609–1656) were
also painters. Around 1637, Philips was apprenticed to his brother Jacob in Rotterdam. There,
on January 1, 1641, he married Cornelia Furnerius, the daughter of a Rotterdam barber-surgeon
and organist and the sister of Abraham Furnerius (ca. 1628–1654). Furnerius was a follower
of Rembrandt; his drawing style bore a resemblance to that of Koninck. In the same year or in 1642,
Koninck moved back to Amsterdam, where in 1642 his young wife died. On May 16, 1657, he
married Margaretha van Rijn, who bore him a son and four daughters. A document of 1687 men-
tions Koninck as the owner of a boat service operating between Amsterdam and Leiden and
Rotterdam. He also owned a tavern and his wife was the proprietor of the ferry service to Gouda.
Thus, Koninck was financially independent and could afford to paint only as a hobby. He belonged
to the well-to-do bourgeoisie and counted among his friends several prominent citizens, such
as the celebrated poet Joost van den Vondel. In 1658, Koninck was living on Prinsengracht; later he
moved to Leidsegracht and at the time of his death in 1688 he was living on Reguliersgracht. He
was buried on October 6, 1688.

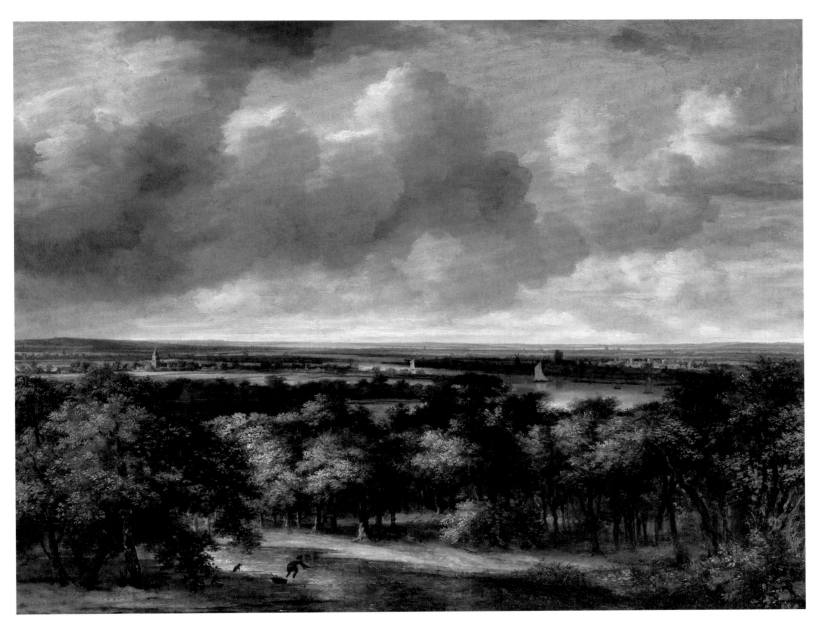

CATALOGUE 34. *Panoramic Wooded River Landscape*, ca. 1650. Oil on canvas,
23 5/8 × 30 3/8 inches (60 × 77 cm).

Houbraken stated that Koninck was a pupil of Rembrandt.[1] While his work does indeed show a number of Rembrandtesque elements, there is no archival evidence to support Houbraken's claim. Koninck's early landscapes above all are strongly influenced by Rembrandt. It seems certain that the two artists were friends in the 1650s. In 1658/59, Koninck asserted that seven years earlier Rembrandt had given him a string of pearls as a gift.[2] The landscapes of Hercules Seghers (1589/90–1633/38) also seem to have influenced Koninck.

Philips Koninck was highly respected in Amsterdam. He was regularly consulted in disputes about the authenticity of paintings. The fact that in 1667 Cosimo III de' Medici, grand duke of Tuscany, acquired a self-portrait by Koninck for his gallery of self-portraits in Florence shows that the artist had also made his name elsewhere. During his lifetime, he enjoyed a great reputation as a painter and draftsman of genre scenes and portraits. Today, he is chiefly admired for his landscapes: his drawn and painted panoramas made an important and original contribution to Dutch landscape art of the seventeenth century.

Literature: Gerson 1936; Sumowski 1983, vol. 3, pp. 1530–1626; Zadelhoff 2000, pp. 183–84.

CATALOGUE 34

PANORAMIC WOODED
RIVER LANDSCAPE

THE HIGH POINT OF VIEW in Philips Koninck's painting provides a broad panorama of a typically Dutch, almost flat, landscape. The foreground is largely taken up by a wood with a river where a solitary figure, accompanied by his dog, is fishing. A little more toward the middle, on the other side of the water, a cart track runs through the wood; farther up a woman walks along it. Sunlight sweeps over the foliage of the trees and at the same time creates a clear strip in the wood from which individual tree trunks stand out. Above the trees stretches an extensive river landscape: to the right on the horizon is a town partly shining in the sun while to the left is a church tower amidst several houses. The river winding its way toward the horizon is a characteristic feature of Koninck's landscapes. Several boats with white sails enliven the water. Horizontal bands, alternately in the sunshine and in shadow, give the landscape a convincing effect of depth. Above the horizon, which shows a somewhat uneven terrain, a light band of sky clearly marks the division between land and sky. Above the band is an imposing, impasto-painted, cloudy sky. The slightly pink hue of the clouds, especially on the left side of the sky, may be a sign of approaching sunset. It gives the painting an almost charged atmosphere. The many dark shades of grayish-green, gray, and brown together with the cloudy sky create a slightly dramatic effect. It is exceptional for the sky to be so well preserved; in many other paintings by Koninck the sky is often badly worn. While vistas of this kind can still be found in the Netherlands, mainly in the eastern part, here as in most of his landscapes, Koninck has not depicted a specific location.

Koninck's earliest known landscapes, painted around the mid-1640s, clearly show the influence of Rembrandt's landscapes of 1638–40. Some of these early pieces were even attributed to Rembrandt for a long time. Towards 1650, Koninck began to develop more of a style of his own, which culminated in a series of majestic panoramas around the mid-1650s. The upper half of this painting already looks forward to those monumental landscapes. The influence of Rembrandt is scarcely present here, whereas the panoramic element, so characteristic of Koninck's work a few years later, is already visible. Thus, this painting probably dates from around 1650. Both in composition and in painting manner, there are similarities with *Landscape with a Town on a Hill* (Museum Oskar Reinhart, Winterthur), which is dated 1651.[3]

Provenance: George, Second Duke of Sutherland, Stafford House, London, by 1844; George, Third Duke of Sutherland, Stafford House, London; with Thomas Agnew & Sons, London, 1921–26; with A. S. Drey, Munich, 1930; Dr. H. Burg, Haarlem, by 1935; anonymous sale, London (Christie's), January 29, 1954, no. 98 (£400 to F. Sabin); with Edward Speelman, London; The British Rail Pension Fund, London; sale, London (Sotheby's), July 3, 1996, no 69; acquired from Noortman Master Paintings, Maastricht, in 1997.

Exhibitions: The British Institution, London, *Exhibition of the Works of Ancient Masters and Deceased British Artists*, 1859; Royal Academy, London, *Exhibition of the Works of the Old Masters, Associated with A Collection from the Works of Charles and Robert Leslie, R. A., and Clarkson Stanfield, R. A.*, 1870; Royal Academy, London, *Exhibition of Works by the Old Masters and by Deceased Masters of the British School, Winter Exhibition*, 1876; on loan to Barnard Castle, Bowes Museum, 1977–85; Thomas Agnew & Sons, London, *Thirty-five Paintings from the Collection of the British Rail Pension Fund*, 1984; on loan to the Fitzwilliam Museum, Cambridge, 1985–94.

Literature: Jameson 1844, p. 206; Waagen 1854, p. 70 ("we here see a rich plain, with a river winding through it; of astonishing depth and power, with the most brilliant effect of light"); *Exhibition of Works of the Ancient Masters and Deceased British Artists* 1859, p. 11, no. 77; *Exhibition of the Works of the Old Masters and by Deceased Masters of the British School* 1870, p. 14, no. 138; *Exhibition of Works by the Old Masters and by Deceased Masters of the British School* 1876, p. 19, no. 147; Gerson 1936, pp. 18, 108–109, no. 45, ill. pl. 3; Sumowski 1983, vol. 3, pp. 1533, 1546, no. 1051, ill. p. 1601; *Thirty-five Paintings from the Collection of the British Rail Pension Fund* 1984, p. 20, no. 13.

Notes:
1. Houbraken 1718–21, vol. 2, p. 53.
2. Bredius 1885, pp. 85–107.
3. Gerson 1936, cat. no. 60.

JAN LIEVENS

LEIDEN 1607–1674 AMSTERDAM

Jan Lievens was born in Leiden on October 24, 1607; he was the son of the hat-maker Lieven Hendricxz. According to the city's biographer Jan Orlers, his talents were soon recognized and he was given his first painting lessons at the age of eight by the still-life painter Joris van Schooten (ca. 1587–ca. 1653).[1] Later, he was taught in Amsterdam by the history painter Pieter Lastman (1583–1633). From 1625 to 1631, he worked closely with Rembrandt in Leiden. From 1632 to 1634, Lievens was in England and from 1635 he lived in Antwerp, where he became a member of the local guild. It was there in December 1638 that he married Susanna de Nole, the daughter of the eminent sculptor Andries de Nole the Elder (1598–1638). In December 1640, Lievens acquired civil rights in Antwerp. Despite securing various commissions, he got into financial difficulties and in 1643 his possessions were seized. In January 1644, his son Jan Andrea (1644–1680), who would also become an artist, was baptized in Antwerp. By March of that year, Lievens had moved back to Amsterdam, where shortly afterward his wife died. In the following years, he obtained many important commissions in Amsterdam, The Hague, Berlin, and Leiden from, among others, Amalia van Solms, the widow of *Stadholder* Frederik Hendrik, and the city of Amsterdam. On August 2, 1648, he married Cornelia de Bray, the daughter of an Amsterdam notary. Between 1654 and 1658, he lived in The Hague, where in 1656 he was one of the founders of the *Confrérie Pictura*, the local fraternity of painters and connoisseurs. In March 1659, he moved back to Amsterdam and then to Leiden. In February 1674, Lievens again settled in Amsterdam, where on June 4 he died – in poverty, despite his many significant commissions.

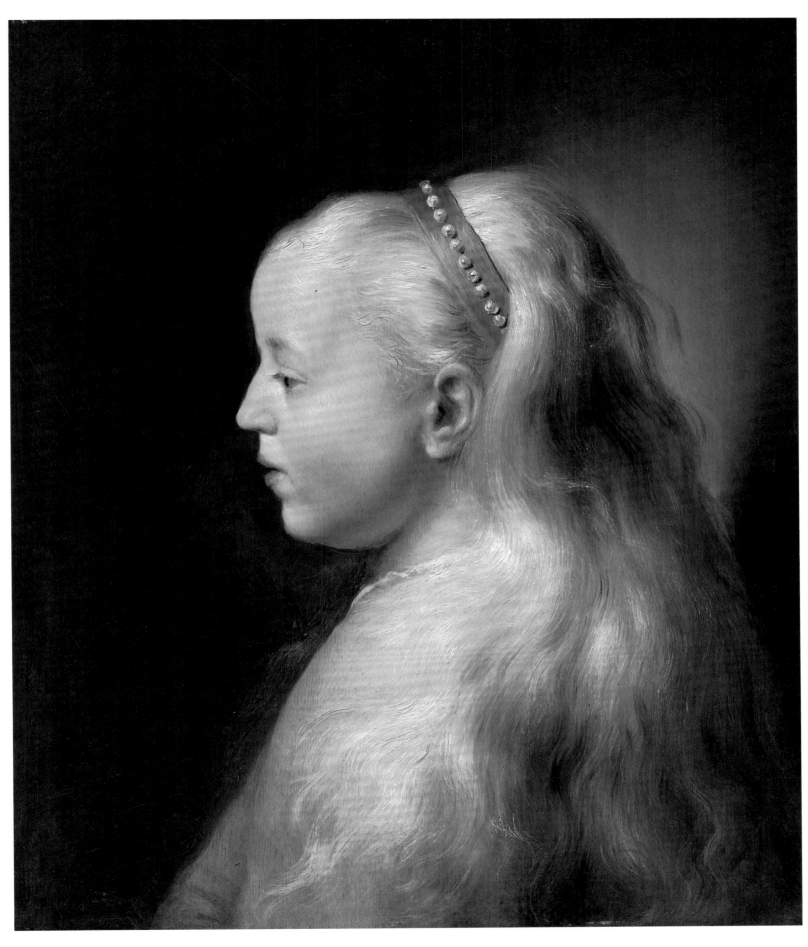

CATALOGUE 35. *Young Girl in Profile*, ca. 1631–32. Oil on panel, 17 3/4 × 15 inches
(45 × 38.3 cm). Signed lower left: *L*

One of the first to recognize the talents of the young Lievens was the poet and connoisseur Constantijn Huygens. In the unfinished autobiography he wrote between 1629 and 1631, he praised Lievens in the same breath as Rembrandt. Orlers also had high praise for Lievens in his *Beschrijvinge der Stadt Leyden* of 1641.[2]

Lievens was an extraordinarily versatile artist. He painted portraits, history pieces, biblical scenes, genre scenes, and landscapes. In addition, he was very active as a draftsman and graphic artist. Initially, his work showed great affinity with that of Rembrandt. In Antwerp, he was strongly influenced by Peter Paul Rubens (1577–1640) and Anthony van Dyck (1599–1641), as is seen especially in his portraits. In the same period, he also began painting landscapes that reveal the influence of Adriaen Brouwer (1605/1606–1638). After his return to Holland, he concentrated on portraits and large-scale history pieces and allegorical scenes. Lievens's drawn oeuvre in various techniques consists mainly of portraits, which also show the influence of Rubens and Van Dyck, and landscapes.

Literature: Schneider 1932; Schneider and Ekkart 1973; *Jan Lievens, Ein Maler im Schatten Rembrandts* 1979; Sumowski 1983, vol. 3, pp. 1764–1950; *Jan Lievens: A Dutch Master Rediscovered* 2008–2009.

CATALOGUE 35

YOUNG GIRL IN PROFILE

IN ADDITION TO PAINTING, drawing, and etching formal portraits with great success almost to the end of his career, Jan Lievens took a keen interest in *tronies* (studies of heads and facial expression). He made a great many of these studies, particularly between 1625 and 1631 in Leiden when he worked closely with his friend Rembrandt and may even have shared a studio with him for some time. Just like Rembrandt, the young Lievens not only painted such studies but also drew and etched them. Around 1635, a series of such etchings by Lievens was published under the title *Diverse Tronikens geetst van IL*. Although artists often used models for this sort of work, the aim was not to produce the best possible likeness. What mattered was to portray certain characters, moods, or expressions convincingly.

Figure 1. Jan Lievens, *Portrait of a Young Woman with Her Hair Down*, 1632–34. Oil on panel, 17 × 13 3/4 inches (43 × 35 cm). Museum der Bildenden Kunst, Leipzig.

Figure 2. Jan Lievens, *Portrait of a Young Woman, Looking to the Right*, ca. 1628–31. Etching, 6 3/8 × 5 5/8 inches (16.2 × 14.3 cm). Städel Museum, Frankfurt, Graphische Sammlung.

Lievens painted this *Young Girl in Profile* at the end of his time in Leiden, around 1631–32. It is one of his finest *tronies*. The identity of the girl is not known but there is no doubt that Lievens used a model because the same girl appears in a second study of about the same time (figure 1).[3] This latter study was already described as a *tronie* in an inventory of 1641.[4] In that panel of roughly the same size, the girl wears the same red hair band set with pearls. An etching by Lievens from the same period probably shows the identical model (figure 2).[5] Just as in the two other studies, the girl's long blond hair is a prominent feature. Lievens depicted her hair with great skill: here and there he scratched in the wet paint with the point of his brush to make it appear more true to life. Around the face, the hair is pulled back tightly by the hair band, but from there it tumbles like a steadily widening waterfall down her shoulders and back. Along with her face, it stands out against the predominantly dark background. Here, precisely because Lievens depicted the girl in profile, the emphasis is entirely on her face and golden hair, which gleam in the soft light. Lievens employed a limited palette: apart from the gold of the hair and the red of her hair band and lips, the colors are mainly restricted to the flesh tones of the face.

Provenance: Baron von Bussche-Hünefeldt, Osnabrück, his sale, Amsterdam (Van de Schley/Yver), June 20, 1810, lot 42 ("Een jong bevallig Meisje, meesterlijk geschilderd op panel, door J. Lievens, Hoog 18, breed 15 duimen") (sold for fl. 1,–); Bernard Hausmann (1784–1873), Hanover-Linden; George V, king of Hanover (1797–1857) (his collector's mark, crowned GRV, on the reverse of the panel); Herzog von Braunschweig, by 1902 (inv. no. 281), sale ("Gemälde aus der ehemaligen Galerie eines Deutschen Fürstenhauses"), Berlin (Lepke), March 31, 1925, no. 38 (as "Ein Osnabrück'sches Landmädchen . . .") (sold for mk. 7,500); Dr. James Simon, Berlin, his sale, Amsterdam (Fred. Muller), October 25, 1927, no. 27; Guttmann Collection, Berlin, ca. 1927; Bett family, and thence by descent; sale, London (Bonhams), December 6, 2006, no. 85; acquired from David Koetser, Zurich, and Galerie Neuse, Bremen, in 2007.

Exhibitions: On loan to the Provinzialmuseum, Hanover, after 1886 and 1905 (cat. no. 207); The Matthiesen Gallery, London, *Rembrandt's Influence in the 17th Century*, 1953; on loan to the Fitzwilliam Museum, Cambridge, 1990–2006; National Gallery of Art, Washington, Milwaukee Museum of Art, and Rembrandthuis, Amsterdam, *Jan Lievens; A Dutch Master Rediscovered*, 2008–2009.

Literature: Probably *Führer durch die Museen in Hannover und Herrenhausen*, Hanover [after 1886], p. 18 (in Old Masters, 5th Cabinet, as "Jan Livens, Brustbild eines jungen Mädchens"); probably *Ein Gang durch die Cumberland-Galerie in Hannover* [after 1886], p. 7 (in Old Masters, 5th Cabinet, as "Jan Livens, Brustbild eines jungen Mädchens"); Six 1919, p. 86; Schneider 1932, p. 142, cat. no. 216; *Rembrandt's Influence in the 17th Century* 1953, cat. no. 47; *The Connoisseur* 1953; *The Illustrated London News* 1953; Plietzsch 1960, p. 177; Schneider and Ekkart 1973, pp. 142, 332, cat. no. 216; Sumowski 1983, vol. 3, p. 1805, under no. 1275; Foucart 1996, p. 78, ill.; *Jan Lievens: A Dutch Master Rediscovered* 2008, pp. 136–37, 291, cat. no. 28, ill.

Notes:
1. Orlers 1641, pp. 375–77.
2. Huygens 1897, pp. 76 ff; Orlers 1641, pp. 375–77.
3. Schneider and Ekkart 1973, cat. no. 217.
4. Blaukert in *Rembrandt: A Genius and His Impact* 1997, pp. 216–19, n. 1.
5. Hollstein 1949–, vol. 11, no. 43.

NICOLAES MAES

DORDRECHT 1634–1693 AMSTERDAM

Nicolaes Maes was born in January 1634 in Dordrecht, the son of the wealthy merchant Gerrit Maes. According to the biographer Arnold Houbraken of Dordrecht, he was taught drawing by "an ordinary master" before he became a pupil of Rembrandt in the late 1640s or early 1650s.[1] By December 1653, Maes had moved back to Dordrecht and on January 31 of the following year he married Adriana Brouwers, the widow of a minister. In 1658, Maes bought a house on Steechoversloot. In the Dordrecht municipal archives, Maes is recorded as a merchant as well as a painter. According to Houbraken, Maes traveled to Antwerp, around the mid–1660s it is thought, to see the work of leading Flemish masters such as Peter Paul Rubens (1577–1640) and Anthony van Dyck (1599–1641). Maes lived in Dordrecht until 1673, when he moved to Amsterdam. He died in Amsterdam in 1693 and was buried in the Oude Kerk on December 24.

Maes is considered one of Rembrandt's most important pupils. Initially, he painted biblical scenes that clearly show the influence of his master. Around 1654, he began painting domestic scenes with one or two figures, and a year later he tried his hand at portraits. Apparently, his genre scenes were not a great success, because from 1659 onward he concentrated entirely on painting elegant portraits that show the influence of Van Dyck above all. The difference in style between his genre scenes and his portraits is so marked that it was sometimes previously thought that they could not be by the same hand.

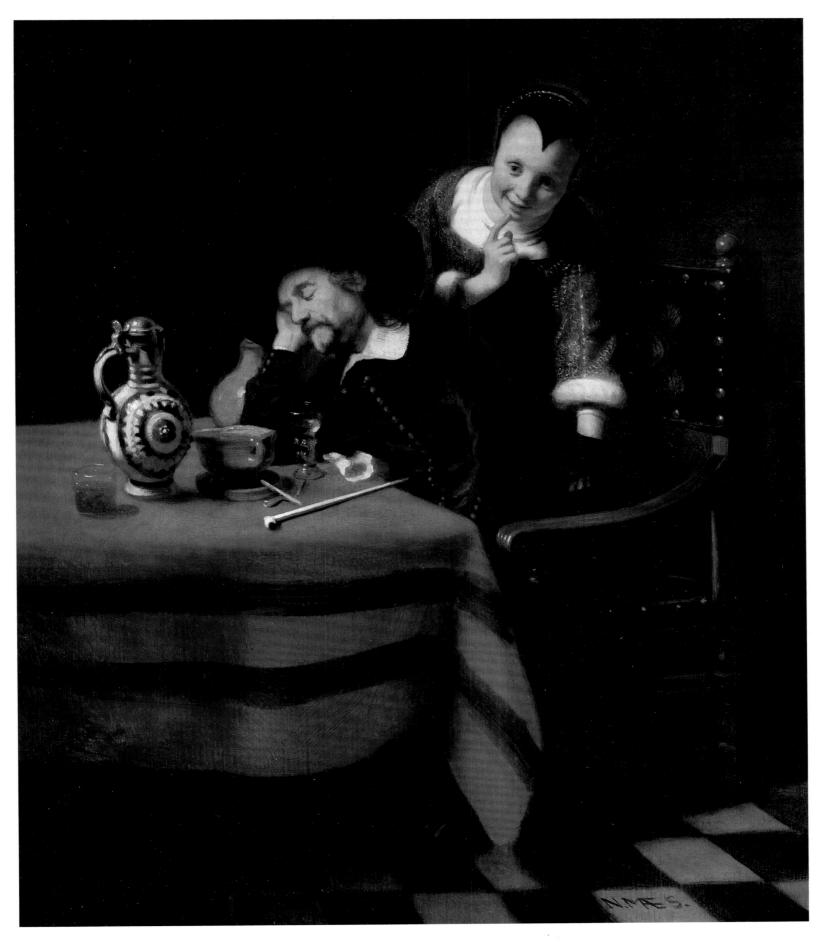

CATALOGUE 36. *Sleeping Man Having His Pockets Picked*, ca. 1655. Oil on panel, 14 × 12 inches (35.5 × 30.3 cm). Signed lower right: *N.MAES.* (*MAE* in ligature)

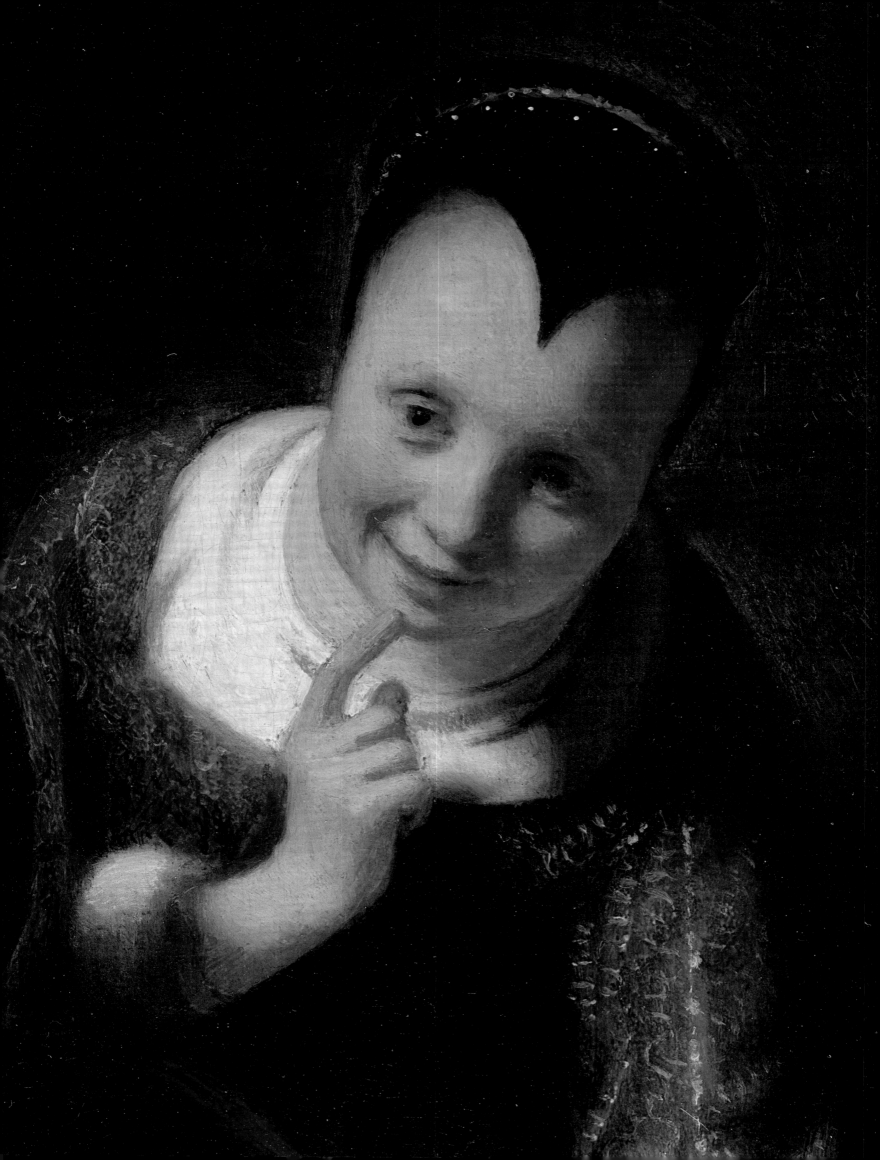

DETAIL OF
CATALOGUE 36

In his day, Maes was most successful with his portraits, but at present his genre scenes are more highly regarded, in part because he made important innovations in this field. His intimate domestic scenes, partly inspired by Rembrandt's chiaroscuro, were a source of inspiration for Pieter de Hooch (1629–1684) and Johannes Vermeer (1632–1675).

Literature: Hofstede de Groot 1907–28, vol. 6, pp. 473–605; Valentiner 1924; Sumowski 1983, vol. 3, pp. 1951–2174; W. W. Robinson 1996; Krempel 2000.

CATALOGUE 36

*SLEEPING MAN
HAVING HIS POCKETS
PICKED*

IN A ROOM WITH A BLACK-AND-WHITE TILED FLOOR and a map on the right-hand wall, a young woman uses her left hand to pick the pockets of a man who has nodded off in his armchair at the table. On the table, two earthenware jars, two half-empty glasses, a rummer (large drinking glass) and a beer glass, two clay pipes and spent matches, and a twist of paper with tobacco seem to suggest that tobacco and alcohol are the cause of his sleepiness. The artist has left us in the dark as to who used the second glass – the young woman or a guest who has left. The woman looks at the viewer somewhat mischievously and places her right index finger on her lips to signal for silence. The painting corresponds closely to six other genre scenes by Nicolaes Maes in which the main figure asks for silence or secrecy with an almost identical gesture, and thus involves the viewer in the scene as if sharing a secret. Each of these other paintings concerns an eavesdropper – a woman or in one case a man – who stands on or near a staircase and spies on or listens to a pair of lovers or a scolding housewife in a room some distance away. Maes painted these scenes at the beginning of his career in the years 1655 to 1657. Four of these paintings are dated 1655, 1656, or 1657. This panel appears to be among the earliest in the series. This is confirmed by the form of the signature, which he used only through 1656. The source of inspiration for these scenes probably lay in a work of the little-known painter Isaack Koedijck (catalogue 33) that was lost in a shipwreck in the eighteenth century but is known through a watercolor copy by Willem Joseph Laquy (1738–1798) in the Amsterdams Historisch Museum, Amsterdam. It shows an interior with a young man on a spiral staircase who asks for silence with his finger on his lips while a view toward the cellar shows a young man fondling a maid indecently. The arrangement of space and the theme of Koedijck's painting so closely resemble Maes's eavesdroppers that it may be said that Maes almost certainly must have known it. Koedijck painted the work around 1650 in Amsterdam when Maes was a pupil of Rembrandt in the same city.

While the present painting is entirely in line with Maes's group of genre scenes with eavesdroppers in various respects, there is a difference. Judging by their clothing and aprons, the women in the eavesdropper series can be characterized in most cases as maidservants, whereas the woman here with her fur-trimmed coat seems too expensively dressed for that. Is she the wife of the dozing husband trying to warn him playfully about the dangers of excessive drinking and smoking? Is she a guest taking advantage of the situation? In either case, the scene holds a moralizing message for the viewer.

The painting has also been linked to popular themes in the art of the fifteenth, sixteenth, and seventeenth centuries such as mismatched lovers and brothels where young prostitutes rob their clients. The room that Maes has painted here suggests an ordinary house rather than a brothel, while the young lady looks far too elegantly dressed for a woman of easy virtue. Other conventional indications such as a deep décolletage or a bed in the background are also missing.

The subdued palette characteristic of Maes with warm reds and browns and accents in white and black heightens the intimacy of the scene. His eye for detail found expression splendidly in the still life on the table, the texture of the man's velvet jacket, the silk coat embroidered in gold and trimmed with fur, and the wooden chair with leather covering.

For a long time, *Sleeping Man Having His Pockets Picked* led an almost hidden existence. For nearly 150 years, it hung in a castle in Wales. It was first exhibited in 1952 and reproduced for the first time only in 1984.

Provenance: Prince Eugene of Savoy, Vienna; Admiral Lord Radstock, his estate sale, London (Christie's), May 13, 1826, no. 13 (£111,6s to Baker); James B. Baker, London, his estate sale, London (Christie's), May 14, 1855, no. 98 (£115,5s to Nieuwenhuys); probably J. T. Dorington, 1863; possibly General Phipps (according to Douglas-Pennant 1902, under cat. no. 37); Edward Douglas-Pennant, First Baron Penrhyn of Llandegai, Penrhyn Castle, 1855; by inheritance to Hugh Napier Douglas-Pennant, fourth Baron Penrhyn, Penrhyn Castle; by inheritance to Lady Janet Harpur, née Pelham, Penrhyn Castle; Edward, Lord Penrhyn, Penrhyn Castle/Mortimer House, Bangor, by ca. 1865 (see Douglas-Pennant 1902, cat. no. 37); Lady Janet Douglas-Pennant, Bangor, North Wales, until 2002; acquired from Johnny Van Haeften Ltd., London, in 2002.

Exhibitions: Royal Academy of Arts, London, *Dutch Pictures 1450–1750, Winter Exhibition*, 1952–53.

Literature: Smith 1829–42, vol. 4, p. 246, no. 14; Douglas-Pennant 1902, cat. no. 37; Hofstede de Groot 1907–28, vol. 6, p. 505, no. 102; Valentiner 1924, p. 10; *Dutch Pictures 1450–1750* 1952–53, p. 96, cat. no. 513; Plietzsch 1953, p. 131; Sumowski 1983, vol. 3, p. 2015, no. 1344, ill. p. 2070; Sutton 1984, pp. 48–49, ill. fig. 92; *Masters of Seventeenth-Century Dutch Genre Painting* 1984, p. 366, cat. no. 66 n. 2; W. W. Robinson 1987, p. 289, fig. 7, pp. 291–97; W. W. Robinson 1996, pp. 167, 245, no. A-19, ill. fig. A–19; Krempel 2000, pp. 33, 49, 362, no. D39, ill. fig.16.

Notes:
1. Houbraken 1718–21, vol. 2, pp. 273–74.

GABRIËL METSU

LEIDEN 1629–1667 AMSTERDAM

Little is known about Gabriël Metsu. He was born in Leiden between November 27 and December 14, 1629, some months after the death of his father, the Flemish painter Jacques Metsue (1587/89–1629). Gabriël must have been a precocious painter because in 1644, when he was only fourteen or fifteen, he was already included in a list of thirty Leiden artists, art lovers, and dealers in the *Schilder-Schultboek*, a sort of cash book for transactions between artists. It is not known who taught him. From 1648 on, he was a member of the St. Luke's Guild, which had just recently been founded. According to the guild books, he lived briefly elsewhere, probably in Utrecht, around 1650–52. In 1657 or earlier, he left Leiden for Amsterdam, where in July 1657 he moved into a house on Prinsengracht. On April 12 of the following year, he married Isabella de Wolff, who was related on her mother's side to the Haarlem painter Pieter de Grebber (1600–1652/53). Not long afterward, on January 9, 1659, Metsu obtained civil rights in Amsterdam. On July 22, 1664, he and his wife made their wills. According to Houbraken, the Rotterdam portrait and genre painter Michiel van Musscher (1645–1705) was a pupil of Metsu for a short time in 1665.[1] Metsu died in 1667, at only age thirty-seven. At that time, he was living "at the beginning of Leysestraet." He was buried in the Nieuwe Kerk on October 24.

Metsu painted mainly genre scenes, but his early work also included market scenes and religious subjects; a few still lifes and portraits are also credited to him. Only a few drawings are extant. A chronology of his work is rather difficult to establish because he rarely dated his paintings. After 1650, the somewhat broader brushwork betrays the influence of the Utrecht painters Nicolaes Knüpfer (ca. 1609–1655) and Jan Baptist Weenix. His genre scenes reflect the influence of Gerrit Dou, Nicolaes Maes, Jan Steen, and Gerard ter Borch (1617–1681). His work was already greatly admired during his lifetime, but his reputation reached its zenith in the eighteenth century and many of his paintings were acquired by leading, often royal, European collectors.

Literature: Hofstede de Groot 1907–28, vol. I, pp. 253–335; F. W. Robinson 1974; Waiboer 2005, pp. 80–90.

IN A HUMBLE ROOM, an old woman sits eating porridge from a glazed earthenware pot, which she holds obliquely on her lap with her left hand. She blows at her spoonful of porridge to cool it and spills a little. She appears lost in thought. Keeping her company, a spotted cat at her feet stares into space. On the wooden floor lie a shoe and a large overturned glazed earthenware cooking pot, a so-called *grapen*, with a ladle. The woman leans with her right elbow on a table partly laid with a white tablecloth on which is the rest of her modest meal: a dish, a bowl, loaves, a cheese, and a lidded stoneware tankard. The light streaming in through the open window is reflected by various objects, such as the tankard, the *grapen*, the ladle, and the pot. Several reflections also appear in the leaded window above the table and in the broken pane at the bottom. Through the open window is an ivy plant with one branch that hangs inside. The room is extremely simply furnished, with an open wall cupboard and a shelf with a few objects on the wall.

In the fairly monochrome and transparently painted room, the woman rendered in much thicker paint stands out handsomely with her white cap, white collar, blue apron, and red petticoat. The same applies to the still life on the table and the cat and objects on the floor. The scene offered Metsu every opportunity to demonstrate his outstanding technique: the beautifully observed still life on the table, the play of light and dark, and the rendering of the different surfaces such as the glaze of the *grapen*, the soft fur of the cat, and the wrinkled face and hands of the old woman.

The panel was probably painted around 1656–58, when Metsu had been living in Amsterdam for a number of years. The subject, however, came from Leiden. Gerrit Dou introduced the theme of an old woman eating porridge in a humble room around 1632–35 (Diethelm Doll Collection, Bad Godesberg, Germany), and several of his Leiden followers, such as Dominicus van Tol (ca. 1635–1676) and Quiringh Gerritsz. van Brekelenkam (after 1622–ca. 1669) adopted it.[3] Particularly close to the present painting is Van Brekelenkam's *Old Woman at Table* of 1654 (Staatsgalerie im Neuen Schloss Bayreuth), which depicts an old woman, sitting beside a table with bread and cheese, who blows at her spoon and spills some of her porridge; on the floor lie slippers and an earthenware cooking pot with a ladle. Frans van Mieris the Elder, Dou's most important pupil, had painted a few humble interiors with older women and men having a modest meal slightly earlier than Metsu. Metsu himself had already treated this subject in a larger format (figure 1). In that work, as in the present one, a cat is the old woman's only company. For these paintings, Metsu may also have drawn inspiration in Amsterdam from Nicolaes Maes, who had painted a somewhat related piece shortly before (Rijksmuseum, Amsterdam). It shows a humble interior with an old woman wearing a white cap and white collar who has folded her hands before eating her porridge and the rest of the meal.

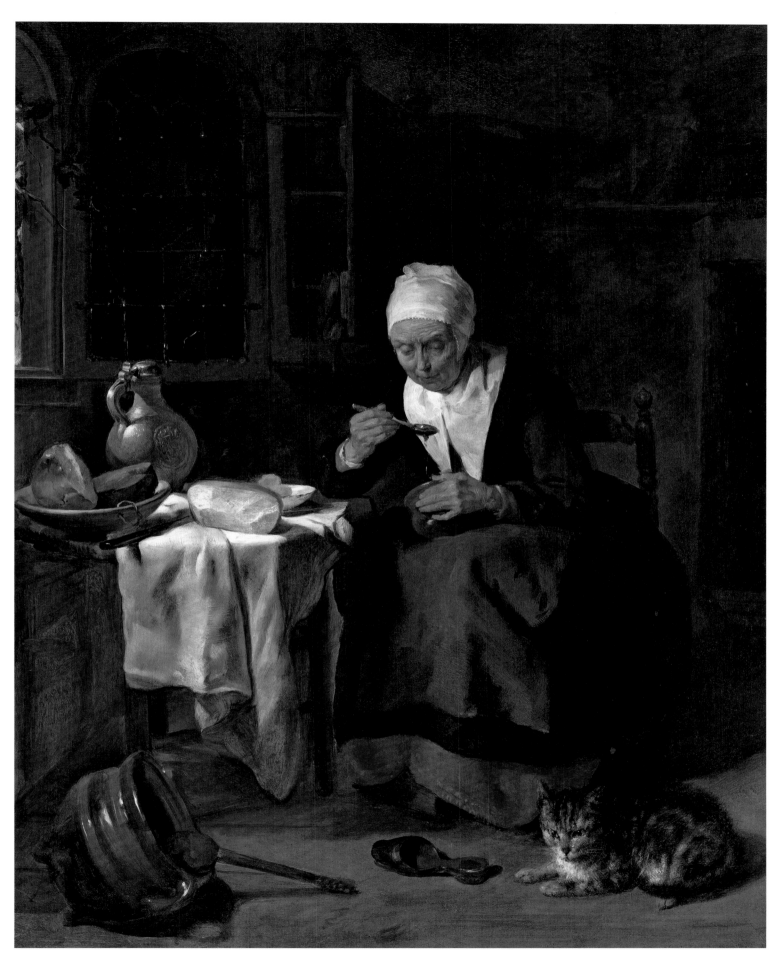

CATALOGUE 37. *Old Woman Eating Porridge*, ca. 1657.[2] Oil on panel, 14 × 11 inches (35.5 × 28 cm).
Signed top center on the closet: *Gmetsú* (*Gm* in ligature).

Other painters, Gerrit Dou in particular, may have influenced Metsu in this composition. In the second half of the 1640s, Dou painted *Old Woman Praying Before a Meal* (see Dou, figure 1). Once again, the setting is a humble room with an open, round-topped window; a dog instead of a cat is at the woman's feet.

Metsu's painting and these related works generally held symbolic significance for the seventeenth-century viewer: elderly women in their humble setting with a simple meal embodied such virtuous qualities as frugality and modesty, and simultaneously alluded to the transitory nature of life. In the present painting, religious references are less prominent than in the scenes of old women at prayer, but the atmosphere remains one of contemplation and reflection.

At various points, such as the left-hand loaf, the underdrawing is visible. Originally, Metsu painted a second slipper on the floor.

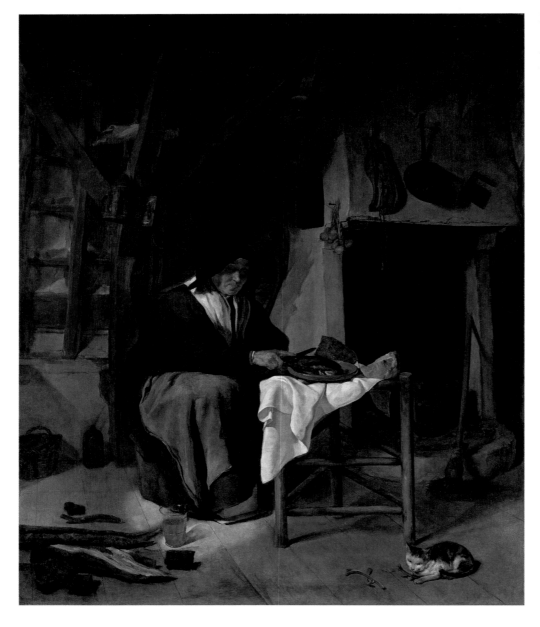

Figure 1. Gabriël Metsu, *Old Woman at Her Meal in an Interior*, date unknown. Oil on canvas, 32 1/4 × 27 1/4 inches (81.9 × 69.2 cm). Private Collection, New York.

Provenance: Probably Jacob Schardinell, Amsterdam, widower of Agneta Fonteyn, inventory of his estate, August 5 et seq., 1684 ("Een besje dat pap eet van Gabriël Metsu"); Antoni Bierens, Amsterdam, inventory of his estate, February 17, 1747, his sale, Amsterdam (De Stoppelaar), July 20, 1747, no. 3 (sold for ƒ590,–); Jacob Bierens, Amsterdam, by 1752; Mrs. Bierens de Haan, Amsterdam, by 1842, thence by descent to David Bierens de Haan, his estate sale, Amsterdam (Muller), November 15, 1881, no. 12 (ƒ13.000 to Sedelmeyer Gallery, Paris); E. Secrétan, 1881 (bought for ffr. 36.000), his sale, Paris (Chevalier, Aulard), July 1–4, 1889, no. 143 (ffr. 80.000 to Thomas Agnew & Sons, who bought the painting for Guinness and sold it to him for £3528; Sir Edward C. Guinness, Bt., later baron, viscount, and earl of Iveagh, Elveden Hall, Suffolk and Kenwood House, London, 1889; sold by his heirs to Noortman Master Paintings, Maastricht; private collection, London; acquired from Noortman Master Paintings, Maastricht, in 2009.

Exhibitions: Royal Academy, London, *Exhibition of Works by the Old Masters and by Deceased Masters of the British School*, 1891; Sedelmeyer Gallery, Paris, *Exhibition of 300 Paintings by Old Masters of the Dutch, Flemish, Italian, French and English Schools . . .* , 1898; Museum Boijmans Van Beuningen, Rotterdam, and Städelsches Kunstinstitut and Städtische Galereie, Frankfurt, *Zinnen en Minnen: Schilders van het dagelijkse leven in de zeventiende Eeuw*, 2004–2005.

Literature: Hoet 1752, p. 199, no. 522 (as in the collection of Jacob Bierens: "Een oud Vrouwtje zittende te Eeten, aan een Gedekte Tafel, daar by een Katje, door *G. Metzu*, br. 1 v., h. 1 v. 3 d. [11 1/8 × 14 3/16 inches (28.3 × 36 cm), note that width precedes height]"); Descamps 1753–54, p. 245 ("Chez M. Bierens, une vieille Femme à table"); *Exhibition of Works by the Old Masters and by Deceased Masters of the British School* 1891, p. 23, cat. no. 96; *Exhibition of 300 Paintings by Old Masters* 1898, p. 106, no. 90, ill. p. 107; Smith 1829–42, vol. 4, p. 518, no. 4; Von Würzbach 1910, p. 150; Hofstede de Groot 1907–28, vol. 1, pp. 291–92, no. 134; Kronig 1909, no. 144, p. 222; Holmes 1928, p. 15, pl. 17; F. W. Robinson 1974, p. 34, fig. 59; Bénézit 1976, p. 359; *Zinnen en Minnen* 2004–2005, pp. 210–12, no. 58, ill.; Spaans 2009, p. 14, ill.; Adriaan E. Waiboer, Metsu catalogue raisonné (forthcoming), cat. no. A 27.

Notes:
1. Houbraken 1718–21, vol. 3, p. 211.
2. On the verso is the red wax seal of Sedelmeyer Gallery, a seal of the Royal Academy exhibition of 1891 (partially torn off), and a seal with the inscription: *Gabriël Metsu/(Le Déjeuner.) /"Breakfast"/Secritain Sale. No. 143./Bought by Thos. Agnew & Sons./for Sir E.C. Guinness Bart./July 2nd 1889.*
3. The present whereabouts of the Van Tol is unknown; it is illustrated in F. W. Robinson 1974, pl. 60.

FRANS VAN MIERIS THE ELDER

LEIDEN 1635–1681 LEIDEN

Frans van Mieris was born on April 16, 1635; he was the son of the Leiden goldsmith Jan van Mieris (1585/86–1650). Frans was intended to follow in his father's footsteps. At age ten, he was apprenticed to Willem van Mieris, a great-nephew of Frans who was also a goldsmith. Then he became a pupil with the glass painter Abraham Toorenvliet (ca. 1626–1692), the Leiden genre painter Gerrit Dou, and the portrait and history painter Abraham van den Tempel (1622/23–1672). Before 1655, Van Mieris went back to Dou's studio. According to Houbraken in his *Groote Schouburgh*, Van Mieris was "the Prince of his pupils."[1] On May 14, 1658, Van Mieris was registered with the St. Luke's Guild of Leiden. He must have been working as an independent master for several years prior, as is shown by a series of paintings that are or can be dated earlier. In March or April 1657, he married Cunera van der Cock. The couple had two daughters and two sons, Jan (1660–1690) and Willem (1662–1747), who both became painters. In 1663 and 1664, Van Mieris held the post of warden in the guild, and that of dean in the following year. He lived his whole life in Leiden and died there at age forty-five on March 12, 1681. He was buried in the Pieterskerk.

Next to Gerrit Dou, Van Mieris was the most gifted and most successful of the Leiden *fijnschilders* (fine painters). In their meticulous and smoothly painted works, these artists aimed to achieve perfect rendering of textures. The oeuvre of Frans van Mieris consists mainly of small scenes from everyday life. In addition, he painted portraits and several history pieces. In the period 1657 to 1668, he created a series of masterpieces, but his later work is inferior in quality. Among his thirty known drawings are a number of studies for paintings. Like his teacher Dou, Van Mieris enjoyed great fame at home and abroad during his lifetime, and his paintings fetched exceptionally high prices. He secured important commissions from Grand Duke Cosimo III de' Medici and Archduke

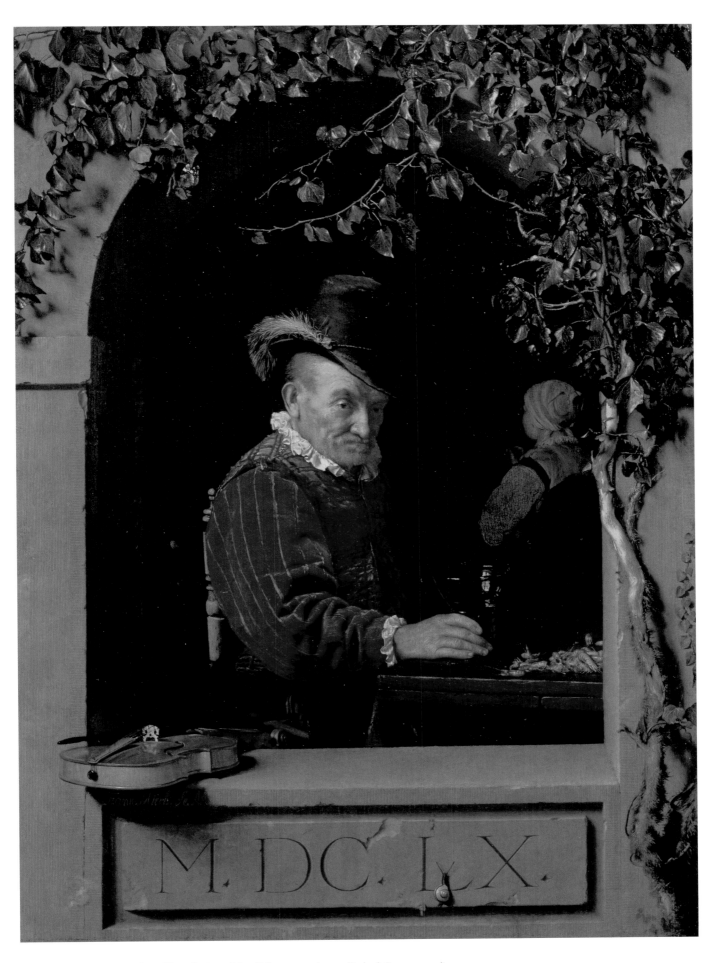

CATALOGUE 38. *The Old Violinist*, 1660. Oil on panel, 11 × 8 1/4 (28.1 × 21 cm).
Signed and dated lower center below the violin: *F. van Mieris.fe A°. | M. DC. LX.*

Leopold Wilhelm, who also offered him the post of court painter in Vienna. To distinguish him from his grandson, who had the same name and was also a painter, Frans van Mieris is always known as "the Elder." In addition to his two sons, the genre painter and portraitist Carel de Moor (1655–1738) was also a pupil of Van Mieris.

Literature: Hofstede de Groot 1907–28, vol. 10, pp. 7–9, 1–102; Naumann 1981; *Frans van Mieris 1635–1681* 2005–2006.

CATALOGUE 38

THE OLD VIOLINIST

AN OLD VIOLINIST with a beaker with prunts in his hand sits at a table by a stone window. He appears to be lost in thought. He is dressed in a handsomely finished outfit with a red velvet doublet, a brown smock, a white ruff, and a hat with a feather. He has laid his violin and bow on the window ledge next to him. Beside his glass on the table lie some shrimp, which were eaten as snacks in those days. A snail crawls upward over the "L" of MDCLX (1660) – the date of the painting – "carved" in Roman numerals in the stone. The trompe-l'oeil effect of the stone niche is strengthened by the occasional cracks and breaks, especially where the date has been chiseled. Ivy grows along the window; where the yellow pigment has faded, its leaves have turned somewhat blue. On one leaf at the upper left, an Atalanta butterfly has landed. In the back of the tavern stands a barmaid with her back to the violinist. On a blackboard, she keeps a note of how much each customer has drunk. Van Mieris's fantastic ability to convincingly depict materials and surfaces is seen here at its best in the soft velvet of the doublet, the reflecting glass, the feather in the hat, the cold stone of the window, and the shining violin. Van Mieris borrowed the motif of a stone window from Gerrit Dou, who was highly successful with an illusionistic niche; many of his pupils copied the theme. In his palette, however, Van Mieris was very different from his teacher: he used many bright and warm colors while Dou often preferred more subdued and somber hues.

The motif of keeping tabs on how much is drunk is also seen in a print with a drinking "philosopher" in Joost van den Vondel's *Gulden Winckel* of 1613. The accompanying verse urges moderation in drinking: "Here sits a wise man, he lets no more be tapped / until the midday meal, and then just three moderate measures." The philosopher evidently follows this advice for next to him stand three beakers on the table. Van Mieris seems have applied the motif of the woman turned away as a silent but critical commentary on the drinking of the old violinist. The ivy also fits with this interpretation: it was often depicted as one of the attributes of Bacchus, the Roman god of wine and the personification of excess. The image of the drinking violinist also elicited criticism in the eighteenth century, as shown by the verse accompanying a print after this painting by Cornelis van Meurs:

The wine makes me joyful today.
Let us empty the bottle, we have no cares.
A young girl will look after me.
By constantly writing down the glasses that I drink.

As can be clearly seen in raking light, Van Mieris first painted the scene without the frame of the window. Evidently, at a later stage he decided to enlarge the panel, which was originally semi-circular at the top, and to broaden it to a rectangular format with a niche in a wall and ivy growing up it. In another version, possibly by a studio assistant (Pushkin Museum, Moscow), a

panel with sufficient space for the window was chosen from the outset. The window was also adapted in ten later copies.

The earliest references to *The Old Violinist* make no mention of a pendant. Yet, a painting of an old woman selling lobsters perfectly matches this panel in composition and format. The quality of this possible pendant makes it clear that it is not autograph, but it may be a copy of a lost work by Van Mieris. It is also possible, however, that *Old Woman with Lobster* was painted only after the death of Van Mieris as a companion-piece to one of the many copies of *The Old Violinist*.

Provenance: Cornelis Wittert, Heer van Valkenburg, Rotterdam, his sale, Rotterdam (catalogue by Willis), April 11, 1731, no. 32 (800 florins); probably Jacob van Reygersberg, Heer van Couwerve, Middelburg, his sale, Leiden (Van der Eyk), July 31, 1765, lot 31 ("een geen minder kragtig en uitvoerig Kabinet-stukje, waar op een Man aardig gekleed met een Hoed op, en een Wijnroemer in de hand: achter hem een Meid die het gelag opneemt, dit alles is verbeeld in een Isje, op welke kant een Fiool ligt, langs de Nis is een klimop-boom, en verscheide Insectens daarin; verwonderlyk geschildert, door denzelven [Frans van Mieris, den Ouden, sic.]") (1100 fl. to Bisschop); Pieter and Jan Bisschop, Rotterdam, 1765–71 (collection sold en bloc to the Hope brothers in 1771 following the death of Jan Bisschop); Adriaan and John Hope, Amsterdam, 1771–81; John Hope, 1781–84; thence by descent to Hope (Hoop), Bosbeek, Heemstede, 1784–94; Henry Hope, London, 1794–1811; Henry Philip Hope, London, 1811–39 (temporarily Thomas Hope of Deepdene, London, 1819–31); Henry Thomas Hope, London, 1839–62; his widow, Adèle Bichat, London, 1862–84; Henry Francis Pelham-Clinton-Hope, London, 1884–98; with Colnaghi & Wertheimer, London, 1898; anonymous sale L. Neumann et al., London (Christie's), July 4, 1919, lot 9; with Knoedler Galleries, London, 1929; Leonard Gow, Camis Eskan, Dunbartonshire, his estate sale, London (Christie's), May 28, 1937, lot 100 (for £1120 to W. E. Duits); with M. Knoedler & Co., New York, before 1946 (no. A580); A. Brenninkmeijer Collection, The Netherlands, ca. 1946–ca. 1999; sold to Sotheby's New York and Anthony Speelman, London; where acquired in 2000.

Exhibitions: British Institution, London, *Exhibition of Pictures by Rubens, Rembrandt, Van Dyke and other Artists*, 1815; possibly British Institution, *An Account of All the Pictures Exhibited in the Rooms of the British Institution from 1813 to 1823*, London, 1824, no. 2; British Institution, London, *Exhibition of Pictures by Italian, Spanish, Flemish, Dutch, French and English Masters*, 1851; Manchester, England, *Art Treasures of the United Kingdom Collected at Manchester in 1857*, 1857–58; British Institution, London, *Exhibition of the Works of Ancient Masters and Deceased British Artists*, 1867; Royal Academy, London, *Exhibition of Works by the Old Masters and by Deceased Masters of the British School*, Winter Exhibition, 1881; on loan to the South Kensington Museum (now Victoria & Albert Museum), London, 1891–98 (cat. 1891, no. 26); Rijksmuseum, Amsterdam, *Tentoonstelling van Oude Kunst uit het Bezit van den Internationalen Handel*, 1936; Museum of Fine Arts, Boston, *Poetry of Everyday Life: Dutch Painting in Boston*, 2002; Mauritshuis, The Hague, and National Gallery of Art, Washington, *Frans van Mieris 1635–1681*, 2005–2006.

Literature: Hoet and Terwesten 1770, p. 481, (reference to 1765 sale); *Exhibition of Pictures by Rubens, Rembrandt, Van Dyke and other Artists* 1815, p. 16, cat. no. 62 (as "a Man eating Shrimps"); Reynolds 1890, p. 202; *An Account of All the Pictures Exhibited in the Rooms of the British Institution from 1813 to 1823* 1824, pp. 222–23, no. 2; Smith 1829–42, vol. 1, p. 246, no. 37; *Exhibition of Pictures by Italian, Spanish, Flemish, Dutch, French, and English Masters* 1851, p. 8, cat. no. 31; Waagen 1854, vol. 2, p. 117 ("This picture painted when he was only twenty-six years of age, is one of his greatest masterpieces with the depth and glow of an Ostade, it combines the most solid impasto and the most masterly modeling"); *Art Treasures of the United Kingdom Collected at Manchester in 1857* 1857–58, p. 74, cat. no. 1073; Blanc 1863, p. 23, under François Mieris le Vieux (sic.); Thoré 1865, p. 279; *Exhibition of the Works of Ancient Masters and Deceased British Artists* 1867, p. 8, cat. no. 16; Gower 1881; *Exhibition of Works by the Old Masters and by Deceased Masters of the British School* 1881, p. 27, cat. no. 121; South Kensington Museum 1891, p. 6, cat. no. 26; *Hope Collection of Pictures of the Dutch and Flemish School* 1898, no. 26, ill.; Nagler 1907, p. 327; Hofstede de Groot 1907–28, vol. 10, p. 40, no. 153; Wiersum 1910, p. 173; *Tentoonstelling van Oude Kunst uit het Bezit van den Internationalen Handel* 1936, p. 27, cat. no. 109; *The Art News* 1937, pp. 12–13, ill.; Bénézit 1976, p. 401; Plietzsch 1960, p. 52; MacLaren 1960, p. 255, under inv. no. 2952; F. W. Robinson 1974, p. 29, ill. fig. 32; Naumann 1978, p. 33; Naumann 1981, pp. 58–59 and n. 53, 63, 64, 123 and n.195, 211; vol. 2, pp. 36–40, cat. no. 33, ill. pl. 33 (as present whereabouts unknown); Niemeijer 1981, p. 189, no. 150; Klessmann 1983, p. 135; Moiso-Diekamp 1987, pp. 103, 374–75, no. B 2; MacLaren 1991, pp. 268–69, under inv. no. 2952, no. 1, ill. fig. 64; Baker and Henry 1995, p. 456; Reynolds and Mount 1996, pp. 100, 171 n. 501; Seneko 2000, pp. 229–30; *Poetry of Everyday Life* 2002, p. 78, ill.; *Frans van Mieris 1635–1681* 2005–2006, p.33, fig. 8, pp. 136–38, cat. no. 22, p. 227, cat. no. 22, p. 233, cat. no. 33; Buvelot and Naumann 2008, pp. 102–103, ill. fig. 38 and cover.

Notes:
1. Houbraken 1718–21, vol. 3, p. 2.

CLAES MOEYAERT

DURGERDAM 1591/92–1655 AMSTERDAM

Claes Cornelisz. Moeyaert was probably born in Durgerdam in 1591. He was the son of an aristocratic Catholic merchant. In 1605, after the death of his mother, the family moved to nearby Amsterdam. It is not known who his teacher was. He was married in Amsterdam on April 20, 1617. His artistic abilities evidently drew attention early on, for in 1618 he was praised by Theodore Rodenburgh in his poem *Opsomming van de beroemdste Amsterdamse kunstenaaars* (List of Best-known Amsterdam Artists).[1] The appreciation of his work is also evident from the fact that the city of Amsterdam commissioned him to design the decorations for the ceremonial entry of Maria de' Medici in 1638. In 1639, the king of Denmark commissioned Moeyaert to paint two large history pieces for Kronborg Castle. Between 1639 and 1641, he was closely involved with the Amsterdam Theatre as a set designer and governor. Partly thanks to several legacies, Moeyaert was able to amass a substantial fortune. He died a wealthy man in 1665 in Amsterdam where he was buried in the Oude Kerk on August 26.

Moeyaert was the most productive painter and draftsman among the so-called "Pre-Rembrandtists," who specialized in scenes with biblical and mythological figures and emphasized psychological and dramatic effects. His oeuvre also consists of portraits. Dated pieces are known from almost all the years between 1624 and 1653. Moeyaert was not a great innovator. Initially, he was influenced by the work of Adam Elsheimer (1578–1610), and later more by that of Pieter Lastman (1583–1633) and of the brothers Jan (1581/82–1631) and Jacob Pynas (1592/93–after 1650). After 1630, the influence of Rembrandt is also recognizable. Moeyaert had numerous pupils, among them Salomon Koninck (1609–1656), Nicolaes Berchem, and Jan Baptist Weenix.

Literature: Tümpel 1974, pp. 1–163, 245–90.

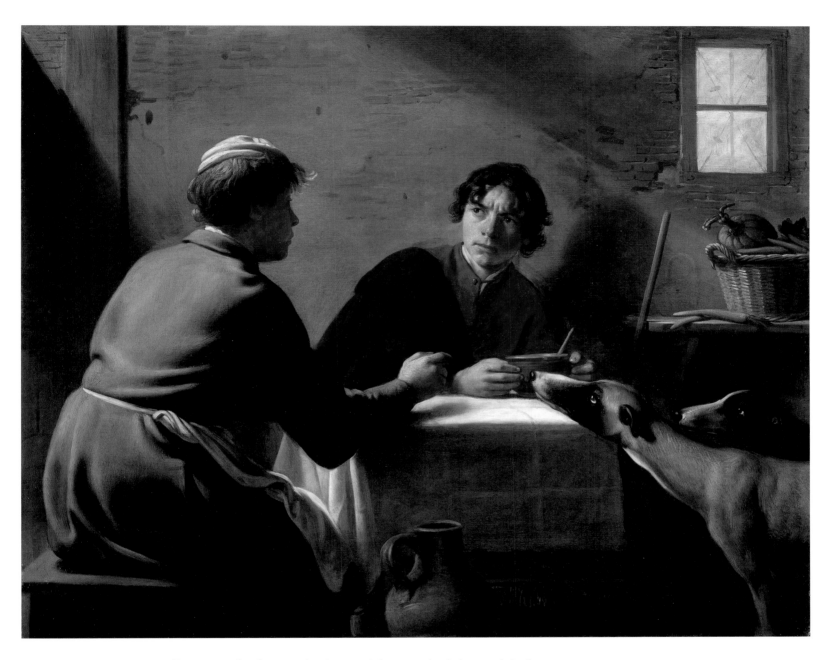

CATALOGUE 39. *Esau Selling His Birthright to Jacob*, 1630–35. Oil on panel, 26 1/2 × 32 1/2 inches (67.5 × 82.5 cm). Signed lower left on the bench: *CL M f.* (*CL* in ligature)

CATALOGUE 39

*ESAU SELLING HIS
BIRTHRIGHT TO JACOB*

UNTIL NOW, this panel has never been published or exhibited. It depicts the Old Testament story of Jacob and Esau, twin sons born to Isaac and Rebecca (Genesis 25: 29–34). Esau, the first-born, was an outdoorsman and a hunter, while the more serious Jacob was often to be found at home with his mother. "And Jacob sod pottage: and Esau came from the field, and he was faint: And Esau said to Jacob, Feed me, I pray thee, with that same red pottage; for I am faint. . . . And Jacob said, Sell me this day thy birthright. And Esau said, Behold, I am at the point to die: and what profit shall this birthright do to me? And Jacob said, Swear to me this day; and he sware unto him: and he sold his birthright unto Jacob. Then Jacob gave Esau bread and pottage of lentiles; and he did eat and drink, and rose up, and went his way: thus Esau despised his birthright."

In this painting, Jacob, wearing an apron, sits on the left while on the right Esau looks doubt-fully at his twin while he draws the plate of lentils closer. Two hounds and a staff indicate that Esau has just returned from hunting. Claes Moeyaert's source of inspiration for this Old Testament story is not clear. It was not particularly popular among Amsterdam artists, although Rembrandt made a drawing of this subject, probably dating from the first half of the 1640s, with Jacob in profile on the left and Esau posed almost frontally on the right, just as in this panel (figure 1). This story was chosen as a subject several times, mainly by painters in Utrecht. In the 1620s,

Figure 1. Rembrandt van Rijn, *Esau Selling His Birthright*, ca. 1645. Pen and brown ink and corrections in white, 6 1/2 × 6 1/8 inches (16.6 × 15.7 cm). Amsterdams Historisch Museum, Amsterdam, C. J. Fodor Collection.

Hendrick ter Brugghen (1588–1629) painted two works with Jacob and Esau (Gemäldegalerie, Berlin, and Museo Thyssen-Bornemisza, Madrid) and Joachim Wtewael (1566–1638) depicted the story on a large canvas (formerly with Matthiessen Fine Art, London). Their source of inspiration, and probably Moeyaert's, too, may have been an engraving of 1609 by Willem Swanenburgh (1581–1612) after a composition by the Utrecht artist Paulus Moreelse (1571–1638).[2]

Within Moeyaert's oeuvre, the two figures display some similarity with the two main figures in a canvas of around 1634 depicting the Good Samaritan.[3] There, Moeyaert painted a similar half-lit head and the other head is in profile and partially strongly lit.

The early provenance of this panel is unknown; it cannot be related to pieces listed in old auction catalogues or inventories. However, the inventory of Aert de Koninck, the father of the painter Philips Koninck, and Margaretha van Rijn, Koninck's widow, drawn up on April 13, 1639, describes a "Jacob en Esau nae Claes Moeyaert" on canvas.[4]

Provenance: Jonkvrouwe Suzanna Sophia de Mol van Otterloo-Röell (1863–1946); by descent to Willem Frederik de Mol van Otterloo (1946–54); by descent to Tom de Mol van Otterloo; acquired in 1994.

Notes:
1. De Roever 1885; Tümpel 1974, p. 17.
2. Hollstein 1949–, vol.14, p. 14, no. 2, ill. p. 15.
3. Tümpel 1974, cat. 121, p. 98, fig. 133.
4. Bredius 1915, p. 151, no. 38.

AERT VAN DER NEER

GORINCHEM? 1603/1604−1677
AMSTERDAM

Aert or Aernout van der Neer was probably born in 1603 or 1604 in Gorinchem (Gorkum), east of Dordrecht. Houbraken stated that he lived for some time in Arkel, near Gorinchem.[1] There, he was employed as steward (*majoor*) by the lords of Arkel. It is not known with whom or where Van der Neer did his apprenticeship. The brothers Jochem Govertsz. Camphuysen (1601/1602−1659) and Raphael Govertsz. Camphuysen (ca. 1597/98−1657), both from Gorinchem, have been mentioned in this connection but there is no documentary confirmation. On April 1, 1629, Aert van der Neer "painter, age 25 years" was married to Lijsbeth Goverts in the Nieuwe Kerk in Amsterdam. At that time, he was living on Herenmarkt in Amsterdam. The couple had six children. Their eldest son was the later genre painter Eglon Hendrick van der Neer (1635/36−1703); their son Johannes (1637/38−1665) also became a painter, apparently working mainly in his father's manner. The income from painting was evidently insufficient for both father and son, for they are each named on a list of Amsterdam innkeepers (*wijntappers*) of 1659 and again in 1662. Aert van der Neer was the landlord of the *Graeff van Hollandt* on Kalverstraat, but that did not prove sufficient either: he was pronounced bankrupt in December 1662 and required to undergo a forced sale of his property. His paintings did not raise much and the auction did not bring about a structural improvement in Van der Neer's financial situation. He died in complete poverty on Kerkstraat near Leidse Gracht in Amsterdam on November 9, 1677.

 Van der Neer painted mainly winter landscapes and landscapes by moonlight, sunrise, and sunset. He was probably already slightly older than usual when he began painting. Surprisingly, his earliest work, from 1632, is a genre scene; his earliest dated landscape was painted a year later.

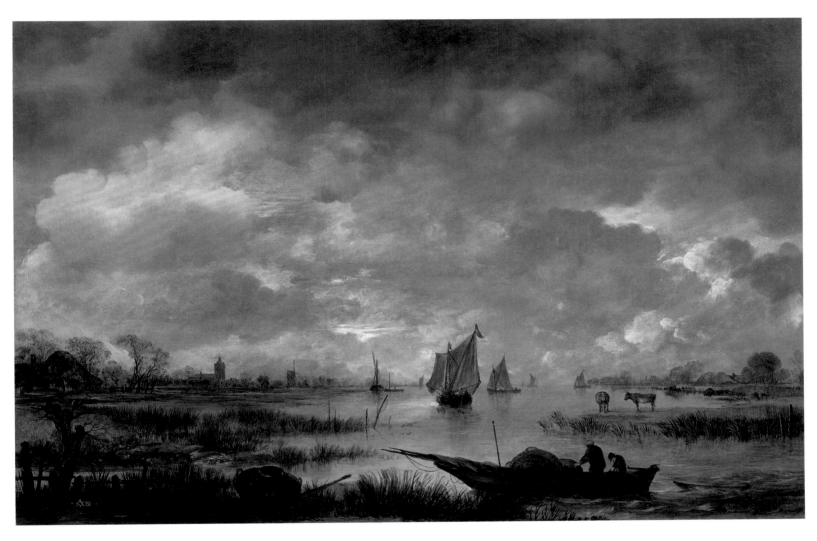

CATALOGUE 40. *Estuary at Twilight*, ca. 1655–60. Oil on panel, 18 3/8 × 27 1/2 inches
(46.5 × 70 cm). Signed lower left: *.AV DN. (AV* and *DN* in ligature).

His work was hardly appreciated at all in his lifetime. During the Romantic period, however, when artists such as J. M. W. Turner (1775–1851) and Caspar David Friedrich (1774–1840) began to draw and paint a similar atmosphere, his works were much sought-after, especially his poetic river landscapes by moonlight, sunset, and sunrise. In contrast to most of the Dutch landscapists of his day, Van der Neer included the light source in his compositions, sometimes wholly or partly concealed behind clouds. His painted oeuvre consists of hundreds of works, but his drawings are extremely rare; only a dozen can be definitely attributed to him.

Literature: Hofstede de Groot 1907–28, vol. 7, pp. 323–473; Bachmann 1982; Schulz 2002.

CATALOGUE 40

ESTUARY AT TWILIGHT

AERT VAN DER NEER must have been fascinated by those moments when the light is special. In this river landscape, the moon glimmers vaguely through the clouds, but the emphasis is on the atmospheric mood during twilight. The painter captured beautifully the special light on both the land and the sky at that late moment in the day.

In the right foreground, two fishermen appear to be on their way home. They are sailing their boat with two big fish baskets toward the bank on the left. The sails have been lowered, and they are towing a second, smaller boat. In the left foreground lies a third fish basket which, together with the dark silhouette of a pollard willow, acts as a *repoussoir*. Almost the entire middle ground is taken up by a broad river on which there are several sailboats. On the left bank is a thatched farmhouse among the trees, and a little farther away is a church in the midst of several houses and a windmill. On the right bank, two cows stand on a spit of land and in the distance are some farmhouses between trees. The composition is dominated by a sky in which a few bits of blue can still be seen amidst the white and gray clouds.

Van der Neer used a very limited, rather monochrome palette of mainly soft gray, blue, and brown tones alternating with white accents, while in the foreground in particular he used black and brown to impose structure. As is typical in his work, he has not tried to depict a location that can be identified topographically. The complete absence of travel sketches confirms that Van der Neer was not interested in portraying recognizable locations but in depicting the Dutch countryside with its water and its pastures when the light was special.

Van der Neer rarely dated his paintings and particularly after 1646 his dating was only sporadic. Moreover, most of the dated pieces are winter landscapes, thus it is very difficult to determine the date of other landscapes such as this river scene. Only a rough dating is possible based on some general developments in his work. In the 1630s and 1640s, figures, cattle, and trees still play a leading role in Van der Neer's landscapes. In the course of the second half of the 1640s and during the 1650s, the emphasis gradually came to lie more on special light effects and the depiction of the open countryside. Elements in the foreground are often painted in silhouette and function as *repoussoirs*, as is the case in this painting. After 1660, a definite decline in Van der Neer's work seems to be discernible and his facture becomes less delicate. Moreover, he often opted for a slightly higher point of view. Based on the above, a date in the second half of the 1650s seems probable for this river landscape, slightly later than the two dated river landscapes from the 1650s that are known: a moonlit landscape and a night landscape that both bear the date 1653.[2]

Provenance: George Salting (1836–1909), St. James's, London; by descent to his niece, Katherine, Lady Binning; by descent to her son, George Baillie-Hamilton, Twelfth Earl of Haddington, Mellerstain House, Gordon, Berwickshire, Scotland; by descent to the Trustees of the Mellerstain Trust, their sale, London (Sotheby's), July 8, 1987, no. 13 (to Green); with Richard Green, London, and Johnny Van Haeften Ltd., London; Charles C. Cunningham, Boston, 1988; acquired in 2004.

Exhibitions: Thomas Agnew & Sons, London, *Exhibition of the Collection of Pictures and Drawings of the Late Mr. George Salting*, 1910; Museum of Fine Arts, Boston, *Prized Possessions: European Paintings from Private Collections of Friends of the Museum of Fine Arts*, 1992; Museum of Fine Arts, Boston, *Poetry of Everyday Life: Dutch Painting in Boston*, 2002.

Literature: *Exhibition of the Collection of Pictures and Drawings of the Late Mr. George Salting* 1910, p. 10, no. 200; *Prized Possessions* 1992, p. 189, no. 105, pl. 47; Schulz 2002, p. 264, no. 540, col. pl. 44, pl. 205; *Poetry of Everyday Life* 2002, p. 117, ill.

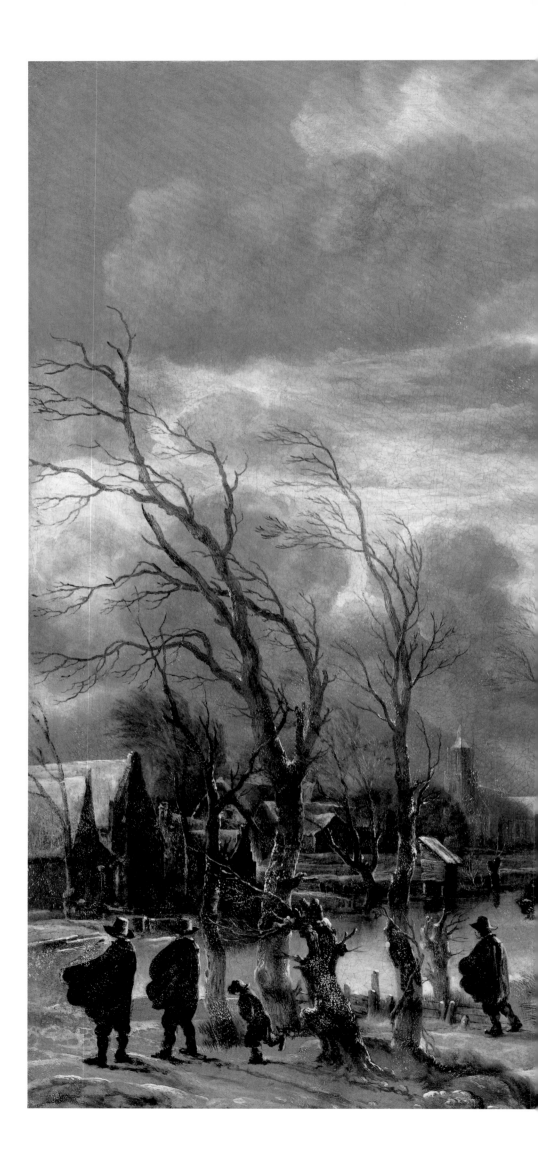

CATALOGUE 41. *Winter
Landscape with Figures in a
Snowstorm*, ca. 1655–60. Oil on
canvas, 24 × 29 7/8 inches
(60.8 × 75.7 cm). Signed lower
left center: *AV DN* (*AV* and *DN*
in ligature)

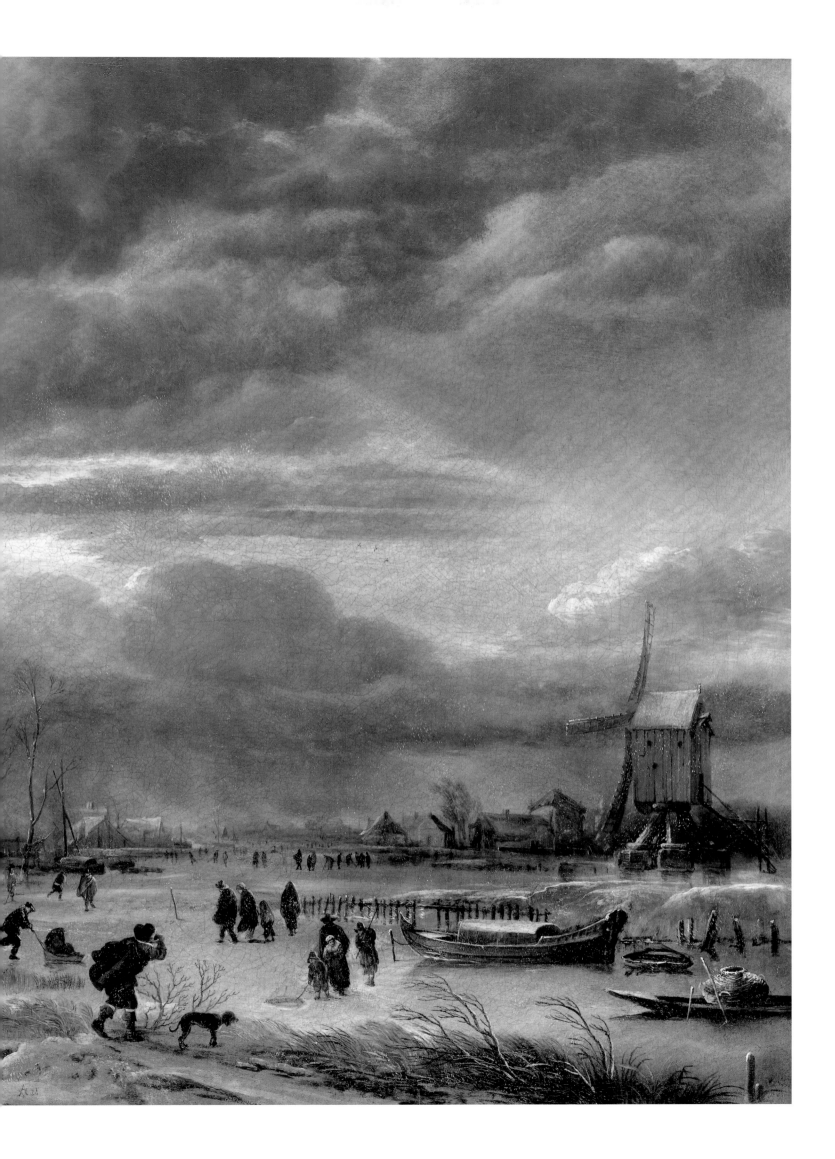

WINTER LANDSCAPES were a favorite subject with many Dutch painters in the seventeenth century. It may have been the Flemish painters in the sixteenth century, led by Pieter Bruegel the Elder (1525/30–1569), who introduced the theme, but it was the painters from the Northern Netherlands who popularized the genre. In the first decades of the seventeenth century, Hendrick Avercamp was the leading master. Esaias van de Velde, Arent Arentsz., named Cabel (1585/86–1631), and Jan van Goyen were among the most important masters who followed in Avercamp's footsteps. Around the middle of the seventeenth century, it was Aert van der Neer who was preeminent in this genre. This canvas is one of the finest examples of his work.

Rarely has a painter succeeded so convincingly in depicting not only winter's passive consequences, such as ice, snowy ground, and frost, but also the active effects such as the stiff wind sweeping across the land and the falling snow. In the case of the three men walking in the left foreground, their capes and hat brims are blown upward. In between them runs a boy, huddling to protect himself from the cold. The tops of a pair of bare trees bend in the wind. In the middle, a man with a dog steps from the bank onto the frozen river, which extends from the right foreground to the middle of the horizon. His cloak also blows up and he has to hold onto his hat to stop it from blowing away. Farther back on the left bank is a village with a church; on the right bank stands a windmill with a few farmhouses behind it. The roofs are white with snow. In the middle ground and farther back, there are all sorts of figures on the ice: one pushes a sled, others skate, walk, play "kolf," or fish through holes in the ice. On the right are several boats frozen in the ice. Snow falls from the mostly dark clouds that cover the sky.

This painting occupies an almost unique place among the many winter landscapes by Aert van der Neer and other Dutch painters, too: it is most unusual for falling snowflakes to be depicted. After he had finished the painting, Van der Neer took up the challenge of applying hundreds of small white dots of paint over the whole canvas. The flakes can be seen best against the dark clothing of the figures and the tree trunks. He repeated this only once or twice, for example on a later work now in the Wallace Collection in London,[3] despite painting numerous winter landscapes.

In 1604, in his *Den grondt der edel vry schilder-const*, Karel van Mander (1548–1606) had called on his colleagues to depict the "gloomy winter days" as well as the lovely ones, the days on which "snow, hail and rain showers, ice, rime and choking fogs" changed the landscape into a world that made one somber.[4] Apparently, only Van der Neer heeded this appeal. Earlier, a few Flemish masters such as Pieter Bruegel the Elder, Lucas van Valckenborch (1535 or later–1597), and Jacob Grimmer had painted winter landscapes with falling snow.[5]

Van der Neer rarely dated his paintings, so it is difficult to trace his artistic development. The earliest extant dated winter landscape (present whereabouts unknown) by his hand dates from 1642, nearly ten years after he painted his first landscapes.[6] His best work was done in the second half of the 1640s and the 1650s, and this also applies to his winter landscapes. This painting probably dates from between 1655 and 1660, when he was at the height of his powers.

Provenance: Probably Diederik Middeldorp, Leiden, his estate sale, Leiden (Van der Eyk), October 21, 1761, no. 7 (fl. 180 to Haazebroek for Neufville Brothers) ("Een Winter daar het Sneeuwt, by uitneemenheid natuurlyk verbeeldt door *Aart van der Neer*. Breedt 29 hoog 23 1/3 duim."); possibly Johan Willem Frank (1720–1761), The Hague, his estate sale, The Hague (Francken), April 5, 1762, no. 33 (fl. 47 to Verschuuring) ("Een Capitaale Winter met meenigte van Beeltjes op het Eys, door A. van der Neer, hoog 23 duym, breed 2 voet 4 duym."); possibly Hendrik Verschuuring (ca. 1695–1769), commissioner of Finances of Holland, The Hague, his estate sale, The Hague (Rietmulder), September 17, 1770, no. 121 ("Een Winter, zynde een Binnegragt in een Stad, vol gewoel van Beelden; zeer natuurlyk en meesteragtig geschildert, op D."); with Dale Gallery, London, 1770; Sir Francis Cook, first

baronet, visconde de Monserrate (1817–1901), Doughty House, Richmond, after 1860, bought from Dale for £400; by descent to Sir Frederick Cook (1844–1920), Doughty House, Richmond; by descent to Sir Herbert Cook (1868–1939); by descent to Sir Francis Ferdinand Maurice Cook, fourth baronet (1907–1978); with Thomas Agnew and either D. Katz, Dieren, or Edward Speelman, London, 1956; Sidney van den Bergh, Wassenaar, by 1959 until 1973; private collection, South Africa, 1974–77; with Leonard & David Koetser, Geneva and Zurich, by 1977; Diethelm Doll, Bad Godesberg, Germany, sale, London (Sotheby's) July 9, 2008, no. 40; acquired from Johnny Van Haeften Ltd., London, in 2008.

Exhibitions: Royal Academy of Arts, London, *Exhibition of Dutch Art 1450–1900*, 1929; Royal Academy of Arts, London, *An Illustrated Souvenir of the Exhibition of 17th Century Art in Europe*, 1938; Singer Museum, Laren, N. H., *Kunstschatten: Twee Nederlandse collecties schilderijen uit de vijftiende tot en met de zeventiende eeuw en een collectie oud aardewerk*, 1959; Stedelijk Museum de Lakenhal, Leiden, *17de Eeuwse Meesters uit Nederlands particulier bezit*, 1965; California Palace of the Legion of Honor, San Francisco, Toledo Museum of Art, Ohio, and Museum of Fine Arts, Boston, *The Age of Rembrandt* 1967; Paleis voor Schone Kunsten, Brussels, *Rembrandt en zijn tijd*, 1971; Rijksmuseum, Amsterdam, Museum of Fine Arts, Boston, and Philadelphia Museum of Art, *Masters of 17th Century Dutch Landscape Painting*, 1987–88; Mauritshuis, The Hague, *Holland Frozen in Time: The Dutch Winter Landscape in the Golden Age*, 2001–2002.

Literature: Hoet and Terwesten 1770, p. 247 (lot 33 in 1762 sale); Cook 1903–14 (as in the Long Gallery), no. 148; Kronig 1914, p. 63, no. 294, ill. pl. XV (as in the Long Gallery, no. 72); Hofstede de Groot 1907–28, vol. 7, p. 450, no. 531; *Exhibition of Dutch Art 1450–1900* 1929, pp. 100–101, no. 203; Brockwell 1932, p. 37, no. 294 (72) (as in the Long Gallery); *Exhibition of 17th Century Art in Europe* 1938, p. 68, no. 133; *Illustrated Souvenir of the Exhibition of 17th Century Art in Europe* 1938, p. 64; *Kunstschatten: Twee Nederlandse Collecties Schilderijen uit de Vijftiende tot en met de Zeventiende eeuw en een Collectie oud Aardewerk* 1959, no. 60, ill. fig. 31; A. B. De Vries 1964, p. 357, ill. p. 355, fig. 6; *17de Eeuwse Meesters uit Nederlands particulier bezit* 1965, pp. 9–10, no. 31, ill. fig. 8; Bachmann 1966, p. 55; Stechow 1966, p. 204 n. 44; *The Age of Rembrandt* 1967, p. 91, no. 52, ill.; A. B. De Vries 1968, pp. 78–79, ill.; *Rembrandt en zijn tijd* 1971, p. 90, no. 70, ill. p. 91; Müllenmeister 1973–81, vol. 1, p. 167, ill.; Bachmann 1982, p. 117, ill. p. 90, col. fig. 88, fig. 88a; *Masters of 17th Century Dutch Landscape Painting* 1987–88, pp. 40, 164, 386–87, pl. 43, no. 61, ill.; Schulz 2002, p. 143, no. 65, ill., col. pl. 18, pl. 34; *Holland Frozen in Time* 2001, pp. 62, 106–107, 161–62, no. 17, ill. p. 107.

Notes:
1. Houbraken 1718–21, vol. 3, p. 172.
2. Hofstede de Groot 1907–28, vol. 7, no. 226; Schulz 2002, no. 923; and not mentioned by Hofstede de Groot but in Schulz 2002, no. 620.
3. Schulz 2002, no. 31.
4. Miedema 1973, pp. 206–209 (chapter 8, folio 35, recto and verso).
5. *Adoration of the Kings* (1567; Collection Oskar Reinhart, Winterthur); *Winter View near Antwerp* (1575; Städelsches Kunstinstitut, Frankfurt); and see catalogue 26, respectively.
6. Hofstede de Groot 1907–28, vol. 7, no. 499; Schulz 2002, no. 75.

CASPAR NETSCHER

HEIDELBERG? CA. 1635/36–1684
THE HAGUE

There is great uncertainty about the place and date of Caspar Netscher's birth. Houbraken stated that he was born in Prague in 1639, but elsewhere in his biography of the painter he said Heidelberg was his birthplace. According to Roger de Piles, Netscher was born in Prague in 1635 or 1636.[1] At an early age, Netscher came with his mother to Arnhem, where he was apprenticed to the not very talented painter of still lifes, portraits, and genre scenes Hendrick Coster (active 1638–1659). Around 1654–55, he became a pupil of Gerard ter Borch (1617–1681) in Deventer. After four or five years, he left his studio and shortly afterward took ship to Bordeaux with the intention of traveling on to Italy. According to Houbraken, on November 25, 1659, in Bordeaux, he married Margareta Godijn, the daughter of a Protestant engineer from Liège. Because of their religion, a few years later they felt compelled to go to Holland, where they settled in The Hague. Soon afterward, in October 1662, Netscher became a member of the *Confrérie Pictura*, the local fraternity of painters and connoisseurs. In 1668, he obtained local civic rights. He does not seem to have left The Hague for a long time and he died there on January 15, 1684. Like many of his colleagues, he was active not only as a painter but as a dealer, too. Houbraken stated that he left a fortune of eighty thousand guilders. Several of his nine children, including Theodorus, Constantijn, and Anthonie, also became painters.

At first, Netscher painted mainly genre scenes, which show the influence of Ter Borch, and history pieces. His years in Bordeaux resulted in an elegant and clearly French accent in his paintings. In the years 1670–80, he concentrated on portraits, according to Houbraken, because that was the best way to earn the money he needed to feed his ever-growing family.

Literature: Hofstede de Groot 1907–28, vol. 7, pp. 146–308; Wieseman 2002.

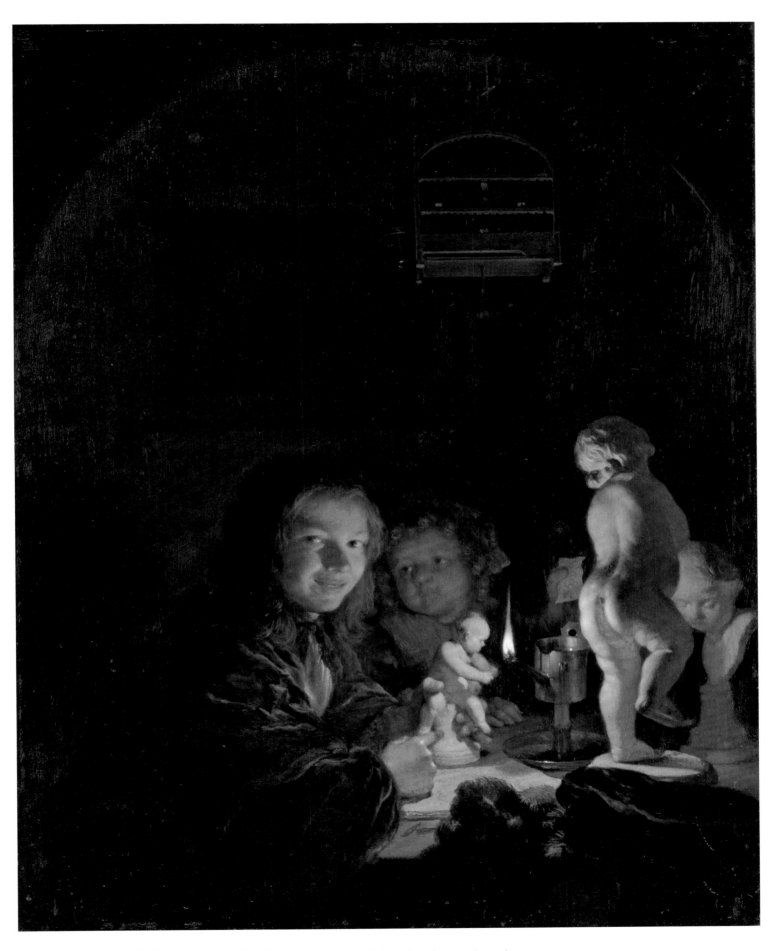

CATALOGUE 42. *The Young Artists*, 1666. Oil on panel, 8 1/2 × 6 1/2 inches (21.5 × 16.5 cm)
Signed and dated lower right: *1666/ CNetscher* (*CN* in ligature).

CATALOGUE 42

THE YOUNG ARTISTS

IN THIS UTTERLY CHARMING PAINTING, Caspar Netscher painted two children drawing from plaster figures by the light of an oil lamp. The use of a single light source in an otherwise dark interior resulted in sharp shadows that could aid the budding draftsman in depicting three-dimensionality. Here, it also resulted in a lively alternation of light and dark and created great intimacy. The elder child smiles mischievously at the viewer while pointing at a figure of a putto he is holding in his left hand. The figure is probably a cast from a sculpture by the Flemish artist François du Quesnoy (1597–1643).[2] It evidently enjoyed some popularity, for it was used as a model by other painters, such as the Flemish artist Jacob Jordaens (1593–1678), who drew several studies of this figure.[3] At the table sits a second, younger child who looks expectantly at the boy next to him while holding up in his left hand an extremely simple drawing of a doll. To the right of the oil lamp stands a larger figure of a putto skating, the personification of Winter. Netscher painted the same figure in his *Portrait of a Magistrate and His Family* (1667; Museum Boijmans Van Beuningen, Rotterdam).[4] Originally, the figure was probably part of a series of the four seasons.[5] Evidently, it was also regularly part of an artist's studio equipment. The same figure can be seen in a painting attributed to Hendrick van der Burgh (1627–1665 or later) in The Art Institute of Chicago. On the far right in the present painting, another plaster child's head on a base stands on the table. In a painting by Gabriël Metsu in the National Gallery in London, a woman in a studio is seen drawing from the same portrait bust. At the top, the composition is similarly completed by a birdcage.

Drawing from prints, paintings, or statues was a normal part of an artist's training. According to the theorists, artists had to progress through a number of increasingly difficult phases: first, copying prints or drawings; second, drawing after paintings; third, drawing after free-standing figure models, as is being done here; and last, drawing from live models. In 1668, the writer and publisher Willem Goeree published a comprehensive treatise on drawing. He advised pupils to work in the evening when they wanted to draw copies of figures: "One can fittingly use candle light in the evening, which some prefer to the day because of the even shadows."[6] Moreover, he also expressed a preference for an oil lamp rather than a candle because as the candle burnt down the height of the flame changed.

Pupils drawing from figures or prints by other artists in a studio is a subject that has been portrayed by various artists. Jan Steen did at least three such paintings, one of which is in the Van Otterloo collection (catalogue 58; Stedelijk Museum de Lakenhal, Leiden; and J. Paul Getty Museum, Los Angeles). In addition to the Metsu painting mentioned above, Michael Sweerts (1618–1664), Wallerant Vaillant (1623–1677), and Gerrit Dou all chose it as the subject of one or more works.[7] An only slightly larger panel by Dou, *Young Man Drawing from a Figure*, also with a rounded top, resembles the painting by Netscher particularly closely. There, too, an oil lamp is the only light source in a studio where a young draftsman is making a sketch of a plaster figure, probably a personification of Spring from the same series as the Winter in Netscher's piece.

Netscher may have portrayed one of his own children here. In a drawing now in the Amsterdams Historisch Museum, Amsterdam, he appears to have drawn the same child with corkscrew curls. Based on the date of the painting, he would be Theodorus, born in 1661, or, more likely, Caspar Jr., born July 22, 1663.

Provenance: Possibly Prince du Conti, Paris, his sale, Paris (Boileau/Francastel), March 15, 1779, no 140 ("Un tableau representant des Enfrants qui dessinent d'après la bosse, a la lueur de la lampe. L'un d'eux est appuyé devant un table, et a la main droite sur son porte-feuille; près de lui on voit un autre Enfant qui semble lui parler," panel, 8 × 7 inches; ffr. 900, to Chevalier de Cossé); possibly supplementary sale, Amsterdam, June 22, 1817, no. 217

(as by G. Schalcken; according to Wieseman 2002); Abraham Jacob Saportas, Amsterdam, his estate sale, Amsterdam (De Vries/Roos), May 14, 1832, no. 84 (as by G. Schalcken, on copper, ca. 26 × 20 cm., arched top; fl. 99 to Brondgeest); Johannes Rienksz. Jelgerhuis (1770–1836), artist and actor, and A. J. Saportas, Amsterdam, their estate sale, Amsterdam (De Vries/Roos/Brondgeest), December 12, 1836, no. 44 (as by G. Schalcken, on copper, 26 × 20 cm.; fl. 170 to Roos); Princess Wolkonski, St. Petersburg, her sale, Paris (Blée/Boudin), May 26–29, 1902; H. Michel-Lévy, Paris, sold to Sedelmeyer on June 10, 1902, for ffr. 1500 (according to a note in the Sedelmeyer catalogue of 1902); with Charles Sedelmeyer, Paris, 1902, sold to Schloss on June 26, 1902, for ffr. 2200 (according to a note in the Sedelmeyer catalogue of 1902); Adolphe Schloss (1842–1910), Paris; by descent to his wife Lucie Schloss (1858–1938) and subsequently to their children, Château de Chambon, Laguenne, France); looted by the Nazis in April 1943, subsequently restituted to the Munich Collecting Point, no. 13892 (1947); Adolphe Schloss (and descendants), his estate sale, Paris (Galerie Charpentier), May 25, 1949, no. 43, ill. (ffr. 560.000); sale, Vienna (Dorotheum), November 30, 1976, no. 84, fig. 31; private collection, France, until 1996; acquired from Galerie Sanct Lucas, Vienna, in 1996.

Exhibitions: Sedelmeyer Gallery, Paris, *The Eigth* (sic) *Series of 100 Paintings by Old Masters of the Dutch, Flemish, Italian, French, and English Schools, Being a Portion of the Sedelmeyer Gallery Which Contains About 1500 Original Pictures by Ancient and Modern Artists*, 1902.

Literature: Smith 1829–42, vol. 6, pp. 151–52, no. 20 (sale 1779); *The Eigth* (sic) *Series of 100 Paintings by Old Masters* 1902, p. 36, no. 28, ill. p. 37; Hofstede de Groot 1907–28, vol. 5, p. 199, no. 147 (as with Sedelmeyer; possibly identical to Hofstede de Groot 1907–28, vol. 5, no. 79 (as by G. Schalcken), and p. 199, no. 146 [sale 1779]; Hofstede de Groot 1907–28, vol. 5, pp. 390–91, no. 279 (as by G. Schalcken, in sales 1817, 1832, 1836, and 1893 [see Wieseman 2002, copy a]; Naumann 1981, vol. 1, p. 79 n. 5 (as strongly dependent on Van Mieris); Beherman 1988, p. 405, no. 279 (as lost); Wieseman 1991, pp. iv, 57, 334–35, no. 53, ill.; Wieseman 2002, pp. 61, 208–209, no. 55, ill. pl. 11; Scholten 2004–2005, p. 80, ill. p. 81, fig. 36.

Notes:
1. Houbraken 1718–21, vol. 1, p. 6, vol. 3, p. 92; Roger de Piles 1699, pp. 441–45.
2. There is one in terracotta in the Musée national de la Renaissance, Écouen; see *François du Quesnoy, 1597–1643* 2005, pp. 318–19, no. In.99; there is one in wood in the Museum of Fine Arts, Boston.
3. Sale, London (Sotheby's), November 10, 1998, no. 34.
4. Wieseman 2002, no. 69.
5. Probably by the sculptor Johan Larson (?–1664) of The Hague. With thanks to Frits Scholten for the identification. Four later lead copies after this series are in the Rijksmuseum, Amsterdam.
6. Goeree 1668, p. 25.
7. For Sweerts (Rijksmuseum, Amsterdam, and Minneapolis Institute of Arts); for Vaillant (Koninklijke Musea voor schone Kunsten, Brussels); for Dou (Musée du Louvre, Paris, and Musée des Beaux-arts, Lille).

ADRIAEN VAN OSTADE

HAARLEM 1610–1685 HAARLEM

Adriaen Jansz. van Ostade was baptized on December 19, 1610; he was the fifth of ten children
born to the linen weaver Jan Hendricx van Ostade. The name Ostade was taken from that of a
small place near Eindhoven, where the family originally came from. Houbraken wrote that Adriaen
van Ostade was apprenticed to Frans Hals at the same time as Adriaen Brouwer (1606–1638).[1]
There are no documents to confirm this and nothing in Van Ostade's work reveals the influence
of Frans Hals. That of Brouwer, however, who lived in Haarlem between 1623/24 and 1631/32,
is clearly evident. In all probability, Adriaen van Ostade joined the guild in 1632, but the exact date
is not known. From 1633 to 1669, he served in the St. George's civic guard. On July 25, 1638, he
married Machteltje Pietersdr., a Catholic, and converted to her faith. The marriage remained child-
less and his wife died in September 1642. Van Ostade lived his whole life in Haarlem, from 1650
in a house on Kromme Elleboogsteeg and from 1680 on the corner of Nieuwe Kerkstraat and St.
Pietersstraat. He owned several other properties as well. On May 26, 1657, he married Anna
Ingels in Amsterdam; she came from a leading, wealthy Catholic family in the city. They had a
daughter, Johanna Maria. On November 5, 1666, the couple, both ill, made their wills. Anna
died not long afterward and was buried in the St. Bavokerk on November 24. She left her husband
a substantial legacy. Adriaen recovered and lived nearly twenty years more. He was buried in
the family grave in the St. Bavokerk on May 2, 1685. Beginning on July 3 of that year, Van Ostade's
art collection was auctioned. It included more than two hundred of his paintings, drawings,
etching plates, and etchings, as well as paintings and drawings by other artists.

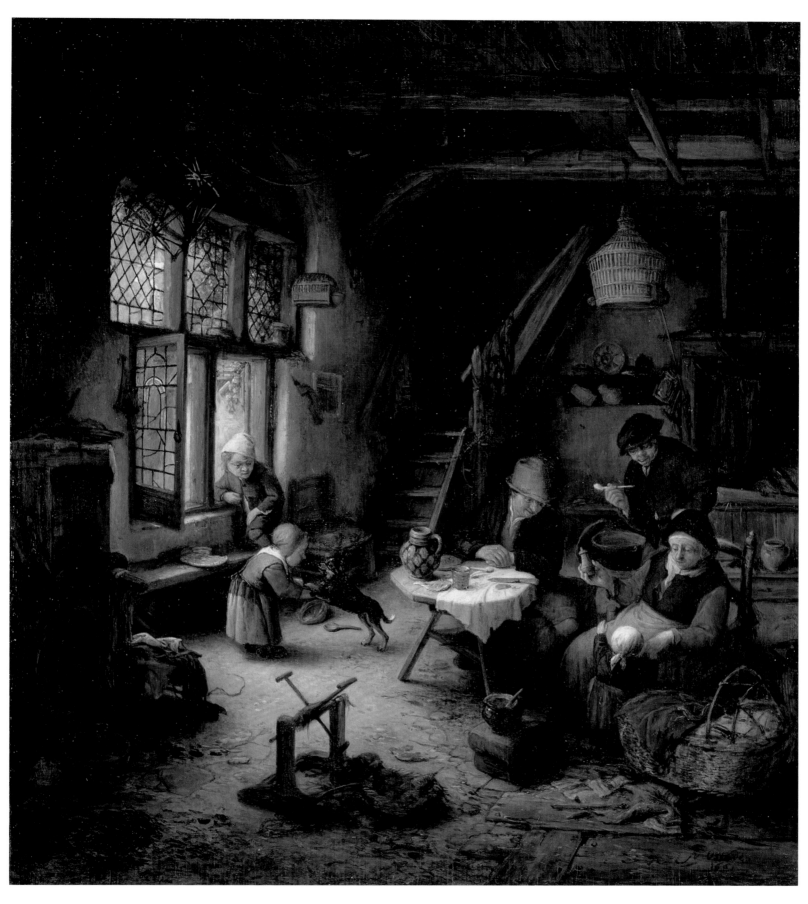

CATALOGUE 43. *Peasant Family in a Cottage Interior*, 1661. Oil on panel, 13 3/4 × 12 1/4 inches
(35 × 31 cm). Signed and dated lower right: *Av Ostade/1661* (*Av* in ligature)

Van Ostade's extensive oeuvre included paintings, drawings, watercolors, and etchings of genre scenes with peasants, but he also produced a few portraits, biblical scenes, and landscapes. Among his pupils were his younger brother Isack and Cornelis Dusart (1660–1704); according to Houbraken, Cornelis Bega (1631/32–1664) and Michiel van Musscher (1645–1705) were also his pupils, and according to Weyerman, so was Jan Steen.[2]

Literature: Hofstede de Groot 1907–28, vol. 3, pp. 140–436; Schnackenburg 2000A, pp. 236–41.

CATALOGUE 43

PEASANT FAMILY IN A COTTAGE INTERIOR

FROM A SLIGHTLY ELEVATED VIEWPOINT, Adriaen van Ostade has offered us a glimpse inside the humble house of a peasant family. A man and a woman sit at a table, where a beer glass, an earthenware jug, a plate, a dried fish, and a knife indicate a modest meal. A second man, probably a farmhand, stands smoking a clay pipe. A boy at the window watches a girl playing with a dog, while in the right foreground a woman beside a cradle tends to a younger child. The furnishings are very meager and instead of tiles or planks the floor appears to be mud, which is cracked here and there. Objects are scattered about the place – a broken plate on the window sill, a basket and spoon on the floor by the girl, and a rag or blanket in front of the cradle. In the foreground stands a simple spinning wheel. Despite the inelegant figures and the humble surroundings, the scene exudes an atmosphere of peace and harmony. In that respect, it differs from the genre scenes filled with feelings of unrest, aggression, and poverty that Van Ostade painted at the beginning of his career, in which peasants and ragged paupers were engaged in drinking bouts or fist fights in run-down taverns and peasant interiors. Van Ostade probably drew his inspiration from the work of Adriaen Brouwer, who in his peasant scenes often seems to be poking fun at the wretched circumstances of the lower classes. From the mid-1640s on, Van Ostade's taverns and peasant interiors look less dilapidated and the figures are better dressed; they seem content and they behave themselves. That is also the case in this relatively late work. Moreover, he has introduced some elements that would never be encountered in a humble peasant cottage, such as the high ceiling and the quite expensive leaded stained glass in the windows.

Van Ostade employed a richly varied but restrained palette. The soft light streaming in through the partly open window catches several white accents, such as the cloth on the table, the headscarf of the girl on the right, the standing peasant's pipe, and the collars of the girl on the left and the woman. They stand out brightly against the mainly pastel hues of the interior and the other clothing of the figures. In the 1660s, Van Ostade showed a preference for the theme of a peasant interior with a contented family, and also for this type of composition. A few years later, in 1668, he painted *Interior of a Peasant's Cottage*, which portrays an almost identical room with a peasant family (Royal Collection, Buckingham Palace, London).[3]

Peasant Family in a Cottage Interior is a superb example of the type of painting at which Van Ostade excelled and on which his reputation is largely based. Houbraken must have had paintings such as this in mind when he praised Van Ostade: "He has depicted as ingeniously and naturally as anyone has done peasant huts, sheds, stalls, especially interiors, with all their dilapidated household effects . . . as well as the figures in their clothing and all kinds of activities, so naturally rustic and ingenious, that it is a wonder how he managed to think of it all."[4] A century later, the well-known English dealer John Smith was just as impressed by this painting: "It is impossible to speak too highly of this gem; in luminous effect, and brilliancy of color and finish it has never been surpassed."[5]

The great popularity through the centuries of this type of painting in general and this panel in particular is evident in its imposing provenance. In France in the eighteenth century, it was part of the renowned collections of the prince de Conti and of the duc de Choiseul. In the nineteenth century, it came into the possession of Robert Holford, who had one of the finest private collections in England, including the Paulus Potter in the Van Otterloo collection (catalogue 47).

Engraved by: Jacques Philippe Le Bas (1707–1783), when in the Choiseul-Praslin collection (as *"Le Ménage Hollandais"*); Bond in *Treshams British Gallery*; J. Fittler in *Forster's Engravings*.

Provenance: Possibly Quirijn van Strijen, his estate sale, Haarlem (Princehof), April 2, 1715, no. 4 ("Boere Huyshouden, door Adr van Ostade, zyn allerbeste soort") (for fl. 355 to Mevrouw Trappentier); probably Graaf Johan Hendrik van Wassenaer Obdam, The Hague, his sale, The Hague (De Hondt), August 19, 1750, nos. 27–43bis (one of thirteen Van Ostade works in the sale, but not exactly matching Hoet's brief description of any of them; see below, Literature); Louis-César-Renaud de Choiseul, duc du Praslin, Paris, his sale, Paris (Paillet/Boileau), April 6, 1772, no. 43; Louis-François de Bourbon, prince de Conti (1717–1776), Paris, his estate sale, Paris (Rémy), April 8, 1777, no. 309 (sold to Rémy); duc de Choiseul-Praslin, Paris, his estate sale, Paris (Paillet), February 18, 1793, no. 57 (to Montaleau); Maurice Montaleau, Paris, his sale, Paris (Paillet/Delaroche), July 19–29, 1802, no. 110 (ffr. 6,500); Jeremiah Harman (ca. 1764–1844), Woodford, Essex, by 1829, his estate sale, London (Christie's), May 17–18, 1844, no. 100 (to the dealer William Buchanan [1777–1864] for Stayner Holford for gns. 1,386; Robert Staynor Holford, MP (1808–1892), Dorchester House, Park Lane, London, and Westonbirt, Gloucestershire; thence by descent to his son, Sir George Lindsay Holford, Dorchester House, London, and Westonbirt, Gloucestershire, his estate sale, London (Christie's), May 17, 1928, no. 27 (to Thomas Agnew's, on behalf of J. S. Phipps); Carel Goldschmidt (1904–1989), Mount Kisco, New York, by 1965 (Goldschmidt's collection was made into the Helena Trust), his estate sale, New York (Christie's), January 11, 1995, no. 112; with Richard Green, London; private collection, sale, London (Sotheby's), July 7, 2005, no. 18; acquired from Noortman Master Paintings, Maastricht, in 2006.

Exhibitions: British Institution, London, *Exhibition of Pictures by Rubens, Rembrandt, Van Dyke and Other Artists of the Flemish and Dutch Schools*, 1815; Manchester, England, *Art Treasures of the United Kingdom Collected at Manchester in 1857*, 1857–58; Royal Academy, London, *Exhibition of the Works of the Old Masters and by Deceased Masters of the British School*, 1887; Burlington Fine Arts Club, London, *Exhibition of Pictures by Dutch Masters of the Seventeenth Century*, 1900; National Academy of Design, New York, *Dutch and Flemish Paintings from New York Private Collections*, 1988; shown at The European Fine Arts Fair, Maastricht, March 1995; Richard Green Gallery, London, *The Cabinet Picture: Dutch and Flemish Masters of the Seventeenth Century*, 1999.

Literature: Hoet 1752, vol. 1, p. 177, and probably vol. 2, p. 401; Descamps 1753–54, p. 179; *Exhibition of Pictures by Rubens, Rembrandt, Van Dyke and Other Artists* 1815, p. 18, no. 88; Smith 1829–42, vol. 1, p. 136, no. 104; *An Account of All the Pictures Exhibited in the Rooms of the British Institution from 1813 to 1823* 1824, pp. 186–87, no. 4; Waagen 1854, p. 200; Blanc 1858, pp. 194, 379; *Art Treasures of the United Kingdom Collected at Manchester in 1857* 1857, p. 72, no. 1047; Thoré 1860A, p. 314; *Exhibition of the Works of the Old Masters* 1887, p. 24, no. 102; *Exhibition of Pictures by Dutch Masters of the Seventeenth Century* 1900, p. 30, no. 35; Hofstede de Groot 1907–28, vol. 3, p. 283, no. 463; Graves 1913–15, vol. 2, pp. 887, 891–92; Graves 1921A, vol. 2, p. 303; Benson 1927, pp. 33–34, no. 159, ill. pl. 144; *Dutch and Flemish Paintings from New York Private Collections* 1988, p. 99, no. 34, ill. p. 83; *The Cabinet Picture* 1999, pp. 26, 196–97, ill. p. 27; Franits 2004, pp. 135–37, ill. p. 136, fig. 121.

Notes:
1. Houbraken 1718–21, vol. 1, p. 347.
2. Ibid., vol. 1, p. 349 and vol. 3, p. 211; Weyerman 1729–69, vol. 2, p. 348.
3. Hofstede de Groot 1907–28, vol. 3, nos. 460, 774a.
4. Houbraken 1718–21, vol. 1, pp. 347–48.
5. Smith 1829–42, vol. 1, p. 136, no. 104.

ISACK VAN OSTADE

HAARLEM 1621–1649 HAARLEM

Little is known about the short life of Isack Jansz. van Ostade. He was baptized on June 2, 1621, the youngest of the ten children of the linen weaver Jan Hendricx van Ostade. According to Houbraken, he learned to paint from his brother Adriaen van Ostade, who was eleven years older.[1] It is not known when Isack joined the local guild, but he is first mentioned there in 1643. He died in 1649 at only twenty-eight years old and was buried in the Grote or St. Bavokerk in Haarlem in the week of October 16.

Isack painted and drew peasant interiors in the style of his elder brother, winter landscapes, and genre scenes at inns and farmhouses. His earliest work dates from 1639 and, given his short life, it is not surprising that his oeuvre is relatively small. Nonetheless, he made an important contribution to Dutch painting and drawing. A number of his unfinished paintings were completed by Cornelis Dusart (1660–1704), a pupil of Adriaen van Ostade.

Literature: Hofstede de Groot 1907–23, vol. 5, pp. 437–556; Schnackenburg 2000B, pp. 241–44.

AT FIRST, Isack van Ostade painted mainly peasant interiors, but after 1640 until 1647, two years before his premature death, the winter landscape became another of his specialties. His earliest paintings in this genre – all of which are small in format, fluently painted, and rather monochrome – betray the influence of the early work of Salomon van Ruysdael, who was also active in Haarlem, and possibly also that of Jan van Goyen. Over the years, the compositions of Van Ostade's "winters" became more subtle, his palette slightly less monochrome, and his manner of painting more refined, with his meticulous attention to detail constantly in evidence. At times, he ventured to produce work in larger formats. In these more mature pieces, he generally combined the ice scene with a view of a country inn, as depicted in other of his compositions, such as *Travelers outside an Inn* (1645; Mauritshuis, The Hague). The close attention he paid to the figures and their various activities enabled him to arrive at a successful synthesis of genre and landscape painting.

The present panel is one of the most beautiful and best preserved winter landscapes by this artist. Like many of his more elaborate pieces, the composition is constructed along an imaginary diagonal. The viewer's eye is drawn from a low viewpoint upward to an inn – recognizable by its sign – on the right, while on the left, children and adults alike amuse themselves by skating and sledding on a frozen expanse of water. The most salient motif is the white horse in the foreground, which is guided by a farmer as it struggles to pull a heavily laden sleigh up the river bank. Slightly behind them is another horse-drawn sleigh with a man accompanying it; next to them stand two well-dressed gentlemen and a lady, apparently engaged in conversation. Between the two sleighs, a boy is busy tying on his skates. Farther back are several houses, a small church, and the masts and sails of a few boats.

On the road winding upward to the right are various children and adults, a horse-drawn covered wagon, and an unharnessed horse and wagon. In the middle distance, a pollard willow frames the composition on the right. Occupying what is almost the central point of the picture is a crooked tree whose bare branches stand out against the partly cloudy sky. The vaguely pink tonality of some of the clouds suggests the approach of sunset. On the left-hand side, the composition is closed off by a *repoussoir* formed by a boy sitting on the edge of a boat, tying on his skates, while another boy stands next to him, waiting. More to the back are several farmhouses and a windmill; numerous figures are also discernible. The palette – consisting mainly of brown tones, with accents in white, yellow, and soft red – admittedly displays richer hues than Van Ostade's earliest "winters," but it is nonetheless very subdued.

Although winter landscapes were one of Isack van Ostade's favorite themes, we know only one drawing of this subject by his hand: the sketch, rapidly executed in black chalk, on the back of the pen and wash drawing *Village Inn with Peasants Unloading a Wagon* (Teylers Museum, Haarlem). Even though this sheet cannot be considered a preparatory drawing (for this painting or any other known work), it displays many of the same elements, such as a diagonally constructed composition with an inn on slightly elevated ground to the right, a large, bare-branched tree in the middle, and a view of a frozen river with numerous figures on the left.

Several other works are similar in conception: a large, undated canvas in the Musée du Louvre, Paris; an equally large canvas, dated 1643, in the Kremer Collection, The Netherlands; and a smaller panel, dated 1644, in a private collection in Wassenaar, The Netherlands. They not only display compositions built up along diagonals, but also have other elements in common, including a conspicuous sleigh drawn by a white horse, numerous skaters, an inn, a windmill, and bare trees. The composition of the Wassenaar panel, however, is reversed with respect to the painting discussed here and the others mentioned above.

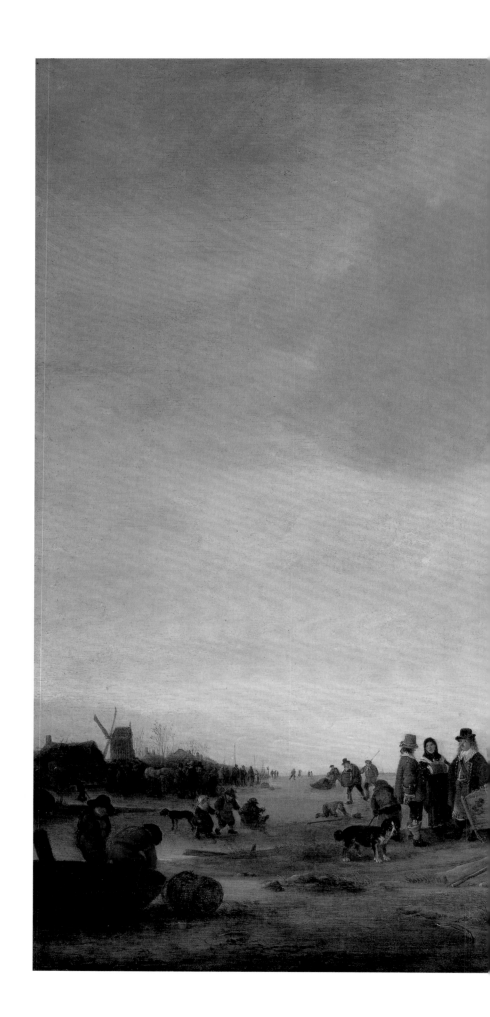

CATALOGUE 44. *Ice Scene near an Inn*,
1644. Oil on panel, 25 1/4 × 33 3/4 inches
(64.1 by 89 cm). Signed and dated lower left:
Isack van Ostade/ 1644.

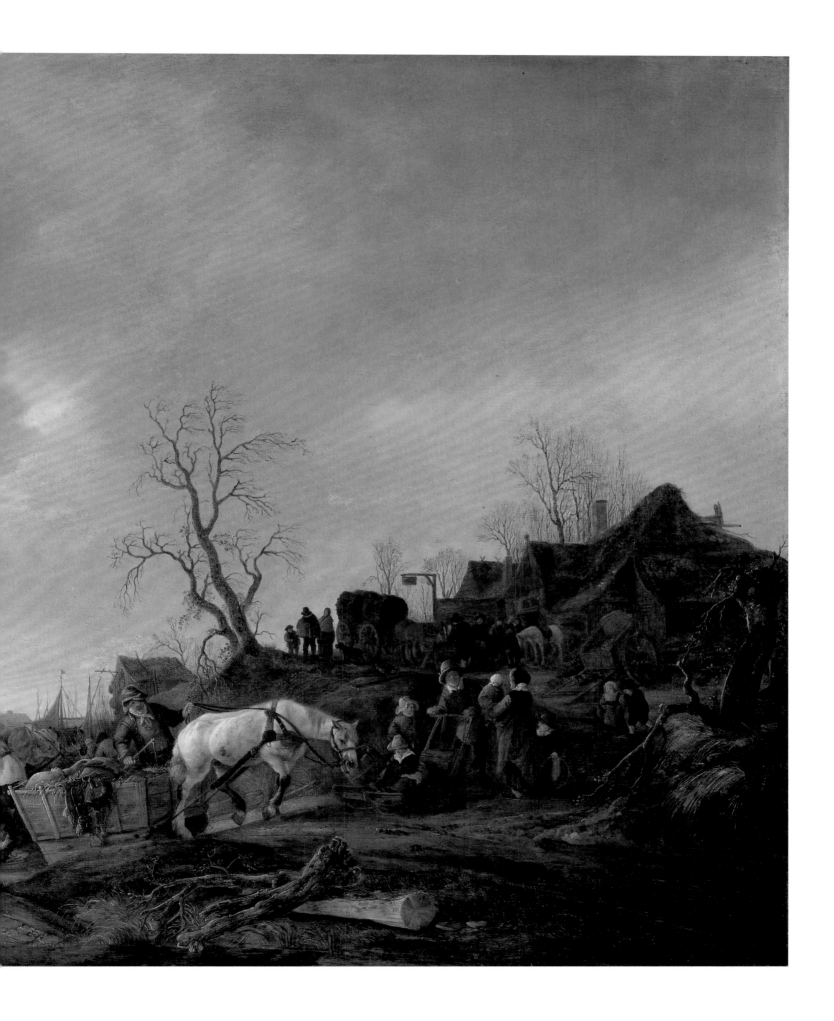

Either the present painting or a closely related composition must have been the source of inspiration for the only known winter landscape by the genre painter Jan Steen (Skokloster Castle, Bålsta, Sweden). According to the artist's biographer Jacob Campo Weyerman, Steen trained for a time in Haarlem with Isack van Ostade's brother Adriaen. It was perhaps in this period that Steen produced that youthful work, which can be dated to before 1651.[2] Finally, Van Ostade's winter landscapes clearly influenced such Haarlem painters as Philips Wouwerman and Claes Molenaer (ca. 1626/29–1676).

Provenance: Graf Josef Fries (d. 1788), Vienna; by descent to his son, Reichsgraf Moritz Christian Fries (1777–1826), where displayed in the Erste Zimmer of the Graf Fries Palais (Josephsplatz, today Palais Pallavicini), in Vienna until ca. 1821; bought by King Maximilian I Joseph of Bavaria (d. 1825) ca. 1821 for his "Privat Gemälde Sammlung" (Private Collection of paintings), and kept at the Residenz, Munich (no. 98 in an inventory of his collection drawn up by Georg von Dillis in 1823–25); his estate sale, Munich, December 5ff, 1826; there acquired with several other paintings for the Königliche Gemäldegalerie; deaccessioned in 1940 (approval given by the Bavarian State Ministry on January 16, 1940) and sold by exchange to Walter Andreas Hofer, Berlin; Adalbert Bela Mangold, Cannes, until 1966; with H. Terry Engell, London, 1966–67 (Important Old Master Paintings, 1966, no. X, ill.); with Gebr. Douwes, Amsterdam, 1967, by whom exhibited in the Delft Fair in that year; Herbert Girardet, Kettwig (1967–1978); private collection, Bad Godesberg; acquired at sale, London (Sotheby's) July 7, 2010, lot. 27.

Exhibitions: Pinakothek, Munich (now Alte Pinakothek) from 1836, as part of the Zentralgemäldedirektion, and subsequently the Bayerische Staatsgemäldesammlungen from 1856 onward; Königlichen Pinakothek, and subsequently Alte Pinakothek, Munich, until 1940; Museum Het Prinsenhof, Delft, XIXe Oude Kunst- en Antiekbeurs, 1967 (exhibited by Gebr. Douwes); Wallraf-Richartz-Museum, Cologne, and Museum Boijmans Van Beuningen, Rotterdam, Sammlung Herbert Girardet. Holländische und Flämische Meister, 1970, no. 39; Mauritshuis, The Hague, Terugzien in bewondering, 1982, no. 64; Rijksmuseum, Amsterdam, Museum of Fine Arts, Boston, and Philadelphia Museum of Art, Masters of 17th Century Dutch Landscape Painting, 1987–88; Museo Thyssen-Bornemisza, Madrid, The Golden Age of Dutch Landscape Painting, 1994; Mauritshuis, The Hague, Holland Frozen in Time: The Dutch Winter Landscape in the Golden Age, 2001–2002.

Literature: Von Dillis 1838, p. 569, no. 251 (reprinted in Böttger 1972); Verzeichnis der Gemälde in der Königlichen Pinakothek zu München 1838–65, 1838, 1839, 1845, p. 220, 1853, p. 205, 1856, p. 204, 1865, p. 183, always as no. 251; Waagen 1862, p. 150; Gaedertz 1869, p. 135 (as Isack van Ostade); Marggraff 1872 (3rd ed.; 1st. ed., 1865)], pp. 175–76, no. 843 (251 in Von Dillis 1838); Von Reber 1879–1911, 1879, 1881, p. 148, no. 378, 1884, 1886, 1888, 1891, 1893, p. 81, no. 378, 1896, 1898, 1901, p. 90, no. 378, 1908, p. 88, no. 378, 1911, p. 110, no. 378; Hirth and Muther 1888, p. 163; A. Rosenberg 1900, p. 100; Hofstede de Groot 1907–28, vol. 10, p. 463, no. 83; Von Wurzbach 1906–11, vol. 2, p. 288; Von Frimmel 1913–14, pp. 416, 420; Errera 1920–21, p. 240; Katalog der Älteren Pinakothek zu München 1922, p. 110, 1925, p. 111, 1928, p. 101, 1930, p. 117, 1936, p. 180, always as no. 1037; Stechow 1928, p. 173, ill. p. 175; Martin 1935, p. 404, ill. p. 405, no. 244; Weltkunst 1966, p. 939; Burlington Magazine 1966, ill. pl. XII; Kist 1967, pp. 424–25, no. 13, ill..; Sammlung Herbert Girardet. Holländische und Flämische Meister 1970, n.p., no. 39, ill.; Böttger 1972, p. 569 (republishing Von Dillis 1838 inventory; Scheffler identified the painting as inv. no. 1037); Bénézit 1976, p. 48; Meisterwerke der Malerei in Deutschen Museen 1977, under I. von Ostade; Kirschenbaum 1977, p. 35, ill. p. 168, fig. 23; Braun 1980, p. 86, under no. 11, ill. p. 87, no. 11a; Müllenmeister 1973–81, vol. 3, pp. 17, 18, no. 292, ill. fig. 292; Terugzien in bewondering 1982, no. 64, p. 168, ill. p, 169; Masters of 17th Century Dutch Landscape Painting 1987–88, pp. 392–94, no. 64, ill., and in col. pl. 46; The Golden Age of Dutch Landscape Painting 1994, p. 160, no. 42, ill.; Steeb 1996, pp. 257–58; Holland Frozen in Time 2001, pp. 110–11, no. 19, pp. 162–63, no. 19, ill.; to be included in Hiltraud Doll, catalogue raisonné of the paintings of Adriaen and Isack van Ostade (forthcoming).

Notes:
1. Houbraken 1718–21, vol. 1, p. 347.
2. Weyerman 1729–69, vol. 2, p. 348.

ADAM PIJNACKER

SCHIEDAM? CA. 1620–1673 AMSTERDAM

Adam Pijnacker's exact date of birth is not known, but 1620 or early in 1621 seems most probable because on January 22, 1652, he stated that he was thirty-one years old.[1] He was most probably born in the port of Schiedam, a little to the west of Rotterdam. His father was a prosperous wine merchant who owned a fleet of sea-going ships; in addition, he held the posts of sheriff and city council member. It is not known who taught Adam, and he did not join the St. Luke's Guild in Schiedam, which may suggest that he was a businessman first and foremost. Houbraken stated that Pijnacker spent three years in Italy, perhaps primarily on business.[2] This journey probably took place between 1645 and 1648, but no documents confirm this. Between 1649 and 1657, Pijnacker is reported in Delft several times but it is doubtful whether he ever moved there. In 1652 and 1657, he is mentioned in the Schiedam archives and on September 7, 1658, there is the announcement of his marriage to Eva de Geest, the eldest daughter of the Frisian portrait painter Wybrand de Geest (1592–ca. 1661). The marriage took place on September 20 of that year in Dantumadeel in the province of Friesland. Around that time, Pijnacker must have adopted the Catholic faith of his in-laws since in 1660 and 1661 the couple's two children were baptized as Catholics. In 1661 or soon afterward, the family moved to Amsterdam, where Pijnacker died in 1673 and was buried on March 28.

Pijnacker was undoubtedly one of the most original Italianate landscape painters. He had a style all his own from the very beginning. He showed a clear preference for carefully executed, lucid lighting, and highly detailed painting. Establishing a chronology for his work is difficult because he seldom dated his paintings. His rare drawings also show great originality.

Literature: Hofstede de Groot 1907–28, vol. 9, pp. 519–68; *Dutch 17th Century Italianate Landscape Painters* 1978, pp. 184–94; Harwood 1988.

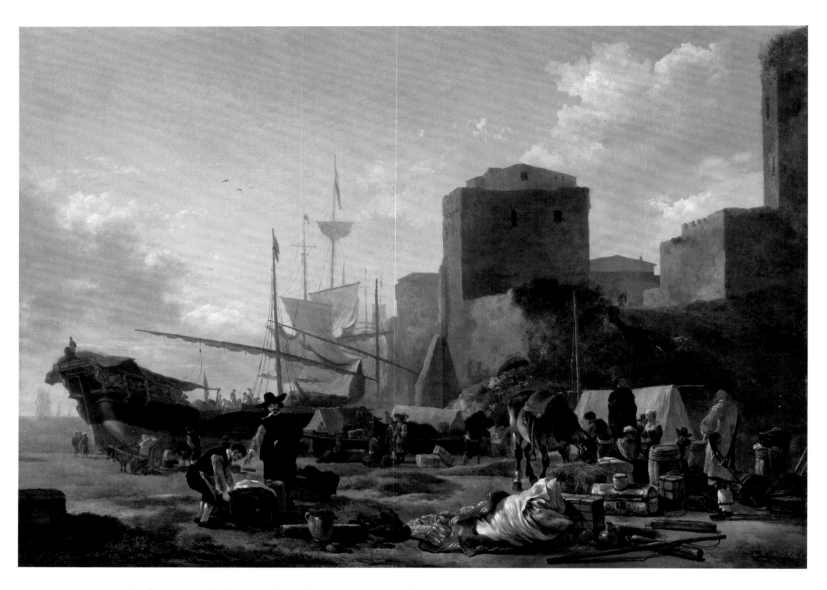

CATALOGUE 45. *Mediterranean Harbor*, ca. 1650. Oil on panel, 13 × 18 3/8 inches
(33.1 × 46.5 cm). Signed lower right: *AP ÿnacke*r (*AP* in ligature)

TOWARD THE END OF THE 1640S, Southern harbor scenes became a popular subject for the Dutch Italianate painters. Jan Baptist Weenix, and to a lesser extent Jan Both and Jan Asselijn, introduced this theme in the Northern Netherlands. Over the next decade, their colleagues Nicolaes Berchem, Johannes Lingelbach (1622–1674), and Adam Pijnacker regularly tackled this genre. The earliest known painting of this type is *View of Naples* of around 1558 by Pieter Bruegel the Elder (1525/30–1569) in the Galleria Doria Pamphilj in Rome. But more important in this connection is the work of Paul Bril (1554–1626). A native of Antwerp, he went to Italy at an early age and lived there for the rest of his life. His Southern landscapes greatly influenced the Italianate landscapists from the North. One of the earliest examples of an imaginary Southern harbor is Bril's *River Landscape with a Ruined Tower* (1600; Kunsthistorisches Museum, Vienna). Bril's influence on other painters is apparent from a drawing of a Southern harbor by Claude Lorrain (1600–1682) in the British Museum in London.[3] This drawing, a version of Bril's impressive harbor view in the Musées Royaux des Beaux-Arts de Belgique in Brussels, clearly reveals Claude's debt to Bril. Dutch artists who visited Italy in the first half of the seventeenth century would no doubt have seen harbor views by Claude and Bril and, inspired, several of them concentrated on painting Mediterranean harbor views after returning North. In most cases, these were imaginary harbors but sometimes they incorporated existing architecture or sculpture. Pijnacker's *Mediterranean Harbor* appears to be entirely imaginary. Traders, workmen, travelers, and oriental figures wearing turbans and exotic caps engage in all manner of activities on the quay of a Southern harbor. On the right stand some unidentified buildings and on the left lie large and small ships, while behind them the sea and a few ships can just be seen. In the foreground, various goods are displayed for sale, amidst which a mule is eating from a basket of hay.

A warm golden sunlight characteristic of Pijnacker's work permeates the scene. White sails stand out against the predominantly blue sky. The bright red cloak of the man on the right provides a striking color accent, which is balanced by several other red objects.

The panel is not dated, but a date around 1650, shortly after his return from the South, seems likely. A related harbor view by Pijnacker in a private collection in England is dated 1650.[4] It shows an almost identical sailing ship, and the man standing on the right in the dark cloak and red cap also recurs in it. It may be assumed that at least for the ship and this standing man, Pijnacker made use of now lost studies or sketches possibly made in Italy. Until a few years ago, this painting led a hidden life, so it is an important addition to the painter's work. It is published here for the first time.[5]

Provenance: Lürman, Bremen; Kunstsalon Abels, Cologne, 1952 (label on verso); private collection, Bremen; collection of a merchant bank, Hamburg, until 2000; anonymous sale, Cologne (Lempertz), November 25, 2000, no. 1227; acquired from Haboldt & Co., Paris and New York, in 2001.

Notes:
1. Schiedam Municipal Archives, O. R. A., inv. no. 751, folio 766; Harwood 1988, pp. 202–203.
2. Houbraken 1718–21, vol. 2, p. 96.
3. Pen and gray wash, Liber Veritatis 30 (British Museum, London).
4. Harwood 1988, no. 155.
5. Not in Harwood 1988 (possibly under Lost Paintings: p. 158, no. D22: *Italian Landscape with Seaport*, Hoet 1752, vol. 1, p. 106, no. 33 [sale 1707] or no. D23: *Landscape with Seaport*, Hoet 1752, vol. 1, p. 176, no. 17 [sale 1714]).

JAN PORCELLIS

GHENT BEFORE 1584–1632 ZOETERWOUDE

Jan (or Joannes) Porcellis was born in Ghent in the Southern Netherlands between 1580 and 1584. Like so many others, his parents fled to the North in 1584 to escape the Spanish invasion. They settled in Rotterdam. The earliest mention of Porcellis is in 1605, when he married Jaquemijntje Jans in Rotterdam. Little is known about his training and possible teachers. According to Houbraken, he was a pupil of the Haarlem marine painter Hendrick Cornelisz. Vroom (ca. 1563–1640), but that cannot be confirmed.[1] Prior to 1615, he spent some time in London, where one of his daughters was born. In 1615, he is mentioned as a painter in Antwerp, where he had gone with his wife and three daughters after going bankrupt in Rotterdam. His financial position remained precarious, however, and a short time later he was forced to sign a contract to produce forty paintings in twenty weeks for a fixed sum. He became a member of the St. Luke's Guild in Antwerp in 1617. After living in Antwerp for nine years, he returned to the North, now a widower, and settled in Haarlem. There, on August 22, 1622, he married Janneke Flessiers, the daughter of the painter and print publisher Balthasar Flessiers (before 1575–in or before 1626). In 1624, the couple moved to Amsterdam and two years later to Voorburg near The Hague. Porcellis spent the last years of his life in Zoeterwoude near Leiden. By then, his financial position was much improved: he owned several houses in Leiden and The Hague. He died in Zoeterwoude on January 29, 1632. His only son, Julius Porcellis (before 1610–1645), who painted marines in the style of his father, inherited his studio.

Jan Porcellis painted and drew marines and beach views exclusively. His emphasis was not so much on the ships as on the atmosphere on the water. He was one of the most innovative artists of his time. Contemporaries were full of praise: Constantijn Huygens, *Stadholder* Frederik Hendrik's

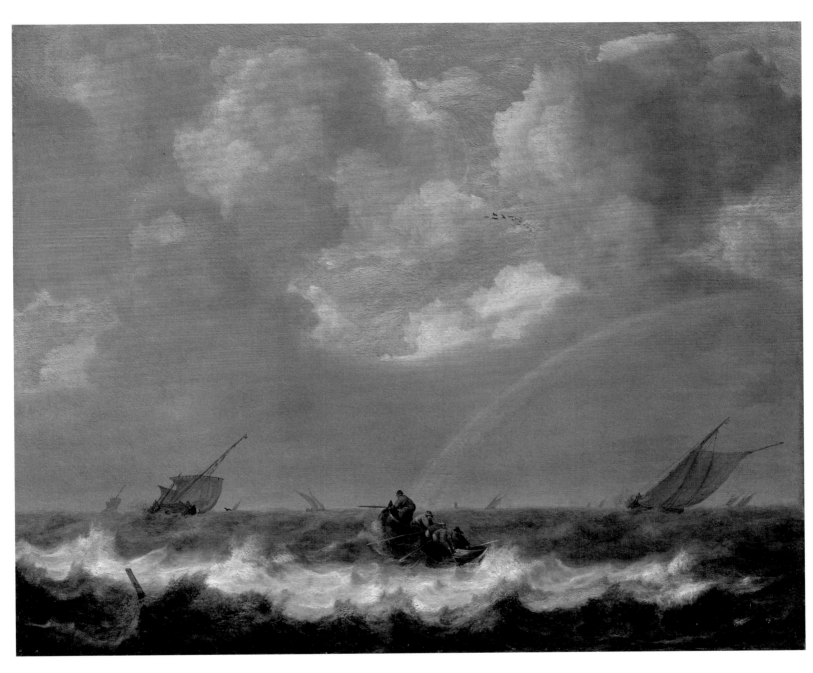

CATALOGUE 46. *Seascape with a Rainbow*, ca. 1631. Oil on panel, 12 3/4 × 15 3/8 inches
(32.4 × 39.1 cm). Monogrammed lower left on a piece of driftwood: *IP*

secretary and a great connoisseur, wrote enthusiastically about Porcellis in his diary. He received
even greater praise from Samuel van Hoogstraten, who in 1678 called him "the great Raphel [sic] in
sea painting."[2] Other artists also admired his work: Rubens (1577–1640) owned a painting by him,
Rembrandt had six, and Jan van de Cappelle no fewer than sixteen. In the eighteenth and nineteenth
centuries, Porcellis's name was almost forgotten, but now his work is again much sought-after.
His oeuvre is fairly small: at present we know of about sixty paintings, thirty drawings, and a series
of etchings.

Literature: J. J. Walsh 1971; J. J. Walsh 1974, pp. 653–62, 734–35.

CATALOGUE 46

SEASCAPE WITH A
RAINBOW

MORE THAN ANY OTHER PAINTER of his day, Jan Porcellis succeeded in limiting his
naturalistic seascapes to the most essential elements. That applies equally to this panel, where under
a high, cloudy sky there is a choppy sea and on it, in the center foreground, a fishing boat and
closer to the horizon several sailboats. The spray from the waves and the angle of the boats in the
water show that a stiff wind is blowing. The rainbow is a striking element, indicating that it
has just rained.

Various masters from the so-called "tonal phase" of Dutch landscape painting took a keen
interest in weather. Apart from Porcellis, mention must be made of Jan van Goyen, Pieter van
Santvoort (1604/1605–1635), Salomon van Ruysdael, and Pieter de Molijn (1595–1661).
Each of them painted landscapes with heavy clouds and wind and rain raging over them, sometimes
with lightning in the sky. Rainbows, however, are seen only sporadically in Dutch landscapes
and marines. In 1614, Adriaen van de Venne (1589–1662) painted a big rainbow in *Fishing for Souls*
(Rijksmuseum, Amsterdam), but there it has symbolic meaning and is not primarily a landscape
motif as in Porcellis. So far as is known, with this panel Porcellis became the first Dutch
artist to depict this natural phenomenon in a landscape or marine painting. It was not until
1641 that Van Goyen painted a landscape with a rainbow (Hallwylska Museet, Stockholm),[3] and
even later, around 1660, until Jacob van Ruisdael painted his famous *Jewish Cemetery*, in which
a rainbow is also prominent.[4] In Flanders, Rubens had already painted a landscape with a rainbow
around 1636 (Wallace Collection, London). In the seventeenth century, however, it remained an
unusual motif in both the Northern and the Southern Netherlands. It is curious that Porcellis used
only blue and yellow for the rainbow; if he had forgotten which colors to use, he could have con-
sulted Karel van Mander's didactic poem *Den grondt der edel vry schilder-const* of 1604, which was very
familiar to painters at that time. It stated that the rainbow consists successively of the colors
purple, "incarnate," orange or rich red, yellow, soft green, blue, and purple again.[5]

The rainbow in the panel by Porcellis not only indicates a certain type of weather, but also
plays a role in the composition, adding emphasis to the fishing boat in the foreground because the
end of the rainbow is located just behind it. In the boat, the fisherman farthest forward with the
red cap and reddish-brown coat is pulling in the net; three others row while the fifth is forward in the
boat keeping a lookout. A large part of the water surface lies in shadow, but just in front of the
boat the sunlight sweeps over a strip of water. Here and there, the bright blue of the sky is reflected
in this strip of light. Between two dark clouds on the right flies a flock of birds, while to the right
of the left-hand sailboat an occasional bird can be seen above the horizon. The only sign of land is
the lighthouse or church tower in the middle of the horizon.

Porcellis probably painted *Seascape with a Rainbow* at the end of his life, around 1631. At that time, he also painted *Three "Damlopers" in a Fresh Breeze* (Ashmolean Museum, Oxford). In these last marines, he put greater emphasis on the atmosphere, the heaving sea with a few small ships, and the heavily clouded sky that bright light shines through here and there. Porcellis's reputation largely rests on atmospheric panels of this kind, which made a significant contribution to the "tonal phase" of Dutch landscape and marine painting.[6]

Provenance: With E. Plietzsch, Berlin, before 1938; O. Rosler, Berlin and Düsseldorf, in or after 1938–61; by descent to B. Rosler, Düsseldorf 1961–67; thence by descent to H. E. Rosler, New York, 1967–81, his sale, New York (Phillips), June 10, 1981, no. 74 (sold for $39,600); with Harari & Johns, London, 1981–82, from whom acquired by a private collector; anonymous sale ("Property of a Private Collector"), New York (Sotheby's), January 23, 2003, no. 13 (sold for $288,000); acquired from Otto Naumann, New York, in 2003.

Literature: J. J. Walsh 1971, pp. 119, 246, no. A50, ill. fig. 72.

Notes:
1. Houbraken 1718–21, vol. 1, p. 213.
2. Huygens 1897, vol. 18, p. 70; Van Hoogstraeten 1678, p. 238.
3. Beck 1972–91, vol. 2, no. 1145.
4. Two autograph versions are in The Detroit Institute of Arts, and Staatliche Kunstsammlungen, Dresden; see Slive 2001, nos. 178, 180.
5. Miedema 1973, pp. 188–89.
6. An almost identical scene but without a rainbow was auctioned as Simon de Vlieger on March 5, 1928, in Brussels (Galerie Georges Giroux), no. 24 (oil on panel, 12 1/5 × 16 inches [31 × 40.5 cm], signed on driftwood l. l.).

PAULUS POTTER

ENKHUIZEN 1625–1654 AMSTERDAM

The son of the still-life and landscape painter Pieter Potter (1597/1601–1653), Paulus Potter was baptized in Enkhuizen on November 20, 1625. In 1628, he moved with his parents to Leiden, where his father registered with the glassmakers' guild; they lived near the university and were in touch with several eminent families. In 1631, the family moved to Amsterdam. According to Houbraken, Paulus received his first art lessons in his father's studio.[1] Although this is not documented, on the basis of Potter's early work it is thought that he was also taught by the Amsterdam painter Claes Moeyaert (1591/92–1655). According to a sketchbook belonging to Jacob de Wet (ca. 1610–before 1691) with notes from the period 1636–71, Potter paid Moeyaert money for lessons on May 12, 1642.

On August 6, 1646, Potter joined the St. Luke's Guild in Delft. Probably from 1647 but in any case from 1649, he was in The Hague, where he rented a house on Dunne Bierkade from the painter Jan van Goyen, who lived next door. In the same year, Potter registered with the guild in The Hague. On the other side of Potter's house lived the master carpenter Claes Dircksz. van Balckeneynde with his family. On July 3, 1650, Potter married Van Balckeneynde's eldest daughter, Adriana. The couple then left for Amsterdam, where Potter lived from 1652 until his death. This last move may have had to do with a dispute in 1651 over supplying paintings to the *stadholder's* court in The Hague. Potter died of tuberculosis at only age twenty-nine and was buried in the Nieuwezijdskapel in Amsterdam on January 17, 1654.

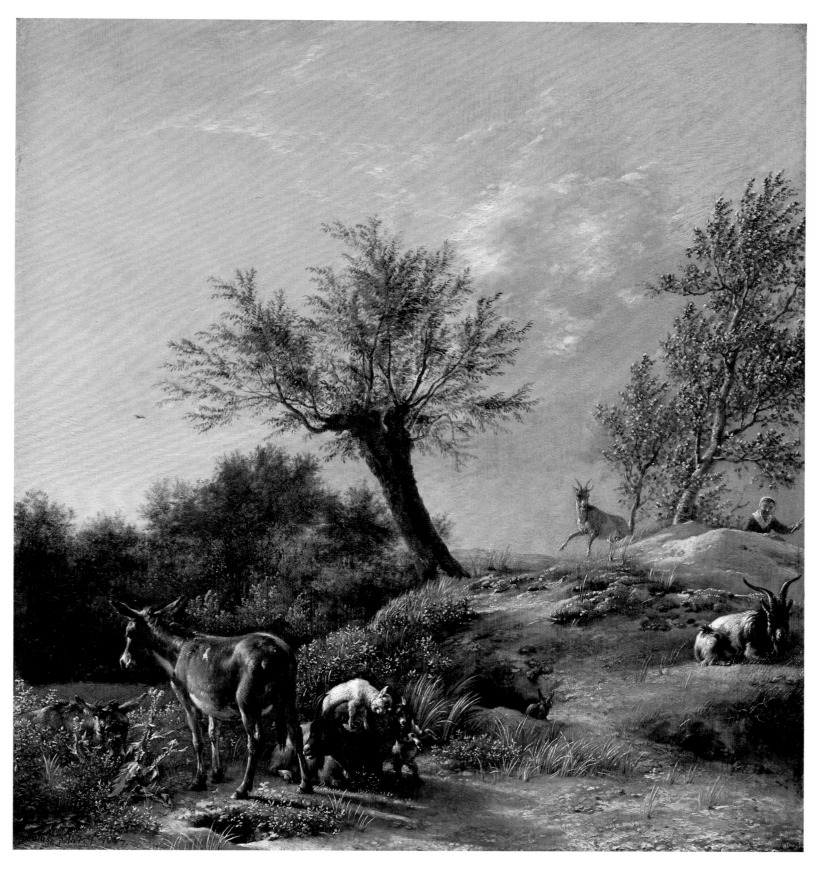

CATALOGUE 47. *Spring Landscape with Donkeys and Goats ("The Rabbit-Warren")*, 1647. Oil on panel, 15 1/2 × 14 1/4 inches (39.5 × 36 cm). Signed and dated lower left: *Paulus. Potter: f./1647*

Houbraken claimed that on his great-grandmother's side, Potter came from an old aristo-cratic family. Whatever truth there may be in this, it is clear that he had contacts and patrons in the cultivated upper crust of the Dutch Republic. Houbraken stated, for example, that Count Johan-Maurits van Nassau-Siegen and other highly placed persons regularly visited Potter's studio in The Hague, and that the painter later moved to Amsterdam on the recommendation of the celebrated physician Nicolaes Tulp.[2] Potter also received an important commission from Amalia van Solms, the widow of *Stadholder* Frederik Hendrik.

Despite his short life, Potter left a most original oeuvre of high quality in which the subject of cattle was central. His idyllic landscapes with cattle reflect the vision of the well-to-do city-dweller trying to escape from hectic, noisy urban life into the country. Potter's earliest work, which con-sists mainly of history pieces, dates from 1641, when he was barely fifteen. In addition to paintings, a limited number of drawings and a series of about twenty etchings are known. In the eighteenth and nineteenth centuries, his work was particularly popular with French and English collectors.

Literature: Hofstede de Groot 1907–28, vol. 4, pp. 582–670; A. L. Walsh 1985; *Paulus Potter* 1994–95.

CATALOGUE 47

SPRING LANDSCAPE WITH DONKEYS AND GOATS ("THE RABBIT-WARREN")

THIS EXCELLENTLY PRESERVED PAINTING takes its title from the rabbit warren in the middle at the foot of the dune with its occupant in front. But the scene involves much more. Around the warren are all kinds of animals. In the left foreground stands a donkey and to the left of it another one rests amidst the thistles. In the middle lies a goat with two frolicking kids. On the far right is another goat and a third jumps up from behind the dune. Half-hidden behind the dune, next to two birches, is a peasant woman or shepherdess with a distaff. The horizon is largely obscured by the dune and the bushes. A crooked pollard willow stands out against the lightly clouded sky. The characteristic light of the low, late afternoon sun washes over the scene with a warm glow, creating long shadows. Potter has used countless highlights in white to depict the glistening reflections of the last rays of sun. This and other paintings with *contre-jour* (from behind) lighting, such as *Farmhouse near The Hague* (collection of the Duke of Westminster) and *Cows on Their Way to Pasture* (Residenzgalerie, Salzburg), both of 1647, reveal Potter's marked preference for landscapes lit by the warm glow of the setting sun.

Potter was preeminently a painter of cattle, but, as here, landscape elements always play an important role in his compositions. He always gave great attention to such details as the vegetation and the different kinds of trees and depicted the animals very realistically and convincingly. Thus, in this painting, the goat lying on the right can be identified by its long hair and twisted horns as a Dutch "land goat" (*landgeit*). So, it is most likely that Potter based it on sketches he had done from life. Houbraken confirmed this with a quotation from a letter from a son of Potter's widow, who wrote that when he had time "to go out for a walk, [he] always took a notebook in his pocket so that if he saw something of interest . . . he could sketch that object later."[3] We can assume that he regularly went for walks from his house, which was on the edge of The Hague and looked out over meadows, to make sketches. Indeed, a number of fluent sketches by Potter of different kinds of cattle have survived. He would have used one or more no longer extant sketches for this painting. This can also be deduced from a comparison be-tween this panel and a painting of 1643 in which the same group of the goat and her kids playing appears (Institut Néerlandais, Frits Lugt Collection, Paris). The subject of this panel, a shepherdess with animals in a sun-drenched, hilly landscape, shows a close affinity with the work of Dutch Italianate painters such as Nicolaes Berchem, Karel du Jardin, and chiefly Pieter van Laer (1599–after 1642). An etching by Van Laer of 1636 also shows a shepherdess with a distaff and a donkey standing and one lying down.[4] In other compositions, too, Potter demonstrated that he was well acquainted with Van Laer's work.

Potter preferred smaller formats, so-called cabinet pieces, for his cattle paintings, which were mainly done on panel. Yet, he sometimes chose a large format, whether or not at the patron's request, as his best-known work, *The Bull* (Mauritshuis, The Hague), demonstrates. This monumental canvas – in format, subject, and detailed execution an exceptional work in every respect – was painted in the same year as *"The Rabbit Warren,"* when Potter was only twenty-two. As this panel and other works show, he was already an accomplished master who had completely absorbed the influences of his teachers and of artists such as Van Laer, and developed a style of his own. Despite his careful and detailed painting manner, Potter worked quite quickly. In addition to the present panel and *The Bull*, there are at least ten other dated pieces from 1647.

Provenance: Probably Cornelis van Dyck, The Hague, his estate sale, The Hague, May 10, 1713, no. 31 (dfl. 60; "Een stuk met Ezels en Geyten, oudt en jong, zeer lieflyk en bevallig van kouleur en van zyn beste tydt, door Paulus Potter, verbeeldende een Duyntje;" see Hoet 1752, vol. 1, p. 162); Eynard, Paris, by 1829, from which bought by John Smith, for ffr. 7,000 (see below, Literature, Smith); with John Smith, London; Michael M. Zachary, before 1828, his sale, London (Phillips), May 31, 1828, no. 54 (unsold), his estate sale, London (Christie's), March 30, 1838, no. 43 (£351.15. to Bredel); Charles A. Bredel, London, 1838 (£735 to Brown); purchased from Brown in 1841 for the Holford Collection; Robert Staynor Holford, MP (1808–1892), Dorchester House, London, and Westonbirt, Gloucestershire; thence by descent to his son, Sir George Lindsay Holford, Dorchester House, London, and Westonbirt, Gloucestershire, his estate sale, London (Christie's), May 17, 1928, no. 30 (gns. 8,000 to Frits Lugt on behalf of Dr. F. H. Fentener van Vlissingen, Vught/Utrecht); heirs of Fentener van Vlissingen, until 1988; anonymous sale ("The Property of a Lady"), London (Sotheby's), December 7, 1988, no. 93; private collection, Wassenaar; acquired from Johnny Van Haeften Ltd., London, in 1996.

Exhibitions: British Institution, London, *Exhibition of Pictures by Italian, Spanish, Flemish, Dutch and English Masters*, 1829; British Institution, London, *Exhibition of Pictures by Italian, Spanish, Flemish, Dutch, French, and English Masters*, 1836; Manchester, England, *Art Treasures of the United Kingdom Collected at Manchester in 1857*, 1857–58; Royal Academy, London, *Exhibition of Works by Old Masters and by Deceased Masters of the British School*, 1887; Burlington Fine Arts Club, London, *Exhibition of Pictures by Dutch Masters of the Seventeenth Century*, 1900; Museum Boymans, Rotterdam, *Meesterwerken uit Vier Eeuwen* 1938; Van Abbe Museum, Eindhoven, *Nederlandse Landschapskunst in de Zeventiende eeuw*, 1948; Musée de l'Orangerie, Paris, *Le Paysage Hollandais au XVII Siècle*, 1950–51; Museum Boijmans Van Beuningen, Rotterdam, *Kunstschatten uit Nederlandse Verzamelingen*, 1955; Institut Néerlandais, Paris, *Bestiaire Hollandais*, 1960;, Dordrechts Museum, Dordrecht, *Nederlandse Landschappen uit de Zeventiende eeuw* 1963; on loan to The Metropolitan Museum of Art, New York, 1985–88; Mauritshuis, The Hague, *'t Land van Paulus Potter*, 1994–95.

Literature: Hoet 1752, vol. 1, p. 162, no. 31; *Exhibition of Pictures by Italian, Spanish, Flemish, Dutch and English Masters* 1829, p. 14, no. 17; Smith 1829–42, vol. 5, p. 145, no. 65; *Exhibition of Pictures by Italian, Spanish, Flemish, Dutch, French, and English Masters* 1836, p. 10, no. 55; Smith 1829–42, vol. 9, p. 627, no. 25; Waagen 1854, p. 201; *Art Treasures of the United Kingdom Collected at Manchester in 1857* 1857, p. 70, no. 1002; Blanc 1858, pp. 161, 379; Thoré 1860, p. 284; Van Westrheene 1867, pp. 83, 157–58, no. 38; *Exhibition of the Works of the Old Masters and by Deceased Masters of the British School* 1887, p. 22, no. 91; *Exhibition of Pictures by Dutch Masters of the Seventeenth Century* 1900, p. 19, no. 1; Hofstede de Groot 1907–28, vol. 4, no. 136 and probably no. 136a; Graves 1913–15, vol. 2, pp. 946–48; Benson 1927, p. 27, no. 145, ill. pl. CXXX; Borenius 1928, p. 223, ill. p. 224; Michel 1930, p. 76; Arps-Aubert 1932, p. 36, no. 19; *Meesterwerken uit Vier Eeuwen* 1938, p. 30, no. 123, ill. fig. 109; *Nederlandse Landschapskunst in de Zeventiende eeuw* 1948, p. 23, no. 49; *Le Paysage Hollandais au XVII Siècle* 1950–51, p. 35, no. 60; *Kunstschatten uit Nederlandse Verzamelingen* 1955, p. 48, no. 97, ill. p. 95, fig. 95; Gerson 1952, p. 49, ill. fig. 141; *Bestiaire Hollandais* 1960, p. 29, no. 148; *Nederlandse Landschappen uit de Zeventiende eeuw* 1963, p. 32, no. 99, ill. fig. 95; *Paulus Potter* 1994–95, pp. 84–86, no. 10, ill.; A. L. Walsh 2009, p. 25; *A Choice Collection* 2002, p. 145, fig. 25d, p. 215 n. 22.

Notes:
1. Houbraken 1718–21, vol. 2, p. 126.
2. Ibid., vol. 2, pp. 126–29.
3. Ibid., vol. 3, p. 129.
4. Duthuit 1881–88, vol. 5, p. 37, no. 4; Hollstein 1949–, vol. 10, pp. 5–6.

REMBRANDT VAN RIJN

LEIDEN 1606–1669 AMSTERDAM

Rembrandt Harmensz. van Rijn was born on July 15, 1606, the son of a miller in Leiden. According to the city's historian Jan Orlers, he attended the Latin School for seven years until in May 1620, when he was nearly fourteen, he registered with the University of Leiden.[1] But he soon gave up his studies in order to devote himself fully to art. From 1621 to 1623, he was taught by Jacob van Swanenburg (ca. 1571–1638) in Leiden and then for six months by the history painter Pieter Lastman (1583–1633) in Amsterdam. Van Swanenburg does not seem to have greatly influenced Rembrandt, but Lastman did. Around 1624/25, Rembrandt set up as an independent artist in Leiden. His earliest work consists chiefly of history pieces but during this period he also painted genre scenes and *tronies* (studies of facial expressions). In his Leiden years, Rembrandt worked closely with Jan Lievens. Around 1630, Constantijn Huygens, the secretary of *Stadholder* Frederik Hendrik, wrote about these two highly promising young Leiden artists in his diary.[2] At about this time, Rembrandt was focusing on the graphic arts. In 1631 or 1632, he left Leiden for Amsterdam. He moved in with the successful dealer Hendrick Uylenburgh on Sint Anthoniesbreestraat, with whom he entered into a partnership. From the moment he arrived in Amsterdam, he was given numerous commissions for portraits, including the important one for a large group portrait, *The Anatomy Lesson of Dr. Tulp* (1632; Mauritshuis, The Hague). In 1634, he registered with the Amsterdam St. Luke's Guild and in June of that year he married Saskia Uylenburgh, a cousin of Hendrick van Uylenburgh and the daughter of a wealthy lawyer. Of the couple's four children, only Titus, born in 1641, survived. By then, Rembrandt had become the most sought-after portraitist in Amsterdam.

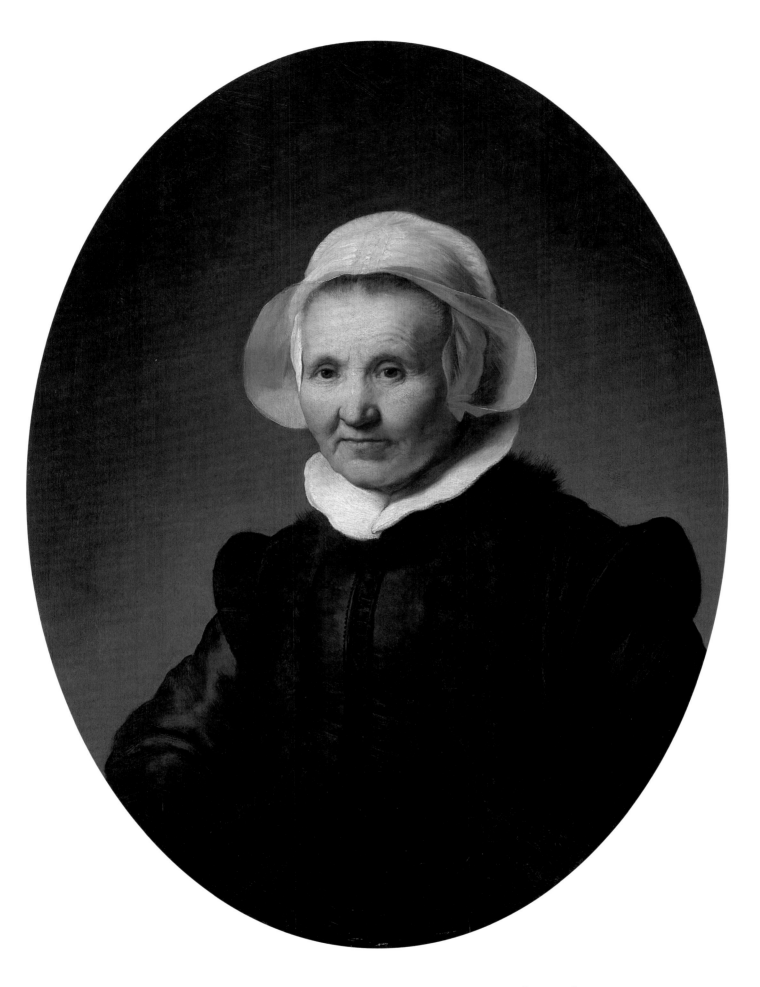

CATALOGUE 48. *Portrait of Aeltje Uylenburgh*, 1632. Oil on panel, 29 × 22 inches (73.7 × 55.8 cm). Signed and dated upper right: *RHL van Ryn/1632* (*RHL* in ligature); inscribed upper left: *Æ 62*

Between 1633 and 1639, Rembrandt made a series of six paintings of Christ's Passion for Frederik Hendrik, a commission he owed mainly to Huygens. In 1639, Rembrandt bought a large house on Sint Anthoniesbreestraat that was well beyond his means. In 1642, at the height of his success, Saskia died. In that year, he completed his most famous painting, the so-called *Night Watch* (Rijksmuseum, Amsterdam). After Saskia's death, he had an affair with his housekeeper Geertge Dircx. When Rembrandt abandoned her in favor of Hendrikje Stoffels, she sued him for breach of promise. From that point on, Hendrikje lived with Rembrandt but they did not marry because then he would have lost his legal right to participate in Saskia's legacy. Despite Hendrikje's efforts to economize, Rembrandt's financial problems soon worsened and in 1656 he was declared bankrupt; his house, possessions, and extensive art collection were auctioned. A few years later, Rembrandt and Hendrikje moved into a house on Rozengracht. To protect Rembrandt against creditors, Hendrikje and Titus set up a firm that employed the artist. In 1661, he was commissioned to paint a large canvas of *The Conspiracy of Claudius Civilis* (Nationalmuseum, Stockholm) for the new city hall of Amsterdam, but the painting was rejected and returned. In the following year, he painted his last group portrait, *The Syndics* (Rijksmuseum, Amsterdam). In the final years of his life, he remained productive and created some of his most penetrating and painterly works. After the death of Hendrikje in 1663 and then his son Titus in 1668, Rembrandt became increasingly isolated. He died in Amsterdam on October 4, 1669, and was buried in the Westerkerk on October 8.

Rembrandt was by far the most gifted and versatile artist in seventeenth-century Holland. Unlike almost all his contemporaries, he did not specialize in one or two genres. He painted, drew, and etched landscapes; still lifes; biblical, mythological, and historical scenes; and, above all, portraits.

Throughout his career, Rembrandt was much in demand as a teacher. His pupils and assistants brought about a wide dissemination of his ideas, style, and methods. Gerrit Dou was his most important pupil in Leiden. In Amsterdam, Govaert Flinck (1615–1660), Gerbrand van den Eeckhout (1621–1674), and Ferdinand Bol (1616–1680) worked in Rembrandt's studio. Samuel van Hoogstraten (1627–1678), Carel Fabritius (1622–1654), Lambert Doomer (1624–1700), and Nicolaes Maes were his pupils in the 1640s. Arent de Gelder (1645–1727) was his last pupil around 1661.

Literature: Hofstede de Groot 1907–28, vol. 6, pp. 1–472; Bredius 1935; J. Rosenberg 1948; Bauch 1966; Gerson 1968; Bredius 1969; Benesch 1973; Bruyn et al. 1982–89; Tümpel 1993; Schwartz 2006.

CATALOGUE 48

PORTRAIT OF AELTJE UYLENBURGH

IN THE FIRST YEARS after 1631 or 1632, when the young Rembrandt had moved from his native city of Leiden to Amsterdam, he produced a substantial number of portraits. Besides painting relatives of Hendrick Uylenburgh, in whose house in Amsterdam Rembrandt lived in his first years and for whom he also worked, he made portraits of many merchants, officials, and ministers. He regularly used an oval format. This painting from 1632 is not only a characteristic example of the style and technique of his portraits of those years, it is also one of his finest and best preserved.

It was only a few years ago that the woman depicted, who was sixty-two years old according to the inscription, was identified as Aeltje Pietersdr. Uylenburgh (1570?–1644).[3] Aeltje was married to the Reformed minister Johannes Sylvius (1564–1638). The couple were part of Rembrandt's intimate circle because she was not only a cousin of the Amsterdam art dealer Hendrick Uylenburgh, in whose house Rembrandt was living, but also of the much younger Saskia Uylenburgh, whom the painter married in 1634. The fathers of Hendrick, Saskia, and Aeltje were brothers. Aeltje and

her husband were witnesses at the baptism of some of Rembrandt's children.[4] The identification of the sitter was made on the basis of a will of 1681 made by Cornelis Sylvius, the son of Aeltje and Johannes, in which portraits of the couple by Rembrandt are described.[5] The painting of Sylvius is probably lost. We know his features from two etchings Rembrandt made of him, one from 1633.[6] We can get an idea of the composition of the lost painting of Sylvius, which was intended to hang on the left of the portrait of Aeltje, from a portrait of a man by Rembrandt that also dates from 1632 and is likewise painted on an oval panel with the same dimensions (figure 1).[7] In this portrait, the sitter – just like Aeltje – is shown to the waist and looks directly at the viewer.

This portrait clearly demonstrates that by 1632 the twenty-six-year-old Rembrandt was an accomplished portraitist, and thus it is not surprising that he quickly became the most sought-after portrait painter in Amsterdam. Aeltje seems to look at the viewer with a faint smile on her lips. Rembrandt has gently immortalized how time has left its mark on the features of the woman, who had reached what was then a venerable age. He used a subdued palette with mainly browns and grays in addition to black and white, so that the flesh tones of her face in combination with the light colors of the cap attract all the attention. Her face is depicted down to the last detail, with

Figure 1. Rembrandt van Rijn, *Portrait of a Man*, 1632. Oil on wood, 29 3/4 × 20 1/2 inches (75.6 × 52.1 cm). The Metropolitan Museum of Art, New York, Gift of Mrs. Lincoln Ellsworth, in memory of Lincoln Ellsworth, 1964.

wrinkles in the soft skin at her mouth, eyes, and forehead. The painting technique whereby opaque and transparent paint layers are combined makes the face lifelike. Its liveliness has been strengthened by the application of a line of white paint near the right eye. Placed before a virtually neutral background on which no shadow is depicted, the face is framed by the white cap and collar which subtly catch the light. Rembrandt has convincingly portrayed the partial transparency of the cap. He searched for the right position for the seated woman, choosing this time not to depict the back of the chair, as he had done in a portrait of a woman from the same year (Gemäldegalerie der Akademie der Bildenden Künste, Vienna).[8] An X-ray photograph shows that the contours of the figure were changed twice; the right shoulder was originally slightly higher.[9] The woman's clothing is painted in diverse shades of black and gray. The dark fur of her collar stands out subtly against the background.

Provenance: Together with (lost) pendant Johannes Cornelisz. Sylvius (1564–1638) and Aeltje Pietersdr. Uylenburgh (1570–1644), Amsterdam; their son, Cornelis Jansz. Sylvius (1608–1685), Amsterdam and Haarlem, 1644–85 (with pendant); his son, Johannes Sylvius Jr. (1652–1710), Haarlem 1685–1710 (with pendant); probably his son Cornelis Sylvius Jr., Haarlem (1687–1738) (with pendant); Prof. Jean Jacques Burlamacchi (1694–1748), Geneva; Mrs. and Mrs. Chapeaurouge, Geneva; with Dubois, Paris, ca. 1825; William G. Coesvelt, London, his sale, London, May 2, 1828, no. 37 (unsold); with John Smith, London (sold to Brondgeest); Albertus Brondgeest (1786–1849), Amsterdam, 1835; Baron James de Rothschild, Paris (1792–1868); his widow Betty de Rothschild (1805–1886), Paris; Baron Alphonse de Rothschild (1827–1905), Paris, until 1905; by descent to Baron Edouard de Rothschild (1868–1949), Paris, until 1949; by descent to Baronesse Bathsheva de Rothschild, Tel Aviv, her sale, London (Christie's), December 13, 2000, no. 52; Noortman Master Paintings, Maastricht, 2000–2005; where acquired in 2005.

Exhibitions: Musée de l'Orangerie, Paris, *Les Chefs-d'oeuvres des Collections Françaises retrouvés en Allemagne par la Commission de Récuperation artistique et les Services alliés*, 1946; National Gallery of Scotland, Edinburgh, *Rembrandt's Women*, 2001 (traveled to Royal Academy of Arts, London); Denver Art Museum, and Newark Museum, *Art & Home: Dutch Interiors in the Age of Rembrandt*, 2001–2002; Städelsches Kunstinstitut and Städtische Galerie, Frankfurt, *Rembrandt 'Rembrandt,'* 2002–2003; Albertina, Vienna, *Rembrandt*, 2004; on loan to the Mauritshuis, The Hague, 2005–2008; Dulwich Picture Gallery, London, and Museum Het Rembrandthuis, Amsterdam, *Rembrandt & Co.: Dealing in Masterpieces*, 2006; National Gallery, London, and Mauritshuis, The Hague, *Dutch Portraits: The Age of Rembrandt and Frans Hals*, 2007–2008; on loan to the Museum of Fine Arts, Boston, since 2008.

Literature: Bredius 1935, no. 333; *Les Chefs-d'oeuvres des Collections Françaises retrouvés en Allemagne par la Commission de Récuperation artistique et les Services alliés* 1946; Bredius 1969, no. 333; Bruyn et al. 1982–2005, vol. 2, no. A 63; Van der Veen 2000, pp. 132–37, no. 52; *Rembrandt's Women* 2001, pp. 86–87, no. 18; *Art & Home* 2001–2002, p. 181, no. 56a; *Rembrandt 'Rembrandt'* 2002–2003, pp. 76–79, cat. no. 12; *Rembrandt* 2004, pp. 192–93, no. 80; Buvelot 2005, no. 3, pp. 22–26; Schavemaker 2005, pp. 320–23, no. 95; Broos and Panhuysen 2006, pp. 42–68, ill. p. 49, fig. 6; Dudok van Heel 2006, p. 257; *Rembrandt & Co.* 2006, pp. 139–40, ill. p. 138, fig. 81; *Dutch Portraits* 2007–2008, pp. 186–87, 253, no. 52, ill.; Broos 2008, pp. 8–12, ill. (detail); Van der Ploeg and Buvelot 2008, p. 19, fig. 16; Broos 2009A, p. 50, fig. 5; Broos 2009B, p. 10, fig. 2.

Notes:
1. Orlers 1641, p. 375.
2. Huygens 1897, vol. 18, pp. 76ff.
3. Jaap van der Veen, in sale cat., London (Christie's), December 13, 2000, pp. 132–37, no. 52; *Rembrandt's Women* 2001, p. 86.
4. For the contacts between Sylvius, Aeltje Uylenburgh, and Rembrandt, see Strauss and Van der Meulen 1979, pp. 107, 110, 124, 155, 209, 250–52.
5. "Twee contrefeytsels van zijn heer testateurs vader en moeder saliger door Rembran[d]t van Rijn geschildert;" see note 1.
6. Bartsch 1797, nos. 266, 280.
7. Bredius 1969, no. 160; Bruyn et al. 1982–2005, vol. 2, no. A 59 and for the supposed pendant of this painting, no. A 62.
8. See Bruyn et al. 1982–2005, vol. 2, no. A 55; *Rembrandt's Women* 2001, no. 17.
9. *Rembrandt 'Rembrandt'* 2002–2003, p. 76.

JACOB VAN RUISDAEL

HAARLEM 1628/29–1682 HAARLEM?

Jacob Isaacsz. van Ruisdael was born in Haarlem; he was the son of the frame-maker, dealer, and painter Isaack Jacobsz. de Gooyer, alias van Ruysdael (1599–1677). Around 1623, the family name De Gooyer was replaced by Van Ruysdael, after, it is thought, the castle Ruisdael or Ruisschendael near Blaricum, where the grandfather of Jacob may have lived. Jacob was probably first taught by his father and later by his uncle, Salomon van Ruysdael. The young Jacob was the only one in the family to use the spelling Ruisdael, probably to distinguish himself from his uncle. Although Jacob did not join the Haarlem guild until 1648, his earliest dated works bear the year 1646. Probably in 1650, he traveled with his friend the painter Nicolaes Berchem to Twente and Westphalia in the area of the German border. Possibly around 1655, Van Ruisdael, who never married, moved to Amsterdam. Houbraken stated that he was also active there as a physician carrying out "manual operations."[1] Moreover, the register of Amsterdam physicians lists a "Jacobus Ruijsdael" who had been awarded a medical degree in 1676 by the University of Caen in Normandy. It remains doubtful, however, whether Van Ruisdael was active as a doctor, partly because this entry in the register was the only one to have been crossed out. In 1657, Van Ruisdael was baptized as a member of the Mennonite congregation in Ankeveen. In 1659, he was registered as a citizen of Amsterdam. He first lived on Kalverstraat and later on the south side of Dam Square. He died on March 10, 1682, in Amsterdam or in Haarlem, and was buried in the Grote or St. Bavokerk in Haarlem on March 14. His paintings were auctioned on June 2 in Haarlem.

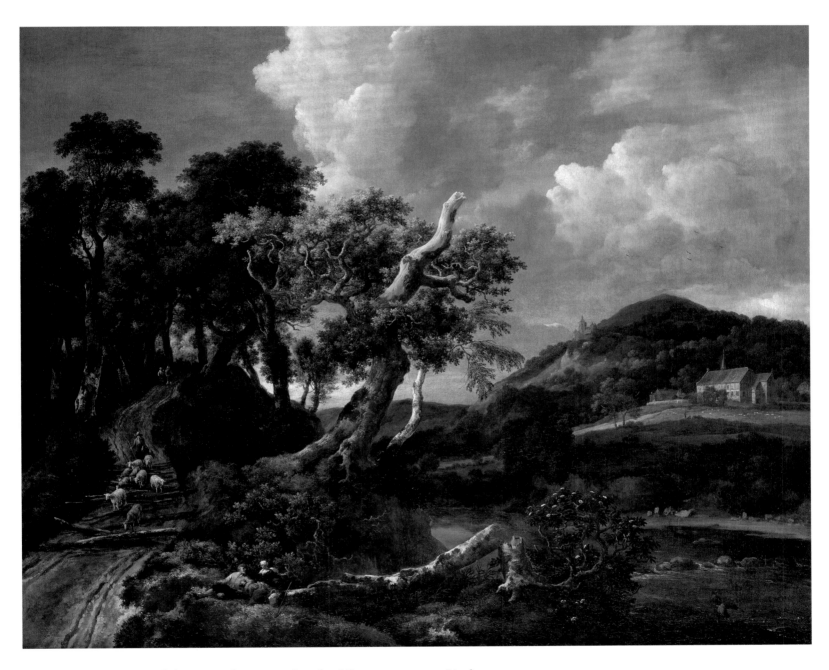

CATALOGUE 49. *Wooded River Landscape*, ca. 1655–60. Oil on canvas, 43 × 56 inches (109.2 × 142.2 cm). Signed left of center along lower edge: *vRuisdael* (*vR* in ligature).

Jacob van Ruisdael is generally regarded as the best and most versatile Dutch landscape painter. His early work, from the second half of the 1640s, still shows the influence of Cornelis Hendriksz. Vroom (1591/92–1661), but toward 1650 he had developed a style all his own. With his dramatic vision of landscape, Van Ruisdael liberated himself from the naturalism of his uncle Salomon and of Jan van Goyen. His oeuvre consists exclusively of landscapes, but within that genre he painted every conceivable type and subject: vistas over the bleaching grounds at Haarlem, landscapes with half-ruined watermills and windmills, sandy roads through wheat fields, beach scenes, marines, cityscapes, wooded landscapes, winter landscapes, and, encouraged by the success of Allart van Everdingen (1621–1675), waterfalls. Van Ruisdael left a large oeuvre of about seven hundred paintings, more than one hundred drawings, and thirteen etchings.

His only documented pupil, in the second half of the 1650s, was Meindert Hobbema (1638–1709). Van Ruisdael's followers included several Haarlem landscapists, such as Roelof van Vries (ca. 1630–after 1681), Cornelis Decker (ca. 1615–1678), Jan van Kessel (1641–1680), and his nephew Jacob Salomonsz. van Ruysdael (1629/30–1681).

Literature: Hofstede de Groot 1907–28, vol. 4, pp. 1–348; Simon 1927; J. Rosenberg 1928; *Jacob van Ruisdael* 1981–82; Slive 2001.

CATALOGUE 49

WOODED RIVER
LANDSCAPE

DESPITE ITS LARGE SIZE, for a long time this river landscape led a hidden existence: it hung in the same house for more than two hundred years and was published for the first time in 2001. The composition is dominated by an impressive oak tree on the rocky bank of a river. A gale or lightning has removed the top of the crooked tree; the bare crown is bathed in bright sunlight and thus attracts attention. The oak is otherwise swathed in light shadow and at its foot is a large birch that has broken off. To the right of it stands an elder bush. In the foreground, two travelers, a man and a woman, are resting beside the road. He leans against the top of the fallen tree trunk and she sits on it while pointing to the broken birch. On the far left, a mountain road winds between a group of oaks and birches. A shepherdess with a flock comes down the road while two small figures in the distance go up. Small logs have been laid across the road to make the steep descent easier. To

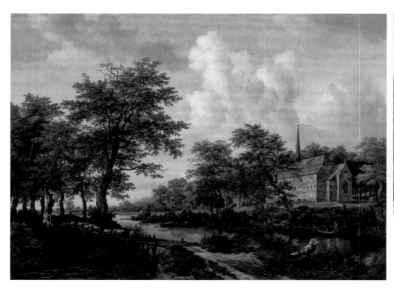

Figure 1. Jacob Van Ruisdael, *Church in a River Landscape*, mid-1660s. Oil on canvas, 42 × 59 1/2 inches (106.6 × 151 cm). Calouste Gulbenkian Museum, Lisbon.

Figure 2. Jacob Van Ruisdael, *Church near a Torrent*, ca. 1670. Oil on canvas, 28 × 21 3/4 inches (71 × 55.2 cm). The Cleveland Museum of Art, Bequest of Jane Taft Ingalls, 1962.256.

the right of the oak, on the other side of the river, there is a mountainous landscape. On the hillside on the right is a church or monastery complex with a tower, while higher up the slope is a castle. A shepherd and shepherdess keep watch over a flock of sheep. The staffage consists additionally of two fishermen wading through the water as they pull in their net. The composition is crowned by a partly bright blue, partly cloudy sky in which a few birds circle on the right. The erratic forms of the land, trees, rocks, and bushes in the foreground where nature rules are underlined by the friendly rolling hills and man-made buildings on the other side of the river.

In the years after his journey to the eastern Netherlands and the area near the German border in the early 1650s, Van Ruisdael developed a new type of landscape that was to be of great influence on Dutch art. This new phase, in which he often chose large formats, was characterized by the use of stronger color contrasts and an atmospheric brightness. The compositions are often dominated by one or more objects, for example, groups of trees or buildings, which are usually depicted from a low vantage point, producing a monumental effect. This phase of landscape painting, roughly from 1650 to 1665, is known as the "classical period." *Wooded River Landscape* is an outstanding example of this development. More than any other Dutch painter, Van Ruisdael succeeded with landscapes of this kind in convincingly depicting the grandeur of nature. The dramatic forms of the gnarled oak and the broken birch emphasize this grandeur, against which the figures are insignificant. The palette, consisting mainly of light green, gray, and brown tones, is enlivened by a few red and ocher-yellow accents in the staffage and the white of the clouds, birches, sheep, and flowers of the elder bush.

In this landscape and many others, Van Ruisdael demonstrated his close and careful observation of every manifestation of nature. His earliest works already show a clear interest in the lifelike depiction of trees ravaged by age and natural disasters, such as an old pollard willow in *Landscape with Hut* (1646; Kunsthalle, Hamburg).[2] In 1652, Van Ruisdael chose a gnarled oak whose top was partly gone, just like the oak in this painting, as the main subject of a work (Los Angeles County Museum of Art).[3] Although each of these landscapes is doubtless imaginary, all the components are realistically depicted. The complex of half-timbered buildings on the hill is a reminder of Van Ruisdael's journey to Westphalia, where this style was common. He probably used a now lost travel sketch because the same building seen from the same angle appears in *Church in a River Landscape* from the mid-1660s (figure 1) and in *Church near a Torrent*, ca. 1670 (figure 2).[4]

Since Jacob van Ruisdael rarely dated his paintings after 1653, it is impossible to give an exact date for this work. In view of the plan of the composition, colors, heroic character of the landscape, and format, a date in the second half of the 1650s seems the most likely. The steeply descending road on the left is reminiscent of *Landscape with Large Oak by a Wheat Field* (Herzog Anton Ulrich-Museum, Braunschweig), which is usually dated slightly earlier.[5]

Provenance; By descent in the Foljambe family, Osberton Hall, Nottinghamshire (probably purchased toward the end of the eighteenth century); with Simon Dickinson, London, by 1998; acquired from Noortman Master Paintings and Haboldt & Co., London and Paris, in 1998.

Exhibitions: On loan to the Mauritshuis, The Hague, 1999; Museum of Fine Arts, Boston, *Poetry of Everyday Life: Dutch Painting in Boston*, 2002.

Literature: Slive 2001, p. 353, no. 479, ill. pp. 352–53, figs. 479a–b; *Poetry of Everyday Life* 2002, p. 122, ill.

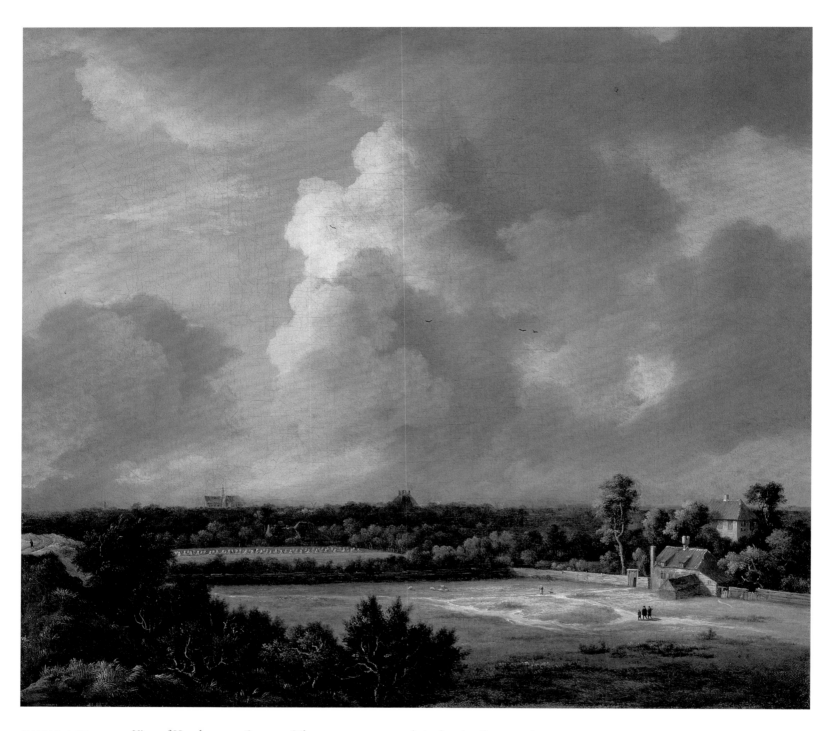

CATALOGUE 50. *View of Haarlem*, ca. 1670–75. Oil on canvas, 14 × 15 3/4 inches (35.6 × 40 cm).

CATALOGUE 50

VIEW OF HAARLEM

IN THE COURSE OF THE 1660S, Jacob van Ruisdael began to paint panoramas. Several views of Amsterdam and a series of *Haerlempjes* (views of Haarlem), as they were called as early as 1669, are among the highlights of his oeuvre. They are very different in approach from his earlier landscapes, in which he placed the emphasis on nature in many of her often impressive and dramatic manifestations. In contrast, the panoramas of the 1660s and 1670s are charming and tranquil in mood. With their topographical character and their small vertical or nearly square format, they also differ fundamentally from the monumental panoramas by Philips Koninck from the mid-1650s.

Van Ruisdael based his painted *Haerlempjes* on sketches he made in situ. Some of these sheets have been preserved, such as three in the Museum Bredius, The Hague, and a fourth in the Rijksmuseum, Amsterdam.[6] They were probably part of a sketchbook that Van Ruisdael used around 1670. In contrast to these sketches and most of Van Ruisdael's *Haerlempjes*, this painting depicts Haarlem not from the northwest but from the southwest, as it would have appeared from the dunes at Heemstede. No sketch of this view has survived. As in almost all *Haerlempjes*, the late Gothic St. Bavokerk can be seen on the horizon. More toward the center, the roof with four chimneys of an as yet unidentified house protrudes above a wood that extends over the entire width of the painting. In the left foreground is a dune with boscages that serves as a *repoussoir*. On the far left, a man walks along a sandy road. In contrast to most *Haerlempjes*, the foreground and middle ground are not taken up by bleaching fields with long strips of linen but by a meadow with a few sheep and surrounded by a wooden fence. The rest of the staffage consists of three men and farther along a woman walking with a dog. On the far right, there is a country house amid trees with a farmhouse in front of it. Farther back is a piece of land with wheat sheaves near a second farmhouse.

Characteristic of this type of panorama by Van Ruisdael is the cloudy sky, which takes up more than two thirds of the canvas. White, gray, and dark-gray clouds stand out sharply against a bright blue sky. Sunlight shining through the clouds creates splendid contrasts in the landscape. The buildings on the left and part of the meadow are brightly lit and two mills on the horizon to the right of center catch the light against the dark sky. A few black birds enliven the sky.

Provenance: Charles Auguste Louis Joseph, duc de Morny, his estate sale, Paris (Laneuville), May 31ff, 1865, no. 75 (ffr. 30,100 to Demidoff); Prince Paul P. Demidoff (1839–1885), Paris, his sale, Paris (Pillet), April 1–3, 1869, no. 23 (as on panel and signed with monogram lower left); C. G. de Candamo, his sale, Paris (Charpentier), December 14–15, 1933, no. 42 (ffr. 180,000 to Massart; as signed with monogram lower left, and as possibly transferred from panel to canvas); Raoul D'Abstrac; thence by descent to Madame H. Lacroix, Aiguillon; acquired from Edward Speelman Ltd., London, in 1997.

Exhibitions: Salle des États au Louvre, Paris, *Exposition au profit de l'oeuvre des Orphelins d'Alsace-Lorraine*, 1885, p.118, no. 430; Museum of Fine Arts, Boston, *Poetry of Everyday Life: Dutch Painting in Boston*, 2002.

Literature: *Exposition au Profit de l'oeuvre des Orphelins d'Alsace-Lorraine* 1885, p.118, no. 430; Hofstede de Groot 1907–28, vol. 4, p. 49, no. 139b; Moes 1913, p. 297; Davies 1992, pp. 67–68 n. 11, 70–71 n. 23, 141–42, in no. 36; Slive 2001, pp. 92–93, no. 68, ill.; *Poetry of Everyday Life* 2002, p. 124, ill.

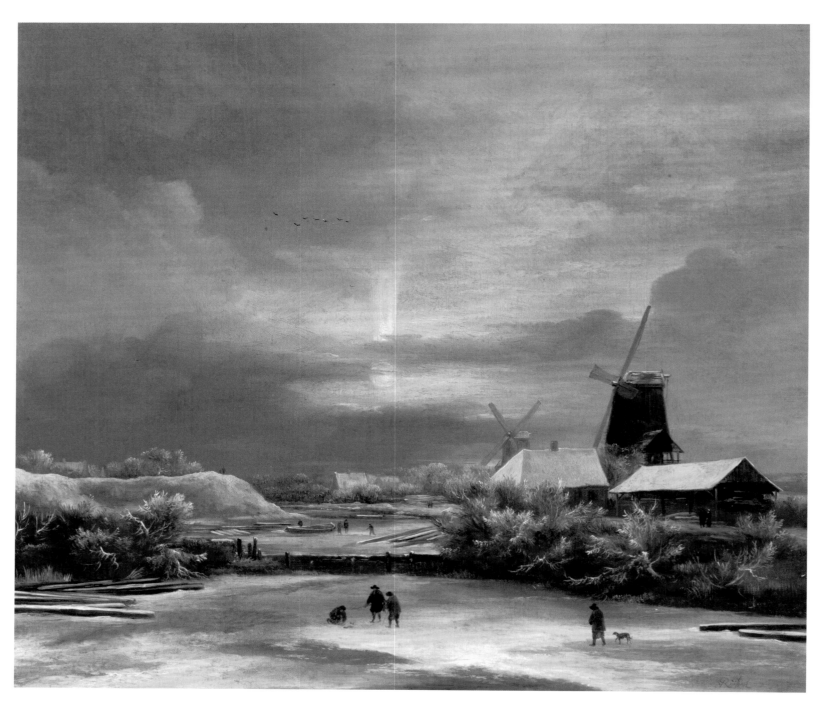

CATALOGUE 51. *Winter Landscape with Two Windmills*, ca. 1675. Oil on canvas, 15 1/8 × 17 1/8 inches (38.5 × 43.4 cm). Signed lower right: *JvRuisdael* (*JvR* in ligature)

CATALOGUE 51

WINTER LANDSCAPE
WITH TWO WINDMILLS

WINTER LANDSCAPES form a fairly small part of Jacob van Ruisdael's work. Most of his approximately thirty *wintertjes* were painted later in his life, in the 1660s and 1670s. The high point consists of a small series of winter landscapes from the middle and the second half of the 1670s. The present painting, and *Winter Landscape with Mill* (private collection, Europe); and *Winter Landscape with a Windmill and a Manor House* (Private Collection, New York),[7] belong to this group. *Winter Landscape with a Windmill* (Frits Lugt Collection, Paris), which was probably painted slightly earlier, is very much in keeping with these.[8] These paintings are all characterized by modest dimensions, a windmill in the middle of some humble houses or barns as the main motif, a low horizon, a high, cloudy sky, and a pronounced effect of space. In mood and composition, they are very different from the winter landscapes Van Ruisdael had painted in the years prior. The strongly diagonal structure of his winter landscapes of the 1660s has been replaced by a more horizontal emphasis, and there are no heavy accents or striking *repoussoirs* in the foreground. The result is a greater feeling of space. The same development is seen in the other compositions Van Ruisdael painted at this time, such as his series of *Haerlempjes*. The threatening cloudy skies and the sometimes ominous atmosphere of his winter landscapes of a few years earlier have gone. The palette with soft, transparent gray hues is lighter and the colors in the sky are entirely in harmony with the snow-covered landscape. As a result, the scene is suffused with a milder atmosphere; the winter and the frost seem to have lost their menacing aura.

As with Van Ruisdael's other winter landscapes, the location is imaginary. The main motif is formed by a sawmill on the right with a house and storage space, and a second, more distant mill. A frozen river extends from the whole width of the foreground almost to the horizon. On the left, the landscape ends in a slightly receding bank. Snow-covered roofs and bushes with hoarfrost stand out attractively against the sky, which gets darker closer to the horizon. Higher up, there are even some bits of blue between the clouds. A striking component in the composition is the sun, partly veiled by clouds, which puts in an appearance not long before sunset. It is rare for Dutch seventeenth-century painters to show the light source in their landscapes. The most important exception to this rule is Aert van der Neer, who specialized in landscapes at sunrise or sunset and by moonlight.

The staffage consists of a handful of small figures whose insignificance further underscores the spaciousness of the landscape. In the right foreground a man is walking with his dog and farther along two "kolf" players wait for their companion to tie on his skates. In the middle ground, several figures are skating near a boat frozen in the ice. This painting does not exude a gloomy atmosphere, yet it is far removed from the innocent fun and cheerful winter mood in paintings by Hendrick Avercamp, Jan van Goyen, and Aert van der Neer.

Provenance: Sabatier, his estate sale, Paris (Paillet/Delaroche), March 20–21, 1809, lot 47 (ffr. 1001); John Maitland of Woodford Hall, Essex, his estate sale, London (Christie's), July 30, 1831, no. 88 (£47.5 to Seguier; the catalogue wrongly states the painting was in the "Geldermeester Cabinet")[9]; Sir Francis Cook, First Baronet, Visconde de Monserrate (1817–1901), Doughty House, Richmond; by descent to Sir Frederick Cook (1844–1920), Doughty House, Richmond; by descent to Sir Herbert Cook (1868–1939), Doughty House, Richmond; with Thomas Agnew, London, 1956; private collection, England, from which it was sold, through Agnew, to a private collection in 1986; with Thomas Agnew, London; Charles C. Cunningham, Boston, 1986–2004; acquired in 2004.

Exhibitions: Guildhall Art Gallery, London, *Catalogue of the Loan Collection of Pictures*, 1895; Museum of Fine Arts, Boston, *Prized Possessions: European Paintings from Private Collections of Friends of the Museum of Fine Arts, Boston*, 1992; Museum of Fine Arts, Boston, *Poetry of Everyday Life: Dutch Painting in Boston*, 2002; Los Angeles County Museum of Art, Philadelphia Museum of Art, and Royal Academy of Arts, London, *Jacob van Ruisdael. Master of Landscape*, 2005–2006.

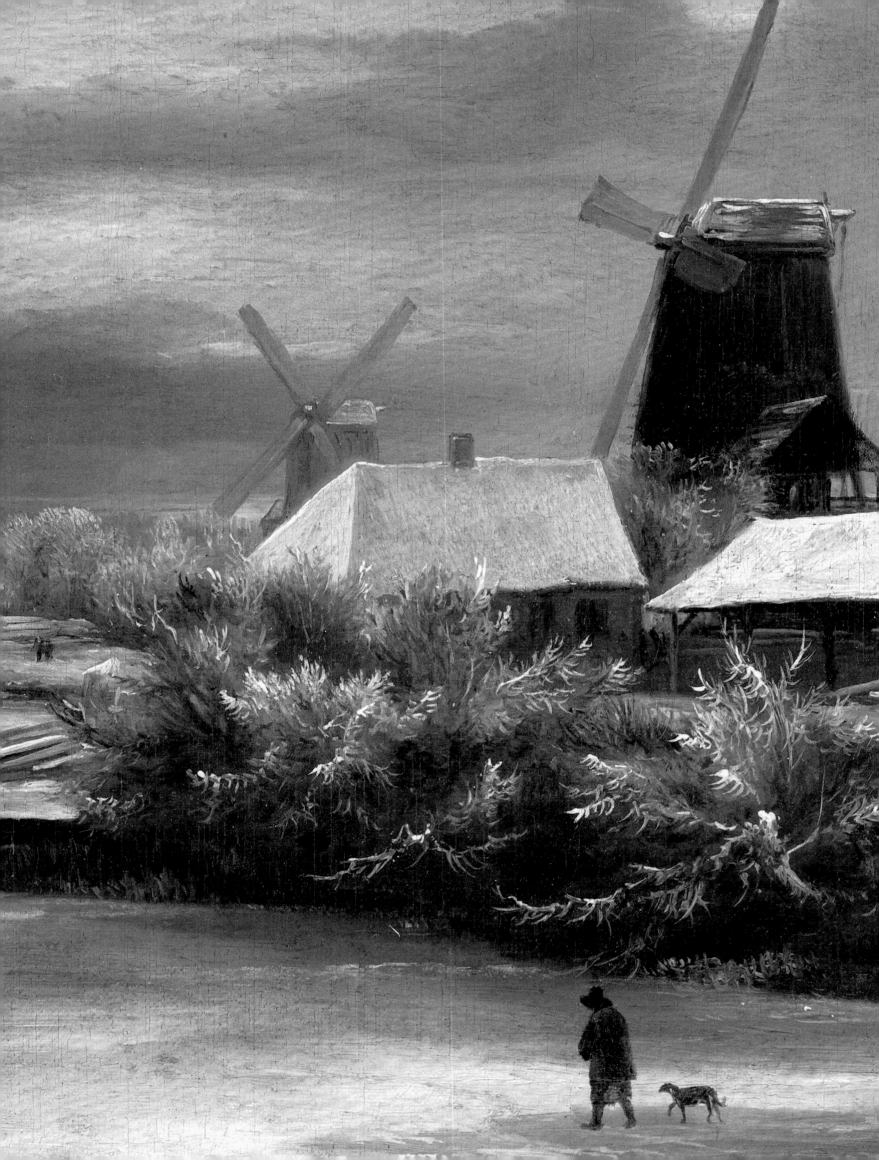

Literature: Smith 1829–42, vol. 6, p. 39, no. 120; *Catalogue of the Loan Collection of Pictures* 1895, p. 67, no. 94, Hofstede de Groot 1907–28, vol. 4, p. 312, no. 1006, and p. 319, no. 1025 (as pendant to no. 1024, together in sales at Sabatier and Maitland); Kronig 1914, p. 93, no. 348, ill. pl. XXI (Long Gallery, no. 100); Rosenberg 1928, p. 111, no. 626; Nihom-Nijstad 1983, p. 118; *Prized Possessions* 1992, p. 202, no. 127, ill. p. 44, pl. 44; Slive 2001, pp. 488–89, no. 694, ill.; *A Choice Collection* 2002, p. 217 n. 10; *Poetry of Everyday Life* 2002, p. 123, ill.; *Jacob van Ruisdael* 2005–2006, pp. 160–61, no. 56, ill.

Notes:
1. Houbraken 1718–21, vol. 1, p. 65.
2. Slive 2001, no. 569.
3. Ibid., no. 380.
4. Ibid., nos. 538 and 170, respectively.
5. Ibid., no. 84.
6. Slive 2001, nos. D67–D69, D5, respectively.
7. Slive 2001, nos. 693 and 683, respectively.
8. Ibid., no. 686.
9. The winterscape that was in the J. Gildemeester's collection appeared in his sale, Amsterdam, June 11–13, 1800, no. 191, and is now in the Museo Thyssen–Bornemisza, Madrid; Slive 2001, no. 681.

RACHEL RUYSCH

THE HAGUE 1664–1750 AMSTERDAM

Rachel Ruysch was born into an eminent family in The Hague on June 3, 1664. Her father was the well-known anatomist and botanist Frederik Ruysch (1638–1731) and her mother was the daughter of the leading Dutch architect and also painter Pieter Post (1608–1669). When her father was appointed a professor at the Athenaeum Ilustre in Amsterdam, the family moved there. Rachel helped her father, who had assembled a unique anatomical and natural cabinet, by decorating his specimens with lace and flowers. From 1679, when she was only fifteen, to 1683, she was taught by the still-life painter Willem van Aelst in Delft. In 1693, she married the moderately talented portrait painter Juriaen Pool (1666–1745); they had no fewer than ten children. In 1701, they moved to The Hague, where that same year she registered with the local guild. She established such a good reputation that in 1708, together with her husband, she was appointed court painter to Elector-Palatine Johann Wilhelm II in Düsseldorf. He had brought together one of the finest collections of paintings in Europe, with work by Peter Paul Rubens (1577–1640) and Anthony van Dyck (1599–1641) as well as Italian and Dutch painters. All the works Ruysch painted in these years were intended for the elector. He kept most of them for his own collection and gave some away as presents, for example, to his father-in-law Cosimo III de' Medici, grand duke of Tuscany, in Florence. The couple remained in the service of the elector until his death in 1716 and then returned to Holland, where they settled in Amsterdam. Ruysch continued to be given numerous commissions and her work commanded high prices. In 1723, she and her husband became financially independent when they won seventy-five thousand guilders in the state lottery. On August 12, 1750, she died at the age of eighty-five in Amsterdam.

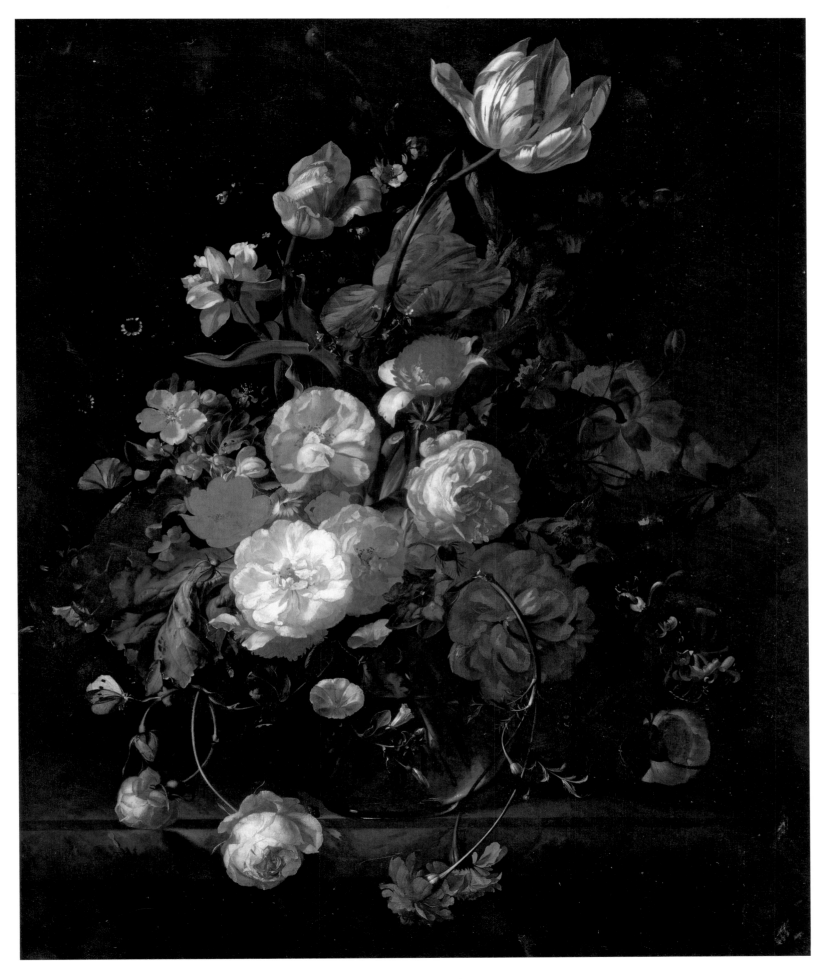

CATALOGUE 52. *Still Life with Flowers*, 1709. Oil on canvas, 30 3/4 × 25 1/4 inches
(78 × 64 cm). Signed and dated lower right: *Rachel Ruysch 1709*

Ruysch continued to paint at a very advanced age. She was already famous during her lifetime. In 1750, a collection of eleven poems dedicated to her by contemporaries over the years was published; her work is lavishly praised. No Dutch artist had ever received such an honor. Ruysch recounted the story of her life to Jan van Gool, who noted everything down carefully and published it in 1750 in *De Nieuwe Schouburgh der Nederlandsche Kunstschilders en Schilderessen*.[1]

Ruysch's oeuvre consists mostly of still lifes of flowers in vases, but she also painted simple flower bouquets on stone tables, and still lifes with fruit or flowers and grasses in nature. Dated pieces are known from most years from 1681 to 1747 (when she was eighty-three). Although most of her paintings date from the eighteenth century, they are entirely in keeping with the seventeenth-century tradition of floral still lifes. No drawings or studies by her are known.

Literature: Hofstede de Groot 1907–28, vol. 10, pp. 307–32; Grant 1956.

CATALOGUE 52

STILL LIFE WITH FLOWERS

IN THIS CLASSIC STILL LIFE, Rachel Ruysch painted a bouquet with a great diversity of flowers in a round vase. As in many of her still lifes, the vase sits on a marble table. The form of the vase is repeated on the left side by a branch of a pink rose and on the right by a broken marigold stem. One linking factor in the composition is the elegant "S" form that curves from the tulip and its stem at the top right toward the center and from there via the stem of the marigold to the bottom. The composition is a series of round and curved forms and the result is an extraordinarily harmonious, dynamic, and elegant entity. The abundance of chiefly red, pink, and white hues with accents in blue and yellow stands out brilliantly against the dark, almost uniform background.

As is also the case with the earlier Dutch and Flemish floral still lifes, such as those by Jan Brueghel the Elder, Ambrosius Bosschaert the Elder, Balthasar van der Ast, and Jan Davidsz. de Heem, the composition of the bouquet derives from the artist's imagination, because the flowers depicted bloom in different seasons. At the top are three tulips and a double narcissus. In the center are one double anemone; one yellow, two white, one pink, and one red rose; a white convolvulus; and a blue gentian. The right side ends with two poppies and a branch of honeysuckle, and the left with a sprig of apple blossom and a blue convolvulus. Each flower is painted with great care. A white butterfly flutters at the lower left.

With this and other related still lifes, Ruysch appealed perfectly to the taste of the time. In contrast to earlier floral and other still lifes, here the *vanitas* idea is relegated to the background. Just as in the work of her contemporary Jan van Huysum (1682–1749), the emphasis is on the decorative effect and no longer on any moralizing iconography.

This work is one of the still lifes Ruysch painted for Elector-Palatine Johann Wilhelm II in Düsseldorf and it was part of his renowned collection for a long time. Until 1937, when it was sold by the Alte Pinakothek in Munich, it had been in leading royal and museum collections almost without interruption.

Provenance: Probably commissioned by Elector-Palatine Johann Wilhelm II von der Pfalz (r. 1690–1716), Düsseldorf; probably thence by descent to Karl Theodor von Pfalz-Sulzbach (1724–1799), in the Kurfürstliche Galerie Mannheim, by 1756 (reference to an unidentified inventory of 1780, no. 295); probably moved to Munich in 1794; Hofgarten Galerie, Munich, by 1805 (inv. no. 924); Galerie Schleissheim, Munich, by 1810; Alte Pinakothek, Munich, by 1836; deaccessioned in 1937; with Neumann & Salzer, Vienna, 1937; with John Mitchell, London, 1938; George L. Lazarus, England, by 1952; with John Mitchell & Son, London, 1996–2005, by whom sold, New York (Christie's), April 6, 2006, no. 52 (sold for $464,000); with Colnaghi & Bernheimer, London, by 2006; where acquired in 2007.

Exhibitions: On loan to the Königliche Gemäldegalerie, Erlangen, in 1906; Royal Academy, London, *Dutch Pictures 1450–1750, Winter Exhibition*, 1952–53; John Mitchell & Son, London, *The Inspiration of Nature. Paintings of Still Life, Flowers, Birds and Insects by Dutch and Flemish Artists of the 17th Century*, 1976; Dulwich Picture Gallery, *Dutch Flower Painting 1600–1750*, 1995; Museo del Territorio, Biella, Italy, *Fiori: Cinque Secoli di Pittura Floreale*, 2004.

Literature: Possibly *Catalogue des tableaux qui sont dans les quatre cabinets de S.A.S.E. Palatine à Mannheim 1756*, p. 14, no. 89 (second cabinet: "Un pied de Fleurs. Par *Rachel Ruysch*, haut. 2 pieds 3 pouc. & demi. Larg. 1 pied 10 pouc." [29 5/16 × 23 1/3 inches (74.5 × 59.6 cm)]; Von Mannlich 1810, vol. 3, no. 924; Von Dillis 1845, p. 224, no. 270 (Cabinet XI: "Ein Bouquet Blumen in einem mit Wasser gefüllten Pocale. – auf Leinwand "9,'" L. 1'11"6'"); *Beschreibung des Inhaltes der Sammlung von Gemälden älterer Meister des Herrn Johann Peter Weyer in Coeln 1852*, no.333; *Catalog der Sammlung von Gemälden älterer Meister des Herrn Johann Peter Weyer, Stadtbaumeister a. D. und Ritter des Leopold Orden 1859*, no. 502; Marggraff 1866, p. 182, no. 270 (seconde partie, 11ᵉ cabinet: "Des fleurs (tulips, roses, narcisses) dans un bocal de cristal. Designé: Rachel Ruysch 1709. Toile, h. 2'4"9,'" L. 1'11"6'"); Marggraff 1878, p. 41, no. 862 ("Blumen in Krystallenem Pokale"); Von Reber 1879–1911, 1885, pp.134, 286, no. 656 (862), 1904, p. 149, no. 656, 1906, p. 141, no. 656, 1908, p. 141, no. 656 (now in the Galerie Erlangen, no. 74); *Dutch Pictures 1450–1750* 1952–53, p. 102, no. 553; Grant 1956, p. 30, no. 58; *Katalog der Gemälde-Sammlung der Königlichen älteren Pinakothek in München: Amtliche Ausgabe* 1908, p. 141, no. 656 (now in the Galerie Erlangen, no. 74); Hofstede de Groot 1907–28, vol. 10, p. 312, no. 16; ill. pl. 2; Mitchell 1973, pp. 222–23, ill. pl. 305 on p. 216; *The Inspiration of Nature* 1976, pp. 42–43, ill. p. 43; Gemar-Koeltzch 1995, p. 855, no. 340/24 (as in Munich, inv. no. 888); *Dutch Flower Painting 1600–1750* 1995, pp. 80–83, no. 27, ill. p. 83 (erroneously dated 1715 and with measurements 75 × 59 cm); *Still-Life Paintings from the Netherlands 1550–1720* 1999–2000, p. 283 n. 4; *Fiori: Cinque Secoli di Pittura Floreale* 2004, pp. 284–85, no. 115, ill. p. 299; Marianne Berardi, catalogue raisonné of the artist's works (forthcoming).

Notes:
1. Gool 1750–51, vol. 1, pp. 221–33.

SALOMON VAN RUYSDAEL

NAARDEN 1600/1603–1670 HAARLEM

Little is known about the early life of Salomon Jacobsz. van Ruysdael. He was born in Naarden, the son of Jacob Jansz. de Goyer, a wealthy Mennonite cabinet-maker who originally came from Blaricum. He was the younger brother of the frame-maker and painter Isaack de Gooyer, alias Van Ruysdael (ca. 1599–1677). A few years after the death of his father, Salomon, like two of his three brothers, took the name Ruysdael, after the Ruisdael or Ruisschendael estate near Blaricum. The three brothers always wrote their name with a "y," but Salomon's nephew, the landscape painter Jacob, consistently spelled his name as *Ruisdael*. In 1623, Salomon van Ruysdael became a member of the Haarlem guild; he had probably moved to Haarlem a few years earlier. He owned several houses over the years, but he probably lived mostly on Kleine Houtstraat. Before 1627, he married Maycke Willemsdr. Buyse. Salomon was the father of the much less talented landscapist Jacob Salomonsz. van Ruysdael (1629/30–1681) and the uncle of the much more celebrated Jacob van Ruisdael. Both were probably taught for some time by Salomon, who lived and worked in Haarlem until his death and established a considerable artistic reputation and social position there. He played a role in the guild, where he was warden (*vinder*) in 1647, dean in 1648, and warden again in 1663/64 and 1669/70. In 1628, when he had been registered with the guild for just two years, Salomon was mentioned as an excellent landscape painter by the Haarlem chronicler Samuel Ampzing in his *Beschryvinge ende lof der stad Haerlem*.[1] In 1651, he is referred to as a merchant in a notary document; he traded in *blauwverf*, an agent for bleaching linen. He was buried in the St. Bavokerk in Haarlem on November 3, 1670.

Throughout his life, Van Ruysdael was a particularly productive painter, so it is all the more surprising that not a single drawing can be attributed to him. The fluent underdrawing sometimes visible in his paintings would suggest that he did a lot of drawing. Van Ruysdael's fame rests chiefly on his river landscapes, but he also painted dune landscapes, lake views, winter landscapes, and several still lifes and scenes of fighting. His teacher is unknown, but his early work shows the influence of older Amsterdam and Haarlem landscape draftsmen and painters such as Jan van de Velde (ca. 1593–1641) and Esaias van de Velde. His earliest dated painting bears the year 1626.

Superficially, Van Ruysdael's landscapes often appear to resemble each other, but he never resorted to mechanical repetition and his art always looks fresh and original. Together with Jan van Goyen and Pieter de Molijn (1595–1661), he gave landscape art in the Northern Netherlands fresh impetus with the introduction of simpler compositions and a practically monochrome palette. After 1640, his landscapes became brighter and more varied in color.

Literature: Stechow 1938; Stechow 1975.

CATALOGUE 53

*RIVER LANDSCAPE
WITH A FERRY*

ON AN ALMOST UNRUFFLED RIVER, a motley band of peasants, riders, cows, and dogs are being taken across by ferry. The skipper at the rear uses a pole to push the overcrowded boat along. On the left and in the center, the river extends to the horizon. Beyond the ferry, three ships with swollen sails are catching the wind. On the left and right, all kinds of rowboats and sailboats are moving on the water. A group of dark trees dominates the right bank and acts as a *repoussoir*. Through the tree trunks, a castle can be seen and nearer to the middle of the painting is a city surrounding a large church. The river extends over the whole width of the painting, so that the viewer has the impression that he is also on the water. A high sky with clouds being driven away by the wind gives the landscape a sweeping and atmospheric character.

Beginning in 1631, river landscapes with ferries formed an important part of Salomon van Ruysdael's repertoire. Practically without exception, the format is horizontal and the horizon low. The river bank often runs toward the horizon diagonally and the water generally covers the entire bottom edge of the scene. The river landscape is associated more with Van Ruysdael than with any other Dutch painter and this impressive panel is one of his finest and most beautiful examples.

Jan Brueghel the Elder introduced the theme of a river landscape with a ferry at the beginning of the seventeenth century: a panel of 1603 in the Musées royaux des Beaux-Arts de Belgique, Brussels, shows a river with a ferry and other boats near a village. Subsequently, it was chiefly Esaias van de Velde and his pupil Jan van Goyen who popularized the subject in the Northern Netherlands. Many elements in the present painting can also be found in Van de Velde's *River Landscape with Ferry* (1622; Rijksmuseum, Amsterdam). The main differences are in the depiction of both banks and the much lower sky, which makes Van de Velde's composition more intimate but less spacious. In 1625, Jan van Goyen painted *River Landscape with Ferry and Windmill* (Foundation Emil-G. Bührle, Zurich), for which Van de Velde's work was clearly the source.

The composition used here exists in several variations in the oeuvre of Salomon van Ruysdael. It goes back to the elongated triangle developed in Haarlem by Van Ruysdael, Van Goyen, and Pieter de Molijn at about the same time, around 1630. The strongly diagonal structure of their landscapes was usually accentuated by the angle of a country road or a river, or the placement of a fence.

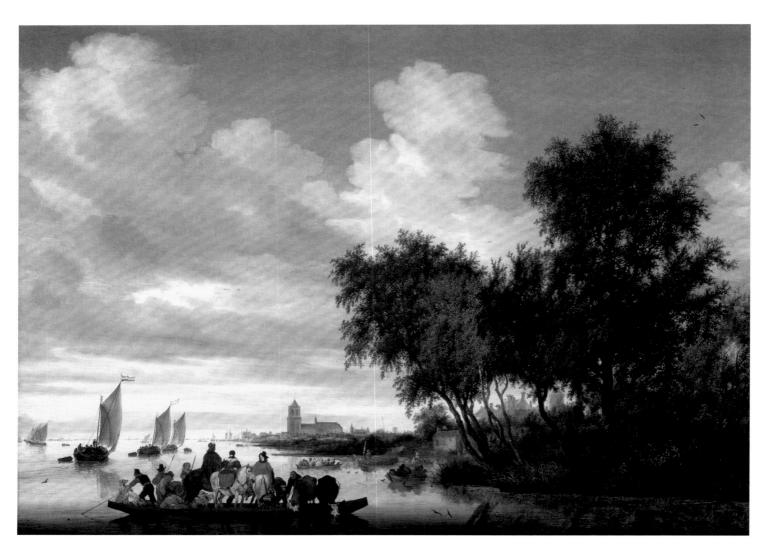

CATALOGUE 53. *River Landscape with a Ferry*, 1649. Oil on panel, 35 7/8 × 49 5/8 inches (91 × 126 cm).
Signed and dated lower left on the ferry: *S.vRuysDAEL/1649* (*vR* in ligature)

The tranquil mood characteristic of Van Ruysdael's river landscapes is apparent. There is never any question of dramatic weather conditions. The calmly flowing water with its reflections of clouds, boats, sails, and vegetation is only superficially ruffled by the ships gliding past on a gentle breeze. Van Ruysdael's evenly balanced brushwork also contributes to the harmonious and stately character of this work and related paintings.

Following the tonal phase of the 1630s, Van Ruysdael's oeuvre after 1640 is marked by gradually more fluent brushwork and a more forceful use of color, as are superbly demonstrated in this river landscape dated 1649. The bright red of the rider's cloak and the clothing of the horsewoman beside him in the ferry provide striking accents that are further enhanced by their proximity to the white coats of their horses and the surface of the water catching the light. The white and light-gray clouds stand out against the bright blue sky and the dark foliage of the group of trees on the right.

The buildings in Van Ruysdael's paintings have been identified only sporadically. Even though they look highly realistic, the church and the castle in this panel were probably derived from the artist's imagination. Unlike Van Goyen, who left hundreds of travel sketches and incorporated them in his paintings faithfully or otherwise, Van Ruysdael left no sketches or drawings at all.

Provenance: Captain Webb, Woodford, Ashford, Kent; with W. E. Duits, London, 1934; with Kunsthandel Gebroeders Douwes, Amsterdam, 1934; private collection, England, by 1938, their sale ("Trustees of the Mendel Furniture Settlement"), London (Sotheby's), November 30, 1983, no. 89; with E. Speelman Ltd., London; Charles C. Cunningham, Boston; with Noortman Master Paintings, Maastricht and London, 1989; private collection, London and Brussels, 1989; acquired from Noortman Master Paintings, Maastricht, in 2006.

Exhibitions: Gebroeders Douwes, Amsterdam, *Catalogus der Tentoonstelling van Oude Schilderijen*, 1934; Rijksmuseum, Amsterdam, Museum of Fine Arts, Boston, and Philadelphia Museum of Art, *Masters of 17th Century Dutch Landscape Painting*, 1987–88; on loan to the National Gallery, London 1989–94; Mauritshuis, The Hague, *The Amateur's Cabinet: Seventeenth-Century Dutch Masterpieces from Dutch Private Collections*, 1995–96; on loan to the Rijksmuseum, Amsterdam, since 2006.

Literature: *Catalogus der Tentoonstelling van Oude Schilderijen* 1934, p. 27, no. 58, ill. p. 26; Stechow 1938, p. 110, no. 357; Stechow 1975, p. 123, no. 357; *Masters of 17th Century Dutch Landscape Painting* 1987–88, pp. 472–74, no. 94, ill. pl. 48; National Gallery 1989, ill; National Gallery 1990, p. 29, ill.; *The Amateur's Cabinet* 1995–96, p. 54, no. 23, ill. p. 55; Lamoree 2006, p. 99.

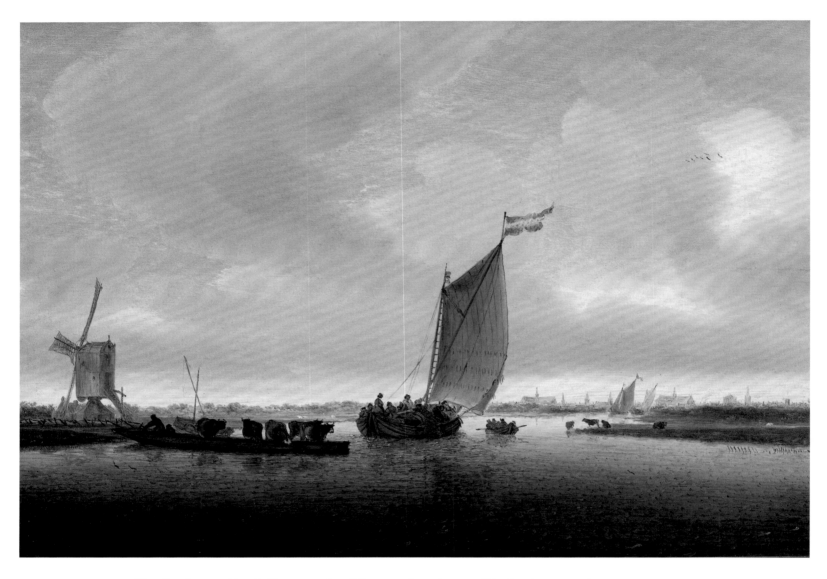

CATALOGUE 54. *River Landscape with a Sailboat*, ca. 1655. Oil on panel, 12 1/4 × 17 3/8 inches (31 × 44 cm). Signed and indistinctly dated on the ferry: *SvR/1655* (*SvR* in ligature)

CATALOGUE 54

RIVER LANDSCAPE
WITH A SAILBOAT

RIVER LANDSCAPES WITH FERRIES were a favorite subject of Salomon van Ruysdael. In this superbly preserved panel, he depicted the most characteristic elements of the broad Dutch river landscape. The composition is dominated by a sailboat that glides over the rippling river toward the city on the horizon. Farther up is a rowboat and in the distance another two sailboats can be seen. The left side of the composition ends with a closed post mill. On the left, two men with five cows are mooring their ferry. In the right middle ground, several cows stand out against the water as it catches the light. As is often the case with Salomon van Ruysdael, the whole foreground is taken up by water. Partly because of the particularly low vantage point, the viewer gets the feeling that he too is on the water. A light breeze together with the sailboat cause a few ripples on the surface of the water. The sky occupies the larger part of the composition: light clouds hide part of the bright blue and a flock of birds adds a lively touch.

In this composition, which stands out because of its simple and peaceful atmosphere, the eye is drawn from the dark water in the foreground via the ferry and the sailboat over the water that steadily lightens toward the background, past the two sailboats in the distance, to the city on the horizon. The date 1655 is not clearly legible but the stylistic features indicate that Van Ruysdael must have painted it in or around that year. The panel exhibits all the hallmarks of his more mature style, after the tonal phase of the 1630s and early 1640s, when he returned to using local color. His remarkably skilled painting technique of these years is excellently demonstrated: he seems to have painted the composition without hesitation, using pointed, partly wet-in-wet, fluent brushstrokes and a restrained and harmonious palette.

Various attempts have been made to identify the city in the background. The university city of Leiden has often been mentioned in this context, with the painting said to show Leiden from the northeast from Kromme Zijl. The church on the left would then be the Hooglandse Kerk, with to the right of it the tower of the Saaihal, the tower of the city hall, and farther to the right the Pieterskerk. But, as a comparison with the various drawings and paintings of Leiden made by Van Goyen in the same period shows, this identification is very doubtful.[2] In reality, the Hooglandse Kerk and the Pieterskerk are much higher and the characteristic dome of the Marekerk completed in 1649 and the towers of the Vrouwekerk, which should be to the right of the Pieterskerk, are completely missing. Van Goyen often depicted recognizable locations, though with all sorts of artistic liberties, but this happens much less often with Van Ruysdael. The complete absence of travel sketches and drawings by him gives support to the idea that landscapes of this type, however typically Dutch, came from his imagination.

For some time, the painting was in the collection of the eminent and influential art historian Wilhelm von Bode (1845–1929), who in 1905 became director-general of the Berlin Museums and proceeded to make Berlin the most important art center in Germany. He was regarded as one of the greatest specialists in the field of Dutch seventeenth-century painting.

Provenance: Baron von Loë, Germany (the verso of the panel bears a wax seal with the Von Loë coat-of-arms); Wilhelm von Bode (1845–1929), Berlin; with Van Diemen, Berlin, in or before 1925; Dr. Viktor Bruns, Berlin, 1925–after 1938; private collection, Germany, until 2006; acquired from Johnny Van Haeften Ltd., London, in 2006.

Exhibitions: Akademie der Künste (Kaiser-Friedrich-Museums-Verein), Berlin, *Gemälde alter Meister aus Berliner Besitz*, 1925.

Literature: *Gemälde alter Meister aus Berliner Besitz* 1925, p. 53, no. 340; Grosse 1925, p. 127, ill. pl. 61 on p. 63 in illustrations; Stechow 1938, p. 101, no. 290; Stechow 1975, p. 112, no. 290.

Notes:
1. Ampzing 1628, p. 372.
2. For example, *View of Leiden* (1650; Stedelijk Museum de Lakenhal, Leiden).

PIETER SAENREDAM

ASSENDELFT 1597–1665 HAARLEM

Pieter Jansz. Saenredam was born on June 9, 1597, in Assendelft, a town northeast of Haarlem. He was the only son of the talented mannerist draftsman, engraver, and map-maker Jan Saenredam (1565–1607), who was also an active investor in the Dutch East India Company. His investments proved so profitable that his son never had to depend on his income as an artist, but could afford to paint simply for the love of it. In 1608, after the premature death of his father the previous year, Pieter and his mother moved to Haarlem, where he became apprenticed in May 1612, at the age of fifteen, to the history painter Frans de Grebber (1573–1649). He continued to work in De Grebber's studio for about ten years, presumably first as a pupil and later as an assistant. This unusually long period of training might have been due to Saenredam's physical condition, since he was a hunchback. On April 24, 1623, he became a member of the Guild of St. Luke. In 1635 and 1640, he held the post of warden (*vinder*) of the guild, and in 1642 he served as dean (*deken*). In Bloemendaal, on December 5, 1638, he married Aefje Gerritsdr., who had been living on St. Jansstraat in Haarlem. Saenredam's precisely dated drawings tell us with reasonable accuracy when and where he worked. In 1632, he spent some time in Den Bosch; in 1633 and 1634 in his home town of Assendelft; in 1635 in Alkmaar; in 1636 in Utrecht; in the late 1630s again in Alkmaar; in 1641 in Amsterdam; in 1644 in Rhenen; in 1654 again in Assendelft; and in 1661 again in Alkmaar.

Saenredam had a large library of scholarly publications and a collection of paintings and drawings, including a sketchbook with views of Rome by the sixteenth-century Haarlem artist Maerten van Heemskerck (1498–1574). Saenredam died at the end of May 1665 and was buried on May 31 in the Grote or St. Bavokerk.

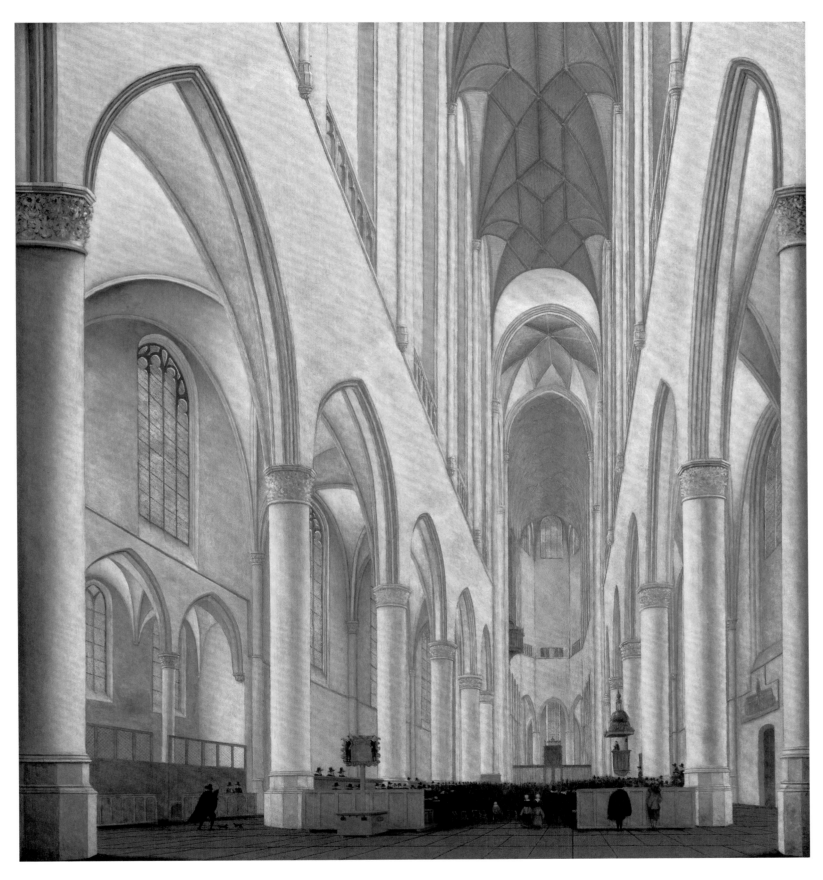

CATALOGUE 55. *Interior of the St. Bavokerk, Haarlem,* 1660. Oil on panel, 22 1/2 × 20 1/4 inches
(57 × 51.5 cm). Signed and dated lower left: *P. Saenredam A° 1660*

Saenredam, the first artist to specialize in the depiction of existing church interiors, is also considered the most important painter of architectural pieces in seventeenth-century Holland. His extremely accurate drawings of the interiors and sometimes the exteriors of various churches and other important buildings, as well as the refined paintings based on them, constitute a separate chapter in Dutch painting of the seventeenth century. Owing largely to Cornelis de Bie's *Het gulden cabinet van de edele vry schilder-const* of 1661, we are reasonably well informed about his life and work. De Bie wrote that "around 1628 [Saenredam] devoted himself entirely to painting perspectives, church interiors, galleries, buildings and other things, both from the outside and the inside, from life."[1] His earliest known painting, the interior of the St. Bavokerk in Haarlem, is indeed dated 1628, and he had made a drawing of the same church the previous year. His teacher in the art of perspective was probably Pieter Wils (active 1621–died ca. 1647), a surveyor, mathematician, and urban architect active in Haarlem. Like Saenredam, Wils was involved in the illustration of Samuel Ampzing's *Beschryvinge ende lof der stad Haerlem in Holland* of 1628. The famous Haarlem architect Jacob van Campen (1596–1657), who drew a portrait of Saenredam in 1628, undoubtedly stimulated his interest in architecture.

For a long time, relatively little interest was taken in Saenredam. Only in the period between the world wars and particularly after the Second World War did his work begin to grow in popularity. Today, his paintings and drawings are considered highlights of seventeenth-century Dutch art.

Literature: Swillens 1935; Van Regteren Altena 1961; Schwartz and Bok 1990.

CATALOGUE 55

INTERIOR OF THE ST. BAVOKERK, HAARLEM

THE LATE-GOTHIC GROTE or St. Bavokerk still dominates the image of Haarlem. Construction began on this large cruciform basilica, with its transept and triple-aisled nave, in the last years of the fourteenth century and continued through the first half of the sixteenth century. The stellar vault in the central bay is of stone, but a lack of materials resulted in the use of wood for the rib vaults in the nave and the choir, as seen in this painting. The choir, which belongs to the oldest part of the church, is uncommonly large. The church is dedicated to St. Bavo, patron saint of the city of Haarlem and also of Ghent.

In 1627, prints were made by a number of engravers after fourteen paintings by Pieter Saenredam, which served to illustrate the history compiled by Samuel Ampzing and published in 1628. This series included a print of the exterior and one of the interior of the St. Bavokerk etched by Jan van de Velde after Saenredam. Saenredam's 1627 drawing of the interior and the etching based on it, both in horizontal format, depict the nave looking from west to east. As was usual in Saenredam's drawings, this drawing shows no people in the church, whereas the print features a minister preaching from the pulpit to a large congregation (Noord-Hollands Archief, Haarlem).[2] In 1631, Saenredam used the same drawing as the basis of a painting in horizontal format of the church's interior. This time he omitted the pulpit, preacher, and congregation, and depicted a group of fashionably dressed people promenading through the church (Philadelphia Museum of Art, John G. Johnson Collection).[3] Saenredam often took a drawing he had made many years earlier and used it as the point of reference for a new painting. In fact, he used the above-mentioned drawing of 1627 nearly thirty years later to make another painting from the same vantage point. In the case of the present panel of 1660, he chose a vertical format, in order to enhance the feeling of space and emphasize the church's height. To this end, Saenredam not only omitted the foremost bay

of the nave but also extended such architectural elements as the pillars, walls, and windows.
He took similar artistic liberties on more than one occasion. Also in 1660, for example, he painted
a vertical panel depicting the choir of the St. Bavokerk, seen from the nave (Worcester Art
Museum, Worcester, Massachusetts), based on a drawing in horizontal format (Schlossmuseum,
Weimar).[4] In that painting, in which he likewise eliminated the front bay of the nave, the ceiling
makes a much higher impression than in the drawing – higher even than it actually is. In the
present painting, the omission of the foremost bay causes the image to be framed on the left and
right by tall pillars instead of half-arches, which also heightens the spatial effect. Above the
aisle on the right hangs a scale model of the church, still in situ, which was probably painted by
Pieter Gerritsz. (active ca. 1518) in 1518. The box on the left in front of the pews was the collection
box for the Boys' Orphanage.

Another striking difference between the present painting and the 1627 drawing on which it is
based is the staffage, which accords with the 1628 print and features a minister on the pulpit;
the two women in the middle and the two men on the right, seen from the back, are practically
identical to the figures in the print.

This painting was long relegated to obscurity, and for a time its authenticity was even in doubt.
Since the discovery of the signature and date, however, there is no reason to mistrust the attribu-
tion. In fact, in terms of execution and spatial viewpoint, it is perfectly in keeping with other work
by Saenredam from the same period. A drawing by an unknown hand in the Städelsches
Kunstinstitut, Frankfurt, depicts the church with the same staffage and seen from the same angle.

Provenance: Anonymous sale (collection Théophile de Bock and other provenances), Amsterdam (F. Muller),
March 7–10, 1905, no. 662 (as on canvas); Prof. Jhr. Dr. Jan Six van Hillegom van Wimmenum (1857–1926),
Amsterdam; by descent to his son Jhr. Ir. Gijsbert Christiaan Six van Wimmenum (1892–1975), Laren, N. H.; sale,
London (Sotheby's), December 9, 1987, no. 83 (as Follower of Saenredam); with Harari & Johns, London;
acquired from Noortman Master Paintings, London, in 1995.

Exhibitions: Centraal Museum, Utrecht, *Pieter Jansz. Saenredam*, 1961; Mauritshuis, The Hague, *The Amateur's
Cabinet: Seventeenth-Century Dutch Masterpieces from Dutch Private Collections*, 1995–96; Museum of Fine
Arts, Boston, *Poetry of Everyday Life: Dutch Painting in Boston,* 2002.

Literature: Van Regeteren Altena 1961, pp. 77–78, cat. no. 32, ill. fig. 33 (as not signed and dated; as doubtful);
Schwartz and Bok 1990, p. 259, cat. no. 32 (as possibly an early work by Isaak van Nickelen [1632/33–1703]); Giltaij
1990, p. 90; *The Amateur's Cabinet* 1995–96, p. 58, cat. no. 25, ill. p. 59; *Poetry of Everyday Life*, 2002, p. 126, ill.

Notes:
1. De Bie 1661, p. 246: "omtrent den jare 1628 gheheel tot schilderen van perspectieven/ kercke saelen/ galderyen/
 ghebouwen/ en andere dinghen soo van buyten als van binnen soo naer het leven doende."
2. Schwartz and Bok 1990, cat. no. 30.
3. Ibid., cat. no. 29.
4. Ibid., cat. nos. 33, 34, respectively.

GODFRIED SCHALCKEN

MADE 1643–1706 THE HAGUE

Godfried Schalcken was born in 1643 in the little town of Made, located between Dordrecht
and Breda. He was the son of Cornelis Schalckius, parish minister of Made. In 1654, the family
moved to Dordrecht when Schalcken's father was appointed rector of the local Latin School.
Houbraken reported that Schalcken studied there with Samuel van Hoogstraeten (1627–1678) and
in Leiden with Gerrit Dou.[1] By 1665, back in his native town, the artist was recorded as the
ensign of one of the Dordrecht militia companies. On October 31, 1679, he married Françoise van
Diemen of Breda. In 1686, he moved to Wijnstraat in the center of Dordrecht. On February
28, 1691, Schalcken paid his membership to Pictura, the painters' fraternity in The Hague, but he
does not seem to have moved there, for in November of the same year he is reported as residing
in Dordrecht. In May 1692, Schalcken moved to London where he remained until 1697. During those
years, he painted several portraits of William III, the king and *stadholder,* including one by candle-
light (Rijksmuseum, Amsterdam), and he was commissioned by Cosimo III de' Medici to paint
a self-portrait (Galleria degli Uffizi, Florence). By June 1698, the painter had returned to The Hague
where he obtained citizenship on August 31, 1699. In 1703, he is mentioned in Düsseldorf,
working for Elector-Palatine Johann Wilhelm II. On August 29, Schalcken made his will and he
died in The Hague the following year on November 13.

 Godfried Schalcken painted, drew, and etched primarily portraits, genre scenes, and biblical
and mythological subjects, often in a nocturnal setting with artificial light. Both his style and
subject matter are strongly reminiscent of the Leiden "fine painters" (*fijnschilders*). His sister Maria,
as well as Carel de Moor (1655–1738) and Arnold Boonen (1669–1729), studied with Schalcken.

Literature: Hofstede de Groot 1907–28, vol. 5, pp. 309–419; Beherman 1988; Jansen 2000, pp. 328–29.

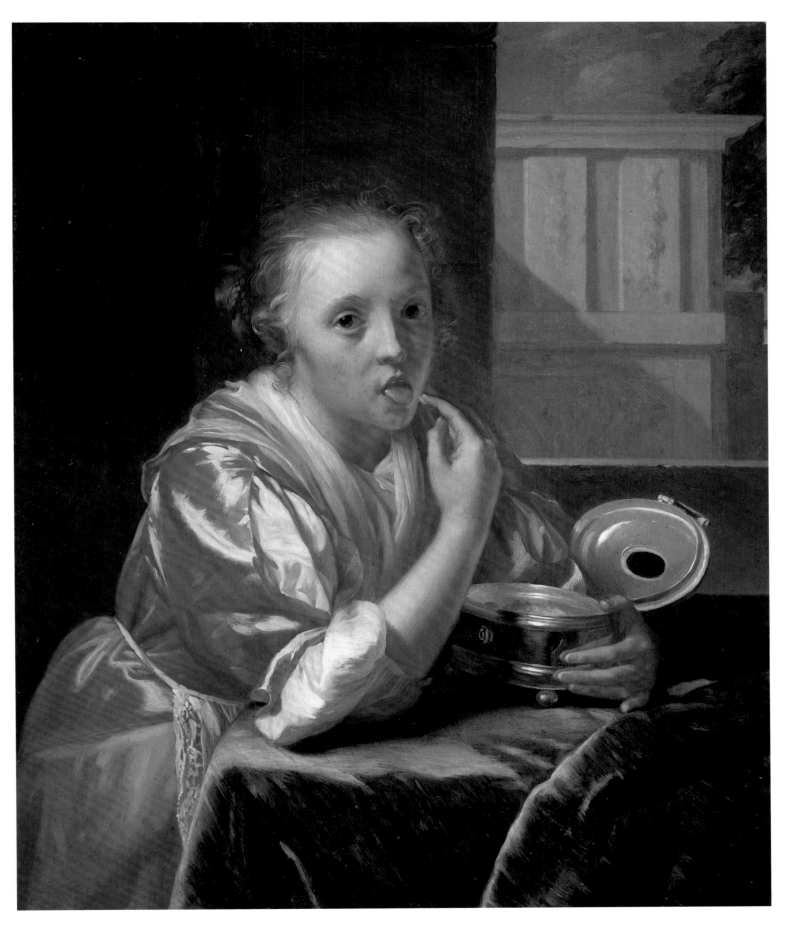

CATALOGUE 56. *Young Girl Eating Sweets*, 1680–85. Oil on panel, 7 3/8 × 6 1/8 inches (18.6 × 15.5 cm). Signed upper left: *G. Schalcken.*

CATALOGUE 56

*YOUNG GIRL EATING
SWEETS*

IN THE REFINED STYLE OF PAINTING characteristic of his work, Godfried Schalcken
depicted a girl wearing an orangey-pink dress and holding in her left hand a beautiful oval silver box
containing sugar. Having just dipped her finger in the sugar, she is now poised to lick it off. She
looks teasingly at the viewer as she sticks her tongue out slightly in anticipation, resting her arms
on a table covered with a blue cloth. Visible on the right is a distant view of a landscape with a
building resembling a classical temple. Like the Leiden "fine painters," Schalcken devoted a great
deal of attention to the rendering of the various materials, such as the shiny silver of the box
and the girl's gleaming silk dress.

It is unclear whether this picture was intended to have any iconographic meaning. In the
seventeenth century, sugar was a costly product that was imported, for example, from Brazil. Some
"experts" warned against its use, calling it a delicious but dangerous temptation. Moreover,
sweets were often connected with pregnancy and a fixation on sweet foods, but it is questionable
whether the girl in Schalcken's painting is pregnant.

In the eighteenth century, this panel – then in the Slingeland collection – was the pendant to
a small painting by Schalcken portraying a young woman standing in front of a mirror and
holding a waffle (Wallraf-Richartz-Museum, Cologne). At some point, however, these pendants
were separated. In the first half of the nineteenth century, *Young Girl Eating Sweets* was part of
the famous collection belonging to Johan Goll van Franckenstein Jr., which also included paintings
by Rembrandt, Jan Steen, Gabriël Metsu, Paulus Potter, and Jacob van Ruisdael. From the mid-
nineteenth century onward, its location was unknown until it surfaced in 1996. The picture is illus-
trated here for the first time. A copy painted by Schalcken's pupil Arnold Boonen (1669–1729)
was for a time with the art dealer Caretto in Turin.[2]

Provenance: Johan Diderik van Slingeland, The Hague, by 1752; by descent to his wife Petronella van Slingeland-
van der Burch in 1757; her estate sale, The Hague (Thierry/Mensing), November 16, 1790, lot 6 ("Een Vrouwtje dat
Suyker likt door G. Schalken;" sold together with pendant *Lady Looking into a Mirror*; see Hofstede de Groot
1907–28, vol. 5, cat. no. 119; bought by Van Cleef for fl. 300); Johan Goll van Franckenstein Jr., Velsen and Amsterdam
(d. 1821); by descent to his son, Pieter Hendrik Goll van Franckenstein (d. 1832); his estate sale, Amsterdam
(De Vries/Brondgeest), July 1, 1833, lot 71 (bought by Woodin for fl. 141); Charles Brind, London, his estate sale, London
(Christie's and Manson), May 10, 1849, lot 42 (bought by J. Brind for £18:7:6); private collection, France, since
the nineteenth century; acquired from Bob P. Haboldt & Co., New York, in 1996.

Literature: Hoet 1752, vol. 2, p. 406; Smith 1829–42, vol. 4, p. 281, no. 66, and vol. 9, p. 591, no. 18; Hofstede de Groot
1907–28, vol. 5, p. 345, no. 123 (as *A Comely Young Girl eating sweetmeats* and as pendant to cat. no. 119); Beherman
1988, pp. 239, 394, no. 123 (in a list of paintings mentioned by Hofstede de Groot, but unknown to the author).

Notes:
1. Houbraken 1718–21, vol. 3, p. 175.
2. Caretto 1989, no. 5.

MARIA SCHALCKEN

MADE? 1647/50–1684/1709 DORDRECHT?

Very little is known of Maria Schalcken. She was born around 1647/50, probably in Made, to the north of Breda, where her father was a clergyman. In 1654, the family moved to Dordrecht, where her father was appointed rector of the Latin School. Maria was the younger sister of the painter Godfried Schalcken, from whom she undoubtedly received her first lessons in painting. Notarial acts of 1684 and 1709 suggest that she never married. It is not known when or where she died: she was still alive in 1684 and was recorded as deceased in 1709.

Maria Schalcken was one of the very few women painters in seventeenth-century Holland. Only two of her paintings are known, so it is impossible to assess her work properly. According to Van Eijnden and Van der Willigen, she devoted herself to painting the "conventional business of daily life" ("van burgerlijke bedrijven des dagelijkse leven") and was so accomplished at it "that her detailed and exemplary cabinet pieces have been placed in reputable art collections" ("dat hare uitvoerige en mals geschilderde kabinetstukjes in aanzienlijke kunstverzamelingen zijn geplaatst geworden").[1] Given the strong similarities between her two known paintings and the work of her brother, it is quite possible that some of the paintings attributed to him were actually made by Maria.

Literature: Van Eijnden and Van der Willigen 1816, p. 186; Veth 1892, p. 6 n. 2.

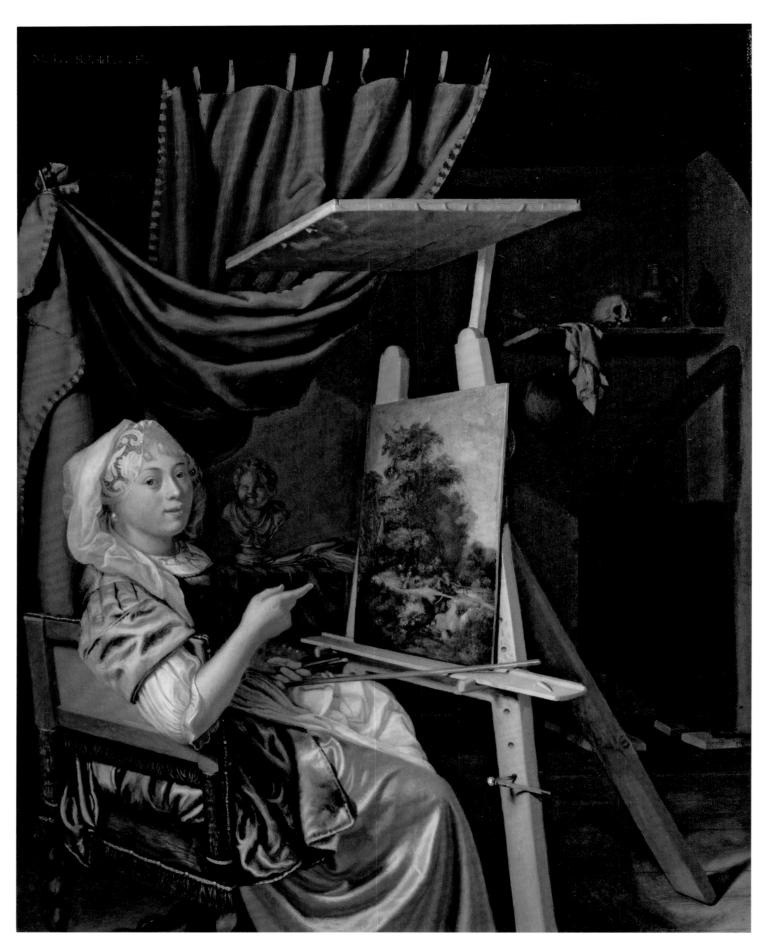

CATALOGUE 57. *The Artist at Work in Her Studio*, ca. 1680. Oil on panel, 17 3/8 × 13 1/2 inches (44 × 34.3 cm). Signed upper left corner: *Maria. Schalcken. F.*

CATALOGUE 57

*THE ARTIST AT WORK
IN HER STUDIO*

HERE, MARIA SCHALCKEN portrayed herself as a painter in her studio. Sitting at the easel, she turns her face toward the viewer, as if looking around to see who has just entered the room. With her right hand, she points to the painting on the easel, a wooded landscape with travelers by a bridge; in her left hand, she holds a palette, brushes, and a maulstick. She is dressed in a violet-blue smock and apricot-colored silk skirt, and on her head she wears a piece of lace – not the kind of clothing one expects to be worn in a painter's studio. The composition is rounded at the top; a red curtain is partly raised and drawn open to the left. On the back wall, a canvas on a stretcher, a skull, and two jugs stand on a shelf, below which hangs a palette. In the corner is a small cupboard with doors, or perhaps a stove standing on four tiles. Mounted above the easel is a stretcher holding a piece of paper, which probably serves to prevent dust from settling on the wet paint.

Just how much Maria's style and technique resembled that of her elder brother is apparent from this self-portrait. The painting was long attributed to Godfried and was not recognized as the work of Maria until ten years ago, when during restoration her name appeared, having been overpainted in the early nineteenth century. The fact that Maria Schalcken depicted herself with a wooded landscape on the easel indicates that she painted landscapes as well as genre pieces.

In addition to this self-portrait, only one other piece has been attributed to Maria Schalcken: *Young Woman at Her Toilet Table in front of a Mirror with a Maidservant.*[2] The signature on that painting is identical to the one on the present picture. Eighteenth-century sources record several other interiors by her hand, and Van Eijnden and Van der Willigen mentioned the "depiction of this painter . . . after a drawing made by herself" ("afbeelding dezer schilderes [. . .] naar ene, door haar zelve gemaakte, tekening").[3] According to Walther Bernt door M. Naiveu (1647–ca. 1721), there was a copy after this painting (oil on canvas, 17 3/8 × 13 7/8 inches [44 × 35.3 cm]), sale, London (Sotheby's), April 18, 2001, no. 41.

Provenance: Thomas Theodore Cremer, Rotterdam, his estate sale, Rotterdam (Van Leen), April 16, 1816, no. 104 (sold for fl. 103,– to Nieuwenhuys, as by Maria Schalcken); Johann Caspar Hofbauer, Vienna, 1835; Josef Scharinger, Vienna, 1840; Adolph Ritter von Grosser, Vienna, 1899; Herman Rasch, Stockholm, 1928–29; Arnold Frowell, London (all the above until 1835 as by Godfried Schalcken); Mrs. Diana Kreuger, Geneva, until 1998, with Galerie Sanct Lucas, Vienna, 1998; from whom acquired in 1999.

Exhibitions: Galerie Dr. Schäffer, Berlin, *Die Meister des holländischen Interieurs*, 1929; Galerie Sanct Lucas, Vienna, *Old Master Paintings*, 1998–99.

Literature: Van Eijnden and Van der Willigen 1816, p. 186; "Verzeichnis der Gemälde-Sammlung des Johann Caspar Hoffbauer in Wien Anno" 1835 (von [Herrn] Rauch für 200fl); Veth 1892, p. 6 n. 2; Von Frimmel 1910, pp. 90–92, ill. p. 91; Hofstede de Groot 1907–28, vol. 5, p. 399, no. 322; Von Frimmel 1913–14, p. 79 (Grosser) and p. 197, no. 22 (Hofbauer; Zimmer V); *Die Meister des holländischen Interieurs* 1929, pp. 28–29, cat. no. 78 (as by Godfried Schalcken); Van Hall 1963, p. 292, no. 2; Beherman 1988, pp. 159–61, cat. no. 61, ill. p. 160 (all the above as by Godfried Schalcken); E. Kloek 1998, p. 163; *Old Master Paintings* 1998–99, pp. 48–49, cat. no. 20, ill. p. 49.

Notes:
1. Van Eijnden and Van der Willigen 1816, p. 186.
2. With Trafalgar Galleries, London 1979, ill. in Beherman 1988, p. 47.
3. Van Eijnden and Van der Willigen 1816, fig. facing p. 236.

JAN STEEN

LEIDEN 1626–1679 LEIDEN

Jan Havicksz. Steen was the first of eight children born to a wealthy Leiden grain merchant and beer brewer of Catholic descent. His exact date of birth and the day of his baptism are not known, but judging by the date of his parents' marriage, November 15, 1625, and the fact that Jan Steen gave his age as twenty in 1646, it may be assumed that he was born in 1626. Little is known of his training as a painter. According to Houbraken, Steen was a pupil of Jan van Goyen. The biographer Weyerman confirmed this in *De levensbeschrijvingen der Nederlandsche konst-schilders en konst-schilderessen* of 1729, and added that before this time, the painter had been apprenticed first to Nicolaes Knüpfer (ca. 1609–1655) in Utrecht and then to Adriaen van Ostade in Haarlem.[1]

On November 1, 1646, Steen enrolled as a liberal arts student at Leiden University, presumably only for financial reasons: students were exempt from the excise tax on wine and beer, and released from compulsory service in the civic militia. He must have completed his training as a painter in 1648, because on March 18 of that year he registered as a master-painter with the recently founded Guild of St. Luke. On October 3, 1649, in The Hague, Steen married Margaretha (Grietje) van Goyen, the daughter of the artist Jan van Goyen. Until mid-1654, the young couple remained in The Hague, where their eldest son, Thaddeus, had been baptized on February 6, 1651. On July 22, 1654, Steen rented a brewery in Delft for a period of six years, for which his father-in-law stood surety. Financial problems led to the termination of the rental contract in July 1657, whereupon Steen left Delft and returned briefly to Leiden. From 1658 to 1660, he lived in Warmond, slightly north of Leiden. In 1661, he registered with the Haarlem guild. On May 8, 1669, Steen's wife was buried in the St. Bavokerk.

After inheriting his father's house on Langebrug in Leiden in 1670, Steen returned to his home town, where he continued to live until his death. He again registered with the guild: in 1671 and 1672 he held the position of senior officer (*hoofdman*) and in 1674 he was appointed dean (*deken*). Like

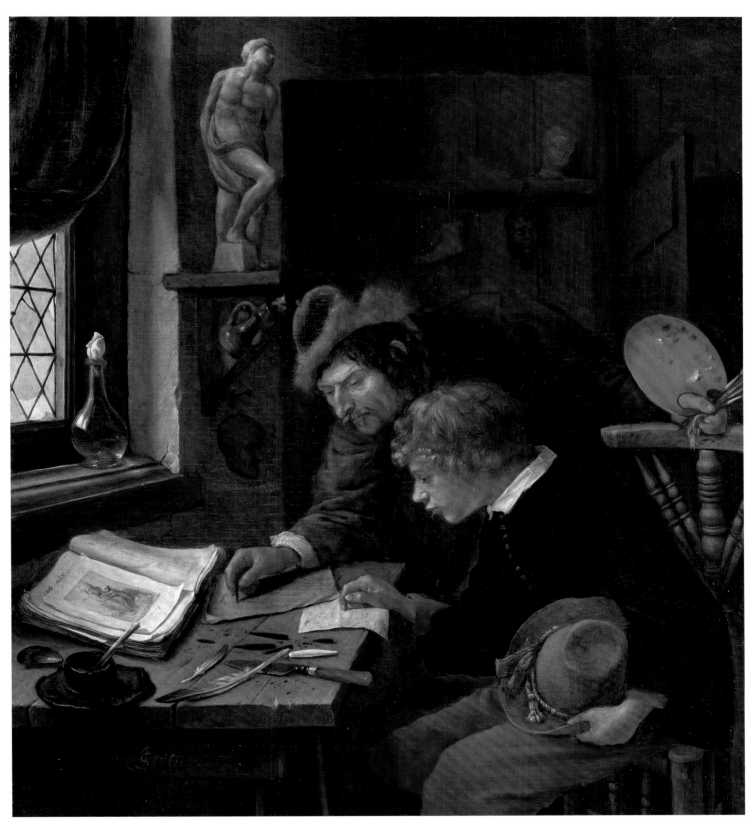

CATALOGUE 58. *"The Drawing Lesson": A Master Correcting a Pupil's Drawing*, ca. 1665–66. Oil on panel,
9 1/2 × 8 inches (24.1 × 20.5 cm). Signed lower left on the side of the table: *JSteen* (*JS* in ligature)

many seventeenth-century Dutch artists, Steen – whose paintings did not fetch high prices – could not make a living from painting. In 1672, the "year of disaster" for the Dutch Republic, he was granted a license to open up a tavern in his house to generate some extra income.

On April 22, 1673, Steen married the widow Maria Dircksdr. van Egmond. He died in Leiden on February 3, 1679, and was buried in the family vault in the Pieterskerk. He was deeply in debt when he died.

Jan Steen was an exceptionally productive and versatile painter. His oeuvre consists largely of genre scenes set in interiors, such as homes, schools, or inns. These highly narrative depictions, conceived almost as stage plays, reveal his passion for the painstaking portrayal of countless details, which usually offer the viewer clues that are useful in unraveling the action in his composi-tions. Almost without exception, his works contain veiled moralizing messages, in which *vanitas* and *eros* play important roles. Steen also produced allegorical representations and history paintings, and a few portraits and landscapes.

Literature: Hofstede de Groot 1907–28, vol. 1, pp. 1–252; Bredius 1927; L. De Vries 1977; Braun 1980; *Jan Steen, Painter and Storyteller* 1996–97; W. Kloek 2005.

CATALOGUE 58

"THE DRAWING LESSON":
A MASTER CORRECTING
A PUPIL'S DRAWING

IN A PAINTER'S STUDIO, next to a window partly covered by a curtain, a pupil pays careful at-tention to his teacher's instructions. While the boy holds his hat in his lap with his left hand and rests his right hand on the table, the painter bends over him, using a piece of charcoal to cor-rect the drawing his pupil has made on blue paper. The boy was probably assigned the task of copying the drawing (or more likely, the print) of a Virgin and Child in the style of Raphael, which lies before him in the open book. The painter leans with his left hand on the back of the chair, still holding his palette and brushes in the other hand, thus suggesting that he has just interrupted work on his own painting to fulfill his teaching duties. The numerous drawing materials lying on the table include pieces of charcoal and white chalk, two goose-quill pens, an inkpot, a knife to sharpen the pens and chalk, and a piece of blotting paper. Standing on the windowsill is a bottle of clear liquid, probably varnish, put there to let the impurities sink to the bottom. On a shelf next to the leaded window stands a small plaster statue modeled on Michelangelo's *Rebellious Slave* in the Musée du Louvre, Paris. Behind the two figures, a variety of objects commonly found in a painter's studio hang on the wall or lie on the floor, such as a stoppered jug that probably contains oil, plaster casts of a foot and head, and some masks. These last items most likely have allegorical meaning: masks symbolized illusion, and were therefore the attribute of *Pictura*, the art of painting, since painters strove to create an illusory reality in their work.

The pupil depicted in profile bears a strong resemblance to another young draftsman, likewise in profile, on a small panel by Steen (figure 1). It is possible that Steen, who frequently had members of his family pose for him, portrayed his eldest son, Thaddeus, in both paintings. Thaddeus did, in fact, follow in his father's footsteps, registering with the Leiden guild as a master-painter in 1664.

Jan Steen also depicted the theme of the master-painter instructing a pupil in another painting, probably made slightly earlier (figure 2). Various elements in that somewhat larger panel are depicted in very similar fashion, such as the artist still holding his palette and brushes while correcting the drawing of his pupil, this time a girl, while a boy watches from behind a reading-desk. The vantage point is slightly farther away, so that the pupil is seen full-length and more of the

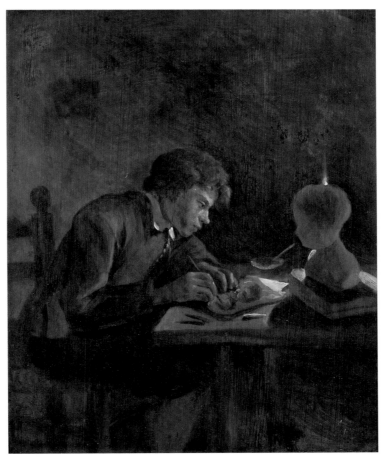

Figure 1. Jan Steen, *Young Artist*,
ca. 1650. Oil on panel, 9 7/8 × 7 7/8
inches (25 × 20 cm). Stedelijk Museum
de Lakenhal, Leiden.

Figure 2. Jan Steen, *Drawing Lesson*,
ca. 1665. Oil on panel, 19 3/8 × 16 1/4
inches (49.2 × 41.2 cm). The J. Paul
Getty Museum, Los Angeles.

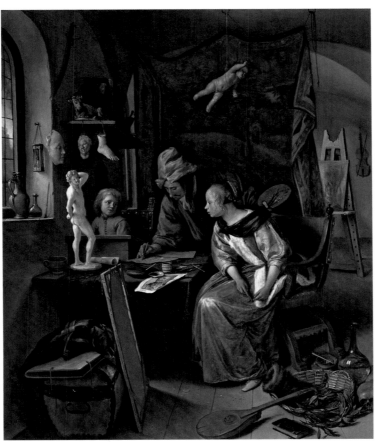

adjacent studio is visible, including an unfinished painting on an easel. In both works, Steen depicted two of the recommended stages of a draftsman's training: copying drawings and prints, and drawing after plaster casts of statues. The final stage of the training consisted of life drawing. In this regard, it is indeed revealing that Dutch art theorists – such as Karel van Mander, Willem Goeree, and Samuel van Hoogstraten – held drawing to be the basis of all the arts, particularly that of painting.[2] Van Hoogstraten wrote, for example, that without drawing, "painting . . . is not only wanting, but entirely dead and non-existent."[3] It is, therefore, not at all surprising that here Steen, in rendering a subject so important to art, omitted the comic element seen in so many of his paintings and created in both this piece and *Drawing Lesson* (figure 2) a composition that is very serious in character. A painter's studio, with or without a pupil, was a subject popular with numerous Dutch artists of the seventeenth century, particularly among the Leiden painters, such as Gerrit Dou, Rembrandt van Rijn, Frans van Mieris, Gabriël Metsu, and Godfried Schalcken. Furthermore, artists from a completely different sphere, such as Michael Sweerts (1618–1664), also devoted themselves to this subject. Together, they provided us with a great deal of information on the studio practices and painting techniques prevailing in the seventeenth century.

Provenance: Johanna Tyler, widow of Lucas van Beek, her estate sale, Amsterdam (De Leth de Bosch), April 30, 1759, no. 23 (to Kalkoen); Hans von der Mühll (1846–1914), Basel, bequeathed in 1915 to the Öffentliche Kunstsammlung, Basel; with P. Cassirer, Berlin; J. W. Nienhuys, Bloemendaal, by 1926; thence by direct descent to Mrs. A. Nienhuys-Versteegh, Aerdenhout, by 1954 until after 1977; by descent to H. C. Nienhuys, the Netherlands and Suffield, Connecticut; acquired from Noortman Master Paintings, Maastricht, in 1998.

Exhibitions: Stedelijk Museum de Lakenhal, Leiden, *Jan Steen*, 1926; Frans Hals Museum, Haarlem, *Kind en Kunst*, 1931; Museum Het Prinsenhof, Delft, *Kersttentoonstelling: Nederlandse meesters uit particulier bezit*, 1952–53; *Schilders, Schilderen, Schilderijen*, Dordrechts Museum, Dordrecht, 1953 (no catalogue); *Holländer des 17. Jahrhunderts*, Kunsthaus Zürich, 1953; Palazzo delle Esposizioni, Rome, *Mostra di Pittura Olandese del Seicento*, 1954; Palazzo Reale, Milan, *Mostra di Pittura Olandese del Seicento*, 1954B; Museum Boymans, Rotterdam, *Kunstschatten uit Nederlandse Verzamelingen*, 1955; De Waag, Nijmegen, *Het schildersatelier in de Nederlanden 1500–1800*, 1964; on loan to the Wadsworth Atheneum, Hartford, Connecticut, ca. 1993 (no. T.L. 92.1993:1); Otto Naumann, New York, *Inaugural Exhibition of Old Master Paintings*, 1995; Mauritshuis, The Hague, *The Amateur's Cabinet: Seventeenth-Century Dutch Masterpieces from Dutch Private Collections*, 1995–96; Museum of Fine Arts, Boston, *Poetry of Everyday Life: Dutch Painting in Boston*, 2002.

Literature: Hofstede de Groot 1907–28, vol. 1, inserted between pp. 64–65, no. 245B=no. 245C: *Die Zeichenstunde*; *Jan Steen* 1926, p. 24, no. 52 (reproduced on a separate postcard published by the "Nederlandschen Bond tot Kinderbescherming" in December 1926, first series, no. 6); Bredius 1927, ill. pl. 83 (description interchanged with pl. 82); *Kind en Kunst* 1931, p. 16, cat. no. 277; De Jonge 1939, p. 21, ill. p. 16; *Kersttentoonstelling: Nederlandse meesters uit particulier bezit* 1952–53, p. 34, cat. no. 69, ill. fig. 7; *Holländer des 17. Jahrhunderts* 1953, p. 66, cat. no. 147, ill. pl. 35; L. De Vries 1977, pp. 37, 157, no. 45; *Mostra di Pittura Olandese del Seicento* 1954A, p. 83, cat. no. 149; *Mostra di Pittura Olandese del Seicento* 1954B, p. 65, cat. no. 152, ill. pl. 57; *Kunstschatten uit Nederlandse Verzamelingen* 1955, p. 57, cat. no. 122, ill. fig. 130; *Het schildersatelier in de Nederlanden 1500–1800* 1964, pp. 19, 69, cat. no. 25; Braun 1980, p. 122, cat. no. 255, ill. p. 123; J. J. Walsh 1989, p. 85 n. 2; Steinberg 1990, pp. 111, 114, 123, 125 n. 11, ill. fig. 4; *Inaugural Exhibition of Old Master Paintings* 1995, pp. 107–110, cat. no. 23, ill. p. 109; *The Amateur's Cabinet* 1995–96, pp. 62–63, cat. no. 27, ill. cover and p. 63; J. J. Walsh 1996, pp. 43, 52, ill. p. 42, fig. 36; *Jan Steen, Painter and Storyteller* 1996–97, p. 186, ill. fig. 1, p. 186; Van der Meer Mohr 1997, pp. 34–36, ill. p. 35; *Poetry of Everyday Life* 2002, p. 77.

Notes:
1. Houbraken 1718–21, vol. 3, p. 13; Weyerman 1729–69, vol. 2, p. 348.
2. Van Mander 1604; Goeree 1668; Van Hoogstraeten 1676.
3. Van Mander 1604, p. 26 ("Schilderkonst, . . . , niet alleen gebrekkelijk, maer geheelijk doot en ganch niet is").

DAVID TENIERS THE YOUNGER

ANTWERP 1610–1690 BRUSSELS

David Teniers was baptized on December 15, 1610, in the St. Jacobskerk in Antwerp. His father, the painter and art dealer David Teniers the Elder (1582–1649), who specialized in small history paintings, was his first teacher. In 1632/33, Teniers the Younger registered with the Antwerp Guild of St. Luke. On June 22, 1633, he married Anna Brueghel, daughter of the painter Jan Brueghel the Elder, who, since the death of her father in 1632, had been living in the house of her guardian, the painter Peter Paul Rubens (1577–1640). The close ties between the young couple and Rubens are also apparent from the fact that Rubens was a witness to their marriage. Moreover, Rubens's wife, Hélène Fourment, acted as godmother to the first of their seven children, David Teniers III. At first, Teniers and his wife lived with her mother. In 1636, Teniers and a number of other painters were invited by Rubens to assist him with a commission he had received from Philip IV of Spain to decorate the king's hunting lodge, Torre de la Parada, near Madrid. In 1642, Teniers and his wife came into the possession of the splendid house *De Meireminne* (The Mermaid), Jan Brueghel's former residence on the Lange Nieuwstraat. In 1645 and 1646, Teniers served as dean (*deken*) of the guild and became a member of the Antwerp rhetoricians' chamber *Liefhebbers van de Violieren* (Lovers of the Stocks). His most important patrons in these years included Antoon Triest, bishop of Ghent, and, in Brussels, Archduke Leopold Wilhelm, the recently appointed regent of

the Southern Netherlands, from whom Teniers received his first commissions in 1647. In 1651, the archduke appointed Teniers court painter and keeper of his collection of paintings. Teniers moved to Brussels, where he played an important role in shaping the archduke's collection, which later became the core of the collection of the Kunsthistorisches Museum in Vienna. Around 1657, the archduke also appointed Teniers to the position of chamberlain. One of his most important commissions as court painter was the production of a series of small oil sketches after all the Italian paintings in Leopold Wilhelm's collection. These served as *modelli* for the 244 engravings in the *Theatrum Pictorium*, which was published in 1660, after the archduke's departure for Vienna.

Teniers's wife Anna died in May 1656, and on October 21 of that year he married Isabella de Fren, the daughter of the secretary of the Souvereine Raad van Brabant (the highest court of justice in the province of Brabant). The couple moved into a spacious house on Rue Terarken in Brussels. From 1656 to 1659, Teniers served as court painter to the new regent, Don Juan José of Austria.

Teniers's success as a painter enabled him to buy, in 1662, the beautiful country house *Dry Toren* (Three Towers) in the vicinity of Perck between Mechelen and Vilvoorde. The same year saw the publication of *Het gulden cabinet van de edele vry schilder-const*, in which Cornelis de Bie expressed high praise for the artist.[1] Owing in part to Teniers's efforts, an academy was founded in Antwerp in 1663 that was based on the examples in Rome and Paris. On April 25, 1690, the painter died in Brussels and was probably buried in the St. Jacob ten Coudenberg, which no longer exists.

Teniers was the most important and most successful Flemish genre painter of the seventeenth century. His large oeuvre also contains landscapes, religious scenes, and even satirical representations featuring costumed monkeys and cats. He designed tapestries as well. It was the peasant genre scenes of Adriaen Brouwer (1605/1606–1638) that first exerted a great influence on him. Teniers was also a productive draftsman. His work was in great demand already in his lifetime, but after his death – in the eighteenth century in particular – his popularity grew even more.

Literature: *David Teniers de Jonge* 1991; *David Teniers der Jüngere, 1610–1690* 2005–2006.

<div style="display:flex">
<div>

CATALOGUE 59

THE TEMPTATION OF SAINT ANTHONY

</div>
<div>

THE BEARDED SAINT ANTHONY sits in a cave, praying at a boulder that serves as an altar. Standing on this makeshift altar is a crucifix; the hourglass, human skull, and book lying at its foot refer to the transience of life. Anthony is dressed in a black robe; visible on his left shoulder, in white, is the Greek letter *tau*, the first letter of the word *theos*, which means God. In the shadow behind him is a pig, which symbolizes the hermit's triumph over lust and gluttony, two of the seven deadly sins. Next to the saint stands an old procuress, wearing a white headscarf with two devilish horns sticking through it. She introduces to Anthony a sumptuously dressed young woman, who tries to seduce him with a glass of wine; her scaly tail and clawed feet betray the woman's true nature. On the right, the owl sitting on a kind of plateau in the rock possibly symbolizes solitude, pride, or folly. The cave is otherwise populated by various monsters and misshapen animals, who are urged on by Satan himself. In the left foreground, the demonic little peasant with clawed feet, who turns his head to look at the viewer, is probably Teniers's idea of a joke, for his face very likely displays the painter's own features. Light streams into the cave from the entrance on the left, through which a cloudy sky is discernible. The picture is painted mostly in shades of gray and brown, enlivened with accents of red, green, white, and blue.

</div>
</div>

CATALOGUE 59. *The Temptation of Saint Anthony*, ca. 1650. Oil on copper, 23 1/4 × 31 1/4 inches (59.1 × 79.4 cm). Signed lower right: *D TENIERS*; inscribed lower right: *294*

According to legend, Anthony of Egypt, also known as Anthony Abbot, gave away all his worldly possessions in the year 272 at the age of twenty-one, and then spent years wandering in the Egyptian desert. There, he suffered hallucinations in which he was beset by Satan and other demons, who attempted, by means of every imaginable earthly enticement, to deflect him from the straight and narrow. Anthony remained steadfast, however, and with the help of prayer and a crucifix resisted all temptation.

In the Middle Ages, Saint Anthony was considered the embodiment of constancy and virtue – an example to humankind. This understanding also emerges from the Latin text below a print by François van den Wyngaerde after a drawing by Teniers of a very similar composition: "Beatus vir qui suffert tentationem quoniam cum probatus fuerit. Accipiet coronam vitae, quam repromisit Deus diligentibus" (Happy the man who resists temptation, for when he has been tried he will receive the crown of life which God has promised to those who love Him).

Since the fifteenth century, the Temptation of Saint Anthony had been a popular theme, owing to the opportunities it afforded painters to depict wild and fanciful motifs. Apparently, this subject exerted an especially strong attraction on Teniers, for in the course of his long life he painted no fewer than twenty compositions featuring this early Christian saint. Teniers's earliest known depiction of Saint Anthony dates from 1634 (Collection Fürst zu Salm-Salm, Museum Wasserburg, Anholt). The present painting, one of the most beautiful of the series, probably originated around 1650, when Teniers was at the height of his powers. With this painting and related compositions, Teniers followed in the footsteps of Hieronymus Bosch (ca. 1450–1516) and Pieter Bruegel the Elder (ca. 1525/30–1569), both of whom found inspiration in the legend of the saint. Not only the theme but also the details, such as the monster on the left with a horse-skull as a head and a cloth over its body, derive from the work of Bosch.[2] A slightly smaller, nearly identical composition is in the Koninklijk Museum voor Schone Kunsten, Antwerp.

Teniers painted approximately one-quarter of his oeuvre on copper. His refined and detailed manner of painting was eminently suited to this smooth support, which – as shown by this painting – did not restrict him to small formats. The good condition and fresh colors of this *Temptation of Saint Anthony* are largely due to Teniers's use of copper as a support.

Provenance: Christiaan IV von Zweibrücken (1722–1775), Bischweiler/Herschweiler-Pettersheim, Rhineland-Pfalz, his estate sale, Paris (Rémy), April 6, 1778, no. 18 ("la composition de ce tableau est riche, ingénieuse & pittoresque; . . . David Teniers l'a fait dans son bon temps") (ffr. 676); M. Lapeyrière, receveur general des Contributions du département de la Seine, his sale, Paris (Henry/Lacoste), April 19, 1825, no. 156 ("ce Tableau est parfait sous double rapport de la touche et du coloris") (ffr. 8.750 to M. Lafitte, sold together with a set of the four seasons); M. Perigeau-Lafitte, Paris, by 1831; Jacques Lafitte, Paris, his sale, Paris (Paillet), December 15, 1834, no. 4 ("Nous ajouterons que les ouvrages de cette importance sont rares, leur mutation peu fréquente, et que l'occasion d'enrichir son cabinet serait peut-être pour un amateur un sujet de regrets, s'il ne se bâtait pas de la saisir") (ffr. 7,980 to Laneuville for England: "Laneuville pour l'Angleterre"); Prince Anatole Nicolaievich Demidoff (1812–1870), Gallery de San Donato, Florence, his sale, Paris (C. Pillet), April 18, 1868, no. 17 ("l'execution de ce tableau est fine et précieuse, tous les details sont d'une vérité inouie") (ffr. 16,500 to F. Petit); Anne Gould (1878–1961), later princess de Sagan, duchess de Talleyrand (formerly the countess de Castellane), New York; Charles Tyson Yerkes, Mendelssohn Hall, New York, his estate sale, New York (American Art Association), April 5–8, 1910, no. 166 ($3,500 to W. Bank); anonymous sale ("The Property of a European Collector"), New York (Christie's), May 18, 1995, no. 132; acquired from Emanuel Moatti, Paris, and Jack Kilgore, New York, in 1996.

Exhibitions: Phoenix Art Museum, Arizona, The Nelson-Atkins Museum of Art, Kansas City, and Mauritshuis, The Hague, *Copper as Canvas: Two Centuries of Masterpiece Paintings on Copper 1575–1775*, 1998–99.

Literature: Galichon 1868, pp. 406–407; Smith 1829–42, vol. 3, p. 392, no. 500 (as "painted with admirable spirit and freedom of hand"); *Catalogue from the Collection of Charles T. Yerkes* 1893, no. 62, ill.; *Exhibition of Paintings and Sculpture in the Collection of Charles T. Yerkes Esq., New York* 1904, vol. 1, cat. no. 98, ill.; *Anatole Demidoff, Prince of San Donato* 1994, p. 56; Vogel 1996, section C, p. 25, ill.; *Copper as Canvas* 1998–99, pp. 293–97, cat. no. 58.

Notes:
1. De Bie 1662, p. 334.
2. For example, Bosch's painting *The Temptation of Saint Anthony* (Museu Nacional, Lisbon) and Bruegel's drawing of the same subject (The Ashmolean Museum, Oxford).

ESAIAS VAN DE VELDE

AMSTERDAM 1587–1630 THE HAGUE

Esaias Hansz. van de Velde was baptized on May 17, 1587, in the Oude Kerk in Amsterdam. He was the son of the Antwerp-born painter Hans van de Velde (1552–1609), who, like so many inhabitants of the Southern Netherlands, immigrated to Amsterdam shortly after 1585 to escape religious persecution. After the death of his father in 1609, Esaias moved with his mother and two sisters to Haarlem, where they took up residence in a house on the Oude Gracht. On August 26, 1609, Esaias is first recorded in Haarlem – "painter of Amsterdam and citizen of Haarlem" ("schilder van Aemstelredamme ende poorter van Haarlem") – acting as the witness to a marriage. In 1610, he became a member of the Reformed Church in Haarlem, and in April 1611 he married Cathelijne Jansdr. Martens of Ghent.

Esaias received his first painting lessons from his father. No work by Hans van de Velde is known, however, so the extent of his influence is impossible to assess. Esaias was probably apprenticed to the Flemish emigrant Gillis van Coninxloo (1544–1606), after whose death he possibly continued his training with another Flemish artist, David Vinckboons (1576–ca. 1632). Esaias van de Velde became a member of Haarlem's Guild of St. Luke in 1612, the year in which Hercules Seghers (1589/90–1633/38) and Willem Buytewech (1591/92–1624) also registered with the guild. The following year, they were joined by Jan van de Velde (ca. 1593–1641), Esaias's cousin, and Pieter de Molijn (1595–1661). This concentration of talented painters and draftsmen must have acted as a great stimulus to them all; it certainly led to spectacular innovations among landscapists and genre painters alike.

In 1618, Van de Velde became a member of the Haarlem rhetoricians' chamber *De Wijngaardranken* (The Branches of the Vine). In April of that year, he moved with his mother and two unmarried sisters from the Begijnhof in Haarlem to The Hague, where he immediately became a member of the guild and on April 17, 1620, acquired citizenship. Esaias van de Velde died in 1630 at only forty-three years of age and was buried on November 30 in the Grote or St. Jacobskerk in The Hague.

An exceptionally versatile and productive artist, Van de Velde played an important role in the development of Dutch landscape painting and drawing. In addition to landscapes, he painted and drew genre and battle scenes, and also made some forty etchings. In Haarlem, he was the teacher of Jan van Goyen and Pieter de Neyn (1597–1639).

Literature: Keyes 1984.

CATALOGUE 60

AN ELEGANT COMPANY IN A GARDEN

AN ELEGANTLY ATTIRED PARTY of young people has gathered in the open air to listen to music, partake of a sumptuous banquet, and enjoy each other's company. The finely built wall on the left, the fountain, and the view to a formal garden suggest the close proximity of a grand country house. Under a canopy suspended between two trees appear a table laden with delicacies and a makeshift sideboard decked with splendid dinnerware. The participants pause between courses: one couple remains seated, while the other two have left the table to carry on their animated conversation. A trio of musicians entertains the company, while a serving boy in the left foreground prepares a plate of oysters, and stylishly dressed waiters serve drinks from a magnificent wine cooler. The young people are colorfully dressed in the latest fashions, wearing extravagantly wide ruffs, lace collars, and tall hats embellished with ribbons and feathers. A festive mood prevails. Although Esaias van de Velde is best remembered as the most innovative Dutch landscapist of his generation, he also produced a small series of paintings of outdoor parties (*buitenpartijen*). His al fresco scenes of merry companies – which number no more than a dozen examples and occupied him for about ten years, starting in 1614 – constitute one of the most important contributions to the development of this popular genre. Its other principal practitioners were David Vinckboons in Amsterdam and Willem Buytewech and Dirck Hals in Haarlem. This particular painting was probably inspired by *Banquet in a Park*, formerly in the Kaiser Friedrichmuseum, Berlin. Untraceable since the Second World War, this painting – generally considered a very early work by Frans Hals of around 1610 – likewise shows an elegant party enjoying a banquet in the open air. The most striking similarity is the canopy suspended between two trees.

This beautifully preserved canvas – which, unusually for a seventeenth-century painting, has never been relined – is one of two depictions of this subject painted by Van de Velde in 1614, the first year in which dated works of his appear. The other painting, *A Garden Party before a Palace*, is in the Mauritshuis, The Hague. The artist's immediate inspiration for such scenes appears to have been the *fêtes champêtres* by David Vinckboons, who was most likely one of Van de Velde's teachers. A possible example is Vinckboons's *Banquet in the Open Air* of about 1610 (Rijksmuseum, Amsterdam), which shows elegantly attired figures making music, feasting, and courting on the grounds of a palace. Vinckboons's painting, in turn, derives its iconography from such pictorial traditions as the medieval Garden of Love and moralizing depictions of the Prodigal Son. Significantly, Vinckboons himself illustrated the parable in 1608 in a series of drawings preserved in the British Museum, London. In one of these drawings, an elegant company, similar in many

CATALOGUE 60. *An Elegant Company in a Garden*, 1614. Oil on canvas, 20 1/2 × 33 3/4 inches (52 × 85.6 cm). Signed and dated lower left: *E. VANDEN. VELDE. | 1614*

respects to the one seen here, indulges in food, drink, music, and dance beneath a leafy arbor, while in the background, the penniless wastrel who squandered his inheritance is thrown out of a tavern. Likewise, in the foreground of Vinckboons's painting in the Rijksmuseum, a drunken reveler collapses in the arms of his lover, recalling the Prodigal Son as depicted in a drawing (Albertina, Vienna) by Hans Bol, another Flemish artist who immigrated to the North and settled in Amsterdam. Further warnings of the consequences of indecorous behavior and a love of gambling and extravagance are provided by the playing cards strewn on the ground, while the bones that have fallen from the table symbolize life's transience.

Although *An Elegant Company in a Garden* draws upon established pictorial traditions, the painting marks a new approach to the subject matter, a shift of emphasis, and an updating of the theme. None of the young men in this painting wears the gold chain associated with the Prodigal Son, nor is there evidence of such wanton activities as gambling and whoring. Instead, the artist stresses the courtly elegance of the protagonists, their fashionable clothing, the sumptuous meal, and the costly tableware. The focus is on their amusements and amorous adventures: the tone is light-hearted and love is in the air. In this portrayal of the *jeunesse doré* of his own day, Van de Velde has captured the carefree mood of a generation growing up in the hard-won peace and prosperity of the Dutch Republic. The picture is not completely without moralizing overtones, however. Warnings of the consequences of overindulgence in sensual pleasures are symbolized by the aphrodisiacal plate of oysters, the empty shells and bones that litter the ground, and the capacious wine cooler garnished with vine leaves, which betokens the temptations of alcohol. Another obvious symbol is the splendid peacock pie, traditionally associated with the vices of pride and lust. Such references, however, are no longer central to the theme, but serve as reminders of the excesses that result if undue homage is paid to Venus and Bacchus.

Provenance: Hans Wetzlar, Amsterdam; Gustaaf and Clara Hamburger, Laren, N. H.; Dr. Mühlmann, The Hague (according to a label on the verso); Hermann Göring, Karinhall; recovered by the Allied Forces, Unterstein, August 1945 (Central Collection Point, Munich, no. 5817); Stichting Nederlands Kunstbezit, no. G. 114; restituted by the above, and thence by descent to the descendants of the Hamburger family, by whom sold, New York (Christie's), April 15, 2008, no. 24 (sold for $2,953,000); acquired from Johnny Van Haeften Ltd., London, in 2008.

Literature: Keyes 1984, p. 137, no. 69, ill. pl. 133 (as location unknown); Briels 1987, pp. 99–101, ill. p. 100, fig. 105; Kolfin 2005, p.106, ill. p. 122, fig. 84.

WILLEM VAN DE VELDE THE ELDER

LEIDEN 1611–1693 LONDON

Willem van de Velde came from a family with close connections to the shipping trade. Born in 1611 in Leiden, he was the son of a Flemish ship captain and the brother of a ship master. At a young age, he accompanied his father on a number of voyages. Little is known about his youth and training. Perhaps Willem was originally intended for a maritime career, as Houbraken suggested, and only later decided to become an artist.[1] In 1631, in Leiden, he married Judicgen Adriaensdr. van Leeuwen. In 1632, their first child, a daughter, was born, followed in December 1633 by their first son, who later became the painter Willem van de Velde the Younger. In the mid-1630s, the family settled in Amsterdam, where their second son, the later landscape painter Adriaen van de Velde, was born on November 39, 1636. In 1652, Van de Velde the Elder was living on the "Nieuwe Waelseijlant" near the IJ river, and in 1657 he appears to have been living on "Korte Conincxstraat." Various archival sources reveal that he was accused of adultery on a number of occasions and that he fathered several illegitimate children. From 1653 onward, he was frequently present at naval battles and went along on important expeditions of the Dutch fleet, which enabled him to record the various stages of battles in hundreds of rapidly executed drawings, which he subsequently used as models for his pen paintings. Later on, Willem van de Velde the Younger would also use these drawings as the basis for paintings. In 1672 – the "year of disaster"

CATALOGUE 61. *The* Brederode *off Vlieland*, ca. 1645. Pen painting on panel, 9 3/4 × 12 3/4 inches (24.7 × 32.5 cm). Signed lower right: *W. V. Velde*; inscribed on the wing transom above the two gunports: *BRE DE RO DE*

in which the Dutch Republic was invaded by France and drawn into a war with England – both father and son moved to England. At first, they worked mainly for King Charles II and his brother, the duke of York, who were both extremely interested in ships and navigation. Starting in 1674, the Van de Veldes each received an annual salary of one hundred pounds from the king, as well as the proceeds from the sale of their paintings. Willem van de Velde the Elder was also commissioned to make tapestry designs. After the death of Charles II, Van de Velde the Elder was employed by the late king's brother, James II. In 1691, the Van de Veldes moved to Westminster in London. Willem van de Velde the Elder died there in December 1693 and was buried in St. James's Church, Piccadilly.

Willem van de Velde left an exceptionally large oeuvre consisting of pen and wash drawings and pen paintings that offer a unique overview of Dutch and English ships and the sea battles that took place in the second half of the seventeenth century. His earliest dated work is a drawing from 1638; he continued to draw and paint until a very old age.

Literature: Baard 1942; M. S. Robinson 1990.

CATALOGUE 61

THE BREDERODE OFF VLIELAND

ON JUNE 9, 1645, a merchant fleet of approximately three hundred ships, headed for the Baltic, set sail from the island of Vlieland in the north of Holland. This impressive fleet was accompanied by forty-seven warships intended to protect the trade ships from privateers, and also from Swedish and Danish warships. This Dutch fleet was under the command of Admiral Witte de With on his flagship, *Brederode*. The *Brederode*, one of the largest Dutch warships of its day, had only recently been launched from the admiralty's dockyard in Rotterdam. It was armed with no fewer than fifty-nine cannon. In a letter written that same year to the States-General in The Hague, De With said that his flagship "was still a virgin" ("daer de maeghtdom noch aen is"). It may be assumed that the present painting records the moment just before the ships set sail for Scandinavia. On the right, we see the *Brederode* with the arms of *Stadholder* Frederik Hendrik, borne by two lions, in the escutcheon on the stern. Slightly below this is the name of the ship. The flag flying on the main mast indicates that the admiral is on board, while the flag (which is probably blue) above the stern is the signal to weigh anchor. The ship to the left of the *Brederode* is the *Huis van Nassau*, the flagship of Vice-Admiral Joris van Cats. Visible at the far left is the shore of Vlieland with its large beacon. Various people watch the departure of the fleet. A sloop makes its way to the flagship. Barely discernible at the far right on the horizon is the island of Terschelling with the Brandaris lighthouse.

Van de Velde was present when the fleet set sail from the Vlierede, as emerges from a series of drawings in which he documented the event. He used these sheets for a number of pen paintings, including this panel. Of particular importance in this context is a sheet in the Museum Boijmans Van Beunigen in Rotterdam.[2] This large drawing, executed in Van de Velde's characteristically fluent style, shows not only the large lighthouse that closes off this composition on the right, but also the numerous ships setting sail in the middle and on the right.

This pen painting probably originated shortly after the fleet's departure, as evidenced by its small format and the fact that no brush was used to lay in the shadows. Over the years, Van de Velde came increasingly to prefer large formats. He subsequently depicted this event in several much larger pen paintings, now in the Stedelijk Museum De Lakenhal in Leiden and the National

Maritime Museum in Greenwich. There is an especially close resemblance between the present panel and the painting in Leiden. In the latter painting, too, the composition is framed on the left by the beacon and on the right by the departing *Brederode*. The foreground of that painting features a sailing vessel, however, whereas the foreground in the present painting is relatively empty, which serves to focus all attention on the *Brederode*.

Provenance: Private collection, Noordwijk; with Rob Kattenburg, Amsterdam, 1988; private collection, Switzerland; private collection, London; acquired from Rafael Valls, London, in 2007.

Literature: Kattenburg 1988; M. S. Robinson 1990, vol. I, pp. 44, 45, cat. no. 817.

Notes:
1. Houbraken 1718–21, vol. 1, p. 354.
2. See R. E. J. Weber 1976, pp. 115–31.

WILLEM VAN DE VELDE THE YOUNGER

LEIDEN 1633–1707 LONDON

Willem van de Velde was baptized in the Hooglandse Kerk in Leiden on December 18, 1633. He was the son of the marine painter Willem van de Velde the Elder. Not long after his birth, the family moved to Amsterdam, where Willem's brother Adriaen (1636–1672) – who was to become a successful landscape painter – was born three years later. The two brothers received their first artistic training in their father's studio in Amsterdam, on the "Nieuwe Waelseijlant" near the IJ river. According to Houbraken, Willem the Younger spent some time as the pupil of his Amsterdam neighbor Simon de Vlieger.[1] In 1649, when De Vlieger moved from Amsterdam to Weesp, Willem van de Velde the Younger probably followed him, for it was there, on March 23, 1652, that he married Pieternelle Le Maire. It was not a happy marriage, however, and the couple divorced the following year. Willem returned to Amsterdam, where he married Magdaleentje Walravens on December 23, 1656. The couple had four children, of whom the last, remarkably enough, was baptized in the Catholic Church. Willem continued to assist his father in his Amsterdam studio, which experienced its heyday between the outbreak of the First Anglo-Dutch War in 1652 and the winter of 1672, the "year of disaster" for the Dutch Republic. In that period, Willem van de Velde the Elder was often under way with the fleet and produced, even during naval action, countless on-the-spot sketches, which served as the basis for his famous pen paintings and also for his son's seascapes. Although documentation is lacking, we may assume, on the basis of various sketches, that the son sometimes accompanied his father. This was certainly the case during the Four-Day Battle between the Dutch and English fleets in 1666.

Willem van de Velde the Younger soon surpassed his father and developed into the most successful Dutch marine painter of the seventeenth century. Nevertheless, from the early years, starting in 1654, there is only one work that bears his signature, and most of the paintings still display the studio signature *WVV* or *W.V.Velde*, written in characteristically angular letters.

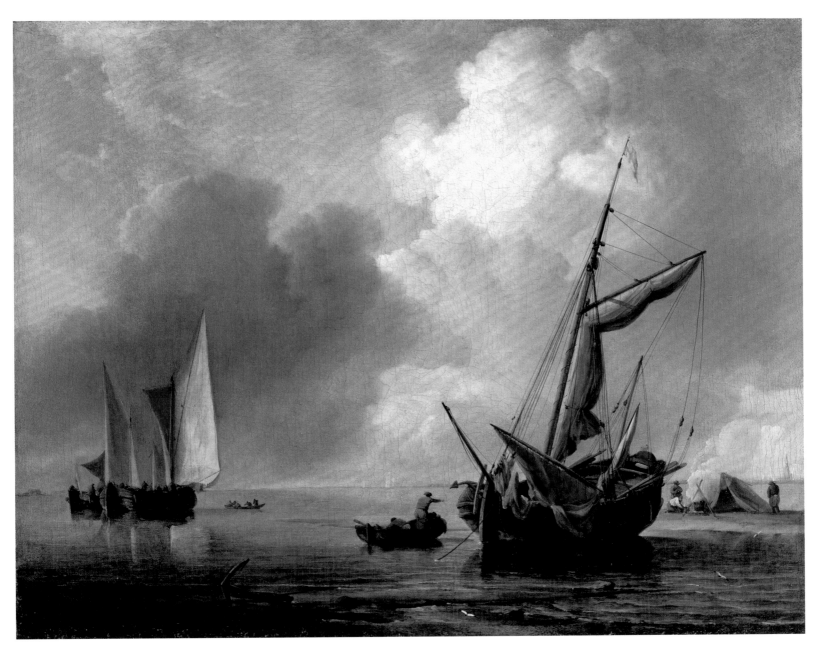

CATALOGUE 62. *Fishing Boats by the Shore in a Calm*, ca. 1660–65.
Oil on canvas, 11 7/8 × 14 3/4 inches (30.1 × 37.4 cm).

In the winter of the disastrous year 1672, both father and son left for England, where it took them only a few years to achieve unparalleled success. Charles II and his brother the duke of York, later James II, gave them each an annual allowance of one hundred pounds and put a house in Greenwich at their disposal. They produced hundreds of drawings that document ships, naval battles, and other maritime events. The division of labor in the studio was roughly the same as it had been in Amsterdam: the father mainly produced pen paintings and his son painted other seascapes, while they both supervised the studio assistants.

In 1691, the Van de Veldes settled in London, where Van de Velde the Elder died two years later. On April 6, 1707, Willem van de Velde the Younger died there as well, and was buried next to his father in St. James's Church, Piccadilly.

Willem van de Velde the Younger was, along with Jan van de Cappelle, the most important representative of the "classical" phase of seventeenth-century Dutch marine painting. He had a remarkably lively and refined manner of painting, in which he succeeded superbly in combining an abundance of detail with freer atmospheric effects, so that ships, sea, and light always combine to form a convincing whole. Of the hundreds of known drawings by Willem van de Velde the Younger, many display exceptional virtuosity.

Literature: Hofstede de Groot 1907–28, vol. 7, pp. 1–73; Baard 1942; M. S. Robinson 1990.

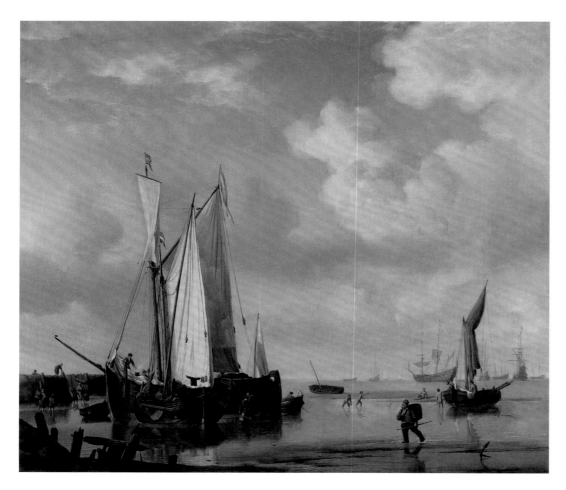

Figure 1. Willem van de Velde the Younger, *Dutch Vessels Close Inshore at Low Tide and Men Bathing*, 1661. Oil on canvas, 24 7/8 × 28 3/8 inches (63.2 × 72.2 cm). National Gallery, London.

CATALOGUE 62

*FISHING BOATS BY THE
SHORE IN A CALM*

IN NEARLY WINDLESS WEATHER, a fishing boat, probably a flat-bottomed *kaag* (a type of
cargo vessel often used as a ferry or a lighter), lies at low tide on a sandbar or tongue of land.
One anchor lies in the left foreground, its cable partly concealed by water; the other dangles from
the railing. The boat seems to be stranded, but presumably the captain has let it run aground on
purpose, which was customary with flat-bottomed boats and other small vessels. The white banner
with the red cross of St. George at the top of the mast seems to mark this as an English boat. In the
right foreground, the white wings of three sea gulls stand out against the dark, rippling water.
On the right, behind the boat, two figures by a fire busy themselves with a large cooking pot, from
which rise clouds of smoke. Farther to the right, a third figure stands next to a simple tent that
has been set up. On the other side of the fishing boat, a rowboat with two men in it moors at the
sandbar. At the far left in the middle distance, some sailboats float – the left-most flies the
Dutch flag – and a rowboat plies the water. On the horizon we see, from left to right, what seem to
be fortifications of some kind, several sailboats, and, at the far right, a tower rising above a city
and several boats in front of it. More than two-thirds of the canvas is taken up by a bright blue sky
with white and dark-colored clouds.

 During the first ten years of his career, Van de Velde painted mainly seascapes displaying calm
weather conditions, as seen in this canvas, which exudes a feeling of peace and serenity. As this
painting clearly shows, the artist had an inimitable feeling for harmonious compositions in which
form and color are completely in balance. The dark-colored *kaag* in the foreground contrasts
with the much lighter sandbar on which it lies, while the mast and the furled sails stand out against
the white and light gray clouds. Otherwise, it is mainly the white sails of the small boats on the
left – reflected in the dark water – that contrast nicely with the threatening clouds on the left. The
two groups are compositionally linked by the subtly rendered horizon and the water extending
across the entire foreground.

 In terms of both atmosphere and compositional type, the painting bears a strong resemblance
to *Dutch Vessels Close Inshore at Low Tide and Men Bathing*, dated 1661 (figure 1). The present
canvas probably originated at about the same time, that is to say, in the first half of the 1660s, when
Willem van de Velde was at the height of his artistic powers.

Provenance: Mr. Lensgreve Holstein-Holsteinborg, Denmark, by 1891; their sale (various owners), Amsterdam
(Mensing/F. Muller), June 20, 1928, no. 51; with N. Beets, Amsterdam; P. Smidt van Gelder, by 1929; with
D. A. Hoogendijk, Amsterdam; anonymous sale (various owners), Amsterdam (F. Muller), November 20–23, 1951,
lot 125 (sold for dfl. 9,200); Sidney J. van den Bergh, Wassenaar, by 1959; with J. R. Bier, Haarlem, by 1960;
thence by descent to Drs. I. Bier, Bloemendaal; J. H. Gispen, Nijmegen, by 1963; thence by descent to Mrs. B.
Gispen-van Eijnsbergen, Nijmegen, by 1964 until after 1990; with Newhouse Galleries, New York; Charles C.
Cunningham, Boston; acquired in 2004.

Exhibitions: Kunstforeningen, Copenhagen, *Fortegnelse over billeder af gammel kunst*, 1891–1892; Royal Academy
of Arts, London, *Exhibition of Dutch Art 1450–1900*, 1929; Singer Museum, Laren, N. H., *Kunstschatten: Twee
Nederlandse Collecties Schilderijen uit de Vijftiende tot en met de Zeventiende eeuw en een Collectie Oud Aardewerk* 1959;
Kunsthandel J. R. Bier, Haarlem, *Tentoonstelling van Hollandse 17e Eeuwse Meesters*, 1960; De Waag, Nijmegen,
Kunst uit Nijmeegs Particulier Bezit, 1963; Dordrechts Museum, Dordrecht, *Zee-, Rivier- en Oevergezichten*, 1964;
Museum of Fine Arts, Boston, *Prized Possessions: European Paintings from Private Collections of Friends of the
Museum of Fine Arts*, 1992; Museum of Fine Arts, Boston, *Poetry of Everyday Life: Dutch Painting in Boston*, 2002.

Literature: *Fortegnelse over billeder af gammel kunst* 1891–92, p. 56, no. 220; Hofstede de Groot 1907–28, vol. 7,
p. 89, no. 323; *Dutch Art 1450–1900* 1929, p. 138, no. 291; *Kunstschatten: Twee Nederlandse Collecties Schilderijen uit de
Vijftiende tot en met de Zeventiende eeuw en een Collectie Oud Aardewerk* 1959, cat. no. 84, ill. fig. 45; *Tentoonstelling
van Hollandse 17e Eeuwse Meesters* 1960, p. 14, cat. no. 26, ill.; *Kunst uit Nijmeegs Particulier Bezit* 1963, p. 17, no. 34;
Zee- Rivier- en Oevergezichten 1964, p. 32, cat. no. 86, ill. pl. 101; M. S. Robinson 1990, vol. 2, p. 713, cat. no. 440;
Prized Possessions 1992, cat. no. 150, ill. no. 45; *Poetry of Everyday Life* 2002, p. 101, ill.

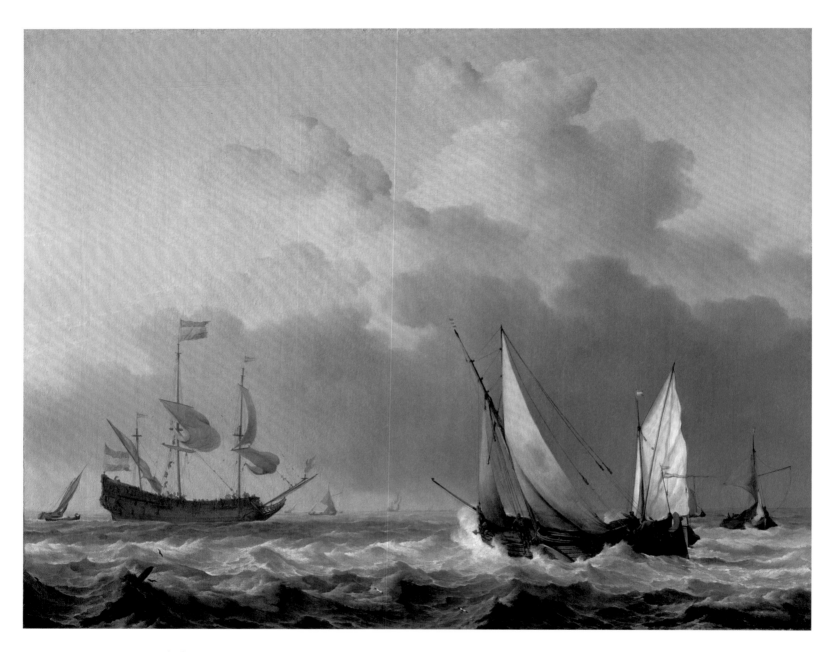

CATALOGUE 63. *A Wijdschip in a Fresh Breeze*, ca. 1665–70. Oil on canvas, 21 × 26 5/8 inches (53.3 × 67.7 cm). Signed with initials on a piece of driftwood on the left: *W.V.V.*

CATALOGUE 63

A WIJDSCHIP IN A
FRESH BREEZE

IN ADDITION TO PAINTING windless seascapes, in which ships are reflected in placid water, Willem van de Velde the Younger excelled at marines with less calm conditions or even stormy seas. They represent a smaller portion of his work than the so-called "calms," but are nonetheless important. His earliest dated painting – made in 1651, when he was probably still working with Simon de Vlieger – depicts a Dutch freighter in a storm (National Maritime Museum, Greenwich). He subsequently painted numerous seascapes featuring ships in storms or rough seas, as is the case here. This and other related paintings clearly show that Van de Velde was highly skilled at rendering ships sailing in a strong wind. In the foreground, a *wijdschip* (literally a "wide ship") sails sharply into the wind in the foaming water. Three men have their hands full trying to keep the ship on course. The *wijdschip* was used on inland waters, mainly the Zuiderzee and the waterways of Holland and Zeeland. To the right of and behind the *wijdschip* is another small ship, probably a *kaag* – also much used on inland waterways – and another such ship is visible at the far right. On the left in the middle distance is a warship with its sails partly lowered and Dutch flags proudly flying at the top. Various crew members climb the rigging. Several small ships sail in the distance. On the right, dark clouds gather on the horizon, above which lighter clouds stand out against a blue sky. Sunlight breaks through the clouds here and there, producing alternating patches of light and dark: in the foreground is a dark strip of water, behind it a lighter strip, then another dark strip. The sails of the *wijdschip* and the *kaag* catch the sunlight, providing bright accents against the gray clouds.

From the very beginning, this type of composition was extremely popular, particularly among British collectors. In the nineteenth century, this painting belonged to Samuel Woodburn (ca. 1780/85–1853), a leading publisher and print seller. He was responsible for amassing the splendid collection of Old Master drawings owned by the painter Sir Thomas Lawrence (1769–1830). When the art dealer John Smith saw the painting, around 1835, he described it in glowing terms: "an example of the rarest excellence, both as regards the general effect, as well as the detail; the latter of which, for delicacy of penciling, has in no instance been exceeded."[2]

Provenance: Probably Edward Knight (d. 1812), Wolverley House, near Kidderminster, by whom bequeathed to his nephew John Knight, Esq., Portland Place, London, his sale, London (Phillips), March 23–24, 1819, no. 39 ("Vandevelde, A Sea Piece") (535 gns. to S. Woodburn); with Samuel Woodburn (ca. 1780/85–1853), London; Jeremiah Harman (ca. 1764–1844), 18 Finsbury Square, London; Michael Zachary (d. 1837), The Adelphi Terrace, London, from whom acquired between 1824 and 1837 by Frederick Perkins, London (with its companion piece "Calm"), and thence by descent to George Perkins, Chipstead (Kent), by 1863, his estate sale, London (Christie, Manson & Woods), June 14, 1890, no. 28 ("Mer houleuse . . . Très beau tableau, d'une tonalité argentine, et de la plus haute qualité du maitre . . .") (997,10 gns. to Jeffery); George Perkins, Chipstead (Kent), his estate sale, Paris (Chevallier/Petit), June 3, 1893, no. 16; with Steinmeyer, Cologne, ca. 1895, from whom acquired by the great grandfather of the previous owners, G. Martius, Kiel, by 1923 until after 1954, thence by descent, by whom sold, London (Christie's), December 13, 2000, no. 33; acquired from Johnny Van Haeften Ltd., London, in 2000.

Exhibitions: British Institution, London, *Exhibition of Pictures by Italian, Spanish, Flemish, Dutch, and English Masters,* 1832; British Institution, London, *Exhibition of Pictures by Italian, Spanish, Flemish, Dutch, and French Masters,* 1836; British Institution, London, *Exhibition of Pictures by Italian, Spanish, Flemish, Dutch, French and English Masters,* 1863; Museum of Fine Arts, Boston, *Poetry of Everyday Life: Dutch Painting in Boston,* 2002.

Literature: Smith 1829–42, pp. 347–48, no. 104; *Exhibition of Pictures by Italian, Spanish, Flemish, Dutch, and English Masters* 1832, p. 11, cat. no. 6; *Exhibition of Pictures by Italian, Spanish, Flemish, Dutch, and French Masters,* 1837, p. 9, cat. no. 45 (as "A Gale, with Fishing-Boats – Man-of-War in the Distance"); *Exhibition of Pictures by Italian, Spanish, Flemish, Dutch, French, and English Masters* 1863, p. 8, cat. no. 15; Graves 1921B, vol. 3, p. 277; Hofstede de Groot 1907–28, vol. 7, pp. 120–21, no. 479; M. S. Robinson 1990, pp. 892–93, cat. no. 725, ill. p. 892; *Poetry of Everyday Life* 2002, p. 101, ill.

Notes:
1. Houbraken 1718–21, vol. 2, p. 325.
2. Smith 1829–42, vol. 6, pp. 347–48, no. 104.

SIMON DE VLIEGER

ROTTERDAM? 1600/1601–1653 WEESP

There is some uncertainty as to Simon Jacobsz. de Vlieger's year of birth. A notarial act of May 16, 1648, records his age as approximately forty-seven, which puts his birth in about 1601. His place of birth is also uncertain, but it is generally assumed that he was born in Rotterdam. In any case, his residence in that city is documented from the time of his marriage to Anna Gerridts van Willige on January 10, 1627, until 1633. In February 1634, De Vlieger rented a house in the nearby town of Delft, where, on October 18 of that year, he became a member of the Guild of St. Luke. In December 1637, he bought a house in Rotterdam from the painter Crijn Volmarijn (ca. 1601–1645), part of which was to be paid in paintings, which De Vlieger had yet to make. On March 1, 1638, he was still living in Delft, but on July 19 of that year he appears to have moved to Amsterdam, where he was granted citizenship on January 5, 1643.

In Amsterdam, De Vlieger's artistic talents blossomed. He lived next door to the marine painters Willem van de Velde the Elder and his son, Willem van de Velde the Younger. On January 13, 1649, De Vlieger bought a house in Weesp, a small town to the southeast of Amsterdam, where he died in March 1653.

De Vlieger, a versatile and successful artist, is considered one of the leading marine painters of his day. He was, moreover, one of the few Dutch artists of the seventeenth century whose artistic

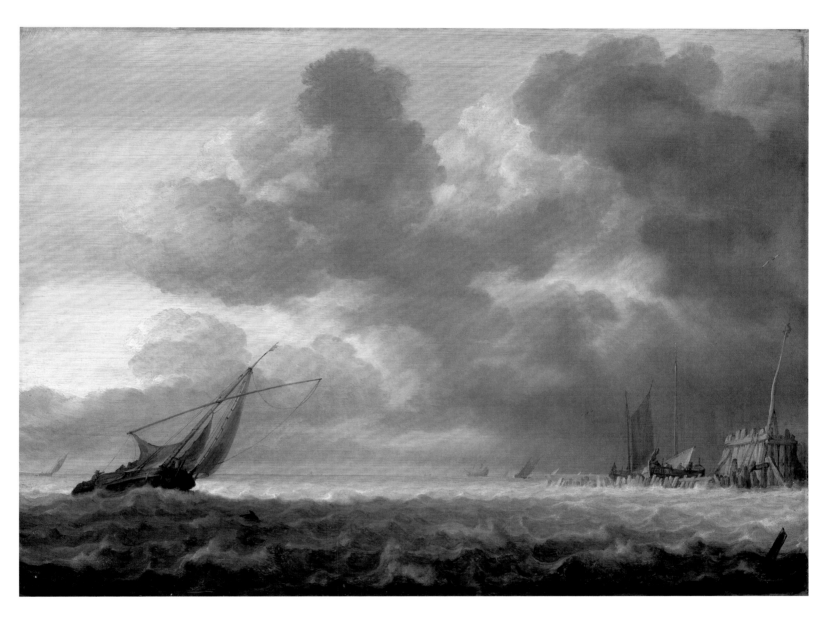

CATALOGUE 64. *Sailing Ships in a Gale*, ca. 1645–50. Oil on panel, 18 × 24 5/8 inches
(45.6 × 61.8 cm). Signed on the spar lower right: *S. Vlieger.*

activities made him a wealthy man. His oeuvre consists largely of seascapes and beach scenes, but he painted a number of landscapes as well. He also received several honorable commissions of an entirely different nature: in 1642, for example, he was asked to paint the shutters of the organ in the Grote or St. Laurenskerk in Rotterdam, for which he was paid, in January 1645, the considerable sum of two thousand guilders. In 1648, he was given the prestigious commission to design several stained-glass windows for the Nieuwe Kerk in Amsterdam, for which he received six thousand guilders. His drawings consist mostly of landscapes, which are generally just as atmospheric as his painted seascapes.

His early work – mostly dramatically rendered marine paintings and shipwrecks with towering waves – initially reveals the influence of Hendrick Cornelisz. Vroom (1566–1640), and later mainly that of Jan Porcellis. Gradually, the work of Simon de Vlieger took on a calmer and more measured character. It was particularly the balanced compositions and remarkable silver-gray tonality of his later work, made between about 1650 and 1653, that influenced the work of Willem van de Velde the Younger, Jan van de Cappelle, and Hendrick Jacobsz. Dubbels (1620/21–1707).

According to Houbraken, Van de Velde the Younger spent some time as De Vlieger's pupil.[1] After De Vlieger's death in 1653, nine of his paintings and more than one thousand of his drawings came into the possession of the Amsterdam painter and collector Van de Cappelle, whose work was clearly influenced by De Vlieger.

Literature: Kelch 1971.

CATALOGUE 64

SAILING SHIPS IN A GALE

UNLIKE HIS SUPPOSED PUPIL Willem van de Velde the Younger, Simon de Vlieger was more interested in depicting various aspects of sea and beach than in portraying ships. The present picture, datable to the late 1640s, is an impressive example of the artist's skill at depicting choppy seas and ships struggling with the elements. Although it is uncertain with whom he studied, De Vlieger must have drawn inspiration from similar scenes by Jan Porcellis, who was instrumental in reforming Dutch seascape painting in the 1620s. Porcellis had developed a new type of marine painting of remarkable simplicity, its main features being a low horizon and towering skies, with the emphasis on the atmosphere, all rendered in gray tonalities. Most of these characteristics are also present in De Vlieger's *Sailing Ships in a Gale*, but the color scheme is less monochromatic. Moreover, De Vlieger's technique, demonstrated by clouds beautifully painted "wet-in-wet," is more refined. The strong contrasts – the light and dark bands of water, for example, and the dark clouds alternating with streaks of light in the sky – add considerably to the dramatic effect.

The present seascape bears a strong similarity to Porcellis's *Seascape with Fishing Boats* in the Ashmolean Museum, Oxford. Both paintings show, on the left, a single-masted ship in a stormy sea. De Vlieger, however, added a jetty with a beacon on the right. While the vessel in the foreground struggles to reach the safety of the pier, other boats have already moored.

The subject of a stormy sea with a sailboat guided by a beacon also features in an emblem with an enlightening motto in Jacob Cats's *Proteus ofte Minne-beelden Verandert in Sinne-beelden, Emblemata Moralia et Aeconomica*, published in Rotterdam in 1627.[2] However, it seems unlikely that De Vlieger had a moralizing message in mind when he painted the present seascape. The beacon motif figures prominently in several seventeenth-century Dutch paintings, and Jacob van Ruisdael even made it the main subject of a large canvas (Kimbell Art Museum, Fort Worth).[3]

Provenance: Possibly the painter Sir Peter Lely (1618–1680), his estate sale, London (Covent Garden), April 28, 1682 (possibly one of the seven "Dankers – landskips" [Van Diest]; see "Editorial: Sir Peter Lely's Collection," *Burlington Magazine* 83, 485 [August 1943], pp. 185–91, esp. p. 187 n. 46); Sir John Griffin (1719–1797), later the first baron Braybrooke (1788), Audley End, Essex, and thence by descent to the Honorable Robin N. C. Neville, Audley End, Essex; with Thomas Agnew & Son Ltd., London, 1980–81; Mr. and Mrs. Michael Hornstein, Montreal, by 1981; anonymous sale ("Property of a Private Collector"), New York (Sotheby's), January 30, 1998, no. 32; with Noortman Master Paintings, London, by 1998, where acquired in 1999.

Exhibitions: Thomas Agnew & Son, London, *Old Master Paintings and Drawings; Autumn Exhibition*, 1980; Minneapolis Institute of Arts, Toledo Museum of Art, Ohio, and Los Angeles County Museum of Art, *Mirror of Empire, Dutch Marine Art of the Seventeenth Century*, 1990–91; Museum of Fine Arts, Boston, *Poetry of Everyday Life: Dutch Painting in Boston*, 2002.

Literature: "Inventory of Audley End," unpublished manuscript, 1797; Walker 1964, p. 20, cat. no. 32 (Drawing Room no. 113 in the 1948 Inventory); *Old Master Paintings and Drawings* 1980, cat. no. 1, ill. p. 4; *Mirror of Empire* 1990–91, pp. 189–91, cat. no. 47; *Poetry of Everyday Life* 2002, p. 98, ill.

Notes:
1. Houbraken 1718–21, vol. 2, p. 325.
2. On pp. 26–27: *Luceat lux vestia hominibus* (Let Your light shine on behalf of mankind).
3. Slive 2001, cat. no. 644.

JAN BAPTIST WEENIX

AMSTERDAM 1620–1659 HUIS TER MEY NEAR VLEUTEN

Jan Baptist Weenix was born in Amsterdam in 1620[1]; he was the son of the architect Johannes Weenix and Grietgen Heeremans. His sister Lijsbeth married the painter Barent Micker (1615–1687), whose brother, Jan Micker (1598/99–1664), was Weenix's first teacher. Weenix subsequently studied with the Utrecht painter Abraham Bloemaert (1564–1651), and completed his training in the Amsterdam studio of Claes Moeyaert. In 1639, Weenix married Josina de Hondecouter, daughter of the landscape painter Gillis Claesz. de Hondecouter (ca. 1570–1638) and sister of the painter Gijsbert Gillisz. de Hondecouter (1604–1653). Weenix had two sons, one of whom, Jan (1642–1719), became a well-known painter of still lifes and landscapes. On October 30, 1642, he made his will before traveling to Italy "to experiment with his art." Weenix lived in Italy from 1643 to 1647. In Rome, he joined the *Bentvueghels* (Birds of a Feather), a society of Netherlandish artists, who gave him the nickname *Ratel* (Rattle) because of his speech defect. Around 1645, he probably entered the service of Cardinal Camillo Pamphili. By June 1647, Weenix was back in Amsterdam, and by 1649 he had settled in Utrecht, where he and Jan Both were elected officers of the local painters' guild. In 1657, Weenix moved to Huis ter Mey, a small castle that no longer exists, some ten miles from Utrecht. There he died in 1659, at the age of only thirty-nine.

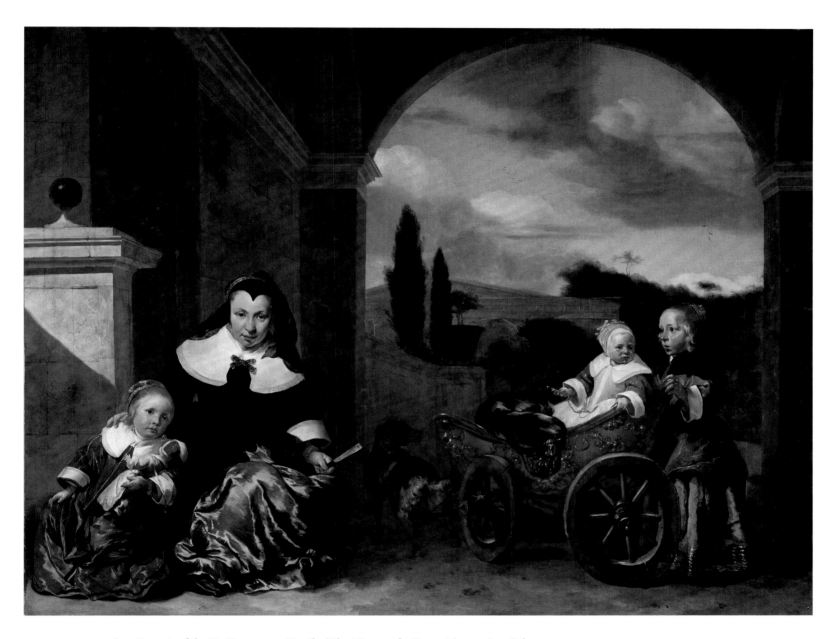

CATALOGUE 65. *Portrait of the De Kempenaer Family (The Margaretha Portrait)*, ca. 1653. Oil on canvas, 36 3/4 × 47 3/4 inches (93.3 × 121.3 cm). Signed on balustrade at the left edge: *Gio: Batta· /Weenix fe*

Together with Nicolaes Berchem and Jan Both, Weenix was one of the more influential of
the second generation of Dutch Italianate painters of the seventeenth century. His exceptional ver-
satility is demonstrated by his paintings and drawings of history subjects, Mediterranean seaports,
landscapes (both Dutch and Italianate), genre scenes, still lifes with dead game, and both individual
and group portraits. Moreover, he is generally considered the best colorist among the Dutch
Italianate painters. After returning from Italy, he invariably signed his name Gio[vanni] Batt[ist]a
Weenix, whereas before he had spelled his name J[ohannes] Weenincx or Weenincks. The addition
of Battista might have been a reference to Cardinal Giovanni Battista Pamphili (who became
Pope Innocent X in 1644), from whom he received at least one commission. Owing in part to his
premature death, his painted oeuvre is relatively small, but he also left us a group of largely
Italianate landscape drawings and a small number of figure drawings on blue paper.

Literature: Stechow 1948, pp. 181–98; Ginnings 1970; *Dutch 17th Century Italianate Landscape Painters* 1978, pp.
174–84.

CATALOGUE 65

*PORTRAIT OF THE
DE KEMPENAER FAMILY
(THE MARGARETHA
PORTRAIT)*

THIS APPEALING PORTRAIT of a mother and three of her children is an exceptional painting as
regards composition, provenance, and its place in the artist's oeuvre. Jan Baptist Weenix owes
his reputation mainly to his Italianate landscapes, but he also had a great talent for portraiture, as
evidenced by this unusually attractive piece. It portrays Christina Lepper (1624–1683), a young
widow, resting her right hand tenderly on the shoulder of the girl on the left. Holding a folded fan
in her left hand, she seems to stare pensively at the viewer. On December 6, 1644, Christina
Lepper married the Utrecht trader Jacobus de Kempenaer (1619–1652). When he died less than eight
years later, on June 28, 1652, four of their six children had already died, and the seventh had not
yet been born. Thanks to an old label, which used to be stuck on the back of the canvas, as well as
recent archival research, all the sitters have now been identified.[2] At the far right is the eldest
daughter, Christina (1647–1683), who would later marry Daniel Ghijs. In the richly decorated dog-
cart in front of her sits her sister Jacoba, who must have been born in 1652 or 1653. In her
right hand, she holds a gold bell, fastened to a gold chain around her waist; around her wrist she
wears a gold bracelet. At the far left sits Margaretha (1649–1726) with a doll on her left arm;
the doll's rattle hangs on a pink ribbon. Like her elder sister, she wears a gold bracelet around her
wrist. Margaretha inherited the painting after the death of her mother in 1683, and for the next
three hundred years the work was almost uninterruptedly passed down from mother to daughter, all
named Margaretha. This long tradition came to an end in 1994, but the centuries-long pattern
of inheritance gave the portrait the nickname *The Margaretha Portrait.* Considering the children's
ages, the painting must have been made around 1653.

Weenix portrayed the mother and her three daughters in an exceptionally refined way, letting
the children keep their childlike traits, unlike the youngsters in many other children's portraits
of the Golden Age. In those days, members of the prosperous upper-middle class always dressed
soberly, but Christina Lepper's black dress, the gray dresses worn by the two elder daughters,
and the eldest daughter's black scarf are signs of mourning. The gleam of the colored petticoats
worn by the mother and the two elder daughters contrasts beautifully with the deep black and
warm gray of their outer garments.

Weenix depicted the girls and their widowed mother – who, in 1657, was to marry the widower Pieter de Visscher – in an Italianate setting. The classical portico as well as the cypresses and the templelike building in the background recall the painter's long Italian sojourn. These elements, so completely foreign to Holland, have no apparent connection with the persons portrayed. The arch lends the composition a certain intimacy, binding the sitters together. It is a motif that the artist also used in his Italianate genre scenes.[3] In family portraits during this period, the parents were generally portrayed standing. Weenix, however, placed the mother on the same level as the children, thus creating greater informality and intimacy. The dog-cart probably belonged to the painter and not to the De Kempenaers. *Portrait of the Van Wijckersloot Family* (1657; Centraal Museum, Utrecht) by a follower of Weenix displays the same cart.

Provenance: Christina Lepper (Amsterdam 1624 – Utrecht 1683), wife of Jacobus de Kempenaer; her daughter Margaretha de Kempenaer van Aken (baptized December 5, 1649), who married Pieter van Aken on January 4 or 25, 1678; her daughter Margaretha van Aken van der Meulen (July 24, 1691–1782), who married Rijnhard van der Meulen in 1720; their son Petrus van der Meulen (baptized January 1, 1728), who married Maria Henrica Fraeranen; their daughter Margaretha Sara van der Meulen (baptized June 16, 1772), who married Gualtherus Jacob van den Bosch on August 14, 1796; their daughter Jacoba Margaretha van den Bosch (1808–1883); her niece Margaretha Sara van den Bosch Playne (1822–1883), who married Frederick Playne, Totteridge Green, Manor Lodge, near London; by descent to Anna Margaretha Graham Howell; by descent to Margaretha Ann Howell LaBrant, until 1994 (Mrs. Donald S. LaBrandt Jr., by whom sold, New York (Sotheby's), May 19, 1994, no.18, col. pl.; Bob P. Haboldt & Co., New York and Paris, 1995 (Haboldt catalogue 1995, no. 49, ill.; and *Catalogue of The European Fine Art Fair* 1995, p. 69); acquired from Noortman Master Paintings, Maastricht, in 1996.

Exhibitions: On loan to the Museum of Fine Arts, St. Petersburg, Florida, 1968–94; Norfolk Museum of Arts, *Masterpieces from Southern Museums*, 1969; Museum of Fine Arts, St. Petersburg, Florida, and High Museum of Art, Atlanta, *Dutch Life in the Golden Century*, 1975; The John and Mable Ringling Museum of Art, Sarasota, Florida, and The State Art Museum of Florida, *Dutch Seventeenth Century Portraiture, the Golden Age. Presented under the Auspices of the Royal Netherlands Embassy*, 1980–81; Bob B. Haboldt & Co., New York and Paris, *Fifty Paintings by Old Masters*, 1995; Frans Hals Museum, Haarlem, and Koninklijk Museum voor Schone Kunsten, Antwerp, *Pride and Joy: Children's Portraits in the Netherlands 1500–1700 (Kinderen op hun mooist)*, 2000–2001; Centraal Museum, Utrecht, *Utrecht's Golden Age: Caravaggisti and Italianate Painters in the Dutch Collection*, 2001; Museum of Fine Arts, Boston, *Poetry of Everyday Life: Dutch Painting in Boston*, 2002.

Literature: Moes 1897, vol. 1, p. 507, nos. 4108, 4109 (Christina and Jacoba de Kempenaer), vol. 2, p. 14, no. 4434 (Christina Lepper); *Tampa Morning Tribune* 1950; Malone 1968, pp. 24–27, ill. p. 25; "A Survey of the Collections in the Museum of Fine Arts, St. Petersburg," *Pharos* 14, 2 (1968), pp. 14–15, no. 26, ill.; *Norfolk Star-Ledger* 1969; *Dutch Life in the Golden Century* 1975, fig. pp. 35–36, cat. no. 22, ill.; *Dutch Seventeenth Century Portraiture, the Golden Age* 1980–81, cat. no. 68, col. pl.; Lesko 1994, pp. 42–43, col. pl.; *European Fine Art Fair* 1995; *Fifty Paintings by Old Masters* 1995, pp. 112–13, cat. no. 49, ill.; *Masters of Light* 1997, pp. 37–38, fig. 16; *Pride and Joy* 2000–2001, pp. 31, 224–25, cat. no. 59; *Utrecht's Golden Age* 2001, cat. no. 61; *Poetry of Everyday Life* 2002, p. 73, ill.; Anke van Wagenberg-ter Hoeven, catalogue raisonné on Jan Baptist Weenix and Jan Weenix (forthcoming).

Notes:
1. Houbraken 1718–21, vol. 2, p. 77.
2. This research was carried out on the occasion of the exhibition *Pride and Joy: Children's Portraits in the Netherlands 1500–1700* 2000–2001, pp. 224–26, no. 59.
3. For example, *Vegetable Merchant* (signed and dated "Ao 1656 Gio. Batta. Weenix f.") in a private collection in New York.

EMANUEL DE WITTE

ALKMAAR CA. 1616/18−1691/92
AMSTERDAM

Emanuel de Witte's exact date of birth is not known. According to Houbraken, he was born
in 1607, but later documents suggest 1616/18 as his year of birth. He was the son of a schoolmaster
who, Houbraken stated, taught him the rudiments of geometry and rhetoric. Houbraken also
wrote that De Witte became a pupil of the still-life painter Evert van Aelst (1602–1657) in Delft.[1] In
1636, De Witte registered with the Alkmaar Guild of St. Luke, but in July 1639 and June 1640
he is recorded in Rotterdam. In 1641, he seems to have settled in Delft, where his daughter was
baptized in October of that year. On June 23, 1642, he became a member of the local guild, and on
October 4 of that year he married the mother of his daughter, at which time he was living on
Choerstraat. Later, he rented a house on the Markt, and in 1650 a house on Nieuwe Langendijk. In
January 1652, he appears to have moved to Amsterdam, where he probably remained until his
death. A poem written in 1654 by Jan Vos, *Strydt tusschen de Doodt en Natuur, of Zeege der Schilderkunst*
(Battle between Death and Nature, or the Victory of Painting), names Emanuel de Witte – as well
as Rembrandt, Govaert Flinck (1615–1660), Bartholomeus van der Helst (ca. 1613–1670), Ferdinand
Bol (1616–1680), and Willem Kalf (1619–1693) – among the painters who can be credited with
spreading the fame of Amsterdam. Meanwhile widowed, De Witte remarried on September 3, 1655.
The marriage contract records Alkmaar as his place of birth. Three years later, his wife was
banned from the city after being found guilty of theft. Despite various important commissions, in-
cluding one from Frederik III of Denmark, De Witte seems to have been in constant financial straits.
Houbraken gave a detailed account of De Witte's exceptionally difficult and melancholic character,

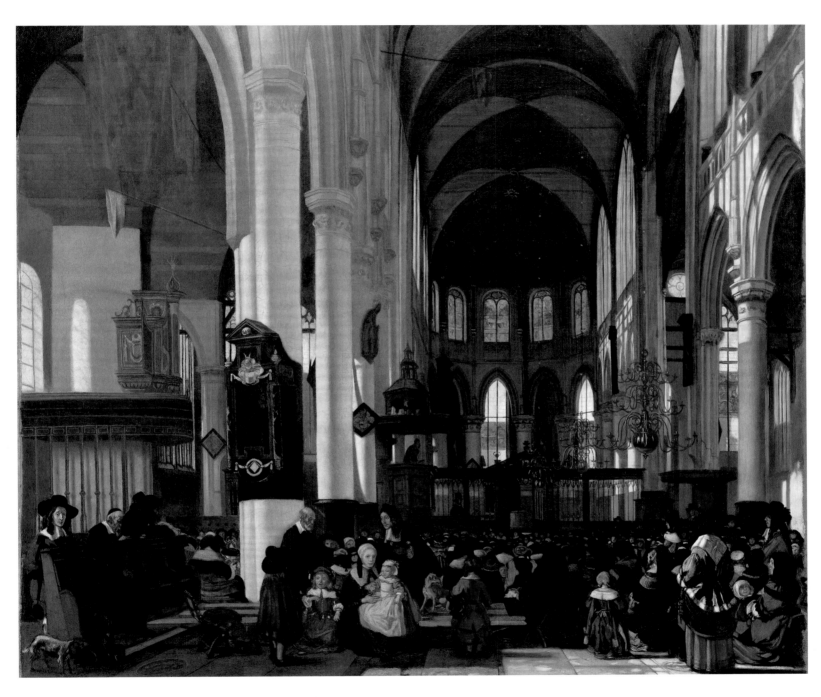

CATALOGUE 66. *Interior of the Oude Kerk in Amsterdam*, ca. 1660–65.
Oil on canvas, 25 3/4 × 28 3/4 inches (65.5 × 73.1 cm).

and his tendency to provoke quarrels with almost everyone. Furthermore, Houbraken related
that in the winter of 1691/92, De Witte had a violent argument with his landlord and subsequently
tried to commit suicide, but the rope broke and he drowned instead. Owing to freezing weather,
his body was not found until eleven weeks later in the Haarlemmersluis in Amsterdam.[2]

At the beginning of his artistic career, De Witte painted biblical and mythological scenes
and a few mediocre portraits. As far as we know, he did not paint his first church interior until after
1650, when he was well over thirty. He was probably inspired to take up this subject by Gerard
Houckgeest, who painted his first pioneering interiors of Delft churches in 1650. De Witte, then
also living in Delft, undoubtedly became acquainted with Houckgeest's work. In the following
decades, De Witte devoted himself almost entirely to painting church interiors, both existing and
imaginary, or a combination of the two. He also painted market scenes and the occasional genre
piece, group portrait, and seascape. Together with Houckgeest and Pieter Saenredam, De Witte is
considered one of Holland's best seventeenth-century painters of church interiors. But while
Saenredam, and to a lesser extent Houckgeest, concentrated on architecture and spatial effects,
De Witte was mainly interested in rendering the atmosphere, the play of light, and the people
in the church.

Literature: Jantzen 1910; Manke 1963; Liedtke 1982.

CATALOGUE 66

*INTERIOR OF THE OUDE
KERK IN AMSTERDAM*

EMANUEL DE WITTE must have been enchanted by Amsterdam's Oude Kerk. Still in existence,
this predominantly late-Gothic church is indeed very picturesque, both inside and out. After moving
to Amsterdam in 1651 or 1652, De Witte made almost thirty paintings of its interior. In depicting
the church from various vantage points, he did not hesitate to take all kinds of artistic liberties. Here,
for instance, he extended the pillars and shifted the pews in order to enhance the spatial dynamism.

The Oude Kerk was originally dedicated to Saint Nicholas, patron saint of the city of Amsterdam.
Construction began in the fourteenth century on this initially three-aisled "hall church." At the
beginning of the sixteenth-century, work was begun on adding two more aisles and a transept, to
convert the building into a cruciform basilica able to accommodate greater numbers of churchgoers.
This reconstruction was never completed, however, so the church is more capricious than monu-
mental in character, which lends it a unique charm.

The present painting affords a view of a religious service, seen from the west through the nave
to the choir. On the left in the nave is the pulpit, dating from 1643, from which a minister delivers a
sermon, bending slightly forward as he speaks. The foreground is filled with a motley group of
churchgoers, not all of whom pay attention to the service. In the foreground, to the left of center, a
mother sits with her back to the pulpit; one child is on her lap and a little boy sits next to her.
Their well-defined features suggest that these are individual portraits. The same is true of the seated
man (wearing a hat) at the far left, and, to a slightly lesser degree, of the man (standing behind
the mother) who puts money in the collection pouch. These figures might be the patron and his
family, if indeed this picture was a commissioned work. In the foregrounds of several other
church interiors, De Witte also painted portraitlike figures who are sometimes taken to be patrons.[3]

The foremost pillar on the left bears an unidentified epitaph. Behind it on the left, in the
north transept, we see the still-extant organ that was built in 1658 by Hans Wolf Schonat. In the
middle distance, slightly beyond the pulpit, the nave is transected by the rood screen. At the

back of the church, light enters through the stained-glass windows above and the mostly colorless tall windows below, providing a sharp contrast to the rather dark choir.

Here, De Witte created more than just a portrait of a church, for he has succeeded convincingly in rendering the atmosphere in the church on a bright day during a service. On the one hand, numerous men, women, children, and even a few dogs play such a prominent role in the composition that it almost has the character of a genre scene. On the other hand, there is the building itself and the immense space inside it. The diffuse light pervading most of the church alternates with the bright light streaming in through the largely invisible north windows that casts both shadows and patches of light onto the white pillars, the walls, and the stone floor, thereby lending the scene a lively note. De Witte used a subtle palette: the architecture is executed in white, brown, and gray tones, while the figures are painted in black, red, white, and accents of ocher.

Two other paintings by De Witte depict the church from approximately the same viewpoint. *Interior of the Oude Kerk* (ca. 1655; Amsterdams Historisch Museum, Amsterdam) shows only a few churchgoers; a piece painted about ten years later (National Gallery of Art, Washington), was made from a vantage point closer to the entrance, so that more of the bays of the nave are visible.[4] The present painting can be placed between these two works and is thus datable to the first half of the 1660s.

With one exception, a *Medusa* from his early years (M. and G. Abrams Collection, Boston),[5] there are no known drawings by Emanuel de Witte, even though he must have based his church interiors on studies or sketches. In all likelihood, he made frequent use of studies for the staffage as well. The figures in the immediate right foreground of this painting – the girl seen from the back, the standing woman, likewise seen from the back, the seated woman with a child, and the standing man in profile behind her – appear in a slightly different arrangement in *Interior of the Oude Kerk, Amsterdam* (National Gallery, London). Repetitions of staffage also occur in other works by De Witte.

According to tradition, this painting was once part of the collection of the painter John Constable (1776–1837). When the painting was conserved in 1985, it appeared that apart from a few figures, the section to the left of the large epitaph had been almost completely overpainted. It is possible that this was done by Constable himself, since it is known that he sometimes restored or "improved" paintings. The conservation treatment in 1985 restored the painting to its original appearance.

Provenance: Probably John Constable (1776–1837), London, his estate sale, London (Foster and Sons), May 15–16, 1838, lot 7 ("De Wytt. An interior of a cathedral, with numerous figures – a chef d'oeuvre") (sold for 27 gns.); Francis Gibson (1803–1859), Saffron Walden, Essex, purchased in 1848 (according to the 1945 Arts Council exhibition catalogue, see below); thence by descent to his son-in-law, the Rt. Hon. Lewis Fry, M.P. (1876–1929), Bristol; thence by descent to his grandson Dr. Lewis S. Fry, Delafords, Epping, Essex, 1945–66; thence by descent to his children, by whom sold, London (Christie's), April 11, 1975, no. 34 (sold for £16,000); anonymous sale ("The Property of a Family Trust"), London (Christie's), April 19, 1985, no. 90 (sold for £129,600); Jaime Ortiz-Patiño, Coral Gables, Florida, by 1985, by whom sold, New York (Sotheby's), January 30, 1998, no. 68 (to Robert Noortman); acquired from Noortman Master Paintings, Maastricht, in 1998.

Exhibitions: Royal Academy of Arts, London, *Exhibition of Works by the Old Masters and by Deceased Masters of the British School, Winter Exhibition*, 1876; Royal Academy of Arts, London, *Exhibition of Works by the Old Masters and by Deceased Masters of the British School*, 1910; Royal Academy of Arts, London, *Exhibition of Dutch Art 1450–1900*, 1929; Arts Council of Great Britain, London, *Dutch Paintings of the 17th Century*, 1945–46; Norwich Castle Museum, Norwich, *Dutch Paintings from East Anglia*, 1966; Mauritshuis, The Hague, and The Fine Arts Museums of San Francisco, *Great Dutch Paintings from America*, 1990–91; Osaka Municipal Museum of Art, *The Public and the Private in the Age of Vermeer*, 2000; Museum of Fine Arts, Boston, *Poetry of Everyday Life: Dutch Painting in Boston*, 2002.

Literature: *Exhibition of Works by the Old Masters and by Deceased Masters of the British School* 1876–77, p. 26, cat. no. 207; *Exhibition of Works by the Old Masters and by Deceased Masters of the British School* 1910, p. 45, cat. no. 172; Jantzen 1910; *Exhibition of Dutch Art 1450–1900* 1929, p. 149, cat. no. 315; *Dutch Paintings of the 17th Century* 1945–46, p. 18, cat. no. 40; Manke 1963, p. 90, cat. no. 55, ill. fig. 49; *Dutch Paintings from East Anglia* 1966, p. 19, cat. no. 52; *The Illustrated London News*, 1966, pp. 26–27, ill.; Van Braam 1975, p. 322; Mayer 1976, vol. 10, p. 1049; Jantzen 1979, p. 243, cat. no. 677; Wrey 1985, p. 37, ill.; *Great Dutch Paintings from America* 1990–91, pp. 476–81, cat. no. 71, ill. pp. 476, 478, fig. 1; *The Public and the Private in the Age of Vermeer* 2000, pp. 86–89, cat. no. 11, ill. pp. 87, 89; *Poetry of Everyday Life* 2002, p. 127, ill.

Notes:
1. Houbraken 1718–21, vol. 2, p. 283.
2. Ibid., vol. 1, pp. 284–87.
3. For instance, *Interior of the Oude Kerk, Amsterdam* (1661; Amsterdams Historisch Museum, Amsterdam). It has also been suggested – probably erroneously – that the figures in *Interior of the Oude Kerk, Amsterdam* of 1678 (G. Kremer Collection, The Netherlands) are the same as those in the only known group portrait by De Witte, also of 1678 (Alte Pinakothek, Munich).
4. Manke 1963, cat. nos. 72 and 65, respectively.
5. In an album containing forty-one drawings by various masters.

PHILIPS WOUWERMAN

HAARLEM 1619–1668 HAARLEM

Philips (Philippus) Wouwerman was baptized on May 24, 1619 in Haarlem; he was the eldest son of Pauwels Joostensz. Wouwerman(s). Houbraken reported that he was a history painter, "but one of little consequence" ("dog van geringe soort").[1] Pieter (1623–1682) and Jan (1629–1666) were born after Philips. These three brothers, born and raised in Haarlem, all became professional painters. It seems only natural that Philips would have received his first drawing and painting lessons from his father. According to the biographer Cornelis de Bie, he then went to study with Frans Hals (1582/83–1666), but there is no trace of Hals's influence in his work.[2] According to the Hamburg painter Matthias Scheits (ca. 1625/30–ca. 1700), in 1638 or 1639 Philips spent several weeks working in Hamburg in the studio of the German history painter Evert Decker (died 1647).[3] Scheits went on to say that Philips had come to Hamburg to marry Annetje Pietersdr. van Broeckhof, who, unlike the Wouwerman family, was Catholic. In 1640, Wouwerman returned to Haarlem, and on September 4 of that year he was admitted to the Guild of St. Luke as a master-painter. On December 22, 1645, he was appointed an officer of the guild for the year 1646. In the following years, he is recorded repeatedly in Haarlem, and there is no evidence that he left the city for any length of time. On September 5, 1658, Philips Wouwerman and his wife made their wills. He died nearly ten years later, on May 19, 1668, and was buried on May 23 in the Nieuwe Kerk in Haarlem. The paintings left at his death were sold at auction on May 7, 1670, in Haarlem. The rather considerable sum of money that each of his children received after the death of both their parents is some measure of the family's prosperity. The numerous houses and gardens that Wouwerman bought and sold in Haarlem over the years give the impression that he speculated in

CATALOGUE 67. *The Stag Hunt*, ca. 1659–60. Oil on copper, 10 5/8 × 13 3/4 inches (27 × 35 cm).
Signed lower left: *PHILS. W* (*PHILS* in ligature)

real estate. It is not always clear which house he actually lived in. In May 1643, he was living "on the Bagynhoff" and in 1667 in the house called *De Haesewint* (The Greyhound) on Bakenessergracht. Philips Wouwerman's numerous pupils and followers included his brothers Pieter and Jan.

Philips Wouwerman was undoubtedly the best and most successful Dutch painter of equestrian scenes. He was exceptionally prolific. Despite his rather premature death, nearly six hundred of his paintings have survived, mostly small cabinet pieces featuring horses, as well as landscapes and history paintings. Remarkably, few of his drawings have been preserved. His early work in particular betrays the strong influence of Pieter van Laer (1599–after 1642). Wouwerman's paintings were in great demand already in his lifetime, and his popularity continued to grow in the eighteenth and nineteenth centuries.

Literature: Hofstede de Groot 1907–28, vol. 2, pp. 249–650; Duparc 1993, pp. 257–86; Schumacher 2006; *On Horseback!: The World of Philips Wouwerman* 2009.

CATALOGUE 67

THE STAG HUNT

SEVERAL ELEGANTLY ATTIRED HUNTERS (one of them female) race through hilly terrain on horseback, heading with their servants and hounds after a stag, which has been cornered at the far right by hounds and by hunters wielding spears. To reach their quarry, the hunting party must cross a shallow stream in the foreground. In the middle distance, diagonally behind the group of trees that stand out brightly against the partly cloudy sky, a horseman blows on his horn – the signal that the chase is on. Part of a castle or country estate is barely discernible at the right on the horizon.

This exceptionally well preserved painting is one of Philips Wouwerman's most beautiful works, in which he succeeded admirably in achieving the perfect balance between landscape and genre elements. The galloping horses, the riders with waving plumes on their hats, the running hounds, and the splashing water lend the scene great dynamism. The use of bright colors, the subtle brushwork, and the type of composition – which focuses on the elegant hunting party – suggest a date of around 1659–60, when the artist was at the height of his powers. The almost complete lack of dated work from the last fifteen years of Wouwerman's life makes it difficult to give a more exact date. Also characteristic of Wouwerman's late work is the white horse in the middle, which is lent added emphasis by the bright red jacket of its rider and the dark *repoussoir* in the left foreground, as well as by its height, for it extends above the horizon slightly more than any of the other horses.

Wouwerman rarely worked on copper, and the few pieces he did paint on this support date mainly from the last ten years of his life. Indeed, particularly at this stage in his career, one would expect him to have made more frequent use of copper, since its smooth surface was eminently suited to the refined painting technique he preferred in this period. The stability of a copper plate means that paint layers generally remain more intact than they do on panel or canvas. This explains, at least in part, the beautiful state of preservation of this small piece.

Hunting scenes were among the painter's favorite subjects, especially in the last decade of his life. Of the approximately six hundred known paintings by Wouwerman, more than one hundred portray themes of the chase – riding out to the hunt, resting during the chase, and returning from the hunt – in every possible variation, not to mention the wide variety of quarry (wild boar, bears, ducks, and deer) and even the pursuit of hawking. It was these elegant hunting scenes

in particular that contributed to the painter's great popularity during the eighteenth century in Germany, England, and especially France. This present painting belonged successively to various prominent collectors in each of those countries.

Provenance: Collection Counts of Schönborn, Pommersfelden, before 1857 (cat. 1857, no. 107; sale, Paris, May 17, 1867, no. 138; possibly Henri d'Orléans, duc d'Aumale, Château de Chantilly; William Ward, first earl of Dudley; Thomas Agnew & Sons, London; private collection, sale, New York (Christie's), May 31, 1989, no. 131; Jaime Ortiz-Patiño, Coral Gables, Florida, 1980; Noortman Master Paintings, London; Benoit Wesley, Maastricht; acquired at sale, London (Sotheby's), December 12, 2002, no. 26.

Exhibitions: Mauritshuis, The Hague, *The Amateur's Cabinet: Seventeenth-century Dutch Masterpieces from Dutch Private Collections*, 1995–96; on loan to Mauritshuis, The Hague, 2003–2004; Frans Hals Museum, Haarlem, and Kunsthalle der Hypo-Kulturstiftung, Munich, *De Gouden Eeuw begint in Haarlem*, 2008–2009; Gemäldegalerie Alte Meister, Kassel, and Mauritshuis, The Hague, *On Horseback!: The World of Philips Wouwerman* 2009–2010.

Literature: Parthey 1863–64, vol. 2, p. 802, no. 50; *Galerie de Pommersfelden* 1867, p. 58, cat. no. 138; Hofstede de Groot 1907–28, vol. 2, pp. 446–47; Duparc 1993, p. 277; *The Amateur's Cabinet* 1995–96, pp. 76–77, cat. no. 34; *Rudolf Bys, Fürtrefflicher Gemähld- und Bilder-Schatz* 1997, p. 80, cat. no. 244; Schumacher 2006, vol. 1, p. 230, cat. no. A 151; *De Gouden Eeuw begint in Haarlem* 2008–2009, cat. no. 114, pp. 148–49; *On Horseback!: The World of Philips Wouwerman* 2009–2010, pp. 35, 114–15, cat. no. 22, p. 175.

Notes:
1. Houbraken 1718–21, vol. 2, p. 70.
2. De Bie 1661, p. 281.
3. Notes of Matthias Scheits written in his copy of Van Mander 1603, formerly in the possession of Alfred Lichtwark. Published in Lichtwark 1899, pp. 43, 44.

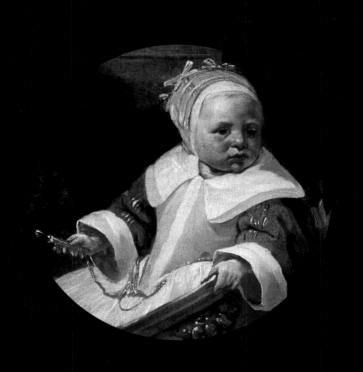

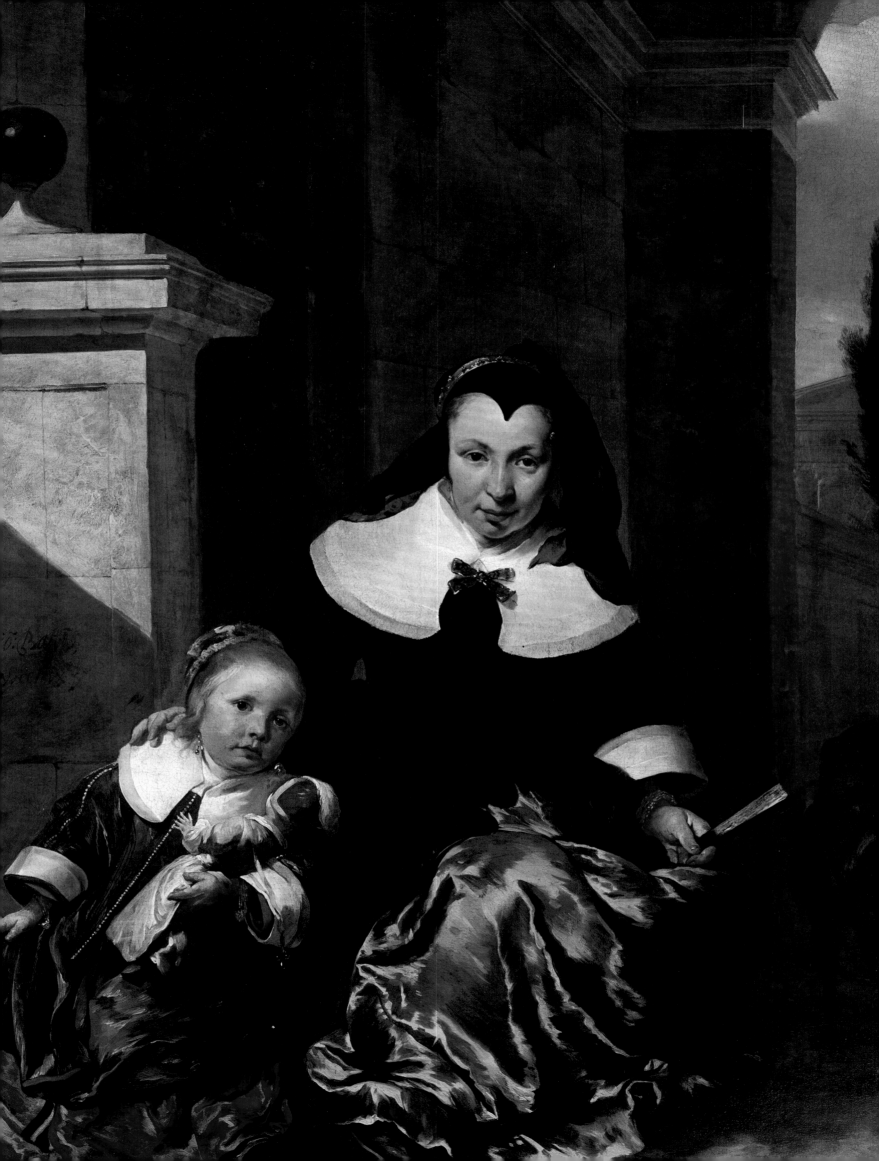

PAINTING

IN SILVER, WOOD, AND

MOTHER-OF-PEARL

REINIER BAARSEN

The Dutch seventeenth century is often perceived above all else as a Golden Age of painting, and it cannot be denied that among the manifold achievements of that extraordinary period – political, economic, scientific, or cultural – its crop of paintings stands out as almost miraculous. It did even to contemporary observers who, when commenting on the arts in the young Dutch Republic, singled out the widespread availability of, and interest in, good-quality paintings. Critics and biographers accorded particular attention to painters; they in turn emphasized the stature of their art by freeing themselves, in some cities at least, from the confines of the traditional guild system.[1]

Commentators on this attempt to achieve a separate, elevated status tended to stress the unique intellectual, "liberal" dimension to the art of painting, but an element of social prestige was clearly also in evidence. When in 1656 the painters and sculptors of The Hague founded Pictura – a voluntary confraternity rather than a compulsory guild – simple house-painters were excluded from membership, but glass-engravers and "amateurs" were not. The last denomination, "amateurs," did not refer primarily to gentlemen of leisure who dabbled in painting or sculpture, but more generally to those who took an informed interest in the arts, occasionally even practicing one themselves; as it happened, many of the best-known glass-engravers fell into that category.

The concept of devoting leisure time to the practice of an art form had an august pedigree, stretching back to Renaissance rulers such as Francesco I de' Medici (1541–1587), grand duke of Tuscany. Princes tended to prefer some mechanical art such as ivory- or wood-turning to painting. The foremost princely patron of the arts in early seventeenth-century Europe, Holy Roman Emperor Rudolf II (1552–1612), learned the art of goldsmithing. Both in their own practical involvement with artistic production and in their collecting activities, Renaissance rulers particularly admired technical virtuosity and the skillful employment of precious, rare, or especially striking natural materials. This taste is abundantly reflected in many of Rudolf II's most extravagant commissions. Although an avid collector of paintings from all over Europe, as a patron the emperor preferred intricate masterpieces of the art of the stone-cutter, the goldsmith, the mosaicist, and so on.

Constantly on the watch for the most talented artists in these fields, Rudolf II drew many foreigners to his court, which he had moved from Vienna to Prague in 1583. Among those who came from the Dutch Republic were the sculptor Adriaen de Vries (1556–1626) and the goldsmith Paulus van Vianen (ca. 1570–1613).[2] Born in Utrecht, Van Vianen had worked in various European cities before becoming attached to the court in Prague in 1603. Rudolf II came to value him above all other goldsmiths, as is evident from his exceptionally high salary. Paulus van Vianen produced a number of outstanding works in Prague, perhaps the best-known being a ewer and basin with stories of Diana (figure 1). Probably commissioned by Rudolf, this was not finished until 1613, a year after the emperor's death. It demonstrates the two fields in which Van Vianen excelled: new and fantastical ornamental forms in the so-called auricular style – a mixture of soft, lobelike shapes, masks, and other distorted human or animal forms – and figurative reliefs that are unrivaled in the beauty of their composition and the quality of their execution.

Paulus van Vianen himself died in Prague in 1613. Extraordinarily, although he had never worked as an independent master in the Netherlands, the Amsterdam silversmiths' guild felt that they had lost the greatest practitioner of their art and commissioned a work to commemorate him. Instead of turning to one of their own members, they approached Paulus's brother Adam van Vianen (1568/69–1627), who worked as a silversmith in Utrecht. Rising to the occasion, this

celebrated artist produced his most striking work ever, an invention in the auricular style of a bold-
ness even Paulus had never attempted (figure 2).

This unique occurrence demonstrates that in early seventeenth-century Holland, a goldsmith
had attained a reputation as an artist that could not easily be matched by any of his painter
compatriots. It also highlights the fact that Paulus's brilliant brother had not felt the need to travel
to Europe's most splendid and sophisticated courts, but found employment and fame among his
own country's cultured individuals. Those who could afford to acquire his works in silver probably
consciously followed the prevalent international tradition of aristocratic collecting. Social prestige
and the emulation of courtly life undoubtedly played a far greater role in the purchasing of intricate
works of art fashioned from precious materials than in the buying of paintings of standard quality.
Very few painters would have been in a position to purchase a work by Adam van Vianen, but many
did admire his art. The ewer of 1614, in particular, is represented in numerous pictures from
the 1610s to the 1650s. The earliest known, dated 1615, is by Pieter Lastman (1583–1633).[3] Lastman's
pupil Rembrandt never actually portrayed any work by the Van Vianen brothers, but he obviously
delighted in it. He owned plaster casts of the famous basin by Paulus and of a sculptural work
by Adam, and often depicted auricular-style silver vessels in his paintings.

How appropriate, then, that a rare and beautiful plaque by Adam van Vianen graces the
collection of Rose-Marie and Eijk van Otterloo (catalogue 70). Signed with the monogram A. D. V. F.
(Adam De Viana Fecit), it shows the conversion of Saint Paul, the apostle, while on his way to
Damascus. Van Vianen has invented a dramatic, highly accomplished composition and rendered
it in delicately chased relief, brilliantly playing on the reflective qualities of the precious metal.[4]
The provenance of the plaque is equally distinguished. In the eighteenth century, it belonged to the
Amsterdam collector Gerrit Braamcamp, who owned one of the finest painting collections in
the country as well as large assemblies of Chinese porcelain, Japanese lacquer, fine furniture,
clocks, and other works of decorative art, no fewer than ten of which he regarded as being by
the Van Vianen brothers.[5] While in Braamcamp's collection, the plaque had an ebony frame and
presumably hung on the wall, inviting direct comparison with the surrounding oil paintings.

Figure 1. Paulus van Vianen,
Ewer and basin with episodes from
the stories of Diana and Callisto
and Diana and Actaeon, 1613.
Silver, ewer H. 13 3/8 inches (34 cm),
basin W. 20 5/8 inches (52.3 cm).
Rijksmuseum, Amsterdam.

Among Braamcamp's other works attributed to the Van Vianens were cups, ewers, and basins chased with mythological stories. They undoubtedly had fanciful shapes, ornamental feet, handles, and borders, and would have announced themselves more explicitly as specimens of the decorative arts.

On a less exclusive level, carved furniture was another favored medium for the representation of biblical and, to a lesser extent, mythological stories. An imposing oak cupboard (*kas* or *kast*) in the Van Otterloo collection is set with large sculptural figures (catalogue 78). The upper row symbolizes the abundance of the seasons, referring in a general manner to fertility and prosperity, whereas the bottom row represents biblical figures. The panels of the doors are carved with female figures symbolizing Christian virtues. On some closely comparable examples, the panels illustrate episodes from the story of Susannah.[6] Her chastity was considered the most important female virtue, and other narrative elements often represent quintessentially male virtues such as courage and valor. Those themes indicate that many of these cupboards were made on the occasion of a marriage; they may be regarded as the Dutch answer to the *cassoni* or wedding-chests of the Italian Renaissance. Probably geared toward a prosperous but not particularly sophisticated audience, such a cupboard not only represented the worldly position of the newlyweds – filled as it was with the costly household linen – but was also intended as a "sermon in wood," an admonishment to virtuous behavior.

In contrast to the plaque by Adam van Vianen, the figures on the cupboard are incorporated into an ornamental entity in which many of them actually perform, or seem to perform, a structural function. In its composition and proportions, the cupboard reflects the language of classical architecture, perhaps the only art form to rival the traditional prestige of painting. At a time when in Holland only a few houses were as yet being built along strictly applied classical principles, a correctly proportioned and detailed cupboard would often have been the most conspicuous sign of a homeowner's awareness of, and adherence to, the architectural orders that were again admired as the heritage of a revered past. Because most early seventeenth-century houses were quite small, a large, richly decorated cupboard, which was often placed in the the large room at the front (*voorhuis*) where one entered from the street, would be the most conspicuous work of art to greet

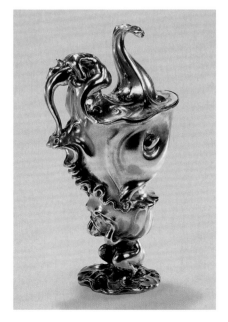

Figure 2. Adam van Vianen,
Covered ewer, 1614. Silver-gilt,
H. 10 inches (25.5 cm). Rijksmuseum,
Amsterdam.

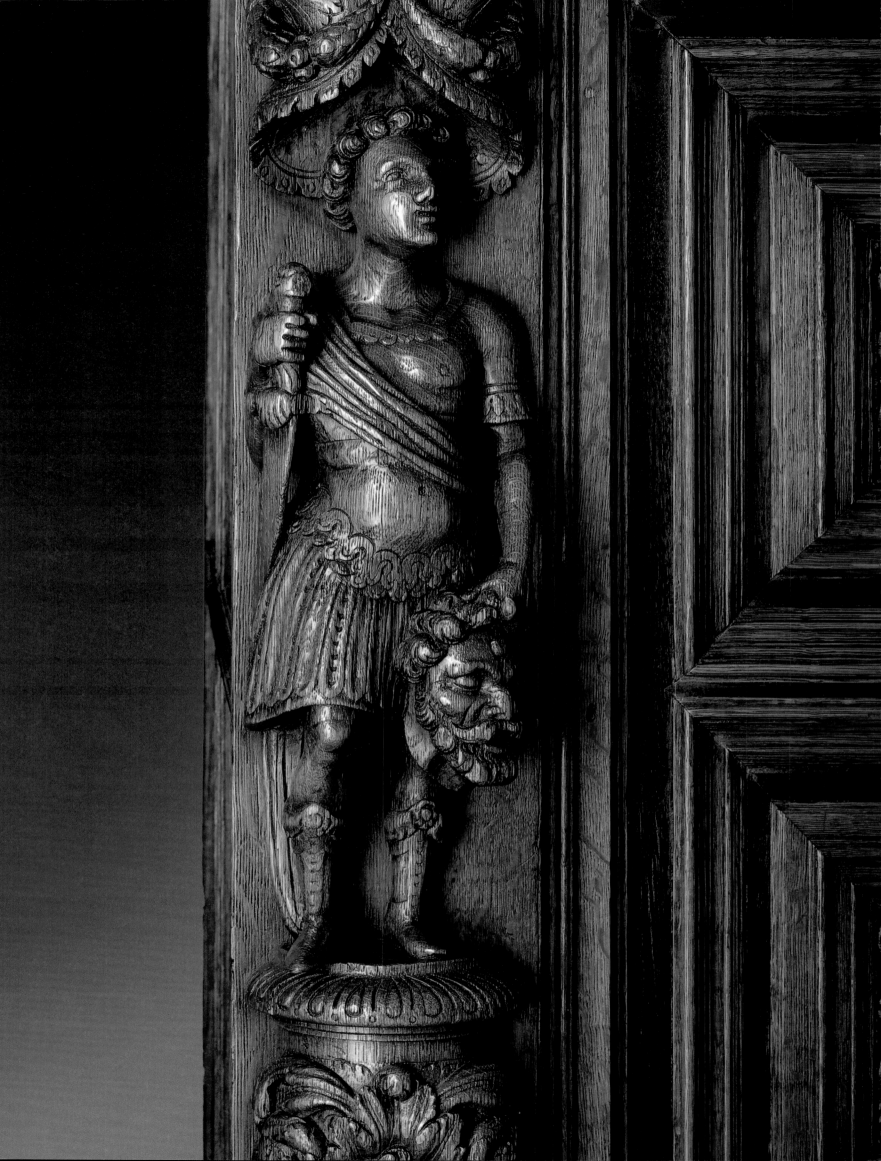

CUPBOARD
(*BEELDENKAST*),
1620–40
(CATALOGUE 78,
DETAIL)

the visitor. In terms of its cost, the important messages it conveyed, and its sheer physical presence, such a piece of furniture would have found its match in a painting in only a limited number of houses.

From the early seventeenth century onward, the position of oak, the traditional wood for furniture-making in Holland, was challenged by exotic woods imported through the burgeoning overseas trading companies, foremost among them the Dutch East India Company, founded in 1602. Ebony – black, shiny, hard, and extremely difficult to work – was the most coveted species. There came into being a new class of furniture-makers, the ebony-workers, who covered the oak core of their pieces with the newly fashionable woods. One of the first to settle in Amsterdam, the German-born Herman Doomer (ca. 1595–1650), was to rise to the peak of his profession. His best-known work, a great cupboard whose ebony veneer is inlaid with flowers of mother-of-pearl (figure 3), must have seemed a veritable marvel to the inhabitants of Amsterdam in its combination of exotic, lustrous materials. Rembrandt, once again, was doubtless a great admirer of Doomer's work. He probably knew the ebony-worker well: he painted portraits of him (figure 4) and his wife.[7] Likewise, he produced an intimate etching of the famous Amsterdam silversmith Johannes Lutma (1587–1669), seated next to a silver dish he had made in 1641 (figure 5).[8] It seems that Rembrandt was closer to, and more interested in, artists who worked in media different from his own but on a comparably high level of imagination and inventiveness, than in the many secondary painters who were catering to a broad market.

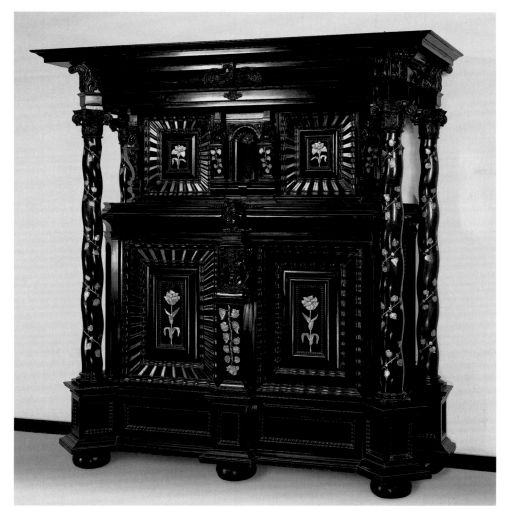

Figure 3. Herman Doomer, Cupboard, 1635–45. Oak, veneered with ebony, kingwood, rosewood, pseudo-acacia, mother-of-pearl, ivory, and mirror glass, H. 85 13/16 inches (218 cm). Rijksmuseum, Amsterdam.

It is not known who executed the mother-of-pearl inlay on Doomer's cupboard, but he must have been a highly specialized craftsman. Perhaps these shimmering flowers represent an early effort by Dirck van Rijswijck. Trained as a goldsmith and always referred to as such, Van Rijswijck may have focused primarily on dealing in silver and gold wares and jewelry. He produced a few medals and carved portrait medallions, probably as a side line, somewhat in amateur fashion. After 1650, when he was already in his mid-fifties, he began to produce the body of works inlaid in mother-of-pearl, many of them signed, that has ensured his lasting fame. In the Van Otterloo collection is a large and elaborate plaque, inlaid on a ground of black slate, signed and dated 1676 (catalogue 69).[9] Its most conspicuous feature is a large garland of flowers, in which Van Rijswijck has employed mother-of-pearl of various hues to render the natural tints of the blooms, fruit, and stalks as realistically as possible. This naturalism, achieved through the use of a material that would not age with time, was much admired in Van Rijswijck's work. The best-known poet of the Dutch seventeenth century, Joost van den Vondel, singled out this aspect in a poem he devoted to the artist's largest and best-known work, an octagonal table-top (figure 6): "This garden of flowers keeps its appearance through all ages and knows of no decay." Van Rijswijck never sold this table-top but kept it in his shop where it was seen and admired by many visitors to Amsterdam, including Grand Duke Cosimo III de' Medici. That he could afford to hold on to such a large and precious piece underscores that he was no mere craftsman working for a living, but rather a prosperous tradesman with a justifiably high opinion of his importance as an artist. In addition to the garland, the Van Otterloo plaque depicts a parrot and a monkey as well as a crane and a fox, the latter pair referring to Aesop's fable.[10] In several ways, such a work of art challenges the supremacy of oil painting: this was undoubtedly one of its appealing traits in the eyes of its original owner and his friends and visitors with whom he discussed its merits.

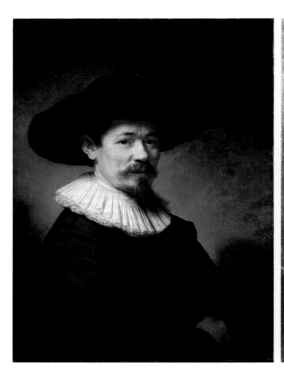

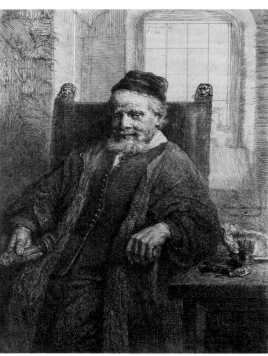

Figure 4. Rembrandt van Rijn, *Portrait of Herman Doomer*, 1640. Oil on wood, 29 5/8 × 21 3/4 inches (75.2 × 55.2 cm). The Metropolitan Museum of Art, New York, H. H. Havemeyer Collection, Bequest of Mrs. H. H. Havemeyer, 1929 (29.100.1).

Figure 5. Rembrandt van Rijn, *Portrait of Johannes Lutma*, 1656. Etching, 7 5/8 × 5 13/16 inches (19.4 × 14.8 cm). Rijksmuseum, Amsterdam.

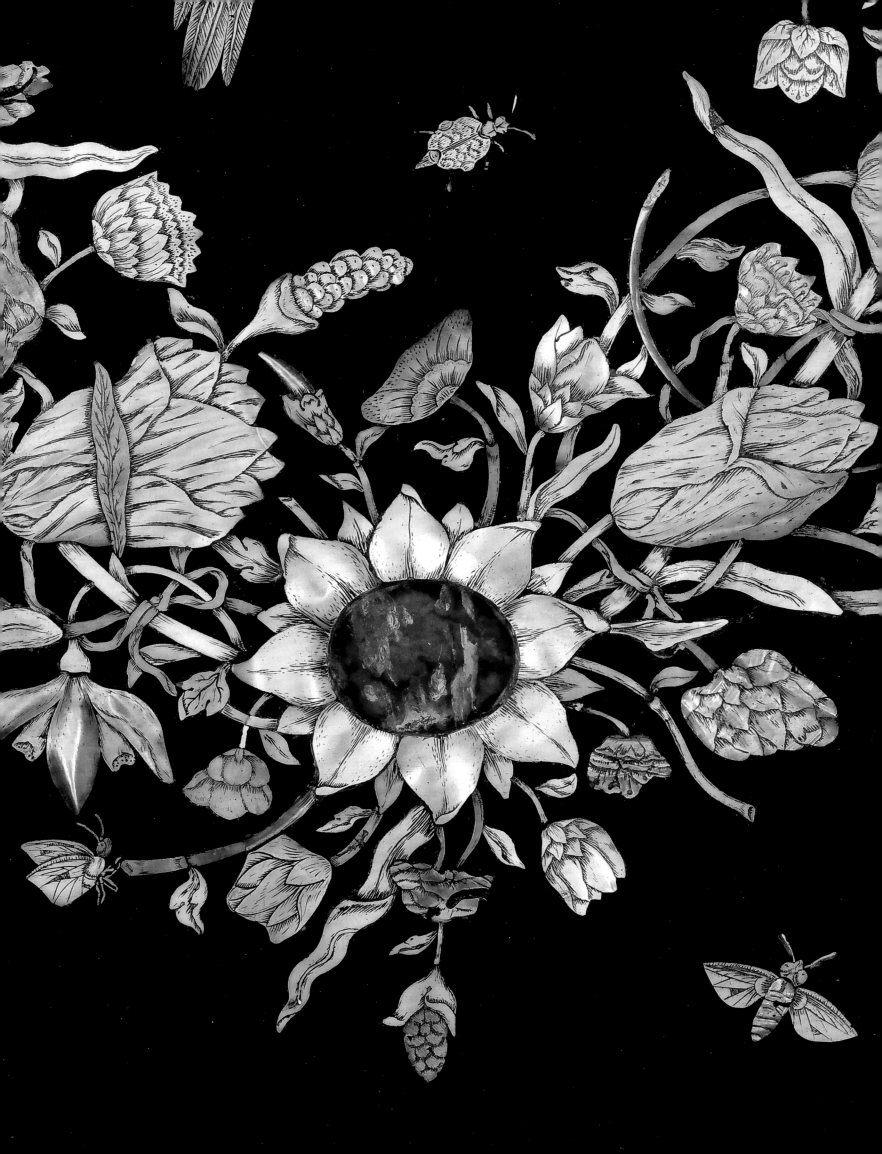

Another artist who worked in mother-of-pearl in Amsterdam during the second half of the seventeenth century was Cornelis Bellekin. Several members of his family, which hailed from France, distinguished themselves in this sphere, but Cornelis was acknowledged to be the outstanding one, known as "the famous Bellekin." He specialized in carving entire shells instead of creating inlaid pictures.[11] A fine example in the Van Otterloo collection, depicting nymphs bathing (catalogue 68), seems to refer almost consciously to Paulus van Vianen's famous composition (figure 1). True collectors' pieces, Bellekin's shells were eagerly incorporated into the cabinets of some of Amsterdam's most prominent connoisseurs at the end of the seventeenth century, such as Albertus Seba, who produced a splendid publication on his own collection of natural curiosities,[12] or Petronella de la Court, famous for her wonderful doll house which in itself was a distinguished assemblage of beautiful works of art.[13] Among Petronella's works by Bellekin was "an [unusually large] shell, carved inside with the Bath of Diana and Callisto;"[14] its carving would have resembled that in the example in the Van Otterloo collection. Collectors of this caliber were naturally familiar with the work of the Van Vianen brothers; Petronella de la Court actually owned a number of plaques attributed to Paulus. The artifacts in the Van Otterloo collection presented in this introduction, such as the silver commemorative medal (catalogue 71), though few, confirm a venerable tradition: they illustrate that informed delight in art forms other than painting remains a distinguishing characteristic of the truly enlightened collector.

Figure 6. Dirck van Rijswijck, Table-top, 1650–60. Slate, inlaid with mother-of-pearl, within an ebony border, 54 5/16 × 54 5/16 inches (138 × 138 cm). Rijksmuseum, Amsterdam.

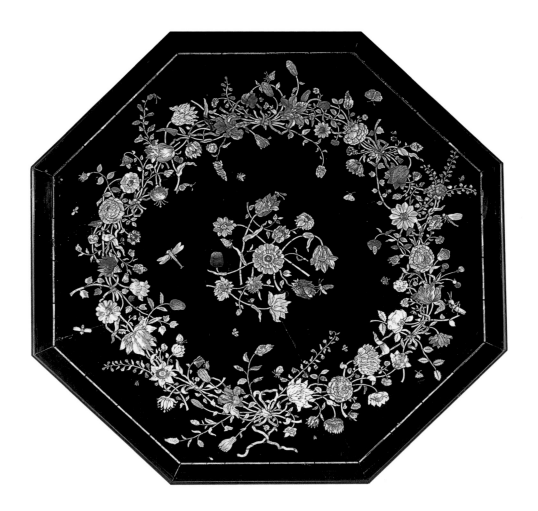

Notes:
1. De Koomen 2001, pp. 21–25.
2. On Rudolf II and his artistic enterprises, see *Prag um 1600: Kunst und Kultur am Hofe Kaiser Rudolfs II* 1988; and *Rudolf II and Prague: The Court and The City* 1997.
3. *Zeldzaam Zilver uit de Gouden Eeuw: De Utrechtse edelsmeden Van Vianen* 1984, p. 24, fig. 17, and cat. no. 112.
4. Ter Molen 1984, vol. 2, p. 99, cat. no. 529; *Zeldzaam Zilver uit de Gouden Eeuw: De Utrechtse edelsmeden Van Vianen* 1984, cat. no. 53.
5. Bille 1961, esp. pp. 93–94; Ter Molen 1984, vol. 2, p. 74.
6. For an example in the Rijksmuseum, see Baarsen 2007, pp. 28–38, figs. 18–21, 27, 28.
7. On Doomer and his work, see Baarsen 1996, pp. 739–49; Baarsen 2007, pp. 80–109.
8. For the dish, see *Amsterdams Goud en Zilver* 1999, cat. no. 11.
9. *De Wereld Binnen Handbereik* 1992, no. 89; Kisluk-Grosheide 1997, pp. 129–30, cat. no. xxII, ill. p. 107.
10. See Gisluk-Grosheide 1997, pp. 126–27.
11. Van Seters 1958, pp. 173–238.
12. See *De Wereld Binnen Handbereik* 1992, pp. 33–35.
13. Ibid., pp. 33–35, 57–60; Pijzel-Dommisse 1987.
14. Sale, Amsterdam, October 20–21, 1707, p. 9, under no. 30.
15. Ter Molen 1984, vol. 1, cat. no. 143.

CATALOGUE 68. Cornelis Bellekin (Amsterdam ca.
1625–before 1711 Amsterdam), Shell with bathing nymphs, 1650–1700.
3 1/4 × 2 7/8 inches (8.2 × 7.2 cm). Signed at bottom: *C. bellekin*

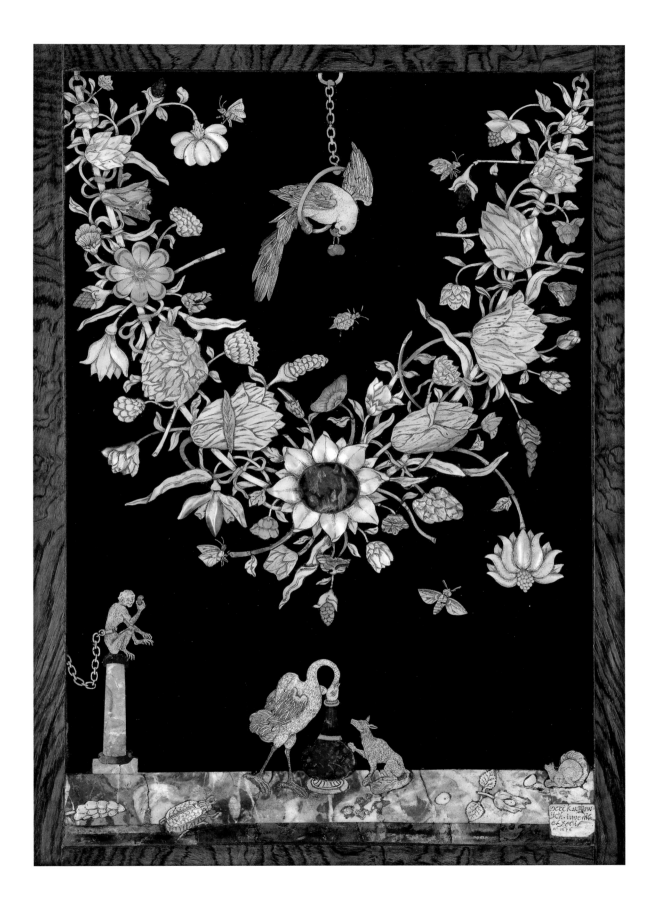

CATALOGUE 69. Dirck van Rijswijck (Cleves 1596–1679 Amsterdam),
Panel with a garland of flowers and animals, 1676. Slate, inlaid with
mother-of-pearl, marble, rosewood, and amber, 16 × 10 1/2 inches (40.5 × 26.7 cm).
Signed and dated (engraved on mother-of-pearl) lower right:
Derck. v. Rÿswÿk. invenit et fecit A° 1676

342

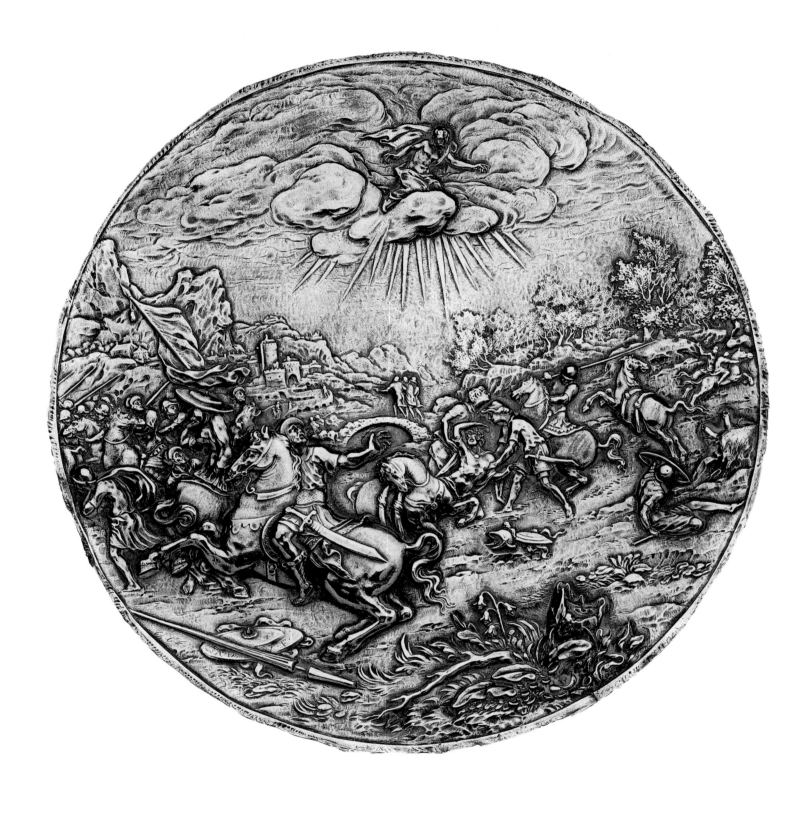

CATALOGUE 70. Adam van Vianen (Utrecht 1568/69–1627 Utrecht),
Plaque depicting the conversion of Saint Paul on his way to Damascus,
1610–15. Silver, diam. 6 3/4 inches (17 cm). Signed (engraved) on shield in
lower left: *A. DV. F*

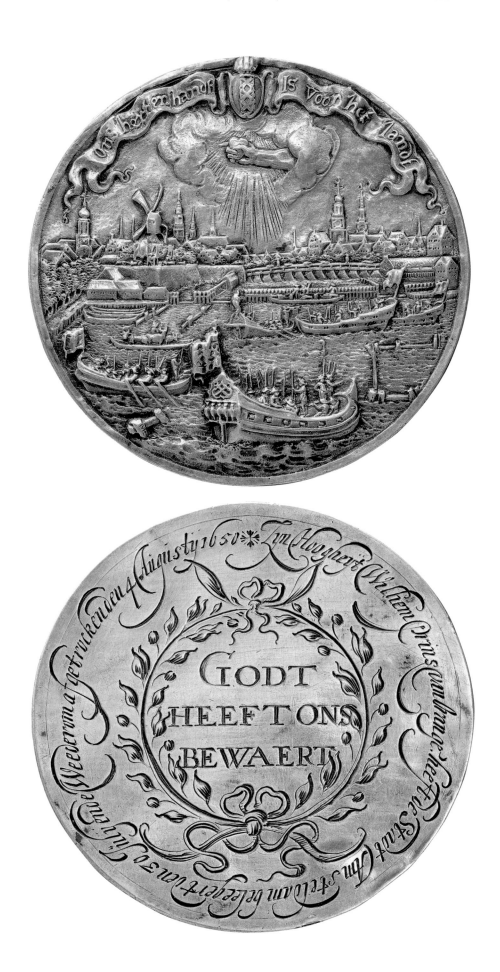

CATALOGUE 71. (front and back) Medal commemorating the Siege of
Amsterdam, 1650–1700. Northern Netherlands. Silver, diam. 2 5/8 inches
(6.7 cm).

DUTCH FURNITURE

FROM THE GOLDEN AGE

LOEK VAN AALST

Little original, unaltered Dutch furniture from the seventeenth century has survived, especially in comparison to Dutch paintings from the Golden Age. This disproportion is not surprising: even at the time, household inventories indicate that wealthy citizens of the Netherlands had a large number of paintings – sometimes literally covering the walls – but only a few pieces of furniture.

The reasons for this are varied. Built on narrow lots along the canals, Dutch houses in the seventeenth century were small, on average 23 feet wide by 49 feet deep (7 × 15 m) with several stories. Fireplaces and box beds built into the walls left little room for furniture.[1] The living and working area was on the first floor and that was where the furniture stood. From the street, one entered the front room (*voorhuis*), where visitors were received and business conducted. To create additional space, a so-called wooden box (*hangkamertje*) was sometimes suspended from the ceiling beams to serve as a small office. With its tall leaded windows, the front room offered an opportunity to showcase the status of the owner through display of the most substantial pieces of furniture. Behind this room lay the primary living space (*binnenhaard*) where the family cooked, ate, and slept. Typically, behind it was a courtyard that brought light into the rear of the house. Wealthy people sometimes converted the outdoor space into a large back room (*sael* or *salet*), which provided more space for paintings and furniture. A rear annex sometimes contained additional rooms.

However, the main reason that furniture was scarce then and now, was that an elaborately worked piece of furniture was very expensive – much more costly than an average painting. In a year, a master cabinet-maker earned around two hundred guilders – not a high wage – and his labor represented only a small portion of the total cost of the piece.[2] He had to invest in expensive oak, most of which the Dutch East India Company imported from the Baltic countries. If he also used tropical hardwoods, which had to be bought at public auctions, this alone would make the piece fairly expensive. By contrast, a painter, unless he was famous, was regarded as a craftsman rather than an artist. All he needed was a canvas or an oak panel and pigments to grind for his paints. The time spent on an average painting was a fraction of what the cabinet-maker needed for a cupboard or table.[3]

Consequently, such furniture could be purchased only by the very rich, who were aristocratic regents, and the class below them to which wealthy merchants and university graduates belonged.[4] The latter group earned a thousand guilders or more a year. Together, these two groups made up less than seven percent of the total population of the Republic of the Seven United Provinces, as the Netherlands was then known.

A NEW STYLE FOR THE NETHERLANDS

The flowering of the Dutch Republic during the early 1600s owed much to the refugees who fled Spanish-controlled Flanders. Merchants, artists, and craftspeople brought their money, expertise, and trading connections to the more tolerant and Protestant Northern Netherlands. They had a great influence on the development of Northern Netherlands furniture. In the sixteenth century, the people of the North were still preoccupied with their struggle against the encroachment of the surrounding sea. There was scarcely any question of economic growth. Their neighbors to the South, the Flemish and the Brabanters, were enjoying their Golden Age: artists found patrons in the prosperous trade centers such as Antwerp, Bruges, and Ghent, and the court itself. This affluence and patronage came to an end with the iconoclasm of the Reformation: a large part of the population fled, first the Catholics and later the Protestants.

The refugees brought with them their knowledge of the latest Italian style, a rebirth of the designs of classical antiquity. Flemish architects and cabinet-makers learned about the Renaissance

through the books of the Italian architect Sebastiano Serlio (1475–1554), whose works were trans-
lated by the sixteenth-century Flemish painter Pieter Coecke van Aelst (1502–1550). The influential
Dutch designer Hans Vredeman de Vries (1527–after 1604/1605) adapted Renaissance ideas
into furniture designs. His book on ornament, published in Antwerp in 1565, brought about the
great "rebirth of the classics" in Dutch furniture. Remarkably, however, while taking account
of Renaissance thinking, the provinces of this small country maintained their local stylistic character.

THE MAKING OF DUTCH FURNITURE

For centuries, furniture had been commissioned by the Roman Catholic Church. Now, the
new patrons in the Dutch Republic were the wealthy burghers. These new clients, who were mainly
Protestant, did not like excess, preferring the sober and sound. They felt entirely at home with
the orderly classical style, which gave them an aura of erudition. As prosperity steadily grew in the
second quarter of the seventeenth century, furniture increasingly became a status symbol and
the more flamboyant Baroque style that had been popular for decades in the South also became
influential in the North. Forms became more imposing and even playful through the use of more
and more carving, ripple molding, pillow forms on panels and posts, spirally twisted rails and legs,
and the frequent use of tropical hardwood veneers.

Dutch furniture from the seventeenth century was largely made of oak, which was considered
to be an attractive but also a reliable type of wood. Seating, however, was almost always made of
walnut. Chairs, whose components were generally turned, were made by turners rather than joiners
(cabinet-makers). It was much easier to make legs on a lathe if they were walnut: in contrast to
resistant oak, walnut has almost no grain and thus can be turned very smoothly.

Preparing oak to be used by the cabinet-maker took a very long time. First, the trunk was
"watered" for years in a river or ditch to remove the tannic acid. Then, still wet, the trunk was sawn,
followed by more years of drying. In the Netherlands, furniture was almost always made from
quarter-sawn oak, known as wainscot. In many other countries in Europe, particularly England,
straight-sawn oak was used. Straight-sawing means to saw the tree along its length into planks.
This process produces wood with a flamed grain: the "flames" are the tree's annular rings that
have been sawn through. The disadvantage of this method is that the planks are likely to warp
and they may shrink by as much as twenty per cent. However, there is less waste and the process is
less labor-intensive than quarter-sawing. In this latter method, the tree is first split into four
equal parts. Then, planks are produced from these trunk quadrants by sawing from the outside to
the core. This process creates wood with flecked silvery lines – formed from the harder pieces in
the wood – that shine when brushed. Although this method is expensive, the wood scarcely warps,
there is next to no shrinkage, and the silvery figures give it a beautiful appearance.

THE GUILDS

All craftsmen, including cabinet-makers and painters alike, were required to join their professional
organization, the guild. Guilds were founded to protect their members and the work they did.
Products were strictly monitored, not only to maintain quality, but also to ensure that competition
remained fair. Guilds also performed a social function: members received financial support when
ill and the guild paid for funerals; a widow received stipends until she remarried. Some guilds
regularly clashed because they infringed on each other's terrain. This happened chiefly with the
guilds of the carpenters, cabinet-makers, woodcarvers, and turners, whose territories overlapped.

To set up his own workshop, a young man first had to be an official resident of the city. At about age twelve, he could become apprenticed to a master for as long as seven years. During this time, he earned nothing and his parents had to make substantial payments for his training, board, and lodging. Following his apprenticeship, the craftsman had to make a masterpiece that the guild deemed suitable. If he was successful, he could become a member of the guild, provided he paid a sizable initiation fee. If he had no money, he worked as an assistant.

CHESTS AND CUPBOARDS (*KISTEN* AND *KASTEN*)

From the 1400s to well into the 1600s, most Dutch homes had at least one chest. This versatile piece of furniture was used for both storage and seating – in fact, the first stools and chairs developed from chests. In general, chests were simple pieces of furniture, but beautifully carved showpieces in oak with ebony accents were also made. Unlike the more utilitarian chests with metal handles on the sides, such chests were fairly fragile and were not intended for storing or transporting heavy goods.

A richly worked chest (*kist*) in the Van Otterloo collection was made in the province of Holland in the Northern Netherlands between 1640 and 1650 (catalogue 76). Its joined construction includes delicate posts and the back consists of horizontally placed thin planks rather than a framed panel. It is likely that costly textiles or wedding presents were stored in it. The exuberant carving, which may have been done separately by a woodcarver, freely interprets the new classical vocabulary. The carving changes from flat strapwork motifs and rosettes to lobelike foliage – a development also seen in four-door cupboards from Holland from between 1640 and 1650. The corner posts are still fluted and are richly decorated with ebony openwork (*zaagstukje*) and turned ornament (*gesphanger*), but they are now also flanked by a carved leaf frame. There is no longer a flat lower rail, but an applied, shaped molding. Just as intricately worked as the front, the sides consist of two panels in a framework of molded rails and posts. The front posts end in ebonized ball feet like those seen on cupboards.

Two-door (*beldenkasten*) cupboards called *ribbanken* (catalogue 80) would have been owned by only the wealthiest households in the Southern Netherlands during the seventeenth century. Several cupboards of this type are mentioned in descriptions of the home of the painter Peter Paul Rubens (1577–1640).[5] The carving on seventeenth-century Flemish furniture was not usually very refined, but this cupboard (formerly in the Château de Walzin, Dinant, Belgium) proves that Flemish carvers could make superb, detailed carving. The very complicated geometrical pattern features thick moldings applied to the doors and sides, accentuated by the use of ebony. This complex pattern is not found in the more modest style of the Northern Netherlands. The low, wide shape of the piece is also typical of Flemish furniture. Only in the northern provinces of Brabant and Zeeland, which border on Flanders, were there cabinets with comparable forms. Like most early Flemish cupboards, this one stands on square posts rather than the ball feet often found in Dutch cupboards.

The decoration of this cupboard, made by a woodcarver and a cabinet-maker, is rich in contrast yet forms a harmonious whole. The back posts are decorated with fauns: one plays a flute and the other a bagpipe. The front posts bear personifications of two divine and one cardinal Virtue: Faith with a book (bible) and cross, Love with two children, and Justice with scales and a sword. The fantasy creatures carved on the two top drawers symbolize Sea and Land. The two bottom drawers depict camels, monkeys, dogs, ostriches, and lions. On the sides are playful

cherubs and fantasy animals. Two figures are centrally placed in the door panels: the one with a bagpipe symbolizes Peace and the other with a knife symbolizes War. Together with the large fauns on the back posts, they look as though they stepped out of a painting by Pieter Brueghel the Younger (1564/65–1636). In the side panels are two male heads: one shouting to symbolize Noise and the other with mouth closed to symbolize Silence.

FLEMISH DESIGN MOVES NORTH

In 1585, a Zeeland toll was introduced on the waterway to and from Antwerp. As a result, the principal Flemish port was largely eliminated as a transit harbor, while Zeeland ports flourished. The provincial capital Middelburg became the most important port after Amsterdam and thus earned a seat on the board of the Dutch East India Company, and later the West India Company.

This growth was caused in part by the flight of many Calvinists from the South to Zeeland. They left their mark not only on the architecture but also on the design and ornamentation of furniture and paneling in Zeeland. These Flemish cabinet-makers had reached a very high standard in decorating furniture with intarsia and marquetry in the sixteenth century, their Golden Age.[6] In their flight to the North and also to Germany, they took their knowledge with them. The ornamentation of lion masks and half-length figures often appears on Zeeland cupboards, as it does, for example, on paneling from Zeeland, now in the Rijksmuseum, Amsterdam.[7]

These cupboards are completely unlike those from the rest of the Netherlands. Because the top lacks a frieze and the plinth has no drawers, the cupboards are low and wide, almost square. They consist of two parts, one on top of the other, which appear to have little in common. Most Zeeland cupboards have four doors, but a few have three instead of two doors in the upper section. The posts of the upper part are adorned with lion consoles and the posts of the lower part have fluting, openwork, and turned ornaments. Sometimes the lower posts are decorated with male and female half-length figures known as atlantes and caryatids.

The chief difference between Holland and Zeeland cupboards is that Holland cupboards were decorated by splendid carving, while Zeeland cabinet-makers chose to partly veneer the cupboards and inlay them with costly tropical hardwoods. Zeeland cupboards after the middle of the seventeenth century were almost completely veneered.

The five-door cupboard (*vijfdeurs kast*) in the Van Otterloo collection (catalogue 81) is a fairly early Zeeland cupboard. This is indicated by the Moresque intarsia decoration in native maple and by the somewhat restrained carving, such as the simple top consoles with leaf pattern and the lion masks in which this pattern recurs. Moreover, there is no drawer between the upper and lower parts. As was typical, a fair amount of ebony and rosewood was used to create contrast with the lighter oak and thus add depth. An ebony geometrical pattern has been inlaid in the horizontal panel on the side of the upper section.

Although called a five-door cupboard, this is in fact a four-door piece. The upper part appears to have four fixed posts, but that is an optical illusion. The right-hand center post is fixed to the right-hand door, thus creating a double opening when both doors are opened. The cupboard originally stood on extended posts, not on ball feet.

LAYETTE CUPBOARDS (*LUIERMAND KABINETTEN*)

In the Dutch Republic, the wealthy usually had a nursery (*kraamkamer*) adjacent to the bedroom of the new mother where visitors were received. It was equipped with a cradle, a couch for the

mother, plus small pieces of furniture. There was also a small layette cupboard (*luiermand kabinet*) in which a (possibly silver) diaper basket was kept.

In its dimensions, this small cupboard (*rankenkastje*) in the Van Otterloo collection (catalogue 79) falls between a normal-sized piece (approximately 78 3/4 inches high [200 cm]) and a miniature cupboard (approximately 13 3/4 inches high [35 cm]). This raises the question of what it was used for. It is of exceptionally high quality, and probably stood in a nursery. Under the corbelled top is a splendid ogee-planed double frieze with consoles in the center and at the corners. Five doves, each with a branch in its beak symbolizing Peace, ornament the frieze. The unusual style of this frieze reveals the influence of the workshop of the Amsterdam ébéniste Herman Doomer (ca. 1595–1650), which suggests that this piece may have been made in an Amsterdam workshop. A striking feature is the diagonal placement of the corner posts, which form a unit and turn with the doors to produce an especially large opening. The center post is fixed to the door, as is the case with all Dutch seventeenth-century cupboards. The three front posts form pilasters with Corinthian capitals and vividly carved foliate trails. In the center of the door panels is a slightly raised panel with foliate trails.

Another cupboard (*tafelkastje*) in the Van Otterloo collection could also have been made for a nursery: a two-part stacked piece consisting of a two-door cupboard with a drawer and a ball-foot table also with a drawer (catalogue 82). Signs of abandoning strict Renaissance rules for a more Baroque approach are clearly evident and indicate a slightly later date around mid-century. For example, because there is no frieze, the cornice turns directly into a narrow carved architrave. Moreover, the Ionic columns against the posts no longer have a weight-bearing function. The table spreads out considerably compared to the cupboard and there are no connecting stretchers between the legs.

It is quite exceptional for the two sections still to be together. That they were originally an entity is established by, among other things, the carving on the front of the cupboard drawers that matches the carving on the sides of the table. The carved Virtues in the panels and the lion consoles are also seen in Dutch four-door cupboards. The door panels depict Prosperity (left) and Victory (right). The palm branch and laurel wreath symbolize Victory and Honor, and the snake stands for Prudence. Prosperity is represented by a Horn of Plenty.

FOUR-DOOR CUPBOARDS WITH FIGURES (*BEELDENKASTEN*)

The four-door cupboard with figures (*beeldenkast*) is probably the best-known form of Dutch furniture. The term *beeldenkast* is used only for these expensive cupboards made of oak (plus ebony or, in Flanders only, tortoiseshell, veneer) with a lot of fine carving. Extremely rare, *beeldenkasten* are regularly featured in publications and have a wide appeal. This showpiece developed from the much simpler Dutch four-door Renaissance pilaster cupboard, characterized by Ionic pilasters on the posts and simple ornaments on the door panels. In the column cupboard, a more elaborate version, Ionic and Corinthian columns alternate.

The rarest and most costly *beeldenkasten* have carved figures on the posts.[8] The door panels contain biblical scenes or allegories. Such cupboards were especially expensive because the carving of the figures, and often the ornament as well, had to be done by a woodcarver – a craftsman capable of handling the coarse grain of oak. This meant that two masters were required.

Almost all of these cupboards were made in Amsterdam, where most of the wealthy lived, and date chiefly from the first half of the seventeenth century. Such a cupboard was not only a

tremendous status symbol, but also a sign of the owner's piety: the figures were often Virtues, while the door panels depicted an edifying story from the bible. The owner managed to display a splendid, expensive cupboard while avoiding the criticism of ostentation. After all, it served as a daily reminder of his religious obligations. On occasion, one of these cupboards would be given as a wedding present.

In the splendid cupboard in the Van Otterloo collection (catalogue 77), the coat of arms of the city of Enkhuizen depicted on the soffit, the underside of the cornice,[9] may indicate a commission from the city authorities. The frieze features four *tronies* (facial studies) of two men flanking those of two women. Between the two female heads is a small frieze depicting the Adoration of the Shepherds. In the cartouches of both friezes are images symbolizing Summer and Fall.

The upper cupboard is divided into two doors with a narrow panel in between. This division into three is most unusual for a *beeldenkast*.[10] The effect is that the doors are flanked by four figures instead of the customary three. More slender in design than those on other known *beeldenkasten*, these are graceful female figures with long necks and bare breasts. The sheer folds of their elegant Classical robes seem almost transparent. From left to right, the women symbolize the Virtues Faith (*Fides*), Love (*Caritas*), Temperance (*Temperantia*), and Hope (*Spes*).[11] The carver must have been strongly influenced by the work of Hendrick de Keyser (1565–1621), who designed the tomb of William the Silent in Delft at around this time (catalogue 32). His figure of Saint John on the choir screen of the Sint Jan Cathedral in 's-Hertogenbosch (now in the Victoria & Albert Museum, London) bears a striking resemblance to the figures on this cupboard.[12] The carving on the two door panels depicts two episodes from the story of the Prodigal Son (Luke 15: 11–32). An interior with a table and benches is visible. In the middle of the richly worked rail between the upper and lower cabinet is a console with Abraham's Sacrifice of Isaac (Genesis 22: 1–14).

The most remarkable feature of this cupboard are the two arches on the doors of the lower section. No other Dutch *beeldenkast* bearing this motif is known. The design of these carved arches is derived directly from a 1583 engraving of the Ten Commandments by Hendrick Goltzius (1558–1617) (figure 1).[13] The superbly carved main figures in the arches are two of the four Evangelists: John with an eagle and Matthew with an angel. On the bases of the Ionic columns placed against the posts are three Virtues: Prudence, Justice, and Perseverance. Flanking the two drawers in the base are the Three Kings, each one placed in an arch: Balthazar bearing myrrh, Caspar incense, and Melchior gold (Matthew 2: 10–12).

A more typical Dutch four-door *beeldenkast*, also in the collection (catalogue 78), offers an instructive comparison. It has the usual arrangement of three figures on the upper posts instead of four. It also has figures on the lower posts, where the Enkhuizen cupboard (catalogue 77) has Ionic columns. The upper figures represent seasons. The figures on the lower posts are, from left to right, young David with the head of Goliath, King David, and Judith with the head of Holofernes. Allegories of Virtues are carved into the door panels. The use of ebony and the elaborate treatment of the sides indicate that this piece is somewhat later, around 1640.

SMALL WORKS IN WOOD

Despite the Reformation, sculptors typically were commissioned to carve ecclesiastical sculptures and copies of Classical figures rather than themes from everyday life. A boxwood sculpture of a man in contemporary clothing (catalogue 72) is a superb and rare example of a small secular carving from the second half of the seventeenth century. Boxwood has a very fine composition with

scarcely any grain, which enabled the carver to achieve extremely nuanced details in the figure's face, arms, and hands. The finely carved clothing creates a sense of movement. Originally, this figure was most likely paired with a boxwood sculpture of a woman with a baby in her arms and a dog at her feet (figure 2). The man carries a sort of cloth – perhaps a diaper – as he walks toward the woman with open arms. He looks both proud and pleased. Together, these two figures represent Parenthood and Faith (symbolized by the dog) – important values in Dutch seventeenth-century society. Small statues such as these two figures were probably ordered to be put in a *kunstkammer*, a room decorated by the wealthy with precious art objects and curiosities for their own pleasure, but certainly also to impress visitors.

This pair of figures must have been made by one of the very best carvers of the period. Seventeenth-century sculptures were rarely signed by a master, but many important Dutch and Flemish sculptors from this period are known through their public commissions. The carved oak pulpit in Amsterdam's Nieuwe Kerk, one of the most important examples of Dutch mid-seventeenth-century sculpture, was made by Albert Jansz. Vinckenbrink, who was also known for his small sculptures. He was the most likely carver of both these figures. The figure of the walking man relates closely to the so-called "*Rattengifverkoper*" (seller of arsenic), a small sculpture attributed to Vinckenbrink in the Rijksmuseum, Amsterdam.

Most rooms in seventeenth-century houses had an open fireplace for burning peat and sometimes wood – the only source of heat during the often long, cold winters. The kitchen fireplace

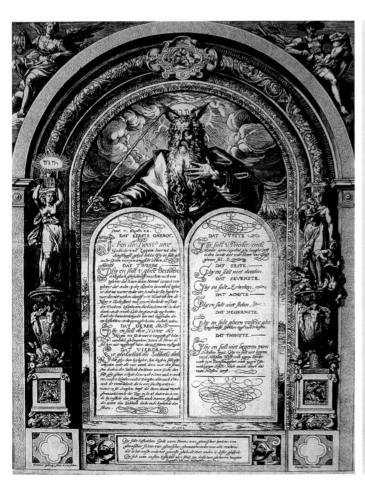

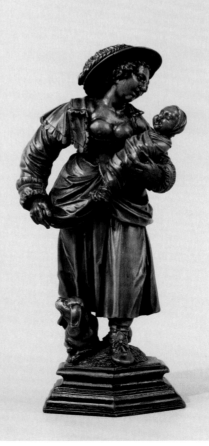

Figure 1. Hendrik Goltzius, *Moses and the Tables of the Law with the Ten Commandments*, 1583. Museum Boijmans Van Beuningen, Rotterdam.

Figure 2. Attributed to Albert Jansz. Vinckenbrink, *Figure of a Woman*, 1650–65. Boxwood. Private Collection, Belgium (formerly Collection Van Aalst Antiquiteiten, Breda).

was also used for cooking. Making a fire with flint and tinder was quite a job and once there was a flame, bellows were used to fan it. No doubt most bellows (*blaasbalgen*) were very plain in design. However, the fireplace bellows in the Van Otterloo collection (catalogue 73) echoes the skillful carving of biblical subjects on furniture. It was probably done by a woodcarver who also worked on the panels of a cupboard. The far from commonplace religious scene comes from the Book of Judges 11: 34–37. A despairing Jephthah is in danger of having no posterity because he has promised God he will sacrifice his only child if God will hear his prayers. This embellished example hung on the wall, so the back was never decorated.

Another household tool was the linen press (*kleine tafelpers*), a small object sometimes mistakenly identified as a book press. Book presses needed to be heavy and powerful, hence they were largely made of iron. By contrast, the wooden hand press in the Van Otterloo collection (catalogue 83) was probably used to put crisp creases into linen napkins and tablecloths. The surprising feature of these small hand presses is how the spindle is turned: the handles are above the scaffold beam instead of above the press plate. The press stands on trestle supports, which are also seen in late sixteenth-century chests. Here, the supports serve as firm anchors for the posts of the scaffold. On the front of the supports are recumbent lions that resemble sphinxes. A drawer between the supports can be pulled out at the back.

TABLES

Tables were very expensive in the seventeenth century. Most families made do with a few planks placed on two barrels or trestles. Nevertheless, tables were made in various forms: bailiff, tilt-top, stool, and *kwab* (auricular- or lobe-shaped), and the best-known style, the draw-leaf table with two leaves under the top that can be pulled out to almost double the length. Because doorways were generally rather narrow, it had to be possible to disassemble the table, which was done by taking out the screws in the housing of the legs and removing the leaves.

Tables served to display food and drink; people then did not sit and eat at the table. Indeed, the stretchers would have made this difficult to do. When the table was not in use, sometimes an Oriental carpet or a wool tapestry specially made for the table and decorated with bouquets and biblical scenes was laid over it. These tapestry tablecloths were a Northern Netherlands speciality and were made mainly in Delft, where the weavers were refugees from Flanders.[14]

In the Van Otterloo collection is a fine example of a Southern Netherlands draw-leaf table (*balpoottafel* or *trektafel*) from the beginning of the seventeenth century (catalogue 84). The ball-shaped legs are characteristic of Dutch draw-leaf tables. In early tables such as this one, they were still fairly cylindrical, but toward the end of the century, as they were going out of fashion, they became much larger and spherical. Rather than waste an extremely thick piece of wood to make the spherical legs, the maker added wood blocks to all four sides of each leg before turning them. The maker did this for several reasons: the leg was made from a single piece of wood; to avoid wasting wood, he thickened the leg only at the position of the ball. This process also reduced the chance of splitting the wood.

The top is held in place by two flat pins. In Southern Netherlands tables, such as this one, they are on the outside of the upper stretcher; in Northern tables they are "invisible" on the inside. The stretchers between the legs strengthen the table. In the first half of the seventeenth century, they form a rectangle; in the second half of the century, the stretcher moved to the middle of the table with a V-shaped connection at the two ends, a so-called double-Y form. The tables themselves changed from solid everyday objects into veneered showpieces with more ornamentation.

The highly functional bailiff table (*betaaltafel*) (catalogue 86) was used for various purposes. Its most important feature is the secure space underneath the table-top containing several compartments and drawers in which money or documents could be stored.[15] It is basically a smaller version of the draw-leaf table, but with a sliding top that could be closed with a large lock. A piece such as this example would have been found in the office of a merchant or notary. A striking feature is the top inlaid with rosewood edging and a large diamond shape.

After the middle of the seventeenth century, a remarkable, characteristically Dutch piece of furniture was created, the so-called *kwabtafel* (catalogue 87). Its development was greatly influenced by examples of the style included in a print series, *Verscheyde Aerdige Compartimenten en Tafels, Nieuwelyckx geinventeert* (Various Nice Compartments and Tables Newly Designed), published in 1655 by Gerbrand van den Eeckhout (1621–1674), a pupil of Rembrandt. These tables could be used in two ways: as a table with a separate top, or, without the top, as a stand for a collector's cabinet.[16] They were showpieces that were originally painted in polychrome or sometimes even gilded; most are in limewood. They were made by a woodcarver, not a cabinet-maker, who first produced a miniature terracotta model (2 3/4 × 4 3/4 × 1 3/16 inches [7 × 12 × 3 cm]) before executing the piece.[17] The fairly recent name *kwabtafel* is derived from the table's relationship to silver in the auricular (*kwab*) style, an organic style that is typically associated with Dutch silversmiths Paulus and Adam van Vianen (catalogue 70).

At first sight, this rare table (*kruktafel*) (catalogue 85) looks like a fairly wide stool – which is not surprising because both forms were constructed in the same way.[18] There are several versions of this table: in addition to the example here with extendable leaves, there is a fixed-leaf type (also represented in the Van Otterloo collection) and one with hinged side leaves. In the present table, the lower leaves slide on two wooden guides placed under the top. When they are pulled out, on the long side, an almost square table top is created. With the draw-leaf table previously described (catalogue 84), the leaves extend on the short side, making it longer. Given its limited height, the present table would probably have had something placed on top, such as a linen press (catalogue 83). One could also sit at this table on a low three-legged stool.

CHAIRS

From antiquity, sitting on a chair was a privilege reserved for those of the highest stature and confirmed their status. No chairs were to be found in middle-class households until late in the Middle Ages. People sat on simple three-legged stools, benches, or "barrel chairs." It was not until the late sixteenth century that heavy oak armchairs appeared in the Netherlands. They were intended for the head of the household, with possibly a slightly lighter version for his wife; no chairs existed for children. A cabinet-maker made chairs, true pieces of furniture with mortise joints and panels in frameworks.

At the beginning of the seventeenth century, the so-called "Spanish chair"[19] appeared, which was partly turned. As the name suggests, its design was influenced by chairs from the Iberian peninsula. It was made of walnut and is much lighter than the sixteenth-century chairs but still robust. The legs were connected by straight stretchers at three places located one above the other; thick leather, fastened with decorative brass nails, covered the seat and back. These were Renaissance chairs with turned balusters in the legs and lion masks at the top of the back posts.[20] After a great deal of conflict among the various woodworkers' guilds, the new guild of the Spanish chair-makers came into existence.

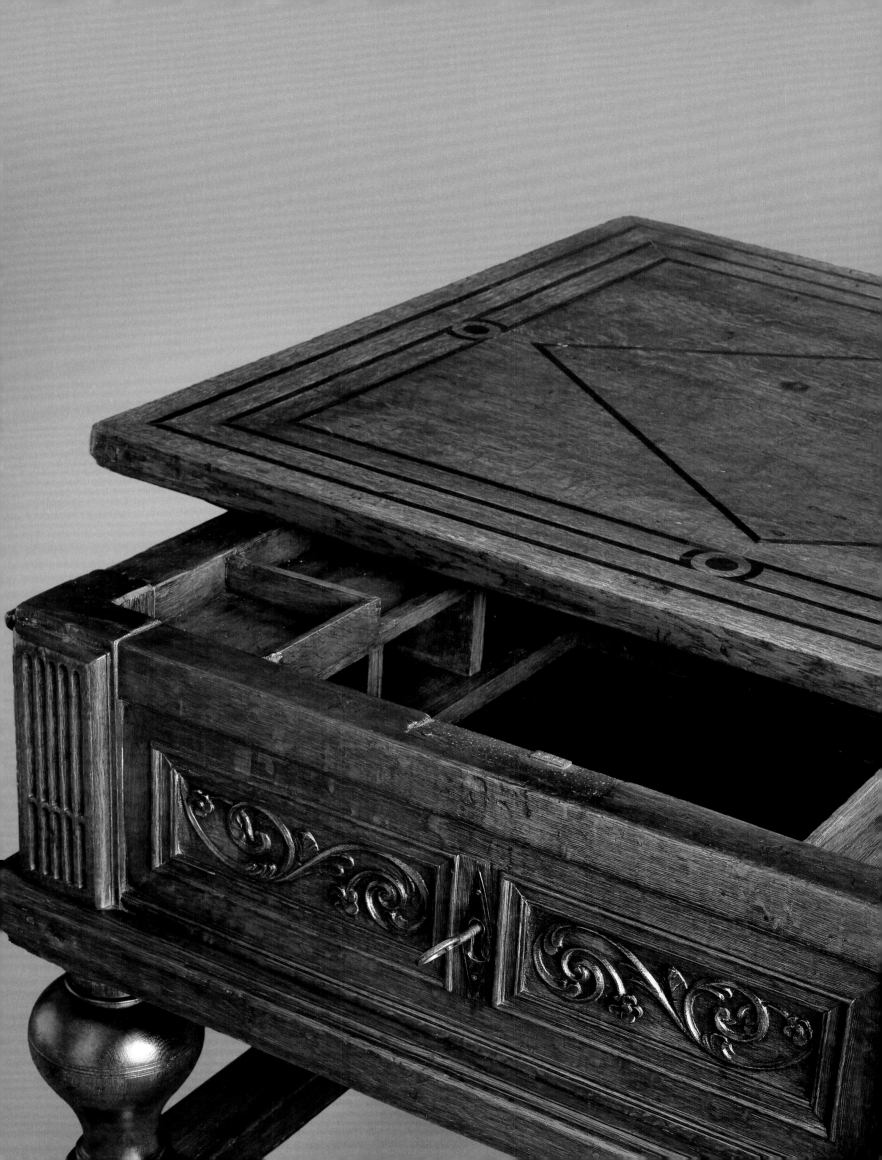

In meeting rooms, the chairs often had cushions embroidered or tapestry-woven with city or provincial arms. For the first time, sets of the same chairs were made. When not in use, they were lined up against the wall. This type of chair was popular with painters and was often used in portraits and genre scenes, such as Nicolaes Maes's *Sleeping Man Having His Pockets Picked* (catalogue 36) and Maria Schalcken's *The Artist at Work in Her Studio* (catalogue 57). When these Renaissance chairs came under the influence of the Baroque style, the model did not change but the decoration did. Ornaments on the top of the back posts disappeared and the balusters and the flat stretchers between the legs gave way to spiraled legs and stretchers. The spiraled decoration remained popular for half a century in the Netherlands, France, and England.

This chair (*stoel*) (catalogue 75) from a set of six in the Van Otterloo collection is a fine example of the spiraled style. The front and back stretchers are now combined in a central stretcher and the side stretchers have vanished, thus indicating a slightly later model. The whole piece was designed to be lighter. These chairs are similar to English types except for the connections between the stretchers and between the stretchers and the legs. With Dutch chairs, the twisted stretchers always end rounded; with English chairs, they end in a square block.

A typically Dutch form of seating is the folding church chair (*kerkstoeltje*) (catalogue 74; see also catalogue 66). It must have been popular because it is regularly listed in household inventories. The fact that few have survived is no doubt due to its weak construction. The back consisted of thin rails and posts, and the seat frame had only two turning points. The folding seat in most cases was made of leather instead of fabric to strengthen the whole piece. The church chairs that have survived are usually made of exotic woods and have carving over the whole frame, front and back. A maid could carry the portable chair, together with a foot-stove, so that her employer could attend the sermon in comfort. Only local dignitaries had their own pew; other worshipers could use their church chair or stand during the often long service. Domestic inventories from Leiden reveal that these chairs were not used in the house but were folded up and hung on a wall in the entrance hall.[21] Thus, the back was clearly visible, which is why it was also richly worked. As with the other types of chairs, there were church chairs for men and for women, as shown by household inventories from Groningen.[22] The smaller size of the Van Otterloos' chair indicates that it was meant for a woman. It is made of walnut, but the knob ornaments on the cresting rail and the twisted posts in the back are of ebony. An almost identical chair in rosewood is in the Rijksmuseum, Amsterdam.

CONCLUSION

Because so little Dutch furniture from the Golden Age has survived, it is significant when collectors such as Rose-Marie and Eijk van Otterloo, who have already assembled an unequaled private collection of paintings from the period, venture into this arena. The Van Otterloos are bringing to the decorative arts, and furniture in particular, the great care and discernment they have demonstrated in their search for paintings. Their collection of Dutch seventeenth-century furniture is substantial and growing. Indeed, it is marvelous to have the very best Dutch *beeldenkast* and the very best Flemish *beeldenkast* in one collection (catalogue 77 and 78). These two pieces alone embody and articulate the different spirits of the Northern and Southern Netherlands.[23]

Notes:

1. Loughman 2000, p. 30.
2. Francis Turner, Money and exchange rates in 1632, online at http://1632.org/1632Slush/1632money.rtf
3. In two cases, we know precisely what cupboards cost their buyers: one cost 111 guilders (about $4,000 in 2010 dollars) and an elaborately carved, larger example 317 guilders (about $11,000), including 49 guilders (about $1,700) for the woodcarver. Archief polder Heerhugowaard inv. no. 257; Archief Waterschap Schermer inv. no. 388.
4. Zandvliet 2006.
5. The former house of Rubens's friend Nicolaas Rockox, mayor of Antwerp, has recently been restored and contains a museum decorated with seventeenth-century furniture. Among the several *ribbanken* is a cupboard similar to this one with the same architecture and the same Virtues on the front posts.
6. *Tussen stadspaleizen en luchtkastelen: Hans Vredeman de Vries en de Renaissance* 2002, cat. 145, shows a door from Antwerp's townhall with inlaid wood decoration (1580; Victoria & Albert Museum, London).
7. Vogelsang 1913, no. 15, p. 21.
8. In the United States, both The Metropolitan Museum, New York, and the Holland Museum, Holland, Michigan, have a Dutch *beeldenkast*. The Philadelphia Museum of Art has a *beeldenkast* that was altered in the nineteenth century.
9. There is one other known *beeldenkast* bearing a city coat of arms, in that case those of both Amsterdam and Hoorn (sale, Amsterdam [Christie's], June 24, 2008, lot 238). It was probably commissioned by a merchant who traded with both cities.
10. This arrangement is found only in seventeenth-century Frisian five-door cupboards, which also have arched panels in the lower doors.
11. Timmers 1974, no. 376.
12. The carving on the cupboard may well have been done by the sculptor Jan Esges of Hoorn, whose name occurs in various documents from around 1615.
13. Van der Waals 2006, fig. 6, p. 13.
14. *Geweven Boeket* 1971.
15. *Art & Home* 2001–2002, fig. 138.
16. Baarsen 2007, fig. 119.
17. A seventeenth-century terra cotta model of a *kwabtafel* is now in the Simon van Gijn Museum, Dordrecht; see Hofstede 2002, fig. 16.04; *Art & Home* 2001–2002, fig. 100. A full-sized *kwabtafel* based on this terra cotta model is in an almshouse in Haarlem; four *kwabtafels* are illustrated in Baarsen 2007, figs. 112–15; and Loughman 2000, p. 166.
18. A similar table is depicted in a painting by Pieter Janssens, named Elinga (1623–1682); see Fock 2001, p. 124, fig. 78.
19. A very celebrated "Spanish chair" is in the Museum het Rubenshuis, Antwerp. On the leather of the back is the name P. Rubens and the emblem of the *De Violieren* chamber of rhetoric.
20. *Portrait of Johan van Beverwijk in His Study* by Jan Olis (ca. 1610–1676) shows the physician and publisher in all his finery seated on a Spanish chair at a table covered by a cloth (ca. 1640; Mauritshuis, The Hague); Loughman 2000, pp. 77, 143–50, fig. 24.
21. Fock 1974, p. 38; fig. 38, a woodcut of 1526 by Dirck Vellert (ca. 1480/85–ca. 1547) shows that these chairs were hung on the wall.
22. De Haan 2005, p. 139.
23. Formerly in the Château de Walzin, Dinant, Belgium.

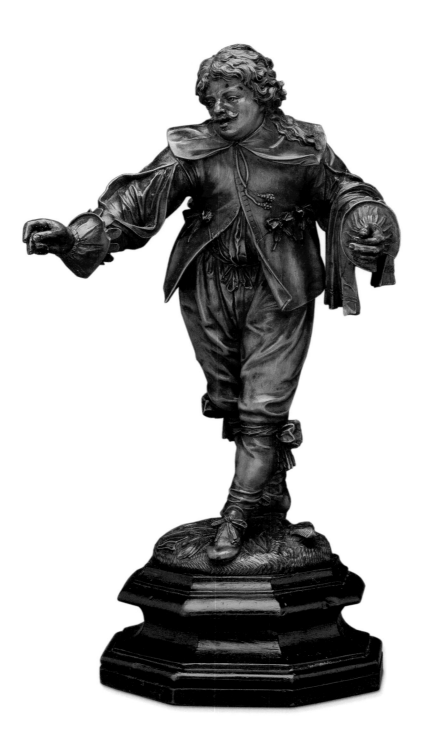

358

CATALOGUE 72. Attributed to Albert Jansz. Vinckenbrink
(Spaarndam ca. 1604–ca. 1664/65 Amsterdam). *Figure of a Man*, 1650–65.
Boxwood, 10 1/8 × 5 3/4 × 4 1/4 inches (25.7 × 14.6 × 10.8 cm).

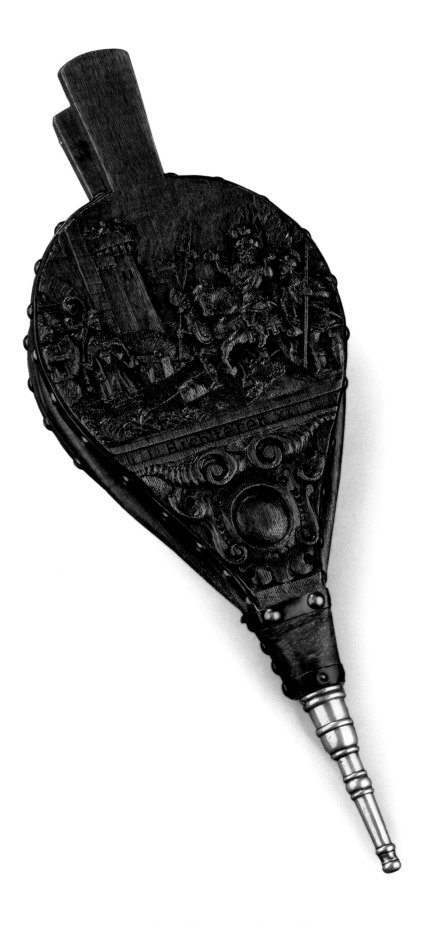

CATALOGUE 73. Bellows (*Blaasbalg*), 1620–40. Northern
Netherlands, probably Province of Holland. Oak, brass, and leather,
20 × 7 1/8 inches (50.8 × 18 cm).

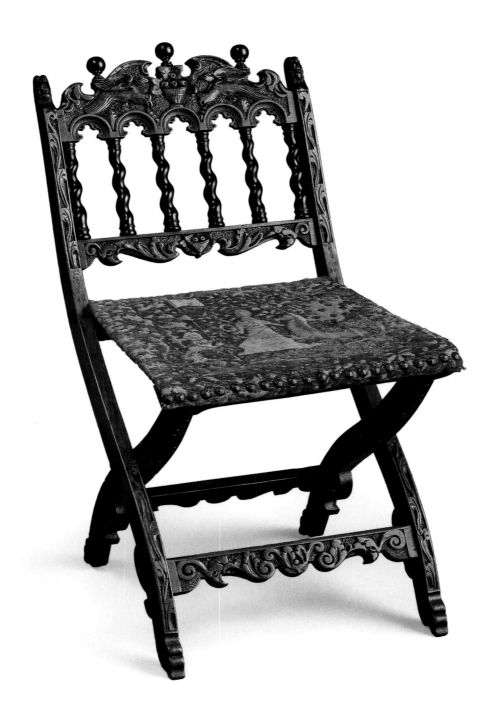

CATALOGUE 74. Chair (*Kerkstoeltje*), ca. 1650. Northern Netherlands. Walnut and ebony, 22 7/8 × 12 1/4 × 17 inches (58 × 31 × 43 cm).

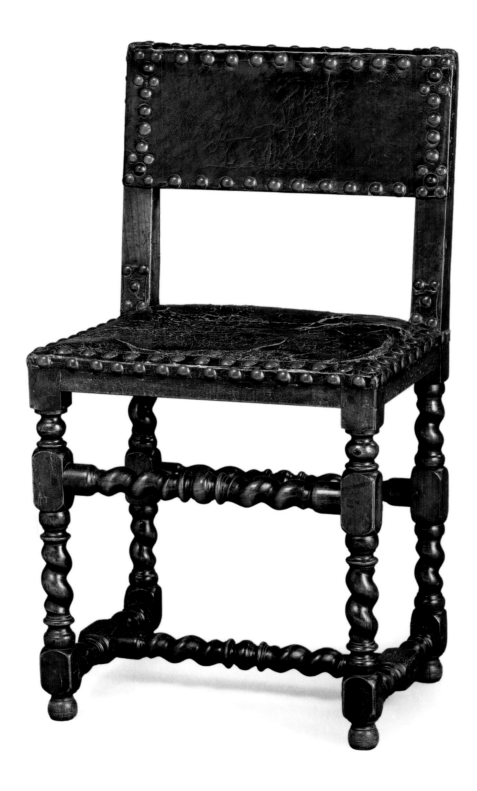

CATALOGUE 75. Chair (*Stoel*) from a set of six, 1650–60.
Northern or Southern Netherlands. Walnut with leather,
34 1/2 × 17 1/2 × 15 3/4 inches (87.5 × 44.5 × 40 cm).

CATALOGUE 76. Chest (*Kist*), 1640–50. Province of Holland, Northern Netherlands. Oak and ebony, 30 3/8 × 60 7/8 × 24 1/2 inches (77 × 154.5 × 62 cm).

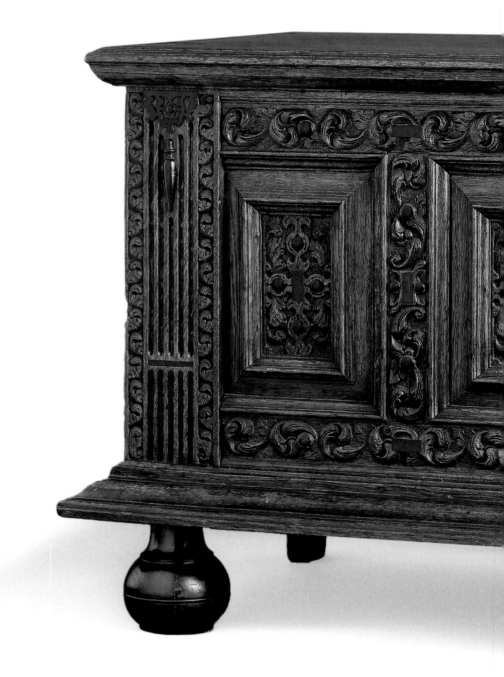

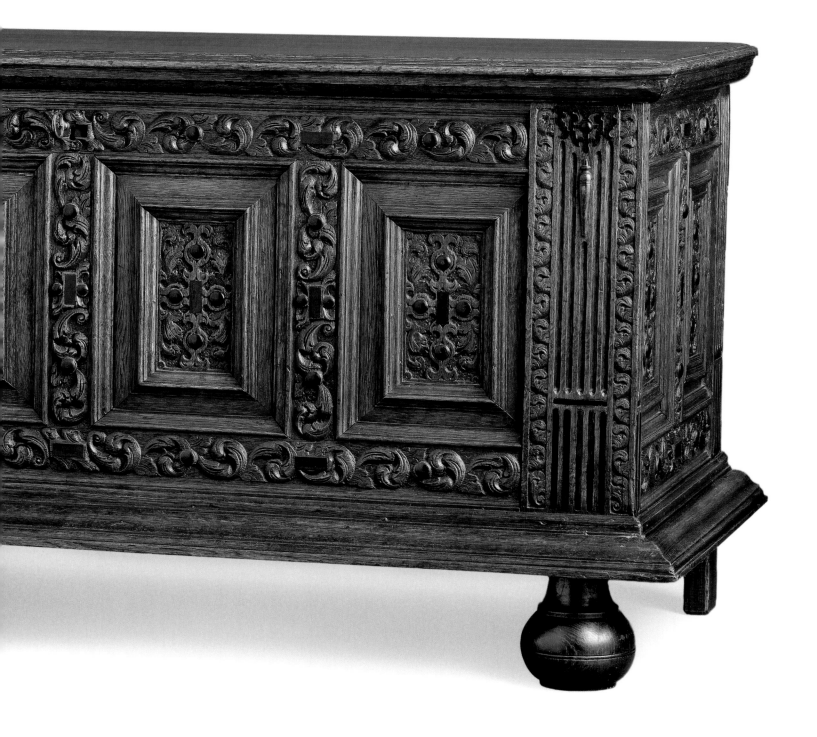

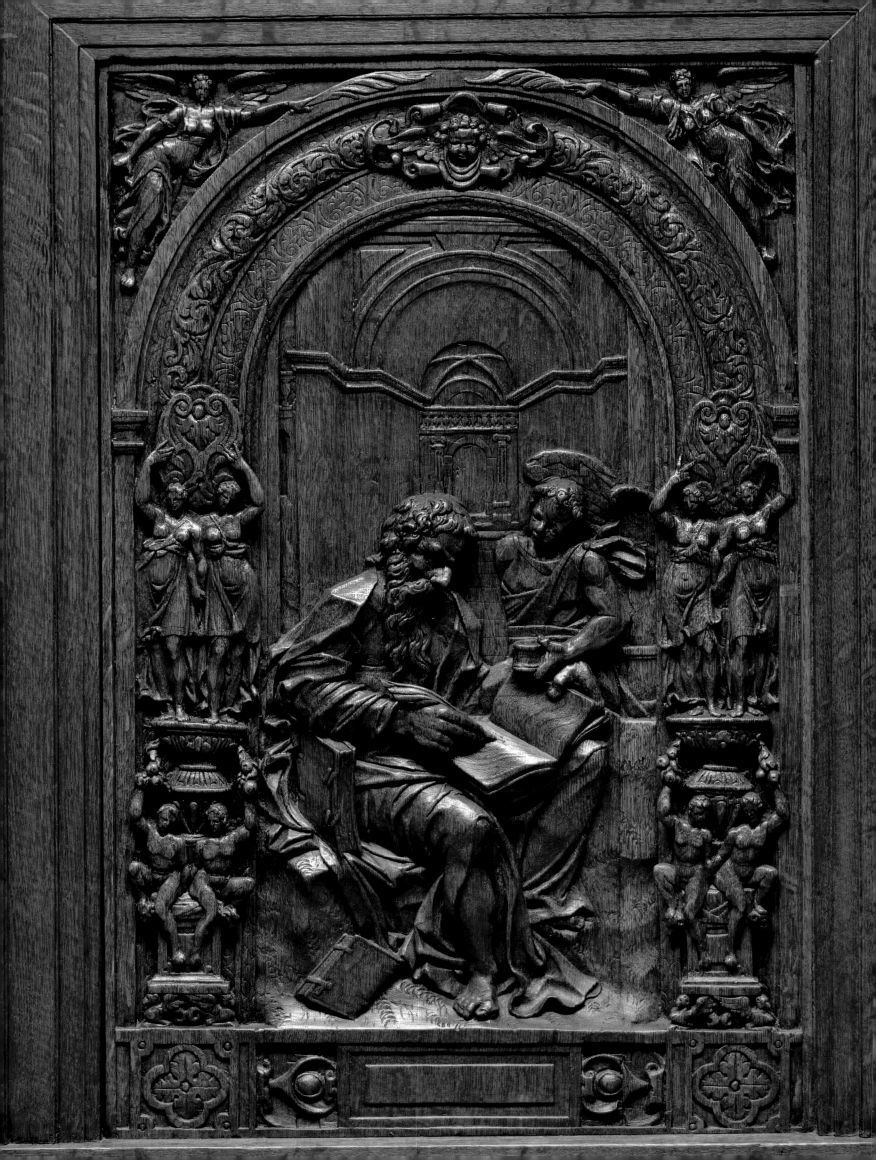

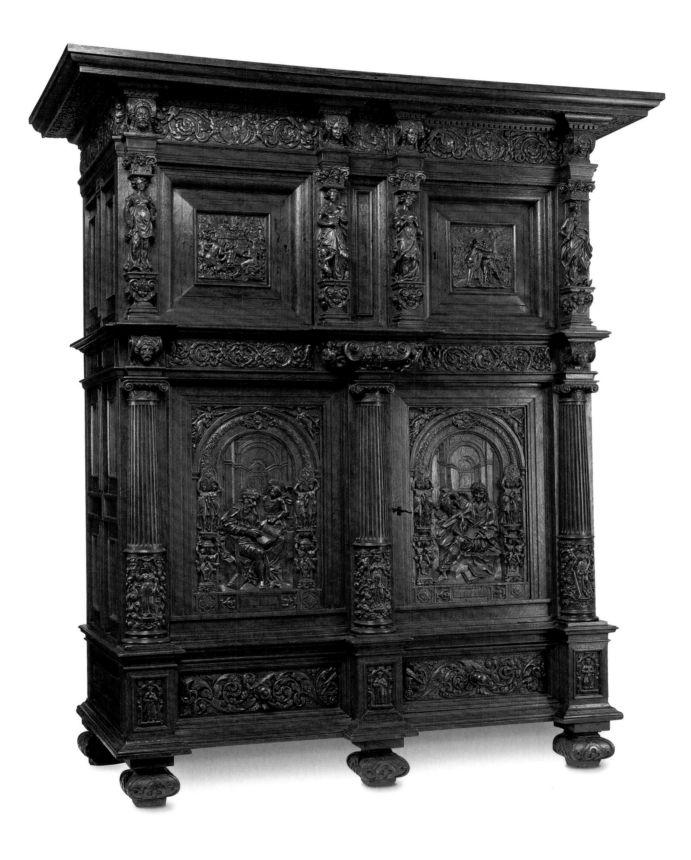

CATALOGUE 77. Cupboard (*Beeldenkast*), 1610–20. Province of Holland, Northern Netherlands. Oak, 89 × 65 3/8 × 32 5/8 inches (226 × 166 × 83 cm).

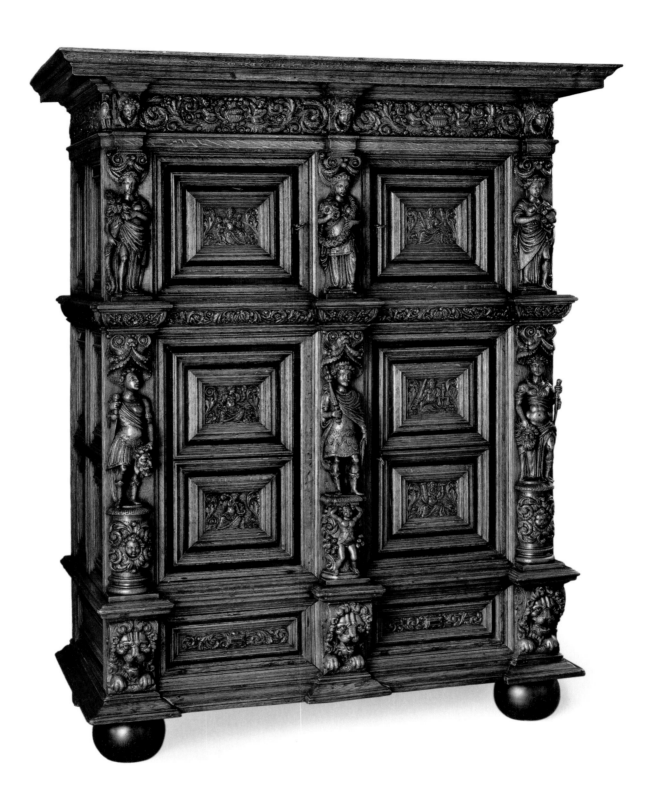

CATALOGUE 78. Cupboard (*Beeldenkast*), 1620–40, Amsterdam, Northern
Netherlands. Oak and ebony, 81 1/4 × 65 3/4 × 31 3/4 inches (206.5 × 167 × 80.6 cm).

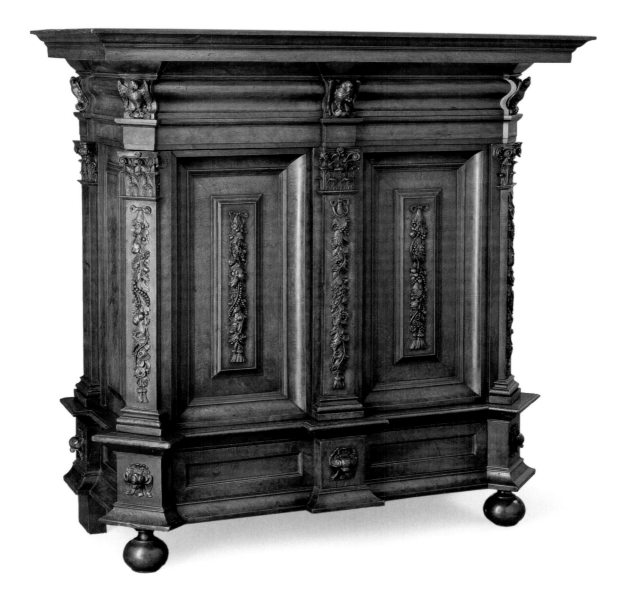

CATALOGUE 79. Cupboard (*Rankenkastje*), 1650–70. Amsterdam, Northern
Netherlands. Oak and walnut, 49 5/8 × 48 1/2 × 21 5/8 inches (126 × 123 × 55 cm).

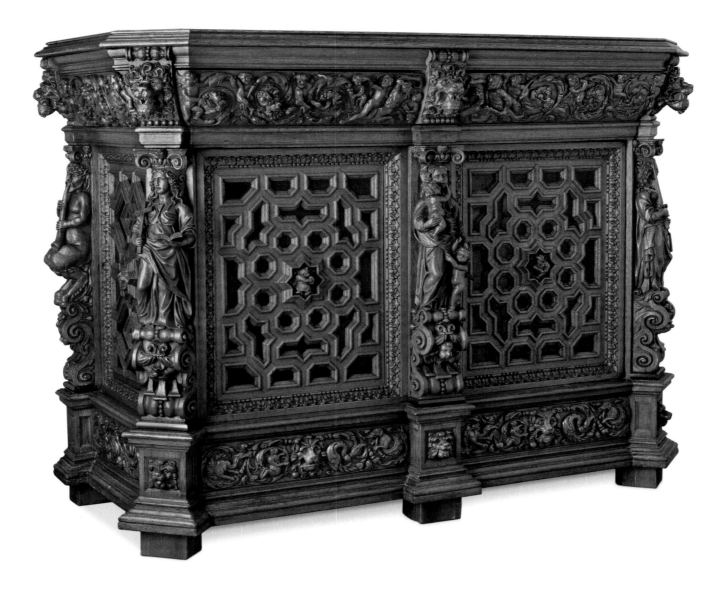

CATALOGUE 80. Cupboard (*Ribbank*), 1620–30. Antwerp, Southern Netherlands.
Oak and ebony, 51 1/4 × 61 3/4 × 30 3/4 inches (130 × 172 × 78 cm).

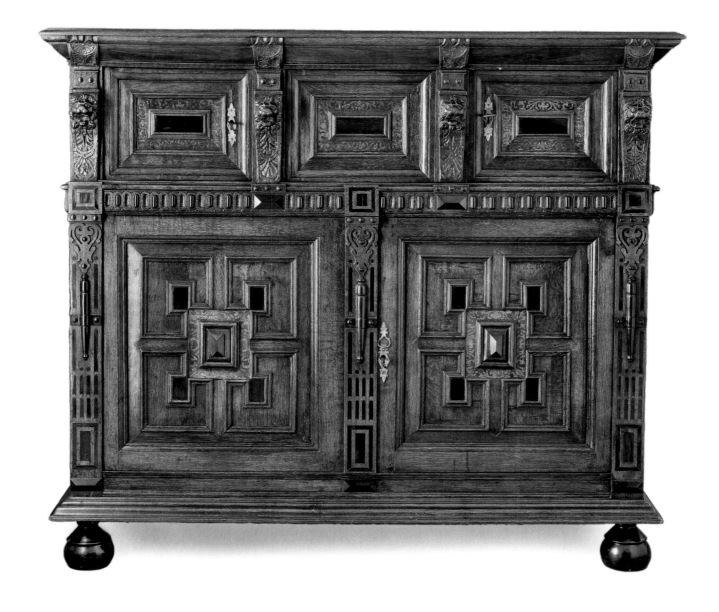

CATALOGUE 81. Cupboard (*Vijfdeurs Kast*), 1620–30. Province of
Zeeland, Northern Netherlands. Oak, maple, ebony, and rosewood,
59 7/8 × 67 3/4 × 27 1/8 inches (152 × 172 × 69 cm).

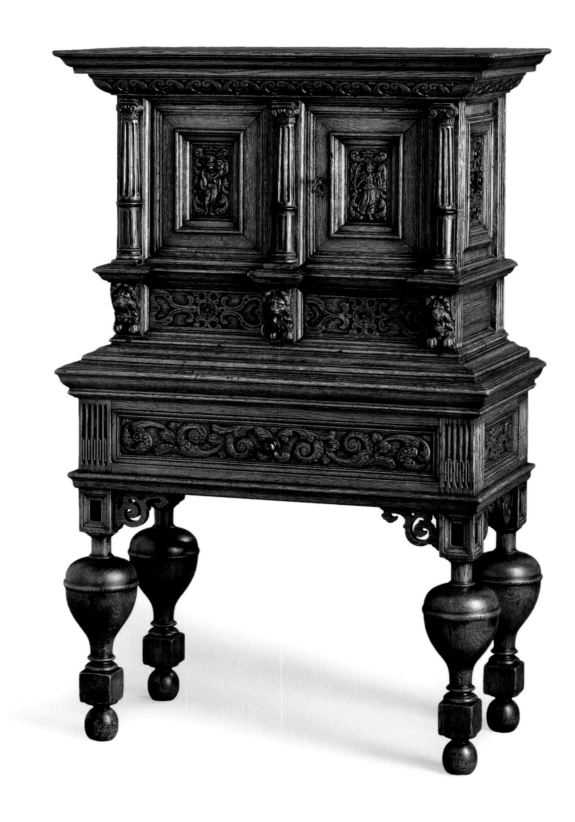

CATALOGUE 82. Cupboard on Stand (*Tafelkastje*), 1640–60. Northern
Netherlands. Oak and ebony, 44 × 28 × 13 3/4 inches (112 × 71 × 35 cm).

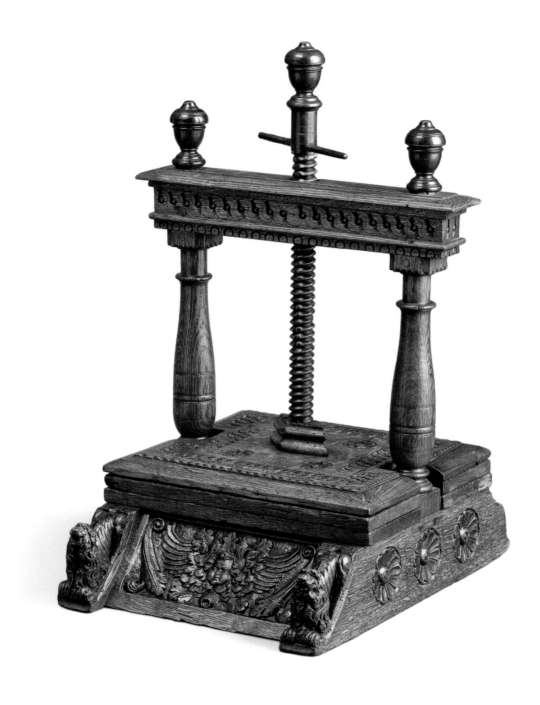

CATALOGUE 83. Linen Press (*Kleine Tafelpers*), 1600–20.
Northern Netherlands. Oak, ebonized fruitwood, and beech,
24 3/8 × 15 3/4 × 17 1/2 inches (62 × 40 × 44.5 cm).

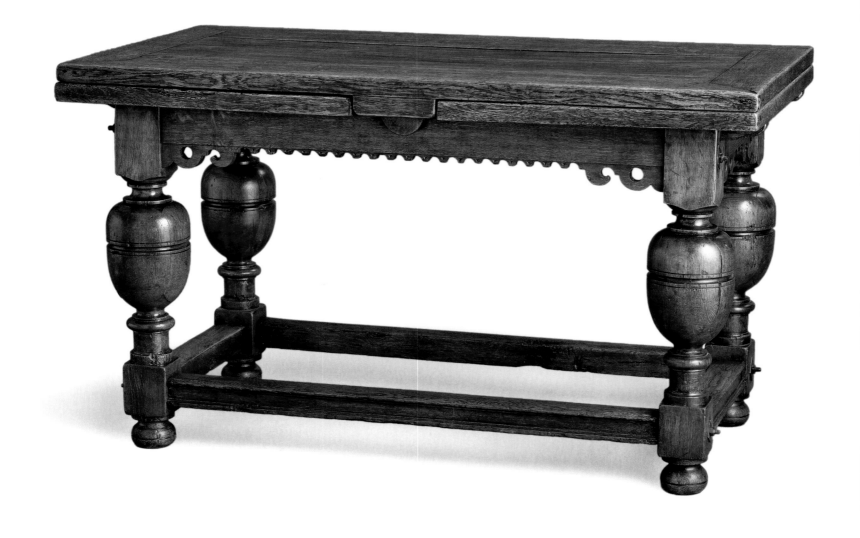

CATALOGUE 84. Table (*Balpoottafel or Trektafel*), 1600–20.
Southern Netherlands. Oak, 31 7/8 × 53 1/8 × 29 1/2 inches
(81 × 135 × 75 cm), length when extended 100 3/8 inches (255 cm).

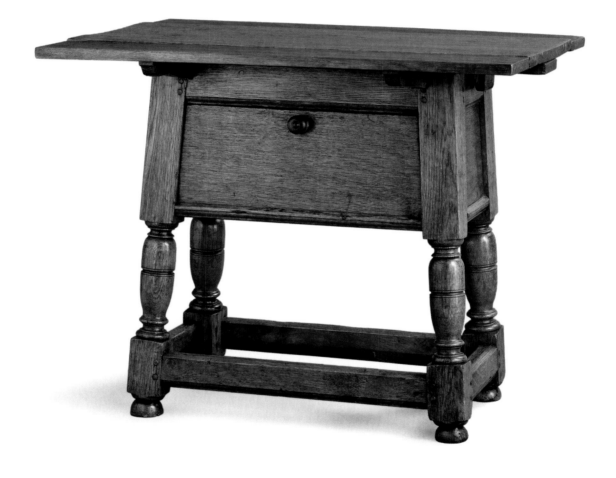

CATALOGUE 85. Table (*Kruktafel*), 1620–40. Northern or Southern
Netherlands. Oak, 23 1/4 × 30 3/4 × 13 3/4 inches (59 × 78 × 35 cm), depth
when extended 23 5/8 inches (60 cm).

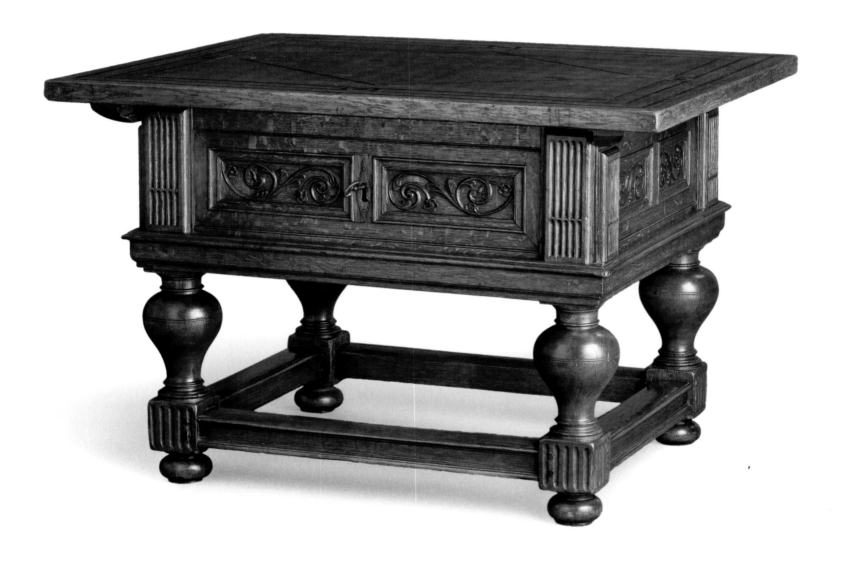

CATALOGUE 86. Table (*Betaaltafel*), 1630–40. Northern Netherlands.
Oak and rosewood, 29 1/4 × 43 1/8 × 34 7/8 inches (74.5 × 109.5 × 88.5 cm).

CATALOGUE 87. Table (*Kwabtafel*) 1675–1700. Northern Netherlands.
Polychromed limewood, 29 3/8 × 38 5/8 × 26 3/4 inches (74.5 × 98 × 68 cm).

CATALOGUE OF THE EXHIBITION

Willem van Aelst
1. *Still Life with a Candle, Walnuts, and a Mouse*, 1647

Jan Asselijn
2. *River Landscape with the Fort Saint-Jean and the Château de Pierre-Scize in Lyon*, ca. 1650

Balthasar van der Ast
3. *Still Life with Flowers*, ca. 1630

Hendrick Avercamp
4. *Winter Landscape near a Village*, 1610–15

Jacob Backer
5. *Young Woman Holding a Fan*, ca. 1645

Ludolf Bakhuizen
6. *Ships in a Gale on the IJ before the City of Amsterdam*, 1666

Osias Beert
7. *Still Life with Oysters, Sweetmeats, and Dried Fruit in a Stone Niche*, 1609

Nicolaes Berchem
8. *Saint Peter*, 1644
9. *Landscape with an Elegant Hunting Party on a Stag Hunt*, 1665–70

Hans Bol
10. *View of Amsterdam from the South*, 1589

Ambrosius Bosschaert the Elder
11. *Still Life with Roses in a Glass Vase*, ca. 1619

Jan Both
12. *Italianate Landscape with Travelers on a Path*, 1645–50

Salomon de Bray
13. *Study of a Young Woman in Profile*, 1636

Jan Brueghel the Elder
14. *Village Scene with a Canal*, 1609

Jan van de Cappelle
15. *A Kaag and a Smak in a Calm*, 1651

Pieter Claesz.
16. *Breakfast Still Life with a Ham and a Basket of Cheese*, ca. 1627

Adriaen Coorte
17. *Still Life with Seashells*, 1698

Aelbert Cuyp
18. *Orpheus Charming the Animals*, ca. 1640

Gerrit Dou
19. *Sleeping Dog*, 1650
20. *Self-Portrait*, ca. 1665

Karel du Jardin
21. *Horseman and His Horse at a River*, 1660

Willem Duyster
22. *Soldiers Dividing Booty in a Barn*, ca. 1630

Hendrik de Fromantiou
23. *Trompe l'Oeil with a Dead Partridge*, 1666

Jan van Goyen
24. *Frozen River with Skaters*, 1637
25. *River Landscape with Peasants in a Ferryboat*, 1648

Jacob Grimmer
26. *February*, 1570–80

Dirck Hals
27. *An Elegant Party Making Music*, 1621

Frans Hals
28. *Portrait of a Preacher*, ca. 1660

Willem Claesz. Heda
29. *Still Life with Glasses and Tobacco*, 1633

Jan Davidsz. de Heem
30. *Glass Vase with Flowers on a Stone Ledge*, 1655–60

Jan van der Heyden
31. *View of the Westerkerk, Amsterdam*, ca. 1667–70

Gerard Houckgeest
32. *The Nieuwe Kerk in Delft with the Tomb of William of Orange*, ca. 1651–52

Isaack Koedijck
33. *Barber-Surgeon Tending a Peasant's Foot*, ca. 1649–50

Philips Koninck
34. *Panoramic Wooded River Landscape*, ca. 1650

Jan Lievens
35. *Young Girl in Profile*, ca. 1631–32

Nicolaes Maes
36. *Sleeping Man Having His Pockets Picked*, ca. 1655

Gabriël Metsu
37. *Old Woman Eating Porridge*, ca. 1657

Frans van Mieris the Elder
38. *The Old Violinist*, 1660

Claes Moeyaert
39. *Esau Selling His Birthright to Jacob*, 1630–35

Aert van der Neer
40. *Estuary at Twilight*, ca. 1655–60
41. *Winter Landscape with Figures in a Snowstorm*, ca. 1655–60

Caspar Netscher
42. *The Young Artists*, 1666

Adriaen van Ostade
43. *Peasant Family in a Cottage Interior*, 1661

Isack van Ostade
44. *Ice Scene near an Inn*, 1644

Adam Pijnacker
45. *Mediterranean Harbor*, ca. 1650

Jan Porcellis
46. *Seascape with a Rainbow*, ca. 1631

Paulus Potter
47. *Spring Landscape with Donkeys and Goats ("The Rabbit Warren")*, 1647

Rembrandt van Rijn
48. *Portrait of Aeltje Uylenburgh*, 1632

Jacob van Ruisdael
49. *Wooded River Landscape*, ca. 1655–60
50. *View of Haarlem*, ca. 1670–75
51. *Winter Landscape with Two Windmills*, ca. 1675

Rachel Ruysch
52. *Still Life with Flowers*, 1709

Salomon van Ruysdael
53. *River Landscape with a Ferry*, 1649
54. *River Landscape with a Sailboat*, ca. 1655

Pieter Saenredam
55. *Interior of the St. Bavokerk, Haarlem*, 1660

Godfried Schalcken
56. *Young Girl Eating Sweets*, 1680–85

Maria Schalcken
57. *The Artist at Work in Her Studio*, ca. 1680

Jan Steen
58. *"The Drawing Lesson": A Master Correcting a Pupil's Drawing*, ca. 1665–66

David Teniers the Younger
59. *The Temptation of Saint Anthony*, ca. 1650

Esaias van de Velde
60. *An Elegant Company in a Garden*, 1614

Willem van de Velde the Elder
61. *The Brederode off Vlieland*, ca. 1645

Willem van de Velde the Younger
62. *Fishing Boats by the Shore in a Calm*, ca. 1660–65
63. *A Wijdschip in a Fresh Breeze*, ca. 1665–70

Simon de Vlieger
64. *Sailing Ships in a Gale*, ca. 1645–50

Jan Baptist Weenix
65. *Portrait of the De Kempenaer Family (The Margaretha Portrait)*, ca. 1653

Emanuel de Witte
66. *Interior of the Oude Kerk in Amsterdam*, ca. 1660–65

Philips Wouwerman
67. *The Stag Hunt*, ca. 1659–60

Cornelis Bellekin
68. Shell with bathing nymphs, 1650–1700

Dirck van Rijswijck
69. Panel with a garland of flowers and animals, 1676

Adam van Vianen
70. Plaque depicting the conversion of Saint Paul on his way to Damascus, 1610–15

71. Medal commemorating the Siege of Amsterdam, 1650–1700

PEABODY ESSEX MUSEUM ONLY

Attributed to Albert Jansz. Vinckenbrink
72. *Figure of a Man*, 1650–65

73. Bellows (*Blaasbalg*), 1620–40

74. Chair (*Kerkstoeltje*), ca. 1650

75. Chair (*Stoel*) from a set of six, 1650–60

76. Chest (*Kist*), 1640–50

77. Cupboard (*Beeldenkast*), 1610–20

78. Cupboard (*Beeldenkast*), 1620–40

79. Cupboard (*Rankenkastje*), 1650–70

80. Cupboard (*Ribbank*), 1620–30

81. Cupboard (*Vijfdeurs Kast*), 1620–30

82. Cupboard on Stand (*Tafelkastje*), 1640–60

83. Linen Press (*Kleine Tafelpers*), 1600–20

84. Table (*Balpoottafel* or *Trektafel*), 1600–20

85. Table (*Kruktafel*), 1620–40

86. Table (*Betaaltafel*), 1630–40

87. Table (*Kwabtafel*), 1675–1700

BIBLIOGRAPHY

For the sake of simplicity, the following bibliography has been organized alphabetically according to the short-form titles used as citations throughout this book. Although every effort was made to cite the exhibition title in the literature in order to maintain consistency for the reader between the two categories of information, on occasion the short forms do not match the original citation because the exhibition title and the catalogue title are different. The exhibition title has been used for the short-form references except where it could not be found. Very long titles have been abbreviated in the short citations. Dutch spelling of names and also the presentation of names with particles (van, von, de, ter, etc.) have been inconsistent in English and usage in this book attempts to present surnames as they have become best known rather than apply a single rule. In English-language sources, capitalization has been standardized; in other languages, it has been retained as given.

17de Eeuwse Meesters uit Nederlands Particulier Bezit 1965
Stedelijk Museum De Lakenhal. *17de Eeuwse Meesters uit Nederlands Particulier Bezit*. Leiden: Stedelijk Museum De Lakenhal, 1965.

A

An Account of All the Pictures Exhibited in the Rooms of the British Institution from 1813 to 1823 1824. British Institution. *An Account of All the Pictures Exhibited in the Rooms of the British Institution from 1813 to 1823*. London: Priestly and Weale, 1824.

Aelbert Cuyp 2001–2002. Wheelock, Arthur K. Jr. with Alan Chong, Emilie E. S. Gordenker, Jacob M. de Groot, et al. *Aelbert Cuyp*. Washington: National Gallery of Art; London and New York: Thames & Hudson, 2001.

Aelbert Cuyp en zijn familie; schilders te Dordrecht 1977–78. Dordrechts Museum. *Aelbert Cuyp en zijn familie; schilders te Dordrecht*. Dordrecht: Dordrechts Museum, 1977.

Aelbert Cuyp in British Collections 1973. Reiss, Stephen. *Aelbert Cuyp in British Collections*. Colchester: Benham; London: National Gallery, 1973.

The Age of Rembrandt 1967. Van Thiel, Pieter J. J. with Horst Karl Gerson. *The Age of Rembrandt: An Exhibition of Dutch Paintings of the Seventeenth Century at the California Palace of the Legion of Honor, San Francisco, Toledo Art Museum and the Museum of Fine Arts, Boston*. Haarlem: J. Enschedé, 1967.

Album Amicorum Jacob Heyblocq, 1645–78 1998. *Album Amicorum Jacob Heyblocq, 1645–78*. Zwolle: Waanders, 1998.

Alsteens and Buijs 2008. Alsteens, Stijn and Hans Buijs. *Paysages de France dessinés par Lambert Doomer et les Artistes Hollandaise et Flamands des XVIe Eeuw et XVIIe siècles*. Paris: Foundation Custodia, 2008.

The Amateur's Cabinet 1995–96. Broos, Ben P. J., Quentin Buvelot, Frederik J. Duparc, et al. *The Amateur's Cabinet: Seventeenth-Century Dutch Masterpieces from Dutch Private Collections.* The Hague: Mauritshuis; Wormer: V+K, 1995. [see also *Uit de schatkamer van de verzamelar* 1995–96.]

Amsterdams Goud en Zilver 1999. Lorm, Jan Rudolf de and Dirk Jan Biemond. *Amsterdams Goud en Zilver.* Zwolle: Waanders; Amsterdam: Rijksmuseum, 1999.

Ampzing 1628. Ampzing, Samuel. *Beschryvinge ende lof der stadt Haerlem in Holland.* Haarlem: Adriaen Rooman, 1628.

Anatole Demidoff: Prince of San Donato 1994. Haskell, Francis with Stephen Duffy. *Anatole Demidoff: Prince of San Donato.* Vol. 1. *Collectors of the Wallace Collection.* London: Trustees of the Wallace Collection, 1994.

Angel 1642. Angel, Philips. *Lof der Schilder-Konst.* Leiden: Printed by Willem Christiaens, 1642.

Apollo 1968. "Golden Jubilee Exhibition of the British Antique Dealers Association." *Apollo,* Supplement, 87 (April 1968) pp. S1-6.

Arps-Aubert 1932. Arps-Aubert, Rudolf von. *Die Entwicklung des reinen Tierbildes in der Kunst des Paulus Potters.* Halle (Saale): Klinz, 1932.

Art & Home 2001–2002. Westermann, Mariët with essays by C. Willemijn Fock, Eric Jan Sluijter, and H. Perry Chapman. *Art & Home: Dutch Interiors in the Age of Rembrandt.* Denver: Denver Art Museum; Newark: Newark Museum; Zwolle: Waanders, 2001.

The Art News 1937. "The Gow Collection in the Saleroom." *The Art News* 35, 31, sec. 2 (May 1, 1937), pp. 12–13.

Art Treasures Centenary Exhibition: European Old Masters 1957. Manchester Art Galleries. *Art Treasures Centenary Exhibition: European Old Masters, City of Manchester Art Galleries.* Manchester: Manchester Art Galleries, 1957.

Art Treasures of the United Kingdom Collected at Manchester in 1857 1857–58. Peck, John. *Catalogue of the Art Treasures of the United Kingdom Collected at Manchester in 1857.* London: Bradbury and Evans, 1857.

Ausstellung von Meisterwerken alter Malerei aus Privatbesitz 1925. Göts, Oswald with Georg Swarenski and Alfred Wolters. *Ausstellung von Meisterwerken alter Malerei aus Privatbesitz.* Frankfurt: Staedelschen Kunstinstituts, 1925.

Ausstellung von Werken alter Kunst aus dem Privatbesitz der Mitglieder des Kaiser Friedrich 1914. Akademie der Künste, Berlin. *Ausstellung von Werken alter Kunst aus dem Privatbesitz der Mitglieder des Kaiser Friedrich-Museum-Vereins.* Berlin, 1914.

Autumn Exhibition of Fine Dutch, Flemish and Italian Old Master Paintings 1973. The Brian Koetser Gallery. *Autumn Exhibition of Fine Dutch, Flemish and Italian Old Master Paintings.* London: L. Leoster, 1973.

B

Baard 1942. Baard, Henricus Petrus. *Willem van de Velde de Oude, Willem van de Velde de Jonge.* Amsterdam: H. J. W. Becht, 1942.

Baarsen 1996. Baarsen, Reinier. "Herman Doomer, Ebony Worker in Amsterdam." *The Burlington Magazine* 128 (1996), pp. 739–49.

Baarsen 2007. Baarsen, Reinier. *Furniture in Holland's Golden Age.* Amsterdam: Rijksmuseum, 2007.

Bachmann 1966. Bachmann, Fredo. *Die Landschaften des Aert van der Neer, Neustadt an der Aisch.* Neustadt an der Aisch: Degener, 1966.

Bachmann 1982. Bachmann, Fredo. *Aert van der Neer, 1603/04–1677.* Bremen: C. Schünemann, 1982.

Baer 1990. Baer, Ronni. "The Paintings of Gerrit Dou (1613–1675)." PhD diss., Institute of Fine Arts, New York University, 1990.

Baker and Henry 1995. Baker, Christopher and Tom Henry, compilers. *The National Gallery: Complete Illustrated Catalogue.* London: National Gallery Publications; New Haven and London: Distributed by Yale University Press, 1995.

Bakker 1991. Bakker, E. "Marina Aarts (Christie's) – Liever tien keer slikken dan een snelle babble." *Kunstbeeld* 3, 2 (1991), pp. 19–21, ill. p. 20.

Bakker 2004. Bakker, Boudewijn in Frijhoff, Willem Theodrus, Marijke Carasso-Kok, and Maarten Prak. *Centrum van de Wereld 1578–1650.* Vol. 2. *De Geschiedenis van Amsterdam.* Amsterdam: SUN, 2004.

Bartsch 1797. Bartsch, Adam von. *Catalogue raisonné de toutes les estampes qui forment l'œuvre de Rembrandt et ceux de ses principaux imitateurs.* 2 vols. Vienna: A. Blumauer, 1797.

Bauch 1926. Bauch, Kurt. *Jakob Adriaensz. Backer: Ein Rembbrandtschüler aus Friesland.* Berlin: G. Grote, 1926.

Bauch 1966. Bauch, Kurt. *Rembrandt: Gemälde.* Berlin: W. de Gruyter, 1966.

Bazin 1950. Bazin, Germain. *Les Grands Maîtres Hollandais from Merveilles de l'Art.* Paris: F. Nathan, 1950.

Beck 1972–91. Beck, Hans-Ulrich. *Jan van Goyen 1596–1656: Ein Oeuvreverzeichnis.* 4 vols. Vols. 1 and 2, Amsterdam: Van Gendt; Vols. 3 and 4, Doornspijk: Davaco, 1972–91.

De Beer 2002. De Beer, Gerlinde. *Ludolf Backhuysen; Sein Leben und Werk (1630–1708).* Zwolle: Waanders, 2002.

Beherman 1988. Beherman, Thiery. *Godfried Schalcken,* Paris: Maeght, 1988.

Benedict 1938. Benedict, C. "Osias Beert." *L'Amour de l'Art* 19 (1938), pp. 307–14.

Benesch 1954–57. Benesch, Otto von. *Rembrandt Drawings: A Critical and Chronological Catalogue.* 6 vols. London: Phaidon Press: 1954–57.

Benesch 1973. Benesch, Otto von. *The Drawings of Rembrandt.* Complete Edition. Vol. 6. London: Phiadon Press, 1973.

Bénézit 1976. Bénézit, Emmanuel. *Dictionnaire critique et documentaire des peintres, sculpteurs, dessinateurs et graveurs de tous les temps et de tous les pays.* Vols. 2 and 7. Paris: Librairie Gründ, 1976.

Benson 1927. Benson, Robert, ed. *The Holford Collection, Dorchester House: With 200 Illustrations from the Twelfth to the Nineteenth Century.* Vol. 2. Oxford: Oxford University Press; London: Humphrey Milford, 1927.

Bergström 1956. Bergström, Ingvar. *Dutch Still-life Painting in the Seventeenth Century.* Trans. Christiana Hedström and Gerald Taylor. London: Faber, 1956.

Bergström 1988. Bergström, Ingvar. "Another Look at De Heem's Early Dutch Period, 1626–1635." *Mercury* 7 (1988), pp. 37–50.

De Bertier de Sauvigny 1991. De Bertier de Sauvigny, Reine. *Jacob et Abel Grimmer: Catalogue raisonné.* Brussels: Renaissance du Livre, 1991.

Beschreibung des Inhaltes der Sammlung von Gemälden älterer Meister des Herrn Johann Peter Weyer in Coeln 1852. Beschreibung des Inhaltes der Sammlung von Gemälden älterer Meister des Herrn Johann Peter Weyer in Coeln. Cologne, 1852.

Best in Show 2006. Brown, Edgar Peters with Carolyn Rose Rebbert, Robert Rosenblum, and William Secord. *Best in Show: The Dog in Art from the Renaissance to Today.* New Haven and London: Yale University Press, 2006.

Bestiaire Hollandais 1960. Institut Néerlandais. *Bestiaire Hollandais.* Paris: Institut Néerlandais, 1960.

De Bie 1661. De Bie, Cornelis. *Het gulden cabinet van de edele vry schilder-const.* Antwerp: Juliaen de Montfort, 1661.

Bille 1961. Bille, Clara. *De Tempel der Kunst of het kabinet van den Heer Braamcamp.* Amsterdam: J. H. de Bussy, 1961.

Blanc 1858. Blanc, Charles. *Le Trésor de la curiosité.* Vol. 1. Paris: Ve J. Renouard, 1858.

Blanc 1863. Blanc, Charles. *Histoire des Peintres de toutes les écoles.* Vol. 2. Paris: Librairie Renouard, 1863.

Bloemenwereld van Oude en Moderne Nederlandse Kunst 1953. Buisman, J. H. van Borssum. *Bloemenwereld van Oude en Moderne Nederlandse Kunst.* Haarlem: Teylers Museum, 1953.

Bloemstukken van Oude Meesters 1935. Kunsthandel P. de Boer. *Bloemstukken van Oude Meesters.* Amsterdam: P. de Boer, 1935.

Von Bode 1914. Von Bode, Wilhelm. *Die Gemäldesammlung Marcus Kappel in Berlin.* Berlin: Im Verlag von Julius Bard, 1914.

Von Bode 1958. Von Bode, Wihelm. *Die Meister der Holländischen und Flämischen Malerschulen.* Leipzig: E. A. Seemann, 1958.

Von Bode and Binder 1914. Von Bode, Wilhelm, ed. with essay by Moritz Julius Binder. *Frans Hals, sein Leben und seine Werke.* Berlin: Photographische Gesellschaft, 1914.

Bol 1952. Bol, Laurens Johannes. "Adriaan S. Coorte, Stillevenschilder." *Nederlandsch Kunsthistorisch Jaarboek* 4 (1952/53), pp. 193–232.

Bol 1960. Bol, Laurens Johannes. *The Bosschaert Dynasty: Painters of Flowers and Fruit.* Trans. A. M. de Bruin-Cousins. Leigh-on-Sea: F. Lewis, 1960.

Bol 1977. Bol, Laurens Johannes. *Adriaen Coorte: A Unique Late Seventeenth Century Dutch Still-life Painter.* Assen: Van Gorcum, 1977.

Borenius 1928. Borenius, Tancred. "London." *Pantheon* 1 (January–June 1928), pp. 223, ill., 224.

Borger 1996. Borger, Ellen. *De Hollandse kortegaard. Geschilderde wachtlokalen uit de Gouden Eeuw, Naarden.* Zwolle: Waanders; Naarden: Nederlands Vestingmuseum, 1996.

Böttger 1972. Böttger, Peter. *Die Alte Pinakothek in München: Mit einem Anhang: Abdruck des frühesten Gemäldeverzeichnisses der Pinakothek aus dem Jahre 1838 von Georg von Dillis. Nach den heutigen Inventarnummern identifiziert von Gisela Scheffler.* Munich: Prestel, 1972.

Van Braam 1969. Van Braam, Frederik A., ed. *World Collector's Annuary: Alphabetical Classification of Paintings, Watercolours, Pastels and Drawings Sold at Auction.* Vol. 21. Harderwijk, 1969.

Van Braam 1975. Van Braam, Frederik A., ed. *World Collector's Annuary* 27 (1975).

Braun 1980. Braun, Karel. *Alle tot nu toe bekende schilderijen van Jan Steen.* Rotterdam, 1980.

Bredius 1885. Bredius, Abraham. "Rembrandt: Nieuw bijdragen tot zijne levensgeschiedenis." *Oud Holland* 3 (1885), pp. 85–107.

Bredius 1890. Bredius, Abraham. *Die Meisterwerke der Königlichen Gemäldegalerie im Haag.* Munich: F. Hanfstaeng, 1890.

Bredius 1909. Bredius, Abraham. "Nieuwe bijzonderheden over Isaack Jansz. Koedyck." *Oud Holland* 37 (1909), pp. 5–12.

Bredius 1913. Bredius, Abraham. "De Bloemenschilders Bosschaert." *Oud Holland* 31 (1913), p. 138.

Bredius 1915. Bredius, Abraham. *Künstler-Inventare: Urkunden zur Geschichte der Holländischen Kunst des XVII 17ten, XVIIten und XVIII 17ten Jahrhunderts.* Vol. 1. The Hague: M. Nijhoff, 1915.

Bredius 1927. Bredius, Abraham. *Jan Steen.* Amsterdam: Scheltema & Holkema's Boekhandel, 1927.

Bredius 1935. Bredius, Abraham. *Rembrandt Gemalde.* 1st ed. *De schilderijen van Rembrandt.* Vienna: Phaidon-Verlang, 1935.

Bredius 1969. Bredius, Abraham, with revisions by Horst Gerson. *Rembrandt: The Complete Edition of the Paintings.* London: Phaidon, 1969.

Breughel-Brueghel 1997. Ertz, Klaus and Christa Nitze-Ertz. *Pieter Breughel der Jüngere, Jan Brueghel der Ältere: flämische Malerei um 1600: Tradition und Fortschritt.* Vienna: Kunsthistorisches Museum; Lingen: Luca, 1997.

Breughel-Brueghel 1998. Ertz, Klaus and Christa Nitze-Ertz. *Breughel-Brueghel, Pieter Breughel de Jonge – Jan Brueghel de Oudere: een Vlaamse schildersfamilie rond 1600.* Vienna: Kunsthistorisches Museum; Lingen: Luca, 1998.

Briels 1987. Briels, Jan. *Vlaamse schilders in de Noordelijke Nederlanden in het begin van de Gouden Eeuw, 1585–1630.* Haarlem: H. J. W. Becht; Antwerp: Mercatorfonds, 1987.

Brinckmann 1756. Brinckmann, Ph. H. *Verzeichniss der in den Churfürstlichen Cabinetten zu Mannheim befindlichen Mahlereyen.* Mannheim, 1756.

The British Antique Dealers' Association Golden Jubilee Exhibition 1968. Victoria & Albert Museum. *The British Antique Dealers' Association Golden Jubilee Exhibition.* London: Victoria & Albert Museum, 1968.

Brochhagen 1958. Brochhagen, Ernst. "Karel Dujardin: Ein Beitrag zum Italianismus in Holland im 17. Jahrhundert." PhD diss., University of Cologne, 1958.

Brockwell 1932. Brockwell, Maurice Walter, ed. *Abridged Catalogue of the Pictures at Doughty House, Richmond, Surrey in the Collection of Sir Herbert Cook, Bart.* London: Heinemann, 1932.

Broos 2000. Broos, Ben. "Willem van Aelst." In Turner, Jane, ed. *The Grove Dictionary of Art. From Rembrandt to Vermeer: 17th-Century Dutch Artists.* From *The Grove Art Series.* New York: St. Martin Press, 2000.

Broos 2008. Broos, Ben. "Aeltje Uylenburgh uit Leeuwarden, petemoei van Rembrandts Kinderen." *Fryslân* 13 (2008), pp. 8–12.

Broos 2009A. Broos, Ben. "Gerrit van Loo, voogd van Saskia, zwager van Rembrandt." *Oud Holland* 122 (2009), p. 50, fig. 5.

Broos 2009B. Broos, Ben. "Rembrandt & Saskia: Recent Research." *Jahrbuch der Berliner Museen: Beiheft,* 2009, p. 10, fig. 2.

Broos and Panhuysen 2006. Broos, Ben and Geert Panhuysen. "Predikant Johannes Sylvius, neef en vriend van Saskia en Rembrandt." *Kroniek van het Rembrandthuis,* 2006, pp. 42–68, ill. p. 49, fig. 6.

Broos and Van Suchtelen 2004. Broos, Ben and Ariane van Suchtelen with contributions by Quentin Buevelot et al. *Portraits in the Mauritshuis.* Ed. Quentin Buvelot. The Hague: Royal Picture Gallery; Zwolle: Waanders, 2004.

Brueghel: Een Dynastie van Schilders 1980. Roberts-Jones, Phillipe. *Brueghel: Een Dynastie van Schilders.* Brussels: Paleis voor Schone Kunsten, 1980.

Brunner-Bulst 2004. Brunner-Bulst, Martina. *Pieter Claesz.: der Hauptmeister des Haarlemmer Stillebens im 17. Jahrhundert.* Lingen: Luca, 2004.

Bruyn et al. 1982–2005. Bruyn, Joshua, Bob Haak, Simon H. Levie, P. J. J. van Thiel, and Ernst van de Wetering. *A Corpus of Rembrandt Paintings.* 3 vols. The Hague, Boston: M. Nijihoff; Hingham, Massachusetts: Kluwer Boston [Distributor for USA and Canada], 1982–2005.

Buchanan 1824. Buchanan, William. *Memoirs of Painting with a Chronological History of the Importation of Pictures by the Great Masters into England Since the French Revolution.* Vol. 2. London: Printed for R. Ackerman, 1824.

Burger-Wegener 1976. Burger-Wegener, Catja. "Johannes Lingelbach 1622–74." PhD diss., Freie Universität, Berlin, 1976.

Burke 1976. Burke, James Donald. *Jan Both: Paintings, Drawings and Prints.* New York: Garland Publishers, 1976.

Burlington Magazine 1966. Supplement. "Notable Works of Art Now on the Market." *The Burlington Magazine,* December 1966, ill. pl. XII.

Burlington Magazine 1971. Advertisement. *The Burlington Magazine* 113 (May 1971), p. 31.

Buvelot 2005. Buvelot, Quentin. "Over Rembrandts 'Portret van Aeltje Uylenburgh.'" *Mauritshuis in Focus* 18, 3 (2005), pp. 22–26.

Buvelot 2008. Buvelot, Quentin. "Ode to Coorte." *Mauritshuis in Focus* 21, 1 (2008), p. 23, fig.13.

Buvelot and Lammertse 2010. Buvelot, Quentin and Friso Lammertse. "Numbered Paintings by Salomon de Bray." *The Burlington Magazine* 152 (June 2010), pp. 390–92.

Buvelot and Naumann 2008. Buvelot, Quentin and Otto Naumann. "Format Changes in Paintings by Frans van Mieris the Elder." *The Burlington Magazine* 150 (February 2008), pp. 102–103, ill. fig. 38 and cover.

C

The Cabinet Picture 1999. Wright, Christopher. *The Cabinet Picture: Dutch and Flemish Masters of the Seventeenth Century.* London: Richard Green Gallery, 1999.

Catalog der Sammlung von Gemälden älterer Meister des Herrn Johann Peter Weyer, Stadtbaumeister a. D. und Ritter des Leopold Orden 1859. *Catalog der Sammlung von Gemälden älterer Meister des Herrn Johann Peter Weyer, Stadtbaumeister a. D. und Ritter des Leopold Orden.* Cologne, 1859.

"Catalogue de la Gallerie de Mannheim" 1799. "Catalogue de la Gallerie de Mannheim Actuellement au Château de Nymphenbourg Commencé à 19 Novembre 1799."

Catalogue des tableaux qui sont dans les quatre cabinets de S. A. S. E. Palatine à Mannheim 1756. *Catalogue des tableaux qui sont dans les quatre cabinets de S. A. S. E. Palatine à Mannheim,* 1756, p. 110.

Catalogue from the Collection of Charles T. Yerkes 1893. *Catalogue from the Collection of Charles T. Yerkes.* Chicago, 1893, no. 62, ill., n. p.

Catalogue of The European Fine Art Fair 1995. The European Fine Art Foundation. *Catalogue of The European Fine Art Fair.* Maastricht: Haboldt & Co., 1995.

Catalogue of the Loan Collection of Pictures 1895. Guidehall Art Gallery, *Catalogue of the Loan Collection of Pictures.* Prepared by A. G. Temple. London: J. Douglass Matthews, 1895.

Catalogus der Tentoonstelling van Oude Schilderijen 1934. Kunsthandel Gebr. Douwes. *Catalogus der Tentoonstelling van Oude Schilderijen.* Amsterdam: Kunsthandel Gebr. Douwes, 1934.

Catalogus van Schilderyen, van den Heer Agent Willem Lormier, in 's Gravenhage 1752. *Catalogus van Schilderyen, van den Heer Agent Willem Lormier, in 's Gravenhage.* The Hague, 1752.

Chefs-d'oeuvre des Collections Parisiennes 1950. Société des Amis de Carnavalet. *Chefs-d'oeuvre des Collections Parisiennes.* Paris: Musée Carnavalet, 1950.

Les Chefs-d'oeuvres des Collections Françaises Retrouvés en Allemagne par la Commission de Récuperation Artistique et les Services alliés 1946. Florisoone, Michel, Carle Dreyfus, and Jeanine Lemoine. *Les Chefs-d'oeuvres des Collections Françaises Retrouvés en Allemagne par la Commission de Récuperation Artistique et les Services alliés.* Paris, 1946.

A Choice Collection 2002. Buvelot, Quentin with Hans Buijs and Ella Eitsma. *A Choice Collection: Seventeenth-Century Dutch Paintings from the Frits Lugt Collection.* The Hague: Royal Cabinet of Paintings, Mauritshuis; Zwolle: Waanders, 2002.

Chong 1994. Alan Chong. "Very Beautiful in All Parts. . . ." *Sotheby's Preview,* July 1994, pp. 30–31, ill.

"Churfürstl. Gemaelde-Samlung von Mannheim, den 26. October 1802."

The Connoisseur 1953. *The Connoisseur* 131, 531 (May 1953), p. 107, ill.

Cooke 1903–14. Cooke, Sir Francis. *Abridged Catalogue of the Pictures at Doughty House, Richmond. Belonging to Sir Frederick Cooke, Bart. Visconde de Monserrate.* London: Meitchm & Sons, 1903–14.

Copper as Canvas 1998–99. Komanecky, Michael. *Copper as Canvas: Two Centuries of Masterpiece Paintings on Copper 1575–1775.* Oxford and New York: Oxford University Press, 1998.

Country Life 1966. *Country Life,* October 6, 1966.

D

David Teniers de Jonge 1991. Klinge, Margaret. *David Teniers de Jonge: Schilderijen, Tekeningen.* Antwerp: Koninklijk Museum voor Schone Kunsten; Ghent: Snoeck-Ducaju & Zoon, 1991.

David Teniers der Jüngere, 1610–1690 2005–2006. Klinge, Margaret and Dietmar Lüdke. *David Teniers der Jüngere, 1610–1690: Alltag und Vergnügen in Flandern.* Karlsruhe: Staatliche Kunsthalle Karlsruhe; Heidelberg: Keher, 2005.

Davies 1992. Davies, Alice. *Jan van Kessel 1641–1680.* Doornspijk: Davaco, 1992.

Dawn of the Golden Age 1993–94. Luijten, Ger. *Dawn of the Golden Age: Northern Netherlandish Art, 1580–1620.* Amsterdam: Rijksmuseum; Zwolle: Waanders; New Haven and London: Yale University Press, 1993.

Delft Masters: Vermeer's Contemporaries 1996. Kersten, Michiel with Michiel Plomp and Daniëlle H. A. C. Lokin. *Delft Masters, Vermeer's Contemporaries: Illusionism Through the Conquest of Light and Space.* Trans. Andrew McCormick. Zwolle: Waanders; Delft: Stedelijk Museum Het Prinsenhof, 1996.

Descamps 1753–54. Descamps, Jean-Baptist. *La Vie des peintres Flamands, Allemands et Hollandois, avec des portraits gravés en taille-douche, une indication de leurs principaux ouvrages, & des réflexions sur leurs différentes manières.* Vols. 1 and 2. Paris: C. A. Jombert, 1753–54.

"Détail des Peintures des deux Cabinets Electoraux à Mannheim" 1736.

"Détail des Peintures du Cabinet Electoral de Düsseldorf" 1719. "Détail des Peintures du Cabinet Electoral de Düsseldorf," ca. 1719, printed manuscript, Herzog August Bibliothek, Wolfenbüttel, no. 25.

Diebstahl von Gemälden 1946. Städelsches Kunstinstitut. *Diebstahl von Gemälden.* Frankfurt: Städelsches Kunstinstitut, 1946.

Die Meister des Holländischen Interieurs 1929. Galerie Dr. Schäffer, Berlin. *Die Meister des Holländischen Interieurs.* Leipzig: Druck von J. Klinkhardt, 1929.

Dijk-Koekoek 2000. Dijk-Koekoek, H. G. "Willem Claesz. Heda." In Turner, Jane, ed. *The Grove Dictionary of Art. From Rembrandt to Vermeer: 17th-Century Dutch Artists.* From *The Grove Art Series.* New York: St. Martin Press, 2000.

Von Dillis 1838. Von Dillis, Georg. *Verzeichnis der Gemälde in der Königlichen Pinakothek zu München.* Munich, 1838.

Von Dillis 1839. Von Dillis, Georg. *Catalogue des Tableaux de la Pinacothèque Royale à Munich.* Munich: J. A. Finsterlin, 1839.

Von Dillis 1845. Von Dillis, Georg. *Verzeichnis der Gemälde in der Königlichen Pinakothek zu München.* 3rd ed. Munich: J. A. Finsterlin, 1845.

Dobrzycka 1966. Dobrzycka, Anna. *Jan van Goyen 1596–1656.* Poznan, 1966.

Douglas-Pennant 1902. Douglas-Pennant, Alice. *Catalogue of the Pictures at Penrhyn Castle and Mortimer House in 1901.* Bangor: Jarvis and Foster, 1902.

Dudok van Heel 2006. Dudok van Heel, Sebastian A. C. "De Jonge Rembrandt Onder Tijdgenoten: Godsdienst En Schilderkunst In Leiden En Amsterdam." *Nijmeegse Kunsthistorische Studies* 14. Rotterdam: Veenman; New York: Distributed by D. A. P., 2006.

Duparc 1985. Duparc, Frederik J. "Een zeldzaam stilleven van de Maastrichtse schilder De Fromantiou." *Bonnefans* 1 (1985), no. 1, pp. 4–5.

Duparc 1993. Duparc, Frederik J. "Philips Wouwerman, 1619–1668." *Oud Holland* 107 (1993), pp. 257–86.

Dutch 17th Century Italianate Landscape Painters 1978. Blankert, Albert. *Dutch 17th Century Italianate Landscape Painters.* Soest: Davaco, 1978.

Dutch and Flemish Paintings from New York Private Collections 1988. Adams, Ann Jensen with Egbert Haverkamp-Begemann. *Dutch and Flemish Paintings from New York Private Collections.* New York: National Academy of Design, 1988.

Dutch Flower Painting 1600–1750 1995. Taylor, Paul. *Dutch Flower Painting 1600–1750*. New Haven and London: Yale University Press, 1995.

Dutch Life in the Golden Century 1975. Robinson, Franklin Wescott. *Dutch Life in the Golden Century: An Exhibition of Seventeenth Century Dutch Painting of Daily Life. Presented under the Auspices of the Royal Netherlands Embassy, Washington, D. C.* St. Petersburg, Florida: Museum of Fine Arts, 1975.

Dutch Masterpieces 1956. Graves Art Gallery. *Dutch Masterpieces: An Exhibition of Paintings.* Sheffield: Graves Art Gallery, 1956.

Dutch Painting in the 17th Century 1945–46. Norris, Christopher. *Dutch Painting in the 17th Century: Illustrated Catalogue.* London: Arts Council of Great Britain, 1945.

Dutch Paintings from East Anglia 1966. Norwich Castle Museum. *Dutch Paintings from East Anglia: A Catalogue of a Loan Exhibition.* Norwich: Norwich Castle Museum, 1966.

Dutch Pictures 1450–1750 1952–53. Royal Academy of Arts. *Dutch Pictures 1450–1750. Winter Exhibition.* London: Royal Academy of Arts, 1952.

Dutch Portraits 2007–2008. Ekkart, Rudolph and Quentin Buvelot. *Dutch Portraits: The Age of Rembrandt and Frans Hals.* Zwolle: Waanders, 2007–2008.

Dutch Seventeenth Century Portraiture, the Golden Age 1980–81. Wilson, William Harry. *Dutch Seventeenth Century Portraiture, the Golden Age. Presented Under the Auspices of the Royal Netherlands Embassy.* Sarasota: John and Mable Ringling Museum of Art, 1980.

Dutuit 1881–88. Dutuit, Eugène. *Manuel de l'amateur d'estampes.* 6 vols. Paris: A. Lévy, 1881–88.

E

De eeuw Van Bruegel 1963. Musées Royaux des Beaux-Arts de Belgique. *De eeuw Van Bruegel: De Schilderkunst in België in De 16e Eeuw.* Belgium: Koninklijke Musea voor Schone Kunsten, 1963.

The Eigth [sic] Series of 100 Paintings by Old Masters 1902. Sedelmeyer Gallery. *The Illustrated Catalogue of the Eigth [sic] Series of 100 Paintings by Old Masters of the Dutch, Flemish, Italian, French and English Schools, Being a Portion of the Sedelmeyer Gallery Which Contains About 1500 Original Pictures by Ancient and Modern Artists.* Paris: Sedelmeyer Gallery, 1902.

Van Eijnden and Van der Willigen 1816. Eijnden, Roeland van with Adriaan van der Willigen. *Geschiedenis Der Vaderlandsche Schilderkunst, Sedert De Helft Der XVIII Eeuw.* Vol. 1. Haarlem: A. Loosjes, Pz, 1816.

Errera 1920–21. Errera, Isabelle. *Répertoire des Peintures datées.* Brussels: G. van Oest & Cie, 1920–21.

Ertz 1979. Ertz, Klaus. *Jan Brueghel der Ältere 1568–1625: Die Gemälde Mit Kritischem Oeuvrekatalog.* Cologne: DuMont, 1979.

Ertz and Nitze-Ertz 2008–2010. Ertz, Klaus and Christine Nitze-Ertz. *Jan Brueghel der Ältere 1568–1625. Kritscher Katalog der Gemälde.* 3 vols. Lingen: Luca, 2008–2009.

Eudel 1887. Eudel, Paul. *L'Hôtel Drouot et la Curiosité en 1885–86.* Paris: G. Charpentier, 1887.

Exhibition of 17th Century Art in Europe 1938. Royal Academy of Arts. *Exhibition of 17th Century Art in Europe.* London: Royal Academy of Arts, 1938.

Exhibition of 300 Paintings by Old Masters 1898. Sedelmeyer Gallery. *Illustrated Catalogue of 300 Paintings by Old Masters of the Dutch, Flemish, Italian, French and English Schools Being Some of the Principal Pictures Which Have at Various Times Formed Part of the Sedelmayer Gallery.* Paris: Sedelmeyer, 1898

Exhibition of the Collection of Pictures and Drawings of the Late Mr. George Salting 1910. National Gallery. *Catalogue of the Collection of Pictures and Drawings of the Late Mr. George Salting.* London: National Gallery, 1910.

Exhibition of Dutch Art 1450–1900 1929. Royal Academy of Arts with Robert Clermont Witt. *Exhibition of Dutch Art 1450–1900.* London: Royal Academy of Arts, 1929.

Exhibition of Paintings and Sculpture in the Collection of Charles T. Yerkes Esq., New York 1904. Yerkes, Charles Tyson. *Catalogue of Paintings and Sculpture in the Collection of Charles T. Yerkes Esq., New York.* Vol. 1. Boston: A. W. Elson, 1904.

Exhibition of Pictures by Dutch Masters of the Seventeenth Century 1900. Burlington Fine Arts Club. *Exhibition of Pictures by Dutch Masters of the Seventeenth Century.* London: Burlington Fine Arts Club, 1900.

Exhibition of Pictures from the Althorp Collection 1947. Thos. Agnew & Sons Ltd. *Exhibition of Pictures from the Althorp Collection.* London: Thos. Agnew & Sons Ltd., 1947.

Exhibition of Pictures of the Italian, Spanish, Flemish, and Dutch Schools 1822. British Institution. *A Catalogue of Pictures of the Italian, Spanish, Flemish, and Dutch Schools.* London: W. Blumer and William Nicol, 1822.

Exhibition of Pictures by Italian, Spanish, Flemish, Dutch, and English Masters 1829. British Institution. *Catalogue of Pictures by Italian, Spanish, Flemish, Dutch, and English Masters.* London: William Nicol, Successor to W. Blumer and Co. Cleveland-Row, St. James's, 1829.

Exhibition of Pictures by Italian, Spanish, Flemish, Dutch, and English Masters 1832. British Institution. *Catalogue of pictures by Italian, Spanish, Flemish, Dutch, and English Masters: with which the Proprietors Have Favoured the Institution, July, 1832.* London: Printed by William Nicol, 1832.

Exhibition of Pictures by Italian, Spanish, Flemish, Dutch, and French Masters 1836. British Institution. *Catalogue of Pictures by Italian, Spanish, Flemish, Dutch, and French Masters* London: W. Clowes and Sons, 1836.

Exhibition of Pictures by Italian, Spanish, Flemish, Dutch, and French Masters 1837. British Institution. *Catalogue of Pictures by Italian, Spanish, Flemish, Dutch, and French Masters.* London: William Nicol, 1837.

Exhibition of Pictures by Italian, Spanish, Flemish, Dutch, French, and English Masters 1851. British Institution. *Catalogue of Pictures by Italian, Spanish, Flemish, Dutch, French, and English Masters.* London: William Nicol, 1851.

Exhibition of Pictures by Italian, Spanish, Flemish, Dutch, French, and English Masters 1863. British Institution. *Catalogue of Pictures by Italian, Spanish, Flemish, Dutch, French, and English Masters: with which the Proprietors Have Favoured the Institution.* London: British Institution, 1863.

Exhibition of Pictures by Rubens, Rembrandt, Van Dyke, and Other Artists 1815. British Institution. *Catalogue of Pictures by Rubens, Rembrandt, Van Dyke, and Other Artists of the Flemish and Dutch Schools.* London: Printed by W. Bulmer, 1815.

Exhibition of the Works of the Ancient Masters and Deceased British Artists 1859. British Institution. *Catalogue of Pictures by Italian, Spanish, Flemish, Dutch, French, and English Masters.* London: J. B. Nichols and Sons, 1859.

Exhibition of the Works of the Ancient Masters and Deceased British Artists 1867. British Institution. *Catalogue of Pictures by Italian, Spanish, Flemish, Dutch, French, and English Masters.* London: J. B. Nichols and Sons, 1867.

Exhibition of the Works of the Old Masters and by Deceased Masters of the British School 1870. Royal Academy of Arts. *Exhibition of the Works of the Old Masters, Associated with a Collection from the Works of Charles Robert Leslie, R. A., and Clarkson Stanfield, R. A., Winter Exhibition.* London: Printed by William Clowes and Sons for the Royal Academy, 1870.

Exhibition of Works by the Old Masters and by Deceased Masters of the British School 1876. Royal Academy of Arts. *Catalogue of Works by the Old Masters and by Deceased Masters of the British School, Winter Exhibition.* London: Printed by William Clowes and Sons for the Royal Academy, 1876.

Exhibition of Works by the Old Masters and by Deceased Masters of the British School 1881. Royal Academy of Arts. *Catalogue of Works by the Old Masters and by Deceased Masters of the British School, Including Drawings by J. Flaxman, R. A., Winter Exhibition.* London: Printed by William Clowes and Sons for the Royal Academy, 1881.

Exhibition of Works by the Old Masters and by Deceased Masters of the British School 1885. Royal Academy of Arts. *Exhibition of Works by the Old Masters and Deceased Masters of the British School, Winter Exhibition.* London: Printed by William Clowes and Sons for the Royal Academy, 1885.

Exhibition of the Works by the Old Masters and by Deceased Masters of the British School 1887. Royal Academy of Arts. *Exhibition of the Works of the Old Masters and by Deceased Masters of the British School, Winter Exhibition.* London: Printed by William Clowes and Sons for the Royal Academy, 1887.

Exhibition of Works by the Old Masters and by Deceased Masters of the British School 1891. Royal Academy of Arts. *Catalogue of Works by the Old Masters and by Deceased Masters of the British School, Including Drawings Illustrating the Progress of the Art of Water Colour in England, Winter Exhibition.* London: Printed by William Clowes and Sons for the Royal Academy, 1891.

Exhibition of Works by the Old Masters and Deceased Masters of the British School 1910. Royal Academy of Arts. *Exhibition of Works by the Old Masters and Deceased Masters of the British School: Including a Collection of Water Colour Drawings; also a Selection of Drawings and Sketches by George Frederick Watts; Winter Exhibition, Forty-first Year.* London: Royal Academy of Arts, 1910.

Exposition au Profit de l'oeuvre des Orphelins d'Alsace-Lorraine 1885. *Exposition de Tableaux, statues et objets d'art au profit de l'oeuvre des orphelins d'Alsace-Lorraine.* Paris: Salle des États au Louvre, 1885.

European Fine Art Fair 1995. *The European Fine Art Fair Handbook.* Maastricht, 1995, p. 106, ill.

European Fine Art Fair 1999. *The European Fine Art Fair Handbook.* Maastricht, 1999, p. 121.

F

Fifteen Important Old Master Paintings 1966–67. H. Terry-Engell Gallery. *Fifteen Important Old Master Paintings.* London: H. Terry-Engell Gallery, 1966.

Fifty Paintings by Old Masters 1995. Bob B. Haboldt & Co. *Fifty Paintings by Old Masters.* New York: Bob B. Haboldt & Co., 1995.

Fiori: Cinque Secoli di Pittura Floreale 2004. Solinas, Francesco, ed. *Fiori: Cinque Secoli di Pittura Floreale.* Rome: Campisano, 2004.

Fire! Jan van der Heyden 1637–1712 2006–2007. Sutton, Peter C. with Jonathan Bikker, Arie Wallert, Taco Dibbets, et al. *Jan van der Heyden (1637–1712).* New Haven and London: Yale University Press, 2006.

Fock 1974. Fock, C. Willemijn. "Hoe zat het in de Middeleeuwem." In Evert van Straaten. *Levenslang zitten.* Leeuwarden: Miedema, 1974, p. 38.

Fock 2001. Fock, C. Willemijn, ed. *Het Nederlandse interieur in beeld 1600–1900.* Zwolle: Waanders, 2001.

Frans Hals 1962. Slive, Seymour and Henricus Petrus Baard. *Frans Hals, Exhibition on the Occasion of the Centenary of the Municipal Museum at Haarlem.* Haarlem: Frans Hals Museum, 1962.

Fortegnelse Over Billeder Af Gammel Kunst 1891–92. *Fortegnelse Over Billeder Af Gammel Kunst.* Copenhagen: Kunstforeningen, 1891.

Foucart 1970. Foucart, J. *Le Siècle de Rembrandt: Tableaux hollandaise des collections publiques françaises.* Paris: Réunion des Musées Nationaux, 1970.

Foucart 1996. Foucart, J. In *Musée du Louvre: Nouvelles Acquisitions du Département des Peintures 1991–95.* Paris: Editions de la Réunion des Musées Nationaux, 1996.

François du Quesnoy, 1507–1643 2005. Boudoun-Machuel, Marion. *François du Quesnoy, 1507–1643.* Paris: Arthena, 2005.

Franits 2004. Franits, Wayne. *Dutch Seventeenth-Century Genre Painting: Its Stylistic and Thematic Evolution.* New Haven and London: Yale University Press, 2004.

Frankfurt 1928. Städelsches Kunstinstitut. Frankfurt, 1928.

Frans Hals 1989–90. Seymour, Slive and Pieter Biesboer. *Frans Hals.* Munich: Prestel, 1989.

Frans van Mieris 1635–1681 2005–2006. Buvelot, Quentin with essays by Otto Naumann and Eddy de Jongh and contributions by Peter van der Ploeg. *Frans van Mieris 1635–1681.* The Hague: Mauritshuis; Washington: National Gallery of Art; Zwolle: Waanders, 2005.

Franz 1965. Franz, Heinrich Gerhard. "Hans Bol als Landschaftszeichner." *Jahrbuch des Kunsthistorischen Instituts der Universität Graz.* Graz: Akademische Druck, 1965, pp. 19–67.

Friedländer 1923. Friedländer, Max J. *Die Niederländischen Maler des 17. Jahrhunderts.* Vol. 12. *Propyläen-Kunstgeschichte.* Berlin: Propyläen, 1923.

Friedländer 1952. Friedländer, Max J. *Collection Dr. H. Wetzlar, Amsterdam.* Amsterdam: J. H. de Bussy, 1952.

Von Frimmel 1910. Von Frimmel, Theodore. "Das Bildnis der Malerin Maria Schalcken." *Blätter für Gemäldekunde* 6 (1910), pp. 90–92, ill. p. 91.

Von Frimmel 1913–14. Von Frimmel, Theodore. *Lexikon der Wiener Gemäldesammlungen: Abschlussbände mit übersichtlichen Zusammenstellungen.* 2 vols. Munich: G. Müller, 1914.

From Botany to Bouquets 1999. Wheelock, Arthur K. Jr. *From Botany to Bouquets: Flowers in Northern Art.* Washington: National Gallery of Art, 1999.

Frozen Silence 1982. Blankert, Albert and Waterman Gallery et al. *Hendrick Avercamp, 1584–1634, Barent Avercamp, 1612–1679: Frozen Silence: Paintings from Museums and Private Collections.* Amsterdam: K. & V. Waterman, 1982.

G

Gaedertz 1869. Gaedertz, Theodore. *Adriaen van Ostade, sein Leben und seine Kunst.* Lübeck: Ronden, 1869

Galerie de Pommersfelden 1867. *Galerie de Pommersfelden: Catalogue de la collection de tableaux anciens du Château de Pommersfelden à M. le Comte de Schönborn.* Paris: De l'imprimerie de J. Claye, 1867.

Galichon 1868. Galichon, Emile Louis. "La Galerie de San Donato." *Gazette des Beaux-Arts* 24 (April 1868), pp. 406–407.

Garlick 1976. Garlick, Kenneth J. "A Catalogue of the Pictures at Althorp." *The Walpole Society* 45 (1976), p. 9, no. 62.

Van Gehren 1979. Van Gehren, Georg. "Jan Brueghel D. Ä." *Weltkunst* 14 (July 15, 1979).

Van Gelder 1941. Van Gelder, Hendrik E. *W. C. Heda, A. van Beyeren, W. Kalf.* Amsterdam: H. J. W. Becht, 1941.

Gemälde alter Meister aus Berliner Besitz 1925. Akademie der Künste. *Gemälde Alter Meister aus Berliner Besitz.* Berlin: Akademie der Künste, 1925.

Gemar-Koeltzch 1995. Gemar-Koeltzsch, Erika and Christa Nitze-Ertz. *Holländische Stillebenmaler im 17. Jahrhundert.* Lingen: Luca, 1995.

Gerrit Dou 1613–1675 2000. Baer, Ronni with Annetje Boersma and Arthur K. Wheelock Jr., eds. *Gerrit Dou 1613–1675: Master Painter in the Age of Rembrandt.* Washington: National Gallery of Art; New Haven and London: Yale University Press, 2000.

Gerson 1936. Gerson, Horst. *Philips Koninck: ein Beitrag zur Erforschung der Holländischen Malerei des XVII. Jahrhunderts.* 1st ed. Berlin: Gebr. Mann, 1936.

Gerson 1952. Gerson, Horst. "Het Tijdperk Van Rembrandt En Vermeer." In *Zes Eeuwen Nederlandse Schilderkunst, Deel II.* Amsterdam: Contact, 1952.

Gerson 1968. Gerson, Horst. *De schilderijen van Rembrandt.* Amsterdam: Meulenhoff International, 1968.

Gerson 1980. Gerson, Horst. *Philips Koninck: ein Beitrag zur Erforschung der Holländischen Malerei des XVII. Jahrhunderts.* 2nd ed. Berlin: Gebr. Mann, 1980.

Geweven Boeket 1971. Burgers, C. A. *Geweven Boeket.* Amsterdam: Rijksmuseum, 1971.

De Ghellinck 1790. De Ghellinck, Thomas Loridon and J. L. Wouters. *Catalogue d'une très belle et riche collection de tableaux des meilleurs & plus-célèbres peintres des école Flamande, Hollandoise, Allemande & Italienne, qui composent le cabinet de Monsieur T. Loridon de Ghellinck.* Ghent, 1790.

Giltaij 1990. Giltaij, Jeroen. "G. Schwartz and M. J. Bok, Pieter Saenredam: De schilder in zijn tijd." *Simiolus* 20 (1990/91), p. 90.

Ginnings 1970. Ginnings, Rebecca Jean. "The Art of Jan Baptist Weenix and Jan Weenix." PhD diss., University of Delaware, 1970.

Gisluk-Grosheide 1997. Gisluk-Grosheide, Daniëlle. "Dirk van Rijswijck (1696–1679), a Master of Mother-of-Pearl." *Oud Holland* 111, 2 (1997), pp. 77–94.

The Glory of the Golden Age 2000. Kiers, Judikje with Fieke Tissink, Jan Pieter Filedt Kok, and Bart Cornelis. *The Glory of the Golden Age: Painting, Sculpture and Decorative Art.* Zwolle: Waanders; Amsterdam: Rijksmuseum, 2000.

Goeree 1668. Goeree, Willem. *Inleydinge tot de Al-ghemeene Teycken-Konst.* Middelburg, 1668.

The Golden Age of Dutch Landscape Painting 1994. Sutton, Peter C. with John Loughman. *The Golden Age of Dutch Landscape Painting.* Madrid: Fundacíon Colección Thyssen-Bornemisza, 1994.

The Golden Age of Dutch Painting from the Collection of the Dordrechts Museum 2002. Van Oosterhout, Carlo. *The Golden Age of Dutch Painting from the Collection of the Dordrechts Museum.* Athens: Museio Alexandru Sutzu, 2002.

Gool 1750–51. Gool, J. van. *De nieuwe schouwburg der Nederlantsche Kunstschilders en schilderessen.* 2 vols. The Hague: J. van Gool, 1750.

De Gouden Eeuw Begint in Haarlem 2008–2009. Biesboer, Pieter. *De Gouden Eeuw Begint in Haarlem.* Haarlem: Frans Hals Museum; Rotterdam: NAi, 2008.

Gower 1881. Gower, Lord Ronald Sutherland. *The Great Historic Galleries of England*. Vol. 4, no. 9. London: Sampson, Low, Marston, Searle and Rivington, 1881.

Grant 1956. Grant, Maurice Harold. *Rachel Ruysch*. Leigh-on-Sea: F. Lewis, 1956.

Graves 1913–15. Graves, Algernon. *A Century of Loan Exhibitions 1813–1912*. 5 vols. London: Graves, 1913–15.

Graves 1921A. Graves, Algernon. *Art Sales from Early in the Eighteenth Century to Early in the Twentieth Century*. Vol. 2. London: Graves, 1921.

Graves 1921B. Graves, Algernon. *Art Sales from Early in the Eighteenth Century to Early in the Twentieth Century*. Vol. 3. London: Graves, 1921.

Great Dutch Paintings from America 1990–91. Broos, Ben P. J. and Edwin Buijsen et al. *Great Dutch Paintings from America*. The Hague: Mauritshuis; Zwolle: Waanders, 1990.

Greindl 1983. Greindl, Edith. *Les Peintres flamands de nature morte au XVIIe siècle*. 2nd ed. Brussels: Sterrebeek, 1983.

Grimm 1988. Grimm, Claus. *Stilleben – Die niederländischen und deutschen Meister*. Stuttgart: Belser, 1988.

Grimm 1989. Grimm, Claus. *Frans Hals, Das Gesamtwerk*. Stuttgart: Belser, 1989.

Grosse 1925. Grosse, Rolph. *Die holländische Landschaftskunst, 1600–1650*. Stuttgart: Deutsche Verlags-Anstalt, 1925.

Guiccardini 1567. Guiccardini, Lodovico. *Descrittione di tutti i Paesi Bassi, altrimenti detti Germania inferior*. Antwerp, 1567.

H

De Haan 2005. De Haan, Johannes Binne Hendrik, *Hier ziet men uit paleizen: het Groninger interieur in der zeventiende en achttiende eeuw*. Aaasen: Koninklijke Van Gorcum, 2005.

Haberland 2000. Haberland, Irene. "Balthasar van der Ast." In Turner, Jane, ed. *The Grove Dictionary of Art. From Rembrandt to Vermeer: 17th-Century Dutch Artists*. From *The Grove Art Series*. New York: St. Martin Press, 2000.

Hairs 1951. Hairs, Marie-Louise. "Osias Beert l'Ancien, Peintre de Fleurs." *Revue Belge d'Archéologie et d'Histoire de l'Art* 20 (1951), pp. 237–51.

Hairs 1955. Hairs, Marie-Louise. *Les Peintres flamands de fleurs au XVIIe siècle*. 1st ed. Paris: Elsevier; Brussels: Lefebvre et Gillet, 1955.

Hairs 1965. Hairs, Marie-Louise. *Les Peintres flamands de fleurs au XVIIe siècle*. 2nd ed. Paris: Elsevier; Brussels: Lefebvre et Gillet, 1965.

Hairs 1985. Hairs, Marie-Louise. *Les Peintres flamands de fleurs au XVIIe siècle*. 3rd ed. Paris: Elsevier; Brussels: Lefebvre et Gillet, 1985.

Van Hall 1963. Van Hall, H. *Portretten van Nederlandse beeldende kunstenaars*. Amsterdam: Swets en Zeitlinger, 1963.

Harwood 1988. Harwood, Laurie B. *Adam Pynacker*. Doornspijk: Davaco, 1988.

Hendrick Avercamp 1585–1634 1979. Welcker, Clara Johanna. *Hendrick Avercamp 1585–1634, bijgenaamd "de Stomme van Campen;" Barent Avercamp 1612–1679, "Schilders tot Campen."* Doornspijk: Davaco, 1979.

Hendrick Avercamp: Master of the Ice Scene 2009–2010. Roelofs, Pieter et al. *Hendrick Avercamp: Master of the Ice Scene*. Amsterdam: New Amsterdam, 2009.

Het Aanzien van Amsterdam 2007–2008. Bakker, Boudewijn. *Het Aanzien van Amsterdam: Panorama's, Plattegronden en Profielen uit de Gouden Eeuw*. Bussum: Thoth; Amsterdam: Stadsarchief, 2007.

Het Nederlandse Stilleven 1550–1720 1999–2000. Chong, Alan with Wouter Kloek. *Het Nederlandse Stilleven 1550–1720*. Amsterdam: Rijksmuseum; Cleveland: The Cleveland Museum of Art; Zwolle: Waanders, 1999. [See also *Still-Life Paintings from the Netherlands 1550–1720* 1999–2000.]

Het schildersatelier in de Nederlanden 1500–1800 1964. De Waag. *Het schildersatelier in de Nederlanden 1500–1800*. Nijmegen: De Waag, 1964.

Hirschfelder 2008. Hirschfelder, Dagmar. *Tronie und Porträt in der niederländischen Malerei des 17 Jahrhunderts*. Berlin: Gebr. Mann, 2008.

Hirth and Muther 1888. Hirth, Georg and Richard Muther. *Der Cicerone in der Königlichen Pinakothek zu München*. Munich: G. Hirth, 1888.

Hoet 1752. Hoet, Gerard. *Catalogus of Naamlyst van schilderyen, met derzelver pryzen zeedert een langen reeks van jaaren zoo in Holland als op andere plaatzen in het openbaar verkogt. Benevens een verzameling van lysten van verscheyden nog in wezen zynde cabinetten*. Vols. 1 and 2. The Hague: Pieter Gerard van Baalen, 1752.

Hoet and Terwesten 1770. Hoet, Gerard. *Catalogus of Naamlyst van schilderyen, met derzelver pryzen zeedert een langen reeks van jaaren zoo in Holland als op andere plaatzen in het openbaar verkogt. Benevens een verzameling van lysten van verscheyden nog in wezen zynde cabinetten*. Vol. 3. Ed. Pieter Terwesten. The Hague: Pieter Gerard van Baalen, 1770.

Hofstede 2002. Hofstede, Annigje C. H. *Meubelkuns: 40 eeuwen meubelgeschiedenis*. Utrecht: Ons Huis/Taurus, 2002.

Hofstede de Groot 1907–28. Hofstede de Groot, Cornelis. *Beschreibendes und Kritisches Verzeichnis der Werke der Hervorragendsten Hollandischen Maler des XVII. Jahrhunderts*. 10 vols. Paris: Esslingen am Neckar, 1907–28.

Hofstede de Groot 1927A. Hofstede de Groot, Cornelis. In Thieme, Ulrich von and Felix Becker. *Allgemeines Lexikon der bildenden Künstler*. Vol. 11. Leipzig: E. A. Seemann, 1927, p. 112.

Hofstede de Groot 1927B. Hofstede de Groot, Cornelis. "Isack Koedijck." In Friedländer, Max J. *Festschrift für Max J. Friedländer zum 60. Geburtstag*. Leipzig: E. A. Seemann, 1927, pp. 181–90.

Holland Frozen in Time 2001. Suchtelen, Ariane van with contributions by Frederik J. Duparc, Peter van der Ploeg, and Epco Runia. *Holland Frozen in Time: The Dutch Winter Landscape in the Golden Age*. Trans. Michael Hoyle and Diane Webb. The Hague: Mauritshuis; Zwolle: Waanders, 2001.

La Hollande en Fleurs 1949–50. Luttervelt, Remmet van. *La Hollande en Fleurs*. Strasbourg: Château des Rohan, 1949.

Höllander des 17. Jahrhunderts 1953. Kunsthaus Zürich. *Höllander des 17. Jahrhunderts*. Zurich: Kunsthaus Zürich, 1953.

Hollandse Schilderkunst; Landschappen 17de eeuw 1980. Duparc, Frederik J. Mauritshuis. *Hollandse Schilderkunst; Landschappen 17de eeuw*. The Hague: Mauritshuis, 1980.

Hollstein 1949–. Hollstein, F. W. H. *Dutch and Flemish Etchings, Engravings, and Woodcuts, ca. 1450–1700*. 10 vols. Amsterdam: M. Hertzberger, 1949–.

Holmes 1928. Holmes, Charles. *Pictures from the Iveagh Bequest and Collections*. London: The Iveagh Trustees, 1928.

Hooft 1912. Hooft, Cornelius G. *Amsterdamse Stadsgezichten van Jan van der Heyden*. Amsterdam: Ten Brink & De Vries, 1912.

Van Hoogstraeten 1678. Van Hoogstraeten, Samuel. *Inleyding Tot De Hooge Schoole Der Schilderkonst: Anders De Zichtbaere Werelt: Verdeelt In Negen Leerwinkels, Yder Bestiert Door Eene Der Zanggodinnen*. Rotterdam: Fransois van Hoogstraeten, 1678.

The Hope Collection of Pictures of the Dutch and Flemish School 1898. Wertheimer, Asher. *The Hope Collection of Pictures of the Dutch and Flemish School: with Descriptions Reprinted from the Catalogue Published in 1891 by the Science and Art Department of the South Kensington Museum*. London: South Kensington Museum, 1898.

Houbraken 1718–21. Houbraken, Arnold. *De Groote Schouburgh der Nederlantsche Konstschilders en Schilderessen*. 3 vols. Amsterdam: Gedrukt voor den autheur, 1718–21.

Huygens 1897. Huygens, Constantijn. "Fragment eener Autobiographie van Constantijn Huygens (Unfinished Latin manuscript)." Ed. Jacob Adolf Worp. *Bijdragen en Mededeelingen van het Historisch Genootschap* 18 (1897), pp. 70–76.

I

The Illustrated London News, 1953. *The Illustrated London News*, 1953, ill.

The Illustrated London News, 1966. *The Illustrated London News*, August 6, 1966, pp. 26–27.

Illustrated Souvenir of Dutch Pictures, 1450–1750 1938. Royal Academy of Arts. *Illustrated Souvenir of Dutch Pictures, 1450–1750*. London: Royal Academy of Arts, 1938.

Illustrated Souvenir of the Exhibition of 17th Century Art in Europe 1938. Royal Academy of Arts. *Illustrated Souvenir of the Exhibition of 17th Century Art in Europe*. London: Printed by W. Clowes and Sons for the Royal Academy, 1938.

In den Bloemhof der Schilderkunst 1947. Frans Hals Museum. *In den Bloemhof der Schilderkunst – tentoonstelling van bloemstillevens uit vier eeuwen*. Haarlem: Frans Hals Museum, 1947.

Inaugural Exhibition of Old Master Paintings 1995. Sutton, Peter C. In Otto Naumann, Ltd. *Inaugural Exhibition of Old Master Paintings*. New York: Otto Naumann, Ltd., 1995.

Ingamells 1992. Ingamells, John. *The Wallace Collection: Catalogue of Pictures, Dutch and Flemish*. Vol. 4. London: Trustees of the Wallace Collection, 1992.

The Inspiration of Nature 1976. Mitchell, Peter with Ignvar Bergstrom. *The Inspiration of Nature: Paintings of Still Life, Flowers, Birds and Insects by Dutch and Flemish Artists of the 17th Century*. London: John Mitchell & Son, 1976.

J

Jacob Backer (1608/9–1651), Rembrandts Tegenpool 2008–2009. Van den Brink, Peter and Japp van der Veen. *Jacob Backer (1608/9–1651), Rembrandts Tegenpool*. Zwolle: Waanders; Amsterdam: Museum Het Rembrandthuis; Aachen: Suermondt-Ludwig-Museum, 2008.

Jacob Gerritsz. Cuyp 2002. Paarlberg, Sander et al. *Jacob Gerritz Cuyp*. Dordrecht: Dordrechts Museum, 2002.

Jacob van Ruisdael 1981–82. Slive, Seymour with Henrick Richard Hoetink. *Jacob van Ruisdael*. Ed. Mark Greenberg. New York: Abeville Press, 1981.

Jacob van Ruisdael: Master of Landscape 2005–2006. Slive, Seymour. *Jacob van Ruisdael: Master of Landscape*. London: Royal Academy of Arts; New Haven and London: Distributed in U. S. and Canada by Yale University Press, 2005–2006.

Jameson 1844. Jameson, Anna A. *A Companion to the Private Galleries of Art in London*. London: Saunders and Otley, 1844.

Jan Brueghel the Elder 1979. Brod Gallery. *Jan Brueghel the Elder*. London: Brod Gallery, 1979.

Jan van Goyen 1996–97. Vogelaar, Christiaan with Edwin Buijsen, Sabine Giepmans, Eric J. Sluijter, et al. *Jan van Goyen*. Zwolle: Waanders; Leiden: Stedelijk Museum De Lakenhal, 1996.

Jan van Goyen 1596–1656: Conquest of Space 1981. Waterman Gallery. *Jan van Goyen 1596–1656: Conquest of Space*. Amsterdam: K. & V. Waterman; Bremen: Schunemann, 1981.

Jan Lievens: A Dutch Master Rediscovered 2008–2009. Wheelock, Arthur K. Jr. with Stephanie S. Dickey et al. *Jan Lievens: A Dutch Master Rediscovered*. Washington: National Gallery of Art; Milwaukee: Milwaukee Museum of Art; Amsterdam: Rembrandthuis; New Haven and London: Yale University Press. 2008.

Jan Lievens, Ein Maler im Schatten Rembrandts 1979. Ekkart, Rudolf E. O. with Sabine Jacob and Rüdiger Klessmann and contributions by Wolfgang J. Müller and Hans Seyffert. *Jan Lievens, Ein Maler im Schatten Rembrandts*. Braunschweig: Herzog Anton Ulrich-Museum, 1979.

Jan Steen 1926. Stedeldijk Museum de Lakenhal. *Jan Steen*. Leiden: A. W. Sijthoff, 1926.

Jan Steen, Painter and Storyteller 1996–97. Chapman, H. Perry with Wouter Th. Kloek and Arthur K. Wheelock Jr. *Jan Steen, Painter and Storyteller.* Washington: National Gallery of Art; Amsterdam: Rijksmuseum; New Haven and London: Yale University Press, 1996.

Jansen 2000. Jansen, Guido M. C. with Marjan Heteren, Ronald de Leeuwe, and Wouter Kloek. *The Poetry of Reality: Dutch Painters of the Nineteenth Century.* Zwolle: Waanders; Amsterdam: Rijksmuseum, 2000.

Jansen 2007. Jansen, Guido M. C. "Exhibition Review Nicolaes Pietersz. Berchem – In het licht van Italië." *The Burlington Magazine* 149 (May 2007), p. 355, ill. p. 356, no. 64.

Jantzen 1910. Jantzen, Hans. *Das Niederländische Architekturbild.* 1st ed. Leipzig: Klinkhardt & Biermann, 1910.

Jantzen 1979. Jantzen, Hans. *Das Niederländische Architekturbild.* 2nd ed. Braunschweig: Klinkhardt & Biermann, 1979.

Johannes Vermeer 1995–96. Wheelock, Arthur Jr., Ben Broos, and Frederik J. Duparc. *Johannes Vermeer.* Washington: National Gallery of Art; The Hague: Mauritshuis; New Haven and London: Yale University Press, 1995.

De Jonge 1939. De Jonge, Caroline Henriette. *Jan Steen.* Amsterdam, 1939.

De Jongh 2006. De Jongh, Eddy. In Haveman, Mariette. *Ateliergeheimen; over de werkplaats van de Nederlandse kunstenaar vanaf 1200 tot heden.* Lochem and Amsterdam: Kunst en Schrijven. 2006.

Jubileum tentoonstelling Douwes 1805–1955 1955. Douwes Gallery. *Jubileum tentoonstelling Douwes 1805–1955.* Amsterdam: Douwes Gallery, 1955.

K

Katalog Bayerischen Staatsgemäldesammlungen 1964. Brochhagen, Ernst. *Katalog Bayerischen Staatsgemäldesammlungen.* Munich: Galerie Aschaffenburg, 1964.

Kattenburg 1988. Kattenburg, Rob. *The Brederode off Vlieland.* Amsterdam: Rob Kattenburg Gallery, 1988.

Kaufman 1988. Kaufmann, Thomas DaCosta. *The School of Prague: Painting at the Court of Rudolf II.* Chicago: University of Chicago Press, 1988.

Kelch 1971. Kelch, Jan. *Studien zu Simon de Vlieger als Marinemaler.* Berlin: Papyrus-Druck, 1971.

Kernkamp 1902. Kernkamp, Gerard Wilhelm. "Memoriën van ridder Theodorus Rodenburg betreffende het verplaatsen van verschillende industrieën uit Nederland naar Denemarken, met daarop genomen resolutiën van koning Christiaan IV." *Bijdragen en Mededelingen van het Historisch Genootschap (gevestigd te Utrecht)* 23 (1902), pp. 216–17.

Kersttentoonstelling: Nederlandse meesters uit particulier bezit 1952–53. Museum Het Prinsenhof. *Kersttentoonstelling: Nederlandse meesters uit particulier bezit.* Delft: Museum Het Prinsenhof, 1952.

Keyes 1982. Keyes, George S. "Hendrik Averkamp and the Winter Landscape." In Blankert, Albert et al. *Hendrik Averkamp 1585–1634, Barent Averkamp 1612–1679: Frozen Silence: Paintings from Museums and Private Collections.* Amsterdam: K. & V. Waterman 1982.

Keyes 1984. Keyes, George S. *Esaias van der Velde 1587–1630.* Doornspijk: Davaco, 1984.

Kind en Kunst 1931. Frans Hals Museum. *Kind en Kunst.* Haarlem: Frans Hals Museum, 1931.

Kilian 2005. Kilian, Jennifer M. *The Paintings of Karel du Jardin (1626–1678): Catalogue Raisonné.* Amsterdam and Philadelphia: John Benjamins, 2005.

Kirschenbaum 1977. Kirschenbaum, Baruch David. *The Religious and Historical Paintings of Jan Steen.* New York: Allanheld & Schramm, 1977.

Kist 1967. Kist, J. R. "Die 19de Antiebeurs." *Toeristen Kampicen* (NAWB) (July 1, 1967), pp. 424–25.

Klessmann 1983. Klessmann, Rudiger and Bernd-Peter Keiser. *Die Holländischen Gemälde.* Braunschweig: Herzog Anton Ulrich-Museum, 1983.

E. Kloek 1998. Kloek, Els. "Lexicon van Noord-Nederlandse Kunstenaressen circa 1550–1800." In *Vrouwen en Kunst in de Republiek, een overzicht. Utrechtse Historische Cahiers* 19. Hilversum: Verloren, 1998, p. 163.

W. Kloek 2002. Kloek, Wouter. "Jacob Gerritz. Cuyp de Dordtse Proteus." In Paarlberg, Sander et al. *Jacob Gerritsz. Cuyp.* Dordrecht: Dordrechts Museum, 2002, pp. 45–62.

W. Kloek 2005. Kloek, Wouter. *Jan Steen (1626–1679).* Amsterdam: Rijksmuseum; Zwolle: Waanders, 2005.

Kolfin 2005. Kolfin, Elmer. *The Young Gentry at Play. Northern Netherlandish Scenes of Merry Companies 1610–1645.* Leiden: Primavera Pers, 2005.

De Koomen 2001. De Koomen, Arjan. "De Wereld Van De 17de-Eeuwse Kunstenaar." In *Nederlandse kunst in het Rijksmuseum 1600–1700.* Amsterdam: Rijksmuseum; Zwolle: Waanders, 2001.

Korthals Altes 2000. Korthals Altes, Everhard. "The Eighteenth-Century Gentleman Dealer Willem Lormier and the International Dispersal of Seventeenth-Century Dutch Paintings." *Simiolus* 28 (2000–2001), pp. 82, 309, no. 49, fig. 33.

Krempel 2000. Krempel, Leon. *Studien Zu Den Datierten Gemälden Des Nicolaes Maes (1634–1693).* Petersberg: M. Imhof, 2000.

Kronig 1909. Kronig, Johann O. "Gabriël Metsu." *La Revue de l'Art Ancien et Moderne* 13 (1909), p. 222, no. 144.

Kronig 1914. Kronig, Johann O. *A Catalogue of the Paintings at Doughty House, Richmond, and Elsewhere in the Collection of Sir Frederick Cook.* Vol. 2. Ed. Sir Herbert Cook. London, 1914.

Kunst uit Nijmeegs Particulier Bezit 1963. Nijmeegs Museum voor Beeldende Kunsten. *Kunst uit Nijmeegs particulier bezit.* Nijmegen: Nijmeegs Museum voor Beeldende Kunsten, 1963.

Kunstschatten: Twee Nederlandse Collecties Schilderijen uit de Vijftiende tot en met de Zeventiende eeuw en een Collectie Oud Aardewerk 1959. Singer Museum. *Kunstschatten: Twee Nederlandse Collecties Schilderijen uit de Vijftiende tot en met de Zeventiende eeuw en een Collectie Oud Aardewerk.* Laren, N. H.: Singer Museum, 1959.

Kunstschatten uit Nederlandse Verzamelingen 1955. Museum Boymans. *Kunstschatten uit Nederlandse Verzamelingen.* Rotterdam: Museum Boymans, 1955.

Kunzle 2002. Kunzle, David. *From Criminal to Courtier: The Soldier in Netherlandish Art 1550–1672.* Leiden, Boston and Cologne: Brill, 2002.

Kurfürst Johann Wilhelms Bilder 2009. Baumstark, Reinhold with Oliver Kase and Christian Quaeitsch. *Kurfürst Johann Wilhelms Bilder.* 2 vols. Munich: Hirmer, 2009.

L

Lammertse 2008. Lammertse, Friso. "Salomon de Bray; Painter, Architect and Theoretician." In Biesboer, Pieter et al. *Painting Family: the De Brays: Master Painters of the 17th Century Holland.* 1st ed. Zwolle: Waanders, 2008.

Lamoree 2006. Lamoree, Jhim. "Een Ruysdael weg, andere terug." *Het Parool* 29 (February 2006), p. 99.

Lawrence 1991. Lawrence, Cynthia Miller. *Gerrit Adriaensz Berckheyde 1638–1698: Haarlem Cityscape Painter.* Doornspijk: Davaco, 1991.

Lesko 1994. Lesko, Diane, ed. *Catalogue of the Collection. Museum of Fine Arts. St. Petersburg, Florida.* St. Petersburg, Florida: Museum of Fine Arts, 1994.

Levitin 1991. Levitin, E. S. *Zapadnoevropejski risunok XV–XIX Vekov – Gosudarstvennyj muzej izobrazitel' nych is kusst vimeni A. S. Puskina.* Moscow: Pushkin Museum, 1991.

Lichtwark 1899. Lichtwark, Alfred. *Matthias Scheits als Schilderer des Hamburger Lebens.* Hamburg: Kunsthalle zu Hamburg, 1899.

Liedtke 1982. Liedtke, Walter. *Architectural Painting in Delft: Gerard Houckgeest, Hendrick van Vliet and Emanuel de Witte.* Doornspijk: Davaco, 1982.

Liedtke 2000. Liedtke, Walter. *A View of Delft: Vermeer and His Contemporaries.* Zwolle: Waanders, 2000.

Liedtke 2008. Liedtke, Walter. *Vermeer: The Complete Paintings.* Ghent: Ludion Press; New York: Distributed by Harry N. Abrams, 2008.

De Loos-Haaxman 1941. De Loos-Haaxman, J. *De Landsverzameling Schilderijen in Batavia; Landvoogdsportretten en compagnietschilders.* Vol. 1. Leiden: A. W. Sijthoff, 1941.

Loughman 2000. Loughman, John. *Public and Private Spaces: Works of Art in Seventeenth-Century Dutch Houses.* Zwolle: Waanders, 2000.

Ludolf Backhuysen, Emden 1630–Amsterdam 1708 1985. Nannen, Henri with contributions by Ben Broos et al. *Ludolf Backhuysen, Emden 1630–Amsterdam 1708: ein Versuch, Leben und Werk des Kunstlers ze beschreiben.* Emden: L. Backhuysen Gesellschaft, 1985.

Ludolf Backhuysen, Emden 1630–Amsterdam 1708 2008–2009. Scheele, Friedrich and Annette Kanzenbach. *Ludolf Backhuysen, Emden 1630–Amsterdam 1708.* Munich: Deutscher Kunstverlag, 2008.

M

MacLaren 1960. MacLaren, Neil. *The Dutch School (National Gallery Catalogues).* London: National Gallery Publications, 1960.

MacLaren 1991. MacLaren, Neil. *The Dutch School 1600–1900.* Revised and expanded by Christopher Brown. 2nd ed. Vol. 1. London: National Gallery Publications, 1991.

Mallalieu 1994. Mallalieu, Huon. "Around the Salerooms." *Country Life* 188, 4 (January 27, 1994), pp. 66–67.

Malone 1968. Malone, L. "Jan Baptist Weenix and the Story of the 'Margaretha Picture.'" St. Petersburg, Florida: Museum of Fine Arts. *Pharos,* Winter 1968, pp. 24–27.

Van Mander 1604. Van Mander, Carel. *Het Schilder-Boeck.* Haarlem: Paschier van Wesbvach, 1604.

Manke 1963. Manke, Ilse. *Emanuel de Witte: 1617–1692.* Amsterdam: M. Hertzberger, 1963.

Von Mannlich 1810. Von Mannlich, Johann Christian. *Beschreibung der Churpfalzbaierischen Gemälde-Sammlungen zu München und zu Schleißheim.* Vol. 3. Munich, 1810.

Marggraff 1866. Marggraff, Rodolph. *Catalogue des tableaux de l'ancienne Pinacotèque Royale à Munich.* Munich: Alte Pinakothek, 1866.

Marggraff 1872. Marggraff, Rodolph. *Die ältere königliche Pinakothek zu München. Verzeichnis und Beschreibung der in ihr aufgestellten Gemälde mit biographischen und kunstgeschichtlich-kritischen Erläuterungen von Prof. Dr. Rudolf Marggraff.* Munich, 1872.

Marggraff 1878. Marggraff, Rodolph. *Kleiner Katalog der älteren königlichen Pinakothek zu München: ein Führer zur leichteren und rascheren Uebersicht der Sammlung und ihrer Hauptwerke.* Munich: Alte Pinakothek, 1878.

Marland and Pelling 1996. Marland, Hilary and Margaret Pelling, eds. *The Task of Healing: Medicine, Religion and Gender in England and the Netherlands, 1450–1800.* Rotterdam: Erasmus Press Publications, 1996.

Martin 1901. Martin, Wilhelm. *Het Leven En De Werken Van G. Dou, Beschouwd In Verband Met Het Schildersleven Van Zijn Tijd.* Leiden: S. C. van Doesburgh, 1901.

Martin 1909. Martin, Wilhelm. "Isaack Jansz. Koedyck, Schilder Van Levensgroote Figuren." *Oud Holland* 37 (1909), pp. 1–4.

Martin 1911. Martin, Wilhelm. *Gérard Dou: Sa Vie et son Oeuvre: Étude Sur la Peinture Hollandaise et les Marchands au dix-septième Siècle.* Paris: Jouve and Cie., 1911.

Martin 1913. Martin, Wilhelm. *Gerard Dou Des Meisters Gemälde in 247 Abbildungen.* Vol. 24. *Klassiker der Kunst in Gesamtausgaben.* Stuttgart and Berlin: Deutsche Verlags-Anstalt, 1913.

Martin 1935. Martin, Wilhelm. *Frans Hals en zijn tid.* Vol. 1 of *De Hollandsche Schilder Kunst in de zeventiende eeuw.* Amsterdam: J. M. Mewenhoff, 1935.

Masters of 17th Century Dutch Landscape Painting 1987–88. Sutton, Peter C. with contributions by Albert Blankert. *Masters of 17th-Century Dutch Landscape Painting.* Boston: Museum of Fine Arts; Philadelphia: Distributed by University of Pennsylvania Press, 1987.

Masters of Light 1997. Spicer, Joaneath A. with Lynn Federle Orr. *Masters of Light: Dutch Painters in Utrecht During the Golden Age.* Baltimore: Walters Art Gallery; San Francisco: Fine Arts Museums of San Francisco; New Haven and London: Distributed by Yale University Press, 1997.

Masters of Middelburg 1984. Bakker, Noortje and Ingvar Bergström, Guido Jansen, Simon H. Levie, et al. *Masters of Middelburg: Exhibition in Honour of Laurens J. Bol.* Amsterdam: Kunsthandel K. & V. Waterman B. V., 1984.

Masters of Seventeenth-Century Dutch Genre Painting 1984. Iandola, Jane Watkins, ed. *Masters of Seventeenth-Century Dutch Genre Painting.* Philadelphia: Philadelphia Museum of Art, 1984.

Mayer 1976. Mayer, Enrique. *International Auction Records.* Vol. 10. Zurich: Edition M, 1976.

Van der Meer Mohr 1997. Van der Meer Mohr, Jim. "Tekenlessen van Jan Steen." *Tableau* 19, 5 (April 1997), pp. 34–36.

Meesterwerken uit Vier Eeuwen 1938. Hannema, Dirk. *Meesterwerken uit Vier Eeuwen.* Rotterdam: Museum Boymans, 1938.

Meijer 1988. Meijer, Fred G. "Jan Davidsz. De Heem's Earliest Paintings, 1626–1628." *Hoogsteder-Naumann Mercury* 7 (1988), pp. 29–36.

Michel 1930. Michel, Emile. *Paul Potter.* Paris: H. Laurens, 1930.

Miedema 1973. Miedema, Hessel. *Den grondt der edel vry schilder-const.* Utrecht: Haentjens Dekker & Gumbert, 1973.

Miedema 1997. Miedema, Hessel, ed. *Carel van Mander, The Lives of the Illustrious Netherlandish and German Painters.* Vol. 4. Doornspijk: Davaco, 1997.

Mirror of Empire 1990–91. Keyes, George S. *Mirror of Empire: Dutch Marine Art of the Seventeenth Century.* Minneapolis: Minneapolis Institute of Arts; Cambridge and New York: Cambridge University Press, 1990.

Mirror of Nature 1981. Walsh, John Jr. and Cynthia P. Schneider. *A Mirror of Nature: Dutch Paintings from the Collection of Mr. and Mrs. Edward Carter.* Los Angeles: Los Angeles County Museum of Art, 1981.

Mitchell 1973. Mitchell, Peter. *European Flower Painters (Great Flower Painters).* London: A. and C. Black, 1973.

Moes 1897. Moes, Ernst Wilhelm. *Iconographia Batava: Bberedeneerde Lijst van Geschilderde en Ebeeldhouwde Portretten van Noord-Nederlanders in Vorige Eeuwen, door E. W. Moes.* 2 vols. Amsterdam: F. Muller & Co., 1897–1905.

Moes 1909. Moes, Ernst Wilhelm and Jean de Bosschere. *Frans Hals, Sa Vie et Son Oeuvre.* Brussels: G. van Oest & Cie., 1909.

Moes 1913. Moes, Ernst Wilhelm. "Review of C. Hofstede de Groot, Beschreibendes…Verzeichnis der Werke der holländischen Maler, Vol. 4, Esslingen-Paris 1911." *Monatshefte für Kunstwissenschaft,* 1913, p. 297.

Moiso-Diekamp 1987. Moiso-Diekamp, Cornelia. *Das Pendant in der holländischen Malerei des 17. Jarhrhunderts.* Frankfurt and New York: Peter Lang, 1987.

Ter Molen 1984. Ter Molen, Johannes Rein. *Van Vianen, Een Utrechtse Familie Van Zilversmeden Met Een Internationale Faam.* 2 vols. Leidendorp: J. R. ter Molen; Rotterdam: Gemeentedrukkerij, 1984.

Von Moltke 1938–39. Von Moltke, Joachim Wolfgang. "Salomon de Bray." *Marburger Jahrbuch für Kunstwissenschaft* 11–12 (1938–39), pp. 309–420.

Von Moltke 1996. Von Moltke, Joachim Wolfgang. "Salomon de Bray." In Turner, Jane, ed. *The Dictionary of Art.* Vol. 4. Oxford and New York: Oxford University Press, 1996.

Mooij 1998. Mooij, Annet. "'De dominantie van de westerse geneeskunde. Overzicht der medische geschiedenis,' review of *The Greatest Benefit to Mankind. A Medical History of Humanity from Antiquity to the Present,* by Roy Porter." *NRC Handelsblad,* May 15, 1998, p. 7.

Mostra di Pittura Olandese del Seicento 1954A. Salerno, Luigi. *Mostra di Pittura Olandese del Seicento.* Rome: De Luca, 1954.

Mostra di Pittura Olandese del Seicento 1954B. Palazzo Reale di Milano. *Mostra di Pittura Olandese del Seicento.* Milan: Silvana, 1954.

Müllenmeister 1973–81. Müllenmeister, Kurt J. *Meer und Land im Licht des 17. Jahrhunderts.* 3 vols. Bremen: Carl Schunemann, 1973–81.

Muller 1919. Muller, G. Frank. "Two Portrait Heads by Claesz Pietersz Berchem." *Art in America* 7 (1919), pp. 79–84.

Müller and Von der Schlichten 1730. Müller, J. C. and J. Ph. von der Schlichten. "Inventarium über die, in Ihrer Churfürstl: Dhltg: beyden Cabineten zu Düsseldorf befundene rahre gemähl. . . ." *Mannheim* 21 (1730).

N

Nagler 1907. Nagler, Georg Kaspar. *Neues allgemeines Künstler-Lexikon oder Nachrichten von dem Leben und den Werken der Maler, Bildhauer, Baumeister, Kupferstecher, Lithographen.* Vol. 10. Linz, 1907.

National Gallery 1989. *National Gallery News,* June 1989, London.

National Gallery 1990. National Gallery. *National Gallery Report April 1989–March 1990.* London: By Order of the Trustees, Publication Dept., 1990, p. 29.

Naumann 1978. Naumann, Otto. "Frans van Mieris as a Draughtsman." *Master Drawings* 16, 1 (1978), pp. 3–34.

Naumann 1981. Naumann, Otto. *Frans van Mieris the Elder 1635–1681.* Doornspijk: Davaco, 1981.

Nederlandse Landschappen uit de Zeventiende eeuw 1963. Bol, Laurens Johannes. *Nederlandse Landschappen uit de Zeventiende eeuw.* Dordrecht: Dordrechts Museum, 1963.

Nederlandse Landschapskunst in de Zeventiende eeuw 1948. De Wilde, Edy. *Nederlandse Landschapskunst in de Zeventiende eeuw.* Eindhoven: Van Abbe Museum, 1948.

Nehlsen-Marten 2003. Nehlsen-Marten, Britta. *Dirck Hals 1591–1656: Oeuvre und Entwicklung eines Haarlemer Genremalers.* Weimar: VDG, 2003.

Nicholas 1994. Nicholas, Lynn H. *The Rape of Europa: The Fate of Europe's Treasures in the Third Reich and the Second World War.* 1st ed. New York: Knopf; Distributed by Random House, 1994.

Nicolaes Pietersz. Berchem: In het Licht van Italië 2006–2007. Biesboer, Pieter. *Nicolaes Pietersz. Berchem: In het Licht van Italië.* Haarlem: Frans Hals Museum; Ghent: Ludon, 2006.

Niemeijer 1981. Niemeijer, J. W. "De kunstverzameling van John Hope (1737–1784)." *Nederlands Kunsthistorisch Jaarboek* 32 (1981), pp. 127–232.

Nihom-Nijstad 1983. Nihom-Nijstad, Saskia. *Reflets du siècle d'or: tableaux hollandais du dix-septième siècle.* Paris: Institut Néerlandais, 1983.

Norfolk Star-Ledger 1969. *Norfolk Star-Ledger* (Norfolk, Virginia), November 4, 1969.

O

Old Master Paintings 1998–99. Auersperg, Prince Johannes. *Old Master Paintings.* Vienna: Galerie Sanct Lucas, 1998.

Old Master Paintings and Drawings 1980. Thos. Agnew & Sons Ltd. *Old Master Paintings and Drawings, Autumn Exhibition.* London: Thos. Agnew and Sons Ltd., 1980.

On Horseback!: The World of Philips Wouwerman 2009. Duparc, Frederik J. and Quentin Buvelot. *Philips Wouwerman; 1619–1668.* The Hague: Mauritshuis; Zwolle: Waanders, 2009.

Orlers 1641. Orlers, Jan Janszn. *Beschrijvinge der stad Leyden.* Leiden: Abraham Commelijn; Delft: Andries Jansz, 1641.

Orlers and Haestens 1610. Orlers, Jan Janszn. and Henrick van Haestens. *Beschrijvinghe ende af-beeldinge van alle de VICTORIEN so te Water als te Lande* Folios 14 and 15. Leiden, 1610.

P

Painting Family: the De Brays 2008. Biesboer, Pieter et al. *Painting Family: the De Brays: Masters of the 17th Century Holland.* Zwolle: Waanders, 2008.

Paintings by Frans Hals 1937. Schaeffer Galleries. *Paintings by Frans Hals.* New York: Schaeffer Galleries, Inc., 1937.

Paintings Looted from Holland 1946. Vorenkamp, Alphonsus Petrus Antonius. *Paintings Looted from Holland, Returned through the Efforts of the United States Armed Forces.* New York: Plantin Press for the Albright Art Gallery, Buffalo, 1946.

Parthey 1863–64. Parthey, Gustav. *Deutscher Bildersaal; Verzeichnis Der In Deutschland Vorhandenen Oelbilder Verstorbener Maler Aller Schulen In Alphabetischer Folge Zusammengestellt.* Vol. 2. Berlin: vol. 2, 1863–64.

Paulus Potter 1994–95. Walsh, Amy, Edwin Buijsen and Ben Broos. *Paulus Potter: Paintings, Drawings and Etchings.* The Hague: Mauritshuis; Zwolle: Waanders, 1994.

Le Paysage Hollandais au XVII Siècle 1950–51. Bruyn, Joshua. *Le Paysage Hollandais au XVII Siècle.* Paris: Musée de l'Orangerie, 1950.

De Piles 1699. De Piles, Roger. *Abregé de la vie des peintres avec des reflexions sur leurs ouvrages, et un traité du peintre parfait, de la connaissance des desseins, & de l'utilité des estampes.* Paris: C. de Sercy, 1699

Pieter Claesz.: Meester van het Stilleven in de Gouden Eeuw 2004–2005. Biesboer, Pieter with Martina Brunner-Bulst and Christian Klemm. *Pieter Claesz.: der Hauptmeister des Haarlemer Stillebens in 17. Jahrhunderts.* Haarlem: Frans Hals Museum; Washington: National Gallery of Art, 2004.

Pijzel-Dommisse 1987. Pijzel-Dommisse, Jet. *Het poppenhuis van Petronella de la Court in het Centraal Museum Utrecht.* Utrecht: Veen, 1987.

Playter 1972. Playter, Caroline Bigler. "Willem Duyster and Pieter Codde: The Duyster Werelt of Dutch Genre Painting circa 1625–1635." PhD diss., Harvard University, 1972.

Plietzsch 1953. Plietzsch, Eduard. "Ausstellung Holländische Gemälde in der Londoner Akademie." *Kunstchronik* 4 (April 1953), p. 131.

Plietzsch 1960. Plietzsch, Eduard. *Höllandische und Flämische Maler des 17. Jahrhunderts.* Leipzig: E. A. Seemann, 1960.

Poetry of Everyday Life 2002. Baer, Ronnie. *Poetry of Everyday Life: Dutch Painting in Boston.* Boston: Museum of Fine Arts, 2002.

Posada Kubissa 2009. Posada Kubissa, Teresa. *Pintura Holandesa en el Museo Nacional del Prado.* Madrid: Museo Nacional del Prado, 2009.

Prag um 1600: Kunst und Kultur am Hofe Kaiser Rudolfs II 1988. Kulturstiftung Ruhr Essen. *Prag um 1600, Kunst und Kultur am Hofe Kaiser Rudolfs II.* Freren: Luca, 1988.

Pride and Joy 2000–2001. Bedaux, Jean Baptist and Rudolph Ekkart, eds. *Pride and Joy: Children's Portraits in the Netherlands 1500–1700 (Kinderen op hun mooist).* Ghent: Ludion; New York: Distributed by Harry N. Abrams, 2000.

Pride of Place 2008–2009. Suchtelen, Ariane van, Arthur K. Wheelock Jr., Boudewijn Bakker, and Henriette de Bruyn Kops. *Dutch Cityscapes of the Golden Age.* The Hague: Mauritshuis; Washington: National Gallery of Art; Zwolle: Wanders, 2009.

Priem 1997. Priem, Ruud. "The 'most excellent collection' of Lucretia Johanna van Winter: The years 1809–22." *Simiolus* 25, 2–3 (1997), pp. 103–235, ill. p. 169.

Prinz von Hohenzollern 1980. Prinz von Hohenzollern, Johann Georg. *Staatsgalerie Schleissheim: Verzeichnis der Gemälde.* Munich: Hirmer, 1980.

Prized Possessions 1992. Sutton, Peter C. and Robert J. Boardingham. *Prized Possessions: European Paintings from Private Collections of Friends of the Museum of Fine Arts.* Boston: Museum of Fine Arts, 1992.

A Prosperous Past 1988–89. Segal, Sam. *A Prosperous Past: The Sumptuous Still Life in the Netherlands 1600–1700.* Ed. William B. Jordan. The Hague: SDU, 1988.

The Public and the Private in the Age of Vermeer 2000. Wheelock, Arthur K. Jr. with contributions by Michiel C. Plomp, Danielle H. A. C. Lokin, and Quint Gregory. *The Public and the Private in the Age of Vermeer.* London: P. Wilson; Wappingers Falls, New York: Distributed in the United States and Canada by Antique Collectors' Club, 2000.

R

Raupp 1996. Raupp, Hans-Joachim. *Genre.* Neiderländische Malerei des 17. Jarhunderts der SØR Rusche-Sammlung. Vol. 2. Münster: Lit, 1996.

Von Reber 1884–1911. Von Reber, Franz. *Katalog der Gemäldesammlung der Königlichen Älteren Pinakothek.* Munich: Verlaganstalt für Kunst und Wissenschaft 1884–89; Knorr und Hirth, 1891–1911.

Van Regteren Altena 1961. Van Regteren Altena, Johannes Q. *Catalogue Raisonné van de Werken van Pieter Jansz. Saenredam, Uitgegeven ter Gelegenheid van de Tentoonstelling Pieter Jansz. Saenredam.* Utrecht: Centraal Museum, 1961.

Reiss 1975. Reiss, Stephen. *Aelbert Cuyp.* Boston: New York Graphic Society, 1975.

Rembrandt 2004. Bisanz-Prakken, Marian and Klaus Albrecht Schröder. *Rembrandt.* Vienna: Albertina; Wolfratshausen: Minerva Herman Farnung, 2004.

Rembrandt & Co. 2006. Lammertse, Friso and Jaap van der Veen. *Uylenburgh & Son: Art and Commerce from Rembrandt to De Lairesse, 1625–1675.* Zwolle: Waanders; Amsterdam: Museum het Rembrandthuis, 2006.

Rembrandt: A Genius and His Impact 1997. Blankert, Albert. In *Rembrandt: A Genius and His Impact.* Melbourne: National Gallery of Victoria; Sydney: Art Exhibitions of Australia; Zwolle: Waanders, 1997.

Rembrandt's Influence in the 17th Century 1953. The Matthiesen Gallery. *Rembrandt's Influence in the 17th Century.* London: Matthiesen Gallery, 1953.

Rembrandt en zijn tijd 1971. Van Thiel, Pieter J. J. with Hans Rudolf Hoetink and Eddy de Jongh. *Rembrandt en zijn tijd.* Brussels: La Connaissance, 1971.

Rembrandt-Hulde te Leiden 1906. Stedelijk Museum De Lakenhal. *Rembrandt-Hulde te Leiden. Catalogus der Tentoonstelling van Schilderijen en Teekeningen van Rembrandt en van schilderijen van andere Leidsche Meesters der Zeventiende Eeuw 15 juli–15 september 1906.* Leiden: Vriesman, 1906.

Rembrandt 'Rembrandt' 2002–2003. Giltaij, Jeroen. *Rembrandt 'Rembrandt.'* Frankfurt: Städtische Galerie; Kyoto: Kyoto National Museum; Wolfratshausen: Edition Minerva, 2003.

Rembrandts Schatkamer 1999. Boogert, Bob van den, ed. *Rembrandts Schatkamer.* Zwolle: Waanders, 1999.

Rembrandt's Women 2001. Williams, Julia Lloyd with Sebastien A. C. Dudok van Heel. *Rembrandt's Women.* Munich and New York: Prestel, 2001.

Reynolds 1890. Reynolds, Sir Joshua. "A Journey to Flanders and Holland in the Year 1781." *The Literary Works of Sir Joshua Reynolds.* Ed. H. W. Beechy. Vol. 2. London: Henry G. Bohn, 1890.

Reynolds and Mount 1996. Reynolds, Sir Joshua. *A Journey to Flanders and Holland.* Ed. Harry Mount. Cambridge: Cambridge University Press, 1996.

F. W. Robinson 1974. Robinson, Franklin Westcott. *Gabriël Metsu 1629–1667: A Study of His Place in Dutch Genre Painting of the Golden Age.* New York: A. Schram, 1974.

M. S. Robinson 1990. Robinson, Michael S. *The Paintings of the Willem van de Veldes.* 2 vols. Greenwich: National Maritime Museum; The Hague: Distributed by Gary Schwartz/SDU, 1990.

W. W. Robinson 1987. Robinson, William W. "The *Eavesdroppers* and Related Paintings by Nicolaes Maes." *Holländische Genremalerei im 17. Jahrhunderts: Symposium Berlin 1984.* Ed. Henning Bock and Thomas W. Gaehtgens. Berlin: Gebr. Mann, 1987, pp. 283–313.

W. W. Robinson 1996. Robinson, William W. "The Early Works of Nicolaes Maes, 1653–1661." PhD diss., Harvard University, 1996.

De Roever 1885. De Roever, Nicolaas. "Drie Amsterdamsche schilders." *Oud Holland* 3 (1885), pp. 171–208.

Rombouts 1864–75. Rombouts, Phillippe Félix and Théodore van Lerius. *De Liggeren en Andere Historische Archieven der Antwerpsche St. Lucasgilde.* Antwerp: Baggerman, 1864–75.

A. Rosenberg 1900. Rosenberg, Adolf. *Adriaen und Isack van Ostade.* Bielefeld and Leipzig: Velhagen and Klasing, 1900.

J. Rosenberg 1928. Rosenberg, Jakob. *Jacob van Ruisdael.* Berlin: B. Cassirer, 1928.

J. Rosenberg 1948. Rosenberg, Jakob. *Rembrandt.* 2 vols. Cambridge: Harvard University Press, 1948.

Rudolf II and Prague: The Court and the City 1997. Fucíková, Eliška, James M. Bradburne, Beket Bukovinska, and Jaroslava Hausenblasova, eds. *Rudolf II and Prague: The Court and the City.* Prague: Prague Castle Administration; London and New York: Thames and Hudson, 1997.

Rudolf Bys, Fürtrefflicher Gemähld- und Bilder-Schatz 1997. Bott, Katharina. *Rudolf Bys, Fürtrefflicher Gemähld- und Bilder-Schatz: Die Gemäldesammlungdes Lothar Franz von Schönborn in Pommersfelden.* Weimar: VDG, 1997.

Russell 1975. Russell, Margarita A. *Jan van de Cappelle.* Leigh-on-Sea: F. Lewis, 1975.

S

Sammlung Herbert Giradet 1970. Museum Boymans Van Beuningen. *Sammlung Herbert Giradet.* Rotterdam: Museum Boymans Van Beuningen, 1970.

Von Sandrart 1925. Von Sandrart, Joachim. *Teutsche Academi. Academie der Bau-, Bild- und Mahlerey-Künste von 1675. Leben der Berühmten Maler, Bildhauer und Baumeister. Hrsg. und Kommentiert von A. R. Peltzer.* Ed. Alfred R. Peltzer. Munich: G. Hirth, 1925.

Schaar 1958. Schaar, Eckhard. "Studien zu Nicolaes Berchem." PhD diss., Universität Köln, 1958.

Schavemaker 2005. Schavemaker, Eddy with Noortman Master Paintings. *One Hundred Master Paintings.* Maastricht: Noortman Master Paintings, 2005.

Schmidt-Degener 1949. Schmidt-Degener, Fredrick. *Het blijvend beeld der Hollandse kunst.* Amsterdam: J. M. Meulenhoff, 1949.

Schnackenburg 1993. Schnackenburg, Bernhard. *Das Kabinett des Sammlers: Gemälde vom XV. bis XVIII. Jahrhundert.* Ed. Mai Ekkehard. Cologne: Locher, 1993.

Schnackenburg 2000A. Schnackenburg, Bernhard. "Isack van Ostade." In Turner, Jane, ed. *The Grove Dictionary of Art. From Rembrandt to Vermeer: 17th-Century Dutch Artists.* From *The Grove Art Series.* New York: St. Martin Press, 2000.

Schnackenburg 2000B. Schnackenburg, Bernhard. "Adriaen van Ostade." In Turner, Jane, ed. *The Grove Dictionary of Art. From Rembrandt to Vermeer: 17th-Century Dutch Artists.* From *The Grove Art Series.* New York: St. Martin Press, 2000.

Schneider 1932. Schneider, Hans. *Jan Lievens, Sein Leben und Seine Werke.* Haarlem: Bohn, 1932.

Schneider and Ekkart 1973. Schneider, Hans with supplement by Rudolf E. O. Ekkart. *Jan Lievens, Sein Leben und Seine Werke.* 2nd ed. Amsterdam: Israël, 1973.

Scholten 2004–2005. Scholten, Frits. "The Larson Family of Statuary Founders: Seventeenth-Century Reproductive Sculpture." *Simiolus* 31 (2004–2005), pp. 54–89.

Schrevelius 1648. Schrevelius, Theodorus. *Haerlemias, ofte, om beter te seggen, de eerste stichtinghe der stadt Haarlem. . . .* Haarlem: Thomas Fonteyn, 1648.

Schulz 2002. Schulz, Wolfgang. *Aert van der Neer.* Doornspijk: Davaco, 2002.

Schumacher 2006. Schumacher, Birgit. *Philips Wouwerman: The Horse Painter of the Golden Age.* Doornspijk: Davaco, 2006.

Schwartz 2006. Schwartz, Gary. *De Grote Rembrandt.* Zwolle: Waanders, 2006.

Schwartz and Bok 1990. Schwartz, Gary and Martin Jan Bok. *Pieter Saenredam: The Painter and His Time.* Maarssen: G. Schwartz/SDU; New York: Abbeville Press, 1990.

Segal 1991. Segal, Sam and Lisbeth M. Helmus et al. *Jan Davidsz de Heem en Zijn Kring.* Braunschweig: Herzog Anton Ulrich-Museum, 1991.

Segal 2002. Segal, Sam. "De Kunstschilder Ambrosius Bosschaert in Breda." In Van Boxtel, H. et al. *Over helden, schurken en Hadewijch – Het geheugen van een stad.* Breda, [2002], pp. 54–69.

Seneko 2000. Senenko, Marina Sergeevna. *Holland XVII–XIX Centuries, Collection of Paintings.* Moscow: Galart, 2000.

Van Seters 1958. Van Seters, W. H. "Oud-Nederlandse Parelmoerkunst, Het Werk Van Leden Der Familie Belquin, Parelmoergraveurs En Schilders In De 17e Eeuw." *Nederlands Kunsthistorisch Jaarboek* 9 (1958), pp. 173–239.

Von Sick 1929. Von Sick, Ilse. *Nicolaes Berchem, ein Vorläufer des Rokoko.* Inaugural diss., Cologne, 1929.

Simon 1927. Simon, Kurt E. *Jacob van Ruisdael: Eine Darstellung Seiner Entwicklung.* Berlin: Druck von Hanewacker & Co., 1927.

Six 1919. Six, J. "Bevestigde overlevering." *Oud Holland* 37 (1919), p. 86.

Slive 1970–74. Slive, Seymour. *Frans Hals.* 3 vols. London: Phaidon, 1970–74.

Slive 2001. Slive, Seymour. *Jacob van Ruisdael: A Complete Catalogue of His Paintings, Drawings and Etchings.* New Haven and London: Yale University Press, 2001.

Small Wonders 2003. Wheelock, Arthur K. Jr. *Small Wonders. Dutch Still Lifes by Adriaen Coorte.* Washington: Board of Trustees, National Gallery of Art, 2003.

Smith 1829–42. Smith, John. *A Catalogue Raisonné of the Works of the Most Eminent Dutch, Flemish, and French Painters.* 9 vols. London: Smith and Son, 1829–42.

Smith 1842. Smith, John. *Supplement to A Catalogue Raisonné of the Works of the Most Eminent Dutch, Flemish, and French Painters, In Which Is Included a Short Biographical Notice of the Artists, etc.* London, 1842.

South Kensington Museum 1891. South Kensington Museum. *A Catalogue of Pictures of the Dutch and Flemish Schools: Lent to the South Kensington Museum by Lord Francis Pelham Clinton-Hope.* London: Eyre and Spottiswoode for H. M. S. O., 1891.

Spaans 2009. Spaans, Erik. "Spanjaarden populair op Russenloze Tefaf." *Het Financieele Dagblad, FD Persoonlijk,* March 21, 2009, p. 14.

Stechow 1928. Stechow, Wolfgang. "Bemerkungen zu Jan Steens künstlerischer Entwicklung." In *Zeitschrift für bildende Kunst* 62 (1928), p. 173.

Stechow 1938. Stechow, Wolfgang. *Salomon van Ruysdael: Eine Einführung in Seine Kunst mit Kritischem Katalog der Gemälde.* Berlin: Gebr. Mann, 1938.

Stechow 1948. Stechow, Wolfgang. "Jan Baptist Weenix." *Art Quarterly* 40 (1948), pp. 181–98.

Stechow 1966. Stechow, Wolfgang. *Dutch Landscape Painting of the 17th Century.* London: Phaidon, 1966.

Stechow 1975. Stechow, Wolfgang. *Salomon van Ruysdael: eine Einführung in seine Kunst: mit Kritischem Katalog der Gemälde*. 2nd ed. Berlin: Gebr. Mann, 1975.

Steeb 1996. Steeb, Christian. "Die Grafen von Fris: Eine Schweizer Familie und ihre wirtschaftspolitische und kulturhistorische Bedeutung für Österreich zwischen 1750 und 1830." PhD diss., Graz, 1996.

Steinberg 1990. Steinberg, Leo. "Steen's Female Gaze and Other Ironies." *Artibus et historiae* 22 (1990), pp. 111, 114, 123, 125.

Steland 1989. Steland, Anne Charlotte. *Die Zeichnungen des Jan Asselijn*. Fridingen: Graf Klenau, 1989.

Steland 2000. Steland, Anne Charlotte. In Turner, Jane, ed. *The Grove Dictionary of Art. From Rembrandt to Vermeer: 17th-Century Dutch Artists*. From *The Grove Art Series*. New York: St. Martin Press, 2000.

Steland-Stief 1971. Steland-Stief, Anne Charlotte. *Jan Asselijn Nach 1610 Bis 1652*. Amsterdam: Van Gendt, 1971.

Steland-Stief 1980. Steland-Stief, Anne Charlotte. "Zum zeichnerischen Werk des Jan Asselyn. Neue Funde und Forschungsperspektiven." *Oud Holland* 94 (1980), p. 253.

The Still Lifes of Adriaen Coorte 2008. Buvelot, Quentin. *The Still Lifes of Adriaen Coorte*. The Hague: Mauritshuis; Zwolle: Waanders, 2008.

Still-Life Paintings from the Netherlands 1550–1720 1999–2000. Chong, Alan and Wouter Kloek with Celeste Brusati. *Still-Life Paintings from the Netherlands 1550–1720*. Amsterdam: Rijksmuseum; Cleveland: The Cleveland Museum of Art; Zwolle: Waanders, 1999. [See also *Het Nederlandse Stilleven 1550–1720* 1999–2000.]

Stilleben in Europa 1979. Klemm, Christian. "Weltdeutung-Allegorien und Symbole in Stilleben." In *Stilleben in Europa: Katalog*. Münster: Landschaftsverband Westfalen-Lippe, 1979.

Stilleben: Meisterwerke der holländischen Malerei 2004. Grohé, Sefan. *Stilleben: Meisterwerke der Holländischen Malerei*. Munich: Prestel, 2004.

Strauss and Van der Meulen 1979. *The Rembrandt Documents*. Compiled by Walter L. Strauss and Marjon van der Meulen with S. A. C. Dudok van Heel and P. J. M. de Baar. New York: Abrais Books, 1979.

Stuurman-Aalbers et al. 1992. Stuurman-Aalbers, Janny et al. *10,000 Schilderijen, Tekeningen en Aquarellen*. The Hague: SDU, 1992.

Suchtelen 1993. Suchtelen, Ariane van. "Hans Bol. Een Van De Eerste Schilders Van Het Hollandse Stadsgezicht." *Antiek* 28 (1993), pp. 220–21.

Sullivan 1984. Sullivan, Scott A. *The Dutch Gamepiece*. Totowa, New Jersey: Rowman and Allanheld, 1984.

Sumowski 1983. Sumowski, Werner. *Gemälde der Rembrandt-Schüler*. 5 vols. Landau: Edition PVA, 1983.

"A Survey of the Collections in the Museum of Fine Arts, St. Petersburg." *Pharos* 14, 2 (1968), pp. 14–15, no. 26.

Sutton 1984. Sutton, Peter C. In Iandola, Jane Watkins, ed. *Masters of Seventeenth Century Dutch Genre Painting*. Philadelphia: Philadelphia Museum of Art, 1984.

Sutton 1992. Sutton, Peter C. *Dutch and Flemish Seventeenth Century Paintings The Harold Samuel Collection*. Cambridge: Cambridge University Press, 1992.

Sutton 2002. Sutton, Peter C. *Dutch and Flemish Paintings in the Collection of Willem Baron van Dedem*. London: Frances Lincoln, 2002.

Swillens 1935. Swillens, P. T. A. *Pieter Janszoon Saenredam: Schilder van Haarlem, 1597–1665*. Amsterdam: De Spieghel, 1935.

T

Tampa Morning Tribune 1950. *Tampa Morning Tribune*, February 27, 1950, p. 315.

Tekenen van Warmte 2001. Schatborn, Peter with Judith Verberne. *Tekenen van Warmte: 17de-eeuwse Nederlandse Tekenaars in Italië*. Amsterdam: Rijksmuseum; Zwolle: Waanders, 2001.

Tentoonstelling van Hollandse 17e Eeuwse Meesters 1960. Rekers, Hans. *Tentoonstelling van Hollandse 17e Eeuwse Meesters*. Haarlem: Kunsthandel J. R. Bier, 1960.

Tentoonstelling van Oude Kunst uit het Bezit van den Internationalen Handel 1936. Rijksmuseum. *Tentoonstelling van Oude Kunst uit het Bezit van den Internationalen Handel*. Amsterdam: Rijksmuseum, 1936.

Tentoonstelling van schilderijen door oud-Hollandsche en Vlaamsche meesters 1932. *Tentoonstelling van schilderijen door oud-Hollandsche en Vlaamsche meesters*. The Hague: Koninklijke Kunstzaal Kleykamp, 1932.

Terugzien in bewandering 1982. Van de Watering, Willem L. *Terugzien in bewandering: wat verzamelaars kozen: een nanderat 17de eeuwse Nederlandse schilderijen voornamelijk uit particulier bezit tentoonggesteld in het Mauritshuis*. The Hague: G. Cramer oude Kunst and Mauritshuis, 1982.

Thirty-five Paintings from the Collection of the British Rail Pension Fund 1984. Thos. Agnew & Sons Ltd. *Thirty-five Paintings from the Collection of the British Rail Pension Fund*. London: Thos. Agnew & Sons Ltd., 1984.

Thoré 1860A. Thoré, Theophile E. J. *Trésors d'art en Angleterre*. 2nd ed. Paris: Imprimerie Générale de Ch. Lahure, 1860.

Thoré 1860B. Thoré, Theophile E. J. *Musée van der Hoop à Amsterdam et Musée de Rotterdam*. Vol. 2 from *Musées de la Hollande*. Paris: J. Renouard; Brussels: F. Claassen, 1860.

Thoré 1865. Thoré, Theophile E. J. *Trésors d'art en Angleterre*. 3rd ed. Paris, J. Renouard, 1865.

Timmers 1974. Timmers, Jan Joseph Marie. *Christelijke Symboliek en Iconogragie*. Bussum: Fibular-Van Dishoeck, 1974.

Trezzani 2000. Trezzani, Ludovica. "Jan Both." In Turner, Jane, ed. *The Grove Dictionary of Art. From Rembrandt to Vermeer; 17th-Century Dutch Artists*. From *The Grove Art Series*. New York: St. Martin Press, 2000.

Tümpel 1974. Tümpel, Astrid. "Claes Cornelisz. Moeyaert." *Oud Holland* 88 (1974), pp. 1–163, 245–90.

Tümpel 1993. Tümpel, Christian. *Rembrandt*. 2nd ed. Antwerp: Fonds Mercator; New York: Distributed by Harry N. Abrams, 1993.

Turmoil and Tranquillity 2008. Gaschke, Jenny. *Turmoil and Tranquillity: The Sea through the Eyes of Dutch and Flemish Masters, 1550–1700*. Greenwich: National Maritime Museum, 2008.

Tussen stadspaleizen en luchtkastelen: Hans Vredeman de Vries en de Renaissance 2002. Borggrefe, Heiner, Thomas Fusenig, and Barbara Uppenkamp. *Tussen stadspaleizen en luchtkastelen: Hans Vredeman de Vries en de Renaissance*. Amsterdam: Ludion Gent, 2002.

U

Uit de schatkamer van de verzamelaar 1995–96. Broos, Ben P. J., Quentin Buvelot, Frederik J. Duparc, et al. *Uit de schatkamer van de verzamelaar: Hollandse Zeventiende-eeuwse meesters vit Netherlands particular benezit*. The Hague: Mauritshuis, Wormer: V+K, 1995.
[See also *The Amateur's Cabinet* 1995–96.]

Utrecht's Golden Age 2001. Blankert, Albert. *Utrecht's Golden Age. Caravaggisti and Italianate Painters in Dutch Collections*. Utrecht: Centraal Museum, 2001.

V

Valentiner 1923. Valentiner, Wilhelm R. with Karl Voll. *Frans Hals: des Meisters Gemälde in 322 Abbildungen*. Vol. 28. Berlin and Leipzig: Deutsche Verlags-Anstalt, 1923.

Valentiner 1924. Valentiner, Wilhelm R. *Nicolaes Maes*. Stuttgart: Deutsche Verlags-Anstalt, 1924.

Valentiner 1936. Valentiner, Wilhelm R. *Frans Hals Paintings in America*. Westport, Connecticut: F. F Sherman, 1936.

Van der Veen 2000. Van der Veen, J. In *Catalogue sale London (Christie's)* 52 (December 13, 2000), pp. 132–37.

Van de Velde: A Catalogue of the Paintings of the Elder and the Younger Willem van de Velde 1990. Robinson, Michael Strang. *Van de Velde: A Catalogue of the Paintings of the Elder and the Younger Willem van de Velde*. Greenwich: National Maritime Museum; The Hague: Distributed by Gary Schwartz/SDU, 1990.

Vasari 1550. Vasari, Giorgio. *Vite*, 1550. Ed. G. Milanesi. 1550. Reprint, Florence, G. C. Samsoni, 1878–85.

Vermeer and the Delft School 2001. Liedtke, Walter with Michiel C. Plomp and Axel Ruger and contributions by Reinier Baarsen et al. *Vermeer and the Delft School*. New York: The Metropolitan Museum of Art; New Haven and London: Distributed by Yale University Press, 2001.

Vermeer and the Delft Style 2008. Sutton, Peter C. with Tokyo-to Bijutsukan. *Vermeer and the Delft Style*. Tokyo: Tokyo Metropolitan Art Museum and Hata Stichting Foundation with Random House Kodansha, 2008.

"Verzeichnis der Gemälde der Churfl: Bilder-Gallerie von Mannheim, verfasst den 22ten July 1802." *"Verzeichnis Derjenigen Gemälde, Welche aus der Churfürstl. Mannheimer Gemälde-Sammlung Nach den Churfürstlichen Schloss Schleissheim Abgeschiket Worden Sind."*

"Verzeichnis der Gemälde-Sammlung des Johann Caspar Hoffbauer in Wien Anno" 1835. "Verzeichnis der Gemälde-Sammlung des Johann Caspar Hoffbauer in Wien Anno" 1835, Zimmer V, no. 22.

Verzeichnis der Gemälde in der Königlichen Pinakothek zu München 1838–65. *Verzeichnis der Gemälde in der Königlichen Pinakothek zu München*. Munich: Alte Pinakothek, 1838–65.

Veth 1892. Veth, G. H. "Aanteekeningen Omtrent Eenige Dordrechtse Schilders. XXXII Godefridus Schalcken." *Oud Holland* 10 (1892), p. 6.

Vogel 1996. Vogel, Carola. "Inside Art." *The New York Times*, January 5, 1996, sec. C, p. 25.

Vogelsang 1913. Vogelsang, Willem. *Catalogus van de meubelen in het Nederlandsch Museum voor geschiedenis en kunst te Amsterdam*. Nederlandsch Museum voor Geschiedenis en Kunst, 1913.

A. B. de Vries 1964. De Vries, Ary Bob. "Old Masters in the Collection of Mr. and Mrs. Sidney van den Bergh." *Apollo* 80, 33 (November 1964), p. 357.

A. B. de Vries 1968. De Vries, Ary Bob. *Verzameling Sidney J. van den Bergh*. Wassenaar, 1968.

L. de Vries 1975. De Vries, Lyckle. "Gerard Houckgeest." *Jahrbuch Hamburger Kunstsammlungen* 20 (1975), pp. 25–566.

L. de Vries 1977. De Vries, Lyckle. "Jan Steen: 'de Kluchtschilder.'" PhD diss., University of Groningen, 1977.

L. de Vries 1984. De Vries, Lyckle. *Jan van der Heyden*. Amsterdam: Meulenhoff/Landshoff, 1984.

Vroom 1945. Vroom, Nicolaas R. A. *De Schilders van het Monochrome Banketje*. Amsterdam: Kosmos, 1945.

Vroom 1980. Vroom, Nicolaas R. A. *A Modest Message as Intimated by the Painters of the "Monochrome Banketje."* 2 vols. Schiedam: Interbook International, 1980.

W

Waagen 1854. Waagen, Gustav F. *Treasures of Art in Great Britain*. Vol. 2. London: John Murray, 1854.

Waagen 1862. Waagen, Gustav F. *Handbuch der geschichte der deutschen und niederländischen Malerschulen*. Stuttgart: Ebner & Severt, 1862.

Van der Waals 2006. Van der Waals, Jan. *Prenten in de Gouden Eeuw: van Kunst tot Kastpapier*. Rotterdam: Museum Boijmans van Beuningen, 2006.

Waddingham 1964. Waddingham, Malcolm R. "Andries and Jan Both in France and Italy." *Paragone* 15, 171 (1964), pp. 13–43.

Wagner 1971. Wagner, Helga. *Jan van der Heyden 1637–1712*. Amsterdam and Haarlem: Scheltema & Holkema, 1971.

Waiboer 2005. Waiboer, Adriaan. "The Early Years of Gabriel Metsu." *The Burlington Magazine* 147 (2005), pp. 80–90.

Walker 1964. Walker, Richard John Boileau. *Audley End, Essex: Catalogue of the Pictures in the State Rooms*. 3rd ed. London: H. M. S. O., 1964.

A. L. Walsh 1985. Walsh, Amy L. "Paulus Potter: His Works and Their Meaning." PhD diss., Colombia University, 1985.

A. L. Walsh 1994. Walsh, Amy L. "De Stilistche ontwikkelingin het werk van Paulus Potter." In *Paulus Potter: Schilderijen, tekeningen en etsen*. The Hague: Mauritshuis; Zwolle: Wanders, 1994.

J. J. Walsh 1971. Walsh, John Joseph Jr. "Jan and Julius Porcellis: Dutch Marine Painters." PhD diss., Columbia University, 1971.

J. J. Walsh 1974. Walsh, John Joseph Jr. "The Dutch Marine Painters Jan and Julius Porcellis." *The Burlington Magazine* 116, 861 (December 1974), pp. 653–62, 734–35.

J. J. Walsh 1989. Walsh, John Joseph Jr. "Jan Steen's Drawing Lesson and the Training of Artists." *Source: Notes in the History of Art* 8/9 (Summer/Fall 1989), pp. 80–86.

J. J. Walsh 1996. Walsh, John Joseph Jr. *Jan Steen: The Drawing Lesson*. Malibu, California: J. Paul Getty Museum, 1996.

Waterhouse 1947. Waterhouse, Ellis Kirkham. "The Exhibition of Pictures from Althorp at Messrs. Agnew's." *The Burlington Magazine* 89, 528 (March 1947), p. 77.

G. J. M. Weber 2003. Weber, G. J. M. "Neues zum Werk von Jendrick de Fromantiou, Kunstagent und Hofmaler in Brandenburg." *Dresdener Kunstblätter* 03-2003 (*Beiträge*), p. 137 n. 4.

R. E. J. Weber 1976. Weber, R. E. J. "Willem van de Velde de Oude als Topograaf van Onze Zeegaten." *Oud Holland* 90 (1976), pp. 115–31.

Wegener 2006. Wegener, Gerrit. *Die Münchener Sammlungsgeschichte unter besonderer Berücksichtigung der Werke französischer Meister des 17. und 18. Jahrhunderts*. Berlin: Technische Universität Berlin, 2006.

Welcker 1933. Welcker, Clara Johanna. *Hendrick Avercamp 1585–1634, bijgenaamd "de Stomme van Campen;" Barent Avercamp 1612–1679, "Schilders tot Campen."* Zwolle: De Erven J. J. Tijl, 1933.

Weltkunst 1966. *Weltkunst* 36 (October 15, 1966), p. 939, no. 20.

Weltkunst 1977. Koetser Gallery Advertisement. *Weltkunst* 7 (April 1, 1977), p. 611.

De Wereld Binnen Handbereik 1992. Bergvelt, Ellinoor with Renee Kistemaker. *De Wereld Binnen Handbereik: Nederlandse Kunst- en Rariteitenverzamelingen, 1585–1735*. Zwolle: Waanders; Amsterdam: Amsterdams Historisch Museum, 1992.

Van Westrheene 1867. Van Westrheene, Tobias. *Paulus Potter, Sa Vie et Ses Oeuvres*. The Hague: M. Nijhoff, 1867.

Weyerman 1729–69. Weyerman, Jacob Campo. *De Levens-Beschryvingen Der Nederlandsche Konst-Schilders En Konst-Schilderessen: Met Een Uytbreyding Over De Schilder-Konst Der Ouden*. Vol. 2. The Hague: E. Boucquet, 1729–69.

Wiersum 1910. Wiersum, Eppe. "Het Schilderijen-Kabinet van Jan Bisschop te Rotterdam." *Oud Holland* 28 (1910), p. 173.

Wieseman 1991. Wieseman, Marjorie Elizabeth. "Caspar Netscher and Late Seventeenth-Century Dutch Painting." PhD diss., Columbia University, 1991.

Wieseman 2002. Wieseman, Marjorie Elizabeth. *Caspar Netscher and Late Seventeenth-Century Dutch Painting*. Doornspijk: Davaco, 2002.

Van der Willigen and Meijer 2003. Willigen, Adriaan van der and Fred. G. Meijer. *A Dictionary of Dutch and Flemish Still-life Painters Working in Oils, 1525–1725*. Leiden: Primavera Press in cooperation with the Netherlands Institute for Art History, 2003.

De Winter 1767. De Winter, Hendrik. *Beredeneerde Catalogus Van Alle De Prenten Van Nicolaes Berchem*. Amsterdam: Johannes Smit, 1767.

With Heart and Soul 2008. Van der Ploeg, Peter and Quentin Buvelot. *With Heart and Soul: Frits Duparc as Director of the Mauritshuis 1991–2008*. The Hague: Mauritshuis; Zwolle: Waanders, 2008.

Wrey 1985. Wrey, Mark. *Christie's Review of the Season*. Oxford: Christie, Manson & Woods Ltd., 1985.

Von Würzbach 1906–11. Von Würzbach, Alfred. *Niederländisches Künstler-Lexikon: Auf Grund Archivalischer Forschungen Bearbeitet*. 3 vols. Vienna and Leipzig: Halm und Goldmann, 1906–11.

Z

Zadelhoff 2000. Zadelhoff, Trudi van. "Philipe Koninck." In Turner, Jane, ed. *The Grove Dictionary of Art. From Rembrandt to Vermeer: 17th-Century Dutch Artists*. From *The Grove Art Series*. New York: St. Martin Press 2000.

Zandvliet 2006. Zandvliet, Kees. *De 250 Rijksten in de 17de Eeuw: Kaptiaal, Macht, Familie en Levensstijl*. Amsterdam: Rijksmuseum Nieuw Amsterdam, 2006.

Zee-Rivier-en Oevergezichten 1964. Bol, Laurens Johannes. *Zee-Rivier-en Oevergezichten: Nederlandse Schilderijen uit de Zeventiende Eeuw*. Dordrecht: Dordrechts Museum, 1964.

Zeldzaam Zilver uit de Gouden Eeuw, De Utrechtse edelsmeden Van Vianen 1984. Van Zijl, M. I. E and Johan R. ter Molen. *Zeldzaam Zilver uit de Gouden Eeuw, De Utrechtse edelsmeden Van Vianen*. Utrecht: Centraal Museum, 1984.

Zinnen en Minnen 2004–2005. Waiboer, Adriaan E. In *Zinnen en Minnen: Schilders van het Dagelijkse Leven in de Zeventiende Eeuw*. Rotterdam: Museum Boijmans Van Beuningen, 2004.

INDEX

PHOTOGRAPHY CREDITS

"My Dear Rose-Marie, Dear Eijk"
Figure 1. Image © 2010 Peabody
Essex Museum. Photograph
by Walter Silver. Figure 2.
© Photograph by Peter Strelitski.
Figures 3–5. With thanks to
Marja Stijkel. Figures 6, 7. Image
courtesy Museum of Fine Arts,
Boston.

The Paintings
Catalogue 1, 4, 6, 9, 17, 25, 27,
42, 44, 45, 47, 48, 55, 59, 61, 65,
66. Image courtesy Museum of
Fine Arts, Boston. Catalogue
2, 3, 8, 10, 14, 15, 21, 24, 29, 30,
33, 34, 36, 51, 57, 58. Image ©
2010 Peabody Essex Museum.
Photograph by Michael
Tropea, Chicago. Catalogue 13.
Image courtesy Royal Picture
Gallery Mauritshuis, The
Hague.Catalogue 35, 37. Image
courtesy National Gallery of
Art, Washington, DC. Asselijn
Figure 1. © Staatliches Museum,
Schwerin. Photograph by Elke

Walford. Asselijn Figure 2. Image
courtesy Frits Duparc. Bol
Figure 1. © Fitzwilliam Museum,
Cambridge. Bol Figure 2.
Amsterdams Historisch Museum,
Amsterdam. Bosschaert Figure
1. © Friends of the Mauritshuis
Foundation, The Hague.
Bosschaert Figure 2. Photograph
by Joerg P. Anders, © Bildarchiv
Preussischer Kulturbesitz/
Art Resource, NY. Brueghel
Figure 1. Under license from the
Italian Ministry for Cultural
Goods and Activities. Van de
Cappelle Figure 1. © Friends of
the Mauritshuis Foundation,
The Hague. Van de Cappelle
Figure 2. © The Art Institute of
Chicago. Van de Cappelle Figure
3. © 2010 Kunsthaus Zürich.
All rights reserved. Dou Figure
1. © Bildarchiv Preussischer
Kulturbesitz/Art Resource, NY.
Du Jardin Figure 2. Petit Palais,
Musée des Beaux-Arts de la Ville
de Paris. Grimmer Figures 1–3.

© Christie's Images/The
Bridgeman Art Library. D. Hals
Figure 1. Szépmüvészeti Múzeum,
Budapest. Houckgeest Figure
1. © Friends of the Mauritshuis
Foundation, The Hague. Koedijck
Figure 1. National Galleries of
Scotland Picture Library. Lievens
Figure 1. Bildarchiv Preussischer
Kulturbesitz/Art Resource,
NY. Lievens Figure 2. © Städel
Museum-ARTOTHEK. Moeyaert
Figure 1. Amsterdams Historisch
Museum, Amsterdam. Rembrandt
Figure 1. © The Metropolitan
Museum of Art/Art Resource,
NY. Van Ruisdael Figure 2. © The
Cleveland Museum of Art. Van de
Velde the Younger Figure 1. © The
National Gallery, London/Art
Resource, NY.

Painting – In Silver, Wood, and
Mother-of-Pearl
Figure 4. Photograph by Malcolm
Varon. Image © The Metropolitan
Museum of Art/Art Resource,

NY. Catalogue 68, 69. Image
© 2010 Peabody Essex Museum.
Photograph by Walter Silver.

Dutch Furniture from the
Golden Age
Catalogue 71–76, 78–87.
Image © 2010 Peabody Essex
Museum. Photograph by Walter
Silver. Catalogue 77. Image
courtesy Museum of Fine
Arts, Boston. Figure 2. Image
courtesy Collection Van Aalst
Antiquiteiten, Breda.